Diane Arbus

Diane Arbus

PORTRAIT OF A PHOTOGRAPHER

Arthur Lubow

ecco

An Imprint of HarperCollinsPublishers

HarperCollins books may be purchased for educational, business, or sales promotional use. For information please e-mail the Special Markets Department at SPsales@harpercollins.com.

FIRST EDITION

Designed by Shannon Nicole Plunkett

Library of Congress Cataloging-in-Publication Data has been applied for.

ISBN 978-0-06-223432-2

16 17 18 19 20 OV/RRD 10 9 8 7 6 5 4 3 2 1

For Jason

A photograph is a secret about a secret.
The more it tells you the less you know.

—DIANE ARBUS

CONTENTS

PART THREE: BECOMING A PHOTOGRAPHER

PART FOUR: KNOWING PEOPLE IN AN ALMOST BIBLICAL SENSE

PART FIVE: THE CRYSTAL-CLEAR VISION OF A POET

PHOTOGRAPHS DISCUSSED IN THE TEXT

Room with lamp and light fixture, N.Y.C. 1944

Self-portrait pregnant, N.Y.C. 1945

Laughing girl, Italy, circa 1951

A hill in Frascati, Italy, circa 1952

Nuns and their charges, Italy, 1952

Boy above a crowd, N.Y.C. 1956

Boy in the subway, N.Y.C. 1956

Boy reading a magazine, N.Y.C. 1956

Boy stepping off the curb, N.Y.C. circa 1956

Carroll Baker on screen in "Baby Doll" (with silhouette), N.Y.C. 1956

Couple eating, N.Y.C. 1956

Falling leaf with bare branches in background, N.Y.C. 1956

Kiss from "Baby Doll," N.Y.C. 1956

Lady on a bus, N.Y.C. 1956

Masked boy with friends, Coney Island, N.Y. 1956

People on a bench, Central Park, N.Y.C. 1956

Woman in a bow dress, N.Y.C. 1956

Woman carrying a child in Central Park, N.Y.C. 1956

Three Puerto Rican women, N.Y.C. 1963

Triplets in their bedroom, N.J. 1963

Valentino look-alike at an audition, N.Y.C. 1963

A widow in her bedroom, N.Y.C. 1963

Woman with white gloves and a fancy hat, N.Y.C. 1963

Xmas tree in a living room, Levittown, L.I. 1963

A young waitress at a nudist camp, N.J. 1963

Bishop by the sea, Santa Barbara, Cal. 1964

Bishop on her bed, Santa Barbara, Cal. 1964

Christ in a lobby, N.Y.C. 1964

Lady bartender at home with a souvenir dog, New Orleans, La. 1964

Santas at the Santa Claus School, Albion, N.Y. 1964

A family one evening in a nudist camp, Pa. 1965

Girl and boy, Washington Square Park, N.Y.C. 1965

Girl with a cigar in Washington Square Park, N.Y.C. 1965

John Gruen and Jane Wilson, N.Y.C. 1965

Mrs. T. Charlton Henry on a couch in her Chestnut Hill home,
 Philadelphia, Pa. 1965

Puerto Rican woman with a beauty mark, N.Y.C. 1965

Sharon Goldberg, N.Y.C. 1965

Two friends at home, N.Y.C. 1965

Two young men on a bench, Washington Square Park, N.Y.C. 1965

Young couple on a bench in Washington Square Park, N.Y.C. 1965

Young man and his pregnant wife in Washington Square Park,
 N.Y.C. 1965

A young Negro boy, Washington Square Park, N.Y.C. 1965

Couple in bed, N.Y.C. 1966

Couple under a paper lantern, N.Y.C. 1966

James Brown at home in curlers, Queens, N.Y. 1966

A lobby in a building, N.Y.C. 1966

The 1938 Debutante of the Year at home, Boston, Mass. 1966

PART ONE

A DAUGHTER, A WIFE, AND A MOTHER

1

The Decisive Moment

"I can't do it anymore. I'm not going to do it anymore," Diane announced. It had been a long, stressful workday, a typical marathon of drudgery and anxiety. In the photography studio she and her husband, Allan, used for their fashion shoots, which overlooked the all-white, double-height living room of their triplex apartment on the Upper East Side of Manhattan, the Arbuses had established a routine. Allan set up the lights and the camera, told the models what to do and snapped the pictures. During the session, Diane would monitor details, which usually came down to reassuring the models and checking that the clothes were correctly displayed. "Diane would have to go in and pin the dress if it wasn't hanging right," Allan Arbus recalled half a century later. "It was a very subservient role. It was demeaning to her, to have to run to these gorgeous models and fix their clothes. It was a repulsive role." And now, after a decade of collaboration in which they had meshed as tightly as gear cogs, calling each other "Boy" and "Girl," Diane told him she had had enough.

Both Arbuses were worriers. Their temperaments inevitably dogged them in a venture in which they had to deliver a satisfactory product on deadline on the basis of a onetime session. "We always felt the photographs weren't good enough," Allan

recounted. "We would wait breathlessly for the new *Vogue* and *Bazaar* to come out." Sometimes Diane, her hair a mess, would run to the corner store, carrying her customary paper bag in place of a purse. Allan thought she inspired a *New Yorker* cartoon "of a bag lady asking at the newsstand for the latest copy of *Vogue*."

For Diane, there was, aside from the competitiveness and the uncertainty, a more fundamental problem with fashion photography. Years after she had moved on, she expressed the crux of the difficulty to a reporter. "I hate fashion photography because the clothes don't belong to the people who are wearing them," she said. "When the clothes do belong to the person wearing them, they take on a person's flaws and characteristics, and are wonderful." Founded upon a chasm between the models in the pictures and the editors who determine how they are dressed, fashion photography is designed to lie. Arbus was committed to a photography that told the truth.

It wasn't just truth she was after, but Truth. She wanted her pictures to reveal profound verities, to pry out what was invisible to the casual eye. A photograph is a record of what appears on the surface. How can it be anything other than superficial? Arbus's career as a mature photographer maps a series of strategies to make a photograph yield more than it is naturally equipped to deliver. She photographed freaks, nudists, female impersonators and mentally disabled adults, because, either by choice or by necessity, they disclosed more of themselves in everyday life than the typical person. She spent weeks, and sometimes years, getting to know her subjects so well that they dropped their guard in her presence. If time was limited, she learned to surprise people into candor, or to exhaust them into it. She could be devious in her efforts to produce a photograph she considered honest. "I love secrets, and I can find out anything," she said. As a fashion photographer, she was being paid not to uncover but to conceal. And she wasn't even the photographer. Allan was clicking the shutter.

Allan said that their insecurity motivated them to build an overarching idea into every shoot. Diane was the one who would

come up with the concept. By the time a session took place, once she adjusted the hair and the skirts, her job was mostly done. She would slink along the sidelines, snapping pictures with her 35 mm camera, while Allan, placing his head beneath the cloth of the view camera, shot 8×10 film. It was obvious to everyone that Allan was the professional photographer, Diane a dilettante. With her contradictory blend of ambition and insecurity, Diane was unsure of where she stood. Allan alone, even as he ran a studio in which Diane seemed subordinate, acknowledged without a speck of uncertainty that she was the true artist.

The evening that Diane called it quits, their neighbor Robert Brown was there, as he often was. He watched uncomfortably as the couple's working partnership unraveled. "I remember Allan was stunned, because I don't think this was ever threatened before," Brown recalled. "He gave the room a blank look, like, 'Did I hear that right?' She just raised her voice one octave. Her energy was so controlled. And I think she left the room. And Allan looked at me. I was embarrassed for him that I was there. It was something that happened inside of her. I don't think he expected it. He seemed beyond bewildered. I think Allan was shattered and not prepared for what was going to happen next. And I don't think she was, either."

2

Stage-Set French

Glimpsed from afar, Central Park was a peaceful expanse of green lawns, spreading trees and craggy rocks. But up close, seven-year-old Diane Nemerov faced something else, something alien. Holding the hand of her French governess, whom ten years later she would describe as having "a hard, sad, quite lovely face . . . as if she had a very sad secret and she would never tell anyone," the small girl stared in fascinated bewilderment at a shantytown of shacks made of sheet metal and cardboard. It was 1930. Over a hollow that once held the city's thirty-five-acre reservoir spread New York's most conspicuous Hooverville, an ugly boil at the start of the Great Depression. (Later, it would be flattened into the Great Lawn.) But none of this was comprehensible to a child, and especially not to this child. Throughout Diane's early years, she was kept carefully guarded from the less fortunate aspects of life. "You know, the outside world was so far from us . . . and one didn't ever expect to encounter it," she once explained. "And for a long time I lived that way, as if there was a kind of contagion somewhere." Because these strange creatures in Central Park participated in a life that was closed off to her, she looked on them with a kind of yearning: "I don't mean to say I would have envied those people, but just the idea that you

couldn't get in there, you know, that you couldn't just wander
down and that there was such a gulf."

At the time, the Nemerov family—which consisted of Diane's
parents, older brother, and baby sister—resided in a large Park
Avenue apartment, a succession of chambers draped with heavy
curtains to filter in a perpetual twilight gloom. In this protected
nest, the Nemerovs' needs were ministered to by three nannies,
two maids, a cook, and a chauffeur. The furniture was reproduc-
tion eighteenth-century French, and there was pearl-pink Chi-
nese wallpaper on the dining room walls. Theirs was a cushioned
life that rested on a pile of furs. Frank Russek, Diane's maternal
grandfather, was a Polish Jewish immigrant who opened a small
fur store soon after arriving in New York in the late 1880s, when
he was about fifteen years old. In 1897, he joined forces with two of
his brothers—backed, if family lore is to be trusted, by his book-
maker earnings—to expand to a larger shop. The Russek broth-
ers thrived, and they were able in 1912 to relocate to a longed-for
Fifth Avenue address, where they attracted an affluent clientele.
By then, Frank and his wife, Rose, were raising two children: Ger-
trude, born in 1901, and Harold, who arrived a year later.

Gertrude was only about sixteen when she began noticing a
young window dresser at Russeks Fifth Avenue. David Nemerov
was also the son of Jewish immigrants—less prosperous ones. His
father, Meyer Nemerov, had come to New York from Kiev. Meyer
was a devoutly pious man who, upon retiring from the real estate
business, spent his days studying Talmud in the synagogue and
promoting Jewish philanthropies in his Brooklyn neighborhood.
"I always hated my father and his religion," David would acknowl-
edge late in life. Unlike his father, David moved smoothly through
the material world. He had a keen sense of fashion and an even
greater flair for marketing. Slim and well tailored, he presented
a glamorous figure that was out of keeping with his poverty. The
incongruity bothered him: he did not intend to remain poor for-
ever. Although Frank and Rose Russek discouraged his interest
in Gertrude, their daughter would not be denied. In late 1919,

the charming, ambitious employee and the young, pretty heiress were married. They had given the Russeks no choice. Their first child, Howard, appeared in the world twenty-one weeks later. The family expanded to include Diane, born on March 14, 1923, and finally Renee, born five and a half years afterward. The two older children shared a special bond, into which the youngest did not enter.

The Russeks enterprise continued to flourish. Already one of the city's leading fur stores, it widened its mission to offer a full line of women's clothing and moved in 1924 into a Stanford White building on Fifth Avenue at Thirty-Sixth Street that had been designed for Gorham Silver. The elegant but narrow eight-story structure eventually proved to be too small, and in 1936, the proprietors purchased and annexed a neighboring building. Over the next decade, they opened branches in Brooklyn and Chicago.

David Nemerov also progressed and prospered. He worked long hours at Russeks, first as merchandising director, then as fashion director and vice president, and finally, beginning in 1947, as president. A master at writing ad copy and a proponent of spending money to decorate store windows even during the Great Depression, Nemerov knew that a retailer's first challenge was to attract customers into the shop. Once they were inside, he was adept at providing them with a reason to buy. He was among the first New York merchants to travel regularly to Paris to scrutinize the collections, which he would copy and sell at a cheaper price.

Gertrude loved sailing by ocean liner to France with David to see the couture presentations and to buy new clothes from French designers. (On one occasion, Howard, Diane and Diane's governess were taken along.) While the care and energy that David lavished on Russeks took place mostly out of the children's view, the attention that Gertrude devoted to herself they witnessed daily. Mrs. Nemerov typically stayed in bed in the morning past eleven o'clock, smoking cigarettes, talking on the telephone, and applying cold cream and cosmetics to her face. At noon she liked to meet a friend to go shopping and to lunch at

Schrafft's. Some days she had the chauffeur drive her to Russeks, where she would bask in the deference that was her due. For her husband, the maneuvering of business was a form of art; after his retirement, he would take up painting, a long-held dream. As far as Gertrude's children could tell, their mother's aspirations were narrower. She was a self-involved woman with conventional tastes and prejudices. "I wonder where you children came from," she would say querulously to her artistically minded brood. The art forms she enjoyed were movies and theater. In a nod to these preferences, her older daughter was named for the leading character in a sentimental hit play, *Seventh Heaven,* that Gertrude saw during her pregnancy. The name was pronounced *Dee-ANN,* because that is how the Parisian heroine (who resists pressure from her wealthy relatives and marries the poor man she loves) said it. It was stage-set French, like the fake Louis furniture in the Nemerov apartment.

Not even the Nemerovs escaped the Depression completely. Pinched by the retail slowdown, they reduced expenses. Gertrude sold some of her jewelry. The family relinquished the apartment on Park Avenue and crossed town to a privileged exile in a fourteen-room apartment in the San Remo on Central Park West, with several rooms overlooking the park. Occasionally, less well-off relatives would stay with them; Gertrude's parents came to live in the apartment. None of this was outwardly visible, which was essential, because the Nemerovs were devoted to the world of appearances. "The front would have to be maintained, because I've learned that in business, if people smell failure in you, you've had it," Diane later said. This was especially true in the fashion industry, which, after all, was dedicated to the cultivation and reshaping of the human image.

For the Nemerovs, the importance of appearances extended beyond the business world. Gertrude Nemerov's sense of self was critically dependent on how others regarded her beauty and social status. She did what she thought was expected of her in public and then indulged herself privately. Although she sub-

scribed to the Metropolitan Opera, as a cultivated New York lady should, she had no interest in attending performances. She would rather play cards with her friends or her mother. Howard used the tickets. "We thought she was terribly artificial, concerned with outward appearances only, in how things looked to people," Renee said, recalling how she and Diane regarded their mother. "Preserving an image that she wanted to present to the world: society lady." "Diane was very scathing about it," said Frederick Eberstadt, who knew her as an adult. "She thought it was pretentious and fake. She felt her mother had money but no style. She saw it as a kind of tinny reflection of WASP glory." Another friend from Diane's adulthood took a more sympathetic view: "I felt that most of what Gertrude had and did was representative of something rather than something she wanted herself, which is what made her a sad person."

In her insecurity, Gertrude was vulnerable to spells of anxiety and depression, and when Diane was eleven, she suffered a nervous collapse. Gertrude later recalled that at that time, Diane would grab on to her hand—"clung to me, literally clung to me"—but the little girl could not keep her mother from descending into the underworld. Gertrude withdrew from family life in a depression that persisted for many months. Her children became alien to her. "I started thinking I don't love them, I didn't understand them," she said. "They were all so bright they intimidated me. I started thinking I couldn't care properly for my children. I felt helpless. I was so miserable that I could barely function." She recalled sitting dumbly at the dinner table while her husband instructed the second maid to pack the children's clothes for camp because Mrs. Nemerov was unwell. Diane would retreat into her own bedroom, lock the door and stay there for hours. "Nobody knew what she did in there, and she never confided," Gertrude said. Gertrude likewise never divulged the cause of her pain and anxiety, why she was so immobilized that she couldn't dress or wash herself. When a psychiatrist was consulted, she pulled herself out of this morbid torpor to avoid responding to

his frighteningly intimate questions. Self-revelation was unthinkable. One relative thought she avoided alcohol for fear of making an inadvertent disclosure in an uninhibited state. She even tore up her grocery and shopping lists before discarding them.

Behind Diane's parents' closed doors, many secrets were being whispered. There were the financial strains of keeping a luxury business running during the Depression and the awkwardness of cutting back on expenses without drawing attention to the need. There was gossip about David's philandering, which became painfully public many years afterward, with the identifying of a "Mr. Nemeroff" as a call girl's client in a tabloid-sensation trial in 1955. (Reading her father's name in the *World-Telegram,* Diane imagined that perhaps no one else had noticed.) The family mysteries flashed into view with the mother's breakdown, which went unmentioned. Because all they saw was the surface, the children could only imagine what was being said, what was really going on.

To young Diane, the pretenses that characterized the family's life were mortifying. Her visits to Russeks in Gertrude's company were painful. Mother and daughter would arrive around noon and walk down the purple velvet carpet of the main floor (David Nemerov had determined the décor), past fur coats that were displayed in the hushed, religious atmosphere that such expensive merchandise commanded. Feeling like "a princess in some loathsome movie of some kind of Transylvanian obscure middle European country," Diane would walk by the salespeople, who "bowed slightly and smiled" as if "the obsequies were seasoned with mockeries." Even the mannequins seemed to be leering at her.

She didn't want for anything. Less happily, she didn't want anything, either. "One of the things I felt I suffered from as a kid was that I never felt adversity," she said, late in her life. As she described it, "I was confirmed in the sense of unreality which I only could feel as unreality. . . . I mean that sense of being immune, you know, was, ludicrous as it seems, a kind of painful one." She smothered any desires for the future, believing that if she expressed them, even to herself, she certainly would be disappointed—"that fate

is a trickster who tricks hope and that I will always stand to lose by wanting anything." She recalled that her mother taught her to avoid unhappiness by expecting it, and warned that to look forward to good news would prevent its arrival. And whenever she slipped into an expectation that went unmet, Diane as a child fought back her tears and said "Well" in her best imitation of grown-up bravery.

She retreated from the sham, emotionally remote world into her imagination. A reader of fairy tales, she dwelled in her mind among goblins, trolls and kings, who seemed at least as real as the people around her.

3

Them Against the World

The prince in this chilly, gilded kingdom languished alongside the princess. Howard was a bookish boy with an ostentatiously intellectual manner and a yearning for parental love, especially the paternal love that he never could count on. His father devoted most of the day to the demands of a business empire that interested Howard no more than it did Diane. Nor did the family fortune feel enriching to Howard. Once, when he was three or four, he took an excursion with his German nanny to Van Cortlandt Park in the Bronx and brought home a postcard to show his father. David Nemerov scolded him for the profligate expense—about three cents. The Nemerov children were taught to save, not spend. If their Russek grandfather gave them a ten-dollar gold piece, it came with the understanding that they would put it away, Diane said, "for some illusory future."

Howard believed that his parents doled out approval, not love, and as a consequence he thirsted emotionally. The first time he could remember failing to live up to their expectations occurred when he was two years old. To his parents' distress, he was still sucking his thumb, a babyish habit that they were determined to break. They had a large steel thimble attached to the boy's tiny finger. Howard wept heartbreakingly, but eventually he was

cured. In coming years, he would often cry during arguments with his father. On the other side, David Nemerov subscribed to the manly code of hiding emotion; the telltale sign of his anger was that his voice would drop in volume to a whisper. If Howard acted in a way that annoyed him, the father typically would say nothing until the little boy approached him in the morning at breakfast. At that moment, in a tone that Howard grew to recognize unmistakably, David would thwart him with the words "Don't kiss me, I have a cold." The boy would have to wait until the end of the day "under the threat of his powerful, unforgiving will" to see if Father had forgiven him.

The pinpricks of David's criticisms tattooed Howard's psyche permanently. When he was thirteen and contracted typhoid fever, which required him to be quarantined from his sisters, Howard was given a copy of Dickens's *A Tale of Two Cities*. He complained to his father that in his feverish state he couldn't understand it. "Will you never grow up?" David said with exasperation. Howard painfully recalled that slight many decades later.

As small children, Howard and Diane frequently fought. One time they scuffled over a china doll that broke and cut Diane's lip, leaving a lifelong thin white scar. However, by the time Howard was thirteen and Diane ten, the bickering subsided and they became allies: Howard, the tall handsome boy with a thick head of dark blond hair, an intelligent-looking oval face and a lean, athletic build honed by track practice; and Diane, the pretty sister with a thoughtful frown and an abstracted look in her eyes. "It was them against the world," their excluded little sister Renee recalled. Howard and Diane even resembled each other, or so thought their mother. "They had the same dreamy, faraway expression, the same black eyebrows and thin lips," Gertrude said. "They were both secretive—Diane less verbal but the most original."

Although both excelled in high school, their teachers agreed with Gertrude. Howard was "very arrogant, very opinionated," as their art teacher put it, but Diane was "an original," the one with unique, extraordinary gifts, whose mind moved so rapidly and

unpredictably that her thinking could be hard to follow. Elbert Lenrow, who had taught Howard and found him to be "exceptionally brilliant," awaited Diane's arrival in his senior-year class on Western Literature from Homer to Hardy, and was amazed to discover that "she was far more brilliant than Howard" because "she was very, very brainy, very smart, but she also had great instincts, great intuition." Most of all, he said, she was "totally original." That word, *original,* was glued to young Diane like a Homeric epithet. Howard himself remarked that "she was so much more original and striking than I was." Her vision was startlingly distinctive. "I was more verbal," he said, "although when she made a statement—which wasn't very often—it was precise, epigrammatic, poetic. You'd recognize it, the way you'd recognize one of her pictures." Rather than speak, Diane preferred to watch and listen. A high school girlfriend of Howard's recalled coming to the Nemerov apartment so that Howard could teach her to play the piano. "Diane would come and stand in the doorway and watch us with great curiosity," the friend said. "She would disappear and then she would sneak around and come back, not saying anything. She was peeking around in the hall and lurking."

While physically affectionate, Howard's relationship with his girlfriend, Hope Greer, centered on their shared literary and artistic interests. That was very much Howard's character. Diane looked on herself as a nonlinear thinker whose knowledge was personal, limited and, in a word, "feminine"; and she considered Howard, with his systematic mind, to be the intellectual of the family. Reading excited him, erotically as well as cerebrally. He found exceptionally arousing the mythological tale of the Minotaur, whose bloodthirst was slaked by the periodic sacrifice of seven brave youths and seven fair maidens. He would masturbate to the mental image of the beautiful bound captives. For young Howard, jerking off was a solemn rite; his private name for it was "worship." But one time he was unlucky and his father caught him at it, and told him that if it ever happened again, he would kill him.

What would have been David's reaction had he surprised
Howard during one of his sessions of amorous exploration
with Diane? As Howard later acknowledged, he and his sister
experimented sexually when they were young. Perhaps, as Renee
thought, they indulged in their secret pastime when there was
little risk of discovery, such as during those summer weeks when
they were left alone in the big apartment during their parents'
trips to France. Diane and Howard liked to "play house" in a
tent they constructed by draping blankets over two armchairs.
Within that shelter, they would caress and kiss each other, in imi-
tation of the little gold replica of Rodin's *The Kiss* that adorned
the rim of their mother's jade ashtray.

After they were both adults and he had found his vocation
as a poet, Howard wrote in "An Old Picture" about a portrait of
youthful "betrothed royalties," which, he later realized, resem-
bled an actual painting of himself as a little boy with his younger
sister Diane, all dressed up for the occasion, posed on a red set-
tee. In his erotically charged exposition of the semi-imaginary
painting, composed in painstakingly rhymed couplets, the chil-
dren "go hand in hand" and "exchange a serious look" while a
bishop and a queen disapprovingly "frown upon their love" from
behind a screen. According to this poem, which was published
when Howard and Diane were in their early thirties, the elders
control the children's future:

> It shall be as they have ordained:
> The bridal bed already made,
> The crypt also richly arrayed.

The mood of lugubrious eroticism hangs heavy, as it did in
Howard's youthful masturbatory fantasies.

In later life, Diane's friends and lovers would often charac-
terize her seductive presence as peculiarly sisterly, so much so
that it could have seemed as if the impression of that first erotic

partner—the brother who, like her, was imprisoned in a loveless realm—stayed with her and shaped her subsequent attachments. But it was even more complicated than that. Diane was a great hoarder of secrets, persistently extracting those of others, distributing her own strategically. In the last two years of her life, she paid weekly visits to a psychiatrist in an effort to cope with her depression. She revealed in those sessions that the sexual relationship with Howard that began in adolescence had never ended. She said that she last went to bed with him when he visited New York in July 1971. That was only a couple of weeks before her death.

Characteristically, she referred to their ongoing sexual liaison in an offhand way, as if there was nothing so remarkable about it.

4

Mysterious, but Not Blurry

After an art class trip to see a Dada show at the Museum of Modern Art—which included such wondrous transformations as a teacup, spoon and saucer covered in fur, and a collage of a lion's head on a Victorian woman's body—thirteen-year-old Diane created an unusual painting. It resembled on first glance a Gothic church arch, until you saw at the pointed apex the suggestion of a woman's head, and on closer inspection you noticed the two lines crossed where hands would be, and a pearl in the center of the stomach region. Diane said it was a portrait of a mother.

But even before the Dada outing, she painted in her own way. "Her style really from the beginning was not like ours," said Stewart Stern, a Fieldston School classmate. "She would look at a model and draw what none of us saw. It was never representational." Fieldston was a high school in the affluent Riverdale section of the Bronx that continued the educational program begun at the Ethical Culture School on the Upper West Side. Diane attended both schools, which catered to an upper-middle-class Jewish community. The program was progressive, the student body intelligent and well read, but even among her privileged and gifted peers (Stern, for example, became a distinguished screenwriter), Diane stood out. More impressive than

her technique was the unconventional slant of her vision. If the art teacher, Victor D'Amico, gave her two cups to paint, she would portray the shiny new one with mechanical proficiency, while the blemished, imperfect cup she regarded and represented passionately. "She responded to it like a person," D'Amico said. "She always responded to inanimate objects as if they were people." And when she depicted people, she didn't like them posing. The students took a life study class in which they drew nude models. Diane preferred to represent them half-dressed, during their cigarette break.

Everyone applauded the adolescent's talents. She received a box of oil paints from her parents when she was eleven or twelve, and her father arranged for Saturday lessons with Russeks' illustrator. Relatives and teachers were constantly telling her how "marvelous" her work was. Recommending her for a summer program at the progressive Cummington School of the Arts in western Massachusetts, D'Amico, who would later be the director of education for the Museum of Modern Art, wrote: "Her style is highly individual and her manner of expression unique. We have tried to develop her powers without damaging her personal gifts in any way."

The repeated praise for her paintings and drawings rang hollow to Diane. "The horrible thing was that all the encouragement I got made me think that really I wanted to be an artist and made me keep pretending that I liked it and made me like it less and less until I hated it because it wasnt me that was being an artist; everybody was lifting me high up and crowning me and congratulating me and I was smiling—and really I hated it and I hadnt done a single good piece of work," she wrote. "It was the craziest pretense in the world but even though I was pretending[,] I believed in it."* Despite the applause, she didn't feel worthy. And even though she knew she was simulating, she could find no authentic alternative. She suffered from an uneasy dissatisfaction for four years. By 1940, when she composed this self-reflection at

* I have retained orthographic irregularities when reproducing excerpts of letters.

what must have seemed to her to be the advanced age of seventeen, she had given up wanting to paint or to think of herself as an artist. She said she hated the smell and mess and the squishy sound the paint made when it was applied to paper.

More fundamentally, she felt that anything that came so easily to her could not be any good. "I didn't want to be told I was terrific," she recalled. "I had the sense that if I was so terrific at it, it wasn't worth doing." She was ashamed of her ignorance, her school, her family and her apartment. She worried that her father was mismanaging the business and would wind up in jail. "I somehow couldn't believe that anything I was connected with was 'correct' and modern and the best of its kind," she wrote in her adolescent autobiography. "But most especially I was ashamed of myself. . . . I was always afraid that one day everyone would find out how dumb I was." Fearful of kidnappers, she ran from strangers who might approach her on the street. She imagined that a man was hiding under her bed in wait to grab her by the legs; to thwart him, she would climb out in the morning headfirst.

Infuriated by her timidity, she defied it. She pushed herself to do things that were difficult, even frightening. At school there were frequent opportunities to challenge the authority of the teachers or the domineering students, and once school let out, Diane and her friends would play daredevil games and scramble over stony outcroppings in Central Park. "Whenever there was something a little dangerous or daring to do, like jumping over a wide crevice between rocks or playing a trick on the teacher or teasing one of the strong girls, I would be the leader and the first one to do it," she wrote. "I was always considered the most daring but Im sure I was more afraid than the others. I always forced myself to do the thing even though I hated to and was all hot and frightened." Alone, to test her courage, she stood on the window ledge of the San Remo apartment and gazed out over the vertiginous drop. "I like danger," she would explain years later, as an adult. "And when you face things that scare you and you survive, you've conquered your anxiety, which is worse than the danger could ever be." She

stared unblinkingly at sights that might cause others to look away. During the years that she traveled to the Fieldston School, she counted fourteen exhibitionists in the subway. She could distinctly recall each one and categorize his individual technique—for instance, the man who concealed his penis behind a newspaper that he craftily lowered to expose himself.

Her literary criticism was as singular as her painting. During her senior year, writing a weekly paper for an honors human-ities seminar, she reconfigured the assigned reading into pat-terns as personal as the whorls of her thumbprints. Through her eyes the Western classics were transformed into personal medi-tations—on the differences between men and women, the ways in which people succumb to their fates, and the allure of death to those who are unable to inhabit their lives. The light she cast on these works of literature was idiosyncratic, but more than just a reflection of her own complex personality, it was, like a flare in a dim room, eccentrically and unevenly illuminating. For instance, she applauded Hamlet's death, because she thought he welcomed it. In Diane's view, only by dying could Hamlet love himself and be loved by others. "It is good that he didn't live," she wrote. "When you read it you always want him to die." Soph-ocles's Oedipus and Jocasta inspired her to reflect, in erotically freighted language, on the differences between men and women: she contrasted "the deep slow selfishness of a woman, the way she closes her eyes to everything but the present," with the "young restlessness of man that wants always to know that he is right." She was still a teenager, but she had already arrived at a gen-der dichotomy that she would perceive all her life: typically, in her photographs of couples, especially young couples, the girl casts a profoundly knowing look and the boy glances evasively elsewhere. She conceived Euripides's Medea as a misfit who was suited for solitude but desired human connection, and that led Diane to ponder questions of identity—another enduring preoc-cupation. "If a person is one thing and thinks that it is right to be something else," she wondered, "ought he to try to be that some-

thing else or ought he to be what he is and make himself more good along his lines and not deny his basic self?" She thought that Medea, like Hamlet, could not be content until she died. "There are many women who don't seem made to be in life," she remarked. "There is too much conflict; it is only when they die that they are happy." The teacher read these papers with a mixture of admiration and concern.

Shy and quiet, Diane tugged with a moonlike gravity on the imaginations of those who knew her. She was growing up to be a very pretty girl, endowed with large green eyes and long, wavy brown hair, and she projected a sense of autonomy that was unusual in someone so young. "There was nothing blurry about her—mysterious, but not blurry," Stewart Stern said. Although she had many good friends, he felt that "she seemed remote and always alone," even when she would be talking in a group and her frequent giggle would be rippling above the conversational hum. She seemed to have reached a high level of self-awareness, but not a physical ease. Like most of their well-off, proper Jewish classmates, the young Nemerov girl and the Stern boy attended dancing classes. "She was quite stiff," he recalled. "I don't think she really enjoyed it. She felt very encased in her body." She shied away from physical contact with other people. Sometimes in the middle of a conversation she would drift away, as if she had fallen into a trance, and it could be many moments before she regained focus. Her voice was soft and whispery and spangled with giggles. When speaking, she skittered from one thought to another, not bothering to finish a sentence before starting the next. Her hands traced arabesques in the air; once, to general hilarity at the dinner table, her father placed an ashtray in one of them. Renee believed that she was "always groping for meaning, beyond what she was saying."

Secrets, both her own and those of others, tantalized Diane. She sought friends in whom she might entrust these bits of hidden knowledge. At this point in her life, she was more eager to confide than to be the confidante. When she was fourteen, she

went off to a summer camp and met a girl with whom she would
exchange confessions of unhappiness. But when she reflected on
that friendship three years later, she found it "selfish," because
each of them wanted to talk only about her own life. It troubled
her that this girl "held part of my secret." And it pained her more
deeply to think that she and her friend were so alike: "We both
wanted to tell and neither wanted to hear." The other girl con-
stantly said she understood what Diane was relating to her, and
that was unbearable. How could she possibly understand every-
thing? Wasn't it more "wonderful" to recognize that you are being
told things that you cannot fully comprehend? After this imper-
fect friend left camp early, Diane took up with two other girls
and bestowed upon them "a few of my long-thought-out secrets."
She soon regretted these confidences as well. "By the time we left
camp I felt myself all torn up," she recalled. "I felt as if thousands
of people held my secrets and yet I didnt love any of them . . . I
felt dull and angry at myself for telling them things which they
couldnt respect."

Her inability to communicate to these girls the import of her
secrets made her feel stupid, as did her repeated failures to cap-
ture in paint the elusive images she was after. Only one of the
canvases that Diane completed before she renounced the prac-
tice of painting is known to exist. It dates from the summer of
1938, when she was fifteen and her parents sent her to the sum-
mer program at Cummington in the Berkshire foothills. Beyond
their intention to strengthen her artistic skills, the Nemerovs
hoped, by dispatching their daughter out of New York, to weaken
her attachment to a young man. Her painting, titled *The Angel
Gabriel (Allan Arbus),* is a portrait of him. A small composition
in oils on canvas board, measuring a foot and a half high and
a little more than a foot wide, it depicts a slender, shirtless fig-
ure with thin, elongated arms and an enlarged head, backed up
against a big tree. With its exaggerations and attenuations, the
picture suggests that she had been looking at a lot of Matisses
or Egyptian tomb paintings, or perhaps both; nonetheless, it is

remarkably distinctive and precocious. She gave the picture to Alexander Eliot, a nineteen-year-old friend she met that summer. She was already dissatisfied with her achievements as a painter. "Sometimes, though, I feel as if I could just take anything and know it *my way* and *paint it* but it doesn't paint as well as I *know* it— and that is horrible," she confessed to Alex. She told him that her portrait of Allan wasn't meant to achieve a likeness. She imagined Allan as a melancholy, vulnerable tree king or green-glazed pharaoh. "He's Vegetable, you're Mineral, and I'm Animal," she proclaimed, and she presented Alex with the picture.

As a Vegetable person, Allan would provide Diane with sustenance. The title she gave the painting suggests she was counting on him to do even more. In depictions by Renaissance painters of the Annunciation, the angel Gabriel intrudes unexpectedly to tell the Virgin Mary that a miraculous event is about to transform her. Allan was Diane's herald into a new life.

5

Enter Allan

The romance of Allan Arbus and Diane Nemerov so closely resembled the love story of David Nemerov and Gertrude Russek that it is a wonder Diane's parents opposed it so adamantly. Unless, of course, that is precisely why they did.

Allan Arbus, after dropping out of City College at the age of eighteen, was hired to do paste-up in the Russeks advertising department. A curly-haired, sensitive-looking young man with dreams of becoming an actor and a love for playing the clarinet, he obtained the job through his uncle Max Weinstein, who was David Nemerov's business partner. The Depression was still weighing down the economy, and for anyone seeking employment, connections helped. Like David Nemerov, Allan— notwithstanding his aunt's marriage to a wealthy man—came from that segment of society known as Jews without money.

Diane met Allan at thirteen, on one of her regular visits to the advertising department for her drawing lessons. As she described it, she fell in love with him on sight, in a romance that, taking into account her parents' opposition, sounded at first like *Romeo and Juliet* but was in fact more like Miranda's sighting of Ferdinand in *The Tempest*. Diane had been isolated by a parental moat, as if she were living on a sheltered island.

Victor D'Amico, the Fieldston art teacher, said that Allan represented an escape route for Diane. The title of her painting of him supports that view. But it is a partial view. Allan was the male figure that Diane was seeking: firm and capable, rational and orderly, critical and controlling, yet kind and understanding. His skeptical, measured intelligence nicely balanced her intuitive, associative mind. She recognized that he would protect her.

Allan and Diane were teenagers (Diane just barely) when they began spending Saturday afternoons together, visiting museums and parks. It did not take Diane long to decide that he was meant to be her husband, a conclusion she communicated to her parents. Looking back on it, Allan declared that the Nemerovs' opposition was completely understandable. "She was young and I was Mister Nobody," he explained. "I was really incapable of making a move myself. I couldn't go out and get a job. I was sort of hopeless." He had no clue about finding a way to realize his goals. "I always wanted to be an actor, but I had no idea of how you do it, how you got started," he said.

Allan resembled Howard. Some saw a physical likeness. "Allan always looked like Howard to me—same shape head, same kind of curly hair," recalled Rick Fredericks, a college classmate of Howard's who later knew Allan and Diane. More striking was their temperamental resemblance. Like Howard, Allan was cerebral, detail-focused, fond of wordplay, pedantic and pessimistic. There was something methodically Talmudic in his parsing of minutiae and his worried perfectionism. His mind was tethered. Also like Howard, Allan very much wanted to be successful, although not by conventional standards. What would constitute success remained an anxiety-producing mystery to them both.

Undeterred by parental objections, Diane met Allan secretly, and she also insisted on bringing him over sometimes to join in family meals. If anything, the obstacles intensified their sense that they were natural partners. "In confronting the world, we were really always tremendous allies," Allan said. They were for-

ever kissing, stroking, embracing. "They couldn't touch each other enough," Renee said.

Diane's Fieldston classmates were stunned to learn of her intention to marry young. "To us she was a virgin vessel," Stewart Stern explained. "She seemed so unattainable. None of us could believe it." When Stern eventually met Allan, Diane's choice surprised him at first, but soon he felt he understood. "I thought it had to be Johnny Weissmuller, and he wasn't at all like that," Stern said. "He was like a biblical Puck. He had this marvelous burning Mediterranean darkness in his eyes, and incredible sensitivity and ability to connect. He seemed absolutely right for her. I felt that he had a very grounded, practical sense."

Aside from dispelling her air of chaste apartness, Diane's serious attachment startled those who knew her, because in that upper-middle-class, New York Jewish milieu, dependence on a man was a peculiar route to achieve independence from one's family. In the end, most Fieldston women would assume the roles of wife and mother, but the first station on the way from home was the university. Virtually every member of Diane's class went to college. For a student with such gifts to forgo a higher education was perplexing. Diane's intelligence was obvious, and her schoolmates did not confuse her quietness with self-effacement. Behind her reticence was a nebulous but visible ambition. Her black moods were illuminated by a flashing creativity. In her Fieldston yearbook, she chose a (slightly misquoted) comment to run beneath her picture: "Diane Nemerov. To shake the tree of life itself and bring down fruits unheard of." It comes from a poem by E. A. Robinson, describing William Shakespeare. The words would have made the point better had there been room to publish more of them:

> To-day the clouds are with him, but anon
> He'll out of 'em enough to shake the tree
> Of life itself and bring down fruit unheard-of,—
> And, throwing in the bruised and whole together,
> Prepare a wine to make us drunk with wonder

Allan once told Alex Eliot that he was afraid he would only hold Diane back if he married her. Alex asked Allan why he was getting married if he felt that way. Because Diane wanted to, Allan answered, and he believed he could insulate her against the dangers of the world. Diane could make a man feel awestruck and protective at the same time, which was the way an old-fashioned man was supposed to feel about a woman.

6

A Friendly-Looking Beard

.

One summer afternoon in Cummington, as they talked while lying in the long grass, Alex Eliot removed from Diane's wrist the silver bracelet that Allan had given her. When they left, she forgot to put it back on. Realizing at dinnertime that it was missing, she was so distraught that half a dozen of their friends went out with them in search of it, and to everyone's huge relief, it was found. The piece of jewelry was the chief token of the love that tied Diane and Allan. Inside it, Allan had placed an engraved inscription: " . . . And she was my immunity." Diane said he had presented it to her in place of an engagement ring.

For a fifteen-year-old girl who was madly in love, Diane certainly behaved in an unconventional way when she met Alex, a garrulous, heavy-drinking, overeating and chain-smoking nineteen-year-old. As Alex described it in his minutely detailed written recollections, on their first night at Cummington the school's founder led an outdoor meeting for the summer's new arrivals. In the background, Alex noticed a bewitching creature with "wide green eyes, and hair like smoke of incense" roaming among the assembled onlookers, "lissome as a panther" in her measured, rhythmic movements.

The next day, in the school cafeteria, he asked if he could bring her some coffee.

"Sure," she said.

When he sat down opposite her, he confessed that he had been unable to look elsewhere at the evening introductory get-together.

"I was posing for you," she said.

Emboldened, he told her he had been watching that morning as she painted in the life study class. "You touch the paint to canvas with such tenderness," he said. "Some day you'll be a very important artist."

"I hope not!" she replied, in her soft, tentative voice. "I don't care much for painting. The only reason I came to Cummington for the summer is my parents forced me."

"Why?"

"So's I can't be with my lover."

"Don't tell me about him," Alex said, quickly changing the subject. "You're from New York, I guess."

She nodded. "And I go to Fieldston School. It's all sort of distantly intimate."

"How do you mean?"

"I can't explain," she said. "I used to pose in my lighted bathroom for an old man across the court at home. His wife complained and so I had to stop. Last night, at Miss Frazier's get-together, I felt you looking at me all the time. It gave me a warm feeling. You're not old. Eighteen?"

"Nineteen, but only just."

"Then I almost guessed right. I like you, sort of."

"May I ask what 'sort of' means?"

"Well, first of all, I admire your doing the unfashionable thing—starting a beard so soon in life. It's a friendly-looking beard, so short, almost peach fuzz. Second of all, you're nice and big. And third of all, I go for your watchful, alert look. You look like a great bone, somehow, with a sad smile. It may sound fresh to say this, but young as you are, there's something fatherly about you, too."

Shrugging, Alex said, "Tell me about your real father."

"He runs Russeks department store, in lower Fifth Avenue, in a 'predominantly dominant' manner—you know? The merchant prince. Dapper David Nemerov walks and talks as if he were sitting down all the time. Basically reserved. I must be the opposite."

"You take after your mother, I suppose."

"No, she's hysterical and I hate her," Diane retorted sharply. Then she reconsidered. "Well, that's not true. She's already been on the phone to see if I'm all right. I cried for hours after her call last night."

"Diane, do you mind my asking how old—?"

"Fifteen. Only. That's why, when Allan Arbus asked for my hand in marriage, it shocked Mommy and Daddy out of their wits."

No longer able to avoid the subject, Alex asked about the man he already saw as his rival, and learned that Allan was his age and working at Russeks, a born student who could not afford college.

"You'll see when you meet him, you'll be good friends," she said.

But Alex was already imagining how he might win her for himself. He asked if she would like to go on a walk with him.

"Of course!" she said. "Let's get right away out of sight somewhere, and be private."

He told her there was an old logging trail that led past a graveyard to the ridge.

"Perfect!" she said. "We'll skip supper, okay? Let's stay together the rest of the day."

As soon as they left the school, he took her hand and, to his relief, she did not remove it. While they walked, with their moist palms pressed together and their fingers interlocked, they didn't say much. But in the weeks and years to come, with her probing inquiry she would learn almost everything about him. Alex was descended from a distinguished New England family: his most famous forebear was his great-grandfather, Charles W. Eliot, an admired president of Harvard University. But Alex was a maverick. Instead of following four previous generations of Eliots by attending Harvard, the red-haired young man chose an unortho-

dox brand of higher education and studied for two years at Black Mountain College in North Carolina. The German geometric abstractionist Josef Albers had emigrated in 1933 to inaugurate the visual arts program there. Encouraged by his mother, a writer of children's books, Alex planned to become a painter.

Although they were wearing lightweight shirts and shorts on this July afternoon, they were sweating as they advanced toward the ridge.

"Well, here's the graveyard," Diane said. "This looks appropriate."

"Appropriate for what?"

"If I take off my shirt and lie down in the grass, will you please rub my back?"

"But . . . the grass is kind of long. It may be buggy."

"I know."

"You're Allan's girl," Alex stammered.

"True." The word emerged through the fabric of the shirt that she was pulling over her head. Her small breasts were not as rounded or tanned as her arms and shoulders. But to Alex, aware of her mythological namesake, she resembled the lithe goddess of the hunt. He was ensnared.

"Well, then," he said. "If you'll just lie across this fallen tombstone, I'll give you as good a rub as I can. Be patient, though. I've never done this before."

Pressing his thumbs against her neck, shoulder blades and spine, he believed he could feel a stream of energy coursing through her.

"Where does it go?" he blurted, and then apologized. He hadn't meant to speak. But she seemed to understand his meaning. She loosened her belt so that his fingers could travel to the base of her spine. There he halted. He dared advance no farther.

"How's that?" he asked, climbing off her.

She rolled onto her back and yawned. "You're even better at it than my brother, Howard."

"What's he like?"

"Strange. We all are, though. Isn't that true? I think he's a little in love with me. Yet he seems so superior now that he's at Harvard—like on a bicycle. Well, I don't know. It must be funny."

"What must?"

"Oh, being a boy, and growing up and all. Sometimes I feel sorry for men. Their big ideas, and their trousers ready to burst!"

A large mosquito landed gingerly between Diane's breasts. They both watched, fascinated, as its slender proboscis tickled a freckle on her skin. She made no move to brush it away. Changing its strategy, the insect whined upward and then landed on the nipple of her right breast. This time, it sank its feeder deep into her flesh and drank. Alex looked up at her face. She was looking tenderly at the bug, not at him.

When the mosquito, engorged and drowsy, lifted off, Diane said, "I love insects and childhood. Tell me about the games you played when you were young. Start as far back as you can."

"I will if you put your shirt on."

"Why didn't you say my breasts bothered you? They do me, too, being so small." She slipped her shirt back on. "Well, am I decent now?"

"You're beautiful all over. That's the trouble."

She was not to be deflected from her purpose. Alex began telling her about his upbringing, fielding her frequent interruptions as she pressed for precise sequences of events and additional information about his schoolmates.

"Alex, I'm not like other girls," she said.

"Uh, how do you mean?"

"I'm more serious, in my way. For one thing, I like details."

She certainly did. She was insatiable when it came to details.

After Alex had satisfied some of her curiosity, he rose and stretched out his hands to help her get up.

"Listen, it's still a couple of miles to the hilltop. Are you sure you want to go the whole way?"

"Absolutely!"

Holding hands, they walked through the woods until they

reached the granite outcrop and sat down to watch the sun sink below the hills. As the air cooled, Diane snuggled against his shoulder. They kissed. He looked at her and fumbled for words, trying to explain his sense of rapture. She laughed.

"I want to hear about the other times, the girls you've had, all right?" she said.

"Well, if I told you anything, it would be so you'll understand how different things are between us."

"Liar." She demanded that he describe for her each of his sexual encounters, beginning with the first.

He looked at her sparkling eyes. "I'm going to hate this."

"I know," she said. "You're squirming now, aren't you?" She plunged her hand into his shorts. He gasped as her fingers clenched around him.

"You are my prisoner," she said in a calm voice. "You can't squirm out of this one, so say: Whose were the first fingers, besides your own, which made this stiffen up?"

"I . . . Gosh, Diane."

Alex fell silent. He sensed already who would be controlling this relationship, and he had a premonition that he was out of his depth.

7

Weddings

When Allan came by bus to Cummington to visit Diane, Alex finally met the "fiancé," as she called him, of whom he had heard so much and of whom he was so envious. Is it surprising that the two young men hit it off? They had in common their adoration of Diane. And it was not a contest: she had already declared which man she was going to marry.

It would be a mistake to think that Diane was ambivalent about Allan. She was completely committed to becoming Mrs. Arbus and was waging that campaign with her parents fiercely and incessantly. At the same time, she had a passionate curiosity. Not only did other people fascinate her; she was intrigued by the effect she had on other people, especially men. This adolescent phase of mutual exploration she would never outgrow. In her universe, alternatives did not exclude, and a primary bond did not prevent another attachment. She was multivalent.

Alex was so different from Allan. He took her to meet his parents in nearby Northampton, where his father, who had a bad stammer, taught drama at Smith College. Afterward, Diane told Alex that it was like seeing another piece of the same carpet: the father's patch was faded by the sun and worn by the tread of many feet, while Alex's was still bright and untouched. On her

part, Diane introduced him to Howard, who was pursuing his literary interests as a Harvard undergraduate.

When, following the summer program, Alex went off to Boston to study painting, he developed a friendship with Howard. Visiting New York over the Christmas holidays, Alex stayed with the Nemerovs and saw Allan there, too. At one point, Allan said to him, "I'm nothing, and I'm no good for Diane." Alex's hopes for his own suit rose, but Diane's allegiance to Allan didn't waver, and her mother was as direct as a bucket of cold water. "If you have any hopes of marrying Diane, bury them," Gertrude informed him. "Allan is bad enough. I would never let my daughter marry a *goy*." Alex spent most of the holiday walking around the city with Diane and Allan. He later recalled that he and Allan became "as close as brothers, which was funny because, looking back on it, we were the exact opposite. Allan was cautious, cool, a perfectionist, while I tended to excess." One day, while the three of them were at an Upper East Side delicatessen, Alex revealed with intense feeling that he was desperately in love with Diane. Allan took it in stride. Diane giggled. After one of Alex's visits, Diane wrote to say how much Allan liked him, and added, "You don't know how wonderful he is because you don't love him. He is good. Very good." Reassuringly, she told Alex that he, too, was "very lovely—and good." In a less confident tone, she added, "I want to be good to you."

During this period, Diane also announced that as soon as she turned eighteen, she would marry Allan. David Nemerov issued steely objections that his daughter ostentatiously ignored, leaving him enraged but powerless. The Nemerovs admitted the inevitable. On March 4, 1941, ten days before Diane could legally decide such things for herself, an item in the *New York Times* announced the engagement of Diane Nemerov to Allan Arbus.

Impervious as she seemed to parental disapproval, a stern, implacable voice had taken up residence within Diane's mind. In the autobiography that she wrote during her last year at Fieldston, she described her feelings as an eleven-year-old: "I always

knew when I did something wrong and I felt very badly about it and I disciplined myself always and taught myself to be good but I couldn't stand having anyone else know that I'd been bad. I always thought that everyone else was good and that I was really a sinner." The presence of evil in the world was much on her mind. Repeatedly, she asked Alex if it was evil of her to want both him and Allan. Despite Alex's reassurances, she remained uneasy. She seemed to believe that her own goodness could be achieved only by serving others, and that in any case it was very much in doubt. In her last year of high school, she was troubled by depressions. "I had the feeling that Diane was undergoing much conflict," Lenrow, her literature teacher, reflected, "but there was no way for one to be of help or get her to bring it out into the open." Perturbed, the teacher asked Howard, who was visiting the campus as a Fieldston alumnus, whether something ought to be done to help her. Howard also suffered from black moods. He brushed aside the teacher's concern.

Diane and Allan's wedding took place on April 10, 1941. If Alex still yearned for Diane, he'd found an artful way to conceal it, having already celebrated the first anniversary of his own marriage.

The Eliot romance, from initial encounter to wedlock, swept forward breathlessly. Alex had been living in Boston in a room in a Beacon Street boardinghouse, trying to make a career as a painter. He mooned over Diane until, at a party given at the beachfront estate of an art collector in Ipswich on the North Shore, he met Anne Dick, a beautiful, headstrong, literary-minded blonde from a patrician family who were down on their luck and taking in boarders in their town house, which was situated on Beacon Hill not far from where he lived. The eldest of four daughters, Anne was suffering from a personal setback as distressing as the family's financial woes. She had been jilted. The story of her broken engagement became part of the lore of poetry, because her fiancé was Robert Lowell, and later, in confessional poems, he recounted the breakup in detail. Violating the rules of both the university and polite society, Anne would

visit Lowell, a Harvard undergraduate who was four years her junior, in his room after hours. Discovering this indecency, Robert's father wrote to Anne's father, who in turn sent the letter to his daughter. When she showed it to her youthful lover, he went in a fury to see the senior Lowell and, in the resulting argument, knocked him down with a punch to the jaw. For the rest of his life, this unfilial blow—delivered at Christmastime 1936—echoed guiltily in Lowell's memory. In its aftermath, his engagement to Anne, which had been impulsive and now seemed insubstantial, withered. By the summer, it was officially over.

Like Lowell, Anne aimed to be a writer. It would later become apparent that another thing she and her suitor shared was psychological illness, in her case a severe mood disorder. But what was more obvious was that Anne, in her late twenties, approaching the outer margin of marital eligibility, was feeling fragile and rejected when Alex, another magnetic younger man, arrived in her life. She was still recovering from her ruptured engagement a year earlier. He was trying to reconcile himself emotionally to the knowledge that the girl who mesmerized him and was patently attracted to him would indeed be marrying her fiancé—a rival whom, to complicate matters further, the exuberant Alex embraced as a brother. "It was real for both of us, but we were both on the rebound," Alex said later of his betrothal. Like Diane, Anne was quirkily intelligent, emotionally volatile and sexually forward. At the party where she and Alex met, they went off and made love on the beach. She told him early in their relationship that she was periodically laid low by depression. He dismissed her warning, not comprehending what she meant. They were married in 1940.

The following year, the Eliots were invited to the Arbus wedding, with Alex asked to be best man, but because Anne was too depressed to attend, they missed it. "I would have told the Arbs she was too ill for me to go," Alex recalled. "But probably she threw a fit and said, 'Don't go.'" Instead, on their way to a three-week honeymoon on a farm in upstate New York, Allan and

Diane detoured to Boston to spend the first night at the home of Alex and Anne. When the newlyweds went off to the bedroom, Alex gave Diane a peck on the cheek. Once their door was shut, Allan turned to Diane and said teasingly, "Now, why do you suppose he didn't kiss *me?*"

Alex declared that the four would be mutually engaged and supportive, like the four legs of a table. But it was a funny kind of table, because the legs were unequally balanced. Alex was in love with both Anne and Diane, and he was very fond of Allan. Diane purred with contentment at the adoration of the two men, and she set out successfully to win the friendship of Anne: each woman could empathize with the other's depressions. However, the bond between Allan and Anne was always thin, and there was no denying that the sexual attraction that Diane and Alex felt for each other as well as for their own spouses was the glue holding the wobbly table together.

For the time being, the unstable arrangement held. The Arbuses rented a walk-up apartment on East Thirty-Seventh Street that was shaken by the noise of the newly constructed Midtown Tunnel. To be close to them, and in hopes that Alex might find a job that earned more than the pittance he was bringing in as a painter, the Eliots moved to New York and took an apartment across the hall. Alex found work for twenty-five dollars a week at the American Artists Group, an outfit that printed greeting cards illustrated by lithographs and etchings of well-known artists. He despised it so much that he would cross Fifth Avenue to avoid walking by the entrance on his days off. "It was hateful to me," he recalled. "The whole thing seemed totally phony." Eventually he found more congenial employment at the *March of Time* newsreel production company, a position that would lead to future responsibilities within the parent organization, Time Inc. But even when he and the Arbuses were burdened with jobs they loathed, they exulted in the excitement and anguish of being young, ambitious and hopeful. Anything was possible. "We used to meet almost every evening, the four of us," Eliot recalled. "And

we shared everything. We talked and talked, and we had a lot of complaining about life and work and so forth. It was a very easy, freewheeling and fun relationship."

In the group, Alex was the most garrulous. "I used to talk all the time, but I was inarticulate, really," he said. "I mean, I couldn't think my way out of a paper bag. And Diane of course said very little. Diane was like a lodestone or a touchstone. . . . In that sense she would be the center of things. . . . And Allan was always very strong on the discriminating side. He could say what the experience wasn't. Always. Wonderfully well. This was a great champion to have around to clear the air, to say, Not that, not that." Alex remarked that Diane never mentioned career dreams of her own: "All she wanted at that stage was to be a good wife to Allan."

8

Living, Breathing Photography

Not long after their honeymoon, knowing that Diane was disgusted with painting, Allan presented her with an artistic tool that he hoped she would find more congenial than a paintbrush: a 2¼×3¼ Graflex. A medium-format camera, the Graflex could be attached to a tripod, like the large-format view camera that was the standard in photography studios, but it was compact and light enough to be used on the move. Newspaper photographers often preferred it to the faster, more portable 35 mm cameras that produced pictures on smaller film with less fine-grained definition.

On holiday that summer in Montauk, on the eastern tip of Long Island, Allan posed Diane as a fashion model and photographed her with the Graflex. They showed the pictures to David Nemerov, who responded to their enthusiasm (and their need to earn a living) by hiring them to do advertising work for Russeks. He helped them buy equipment, including a 5×7 Deardorff view camera. "We were living, breathing photography at every moment," Allan recalled. "This was a way to get paid for it."

Diane enrolled in a short course in photography at the New School for Social Research with Berenice Abbott, the prominent documentary photographer. Abbott was a native of Ohio who fled the heartland, first for Greenwich Village and then even farther

to Paris, where she worked as a darkroom assistant for Man Ray and, at his suggestion, tried her hand at portrait photography. Her photographs of leading modernists in the twenties, including James Joyce and Jean Cocteau, alone would have secured her a place in art history. Over time, they proved to be the prologue to a long career.

Through Man Ray, in 1925 Abbott discovered the photographs of Eugène Atget, which documented the streets, shop windows, bridges and hidden corners of Paris. His photographs were largely unpeopled and strangely eloquent, conferring an aura of silent nobility on these aging façades and stained sculptures with an uncertain future. Atget's photographs were elegiac without being sentimental, and in a mysterious way, eschewing soft focus or eccentric vantage points or other blatantly "artistic" devices, they captured the feelings that the scenes evoked in the photographer. He fixed the ephemeral light in patterns that looked eternal, and, conversely, he made buildings of bricks and mortar appear poignantly evanescent. "There was a sudden flash of recognition—the shock of realism unadorned," Abbott wrote of the impact the photographs made on her. "The subjects were not sensational, but nevertheless shocking in their very familiarity. The real world, seen with wonderment and surprise, was mirrored in each print. Whatever means Atget used to project the image did not intrude between subject and observer."

During his lifetime, Atget was hardly known. Upon his death in 1927, Abbott acquired many of his negatives and prints, and she took them with her when she returned to New York the following year. Her persistent efforts eventually won recognition for Atget's achievement. In her own life, his example inspired a comparable undertaking. From 1929 until 1938, supported at the end by the Federal Art Project of the Works Progress Administration, she set about photographing the storefronts and skyscrapers of New York. In a city that was undergoing a transformation far more dramatic than that of Atget's Paris, she recorded both the vestiges of an older way of life—the homely barber poles and

Italian food shops—and the sharply angled, glamorous skyscrapers that overshadowed them. They were contrasting and defining aspects of the city. To her eye, both effused dignity.

At the New School for Social Research, where Abbott began teaching in 1935 to supplement her income as a photographer, she ministered to novices like Diane. She had a scientific bent. A few years after Arbus studied with her, Abbott would inaugurate a new phase of her career, in which she sought to use photography to illustrate the laws of science visually. Diane's own inclinations were less technical. Practicing what Abbott taught in class, she would transmit the lessons to Allan when he came home. In her parents' apartment building at 888 Park Avenue, where the Nemerovs had been renting a ten-room, four-bath flat since 1939, a photo darkroom was reserved for the use of the tenants. Diane and Allan took it over. "As I was looking over her shoulder, it became fascinating to me," Allan recounted. "The technique of photography did not interest her, but it did interest me."

Outside Abbott's classroom, New York offered many opportunities to study contemporary photographs, if you knew where to look. The young couple went often to Alfred Stieglitz's tiny Midtown gallery of modern art and photography, An American Place. "He took quite a shine to her," Allan said. At the Museum of Modern Art, they frequented the newly established photography department, where, if they requested to see a picture by Henri Cartier-Bresson or Walker Evans, an assistant would bring it out for them to examine. They especially admired Cartier-Bresson and the other documentary photographers who worked in those years for *Life* magazine.

As they felt their way along, David Nemerov showered them with encouragement. "Diane's father was so great," Allan later said. "He would rave about the good pictures, and the bad pictures he would pretend to have been too busy to have seen." But Allan also knew that his father-in-law was someone to approach cautiously. After all, Allan had worked for him before marrying into the family and would watch as Nemerov oversaw the Russeks

business, bristling in his office with a dangerous nervous energy. "He paces up and down," Allan told Howard, "and if you get in the way, he walks all over you." Diane was perhaps the only person he didn't walk over. For one thing, he couldn't: as shown when he vehemently opposed her early marriage, she would stand up to him. What's more, he didn't want to. Diane knew, as she once said, that she was "the apple of his eye."

The Japanese attack on Pearl Harbor and the entry of the United States into World War II in December 1941 disrupted the routines of the newlyweds' lives. As the country mobilized for war, photographing sophisticated-looking models in fancy frocks felt trivial. Allan enlisted in the army. Thanks to his training in photography, he was detailed to the Signal Corps and dispatched to Camp Crowder in Missouri for basic training. When he was assigned to Fort Monmouth, New Jersey, Diane joined him there.

At Fort Monmouth, she reencountered Hope Eisenman, whom she knew as Howard's former girlfriend, Hope Greer. Hope's husband, Alvin, was also in the Signal Corps. Allan had introduced himself to Alvin at Camp Crowder, knowing their wives were acquainted and saying it might help make his case for Diane to join him at Fort Monmouth if she knew that Hope would be living there with Alvin. "I was wary of him because of the fact that he had pressed and dry-cleaned fatigues," Alvin said. "We were enlisted men. It seemed very odd. That feeling of oddness continued as long as I knew him." Nonetheless, once Diane joined Allan in an apartment near Fort Monmouth, the couples became friendly, within boundaries set by the Arbuses. "They were very secretive about their relationship," Hope said. "They didn't want to see other people. At first I was kind of insulted, but later I discovered they just wanted to be together."

The Eisenmans had a baby daughter whom Diane volunteered to mind. She wheeled the infant about in a doll carriage, which was all the Eisenmans could find, and freed Hope to do laundry and run errands. She would also bring over lunch for them. Otherwise, she was unoccupied with domestic chores. The Arbuses

ate dinner at the commissary. During the days, while Allan was busy on the base, Diane would practice photography. A large black canvas bag, in which she stashed her camera, always hung from her shoulder. Her subjects ranged from the mundane to the bizarre. She told Hope that she was trying to photograph a lightbulb that hung from the ceiling of her apartment. She was putting into practice the truth Abbott had preached: "What the human eye observes casually and incuriously, the eye of the camera (the lens) notes with relentless fidelity." The photographer had to train her eye to see what the lens did. But along with the Atget-like desire to scrutinize the familiar, Arbus was pulled toward the strange. When a whale washed up on the beach, she photographed it repeatedly. She brought a piece of the carcass back to show Allan. "She was fascinated with odd things like that," Eisenman said. As in her Fieldston days, she preferred to represent the irregular and peculiar.

When Allan was reassigned from Fort Monmouth for further training in Astoria in Queens, the Arbuses moved into a small apartment in the East Fifties in Manhattan. Diane continued to photograph. A picture she took at that time shows a simple ceiling fixture that consists of a shaft culminating in a bulbous baluster from which two bare lightbulbs extend on goosenecks. Below this chandelier is a floor lamp. It is daytime, and neither the chandelier nor the floor lamp is lit. A chain hanging from each of the two lightbulb sockets, the shaft of the chandelier above and the pole of the floor lamp below constitute four perfectly vertical lines of different width, length and intensity. The dark shade of the floor lamp is slightly askew. All of these upright objects are contained in a traditional room in which everything is parallel— except the crown moldings, which lie on the diagonal because of the camera angle, and, if you are paying close attention, that barely crooked shade.

The balance of the composition is exquisite, but the photograph recalls something that Abbott had emphasized. Yes, a coherent composition is essential for a picture to have meaning.

Some photographers, however, "come to believe that if a picture has a good 'composition,' that is all it needs." She warned: "This is not true." The choice of subject matter is critical. It is more difficult in photography than in the other arts to ignore the real world and spin out elegant nonsense. Still, it is possible to employ "splendid rhetoric" without communicating anything.

Arbus was mastering the rules of photographic composition as she groped intuitively toward her subject matter. She had yet to discover what she wanted or needed to say. And yet, even in a picture so prosaic, it is possible that she was doing more than learning her new craft. She depicted these straight, upstanding objects in a genteel setting, which instead of comfortably enclosing them seems to shift away into a different plane, and she bounced the light in such a manner as to give the most prominent position to the subtly off-kilter dark lamp shade, which hugs the corner of the photograph beneath a chandelier that dangles over it like the sword of Damocles. Perhaps she was only learning how to light a scene and control angular distortion. Then again, she might have been whispering something barely intelligible to anyone who was acute enough to hear.

Floating Weightless and Brilliant

Exactly how Diane was acquainted with the bride, Pati Hill never discovered. Pati knew Jessica Patton, although only slightly, because they were both models living in Greenwich Village and they would run into each other at Julius', a bar on West Tenth up the street from Pati's apartment. Conveniently, the wedding reception also took place on West Tenth, a couple of blocks to the east, in the baronial rooms that once housed the painter William Merritt Chase at the Tenth Street Studio Building. That apartment, and several others in the building, belonged to the parents of George Barkentin, the young man who was marrying Jessica. Without ever asking, Pati later assumed that Diane knew Jessica professionally. Blond, chain-smoking, sharply thin and graced with an obscenity-laced wit that projected photographically as no-nonsense American sophistication, Jessica—or, rather, Jessica's image—might persuade someone riffling through the newspaper to purchase a mink coat or a silk cocktail dress at Russeks.

At the Tenth Street Studio Building on that night in April 1942, the only illumination came from the flickering light of votive candles. The war was on, and periodic blackout drills were enforced, as were citywide dimouts as a precaution against German air

raids. The war also accounted for the absence of Allan, at Camp Crowder, and Pati's husband, Jack Long, on his way overseas.

Pati had arrived in New York a year or so earlier on a weekend trip from Washington, D.C. She was a Virginian, raised in Charlottesville but living in Washington ever since her mother remarried and relocated. The sleepy national capital, which already felt confining to a twenty-year-old girl with looks, a vivid sense of style, offbeat intelligence and unbounded dreams, had grown uncomfortably claustrophobic due to the sexual advances of her stepfather. So when the weekend ended, Pati announced to the boyfriend who had driven up with her that he should return to Washington, but she liked New York and was staying. She found a room in Greenwich Village that was succeeded by an apartment in the neighborhood, and when her mother protested that a young woman could not live alone in New York and that Pati was still underage and subject to a parent's edicts, she located a willing young man who would marry her and thereby deflect her mother's objections. She moved into his Tenth Street apartment, and they wed in February 1942, less than two months before Pati's twenty-first birthday. Later she reflected that the arrangement was equally convenient for him, as the agreeable Jack seemed most at home in a coterie of dapper young men similar to himself who held frequent parties for each other (and a few decorative and amusing girls such as Pati). These clean-cut fellows in Brooks Brothers suits had, like Jack, recently graduated from Harvard or the like before coming to New York to take jobs such as the one Jack held in publishing, or in advertising or fashion. Pati made sure that her conjugal life did not interfere with her going out in the evening or earning her way as a model during the day. And when the war called Jack into the service, his disappearance was no more burdensome than his presence had been.

So Pati was alone at the party in the dimly lit basement when the young woman with large gray-green eyes struck up a conversation. While the subject of their talk is long forgotten, the intensity of it was memorable, so that when Pati said she had to

be leaving and Diane replied that she hoped they could continue their discussion another day, Pati agreed and began looking for a paper napkin on which to write her address. Diane said not to bother. She knew where Pati lived. How she knew was another riddle that Pati never solved.

Pati was likewise surprised on the day of their scheduled rendezvous to find that Diane had passed through the outer door, with its habitually broken lock, and into her apartment, which was typically left unsecured, without pausing to knock. Pati invited her to sit down on the other end of the Victorian couch, a treasure Pati had found on the street, dragged upstairs and reupholstered. Diane smiled contentedly as she gazed at her surroundings and enmeshed Pati in a web of questions. She listened to the answers with rapt attention. "I thought the questions she asked were funny," Hill recalled. "I think she taught me somewhat that listening was interesting." And not only interesting; it was "seductive," the way in which Diane listened with her whole being. Though at times she appeared to drift off, she'd much later bring up the story to which it had seemed she was paying no attention at all and suddenly ask, "Was it raining that night?" or "What was in the green box on the table?" Diane could appear absent while actually being present. Sometimes Pati felt that when other people were talking, Diane "was rearranging their words for them so their thought wouldn't unravel and make her miss the point."

Pati also came to suspect that Diane "prepared for what she meant to have happen spontaneously." Events that appeared to occur by chance, such as their initial encounter, had been arranged as carefully as a hunter's trap. This maneuvering was one of her secrets. Indeed, Pati believed that Diane's initial attraction to her was also based in part on calculation, not simply "girlie magic" or physical attraction or a marriage of kindred souls. Hill was writing a monthly column for *Seventeen* magazine and short pieces for several fashion magazines. While Pati didn't regard this work as anything other than a source of income now that she lacked a resident husband to pay half the rent, Arbus

seemed impressed by it and "was interested in talking about how people got there," Hill recalled. "She was very career always, and very aware of the fashion world." But those were things still unknown at the beginning of their long friendship.

At one point during that first visit, Arbus got up from her seat and walked around the room, examining what was on display. She extended her pinkie finger here and there, Hill later recounted, "to indicate an object she particularly favored, like an accomplished buyer at an auction making his decisions known by a savvy glance—in this case before a series of geometry exercises I had cut from a sixth-grade mathematics book and pinned to the wall." She cast an appreciative eye on a papier-mâché unicorn head that hung above the fireplace. In the bedroom, she admired the scarlet walls and the angel covered in candle drippings that presided over the double bed. And so she proceeded to make an inventory of all Hill possessed until she resumed her place on the sofa. She took a cigarette from the packet that Pati produced, even though she didn't usually smoke, and lit it—"gravely and maladroitly puffing to the end," performing a rite of communion that registered as "one of her tender parlor tricks," awkwardly endearing and strangely disarming.

Her questions jumped from the trivial to the outrageous. She wanted to know what Pati and Jack did for birth control. Did they use condoms or a pessary? She loved the word *pessary* (a less word-besotted woman might have said *diaphragm*) and experimented pronouncing it with different accented inflections. Had Pati ever been pregnant, and what had she done with the baby—"as if," Hill thought, "it might be down the hall in the broom closet waiting to be fed." Diane said she didn't care whether she got pregnant herself. Unlike Pati, she felt motherhood was part of her destiny. She confided that when she was growing up she had believed that everyone in the world was Jewish. Pati intuited that her own upbringing in Charlottesville, where almost no one was Jewish, shimmered for Diane like some terrifically exotic realm. She wanted to know the name of Pati's first boyfriend. She had to learn the brand of leg

makeup that her new friend used. At one point Pati protested, "I've told you *everything* and you are still full of secrets," to which Diane replied, "I *need* my secrets." Yet she could also drop morsels of personal information so startling that Hill, who was two years older and thought herself to be, superficially anyway, much more daring and unconventional, needed to disguise her shock.

Despite those few surprising revelations, Hill at first regarded Arbus as a bourgeois Jewish housewife, not the sort of artistic, bohemian iconoclast she had hoped to meet in New York. "She saw in me a means of knowing something wild and different," Hill later speculated. "I was bored to tears by her because I didn't know what I was looking into. I thought she was just a goody-goody girl, and I didn't know that I wanted her as a friend. The number of things she was interested in interested me. But most of it was the way she had of saying things. We were quite apart at first. The friendship was her doing. It was natural to her to wonder and it was natural at that time of my life to *do*. I don't think I asked much of anything."

Reciprocally, the more she knew of Hill, the more Arbus found her new friend to be intriguingly complex. Diane remarked that "her thinking, doing, saying are all working *simultaneously* (but not much together except as in a dance, to meet, to merge, to bow, to entwine) and fast and in every varying relations to each other." She found Pati "bottomless" (by contrast, Alex was "endless"), and she was fascinated to imagine what it would be like to *be* Pati, who lived in the realm of images—which, to Diane's thinking, was completely unlike being a mythologizer or theorist, who is governed by symbols. Pati reacted keenly to the things she saw around her and resisted interpreting them. Things evoked other things, and her mind associated one thought with another, but each thing or thought retained its own autonomy, its proper identity. Images could flicker and alter as quickly as light. In a world of images, Arbus explained, "nothing stands still or gets heavy— the world is leaping bursting dancing, splattering shattering well-used and tireless. And the image and the thing it stands for can

change places anytime. And this is great because reality needs no weight to prove itself." Pati was "floating weightless in a weightless world and brilliant with it."

Arbus fell into the habit of traveling downtown to see Hill. The visits conformed to the patterns of that first get-together. Arbus would come and go according to her own schedule. "She was certainly the most prying person I've ever known, with an almost pathological need to have it all," Hill said. Even if Pati would try to shake off her hold, Diane hung tight. "She was of a persistence not to be believed," Hill said. "I could have said a hundred times on Tenth Street, 'Diane, I've answered enough of your questions, it's time for you to leave,' and she wouldn't leave. If she came to see me and meant to leave at five o'clock, that's what she would do." And if a particular question interested her and she felt unsatisfied by the answer, she would keep asking. "That was one of the things that would enrage me," Hill continued. "Her curiosity of something would have been caught. I would have rushed ahead to show her something but her attention would have been caught by a bunch of briars along the path." As well as the capacity to listen, Arbus taught Hill what it meant to judge. She could be very funny describing ridiculous aspects of other people. "Diane taught me to be pejorative in that way," Hill said. "It was as if she had reached the stage of judgment, and I was at the stage of seeing everything for the first time."

They made love one afternoon. Diane was the seducer: Pati felt little if any sexual attraction to other women. "That word 'seductive' is often applied to her and it's a pretty good word for her," Hill observed. Sometimes when leaving the apartment, Diane would kiss Pati on the lips. Other times she would turn around after she had left, as if to ascertain belatedly whether this person existed or was merely a specter conjured up by her imagination. On one occasion, she took Hill's face in her hands and placed their foreheads together, holding them there for what seemed like a minute, gazing into her eyes. "When I look at you, I don't know if I am seeing you or me," she said.

10

Doon Is Born

In the summer of 1944, soon after Allan shipped out to India with his Signal Corps company, Diane discovered to her surprise that she was pregnant. Immediately upon learning of her daughter's condition, Gertrude insisted that Diane move back into the Nemerov apartment on Park Avenue, to occupy a small bedroom at the end of a hall. Being with child had forced her back into a child's status. She rejoined Renee in the family home.

She was probably already living there when Renee, who was a fifteen-year-old high school student, came to her, distraught. Out late at night, Renee had been confronted and raped by a black man with a knife. Diane consoled and counseled her younger sister, taking her to see a physician. When they were children, it had been Diane, not Gertrude, who cuddled and mothered Renee, who dressed her like a doll and fussed over her, who read to her from the books she loved (*Jane Eyre* became Renee's lifelong favorite novel, always associated with Diane's voice in their shared bedroom). Renee "worshiped" her big sister. As the youngest, Renee wasn't part of the closed club that included only Howard and Diane. Indeed, she had chosen to attend the Dalton School so that she wouldn't be measured against the oversize reputations of her siblings at Fieldston. But Diane had swaddled her

in the maternal affection that Gertrude failed to provide. How would their proper mother, so obsessed with what other people thought, react to the news that her daughter had been raped? And by a black man! They agreed to keep it as their secret.

Howard was long gone. Following his graduation from Harvard College, he had joined the Royal Canadian Air Force as a pilot in 1941, before the United States entered the war. He was flying combat missions out of England. In his Bristol Beaufighter, he kept a wallet-size photograph of Diane, very likely one that Allan had taken, a dreamy look on her face, a blade of grass in her mouth. Howard wrote a poem about the photo, wondering if it offered him

> " . . . some security
> For time, that when I come to you, we'll stay
> Alone for just such time as this (though he
> That took it, stands but twenty feet away?)"

While he was based in London, Howard met and shortly thereafter married a pretty young Englishwoman, Peggy Russell. Feeling emotionally battered by a cycle of dangerous separations and grateful reunions, they decided that Peggy would cross the ocean to live with her in-laws and await Howard's return. A Gentile bride could count on a chilly welcome in the Nemerov household. Intimidated by the barely concealed hostility and unfamiliar opulence, Peggy regarded her pregnant sister-in-law as her only ally. She had eagerly looked forward to their meeting. She understood that Diane was Howard's ideal of a woman.

However, Howard had warned Peggy that his sister didn't talk much, and while Peggy found her to be "not nearly as quiet and uncommunicative as I imagined she would be," Diane was preoccupied with her own problems. Although she had happily antici- pated becoming a mother, she'd never imagined doing it on her own. She confided to Peggy that she didn't want to bear a child in Allan's absence; unfortunately, a regimen of hot baths had failed

to induce the intended spontaneous abortion. "I could not talk easily to her," Peggy recalled. "She was very inward and melancholy, and sort of mooned around." Indeed, Diane's real life was apparently taking place largely through the telling of it, by means of words and images, in her correspondence with her husband. In letters to Allan, she charted the progress of her pregnancy. Using the 5×7 Deardorff view camera that her father had provided, she employed a hand-operated shutter release and documented her swelling belly and breasts. In one photograph that she mailed to him, she is gazing into the full-length mirror of her bedroom-in-exile. She is thin. (The doctor had instructed her not to gain more than twenty pounds.) Wearing only cotton underpants, she looks remarkably young—and slightly out of focus.

It was odd for her to be having a child, because she was clinging to the trappings of childhood herself. Throughout her life, people would comment on her girlish, giggly speech. Her fashion choices, until she reached middle age, were also preadolescent: she favored blouses and dresses with Peter Pan collars and, as she revealed in her self-portrait, cotton briefs. "That Peter Pan collar was not given to her by her mother, she went out and bought it," Pati Hill remarked. "It was the desire of Allan that she should wear that cotton underwear. I think it came more from Allan than from her, the desire to make her a child bride." In those years particularly, it would have seemed that Diane was conforming to Allan's ideals. Yet to separate out what he wanted from what she wanted was a fool's task. Pati remarked that there was something almost Japanese in how Diane "played at submission as a kind of art form." As a child, Diane had seemed remarkably precocious and mature, and as a woman, she appeared childlike. Some people thought this was a strategy—to be sexually seductive or, later, to win the trust of her photographic subjects. But while she was conscious of the image she projected and could use it to her advantage, her self-presentation was more than a calculated act. Not just in her speech and clothing, but also in her curiosity, enthusiasms, mood changes and uncommon insights, she

resembled a very wise child, which may be merely another way of calling her an artist. Possibly, too, there was something childlike about her innocence of propriety. During the period that Allan was overseas, she repeatedly modeled in the nude for Alex, who had moved to a position at the Office of War Information and still hoped to make a career as a painter once the war was over.

On the evening she went into labor, Diane closed the door of her bedroom, departed the apartment unobtrusively and took a taxi to the hospital by herself. Just in case someone came into her room and grew alarmed by her absence, she pinned a note to her pillow, explaining that she preferred to go alone on this special occasion since Allan wasn't there to take her. Returning that night, Gertrude saw the closed door and thought it better not to disturb her. No one knew that Diane wasn't in there until she telephoned from the hospital at five the following morning to ask them to come over. It was April 3, 1945. David, Gertrude, Peggy and Renee were at the hospital by five forty-five and sat with her until seven, when everyone but Gertrude left to find breakfast. At eight, Gertrude was turned out of the room. The baby emerged two hours later, and following the birth, the family went to see Diane, who was smiling. The baby was an eight-pound girl she named Doon. "Diane and Allan thought it out long ago and didn't tell anyone about it," Peggy wrote Howard. Peggy thought it both "a pretty and remarkable name." Along with her delight for Diane, she was personally gratified. "I shall now be out of the limelight for a while, and Diane will take my place," she wrote.

In the immediate aftermath of the birth, which was eased by a short-acting anesthetic, Diane felt curiously detached from her infant. She stared at her quizzically, without the sense of recognition she had anticipated. "I love our lack of connection: that she doesn't feel anything towards me and I feel in such an odd, separate way towards her," she wrote a few days after Doon was born. The baby was beautiful, but Diane thought she didn't resemble either parent. "I expected great changes (first I expected it from

pregnancy, then when it didn't come, I expected it from birth)
but I'm glad I didn't change or at least feel changed," she wrote.
"I trust myself better as I am." That she wrote this letter to Stieg-
litz, the celebrated photographer and art dealer—acknowledging
that he would not recognize her name but trusting that he would
realize she was the pretty, pregnant and inquisitive young woman
who had been frequenting his gallery—suggests that she was
thinking as much about her photography career as about her
new maternal role.

Very soon, however, she became a thoroughly enraptured
mother. In the same fierce way that she had idealized Allan as
the most beautiful, intelligent, sensitive man, she worshiped
Doon, the marvelous child, and created a bower of enchantment
to surround her. She twined orange flowers over the bassinet and
placed postcards of Greek statues, Roman ruins and old English
landscapes on the edge for the baby to see when she woke up.
Diane believed that the mind was susceptible to visual stimuli,
especially at the threshold of slumber. Many years later, as a pro-
fessional photographer, she would pin favorite photographs—
some taken by her, some by others—to boards she arranged
around her bed. She found that when she saw one of her pictures
peripherally, without scrutinizing it, "some funny subliminal
thing happened" and "it really begins to act on you in a funny
way." Those pictures not from her own camera often came from
tabloid newspapers, and they were violent, strange, shocking.
These images she was gathering now for Doon were blissful. In
the vulgar atmosphere of Nemerov pretense, she established an
outpost of classical beauty. And at the center of it was a child
of exceptional physical attractiveness: throughout Doon's early
years, people would remark on how beautiful she was.

Over Gertrude's vehement objections, Diane determined that
she would breast-feed her infant. Gertrude insisted that Diane
was too small-breasted and could not provide enough milk to
nourish Doon adequately. The two generations locked in battle

over the proper way to care for the third. Gertrude hired a German nurse, whom Diane did her best to ignore. Amid the tension, a deal was struck. Before and after each breast-feeding, as verification that the baby was being fortified sufficiently, Doon would be weighed. "I felt so sorry for Diane," Peggy recalled. "She was under such pressure. Lots of times the milk wouldn't flow, she was so nervous. But I remember once after the feeding and the weighing, she ran out into the hall, crying, 'Five and a half ounces!' very proudly."

11

Mr. and Mrs. Inc.

Standing precariously on the thin ledge of a brick wall, Pati Hill struggled to look carefree. "Walk very slowly," Allan called out from below. He placed his head behind the camera and click-click-clicked as Pati walked. "It was quite scary," Hill recalled. "I felt if he had said, 'Be careful,' or 'I'm here, I'll catch you,' or 'If you're afraid of heights, don't do it,' it would have been easier, but he didn't do that." Still learning his trade, Allan wasted no breath on reassurance for his models. At a fashion shoot, he was too consumed by the feeling that he was out on a ledge himself.

Following his discharge from the army in late January 1946, Allan returned to New York to hoist the weight of a family. For a few months, before finding an apartment on West Seventieth Street, they all lived in the Nemerov home as he pondered how he might earn a living. His passions were acting, clarinet playing and photography. Of the three, photography, and especially fashion photography, seemed the least impractical. For a young man who had married into a family that owned a Fifth Avenue department store, entry into fashion photography was smoothed by the guarantee of an initial advertising client. David Nemerov also agreed to help them buy equipment and rent a Midtown studio. Allan and Diane found space on West Fifty-Fourth Street,

just off Sixth Avenue, and nailed up a brass nameplate: DIANE & ALLAN ARBUS. The studio would change address, the partnership would evolve into a solo practice, but the plaque, unaltered, would follow them for more than two decades.

Fashion photography offered opportunities that could nourish not just the body but the spirit. In the forties and fifties, serious photographers lacked places to show and sell their work. Few art galleries exhibited photographs. (Stieglitz's was an exception.) What photographers had were the glossy magazines. Photojournalists could draw a paycheck from *Fortune* or *Life*, which, having in the thirties published classic pictures by Margaret Bourke-White and Walker Evans, continued to showcase great photographs. Or one could become a fashion photographer, like Irving Penn and Richard Avedon, and win contracts from the Condé Nast magazines, of which *Vogue* was the flagship, or from the Hearst Corporation's *Harper's Bazaar*, which at the time held the creative edge. Increasingly, the fashion magazines led the way. "In the 1950s, there weren't many magazines publishing 'serious' photography," reminisced the photographer William Klein, who went on contract for *Vogue* in 1955. "The art magazines almost never did, and photography magazines were mostly preoccupied with sunsets, wrinkled old ladies and fishing ports—and *Life* and *Look* were *Life* and *Look*. It was only in *Harper's Bazaar*, for example, that you could see pictures of Brassaï or Cartier-Bresson. Today, *Vogue* is on the same rack as the *Enquirer* in the supermarkets. But then, for many, *Vogue* was the monthly shot of culture."

Aspiring photographers could drop off their portfolios at the Condé Nast offices on Thursday mornings, where over the next week the art editors of the individual magazines would browse through the pictures. The Arbuses' earliest champion at Condé Nast was Tina Fredericks of *Glamour*. Fredericks, the daughter of a prominent German Jewish publishing executive in Berlin, had been only twelve in 1934, when she joined her family in the United States, all escaping Hitler's rise to power. Educated at Bennington

College, she dropped out after two years to work at Condé Nast and was in her midtwenties when she was made art editor of *Glamour*, a fashion magazine that was a younger sister to *Vogue* (and was aimed at the younger sister or daughter of the typical *Vogue* reader). Alexander Liberman, the powerful art director of *Vogue*, was her mentor. Always in search of talented new artists, Fredericks gave an early break to several who later became renowned, including Andy Warhol. When she invited Diane and Allan to her office, she ended the meeting by promising the couple their initial, crucial editorial support. And for Diane, it was the start of a lifelong friendship with a pretty and career-driven woman her own age who already knew how to navigate the world of New York publishing, and whose husband, with the deliciously upper-crust name of Pierce Griffin Fredericks (a Harvard classmate of Howard's, he was known as Rick), worked as a picture editor at the *New York Times*.

From her side of the desk, Tina Fredericks immediately liked the Arbuses and their photographs. Even before publishing their work, *Glamour* included them in an April 1947 feature story entitled "Mr. and Mrs. Inc.," as one of seven married couples who collaborated professionally. The short piece avowed that Allan, while working in advertising, "became a zealot" for photography and his "enthusiasm converted Diane"; at which point, specializing in fashion, they set up a studio and "landed a large New York store account." In its embroidery of flattering partial truths, the piece served as an apt introduction to the Arbuses' fashion career.

For their editors, if not for their models, the Arbuses' anxious attention to the overall scheme and to every fastidious detail made them appealing. "They were very fun to work with," Fredericks recalled. "Usually, you get pictures and you do a layout. They gave you pictures that could only be laid out one way." The Arbuses thought up a concept for each assignment—or, rather, Diane did. "Diane was the only one that came up with ideas," Allan said. "I was good at taking the photographs." Sometimes they got so caught up in their stage machinery that the conceits overshadowed the clothes. That happened early on with a six-

page portfolio of summer dresses, in which the Arbuses depicted eight women in Central Park, some of whom they directed to hold cameras and appear to be photographing the other women or, in one scene, a pretty toddler. (Doon in her bassinet plays a supporting role.) As pictures of small figures in a landscape the photographs were lovely, but as guides for young women determining fashion purchases they were deficient. Too much zealotry and enthusiasm for photography: the Arbuses were forgetting why they were there. They reshot some of the pictures so that the clothes could be seen more clearly.

Diane was always scouting for suitable locations. How about a woman holding a furled newspaper while she looks up the street for a taxi? Or standing on an art nouveau staircase, wearing a long dress and a straw hat, grasping a letter in her hand and gazing toward the landing above? If Diane came across a building with a graphically interesting striped façade, the kind that Walker Evans might record, she thought, *Why not have a woman walking a poodle in front of it?* The Arbuses liked to use rows of telephone booths and beach changing rooms, with women in different stages of the same activity, to create a feeling of variety that was confined within an orderly framework and allowed the reader to concentrate on the clothing.

Those were simple concepts, like movie stills. At other times, Diane devised scenarios that could have underpinned entire movie sequences. For a feature on graduation dresses, the opening color picture showed a girl in an old-fashioned photographer's studio; on the following pages, a black-and-white oval-shaped photograph of the same young woman, which might have come out of that studio, is shown hanging on a wall papered in a fusty pattern, above a desk with an antique lamp. Similar photographs of girls in their graduation dresses are displayed in the kind of oval frames that were once used for daguerreotypes. Although the dresses are current fashion, the mise-en-scène suggests a flashback to a memorable life passage that took place in the distant past. It feels dreamlike. In an equally elaborate feature, a

color photograph reveals a man standing in an ornate doorway. On the left, his black-and-white portrait is tacked to a wall. A printed page hangs over a tabletop, on which rests a vase filled with dried leaves. Later in the same issue there is another color photograph, this time of a woman cooing at a bird in a hanging cage, near an escritoire that supports a pink vase, a pink plume in an inkstand and some pink paper. Several crumpled pink pages lie on the floor. These might be scenes of a love affair from a Broadway play or Hollywood movie, one that Diane's mother would have applauded.

In addition to the work for *Glamour,* the Arbuses, having won Liberman's provisional trust, soon got assignments for the more prestigious *Vogue.* Although the credit and the models (frequently young socialites) may have been tonier, the photographs were similar. Their first *Vogue* pictures appeared in October 1948. In a two-page spread on hats ("Young Hats, Young Heads, Young Prices"), five smartly attired young heads (and shoulders) could be seen, in a skillfully choreographed ballet of animated interaction, above the doors of a stretch convertible. The car was parked by the recently constructed East River Drive, with the industrial skyline of Queens visible across the river in the background. In the same feature, a pair of color pictures touted the allure of "the reversible bunny fur jacket" and employed an endearingly fluffy cat draped over the model's shoulder as a prop. Over the next two and a half years, more than a dozen *Vogue* pieces were illustrated by Arbus photos. The layouts could be laboriously intricate. One was a "cross-country album" of thirty-three separate pictures of models who had migrated to New York from all over the country. Even more grueling was a guide to Christmas gift ideas. The story comprised twenty-one separate tableaux, some of them constructed with a still-life painter's care (a leatherbound diary on a desk with a telephone off the receiver and a clock) and others with a scenarist's imagination (a man leaning solicitously over a woman in a "reading-in-bed jacket" with a thermometer in her mouth).

Allan and Diane were befriended early on by Richard Avedon, a prodigy fashion photographer and already famous. Like Diane, Avedon was raised by parents of Russian Jewish origins who were in the clothing business—his father owned a small Fifth Avenue clothing store, his mother's family worked in dress manufacture—though the Avedons were not nearly as prosperous as the Nemerovs. Avedon's precocious success might have been something for the Arbuses to emulate, but it wasn't. Indeed, it couldn't have been, because Avedon, despite his restless intensity, radiated a sense of grace and confidence, an assumption that the day's task would be accomplished by the day's end. Later on, he would routinely photograph his models in his studio in front of seamless white paper, so the background was a neutral midtone; he used psychological maneuvers to generate emotional responses if he felt they would help the picture. But even in the more elaborately staged photographs that established his reputation right after the end of World War II—of tall, graceful models wearing this season's styles, striding through Parisian streets or chatting in cafés or laughing in nightclubs, like goddesses who have descended from Olympus—he made the activity seem effortless. The women in Avedon's pictures appeared to be enjoying themselves. They were in motion. They looked alive. The carefully arranged women in Arbus photographs were static. Gazing up the street for a taxi, lost in thought on a stairway, listening on the telephone and, in the most extreme case, hanging on the wall in a framed picture, they were as lifeless as artificial flowers.

At the Arbus studio, the work was painstaking, with the emphasis on *pain*. "It was a fundamental mistake we made which was largely responsible for the stress," Allan Arbus said. "Dick Avedon put up white no-seam and photographed a girl. It was gorgeous. We decided we couldn't work that way, we had to have some concept for the photograph. Looking back, why the hell did we feel that way? I guess we figured if we photographed the way Dick did, it wouldn't come out. We were afraid to try it. I remember

one day he just popped into the studio. No appointment with us. We were talking back and forth. I said, 'When we started in this, I thought it would be so easy.' He said, 'Isn't it?' "

In the studio, along with their worrying, the Arbuses were forever nuzzling each other. Hill, who modeled for them only a few times, watched their mutual caresses and conspiratorial whispering with a quizzical eye. "Was it false or not?" she wondered. "He and Diane seemed like they would be better off in a bed if you would go off and leave them." To Hill, it seemed like theater— comic theater. "The acted-out devotion of Diane I found funny," she said. "That amount of feeling up of each other, touching and whispering and tickling. Looking back, I think I would have preferred that they stop and get on to the work." It embarrassed her. She wanted to creep out of the room and let them go at it. Yet she also suspected that far from intruding, her presence was a necessary element of the scene. "They seemed really to *need* me, as if I had got stuck in a play that depended on some minor character going around emptying the ashtrays or something at the back of the stage," she explained. "Or as if I were the only audience they *had* so I couldn't just walk out." Certainly, they were not oblivious to her presence. Sometimes they would interrupt the shoot to talk to her. Diane told Pati that the main reason they hired her was so that they could talk to her.

Once the day's work was over, the Arbuses would attempt to relax. Allan might take out his clarinet as Diane prepared something to eat. But the exhaustion, mental and physical, that came from the anxious task of trying to please, with work that always seemed wanting, eroded the foundations of their well-being. Diane perceived unhappily that the pressures of fashion photography imposed a structure on their days, one that was distorting but unifying, "because we had, desperately, to make use of life, to force and beg of it, at the same time, the favors we needed of it, and sacrifice, in return, everything we didn't need." The work was both their punishment and their reward. "And then, every

few days, after it had rained like we needed it to, and Liberman had complimented us like we wanted, and the picture was going to be used, and nobody thought it was as bad as it was, then the next day was like a miracle, gratis, but mostly by this time, we were too weak, too bankrupt or guilty, to accept it (so we walked around in the snow, naked, shivering, homeless)." Any reprieve was only temporary.

12

A Mystical Friendship

Looking out from her apartment, Pati sometimes noticed a young, attractive blond woman with the wide face and snub nose of a cat, moving past the curtainless windows in the opposite house on West Tenth Street. At other times, she would see the woman on the street, often with a little African American girl at her side. When they eventually introduced themselves, Hill was invited into the home of the intriguing neighbor—who, she now knew, was called Nancy Christopherson—and discovered behind the plain redbrick façade a sequence of rooms as atmospheric and otherworldly as the sets in a film by Cocteau or Vigo, directors that the film-loving Nancy especially admired. Everything was illuminated dimly, with artificial light from shaded lamps or by sunlight that peeked through the triangles of colored paper she had pasted on the windows. It was all done for no money. She had barely enough to feed her daughter and herself.

Christopherson occupied the entire vacant house without troubling over such prosaic details as landlords or rent. She made the place her own, as a visitor recognized immediately upon seeing the steps of the old interior staircase that were daubed in a rainbow of brilliant hues. Walking from room to room was like traveling through the chambers of a self-intoxicated mind. One space,

painted in earth tones, evoked the dry Sahara. Another was as
densely foliated with plants as a tropical jungle. Christopherson
salvaged objects off the street and assembled them into artful
groupings within rooms she painted in saturated colors. On the
wall above the kitchen sink she had constructed a still life of old
bottles and discarded bric-a-brac. She devoted loving attention to
each orphaned object.

Like so many quintessential New York originals, Christopher-
son originally came from elsewhere. She arrived in the city as
an expectant mother during the war, cast out as a pariah from
Lakewood, Ohio, a suburb of Cleveland, to give birth to her
mixed-race child in a home for unwed mothers. Donald Banks,
the father of Nancy's baby, was a student in the black high school
where her father taught. How the two conceived a child was a story
that Nancy related with mythic—or maybe it was cinematic—
bravura, complete with extravagant lighting effects. One of the
people she told was the diarist Anaïs Nin, whom she met through
the choreographer Maya Deren a year after arriving in New York.
(Both Christopherson and Nin appear in Deren's 1946 film, *Rit-
ual in Transfigured Time*.) Inclined toward romantic melodrama
herself, Nin wrote a story about Nancy and Donald that she titled
"A Child Born out of the Fog." In Nin's telling, Nancy and Don
are walking home through a park after a political meeting as a
summer fog descends. They play a child's game of hide-and-seek
until "she heard the voice of Don and the voices of her feelings
deep like a forest" and "she knew that if she did not find him
again she would be alone."

Out of their tempestuous union, a daughter, whom they named
Diane and called Poni, was conceived. After the baby arrived,
Donald came to New York and married Nancy. The marriage
lasted only about a year. In her story, Nin describes the verbal
abuse and threats that the couple endured from strangers in the
street. But racism wasn't their only problem. Indeed, Donald's
race had been part of his appeal. To a friend, Christopherson
described how as a child, seeing a handsome black boy excluded

from a public swimming pool in Ohio, she trembled at the injustice; she said the memory of it returned to her when she met Donald. To someone else, Nancy explained that since women and blacks were both second-class citizens, she reasoned that she would form an equal partnership with Donald; she discovered with dismay after they were married that in the eyes of any man, even a black man, a woman was inferior. Notwithstanding all of these sociopolitical overtones, her attraction to Banks seemed, as with so many of her choices, primarily an aesthetic one. Pati once asked her why she had married Donald. "She said she loved the looks of him," Hill recounted. "He was so black. He was a beautiful man." Years later Christopherson told another friend that she believed that blacks and whites occupied space differently. "Like negative space and positive space," this friend recalled her saying. "It was imagistic for her, the whole idea of a black person." He was, said another, "one of those gods she needed to be with."

Most people's fantasies intrude from time to time into their real lives. With Nancy, however, real life occasionally poked its unwelcome nose under the tent of her imaginary playground. Or, to put it another way, the everyday world was a transparent scrim behind which she saw a larger, grander epic unfolding. In contrast to Pati, who, as Diane put it, dwelled in a universe of flickering images, Nancy read the world as a sequence of symbols. A passerby on the street would remind her of a Roman god. The layers of paint and old posters peeling off a wall stopped her in her tracks as she contemplated their beauty. Everything reminded her of something else, and nothing was what it appeared at first glance to be. She read constantly. Remarkably well informed on the subjects that interested her, which included mythology, history, gypsy music, foreign films and Native American lore, she would speak of events that occurred centuries ago so vividly and personally that she might have been recounting a childhood memory.

For Hill, who delighted in the actual, Christopherson's charm would quickly wear. "I could tolerate her to an extent, with joy,

but the real world got in the way," Hill said. "I still liked the real world, and Nancy didn't pay any attention to the real world. She had a tremendous feeling that the world owed her a living—no, not *owed* her, because she hadn't paid anything for it. She wanted fairy tales to be true." As Pati saw it, she herself loved real life, Nancy ignored it, and Diane—Diane was somewhere in the middle, constantly assessing and criticizing life, finding the discrepancies between the grandiose and the grubby and laughing about the ridiculousness of it all. "It's as if Nancy turned her back on what I felt was most precious," Hill said. "Nancy wasn't what I came to New York hoping to find, but she may have been what Diane wanted to see." At the very least, Pati suspected that Diane and Nancy would like each other, and so she introduced them. "Diane was fascinated with her, as I thought she would be," Hill said. "She asked her to pose."

It should come as no surprise that Hill and Christopherson recalled that first meeting very differently. Hill was certain that Arbus and Christopherson met in her apartment and sat on the rug beneath the papier-mâché unicorn, talking about ways that a pretty, unemployed single mother might earn money. Obviously, Nancy needed cash. Diane said she should come pose at the Arbus studio, and Pati, who was modeling successfully, made up a list of agencies for her to contact. And on a few occasions, Nancy did work for the Arbuses, who were at first enthusiastic. Then it fizzled out. Nancy was never on time. Beyond that, she lacked the talent of being truly present in the moment, as is required of a model. "She had neither fakery nor reality," Hill remarked. "I wouldn't have chosen her for that reason."

Christopherson's version of how she met Diane was far more evocative. In her telling, she was making the rounds, working from a list of fashion photographers given her by Hill, and she had an appointment to show her portfolio to the Arbuses, whom she had never met. On the way to their Midtown studio, she passed a young woman on Fifty-Fourth Street "with the most extraordinary presence about her." Each stopped to stare at the

other. Christopherson perceived "a nimbus about her—she was fabulous looking." A few minutes later, when she entered the starkly black-and-white Arbus studio in the basement of a rickety building on West Fifty-Fourth, the thin, nervous man with huge, dark eyes who came to the door remarked on her strange expression. She began to explain the peculiar encounter with this "fantastic woman," and at that point the door opened and in walked Diane. "That's her!" Nancy shouted. "I thought you were going out," Allan said, in a voice tinged with irritation. Diane smiled and replied, "I just decided to come back." And that was it. This mystical meeting inaugurated a friendship that Nancy considered to be more than a friendship. "It was as if we'd always known each other," she said. "We were like Siamese twins."

Because Christopherson "lived partly in her head," Hill suggested, she might have gotten so engrossed in anticipating her look-see at the Arbus studio that she forgot entirely what Diane looked like. "I think she could only understand things when she had imagined them into being what she wanted them to be," Hill said. Even more likely, when Christopherson recalled this meeting after the passage of thirty years—with the knowledge of all that had occurred, including the rusting of this magical friendship—she remembered it beginning with an appropriately supernatural recognition scene. Because whatever the literal circumstances of their meeting, Nancy's version captured the underlying truth of a close bond that endured for more than a decade. She enriched Diane's life in numerous ways: introducing her to the allure of the *I Ching* (which Nancy pronounced *Eeking* and consulted regularly), foreign movies, the Puerto Rican neighborhoods on the Lower East Side and the beach at Coney Island. She complemented the protective Allan by serving as Diane's companion in search of adventure. Like Diane, she saw everything through a very personal filter.

Compared to Nancy, Diane at this point in her life was prudent, career-minded, responsible. She had married a nice (although poor) Jewish boy, and she hurried home every evening

to their apartment to make dinner for him and their angelic-looking child; Nancy was squatting in an abandoned house and raising a daughter of mixed race. While Diane worked side by side with her diligent husband, Nancy's only visible source of income (not that it was so evident to the outside world) was her mother back in Ohio. Nancy lived to read, to paint (modernist canvases and the walls of her home, both highly colored) and to trawl the streets for beauty. Both women were fiercely judgmental. "Nancy was the most critical person I ever met," Alex Eliot said. "She disapproved of everybody and everything, except Diane." But Diane was violent in her assessments and cautious in her actions; Nancy did things impulsively and intuitively. She could be hugely generous one minute and exasperatingly demanding the next. Allan, for one, was repeatedly infuriated by "that fiend, that loathsome woman that inconstant antisexual egotist that disorganized disappointing appointment breaker that monster that feeds on men's flesh and doesn't even bother to throw the bones away although she pastes their snapshots in her album—My Nancy, with the unlaughing face."

Throughout Diane's life with Allan, the Arbuses lived in apartments and worked in studios that were devoid of color and sparsely furnished, as if Mrs. Arbus feared replicating the overstuffed apartments of Mrs. Nemerov. Nancy's homes were always filled with things, mostly what others might categorize as junk. Nancy was like a photonegative of Diane, and they both recognized it. In 1959, when their friendship was at its zenith, Diane copied in her notebook something that Nancy had written to her: "For one who cannot distinguish the Beautiful from the Ugly from one who cannot distinguish the Ugly from the Beautiful." Nancy could stand transfixed by a crack in a sidewalk. She saw beauty everywhere. And Diane was someone who would immediately spot the hairline crack in a golden bowl.

13

A Long-Awaited Consummation

"We were really in horrible shape," Diane complained. "We had set our nose so frantically to the grindstone that we couldn't see beyond it." Heading toward Martha's Vineyard in the summer of 1948, the Arbuses felt as flat and worn out as the countryside that rolled by the train windows. It was "*the* most monotonous land-scape this side of Kansas," in Allan's judgment. With character-istic anxiety, he was worrying about the rental house Alex Eliot had found for the two couples to share. It was said to be a "dream cottage." Allan had seen so-called dream cottages before. What was meant, exactly, by the warning that there were chinks in the walls? It was "a euphemism no doubt, more likely walls in the chinks." The house had no shower. Why were they going so far just to be uncomfortable? As they approached their destination, Allan's "heart sunk lower and lower."

But the house was idyllic. Situated on a lagoon, it was big and old. Yes, it needed to be swept clean, but once that had been done, Allan bathed happily in the tub, chopped wood with an ax and flew a kite on the beach. The Eliots had a five-year-old child, May, who was Diane's goddaughter; she was two and a half years older than Doon. Many of the activities centered on the two girls: teach-ing them swimming, taking them rowing, hunting with them for

starfish and crabs. That summer, Allan was fascinated by Hou-
dini, the magician who could escape from any entanglement.
Mastering Houdini's techniques, he would tie up the others with
ropes and then chortle as he showed them how to slip free. The
days passed delightfully. Even so, Allan smiled at Diane's saying
that they were "mending." "One rests, and returns to find every-
thing *exactly* the same," he declared. "I've no illusions."

Losing herself in the present, Diane embraced the role of home-
maker. She was learning to cook wholesome country meals—leg
of lamb, roast chicken, stuffed cabbage. She boasted that "they
taste fabulous—I think *just* like they're supposed to—but more
so." Every normal activity or flavor pulsated with amplified clarity
and force. And with Diane, regardless of the circumstances, emo-
tional gratification arrived as a bounced-back reflection. She was
joyful when she perceived that she was making others happy, and
by arousing desire she felt attractive and powerful. Playing roles,
she waited for the applause that would validate her performance.

Mostly, she was dedicating herself to the role of mother. "My
parenthood is such a joy," she wrote to Tina Fredericks. "It's the
one thing that makes me feel big. Also grown up." If not for their
financial precariousness, she would be "*almost tempted* to have
more kids"—though, she admitted, "actually Doon is sometimes
an awful pain."

A large, stray mutt would visit the house most evenings at dusk
and stare at Diane with gray eyes. Although she didn't much like
dogs, this one fascinated her, because he never licked or barked
to ingratiate himself. He was not cutely conforming to the senti-
mental preconceptions about dogs that people treasure. This was
a dog lacking any affection for humans. He seemed to be looking
straight through her "in a very sort of mythic . . . way." The image
of the cold canine gaze was so "haunting" that she snapped a pho-
tograph, which she regarded as one of her first artistic attempts,
but she felt that the dog didn't like her, she didn't particularly
like him, and for whatever reasons, the picture wasn't very good.

The Arbus and the Eliot marriages were aging, and under-

lying tension had begun to splinter the veneer on both. Alex by now understood what Anne had tried to communicate when she alerted him to her depressions. He had come home once to find her unconscious by an empty bottle of pills; it was luck that allowed him to get her to a hospital to pump out her stomach and save her life. Both he and Anne drank, and when soused, they would berate each other furiously. She was frustrated by her failure to write for publication. He was working as an art writer at *Time* but thinking he should be making art, not commenting on it. When the two couples were together and the Eliots fought, the Arbuses pretended that nothing was happening. In the fall of 1948, the foursome took a car trip through New England to see the autumn foliage. When they stopped in Hanover, New Hampshire, to visit Pati, who was living there temporarily, Diane and Allan walked up the driveway alone to pay the call. They left Alex and Anne in the car, bickering.

The Arbuses did not indulge in alcohol. "Water is an underrated beverage," Diane liked to say. Yet in their relationship, too, the strains were showing. Their workdays were a torment. Allan was much less upbeat and ebullient than Alex. He brooded. He envisioned the worst possible outcomes. And since Diane was fretting as well, their home life teetered. "What matters love? If only 'Glamour' 'loves' our next picture," Diane commented acidly. Allan wanted to be an actor, but how in practical terms to become one mystified him. He played scales mournfully on his clarinet.

Things became clearer, or at least more dramatic, the next summer, when the Arbuses and the Eliots returned to Martha's Vineyard. The sexual electricity between Alex and Diane had been crackling since they first met eleven years earlier. On Alex's side, the feelings were straightforward: he was smitten, enchanted, lustful. Diane's emotions were more complicated. She had posed for Alex at the Cummington get-together even before they met, in much the way that she told him she exhibited herself at night for the man who lived across the courtyard in her apartment building. She sat in the nude for him as an artist's

model while Allan was away during the war, and also presented him with a print of the self-portrait, pregnant and bare-breasted, that she mailed to her husband. She gave him a photograph that Allan had taken of her in the style of Stieglitz's pictures of Georgia O'Keeffe, naked except for her wedding ring, from her shoulders to her groin. She exulted in the effect she had on libidinous men. "I'd love to make Howard happy—you know?" she had said to Alex at Cummington, when describing her sexual games with her brother. "I yearn to have the whole world smiling." On the Vineyard, the two couples would skinny-dip in the lagoon. Alex was so much in her sexual thrall that she had no need to take him into her bed.

That summer of 1949 saw a nonstop deluge of guests. A sardonic artist friend of Anne's, heading for a spree in New York, dropped off his baby and his "agonized porcelain doll" of an English wife, who ignored everyone but Anne—and especially, Diane thought, ignored Diane. Then Anne's father and his second wife arrived with their three-year-old daughter, who spoke, in Diane's barbed telling, "as from a hidden script, lines of unparalleled cuteness and calculation." After only one day's respite, Tina and Rick Fredericks came. "They arent open enough for my taste and they had about them a bit of the smell of corruption of a N.Y. cocktail party," Diane groused. "But this was mostly in our noses." One day after the Frederickses, Howard and Peggy appeared, both of them seeming sad. At that point, limp from the uninterrupted rounds of cooking and conversation, Diane could do no more than smile. She was grateful when all the guests departed and the Arbuses and Eliots were left alone for the penultimate week of August.

Alex was laboring that summer on a novel about the incestuous desires between a brother and sister. The sixteen-year-old girl in his book, *Proud Youth*, closely resembles in appearance and conversation the Diane he knew at Cummington. The book was later described incisively, if cruelly, by Pati: It is "about a boy who got his foot mangled when he was nine years old and now only

has two toes so spends most of his time worrying over it and in the end sails out to commit suicide. (Also he made love to his sister, Diane A.) Except after a long time of last thoughts which I don't think anyone would think except maybe this boy, his father, who is a drunkard, rescues him and dies of cerebral hemorrhage so the boy becomes a Catholic." One day Alex read a chapter of this work in progress to the people he was closest to: his wife and their two best friends. When he finished, no one said anything for a long moment. Then Anne exploded. The book was awful! Why did he think he could write? She was the writer! She angrily left the house, and later that day returned to the mainland. Alex was abandoned to his doubts.

The following afternoon, still disconsolate, he went for a long swim in the ocean. Paddling out to clear his mind, he didn't realize how far he had traveled until he grew tired and began to panic. He could see Allan and Diane on the beach, but when he called for help, they didn't hear him. Floating on his back, waiting for the tides to shift, he eventually collected his strength and made it back to shore. Collapsing on the sand, he told Allan and Diane that he had been so despondent he lost track of where he was and nearly drowned. The three of them talked for hours, and then Allan returned to the house. On the deserted beach, with the sun sinking below the horizon, Diane continued to comfort Alex. And gradually, as her caresses became less maternal, the two of them slipped into the sexual embrace that had been so long forestalled.

Back at the house, Diane immediately told Allan that she and Alex had made love on the beach. He took the news calmly. Passion that flared up under extraordinary circumstances didn't, to him, imply betrayal. Allan had fallen into a wartime homosexual affair with a fellow soldier in Burma, and he had spoken of it openly with Diane and Alex upon coming home, to their unreserved acceptance. But a week or so later, when Anne returned to Martha's Vineyard with a couple of her cousins and they were all dining together, Alex, with a good deal of wine under his belt,

made clear that after all these years he and Diane had consum-
mated their love. Anne, unlike Allan, did not react well to this
revelation. She was outraged, incredulous, stricken. She looked
toward Diane, whom she viewed as her close friend, expecting an
apology or an embarrassed excuse. Diane said nothing.

Many years later, Anne confided to her grown-up daughter
that she had wanted to say to Diane "I forgive you" but couldn't,
because Diane didn't think she had done anything that required
pardon. That refusal to admit wrong was what Anne could not
forgive. Once more she rushed off the island. This time, she did
not return. She never saw Diane again.

Diane confided to Pati that she experienced "almost no
guilt . . . except at odd moments, toward Alex." Nor did she
see any reason for secrecy. "Allan doesn't care," she maintained
(even though he entered psychoanalysis upon returning to New
York). "What makes it seem more important—the tellings or the
silences?" she wondered. She persisted in "blithely seeing the
simplicity in what," she admitted, "could be thought of as a fairly
intricate situation." In the immediate aftermath, her sole day of
feeling "tragic" occurred when she worried that she was confus-
ing both Alex and Allan.

The entire incident seemed "very unreal" to her. Only when
receiving a letter with Pati's quizzical, sharp-tongued reaction did
it assume dramatic proportions, as the letter was "so intense, so
articulate and it seemed to revolve around me." Suddenly, she felt
as if, on a dreary New York day, "sick of my own dullness," she had
entered a neighborhood movie theater and "there on the screen
flashed the title, music swelling, 'Diane,' written, conceived and
directed by Diane, starring Diane. And it wasnt me at all. It was
Ingrid Bergman or Jennifer Jones or someone." She was "swarm-
ing with feelings, none of them significant." One of her feelings
was "This is not me," and also, "There is *almost* no me."

Diane seemed to regard the lovemaking with Alex as literally
a consummation—the ending of a chapter, not the prologue.
She was baffled by her "strangeness" with her old friend. "Utter

inarticulateness, even helplessness, and as if we had just met,"
she reported. "I am suspicious of that place where love and inse-
curity meet. I mean I feel they should never meet—but maybe
they always do." She gave Alex a two-sided photograph, which she
made by pasting two portraits back to back. One was of Anne,
wearing only a slip, seated on the ground with her knees to her
chest and her arms around her legs, her eyes downcast and her
expression forlorn. On the other side was Allan's nude picture
of Diane. With a pencil, Diane had scribbled over the image of
her own body. "Diane did it to say, 'Forget about me, you've got a
beautiful bride there,'" Alex explained. She let the images take
the place of words.

Alex remained, nonetheless, "obsessed" with Diane. In late
September, *Time* sent him to France to try to snare interviews
with Picasso and Matisse; at Diane's suggestion, he asked Pati,
whom he had never met, to assist him. Pati had moved to France
in July to see if Paris might offer the adventures that New York
hadn't quite. Even though, after merely three months in France,
her grasp of the language was rudimentary, she gamely agreed
to be his interpreter. On their flight in a small airplane from
Paris to the French Riviera, Alex talked only of Diane, of her cur-
rent absence from his life, of what place she might occupy in his
future. He debated how their conduct conformed to his moral
standards, and, more unanswerable, whether it accorded with
Diane's. He confessed that he wasn't sure Diane followed an ethi-
cal code in such matters, and furthermore, he didn't know if she
was in love (or at least, in love as he understood it). Did she even
recognize the potential consequences? Although he frequently
dissolved into tears at the pain of it all, he made clear to Pati that
he was open to the prospect of consolation. She was disinclined
to cheer him up in that way, but at night, they left open the door
between their adjoining rooms so they could talk of Diane as
they drifted off to sleep.

Alex accosted Picasso on the beach at Antibes and extracted a
few words from the great man, who, true to form, admired Pati's

faded blue jeans with patches on the rear. Later in the week, hav-
ing been able to secure an appointment, they visited Matisse in
Nice. There, along with translating Alex's questions, Pati shocked
her journalistic colleague by adding one of her own. Of the art-
ist, who was nearly eighty years old and unwell, she asked, "Are
you content or are you still looking ahead?"

 With the passage of time, Alex believed he was slowly recu-
perating. Back in New York, he wrote Pati that he was avoiding
seeing Diane alone—"the obvious cure"—and felt that he was
"nowhere near so OBSESSED by thoughts of her as formerly."
He was "learning to love her a little less selfishly." Of course, he
had no idea what Diane might be learning. Perhaps it was the
unhappy realization she had voiced to Pati: that love, at least for
her, would always be joined with insecurity.

Central Park Prophecy

On one of their regular outings to Central Park with Doon and Poni, who were now five, Diane and Nancy chatted while the girls played and fought. Fought exuberantly—rolling in the dirt, pulling at each other's hair, flailing their little fists. It was "just like a cowboy movie," Arbus thought, and "wonderful to watch." The two grown-ups would intervene only at the last minute, to ward off a possible injury. That was seldom necessary, because it was just theater, in Arbus's view, and the girls "cared about being fierce rather than effective."

It was a drizzly, misty afternoon in mid-July 1950. As the childish shouts and shoves erupted in the background, Arbus was unburdening herself to Christopherson and reproaching herself for her actions, which she couldn't defend or even explain. She had gone to bed with Eliot again. And while the previous summer she was transported by their spontaneous lovemaking, now she felt different—"what was in me lightness a year ago turned into thinness. . . . And what was unexpected and magical became expected and fooled me."

Part of it was Allan. On the Vineyard the year before, he had been "wonderfully un-passive" and "came through exquisitely" so that moving forward was "incredibly easy" for her. But now, once

he learned of this latest indiscretion (because of course she told him), he "was affected in some new way." He had cut off physical affection, so clearly he was feeling wounded.

And it got worse. Alex and Anne were separated. At *Time,* Alex had met another woman, Jane Winslow Knapp, who worked as a foreign news researcher. Raised abroad, mainly in England, Spain and Italy, she was sophisticated, self-reliant and spiritually inclined. She was also beautiful, with deep blue eyes, a wide and full mouth, bronze-colored hair that went down to her hips, and a trim, athletic figure. Diane judged her to be "pretty powerful and very nice." Alex was besotted. As soon as he saw Jane, he decided he needed to get out of his marriage. It had taken him six months to disentangle himself from Anne—and, harder still, from their seven-year-old daughter, May—but now he was free, and romancing Jane in a room in a brownstone near the *Time* offices in Rockefeller Center. Diane recognized that she felt threatened by his new passion. She admitted abashedly that "running to Alex was such an obvious way of getting exactly what I was asking for . . . as if I must have everything—and not lose what I had a year ago." Yet trying to recapture it merely tarnished it all. She criticized herself for being a "spoiled child." That accounted for some of the "ugliness" in what she had done. All in all, the episode had thrown her into gloom for several days, in a way that bewildered her. The only redeeming aspect of this dismal turn of events was how it had toppled her unexpectedly off her dully secure perch. It appeared evident now that her sexual magnetism was limited. After "getting pretty drunk with power," she realized that the power was illusory and not within her at all. She said if nothing else, she welcomed the surprise.

Christopherson was unsympathetic. Like Arbus's other close women friends, she disapproved of the dalliance with Eliot. Sexual power was not a weapon that a woman should brandish proudly. The previous summer, Hill had responded caustically to Arbus's suggestion that perhaps love might be pursued with

changing combinations of people, "like an endlessly delightful 'Paul Jones'" mixer. Christopherson, who disliked Eliot, was more scathing still, and reproved Arbus following this latest escapade for being (and here Arbus was reading between Christopherson's actual words) "perverse and destructive." If she understood Nancy correctly, this distraction with Alex was keeping her at a distance from Allan, and Diane agreed that that would be a great loss. "I think that to go deepest with another person is to succeed most," she declared.

As they headed toward their usual destination, the Central Park Zoo, Christopherson told a story about a very peculiar couple she had seen in the park the day before. What was odd about them was how much the woman resembled Nancy. They would keep turning to stare at each other at the same moment.

Outside the zoo, Diane and Nancy ordered hot chocolates and sat at a long outdoor table. A red-faced drunken woman of about sixty approached and asked unctuously if she might join them. She ranted on and on, extolling the beauty of their children, until at last Christopherson said they had to leave. Walking away, Nancy told Diane that the woman was a possible vision of herself at sixty. They laughed and talked while the children played, until they all went back to the zoo.

"There they are!" Nancy whispered, poking Diane. The two women giggled like schoolgirls as they walked past the couple that Nancy had noted the day before. They all looked at each other, but Arbus and Christopherson kept moving. They were some distance away when they saw that the man was advancing toward them. He came up and said to Christopherson, in a rapid, middle-European-accented speech, "We saw you here yesterday. You noticed us. Why did you look at us?"

Taken aback, Nancy replied that the physical resemblance between herself and the woman had intrigued her. Almost apologetically, she added that her own face used to be fuller and her hair longer.

The man agreed that there was a similarity, then looked at Nancy and Diane. "Are you two sisters?" he asked. "No relation? Look . . . what makes you tick?"

Arbus laughed. It was the kind of question she loathed.

The man continued with Nancy. "You say you are thinner. Why is this?" He wanted to know if she could pinpoint the change to an event. "Was it a loss of faith? Why did you cut your hair?" He invited them to join him and his wife at their table.

Arbus glanced at the time. It was seven. She should be heading home, but how could she refuse? She said maybe for a few minutes, and the man replied that she could not set limits.

At the table they were introduced to the woman, whose name was Mary. Arbus found her "horrid looking," with a "cat like face like Nancy's but doll like too." She was heavily made up and "patient looking, stupid talking."

Leaning close to Nancy, the man, who had a manner somewhere between a psychologist and a fortune-teller, asked, "This loss of faith you speak of? Did it involve a person?" In fewer than twenty questions, most of which he answered himself, he came to a broad but accurate summary of Christopherson's predicament.

"You are completely sensitive, completely vulnerable," he said. "Like a worm you will always survive but you will always take more and more punishment." He turned at one point to Diane and apologized for "paying so little attention" to her but explained that it was because he "felt Nancy so strongly."

Almost two hours had gone by when he suddenly addressed Arbus and inquired whether she was married and for how long. He asked if she was happy.

"Yes," Diane said.

"No," he said. "I don't see it. You can't be happy. I don't see your husband in your face. You may *think* you're happy but there is something wrong. And I don't like your relationship with your child. I think you married too young."

He told her that everyone makes a mistake early in life, he had

never seen an exception, but the crucial thing was to acknowl-
edge it.

"You are off on a tangent," he said. "You haven't been touched.
Some people go through life like that. And if you can do it, I say,
'Fine.'" He remarked that he had resisted telling her this. As she
surely had noticed, he put off talking to her. If she wanted to
dismiss what he had to say as the rants of a crazy man, she should
go ahead. "You have a kind of nervous vitality but it hasn't been
tapped," he said. "You don't use it."

Nancy ventured tentatively that Diane possessed serenity.

"No," the man said. "A potential serenity, yes. But I see only
confusion in the face. Of course, I may be wrong. But I doubt it.
I never have been yet."

Arbus was shaken. Unwilling to protest that she was happy
(how humiliating that would be!) she tried weakly to find holes
in his argument.

The man turned his gaze from Diane and looked at the two
women together. He said that he had watched them laughing
but did not understand their friendship. "I don't think you know
each other," he said. "Of course, I see what *you*"—he pointed at
Arbus—"see in *her*. She makes you feel alive. She is your sunshine.
And you, Nancy, are attracted by *her* nervous vitality, which she
doesn't use. You sense its presence."

Night had fallen. Arbus looked again at the clock. It was nine
thirty! The children, unfed, were running through the zoo.
Their shrieks reverberated in the empty park.

The man said he had more to relate, and he gave Chris-
topherson his name and telephone number, which Arbus politely
declined.

With their girls in tow, the two women ran back to the Arbus
apartment. Diane told Nancy she had to come, because if she
didn't, Allan would never believe her story.

PART TWO

BREAKING AWAY

15

Out the Prison Door

They were happier outside New York. More to the point, they were happier when they were away from the fashion business. In 1950, shunning Martha's Vineyard for understandable reasons, the Arbuses spent August on Lake Champlain in the Adirondacks in upstate New York. They were joined by Nancy and Poni, and also by the man Nancy was seeing and later would wed, Dick Bellamy. (Bellamy's marriage to Nancy was short-lived; his career as an art dealer would be longer and more successful.) They had other guests, too. Alex came with Jane. Rick and Tina Fredericks visited. So did a handsome young man from New Hampshire named Robert Meservey, a former captain of the Dartmouth ski team, who had been working as a ski instructor and was now trying his hand at photography. (He eventually found his calling as a physicist.)

The Arbuses knew Meservey because he had married Pati Hill—in a wedding on skis in January 1947 that was featured in *Life* magazine. Hill fell for Meservey while her husband, Jack Long, was in the army in France. At the close of the war, she and Long divorced every bit as amicably as they had married. (Before going to the courthouse, she returned his autographed book of Auden poems and his leather box of dress studs; he gave her a bottle of Chanel No. 5 and an ashtray from Les Deux Magots.)

And then, two and a half years after she became Meservey's wife, Pati disappeared.

"You should be here," Diane wrote. Aside from Anne Eliot— "how utterly I have lost Anne," Diane ruefully acknowledged—all her closest friends were coming to stay with them on Lake Champlain. All except Pati, who had extended her Paris expedition into an open-ended stay, finding employment as a model for the couturier Edward Molyneux and romance with a sophisticated older man, Count Alain de la Falaise, who was "vaguely separated" from his wife, Maxime. Pati would soon move out to the Burgundy countryside to work on her first novel, isolating herself at first in a chalet that belonged to Alain and then in a secluded farmhouse that she called "the Hermitage." The Hermitage belonged to the family of a young man, half-English and half-French, with whom she was infatuated but who was betrothed to an heiress. Alain visited her there on weekends. She remained married to Bob. As Diane observed, Pati was "enormously complex" and could run simultaneously on different tracks. Riffing on the name Hermitage, Diane compared her to an implacable hermit, "with a terrifying tyrannical sense of having created her world and having to keep on creating it." In her determination to be free, she was "imprisoned by her few ruthless concepts" and fluttered behind their bars like a graceful butterfly. Although she and Nancy never liked each other as much as each liked Diane, to Diane's mind they were much alike, for they were confined within prisons of their own making. "They are independent—free as air as far as people go but walled round by their own idea of their independence," she reflected. She thought she was the opposite: "utterly without prejudice or power in the world—just open and willing." But it is always easier to make out other people's prisons than one's own.

It is easier, also, to critique another's love life. "Im curious to know if you ever compare and keep vivid in your mind *at the same time* all or some of the men you know or knew—or do you try to forget them or keep them apart?" Diane asked Pati. As it happened, at the time that Diane posed this question, Pati was

in France, contemplating a divorce from Bob Meservey; while Diane, in New York, was discussing with Bob whether they should go to bed together. (She had revealed to him her sexual escapades with Alex.) Bob reported it all to Pati in a long letter that calculated the pluses and minuses. He told her that he "could love a lot of people." What interfered with his going ahead and sleeping with Diane was a practical reckoning. "We have added up the totals and know that we would both lose," he explained. "I wouldn't think for instance of trying to get the rest of Diane at the price of losing all of Allan. It would be like giving up one of my legs for a third arm."

What restricted Diane most palpably was the job—and the door to *that* prison, at least, was clearly marked. She and Allan decided that their work was making life too desperate and miserable. Financially and psychologically, they were entirely at the mercy of art directors, who would scold them paternally for the poor quality of their pictures and then praise them for the marvelous photographs that appeared to their creators no better. "It is so disgusting," Diane moaned. "A game which involves all the emotions of life on an even grander scale than life itself." They needed to escape for more than a month's vacation in summer. They would take a year off, traveling in Europe. "We were really running away," Allan later said. Allan thought he would miss little in New York besides his camera store and his psychoanalyst. Oh, and of course, Alex and Jane—Diane and Allan would both miss them terribly, but there was a hope that Alex could arrange with *Time* to spend six weeks working in Europe on a sojourn that would also serve as his and Jane's honeymoon.

Diane was doing all she could to incorporate Jane into a reconfiguration of the old quartet. However, as Diane had noted from the outset, Alex's new girlfriend was tenacious. Jane perceived the intricate interlacing of Alex and the Arbuses, and she wanted to disentangle them. She knew—because he told her—how enamored of Diane Alex used to be (as he put it) or still was (as seemed just as likely). It was understandable for her to

be wary. On top of all that, she found Diane difficult to talk to. Diane said that Jane amazed her—as if, she explained, Jane were "some other kind of creature." And she was determined to "learn more and more" about Jane because it was "what I terribly want to know. I want to learn from you both everything." But Jane had no intention of opening herself up completely to Diane.

The Arbuses sublet the studio for a year, and with six-year-old Doon and their blue Ford sedan, they sailed for France at the beginning of May 1951. Days before their departure, a Museum of Modern Art exhibition, *Abstraction in Photography,* opened; it included one of their non-fashion pictures, *City Bird.* Jointly credited to Diane and Allan, this was the first Arbus photograph to be displayed at the museum. It was an honor and a milestone, and yet all their attention was directed toward getting away. Except for Diane's journeying with her parents to France as a child and Allan's wartime service, neither Arbus had been abroad before. They would start in France: Pati was the one friend whom they planned to visit. Otherwise, they had their car and could improvise. As the art editor of *Time,* Alex had taken command of the color pages newly assigned to his department. He was angling to land the Arbuses a couple of jobs: pictures of the Matisse Chapel in Vence, France, which was opening that year, and a photograph that reproduced *View of Toledo,* the El Greco painting that hangs in the Metropolitan Museum of Art in New York. They had a Paris assignment from Tina for *Glamour.* They would attempt to obtain a few other magazine commissions. But most of their days were free. They could do as they wished. They could photograph what they wanted.

Diane had black circles under her eyes and acted especially remote at a farewell party that the Frederickses gave the night before the ship sailed. Allan made apologies, saying she was ill. Whatever it was that had been ailing her, once the voyage was under way she recovered from it, feeling "marvelously cheerful and well" but also lonely, she wrote to Alex and Jane. "Everyone is afraid of getting stuck with a shipboard bore (not of being one)."

She urged them both—"not just you, Alex"—to follow through on their tantalizing half promise to meet up in Europe, so that all four could be together for a month.

Over the coming weeks, in wrenching spasms, Diane would gradually realize that she had lost most of her power over Alex: Jane was curbing him with a mastery that Anne had never exerted. So the year in which Diane was beginning to free herself from the oppression of fashion photography would also find her struggling to adjust to the loss of Alex's reassuring devotion. Without the magnifying mirror of his ardor, she felt diminished and thin. At the same time, she was plumbing the contours of her relationship with Allan as they were thrown against each other, isolated in towns where they knew no one and often could not communicate with the locals because of language barriers. She found that left on their own, they became "for each other like an image in a mirror, or a brother and sister, curiously unhelpful when help is needed." She was "easily emptied," but strangely, she had "absolutely no way of knowing how full I am until Im half emptied." The sole verification of her being came through the reflection from Allan, and while his attentions were necessary, on their own they did not suffice. Ten days after arriving in France, she would report that she felt "unreal." She and Allan were "skating on the thin ice of Paris but we are so weightless ourselves that we are hideously in no danger of falling in."

Diane defined herself by the way she was seen and, conversely, by what she saw. The photographs that a decade later would establish her reputation seemed new because they recorded the intensity of that reciprocal locked-eye vision: Arbus scrutinizing her subjects, and those subjects illuminating her with their gaze. In a parallel dance of mutual seduction, she told stories to captivate her listeners, and because they wanted to hold her interest, those listeners would offer up secrets in return. "People were interested in Diane, just as interested in her as she was in them," recalled curator John Szarkowski, who in the sixties would champion her work. In her year abroad, unable to use words to forge ties, Diane

was thrown into a disorienting predicament that she bravely chose to regard as a potential advantage. "I think that with no one to tell me who I am, without the sound of my own words to stand for myself for me, I will find the true indigestibleness of me," she wrote. "Its like going around a mirrorless world asking everyone you meet to describe you—and everyone says endlessly 'you have a face even as I do and your eyes are bluer and big'—and even 'my smile when I look at you is you'—but you don't believe it. And then one day you bump smack into a stone wall and no one hears you say 'ouch'—and your whole problem is solved."

A reflected self-image had never satisfied her: it was second-hand and blurry. She wasn't convinced. If only she could learn who she was by experiencing the world directly, she thought she would be a fuller person. But she couldn't. In her childhood, she felt that "the world seemed to me like it belonged to the world and I could learn things but they didn't seem to me to be my experience." Throughout her life, it was a continuing source of distress to Arbus that she did not respond emotionally to things in the direct way that others apparently could. She was intrigued when Hill talked of being transported with happiness in the aftermath of meeting Meservey. Hill came away with the impression that Arbus was unfamiliar with such blissful contentment. Diane pressed "to know what it was simply *like* to be happy, as if she, on the other hand, had not experienced this emotion and wished to," Hill recalled. "As if it were cigarettes or a hayride." In later years, Arbus asked her psychotherapist, "What do people mean when they say they are close?" Unhappiness, too, arrived at her door in the form of a numb emptiness rather than a sharp cut. She told Christopherson that when she was a girl at summer camp, her friends were all bitten by leeches in the lake, and she alone was left unscathed. "Not even leeches bit me!" she wept. She complained that she had rarely felt anything in her entire life. She was untouched by the ordinary joys and pains that make people feel alive. This was her prison.

16

Hermitage Seductions

Not long after the blue Ford pulled up the dusty road to her damp, run-down farmhouse, Pati found herself counting the days and hours until the Arbuses left.

On their arrival, which came soon after their ship docked in France, she greeted them gaily in her best rendition of Southern hospitality. However, she was creakily out of practice, for three months not seeing anyone but the villagers, whom she relegated to a different category of humanity, and Alain, who came only on weekends and probably deserved to be listed in a separate column as well. Out in Montacher, not far from the mist-heavy Yonne River, Pati had gone native, forsaking her stylish New York and Paris frocks for workmanlike blue jeans and boots. "What does it feel like for everyone in the world to wear your clothes now?" Diane asked. Her tone was vaguely aggressive, Pati thought, yet it was a real question that waited expectantly for an answer. Silently, Pati observed that Diane was sporting an outfit that might have been purchased in the resort wear department of Russeks.

Alain, whom the Arbuses had not yet met, was due in a few days. Allan seemed to take it as a personal slight that Alain's name was virtually identical to his own. Furthermore, he was incredulous at the notion that Alain was a count.

"Isn't France a republic now?" he asked.

"Not at the Jockey Club," Pati replied in a lighthearted tone, tacitly acknowledging the existence of certain reactionary elements of French society.

"The Jockey! You mean if you're a jockey you can call yourself a count?"

Maybe he was joking.

Doon sulkily surveyed her surroundings as Diane rummaged through a large trunk, pulling out a blue-and-yellow tablecloth that Pati had never used because it was so huge that she couldn't imagine how it might be washed and ironed before being eventually returned in a pristine state to the house's owners. Gleeful, Diane dug further and found a set of matching napkins. She composed a festive table and clasped her hands in delight.

There wasn't much to eat. In a house without a refrigerator, the market shopping was performed daily, and Pati hadn't known exactly when the Arbuses would be arriving. Diane, always resourceful, surveyed the larder. Pati had plenty of lettuce: she would prepare a big salad for lunch. But Allan balked. Eating the lettuce in rural France would undoubtedly bring on diarrhea or worse. Diane adopted the playful singsong lilt that one might use to address a child. Should she douse all the lettuce with boiling water? Would that kill all the nasty germs?

Maybe she was joking.

Doon reluctantly contributed some peanut butter crackers that she had hoarded during the voyage over. She held herself apart from the adults. But her form of aloofness was intrusive: she would run up from behind and then hang back in a way that made Pati's teeth clench. Pati sensed that Doon disliked her. And what's more, she disapproved of how the Arbuses, especially Diane, marveled constantly at the wondrous doings of their "magical child." Pati thought Doon resembled a "sullen cabbage."

"How can they be so dear in their own element and so godawful here," Pati later complained to Alain, during another visit

from the Arbuses. "Everything terrifies them and nothing is meant to be really squeezed or licked."

But when Diane after lunch announced that she was going to take a walk and visit the farm across the road, it was Pati who snapped that such an adventure was "out of the question." Her misgivings were undefined but firm. In this insular village, where the farmers and shopkeepers tolerated her as a peculiar but inoffensive interloper with a shadowy connection to the English family that owned her house, maybe Pati feared that these American friends would upset her precarious footing. Whatever her motivations, she decreed that Diane was not venturing off to the neighbors'.

The Arbuses were inflated with rare enthusiasm, so unlike their downbeat and pessimistic demeanor back home. In New York, when asked how things were, Diane always said, "Terrible, everything is going wrong," even if she appeared to be perfectly fine and engaged in some activity that she was enjoying. In France, that ambient negativity had drained off, replaced by a holiday euphoria. Although photography was on their minds, the Arbuses weren't taking many pictures. Diane's Nikon camera hung as constantly and decoratively as a bulky pendant around her neck. Allan had an irritating habit of raising both hands to his eyes in the shape of a square frame, then dropping his arms to his sides. Pati began to feel irked that so little in her world merited recording. She turned her manuscript facedown by her typewriter in an act of unfocused hostility.

"I think I'm going to be very good for Diane tonight," Allan whispered in Pati's ear that evening as the Arbuses went off to her remade bedroom while she headed for the mattress in the living room (more Southern hospitality). Having softened toward Diane, whose sympathy and curiosity could calm even the most curmudgeonly temper, Pati slipped her some pages of the manuscript, which featured a protagonist who was based on a girlhood friend from Charlottesville but also bore some brushstrokes of Diane. When this character, named Linda, says to a friend: "Jan,

I *wish* I could see your things, you must have the most wonderful
things in the world. Someday you must show me everything you
have, every little thing"—was that not the voice of Diane? A little
later, Linda fishes a used condom out of a pond and says, "That is
what love is all about, isn't it queer to think that is what love is all
about?" The juxtaposition of the grubby and the transcendent
was, again, just the kind of thing Diane loved. Diane very likely
recognized her own anonymous part in Pati's novel, which was
called *The Nine Mile Circle.* As she read some pages of it under
a flowering cherry tree the next day, she radiated appreciative
encouragement, jumping up when Pati passed by and flinging
her arms around her. "Just think!" she exclaimed. "The next
time we see each other you'll be *famous!*" But Allan was not as
embracing when Pati passed him on the way back to the kitchen.
"Are you seducing my wife?" he asked, once again murmuring
the words under his breath. Pati rushed outside, weeping furious
tears as she sat, her head resting on her drawn-up knees, beneath
an allée of linden trees. After a short time had passed, Diane
came up beside her and picked up Pati's hand and placed it on
her own knee, as tenderly as if it were an injured little animal.

Later that afternoon, Diane was reading in the back of the
house and looked out the window to see Pati pacing back and
forth in the field. When she heard Pati call her name, she went out
to investigate. Doon trailed a little way behind. As soon as Diane
reached Pati, she could see that her suspicions of trouble were cor-
rect. "It was like swimming," Diane later recounted. "We were in a
sort of sea of tall grasses—and of course (I half knew it) she was
drowning." Pati hissed between closed teeth, "I can't stand Doon.
We're going to destroy each other. Just take her, quick, and *get out.*"

Diane was horrified to think Doon was the source of the prob-
lem. On the other hand, she wasn't convinced it was about Doon.

Some time afterward, Pati backtracked in a conversation with
Allan, explaining that her book revolved around girls and their
fantasy selves, and therefore left her susceptible to the presence
of a little girl. This, too, was not very persuasive.

Nevertheless, the storm passed or at least diminished, and the Arbuses stayed. Diane and Pati had many long talks, which Diane relished. "She makes me feel wonderful, richly inventive, which she is," Diane remarked.

The atmosphere changed, although not necessarily for the better, when Alain arrived in his small English sports car from Paris, carrying food for the cats, the third volume of the Moncrieff translation of Proust for Pati, and two large steaks for . . . unfortunately, the four of them, not counting Doon. Since he knew the Arbuses would almost certainly be there, Pati couldn't understand this ill-considered parsimony, and her mood darkened further. That night Alain dominated the conversation with urbane patter about the way things were done in France. The next day at lunch, he regaled them with stories about his older brother's marriage to Gloria Swanson in Hollywood in the twenties as Diane launched artful questions that drew him on.

After lunch, Alain drove to a nearby village to fetch his two small children, who were living there while the parents sorted out their divorce. When he brought them back, Diane at last saw something she would like to photograph. She moved in to capture the beautiful blond boy and girl as they played with pebbles by their father's car. Before she could get going, Alain swooped in to move the vehicle, thinking he was providing a more pleasing background, and also let slip that *Vogue* had photographed the children and *Harper's Bazaar*, too, was contemplating a sitting. Diane returned her camera to its resting position around her neck.

Diane and Alain did not appreciate each other. She confessed that she did not understand why she found him infuriating. It may simply have been that Alain smoothly resisted her flirtations. He was not seducible; if that was to be the game, he was the seducer, and he was definitely not interested in seducing Diane. She regarded him as a fortified castle, a citadel of sophistication, "with nothing to confess, so secret, so complete." He was too inscrutable and polished even to photograph. "Once, when he referred to me in conversation, I felt as if I wasn't there," she

commented. Although she was unable to make a connection with him, she observed his relationship with Pati and found it touching. "Technically she is Alain's mistress," Diane reported. However, it was less romantic than that might sound. Mainly, it was a bond of tender affection. There was not so much sex provided by Pati and rather little money supplied by Alain. "*Still* she feels beholden—not free—so she sets up a hundred traps for him," Diane discerned. She noted wryly that Pati constructed "games with secret rules" that Alain didn't realize he was playing until the moment of checkmate revealed he had lost. Diane saw life as a comedy. Human foibles, pretensions and misunderstandings tickled her, and by pointing out these laughable discrepancies, she could entertain her friends for hours. Her ear was as keen as her eye.

The Arbuses left Montacher a few days earlier than scheduled and went west to Brittany and then south to Spain. But when they came back through France in late July, renting a top-floor apartment in the Neuilly-sur-Seine suburb of Paris for four weeks before proceeding to Italy, they stopped again at Pati's in Montacher. Arriving without warning, they found her once more in a ferocious mood, having been arguing with Alain about a grammatical trifle in her book. Diane, ever the avid spectator, sat "openmouthed, at the tennis match of their conversation." She encapsulated it in a narrative that expressed the dynamic between the patient, worldly older man and his headstrong young mistress. Her sketch in words is as pointed and composed as one of her photographs.

"I'm hungry," Pati said.

"Good, let's eat," Alain replied. "Which do you want first, melon or caviar? I think we should start with the caviar and end with the melon."

"I want my melon first," Pati said.

Emerging from the kitchen, Alain carried melon, caviar, bread and wine to the table, and he arranged the place settings.

"I want a spoon," Pati said. "I *will* not eat melon with a fork."

"Of course, you know, the world is divided that way, between the people who eat melon with a fork and those who prefer a spoon," said Alain imperturbably.

"It's just more difficult with a fork," Pati said. "That's why they do it."

From the kitchen, Alain inquired, "Which do you want—a small one or a large one?"

"I don't care, so long as it's a spoon."

Still in the kitchen, he asked the Arbuses, "Well—did you have some extraordinary adventures in Spain?"

They mumbled an incoherent response.

"But a teaspoon would do better than a tablespoon, of course," Pati called out.

Pati was still fine-tuning *The Nine Mile Circle* when the Arbuses departed Paris for Italy at the end of August. She mailed the manuscript to them in Rome in the winter. After several weeks, they sent her a letter in which Allan joined Diane in congratulations. Each admired the novel unreservedly. Pati was particularly touched by Allan's praise. "I think your book is *MARVELOUS*," he wrote. "I honestly wouldn't enjoy saying it's horrible but I'm a little sorry to have to say marvelous. For a while there I hated you more than anyone I know." Even if the hearing of her name still provoked in him a conditioned reflex of fury, he judged her book to be "superb and extremely musical." He signed himself, "Love and hate, A."

17

A Spanish Impasse

As when they met a decade earlier, Diane believed that Pati, despite frequent denials of any worldly goals, was way ahead in the race for recognition. Diane's accomplishments were meager and her career path was murky. But between the time that she read some pages of Pati's manuscript in France and when she received the entire book in Italy, Diane had traveled through Spain. In a continuous pageant of sights that were both peculiar and universal, Spain ravished her and gestured toward her future. During the Iberian tour, too, an epistolary drama played out, and by the end a door had closed, softly but firmly, on her past with Alex.

On the way—well, really it was an impulsive decision that took them out of the way—the Arbuses explored the forbidding rocky coast of Brittany. Fascinating as she found it, upon reaching Spain Diane regretted that they had not gone there directly, so they could have had more time to explore its "rich and bitter" landscape and consummate strangeness. Spain inundated her with visual stimuli, to which she responded viscerally and voraciously. She wrote to Alex and Jane that everywhere she turned, she saw "images that are so vivid and palpable that my mouth waters—that sounds disgusting—and I dont know whether its

that I want to eat everything or if its something close to tears coming to your eyes—a kind of richness that overflows." They drove first to Toledo, where Diane, despite Allan's skepticism, wished to investigate photographing in color the view El Greco had painted, a picture that Alex thought they could sell to *Time.* If the photographs impressed the magazine's management, she and Allan might meet up with Alex and Jane on assignment later that summer. It turned out that Allan was right. They tried four or five times, in different light, but the view, Diane conceded, was always "too remote, flat, colorless and indistinguishable" to capture in a photograph. El Greco, working with paint on canvas, had condensed and illuminated a scene that no photographer could duplicate.

Aside from wanting to insinuate herself into the good graces of the executive editor of *Time,* Diane was instinctively attracted to the challenge of photographing El Greco's Toledo vista. A photographic simulation of a painted rendering of a physical landscape would raise themes of replication, resemblance and pretense. She keenly felt the pathos—and the absurdity—of trying to be what you are not. Her thinking process was associative and comparative, not logical and direct. Like Nancy and Pati, she would look at something and see a cascade of associated images; unlike them, she wielded a knifelike critical edge that pried into the gap between a thing and its look-alike.

Toledo teemed with sights that evoked for her the paintings of Spanish masters. Although the city view could not be reproduced in a photograph, she saw people who might have walked out of an El Greco canvas: a boy with a greenish face and attenuated hands working on jewelry; a priest with a small head, sharp nose and glinting eyes, who grew "bigger and bigger down to the bottom of him, under his billowing gown, huge folded hands and great massive feet." More than El Greco, Goya came to mind. Several times, for example, she saw a blindfolded donkey with huge ears "walking in a hopeless circle," pulling a water wheel that was attached to a stick. Unfortunately, all the Goya images that drifted through

her mind derived from black-and-white etchings and drawings, and *Time* needed color pictures. She was not coming up with anything that would persuade the executive editor to assign them a series of photographs for the art section. And Allan was feeling dragged down by her relentless determination to do so.

The city was hot enough to induce hallucinations, so they headed for the seashore, first spending a day at an inn in Valencia and then driving to Barcelona, where they arrived after nightfall, exhausted and "separately embittered." Going over Alex and Jane's letters had rekindled Diane's determination to find a way to join them for the month of September. Allan was "terribly firm and angry because I cant give it up." He chided her that he had work of his own to undertake and it was impossible to spend all of September with Jane and Alex; she in turn, "filled with a feverish energy and resentment and crankiness," set herself the task of "trying to make anything but that impossible for him." They both fell sick. She came down with a fever and intestinal infection. And while a doctor's medicines alleviated her illness, Allan continued to suffer. He felt deserted by her, she said. He was depleted of all energy, his feet hurt, he couldn't imagine photographing, and he was "still dead set" against collaborating with Alex and Jane in September. They were at an impasse, "the greatest impasse we've been in . . . with both of us feeling equally strongly opposite ways . . . but Allan gets unshakable, cold, tightlipped, and I get hysterical, fierce, like I'll try anything to get my way." She had even told him to go off to work by himself because she was so unsympathetic to his concerns. On his side, Allan "thinks that it is only that I want to sleep with Alex." He could not comprehend her obvious desire for the four of them to be together. This element of their standoff seemed to elude Diane's otherwise clearheaded analysis; she didn't realize it might be making Allan angry to think that his wife was yearning sexually for Alex, any more than she sensed that Jane might be alarmed and antagonized to learn that Allan thought Diane just wanted to go to bed with Jane's fiancé.

Hurt and annoyed by Diane's campaign, Allan withdrew emo-
tionally, until Diane felt brittle to the point of shattering. "I get
very empty when I'm so separate from him," she confided to
these absent friends she longed to see. "And there is nothing like
getting 'hung up' on one hope, or filled with resentment against
what keeps you from it, for making you empty." She thought that
when people quarreled, it was as if one had gotten stuck at the top
of the Eiffel Tower while the other stood marooned at the base.
What antagonized them weren't the separate vantage points but
the arguments and obfuscations they used to rationalize the dis-
tance. It wasn't necessary to win the dispute: a mere wave of the
hand could span the irreconcilable space that divides them. She
didn't need to convince Allan. She wanted only for them to smile
at each other.

Or so she said, and it sounded pretty, but in fact, she wore away
at Allan until she won the argument and he acquiesced to her
demands. Before the Arbuses sailed for Europe, Alex had recom-
mended that they photograph, along with the El Greco view, the
Matisse Chapel. Diane thought by taking the pictures, they might
yet persuade *Time* to commission a series of art-related photo-
graphs in the company of Alex and Jane. Suddenly one morning,
exhausted by their quarreling, Allan said, "All right." They would
stop in Vence before returning to Paris, where they were commit-
ted to photographing the season's new fashion collections.

But once more, Allan's pessimism proved to be warranted.
They found the details of the chapel lovely, but its totality could
be viewed from distressingly few places, and the colored rays pass-
ing through Matisse's stained-glass windows did not fall on the
floor in graphically pleasing bars. To capture the light within the
chapel, Allan thought he needed to drop a long screen of twelve
sewed-together white sheets outside from the roof. To do that
required permission from Matisse, and the great man's secretary
said it could not be considered before late August. They made
several visits to the chapel but did not take any good pictures.
Diane thought the pale nuns in their eggshell-colored robes were

probably the most photogenic element. Indeed, the only time the purple and green light could be detected was when it bathed the bleached faces and habits of the nuns. Should they eventually do a *Time* piece in Vence with Alex, they would have to be sure to include nuns in some pictures.

Instead, they hurried northwest to be in Paris for the designers' presentations. They never completely escaped the orbit of New York fashion photography. They couldn't afford to. They had gone to Europe with a few magazine assignments and the hope of landing more. In June 1951, one month after they arrived, they learned from Tina Fredericks that *Glamour* was cutting back on its commitment and could use only five pages of Paris pictures from them. That made it hardly worth returning from Spain, but Allan said they could not renege.

And so they drove back from Spain via Vence in time for the shows of the Paris collections in late July. Even before they started taking photographs, they had to spend time with Diane's parents, who were staging their customary summer tour to examine the new French fashions, and see *Vogue* art director Alexander Liberman, who, like an emperor visiting a far-flung territory, made the rounds with a local retinue from French *Vogue*. In imperial style, they all went to dinner at the Ritz, where the Nemerovs, Diane thought, were "crazily familiar in a way that destroys time and space," and Liberman, Allan grumbled, was "ghastly," with "his characteristic thin politeness deliberately betrayed by a mocking, fading smile."

When it came time to shoot their photographs of models dressed in the new Paris outfits, the ordeal proved to be even more "nightmarish" than the socializing. The first batch of pictures were so "awful" they had to be retaken, throwing Diane into a "grim and hopeless funk," until she suddenly realized that the work would get done, and the impediments were much simpler than the complex problems she had constructed in her head. Her bleak mind-set was exacerbated by the hormonal mood swings before the onset of her period, a "dammed up" sensation

that always darkened her outlook, and in this instance all the more so, as she had stashed away her diaphragm at the start of the month in the hope of conceiving a second child. She wasn't pregnant. She was empty.

Should they keep trying to conceive? As she well knew, Allan never liked to let a decision rest if it could be analyzed a second time with Talmudic questioning. But Diane maintained that Allan's relentless exercise of critical judgment made him "magnificent" and "splendid" to be with. It was "like he knows just where the edges and the bottom of everything is . . . problem or joy," she reflected. And "whatever there is, he touches it with awareness." Yet whenever Diane wished to focus on the present, Allan's spasms of doubts and anxieties wouldn't allow it. In his mind, a continuous loop played of Liberman, Penn, Avedon and the other luminaries of New York fashion photography. He complained that, far from having "forgotten what work was like," he could vividly recall "the agony of any sitting of the thousand and some we did."

The Paris fashion shoot was deplorable enough. But then abruptly in early August, they learned that Jane and Alex would not be visiting Europe anytime in the autumn. Before sending him off for six weeks, *Time* wanted Alex to write six art pieces for the color section that could run in his absence. To scare up material, he and Jane would go to the American Northwest. The magazine would send him to Europe later, but their wedding was also being postponed, so the European working honeymoon trip could not occur until after the Arbuses had returned to New York in the spring. Diane wasn't the only one bereft. Allan erupted in dismay. He told Alex that they were "dumbstruck with a bewildering disappointment." He and Diane had been wandering for three months on a continent where Allan lacked any friends (Diane at least had Pati), and Alex was someone with whom he could really talk. That they sometimes discussed Alex's passion for Diane certainly complicated the friendship; nonetheless, they were genuinely fond of each other. But one needn't be skilled in

psychoanalysis to detect a streak of rage and even hatred when Allan added, after bemoaning how much he would miss their visit, "It's the most difficult thing to accept the finality—like a sudden death—that's what it's like as if you died both of you killed in an accident."

The canceled rendezvous marked the high-water line of the Arbuses' friendship with Alex and Jane. After she and Alex were married, Jane saw to it that the Eliots maintained a distance from the Arbuses. She knew what had occurred in Alex's previous marriage and she was not about to let it happen again. For Alex, this was a sacrifice he had to make. And for Allan, too, it was a loss. While it might seem that he would welcome the banishment of a rival (even a friendly one) for Diane's affections, the situation wasn't so simple. Not only was Alex his friend, without Alex, that left just Allan—and, in a different capacity, Doon—to bear the burden of keeping Diane from feeling empty.

Or maybe Diane would find another path to fulfillment, a way apart from the roles of wife, mother and lover. In Europe, surrounded by strangers who spoke languages she did not understand, Diane was inching in the dark toward a vocation that might help fill the void. Just before the letter from Alex crushed her immediate hopes, she was feeling blissfully complete—"so very peace-full," as she put it. Punning, she meant it in two senses: not just that she was calm but also that she could imagine "the world had been folded and cut into a million pieces, thrown up and coming down like a snowstorm," and, watching it drift down, she harbored the vague hope that she might discover "some unity in it, some way of seeing everything relate." The imposition of her vision on the fragmentary world—discovering and arranging the disparate pieces into a pattern that she alone could see— would be her task as an artist. And taking photographs that lent coherence to the surrounding jumble of images and information amplified her sense of herself. It made her feel "peace-full." "And I feel inviolate, which I'm not," she added. As anyone who knew her understood very well, being inviolate, like virginal

snow, is the last thing she would want to be. She craved what she was experiencing: the onrush of sensation. Even as she bubbled in euphoria, however, she kept open a darkly realistic eye. Her inflated spirits would at some point fizzle out. "I can't believe I'll crumble," she remarked, "but I always do."

Italian Street Photographer

Diane was soaking her feet. Now that she had identified the culprit (narrow, pointy Italian shoes) and procured with Allan's help the remedy (Venetian gondolier slippers), she could relax in their house in Frascati, in the countryside a half hour from Rome, and read Ovid and Faulkner for several days until she felt able to walk again.

They had rented the farmhouse in December 1951, following a month in Florence, and would stay there until March, "cosy, anonymous, friendless, much warmed by each other." In general, the New Yorkers they encountered in Europe did not arouse any eagerness in the Arbuses to return home. One couple that passed through Rome, having spent a few days in Israel, regaled everyone who would listen with their stories of that remarkable country. Diane was disgusted by their egotism—she sniped, "They are reporters for the magazine called 'I' (and judge themselves by the circulation)"—but Allan reacted by slipping into insecure self-doubt. In merely a few days these aggressive New Yorkers seemed to him to have extracted a richer flavor of a country and its people than he and Diane had managed to do over several months. They became for him "the incarnation of the reproach I knew would be waiting for me from all bright editorial people

when I return." He hastened to add that in using the word *bright*, he was "*not* being sarcastic." He felt even worse when the voluble couple explicated the significance of an Irving Penn portfolio in *Vogue* that he had somehow failed to appreciate—"and this hurts because in photography, probably because I feel it is possible, I feel I should know everything about everything."

He worried, too, about finances. During their October sojourn in a spacious, high-ceilinged Florence apartment, Diane confessed that she was "a little dampened" by his fretting over "how much longer we can last." Rather than get angry at his gloominess over money, which was descending on them like a cloud less than halfway through their yearlong sabbatical, she self-deprecatingly compared her own obliviousness to future catastrophe with the "courage and clarity" that Allan possessed. "He always knows what comes next," she remarked. And to her relief, once he made all the calculations, he concluded that they could "last long enough not to have to think of not lasting."

Their prospects brightened further in Rome when Liberman, notwithstanding the thinness of his smile, threw two *Vogue* assignments their way soon after the start of the new year. One was the customary photographing of models in evening gowns, this time by Italian designers; the only unusual aspect was that the pictures were to be in color, so they needed to obtain extra equipment. More appealingly, the other story was not a fashion sitting, but a photo-essay on a collector and his paintings. These pictures seemed a step up from the routine commissions they had received from *Vogue* in the past. Encouraged by this token of confidence, Diane began dreaming up other ideas for *Vogue*. If the stories were assigned and published, the Arbuses "could come home as Vogue photographers instead of Glamour photographers who disappeared for a while," and the European sabbatical would have provided them not only with a rest but with a promotion in status.

Their home outside Rome was a picturesque place. Hallways led to many rooms, and a sunny, stone-paved terrace overlooked

a vegetable garden, a vineyard, an olive grove and a barnyard of animals, both pets and livestock, including an enormous pig that was slated for slaughter after Christmas. They enrolled Doon in a Montessori school. Each day, having dropped her off, they were free to go into Rome to photograph. Fascinated by the balletic movements of the traffic guards, Allan experimented, taking stylized shots with a slow shutter speed so the gestures blurred. Diane didn't care as much about camera technology or special effects. Moreover, unlike Allan, she wasn't interested in photographing movement. Her preferred subjects were immobile and timeless. In Frascati, she captured moody landscapes of traditional houses and geometrically pleasing cypresses, in compositions that might have been painted by those earlier pilgrims to Italy, Claude and Corot. In Rome, she liked to photograph children standing still.

With time on her hands thanks to the sore feet, Diane was thinking about how time elapses, moment by moment. For a photographer, this was an apposite reverie, as the art of photography consists of capturing and fixing an isolated instant out of an endless and continuous stream of them. In her mental construct, each moment was distinct, each with its own life, each perishing to give way to the next. In what she called a "funnyugly misshapen thought," she visualized people congregating in eager anticipation of these deaths, "as if there might be something in the will for them." Perhaps there was, at least for the artists, to whom fell the task of "resurrecting" moments that had passed away. Arbus reflected that when she was out and on the move, she participated in the murder of moments, sometimes with her camera, at other times merely with her talk. But resting, with her feet immersed in a basin of water, she felt completely "out of the great game of going out to kill the moments." How would they make do without her? She imagined that with no one to snuff out their existence, they would "come by gracefully expiring at your feet and even begging you to tread on them."

Released from the fashion studio, where time advanced on asynchronous parallel tracks of tedious toil and deadline-driven

urgency, Arbus in Europe was becoming a street photographer. Things needn't be beautiful, only interesting, to be worthy of her camera's lens. The exercise of photography itself was pleasurable; it made her feel as potent as Charles Atlas. Going out with a camera was like "flexing the muscles," and it strengthened her. She conceded that it might leave you, like Atlas, "proud or conceited, but also it surprises you and fills you with secrets you cant understand." Feeling full, not empty: that was a blessing.

Of course, she was discovering territory that was already staked out, and indeed, thickly settled. In one sense, street photography had been around as long as photography itself—if you judged that by taking a camera outside the studio, a photographer became a street photographer. Looked at that way, the mid-nineteenth-century pictures of moonlit seas by Gustave Le Gray or of Egyptian pyramids by Francis Frith were early examples of the genre.

Because of the limitations of the first cameras, which required a long exposure for an image to register, the outdoor shots in nineteenth-century photographs were largely of landscapes, streetscapes, seascapes and monuments. Even when the photographs contained people, the human elements were as still as trees or else were smudged into inconspicuous blurs. In the Civil War images by such photographers as Mathew Brady and Alexander Gardner, the living generals are no more mobile than the fallen bodies; in fact, there was even less difference than you might think, because, with an art director's obsessive attention, the cameramen seem at times to have posed the corpses, repositioning them into more photogenic arrangements. Early war photographers had begun their careers in the studio, and that mind-set didn't vanish when they relocated to the battlefield with portable darkrooms to record scenes of the war.

Photography, with its appearance of scientific objectivity, lent itself naturally to the purpose of documentation. Although the possibilities for photographic deceit were recognized very early (Hippolyte Bayard depicted himself persuasively as a drowned

man in 1840), such manipulation was usually confined to the studio. A photograph taken outdoors was necessarily partial in that it was incomplete, excluding everything that fell outside the frame, but it was assumed not to be partial in the other definition of the word—falsely tendentious. This conventional thinking allowed photographs to be marshaled effectively as evidence: the investigations of poverty that Jacob Riis conducted with his flash-enhanced camera in New York City in the 1890s were so convincing that state legislators changed the law on tenement construction; a couple of decades later, Lewis Hine's pictures of child labor impelled Congress to pass legislation outlawing the practice. Befitting their testimonial function, these pictures aimed to be sharp and clear. The self-consciously soft-focus photographs of pictorialism, promoted by Stieglitz in the early twentieth century to advance photography's claims as an art form, quickly fell from favor (even with Stieglitz). By the time Arbus took her first photography class, just before America's entry into World War II, her teacher, Berenice Abbott, was professing, "Photography is a new vision of life, a profoundly realistic and objective view of the external world," adding that there was a "vogue among the younger documentary photographers for prints on glossy paper, because precise detail is picked out and emphasized."

Improvements in photographic technology and the shortening of time exposures did not immediately overturn the ruling aesthetics of the medium: carefully composed, well-focused pictures. A large-format camera was cumbersome to set up and to load. It did not foster spontaneity. Abbott's great hero, Atget, was perhaps the first true street photographer, working in the early decades of the twentieth century. Mostly he pursued stationary quarry—newspaper kiosks, stone fountains, rain-slicked squares; when he did photograph people on the street, they were typically prostitutes, flower sellers, organ grinders and others whose professions encouraged standing in one place. Abbott's own photographic output was sharply divided in subject matter

between portraits, which she shot indoors, and urban scenes. However, her approach to both kinds of assignment was systematically planned. One of her most famous pictures, *New York at Night,* could be taken only at the time of the winter solstice, when offices were still occupied as darkness fell and the electric lights went on. Once she had that figured out, she determined where to position her camera and how long an exposure was required (fifteen minutes!). Only after many days of logistical preparation was she ready to click the shutter.

When we think of street photography, though, we usually have something different in mind. It is the picture taken on the fly, what Cartier-Bresson, arguably the greatest street photographer, called *images à la sauvette.* Translated imprecisely into English as "the decisive moment," his phrase might be better expressed as "pictures nabbed on the run." With Cartier-Bresson (and he was hardly the first, preceded most notably by André Kertész and giving credit himself to Martin Munkácsi), the essence of street photography was distilled into the capture of a fleeting image. The poetry of street photography often lay in the discovery and emphasis of unexpected, ephemeral rhymes. In Cartier-Bresson's famous *Behind the Gare Saint-Lazare* (1932), the reflections in the puddle of water outside the station are amplified by other doublings: the fence railings with the roof antennas, the ruined ladder on the ground with the (unseen) railroad tracks inside the station, and the leaps by the dancer who is depicted in two tattered wall posters with the puddle jumper who is the one moving figure in this scene. Even the name Railowsky in big letters on the posters is a dual-meaning pun, in French as well as English. The picture is so satisfying because, as ingeniously as a Dickens novel, it assembles fragments of experience into a beautifully patterned and coherent whole.

Discovering hidden harmonies or unrecognized unities was not Arbus's goal. She was looking for the opposite: a seam that was designed to be hidden, a disparity between two things (or people) that were thought to be identical, "a gap," as she put it, "between

intention and effect." At this stage of her career, she was figuring out her subject matter, a choice that is more important for a photographer than for any other kind of artist. On the streets of Spain and later in Italy, she gravitated toward the depiction of children, who in their playfulness, candor and curiosity divulged a peek of the inner emotions and thoughts that their elders sought to mask behind a bella figura. Photographing children was a way of investigating universal truths, because, as Arbus observed at the time, "everything grownup is invented by children."

She took a picture of a young Italian nun with a group of girls, all of them in black robes; three of the girls and the nun are looking at Arbus, amid a sea of other nuns and girls, all gathered in front of a faintly visible church or cathedral. They are dressed the same: it is an anti-fashion picture. There are differences in the accessories—a hair ribbon for a girl, the black veil and white underveil for the nun—but they are minor accents on the dark dresses and habits. Against all that blackness, each of the four faces is as distinct as a bloom in a mixed bouquet, with the budding girls' expressions gloriously open, the nun's blandly and benevolently watchful. And like the flowers in a vase, these people exist outside the confines of any particular time. Their clothing and setting would have looked much like this a century or two before, and probably wouldn't change over the century to come.

The same can be said of other pictures from Arbus's European sojourn. A child clutching her knees has twisted herself into the contortion of a topiary shrub. In another picture of a child, this one of the beatific-looking Doon, the girl's head takes up the bottom right quadrant of the frame, and a misty tree trunk occupies the upper left. It's a moment in a dream (or in a film about a dream). These are subjects that artists have always pursued. Arbus's out-of-focus portrait of an Italian girl—convulsed in gleeful laughter, with each of her four limbs pointing in a different direction—is a figure study that could have been sketched by Degas.

She wasn't after tourist snaps. Furthermore, she wasn't a documentary photographer. There is a line that connects the

anonymous vacationer holding a Brownie in front of Notre Dame Cathedral in Paris to Dorothea Lange among the migrant workers of the Imperial Valley of California. Their cameras are recording and transmitting information about a foreign country. They are gathering data. To be sure, the greatest Lange images transcend their time and place, which is why Lange is remembered; but her investigations were sociological and her aims political. Arbus was oblivious to politics. Even during the war, she displayed a noticeable lack of interest in world events. She was drawn to the things that would be true in any time and place, the customs and rituals that, notwithstanding their individuality, were emblematic, oneiric, mythic.

When Christmas passed and time was up for the "doomed" hog, Arbus stood by and noticed everything. She listened to its screams, which continued unchanging from the moment it was rousted out of its pen until the life left its body. She watched the butcher grimace from the effort of slaughtering it, with his tongue sticking out of his mouth whenever the knife was not clenched between his teeth. She observed how the pig's pupils grew to the point of filling the eyes completely, and it kept looking "terribly hard, up until they closed." In death, the pig, which had been monstrously huge and ugly, now appeared longer and thinner, almost beautiful, "with a cryptic, orientally serene nearly crafty face." Doon had left the murderous scene halfway through to lie down on the stone terrace, but as the carcass was carved up she returned, saying she was waiting to "eat some." The atmosphere was jovial and festive. "I can see that the pig was all sorts of things: lovely and horrid and useful and stupid and tasty and tragic and miraculous," Diane remarked, "but I can never remotely see what Walt Disney sees."

19

Modish and Empty

In a few weeks' time, the goal lines had shifted yet again. The best-paying *Vogue* assignment fell through, and all the scrambling for color supplies seemed suddenly pointless. (However, the other story—on a collection of almost seven hundred tiny paintings, averaging 3¼ by 4 inches, owned by Cesare Zavattini, the neorealist screenwriter of *Shoeshine* and *The Bicycle Thief*—would eventually be published partly in color, partly in black-and-white.) The only new job in the offing was a fifty-dollar assignment for *Glamour,* which they probably wouldn't accept. Instead of extending the European trip, as they had hoped to do, they would return to New York at the end of March, a month earlier than their studio, which they had sublet for a year, would become available to them. Diane told Pati that she dreaded going home and resuming the grind of work, but she did not dread New York, "or Central Park or lots of places (which I secretly think belong to me)." As she had done since adolescence, she slipped into a state of dejection in anticipation of the unhappiness to come, as if by experiencing it now she could ward off its advent once they were back in New York.

During this relatively happy year, she had been felled by recurring spells of despair, of feeling "gloomy and haunted with guilty

echoes of what I should be doing and why I am not." In Venice, running into other New Yorkers of her acquaintance, she was struck by their apparent clarity and certainty—in the case of one woman, even hysterical assertiveness impressed her as relatively "solid, healthy, positive and reliably true, like she knew where it began and would end." In their company, Diane suddenly felt unreal, "like a figment of my own imagination." When her identity dissipated in that way, her remedy was to indulge in "a kind of comfortable hugging of the self to the self to keep self warm." That helped for a while, until she would start to perceive this self-care as selfishness and conceit. Then she worried that "like a miser I've been collecting myself," hoarding away a bounty that she was unable to spend, "that instead I'll bury it, deny its existence, and go around like a pauper." Luckily—no, providentially, irreplaceably—Allan enriched her. "I feel full of him, I mean filled with him, and what a feeling that is," she wrote in mid-December.

There was one benefit awaiting her in New York. Once again the Arbuses would have a darkroom, so they would be able to print their photographs—"that is the one thing that will be in NY, besides NY itself," Diane declared. And by embarking early, they would be home on April 7, a few weeks before Alex's May 3 wedding to Jane. At first, Allan said he would rather return after Alex and Jane had left for their six-week European honeymoon, as seeing them only a couple of times would be worse than not seeing them at all. After reflection, he reversed his position. On her part, Diane had been so distracted by the impossible dream of getting Alex and Jane to Europe before the Arbuses returned to New York that she had to apologize, less than two months before the big day, if "it sounds like I have crassly, coarsely forgotten the great good joy of your marriage and your trip . . . if I sometimes did, I don't anymore." But in the fluid dynamics of Diane's psychology, it was very possible that the marriage might ultimately leave her feeling less full and more empty—as stark as the apartment that she rented with Allan upon their return from Europe.

Although a world apart aesthetically, the triplex apartment on East Seventy-Second Street was as uncomfortable as the apartments she grew up in. Once the Arbuses completed their renovation, it resembled a contemporary art gallery more than a family home. The white, double-height living room contained a built-in cushioned bench along one wall, marble-topped coffee tables and a tall potted tree. To some extent, Diane, like her mother, was enslaved by an idea—obviously a very different idea—of what was fashionable. But Diane's decorating style would change over time, turning cozier and cluttered for a spell, then cavelike and sculptural, and then, at the end, functional and airy. The underfurnished décor expressed how she felt at that moment: modish and empty.

Allan was right, as usual. They came back to New York to find that nothing had changed. The numbing, gnawing cycle of their lives resumed, only now the outlines were more sharply etched, as if backlit by the recent respite. At least the physical work of fixing up the apartment, exhausting as it was, brought them the earthy satisfactions of building and making. Allan was constructing cabinets and installing wiring; Diane was cleaning, painting, staining and waxing.

In the midst of it all came the Eliot wedding. A month after the Arbuses returned, a municipal court judge married Jane and Alex in a small ceremony at Jane's sister's apartment, which overlooked the Museum of Natural History. Afterward, the celebrants walked across Central Park to a reception at the Madison Avenue home of Jane's mother. The Eliots were starting their new life, which Diane still hoped might be merged with the Arbuses'. Before the couple left on their honeymoon, Diane and Allan invited them to rent an unoccupied apartment that connected to the Arbuses' triplex through a small door on the second floor. Although no one used that door, it would have to be plastered over before a realtor could legally offer the apartment, and so only a tenant selected by the Arbuses could rent it. It seemed divinely ordained for the Eliots, but they declined. Jane shunned such an arrangement, and even Alex thought "that would be too close."

Diane craved emotional support, because the return to fash-
ion photography unhinged her. The painter Alfred Leslie, going
out to dinner after a fashion sitting with the Arbuses and his
wife, a model, felt distressed and discomfited by Diane's nonstop
barrage of scathing self-disparagement. She teetered again at a
dinner at Tina and Rick Fredericks' home, hitting "a high note of
hysteria," she said, as she "tried to wiggle out of a sitting" for *Glam-
our*. Afterward, she was awash in self-reproach, calling herself "a
terrible coward, childish, hysteric, quitter." Although she judged
that she wasn't always like that, she declared that there inevi-
tably came a point when she would suddenly "lie down and let
everything walk over" her until the accumulated weight became
"unbearable." She feared that she was no better at parenting than
at photographing. She was relying on her mother to help with
Doon, but that dependence, especially on her mother's maids,
curdled her mood further until she became an "adolescent sort
of ingrate." Whenever Gertrude complimented her, she wanted
"to cry at the injustice of it"; if Gertrude offered advice on what
might be done better, Diane did cry, then felt even more foolish
upon her mother's expressions of sympathy. She wondered why
she was creating these difficulties. "I just want to be competent,
cheerful, serene and virtuous," she avowed. And before long,
with the same inevitability that dictated its arrival, the onrush of
insecurity would recede. She realized that if she teased out the
challenges and undertook one thing at a time, it would be "pos-
sible to take a fashion picture even the first one in a year." And
instead of chastising herself for her inadequacies as a mother, she
could take pride in her accomplishments.

Indeed, she was a wonderfully attentive and involved mother,
if an unorthodox one. The relationship between Diane and Doon
in many ways seemed sisterly. They were in cahoots—conspiring,
confiding, competing. When they were living in the farmhouse
outside Rome, they walked one day to a ruined amphitheater and
sat on a stone bench. As they pretended to be Romans watch-
ing a performance, a British family of tourists wandered onto

the stage, and Doon, continuing the game of make-believe but now with an audience, began mumbling terse, Italian-sounding responses to everything Diane said. Delighted by this spontaneous charade, "like it was the first time I had ever planned a deception or pretended to be what I wasn't or not to be what I was," Diane threw herself into the spirit of the play, until Doon, with no more warning than she had given at the outset, ended the subterfuge by reverting to English.

Back in New York, they indulged in similar shenanigans, egging each other on and baffling the bystanders they incorporated into their routines. On outings to Central Park around the time that Doon was thirteen or fourteen years old, Diane would dare her daughter to crawl between the legs of a man seated on a bench and jump up in front of him to ask where Central Park was. Lying on the lawn and furtively watching, she waited for Doon to return with a detailed report of the man's reaction. And then Doon would say, "I dare you to go up to that governess in the white uniform and ask her to lift you onto that swing." They convulsed with laughter at the reactions they provoked.

These antics weren't so different from those Diane enjoyed when giggling with Nancy Christopherson. After her return to New York in spring 1952, Diane was seeing very few people outside her family, except for Nancy. Although she had moved to a new address, Nancy still lacked a telephone, which meant that Diane had to either make an appointment or else take a taxi and trudge up many flights of stairs without any guarantee of catching her in. Nancy was calmer these days, and more generous in outlook; even Allan enjoyed visiting her.

For the most part, though, the Arbuses were so busy with the apartment renovation and the resumption of their careers that they had scant energy left for a social life. Diane remarked that it was "like we're blowing up the very balloon we are flying in so we've no breath to speak with." When Howard passed through New York and paid a call, she felt herself falling asleep in her chair as he talked in a voice that "undulated wearisomely even

if the words were interesting." She described it as an unpleasant evening. She and Allan thought Howard's smile dripped with "sour grinning disdain." They were probably right. From his less stylish vantage point as an English professor in the provinces (he was now at Bennington College in Vermont), Howard may well have regarded his sister's fancy new digs with a mixture of envy and mockery. "When we were making $2,300 a year, they were making $70,000, but he wasn't liking it," Howard later remarked of Allan. "I didn't know at the time how much he disliked it." Howard felt poor by comparison. Beneath her drooping eyelids, Diane mainly noticed that he put the soles of his shoes on a bench to which she had applied three gleaming coats of off-white paint over the course of three days.

Although Diane and Howard's younger sister lived in New York, the Arbuses saw her only at family gatherings. Renee, who "worshiped" Diane, had followed her example in 1947 by marrying as soon as she graduated from high school. Like Diane, Renee fell in love with a man who was penniless and older. She outdid Diane: Roy Sparkia was fourteen years her senior, and not even Jewish. Gertrude particularly disapproved. She regarded him, Roy believed, as a "cheap, lousy, lazy, fortune-hunting husband." The Arbuses didn't think much of Roy, either. Like Renee, Roy was a sculptor, and the two often collaborated, working in stained glass and updating the technique to the twentieth century through the addition of plastic. As viewed by the Arbuses from the sophisticated heights of fashion and art, Roy's literary ambitions were even more vulgar than his assemblages of colored plastic. He was pitching stories to *True Confessions* in the hope of eventual success as a mystery or crime writer. Sensitive as he was to their condescension toward him, Roy felt even more resentful that the Nemerovs, including Diane and her husband, looked down on Renee. The childhood bond that connected the two sisters was by now irreparably frayed, at least on Diane's side. Believing that Renee had always "lived in Diane's shadow," Roy privately seethed that "Diane still captures all the family first-run love and

attention; Ren gets the fondness of a second-rate pet." One time, at a family gathering, Roy decided he would clear the air by venting his dissatisfaction. Allan stalked out of the room in one of his "self-pampering tantrums," his brother-in-law complained, and didn't speak to Roy or Renee for many days afterward. Diane stayed aloof and disengaged. Roy found her "superficial fakeries" to be at least as annoying as Allan's pique. He concluded that she was "a precious fake, even if unaware of it, and puts on her act because it gets such results, with family, husband and friends."

Compared with the debt-ridden Sparkias, the Arbuses were prospering, although both couples shared the Micawberish plight of living to the edge of their means, and sometimes beyond it. As Diane had predicted hopefully in Rome, she and Allan returned to New York with the credentials of *Vogue* photographers. Since their spacious new flat could accommodate a studio, they ended their lease on the one on West Fifty-Fourth. The formal entrance door to the East Seventy-Second Street studio was on the second floor of the town house, marked by the old brass plaque, DIANE & ALLAN ARBUS. The second-floor entrance was mainly for the models. From within the apartment, you could mount an internal staircase from the ground-floor kitchen to reach the studio and darkroom and a mezzanine that overlooked the double-height living room. The Arbuses spent more time working in the studio than they had before their sabbatical. Instead of dreaming up locations, Diane now devoted most of her energy to styling the models and arranging their outfits.

Although they weren't going out much, they expanded their domestic circle by importing a congenial next-door neighbor. One evening they were invited to dinner at the Fifth Avenue apartment of James Goold, the Macy's marketing vice president who created the Thanksgiving Day Parade, and his wife, Helen, an advertising executive who had done work for Russeks. The Goolds' daughter Leila was recently back in New York from California with her husband, an actor named Robert Brown, and their baby daughter; the young family planned to spend the

summer at the Goolds' Connecticut weekend house and then
find their own place. Looking to introduce the couple to people
their age, the Goolds thought the Arbuses and Browns would
hit it off. They were right. When the dinner broke up, Robert
offered the Arbuses a lift in his borrowed car back to their home
on East Seventy-Second, a few blocks away. As the car pulled up
to the curb, the Browns admired the matched pair of elegant
town houses, both owned by the sculptor Paul Manship. (Man-
ship resided in the one on the right, and his studio was in the
garden behind the other house, the one in which the Arbuses
were living.) Diane pointed to the four windows on the second
floor of her building. "You know, that apartment, they can't rent
it anymore, they didn't cement the doorway," she said. It was the
apartment she had hoped the Eliots would take. Instead, she vis-
ited the small realtor's office across the street and endorsed the
candidacy of the Browns.

Like her parents, Leila Brown worked in advertising, departing
for the office each morning and, as things turned out, departing
from her marriage a few years later. She never entered the Arbus
circle. But Robert was an actor, a classically good-looking man
with a mellifluous voice who was pursuing Allan's fantasy career.
Around the apartment for much of the day, Robert got into the
habit of stopping by to chat with his neighbors, in the kitchen or
the studio, in between their fashion sittings. Indeed, often he was
there to work, because they recruited him for modeling, which
brought in more money than acting. He would go for long walks
with Allan, who talked expansively about his opinions and his
dissatisfactions, although never about Diane. Both Diane and
Allan maintained a veil of reserve, especially when it came to
their relationship. Concerned with his own collapsing marriage,
Robert never suspected there were fault lines that might fracture
the Arbuses'.

20

Circus

The circus was coming to town.

Early in the spring of 1953, Robert was eating Sunday breakfast with the Arbuses at their round kitchen table when Allan passed the newspaper to Diane to show her an advertisement for the Ringling Bros. and Barnum & Bailey Circus. The troupe would arrive in New York by train the next morning, disembark at 125th Street and march down Second Avenue on the way to Madison Square Garden. The ad gave the timing of the route of the parade. It would pass by 72nd Street at five thirty A.M.

"I'd love to see them come down," Diane said.

Allan replied that he couldn't go. He needed the morning to prepare for a session later in the day. Doon, who would be getting ready for school, was also unavailable. Robert volunteered to accompany Diane.

In the chilly gray dawn light, they watched the cavalcade of elephants, horses, clowns and acrobats as it proceeded down the avenue. Diane was entranced. She and Robert went out for breakfast, and then she called an editor at *Vogue* to obtain press credentials to go backstage to photograph the setting up of the circus. That evening, Robert drove her to Madison Square Garden, which was at that time located on Eighth Avenue at Fiftieth

Street. He knew the staff and the regulars at a nearby bar and grill from having attended an acting school in the neighborhood. He said he would drop her off, have dinner and then come back in three hours. He left her at the side door, where the guard checked off her name on a list and let her through.

When Brown returned, the gate was unmonitored. He entered. Walking into the main arena, he observed a frenetic dance of activity as men hauled poles upright with pulleys to erect the tents. He spotted the guard who had admitted Arbus earlier and asked if he knew where she had wandered.

"Oh, the photographer?" the guard said. "She never got very far." He pointed toward the doorway.

When Brown retraced his steps, he found her there, sitting on the floor just inside the entrance, deep in conversation with a group of midgets, some of them in costume. Although a camera was hanging around her neck, she wasn't shooting. She was talking and listening.

The little people were Diane's introduction to the sideshow freaks whose portraits became her trademark. It was a serendipitous gateway, because midgets deviate from normality in unthreatening ways. In folktales, they aren't evil ogres or hostile trolls or teeth-gnashing giants; they are jolly leprechauns and elves. Unlike giants or hermaphrodites, they emit no ominous sexual overtones. Midgets (as distinct from disproportionate dwarves) are childlike in their appeal. At the circus, the midgets Arbus met were genteelly conventional in everything but size. In particular, she befriended Andy Ratoucheff, a clean-cut performer in his early fifties who had acted in Broadway plays by Thornton Wilder and William Saroyan and whose specialties included a captivating impersonation of Maurice Chevalier, complete with miniature cane. Born in Russia, he was the son of actors of normal size. Ratoucheff was only two when his father, realizing that the boy would never grow fully, hit upon the scheme of starting an acting company of midgets in which he could perform. The troupe left Russia after the revolution to tour Europe, dwindling

in number until the four surviving members were invited to the midway sideshow of the New York World's Fair in 1939. Upon the outbreak of war, they stayed.

Over the next years, Diane extended her friendship with Ratoucheff and his community of midget friends. Notwithstanding his circus performance name of "Andy Potato Chips," Ratoucheff was an accomplished pianist and painter with a charming cosmopolitan manner and impeccable tailoring and grooming. Only his diminutive stature of three feet and seven inches distinguished him. Yet it was this extraordinary physical appearance that made him so attractive to Arbus, both professionally and personally. She was hardly the first to recognize that very short people can be the stuff of striking portraits. Velázquez and Manet painted dwarves, Brassaï photographed them. However, for Arbus, professional freaks—and Andy Ratoucheff, who relied on paid gigs in sideshows, was a freak as well as a musician and actor—would figure large. They fascinated her. She said that they were as amazing-looking as movie stars, and yet, unlike celebrities, they had not been photographed incessantly until a coating of defensive shellac masked them. "They were anonymously famous to me, and it was a very beautiful thing, it was much better than the really famous people," she said.

Once she got to know Ratoucheff, she would go uptown to visit him and his Lilliputian friends. (He preferred the word *Lilliputian* to *midget*.) Paying a call on two of Ratoucheff's fellow émigrés, women who were roommates in a building full of run-of-the-mill apartments within a thoroughly ordinary housing project on upper Madison Avenue, Arbus would ring the bell, the door would swing open, and with the whoosh of Alice falling down the rabbit hole, she was in an alternate universe, a place that seemed at once mythic and mundane. The moment always thrilled her. Her best photographs of Ratoucheff and his friends conveyed a contradictory sense of their fairy-tale strangeness and their quotidian normalcy. Like many of the people Arbus photographed, Ratoucheff possessed a remarkable life story. In

a photographic image, that narrative could only be suggested. Diane's friends sometimes experienced a letdown upon seeing her photographs, having heard her lengthy, mesmerizing tales about their subjects.

A year or two later, when the circus was back in town, Arbus wrote of one dwarf, Lauro "Cha-Cha-Cha" Morales, "He gets smaller and smaller towards his extremities like an echo." In the prose of everyday life, such extraordinary people were poetry. Among her relatives, Diane especially admired her grandmother Rose Russek. Unlike Gertrude, Rose never pretended to be anything other than what she was; and yet, in her honest exuberance, this family-oriented, nouveau riche Jewish American woman assumed (at least in Diane's eyes) a larger-than-life aura. In her later years, Rose, a widow since 1948, had declined physically, forcing her (as economic hardship had done during the Depression) into dependence on the Nemerovs. After Diane returned from her European sabbatical, she told Alex that Rose was "sadly ailing, sick and seventy and moving in with my parents, which is like the defeat of a proud spirit who forgot what the fight was all about." Despite those sorrowful sentiments, when Rose died in March 1955, Diane showed no qualms in photographing the corpse. She went right up to the head of her dead grandmother, as if depicting a fallen monument. Years later, walking with her camera down Fifth Avenue, she would see elderly women brimming with brio who reminded her of Rose—she described her grandmother as "rather vulgar but superb, like a contemporary witch"—and she would ask to take pictures of them, in their outrageously fanciful hats and their strands of pearls. Savoring flamboyant display, Diane remarked that she was "a bit enamored of vulgarity, excepting my own of course."

There was a glow of Gilded Age opulence, which some would characterize as faintly vulgar, in the next Arbus residence. The family moved in 1955 from East Seventy-Second Street into another triplex, this one on an even fancier block—East Sixty-Eighth, between Fifth and Madison—in a far grander building:

the Beaux-Arts limestone mansion that the rug-business prince Henry T. Sloane commissioned following the breakup of his marriage. The thirty-six-foot-wide house at 18 East Sixty-Eighth had been divided into nine apartments in the late forties. When he saw the Arbus home at a dinner occasioned by a visit from Howard and Peggy, Roy Sparkia was struck by the grandeur of the "fabulous, crumbling apartment." He ruminated that the rent was $700, and that the Arbuses lived "on the edge of poverty, despite an income that must reach $20,000 a year, or more." (The brothers-in-law had different guesses of the size of the Arbus income; Roy's estimate was probably more accurate than Howard's.) Their opulent way of life was reminiscent of the senior Nemerovs, but without the underlying financial foundation. Back in 1953, Roy and Renee had spent nearly a month at a Westchester mansion that David Nemerov rented for the summer. A vastly expensive replica of an English country house, this spread (Roy observed at the time) featured "acres of manicured lawn" and was maintained by a staff that included a cook, serving maid, chambermaid, laundress, gardener and chauffeur; yet it lacked the enjoyable warm-weather features of a tennis court, riding stable or swimming pool. It was all an ostentatious show, designed to impress others rather than to amuse its occupants. He judged the thirteen bathrooms and innumerable bedrooms to be "not as comfortable or luxurious" as the rooms of a well-designed middle-class home.

The apartment that the Arbuses rented on East Sixty-Eighth was in something of the same spirit, although decorated in a modern style that departed severely from the Nemerov version of old-WASP clutter. The main room flaunted a double-height ceiling and a baronial fireplace. It served as the studio. The dressing room for models and the darkroom were located on that floor as well. Doon slept in a bedroom off the top of that lofty space, reached by one flight of stairs. Allan and Diane slept in the quarters below the studio—and they were not alone down there.

On April 16, 1954, Diane had given birth to a second daughter,

Amy. Coming nine years after Doon, this late addition to the family might indicate that cautious Allan and moody Diane had been dithering ever since they failed to conceive a child in Europe in the summer of 1952. In hindsight, their decision to have another baby looks like an attempt, conscious or not, to buttress a shaky marriage. Allan admired Diane's gifts as vastly more abundant than his own, and he embraced the responsibilities of sheltering her—buoying her up when she sank into despondence, furnishing such necessities as a studio and darkroom, and managing the payment of bills. She, for her part, mastered the roles of wife and mother. "Well, I think that is what femininity constituted in that time, a little bit, you know," she later said. "The idea was you found a man to take care of in exchange for being taken care of, which was really more practical, you know, his end of it." It was like a government: he tended to external affairs, coping with the exigencies of business, and she was in charge of the domestic portfolio. Many years later, after she was out in the world on her own, she reflected that "a woman spends the first major block of her life looking for a husband and being a wife and a mother and trying to actually get those roles down pat—you don't have time to play other roles." As interlocked as actors reading dialogue in a play, neither Diane nor Allan could stop performing without letting the other down. But each was unhappy with the assigned part.

21

Out of Fashion

The Diane and Allan Arbus Studio was a place in which little was left to chance. To the field of fashion, where he was charged with projecting an air of stylish insouciance and sophisticated fun, Allan applied an anxious, analytic mind. Dreading surprises, he devised a system to shut out the unexpected. Lighting in particular obsessed him. It was reasonable for him to worry about lighting, because a wrong exposure might render the frame of expensive 8×10 film unusable; and, at least indoors, the lighting could be completely controlled. To ward off misadventures, he constructed a false ceiling of aluminum foil and rigged it to a pulley. When he posed the model, he handed her a string that had a knot on one end and a stick on the other. She would place the knot to her nose. He would then adjust the height of the foil ceiling as desired by raising the stick to the ceiling and measuring the distance to the nose. Bouncing the light off the reflective surface, he could be confident that his light exposures were correct. And so he would begin photographing, pressing the cable release with a flourish and covering himself with the black cloth as if it were a cape. "He wasn't so much a technical guy, he was a repetitious guy," a studio assistant observed. "He had to know where he was. He wouldn't step out unless he knew what

was going to happen." Everything had to be just so. One time a telephone service man came to install a wall phone in the studio between the dressing room and the darkroom. Allan saw it once the man had left and ran after him on the street. "That is not vertical," he protested. The man shrugged. Allan offered him the use of his level.

In this universe of rules and routines, there was an unpredictable element: Diane. Yet her creativity in dreaming up the concepts served a pretense as shamefully phony as the posturing that had nauseated her as a child. Aside from the boredom and indignity of her chores, she disdained the enterprise itself. She later remarked that fashion photography was treacherous and ultimately futile because it began with a premise of fantasy and sought to infuse its imagined scenes with realistic detail. That was going about things backward. Under the close scrutiny of a photographer, reality might at times appear fantastic, but no amount of doctoring could ever endow the concocted with the clout of the real. What had started out fake would always be thin and shallow.

The major American photography event of the fifties was the show *The Family of Man,* which Edward Steichen produced in 1955 as director of the photography department of the Museum of Modern Art. It was one of the most popular exhibitions in the museum's history. Three thousand people came daily, for a tally of more than a quarter of a million people over the three-month run. In retrospect, *The Family of Man* has come to be regarded as the landmark expression of a middlebrow approach to photography. Like a gigantic version of a magazine photo-essay, it was illustrating a couple of banal precepts: people everywhere are more alike than different, and a tolerant democratic system best accommodates that fact. All over the world, people can be seen falling in love, confiding in friends, learning in class, stuffing ballots in boxes, toiling in fields, dissolving in grief and ending up in graveyards. Inadvertently, the show also revealed how blurry the distinction can be between a newsmagazine's reportage and

a fashion magazine's illustration. In both, the photographer's job is to produce pictures that put across an assigned point of view. Magazine work was Steichen's measuring stick. Although better known for his celebrity portraits, he was also a pioneer of fashion photography; he justifiably boasted that the pictures he took in 1911 for the magazine *Art et Décoration* "were probably the first serious fashion photographs ever made." When recruiting photographers in the forties, Alexander Liberman showed Steichen's 1927 *Vogue* portrait of Marion Morehouse as a consummate example of what he was after, because he thought that it supplied the necessary information on the Chéruit dress, yet transcended the genre by creating "an image of a woman at her most attractive moment, made with a great respect for women."

Steichen said that his assistant on *The Family of Man,* Wayne Miller, sifted through two million photographs in collections throughout the country before the two of them arrived at a short list of ten thousand. They winnowed that number down to five thousand without much second-guessing, but from then on, the cuts were increasingly difficult. "The final reduction from one thousand to five hundred, which was the number considered the limit for the exhibition, became a real struggle and was often heartbreaking," Steichen recalled.

Regardless of what one might think of the aesthetic merits of *The Family of Man,* in a competition so ferocious it was a career triumph for the Arbuses to have one of their photographs included among the 503 chosen. They had shot the picture for *Vogue.* It portrayed a man and a small boy, obviously father and son, reading sections of the Sunday newspaper as they lie stretched out on a sofa facing one another, each with his head on a cushioned arm of the couch. In this relaxed familial encounter, the father is curiously dressed in a coat and tie. The room is furnished in unimpeachable upper-middle-class good taste, with a flower arrangement so lavish as to evoke the unseen presence of a uniformed maid to tidy up dropping petals. Even for a stickily sentimental exhibition, in which many of the photographs had

previously appeared in Time Inc. and Condé Nast magazines, this picture stands out as phony. It is an advertisement for a fifties conventionality that surely no one could believe in, Exhibit A for the kind of fashion photography that Diane denounced. Yet Diane was enough of a careerist to brag to a friend a few years later that the joint byline notwithstanding, that picture was her own. (As it was for a fashion magazine, Allan would have snapped the shutter, with Diane providing the concept and styling.)

Although it appeared in *Vogue,* the portrait of a father and son was not, strictly speaking, a fashion picture. It was part of a photo-essay set at the twenty-eight-room redbrick Locust Valley, Long Island, home of John Monteith Gates, which purported to depict, hour by hour, a typical Sunday for a privileged family in this famously haute WASP hamlet. Sunday began for the Gateses at 10:45 A.M., with the parents and their three children leaving for church. (In the photograph, the imposing house dwarfs the worshipers walking toward their Plymouth station wagon.) The day took on fuller form at 12:45 with cocktails for the parents on the terrace, followed by the midday Sunday meal (prepared by Mrs. Gates) for the entire clan. By 2:30, with the lunch finished and the plates cleared by the children, it was time for the father-and-son reading of the Sunday paper that, as captured by the Arbuses, Steichen thought worthy of his exhibition. (In *Vogue,* it was published as a cropped horizontal, without the flowers, the arm of the chair or the newspaper on the floor, which appear in the print displayed in the show.)

This was a second marriage for both parents, and the father was already a grandfather. An architect by profession, Gates was the design director of Steuben Glass. More relevantly, Evelyn Gates was a designer of sweaters and separates who could count many friends in the realm of fashion, including Diana Vreeland; her career concerns were the impetus to invite *Vogue,* in the person of the Arbuses, into this private home. While the photographers were there, Evelyn, a slim, attractive woman, wore only her own creations.

The pictures accurately documented the Gateses' routine. "That article was to the square inch how we spent our Sundays," recalled Ada Gates Patton, who was nine at the time. The parents did dress for midday cocktails, the children dutifully helped to serve and clear, and Evelyn invariably cooked a rib roast and Yorkshire pudding. Once the children had taken their baths, they would be brought downstairs to say good night to their parents. And so on, for every dip and swirl that the photographers chronicled in the social protocol. But the Arbuses didn't catch their subjects on the fly. They staged the events they photographed. For instance, although the family attended church weekly—all of them in their Sunday best, including the youngest, five-year-old Jono, in a scratchy wool suit—the photograph of the Gateses walking to the car was posed. "We would not have gone to church and kept Diane and Allan Arbus waiting," Ada explained. The picture of Jono kissing his mother was shot at three in the afternoon, with the living room drapes drawn to simulate night; he protested fiercely at the injustice of putting on pajamas so early. Still, these were re-creations of genuine events. Of the dozen pictures, only one piece was purely manufactured, and that was the one that caught Steichen's eye. While it would have been in character for John Gates to remain in a jacket and tie upon returning from church, his five-year-old son did not favor the Sunday *Times* book review. The father-and-son sharing of the newspaper was an invention of Diane's.

The Well-Built Sunday foreshadows Diane's mature work, both in what it was and in what it was not. Like fashion models, the Gateses knew they were being photographed, and they collaborated in the production of the pictures. Yet, unlike fashion models, they were wearing their own clothes and inhabiting their own rooms. Unfortunately, their activities conformed to stereotypes— which did not make the pictures false, as is a fashion picture, only boring. That the photograph winning highest praise was the completely bogus one is a tip-off to the superficiality of them all. They are societal, not psychological: they record the rituals of a

particular class in a specific time and place. Inferring from the photographs, you arrive at sugar coatings and bromides that celebrate "the American way of life." Which, of course, was perfect for Steichen's *Family of Man*. But the glowing portrait of family contentment conformed to the *Vogue* editor's demands, not to Diane's darkly comical inclinations. Praise for such work echoed the cries of "How marvelous!" that had greeted her childhood paintings and had sickened her then. She felt no better about these accolades now.

Nevertheless, in contradiction to that feeling of repulsion, she was attracted to career advancement. And like the nod from Steichen, the thirty-one published articles in *Vogue* in the four years following the Arbuses' return from Europe signaled their climb upward. Upon returning from the sabbatical, they had received some relatively interesting *Vogue* assignments. Aside from the Roman miniature portrait collection of Zavattini, they photographed young Broadway talents in a convertible, the nine-year-old son of the attorney general making chili con carne, and dancer Jacques d'Amboise in midair outside a Mobil station (his breakthrough role was in Lew Christensen's ballet *Filling Station*). Mostly, however, they were photographing ladies' undergarments, schoolgirl dresses, innumerable Christmas gifts, and frocks of all lengths and for all occasions. Allan, whose achievements always fell short of his aspirations, could discuss his discontent with his psychoanalyst. He had been in analysis for years now. "It's as if everything had been taken out and washed and put in the same place, but it doesn't work in quite the same way," Pati Hill observed. "He was always after perfection. During all the time I knew him, I felt nearly everything had to be referred to analysis." Diane was not in analysis. She was merely unhappy.

By Allan's account, it was at the end of a long, difficult shoot for *Vogue* that Diane tearfully decided she was through. She had had enough. She was quitting fashion photography and the business partnership with Allan. The Arbuses may well have been working that day on a photograph of six girls wearing bloomer dresses,

poised on a Gym Dandy swing set; that assignment, which would have taxed anyone's patience, was their last to appear in *Vogue*. When she declared that she could no longer go on collaborating in the fashion photography business, the air in the room seemed to freeze. "It was terrifying for me," Allan later said. "But it came out all right. In some ways, it was easier to work, because I didn't have that load of Diane's disapproval to deal with." One was up when the other was down. "There was that awful seesaw," he said. "When Diane felt okay, I would be in the dumps, and when I would be exhilarated she would be depressed." He knew that she felt terribly constrained. "She was hamstrung," he explained. "She was conceiving some idea that I would execute. In some dim way, she knew that she wanted to photograph other things."

22

Finding Her Spot

Now that she wasn't a fashion photographer, Diane brought her camera to the movies, Coney Island, the subway and Central Park—the sort of places that she felt secretly belonged to her. All of them were also favorite spots of Nancy Christopherson's. Like Nancy, too, Diane became fascinated by the *I Ching*, the Chinese book of divination; and though she did not, as Nancy did, consult the oracular text before making any decision of the remotest consequence, she was free if she wished to throw the I Ching to determine where to photograph on a particular day. Not compelled to show up at the studio at a fixed time to photograph an assigned story, Arbus could choose her subjects herself.

But if she felt in her giddier moments that she owned her new hangouts, she did not enjoy sole custody of them. Street photographers strode so thickly over New York City's terrain that by the midfifties their preferred hunting grounds were beginning to resemble safari parks. A photographer trying to portray something new might easily feel discouraged. Curiously, in such an industrious city, the photographers sought out gathering spots of recreation and relaxation, mostly ignoring the workplaces. They had their reasons. Regimented at work, people looked uniform. Whether they were in a factory or an office, workers wore simi-

lar clothing and engaged in related tasks, so that a photograph
became a reportorial inquiry into the conditions of their labor.
Furthermore, to enter you needed permission, and even if you
were able to pass through the gate, the employees might look
at you self-consciously—or worse, suspiciously—once you were
inside. But a person, especially a woman, snapping pictures on
the street or the beach was completely unremarkable. At mid-
century, a camera was standard equipment for an American off
having fun. When Arbus was starting out, the people she pho-
tographed often didn't notice her. When they did, they looked
intrigued or amused, not threatened or hostile.

Nancy, who took a hands-off approach to child rearing and
had no other fixed responsibilities, guided Diane through the
Lower East Side, with its Russian steam baths patronized by
elderly Jewish women and its Puerto Rican hangouts graced by
bold temptresses and sexy young men. (Nancy was in love with
a beautiful Puerto Rican teenage boy who already had a prison
record.) And they spent many hours at the movies. They would
take Poni and Doon along to see films Nancy adored, such as
Vittorio de Sica's *The Bicycle Thief* and Federico Fellini's *La Strada*.
Nancy had a way of personally incorporating a movie, almost as
if she had digested it, or as if she had shattered and then recon-
structed it into a form that corresponded to her own preoccu-
pations. One time she described the crime thriller *The Asphalt
Jungle*, which Diane hadn't seen. In Nancy's telling, it became a
story of people who made their dreams more unattainable the
closer they seemed to realization, and women who were parasites
or at best useless, and hopelessly self-destructive criminals who
represented all people. Diane recognized that this synopsis bore
some connection to the actual film, in the way that a passerby
resembled Zeus or Bacchus once Nancy pointed out the likeness.
Through Nancy's eyes, everything took on a significance that was
uniquely stamped with her psychological imprint, and was also
universal, resonating with mythic or cosmic import. Yet Nancy
acutely perceived many of the everyday details of what she was

encountering, of what was actually outside her. This trinocular vision—a seamless superimposition of the objective, the personal and the legendary—would characterize Arbus's photography: sharply observed, psychologically projective, mythically grand pictures. Nancy thought that she had influenced Diane, and that could be true. With friendships this close, it is impossible to chart which way the influences flow, or to gauge whether it is chiefly a deepening through mutual reinforcement of the affinities that originally laid the ground for the friendship.

Nancy may have encouraged Diane to go out to Coney Island, and almost certainly she introduced her to the Lower East Side. But it would have been Diane, not Nancy, who realized that movies could be photographed as well as enjoyed. Diane never made films. Nor, unlike Allan, did she explore the possibilities of color photography, except for the occasions in which she was compelled to work in color to fulfill a commercial assignment. Yet she was fascinated by the differences between the black-and-white images she favored and the color photography that was becoming more and more popular. And as a lifelong moviegoer, she was even more attuned to the divergent ways a viewer responded to a photograph and a film. "For some reason, photography tends to deal with facts whereas film tends to deal with fiction," she said. When seeing a film, the spectator suspends disbelief. He doesn't wonder *how* the images were obtained; instead, he immerses himself in the experience. But when facing a photograph, she believed, the viewer inevitably wonders how the artist captured it. She commented that if you see a love scene in a movie, you are transported unselfconsciously into that bedroom, but when you look at a photograph of a couple sexually entwined, your first thought is *What was the photographer doing there and where was the camera positioned?*

In 1956, Arbus took many photographs within cinemas, recording the image of the movie as it flickered on the screen. Sometimes she depicted the silhouette of a patron in the stalls, with the movie in the background. Attending *Baby Doll,* the Elia Kazan film that opened in New York at the end of 1956 amid an

uproar over its sexual content (including a rating of C for "con-
demned" from the Catholic Legion of Decency), she did it both
ways: the fateful kiss of young Carroll Baker with her husband's
virile rival, in an image that emerges from darkness as if spied
through a peephole; and the darkened profile and upper body
of a middle-aged man trudging to or from his seat in front of a
screen that glimmers with Baker's face, eyes closed, lips parted,
her blurred and silvery blond head as distant from this solitary
moviegoer as Venus from a plebeian Roman.

Typically, the theaters Arbus frequented for her photographs
were offering up kitschier fare than the art houses that screened
Italian neorealism. The seedy Times Square movie palaces on
West Forty-Second Street showcased schlock horror movies like
Frankenstein's Daughter, in which (as Arbus described it some years
later to Walker Evans) her screen shot caught the moment in the
film when a pretty girl, having been given an overdose of the
potion "Di-generol" by a mad scientist, sees "her own instanta-
neous putrefaction in a mirror and turns on him in womanly fury
while he runs for the antidote." The comical aspect of these hor-
ror shows—which she called "nightmares to beguile us while we
wait"—delighted her. Yet even when her photographs seemed to
be playing on easy ironies (for instance, a pair of lovers watching
a Ku Klux Klan cross-burning), Arbus was pursuing a bigger sub-
ject: that tenebrous zone in which everyday lives touch something
eternal and unsettling. In movie theaters—where isolated people
congregate in the dark as they engage in individual communion
with the spectral figures on the screen—dreaming becomes vis-
ible. And since these were human dreams, they blended tawdry
hopes and childish fears with grander passions and yearnings.

Arbus was mapping out her territory. She understood that she
was at the outset of her artistic career, and in 1956, she began
the numbering order of her photographic negatives that she
continued for the rest of her life. She was using a 35 mm cam-
era, although she experimented briefly in January 1957 with a
medium-format Rolleiflex. The Rollei produces square images

with high resolution, the type of pictures that later made her rep-
utation. But she exposed only twenty-four frames, many of them
of Times Square store displays of souvenirs and cheap jewelry,
before putting aside the Rollei to return to her 35 mm Nikon,
which takes the fast, spontaneous shots that characterize street
photography. Even in these early, often grainy pictures, you can
see that when she went to the usual places she was looking for
something distinctive, and more than that, something personal.
Coney Island occupied the lenses of many gifted New York pho-
tographers. For Weegee, it was a deliciously rude spectacle; for the
left-wing photographers of the Photo League, the working-class
families and young lovers romping lustily by the ocean offered
a vision of robust, authentic humanity. Arbus trawled for a dif-
ferent catch. Inside the bathhouses, she surreptitiously snapped
half-naked elderly women. When she photographed four teenage
boys roughhousing on Coney Island in 1957, what attracted her
was the peculiar mask—large-nosed, hirsute, middle-aged—that
one of them was wearing. Unlike a Helen Levitt picture, in which
a young child wearing a Halloween mask looks sweetly spooky
and surreal, Arbus's photograph evokes ominous thoughts of
schoolboys taunting an old Jew in a pogrom. Indeed, while two
of the grinning boys are pulling along their masked friend, a
third, who is dancing in front and poking him as a picador would
a bull, wears what strangely looks like a skullcap plucked off the
head of the humiliated victim.

The private rituals of children fascinated her. In a darkly com-
ical picture taken on Halloween 1957, a boy in blackface stares
earnestly at Arbus, while his friend, who actually is black, stands
next to him, half cropped out of the frame. It may be the first of
Arbus's many portrayals of a person taking on a new, preferred
identity. In the picture, as already in many from this early period,
the subjects are not caught unawares. They are looking at the
photographer during their fleeting encounter.

23

Raincoat in Central Park

"Take your hands out of your pockets and let them hang down at your sides."

Reluctantly, she did as she was told.

"Turn the collar back down and button up to the neck."

Once again, she obeyed.

Outside Central Park, close to the south entrance on Fifth Avenue, Pati Hill confronted Diane's camera and submitted to her direction. It was December 1956, and Pati was back in America, having divorced Bob Meservey five years earlier with almost as little friction as when she slipped out of the conjugal ties to Jack Long. Now she was trying to make up her mind whether to marry again. This time the prospective husband was a privileged scion with the suitable name of Brayton Marvell. She had met him long ago in Newport, Rhode Island, back when she was trying to start up a photography business with Bob. She encountered him again in the summer of 1955 and a love affair heated up quickly. Pati loved Brayton's insouciant slant on things, but his lack of concern also troubled her. "He's thirty-eight, doesn't have a job and the main thing he does is sail a boat which is not enough to keep a man busy," Pati told her mother. "I don't mean to marry him until he has some other kind of business."

Pati couldn't envision herself as a Newport society lady. "A life of leisure is very tedious," she felt. And Brayton wanted children: that was another worrisome detail.

She was still spending part of her time in France, staying with Alain in Paris. But Alain had settled into an avuncular posture, and if Pati wanted to marry a rich American playboy, that struck him as a capital idea. With dismay and indignation, as well as insistent offerings of literary advice, he had monitored Pati's difficulties in finding a publisher for *The Nine Mile Circle*. (It took four frustrating years before Houghton Mifflin agreed—two months before this meeting with Diane in the park—to bring it out.) Worldly Alain knew that one needed money to get along in the world.

Wading forth tentatively into the depths, Pati set up house with Brayton in Stonington, Connecticut—a compromise, because she balked at Newport. In Stonington, a quaint seaside village of WASP proprieties and eccentricities ruled socially by affluent old families but lacking the ostentation of Newport, the people they brushed up against either treated them like a married couple or refused to know them at all. In the winter, they moved their base to New York, where Pati found them a small penthouse with a sweeping terrace. It was located a few blocks from the Arbuses.

As part of his project, dictated by Pati, to transform himself into a responsible, professional adult, Brayton was seeing a psychiatrist. Pati thought a psychoanalyst might help sort out her conflicts, too. The psychiatrist she chose, Dr. Saul Heller, was also Allan Arbus's. As his Park Avenue office was near the Arbuses' apartment on East Sixty-Eighth Street, Pati would stop to see Diane after her appointments. Somehow the two friends landed on the notion that Pati should seduce her psychiatrist. With rising hilarity, they proposed the feminine wiles she might employ. (What about just taking off one piece of clothing, and then the next?) After each session, Pati would come by to report on how her homemade version of *Les liaisons dangéreuses* was progressing. She found Dr. Heller old and ugly, yet perversely ("I don't know why," she later admitted) she persisted. The seduction succeeded.

Dr. Heller, who was sixteen years older, succumbed so thoroughly that he pursued Pati to Paris after she went there to escape him. She would later have reason to regret her heartlessness.

Through the froth of Pati's friendship with Diane, a barb occasionally stung. There was, for instance, the time that Diane invited her to a little party. On arriving at the Arbuses' apartment, Pati regarded the other guests: Dr. Heller; Robert Meservey, accompanied by his second wife, Evelyn, whom Pati had never met; and Blair Fuller, a gentlemanly writer with whom Pati maintained a friendly ongoing liaison. Designed to see how Pati and three of her past and present lovers might react when placed, with varying degrees of knowingness, in the same room, the setup was malicious.

It was a curious coincidence that Pati, having conducted such a bohemian life, should be contemplating a staid marriage, just as Diane, whose longings for intense experience and creative achievement had been hemmed in by wedlock, was breaking free. The previous summer, she and Allan with the girls had rented a little wooden house on Shelter Island, a sleepy beach community off eastern Long Island. Pati visited them there. One afternoon, as the two women walked on the beach, they came across a pit in which, as part of a housecleaning, a stash of discarded, old blue-green glass medicine bottles blazed in a fire. Delighted, each fished a trophy from the flames. Pati chose one that was almost untouched, except for a sparkling iridescence at the base. The bottle Diane selected had been melted by the heat until it folded like a glove in a weird and exceptional shape. Certainly Diane was drawn to the bizarre, Pati to the classically beautiful. But could Pati be content if she allowed herself to be bottled up, a bit of glitter at the bottom of a standard container? At this meeting in the park, in addition to acceding to Diane's request to photograph her in a trench coat, she had hoped to discuss her dilemma. She was wearing Brayton's engagement ring on her finger, along with a cashmere sweater, a custom-made shirt and thin gold bracelets. What had happened to the girl in jeans in Mon-

tacher? She wanted to talk about how she had reached this point in her life and to ponder what path to take from here. Diane instead pressed forward with the camera, determined to photograph her in the Burberry raincoat that Pati had just purchased at Abercrombie & Fitch.

The raincoat was a classic WASP garment. Of course, Pati *was* a WASP—but she was also a serious writer with a colorful romantic life and a pride in flouting conventions. A Burberry raincoat constituted a uniform, the fatigues that a society woman would don during the day before putting on a cocktail dress and pearls for the evening. Pati had bought the coat with misgivings, and now that she was wearing it, she felt even more awkward. She turned up the collar, dug her fists in the pockets and tried to look nonchalant and graceful. That relaxed style Diane would not allow. She wanted Pati to look uncomfortable.

Compliant but fuming, Hill wondered why her intimate friend would be deploying her to represent some contemptible social stereotype. Pati was no longer a model. If she were being paid to portray a prim WASP lady, that would be a job and she would strive to fulfill the assignment. But why, Pati asked herself, was Diane having her embody "what is generally thought to be the lowest form of human life"?

Diane told Pati to look beyond the lens of the camera, over her shoulder into the distance. "And stop smiling," she added, with a little smile.

It was around this time, although on a different occasion, with baby Amy sitting in Pati's lap, that Diane again alluded to the patricians of Newport, that gilded world in which Brayton felt at home and Pati moved so warily. It was a social stratum Diane didn't know, and it interested her.

"What about Mrs. Auchincloss?" she asked.

"What *about* Mrs. Auchincloss?" Pati replied.

"You took a picture of her," Diane said.

Diane was referring to a story that Pati had told her years earlier, one of those times when Pati wasn't even certain Diane was

paying attention. In 1947, when Jacqueline Bouvier (the future Mrs. Kennedy) was coming out in Newport, Pati and Robert Meservey, who were passing much of the summer there and trying to get a photography business going, took pictures of the beautiful young debutante at Hammersmith Farm, the grand house that belonged to her stepfather, Hugh Auchincloss Jr. Before the party, Pati cajoled Jackie into running up and down the staircase with her bouquet and snapped the pictures.

"Bob and I took a picture of her," Pati corrected. "I took a picture of *Jackie*."

"That's not what I mean," Diane said. "I mean what about *her*. Mrs. Auchincloss and the baby. You said there was a baby. In his baby carriage."

There had indeed been an infant, Jackie's half brother, James Lee Auchincloss. Not knowing what Diane was prospecting for, Pati picked up the tale. She said that Janet Auchincloss was probably just being polite in asking them to take the pictures, "and because we were *there* in Newport at the time, and probably wouldn't go off with the silver."

"But you said she said something about being old enough to be the baby's grandmother when he was Jackie's age," Diane continued. "You said she said she would be sixty."

"That's about all I said," Pati replied. She added that Mrs. Auchincloss was a pretty woman, and the baby was some distance from them, in his carriage, when she made her comment.

"I'll be forty-nine when Amy is eighteen," Diane said.

"Well, you aren't forty-nine *now*," Pati said.

Diane smiled at her, her closed-mouth smile in which the corners of the mouth turned up and the lips stayed closed.

Because Diane was often oblique when she brought out into the open the things on her mind, Pati couldn't tell if this prospect of middle age intrigued, frightened or amused her. Nor did she really understand the Burberry raincoat photograph. When Diane sent her a print of it, Pati tore it up in fury. The idea that she would be cast as a buttoned-up WASP enraged her.

All she could see in the picture was a mocking depiction of the trappings and customs of her social class. Yet what would have attracted Diane was precisely Pati's chafing in the role that she was ambivalently taking on. A woman just entering early middle age, pressing against the constraints that society placed around her: this was a subject that, in December 1956, was very close to Diane's heart.

24

A Tiny Woman with a Grand Manner

Lisette Model was a tiny woman with a grand manner. As a photographer, she gravitated toward depicting massive people, and if her subjects happened to be small, she made them appear monumental.

Upon ending the photography partnership with Allan in 1956, Diane answered an advertisement for a class with Model. The class may have been oversubscribed, because Arbus had to press for admission. "She kept calling me on the phone and saying she wanted to study with me," Model recalled. "She was very persistent."

Arbus had tried to study photography before the war when she took Abbott's New School class; however, Allan garnered more secondhand from those technical lessons than Diane did directly. Once she and Allan were established in the fashion photography partnership, she went briefly in 1955 to the course given by Alexey Brodovitch, a Russian émigré who brought advanced European magazine design to America as the art director of *Harper's Bazaar,* and whose own grainy, poetic photographs of the ballet feel like the dreamy afterimage of a lost world of St. Petersburg elegance. But Brodovitch by this time was drinking heavily, self-involved and unfocused. The class was useless.

When later in life Arbus referred to "my teacher," she meant Model. Peter Bunnell, a photography curator who knew both women, said, "Model was able to instill in Arbus a self-confidence of approach and engagement that really released Arbus, who in her own personality was rather shy—not what Lisette was, in a European tradition, an independent, aggressive woman. There was a very tight connection, woman to woman, about what was possible." After Arbus's death, Model, who had a habit of contradicting herself, or of saying something and then denying she had ever said it, would at times stress Arbus's acknowledged debt: "She didn't make a single lecture without mentioning me. She would say in a lecture, 'From her, I have learned—what I have learned from her I will use to the end of my life.'" Yet in that very discussion in 1977, indeed, in virtually the same breath, Model observed that she would never claim that her instruction made Arbus a great photographer. "In the same class with Diane there are twelve others," Model said. "Where are they? *She* made it."

Although Lisette wavered on the question of how much Arbus learned from her, she never equivocated, in discussing her own circumstances, on how thoroughly she, Lisette, was self-taught and self-made. Like Arbus, she began life wealthy and found herself scrambling as an adult on the edge of financial embarrassment. Yet—and in this, too, she was like Diane—no matter how shabby her clothing or humble her dwelling, she retained a birthmark of privilege, the ineffable marker that sets apart those who enter the world cosseted by servants and shielded from financial privation.

Born in Vienna in 1901, Lisette grew up in a mansion, but Austria's defeat in World War I severely diminished the family's holdings. After her father's death in 1924, she left Vienna with her mother and her younger sister, Olga, for France. While the others settled in Nice, Lisette, who had studied music with the composer Arnold Schoenberg, moved to Paris to pursue a singing career. She abandoned her training around 1933. As she later described it, "something went wrong with the voice." She resolved instead to take up painting, until a chance encounter with another onetime

student of Schoenberg's jolted her. In Model's telling, this Viennese émigré, who was much more politically attuned, responded incredulously to the news of her artistic intentions. "You must be crazy," he said. "Who needs that? If something happens and the war is going to come, you have nothing in your hands to make a living." Shaken, she reconsidered her professional future. Olga, an amateur photographer, had young women friends who worked as photo lab technicians. That seemed like a practical job, and Lisette decided to train for it. As part of her education, she purchased a Leica and a Rolleiflex, not to become a photographer but so that she could better understand the photographs she was developing.

Possibly, as Lisette insisted, that's all it was, but she took to photography naturally, roaming the Parisian streets with her friend Rogi André. André, at this point ending her marriage to the Hungarian photographer Andre Kertész, was mastering the profession herself. Lisette credited her friend with imparting a vital lesson, one that she would in turn pass on to her own students: "Never photograph anything you are not passionately interested in." In the pictures she took while visiting her mother in Nice in the summer of 1934, less than a year after she had begun using a camera, Lisette demonstrated how well and quickly she'd absorbed that advice. Taken on the fashionable seaside Promenade des Anglais, her photographs of bourgeois characters sitting on rattan chairs, with their walking sticks, little dogs and cigars, evoke a complacency, and in many cases an arrogance, that is heightened by the equilateral frame and unequivocal definition of the medium-format Rolleiflex camera. What's more, because the Rollei is held at waist level, diminutive Lisette shot her subjects from below, a vantage point that emphasized their overbearing presumption. The sunbathers of the Riviera were easy pickings. "People didn't move," she said. Sometimes her subjects were aware of her camera; they glowered at her, but they didn't get up from their chairs. "I appeared to be one of them," she later explained. "I was well dressed, well brought up."

She preferred not to speak to them. Instead, she would approach and click the shutter, and then move forward to take another shot closer up. When she printed the picture in the darkroom, she would crop it so that the figure filled the frame and the encounter appeared even more direct and intense.

In Paris, she turned her lens on the other end of the social spectrum: tramps sleeping on sidewalks, peddlers hawking pamphlets and peanuts. She preferred to photograph the very rich and the very poor. "They *are* extreme people," she agreed. "I never photograph the average." Her own circles in Montparnasse were artistic and bohemian, especially once she started consorting with, and in time marrying, a handsome, popular Russian Jewish émigré painter, Evsa Model. But there were war clouds hanging over Europe, and these thunderheads were especially threatening for Jews. In October 1938, the Models traveled to New York, a city they loved on sight and resolved to make their new home. Although they brought along a comfortable sum of money, money runs out after a couple of years if not replenished, especially in New York. Lisette was the practical member of the couple. "My husband couldn't make a living," she said years later. "He was a saint, but he never made a penny in his life."

She applied for a darkroom technician position at *PM,* a recently established politically progressive paper that showcased photography. With her application, she dropped off a portfolio of her Nice pictures. She said that upon her return to the office to hear whether she was hired, Ralph Steiner, the picture editor, chided her for requesting a lab job. "You must be crazy," he said. "You are one of the greatest photographers in the world." The newspaper ran nine of her photographs under the provocative headline WHY FRANCE FELL in the Sunday edition on January 19, 1941, a little more than half a year after Nazi Germany conquered the French. Model disavowed any responsibility for the political packaging and professed to bear no animus against her subjects. Only after her death did it come out that *Regards,* a French left-wing periodical, published many of the same pictures

six years before, accompanied by an even more vitriolic text. Photographs are ambiguous, and captions often determine how they are understood. Still, it would be hard to interpret Model's portraits of the idling rich as friendly. You may see them as vilifying, satirical or comic, but that marks off the plausible range. They are not sympathetic.

Along with publishing her photographs, Steiner advanced Model's career by introducing her to well-situated colleagues. Most usefully, he connected her with Brodovitch at *Harper's Bazaar*, who was already publishing pictures by Cartier-Bresson, Brassaï and Bill Brandt. Although Model failed in her few attempts at fashion photography, *Bazaar* defined the world of style broadly. Awarded regular freelance assignments for the magazine, Lisette traveled to Sammy's dive bar on the Bowery (Weegee, another of Steiner's favorite photographers, called it "the poor man's Stork Club") and found all together, in one fizzy mixture, bums on a bender, sailors on shore leave and uptown swells on a slumming expedition. She took the subway to the crowded working-class beaches of Coney Island. She visited the sideshow of Hubert's Museum in Times Square, where she found such human curiosities as the hermaphrodite "Albert-Alberta" and Percy Pape, "the Living Skeleton." From these scruffy precincts she returned with powerful images, usually dominated by no more than two people and most often just one. "There are rarely two figures in my photographs," she said. "The one I photograph is so strong there can almost never be anyone else." In contrast to the models on the fashion pages, her chosen figures were rough-edged, overweight or ugly. And *Bazaar* printed what she submitted.

In light of the criticisms that would later be leveled at Arbus, it is revealing that Model, too, was accused of depicting "grotesques." A survey of her photographs comes up with almost no conventional beauties. Like Arbus, who as a child preferred to depict the chipped cup rather than the perfect one, Model inclined toward the odd shape. "When I was painting in Paris, we drew from the models," she said. "And you cannot imagine how

fantastically boring it can be to look hour after hour at a beautiful body. But an ugly body can be fascinating." Her most famous photograph—taken on her first assignment for *Bazaar*—is known as *Coney Island Bather.* It depicts a massively proportioned woman in a bathing suit: her legs are spread wide in a half crouch, her hands are braced on elephantine thighs, and her wide, appealing face radiates delight. In Model's account, the woman called out asking to be photographed; when passersby reacted derisively, the ebullient bather shouted back at them, "You stupid people, have you never seen a fat woman?"

Arbus loved Model's treatment of this subject. The older photographer refused to let her students see her work, for fear of stifling their originality, but Arbus wasn't easily deterred. "She tried to buy my photographs, but I wouldn't allow this," Model said. "I wouldn't even show them to her." Despite the teacher's injunctions, Arbus would have viewed *Coney Island Bather* at a group exhibition at the Museum of Modern Art in late 1957. And she saw the alternate photograph of the same woman at another MoMA exhibition in September 1961—in this version, reclining in the surf and wearing an expression more pensive and less rollicking, but with her body equally sculptural and imposing. By that time, Arbus and Model were close friends, and Arbus mailed her a card praising it. As Model astutely remarked, Arbus had many different handwritings, which she used to express subtextual meanings. (Once she sent Model a letter that read, in its entirety: "Dear Lisette. . . . Diane." The message lies entirely in the penmanship, in which the letters in *Dear Lisette* are twice the height of those in *Diane* and the *Dear* is underlined. Reflecting on that particular letter, Model said, "It was as if she was losing her sense of self, or she was telling me that soon she would lose herself altogether. And also that she found me very powerful and real.") In the postcard about the bather, the letters are firm block capitals, and the signature *DIANE* is the same size as *LISETTE.* Perhaps imbibing vitality from the picture, Diane at that moment was feeling equal to her teacher. Evsa believed that Diane drank up energy from Lisette

like a vampire, and he disapproved when his wife spent too much time with her and returned home exhausted.

The woman in *Coney Island Bather* is typical of Model's subjects, being distinctive and defined. While Arbus in her mature work looked for tentative subjects who were in the process of becoming, Model sought those who were already strongly what they were. This emphatic character of the subject complemented Model's exaggerated, powerful compositional format. Although many of the people in her photographs are physically odd, even ugly, the Coney Island bather, extra poundage notwithstanding, is an attractive woman. You can sense the photographer responding to her joyful energy. Model said that a photographer's choice of subject was no more logical than sexual chemistry. "You are only attracted to this one, and not so much that one, and not at all to the other one," she related. Much as Arbus admired the picture, it is not one she would ever have been attracted to take.

Model's portraits of the rich and poor in Nice, Paris, the Lower East Side and Coney Island bear the most affinity to those of her greatest student. But in addition to them, Model took two other important sequences of photographs: the "running legs" series, in which she photographed moving feet from the vantage point of the sidewalk; and the "reflections" series, in which she explored, as Eugène Atget had done before and Lee Friedlander would after, the images that appear as ready-made photomontages in a storefront window. Unlike Atget and Friedlander, Model was not a technical wizard. Indeed, like Arbus, she discounted technique. Yet these photographs are investigations of light, movement and perspective—the sort of inquiry into the properties of the medium that would have fascinated Allan more than Diane.

By the late fifties, when Diane came to study with her, Lisette had mostly stopped photographing altogether. With the departure from *Bazaar* of Brodovitch and of Carmel Snow, the editor-in-chief who hired him, Model's stream of assignments dried up. Politically, the McCarthy period darkened her outlook on her

adopted home and frightened her away from taking portraits of
the rich and poor, as she and Evsa were suspected of Communist
sympathies; the FBI sent agents to interrogate her and her neigh-
bors in 1954. Instead of making photographs, she was instruct-
ing others on how to photograph. She had first tried teaching
in 1949, when, on a visit to San Francisco, she was prompted by
Ansel Adams to fill in for him at the San Francisco Art Institute.
To her surprise, she discovered she was able to do it. So when Ber-
enice Abbott, recognizing her acute poverty, threw out a lifeline
in the form of a teaching position at the New School for Social
Research in 1951, Model grabbed it. Her success as a teacher,
both at the New School and in private classes, provided the Mod-
els with a modest living, but the time and energy that might have
gone into photography were siphoned off. During much of the
fifties, she was feeling depressed and frustrated.

That deflated mood, camouflaged in Model and obvious in
Arbus, may have contributed to the instant bond between the
two. Diane had been fluctuating between manic euphoria and
debilitating despair. "I've been a balloon for months so that when
I was strong I was so light I almost floated away and a blue bal-
loon is like one of Poohs so no one could tell me from the sky
and when I was weak all the air sputtered and fizzled and flut-
tered out of me," she told Pati. Upon Diane's entering the class,
Lisette was struck by the younger woman's emotional fragility.
"She looked like she was either just before or just after a nervous
breakdown," Model recounted. "The things I said would make
her start to cry. She would burst into tears, she said she was so
moved by them." The photographs Arbus brought to show her
were wispy and frail. One was an out-of-focus shot of a balloon
flying up. Another picture from that period captured a falling
leaf, its edges sharply incised against a blurred matrix of bare
winter branches that are like the capillary tracework in a blood-
shot eye. A third, so dark that its subject was barely discernible,
showed a newspaper blowing down an empty street. In Novem-
ber 1956, Arbus took more than a dozen pictures of wind-tossed

newspapers, two dozen shots of dead leaves on the ground and several close-ups of a torn, discarded cloth doll.

In advance of a field trip scheduled early in the course, Diane said that she could not go because she had two daughters. Lisette told her to bring them along. When the day arrived, Lisette saw that Diane, very pale, would lift the camera to her eye and then lower it. She was following Lisette's instructions to click the shutter only when she saw something that excited her. In the face of what she found, she faltered.

"I can't photograph," she said.

"Why not?" Lisette asked.

"Because what I photograph is evil."

"Evil or not," Lisette replied, "if you don't photograph this you'll never photograph in your life."

Lisette believed that she helped Diane conquer her inhibitions. "You had to reach her where the deepest anxiety lay—that it was evil," she observed. "And I pushed it out. One hundred percent consciously. It was my business as a teacher to get it out. What comes after that I am not responsible for morally."

25

What She Learned

In the narrative of her life that Diane preferred and her intimates endorsed, the classes with Lisette freed her to become an artist. According to this accepted story, Arbus did not adopt Model's stylistic tropes, choices of subject matter or sharply critical bent. Model simply allowed her to express herself. And, for her part, the teacher firmly denied exerting any direct artistic influence. Her impact on Arbus was ostensibly vaguer, more mystical, and consequently more profound. Allan described Diane's artistic development as an overnight transfiguration. "That was Lisette," he said. "Three sessions and Diane was a photographer." But Model's influence on Arbus was more gradual and complicated than that.

Model said that when Arbus initially came to class, "she brought photographs which were nothing but grain." And, like Allan, Model recalled a rapid transformation. "After three months her style was *there*," she said. "First only grainy and two-tone. Then, perfection." In recounting her development as a photographer, Diane, too, credited Model with illuminating the power of clarity. Arbus said that when she started out, she was smitten with the dots that, like the weave of a tapestry, stipple a photograph that is taken on the fly on 35 mm film. According to their density

and contrast, these points of darkness and light arrange themselves into patterns that represent skin or water or sky. The all-encompassing concept that one surface was convertible into any other exerted a magical allure, like a universal code or atomic theory. The printmaking chemicals of the darkroom, with precious silver nitrate and acrid-smelling hypo, already suggested an alchemist's lair. "Lisette talked to me about how ancient the camera was, and she talked about light and that if light really stains the silver, or whatever the heck that stuff on film is, then memory can stain it too," Arbus said. And the notion that a blurred figure, hard to pin down, could represent not merely a particular person but something bigger and less specific seemed like a way to conjure up in a photograph the larger truths of parable or fable. Arbus recognized that "there are an awful lot of people in the world, and it's going to be awfully hard to photograph all of them." The indeterminacy of graininess seemed an ingenious solution, until she realized it was a wrong path. "And I remember, it was Lisette who sort of made it clear to me," Diane told her own students. "She kept saying to me, the more specific you are, the more general it'll be."

But Arbus's descriptions of how she worked—and, even more so, Model's of how *she* worked—can't be accepted implicitly. It is not true that Arbus's photographs before her two courses with Model, in 1956 and 1957, were uniformly grainy and afterward they weren't. Most of her early pictures remain locked up in the Arbus archive, making it difficult to generalize, but the picture she took in the forties of the empty room with the ceiling fixture and floor lamp, as well as one of Hope Eisenman that she made at that time, are sharply focused. More importantly, for several years after her studies with Model she continued to snap pictures that were as grainy as any she ever took. To give one notable example, in 1960 she produced a remarkable series of photographs at Coney Island, which over time have been acknowledged as great achievements even though they bear little formal resemblance to her more celebrated work. In *Coney Island, N.Y. 1960 [windy*

group], what appears to be a large extended family unpacking provisions is huddled together, while a vicious wind knocks over trash cans and blows grit and papers through the air. The texture is as speckled as a half-tone engraving on newsprint; it all looks to be transpiring behind a gray scrim. Two other photographs feature similar filtered lighting and low-contrast tonality but a still darker mood: *Woman shouting, Coney Island, N.Y. 1960* and *Couple arguing, Coney Island, N.Y. 1960.* In each of these power-ful, dreamlike images, a woman is portrayed with face contorted and body clenched in rage: one is standing alone on the beach, with a tranquil, unrelated couple in the background, and one is berating a male companion as she walks with him down the boardwalk. The blurry grain distances the viewer, causing the photographs to vibrate like painful memories retrieved through a numbing gauze.

The Arbus pictures from this period that most resemble Mod-el's are shots she snapped on the street. Through cropping, a practice that Model enthusiastically endorsed, Arbus brought her subjects into close-up. This gave her images a pictorial imme-diacy. At *Bazaar,* Model's patron Brodovitch cropped everything. He resized even the photographs of Cartier-Bresson, an artist who believed, with good reason, that his pictures should never be cropped. A Cartier-Bresson photograph dances to a partic-ular rhythm, in which each element balances every other one. But Brodovitch sought a similar counterpoint and tension on the two-page spread of a magazine, and toward that end, he treated any photograph as an adjustable building block.

In cropping routinely, the art director was following the cus-tom of most photographers; Cartier-Bresson was unusual in his adherence to the integrity of the frame. Far more typical was Model, who believed that clicking the shutter was only the first step to determining the finished image. She manipulated the negative as raw material, and during her studies with Model, Arbus did the same. At a favorite prowling ground of Fifty-Seventh Street near Fifth Avenue, Arbus would lurk unobtru-

sively in a doorway until she saw something that struck her in the gut, as Model had instructed. Then she would dart forward and snap. "I do what gnaws at me," Arbus said. It might be an elderly woman with an uncanny resemblance to her recently deceased grandmother Rose, walking down Fifty-Seventh with face upturned and eyes closed. It could be a woman in attire that was unusual—either exceptionally good or, even better, risibly bad. A photographer who is raised amid fashion and then apprentices in the field is unlikely to lose her fascination with clothing, and Diane never did.

Perhaps because she was a mother for whom photography in these years was a moonlighting profession, she took many shots of children. Staking out another familiar territory, Central Park, she zeroed in on a pretty young woman with a worried look, her arms filled with a sleeping child who, because he is much too large to be transported in this way, registers as an unsupportable burden. Elsewhere in the park, Arbus would focus on a child, typically an odd-looking boy with the dress and demeanor of a much older man. Frequently, he has caught sight of the photographer and is staring at her knowingly, while the surrounding adults are oblivious. One is hoisted high above a crowd who are all (except for him) turned in the direction of what is probably a speaker at a political rally. One boy she found on the subway holding a paper bag, looking with large eyes at the camera; another, similarly attired in a man's overcoat and fedora, is reading a magazine in a drugstore. For the most part, she would take the picture without making contact with the subject. And then, by cropping the image, she would close in on the object of her attention.

Arbus used cropping to simulate intimacy for about two years, and then she stopped. She was not adopting the precepts of Cartier-Bresson. Rather, she was responding to the psychological need that had drawn her to photography: the desire not only to see but to be seen. Unlike Model, she wanted to get as close as she could to the people she was photographing and convert them into collaborators.

Aside from some interesting early experiments that led nowhere, such as a curiously bisected photograph of a sunlit, squinting woman in a white dress standing next to a store window mannequin (the left half of the picture is typical of Arbus's work of the time, the right half might have been in Model's "reflections" series), Diane didn't evince her teacher's style while she was a student. Much of her work was grainier. And even when the resolution and contrasts were high, the subjects themselves were subdued. A sharp-toned horizontal picture of a middle-aged couple at a diner depicts the man gazing vacantly past his coffee cup and the woman staring down at her plate as she eats. A vertical wall strip and a wall-mounted salt-and-sugar stand visibly mark a divide that is evidently much more profound. The liveliest thing in the picture is the gloriously curving feather in the woman's hat. Whereas Model's subjects, even the downtrodden ones, project force, the people Arbus was selecting to photograph look exhausted and depleted. It was not a conscious or voluntary choice. "I don't press the shutter," she remarked. "The image does. And it's like being gently clobbered."

It was not until much later, in the midsixties, once the women were no longer teacher and student but dear friends, that Arbus produced a number of pictures that could be regarded as successors to Model's: unsparing portraits of the rich, which, like Lisette's Promenade des Anglais pictures, might have found a place in *PM*—had *PM* still existed. In *A Jewish couple dancing, N.Y.C. 1963*, *Lady in a tiara at a ball, N.Y.C. 1963* and *Masked man at a ball, N.Y.C. 1967*, Arbus presented wealthy people in expensive formal clothing. They fill the frame of the photograph and emanate a sinister energy; the men, like Model's men of Nice, smolder with an erotic power. However, unlike Model, Arbus came up to these people as close as she could, holding her Rollei and her flash in plain view. And unlike Model's subjects, who scowl at the photographer, look suspiciously through hooded lids or at best ignore her existence, Arbus's subjects welcome her advances. They are smiling at her.

Arbus was as skittish about receiving guidance as Model was about giving it. Once she had graduated from being Lisette's student, Diane would sometimes offer up her photographs for review. "Diane could learn—she was the greatest learner who ever lived," Model remarked. The teacher once told Berenice Abbott, "I've never seen anyone learning like she did," to which Abbott replied (rather magnanimously, as her own instruction had failed to produce comparable advances), "The capacity of learning *is* the talent." But Diane's faith in originality as a hallmark of authenticity counterbalanced, and probably outweighed, the love of learning. She regarded with horror the possibility that she might be imitating others or that others were aping her. At a certain point she decided that she needed to follow her own instincts and break away from her influences. She told Model, "When I photograph, you are always looking over my shoulder." And so, for a time, Lisette stopped commenting on her work.

26

Notes of Unhappiness

Insistently, incessantly, the notes throbbed in doleful cadence on the clarinet. As soon as a fashion sitting ended or the dining table was cleared, Allan would take out his instrument and go off to practice. Tina Fredericks, coming for dinner one night at East Sixty-Eighth, was perplexed when the man of the house absented himself and repaired to the studio antechamber that served as the models' dressing room. "Allan was sequestered in the studio and was blowing on a clarinet," she recalled. "He wasn't very present. He was making noises over there."

Allan bore the responsibility of supporting the family once the fashion photography partnership dissolved, but like Diane, he yearned for more important work. "We felt that we were really something, but we weren't achieving anything like the Great American Novel—what was wrong with us?" Alex Eliot recalled. "I felt that way and so did the Arbuses, Allan especially." Friends believed that Allan—a lover of jazz who could imitate Benny Goodman's solos down to the grace note—dreamed of playing clarinet professionally. That was the plausible explanation for the constant practicing. But Alex had also heard Allan recite Shakespeare soliloquies that sounded so close to Maurice Evans you would be challenged to distinguish the real from the copy. While

Diane was startlingly original, Allan was a brilliant mimic. Peculiarly, he chose to model himself after artists who were already old-fashioned. By the fifties, both Goodman's harmonious swing and Evans's mellifluous baritone emanated the musty scent of a vanished prewar era.

Like Allan, Alex greatly admired Goodman. He persuaded the managing editor of *Time* to assign him a personality profile of the great clarinetist, who had transformed into a classical musician with mixed success. Eliot and Goodman hit it off, and the friendship deepened after the *Time* article led to a Hollywood movie about Goodman's life. When Alex told him he had a pal who could replicate Goodman's riffs with astonishing precision, the clarinetist said he would like to meet such a devoted fan. Impulsive as always, Alex called up Allan to ask if he could introduce him to someone. The Arbuses had just finished dinner. Allan said to come on over.

How Allan felt when he opened the door and saw the hitherto anonymous friend was not immediately apparent.

Seeing the clarinet case, Goodman asked, "Whose is this?"

"That's mine," Allan said. "But I'm not much good."

Opening the box, Goodman saw that it contained a top-flight instrument. "Do you mind if I hear it?" he asked. He picked it up, blew into it and then put it down. "Oh, this reed!" he exclaimed. "Where did you get this?" He told Allan that he had been cutting his mouthpieces incorrectly all these years.

The get-together was lively and congenial, and upon leaving, Goodman thanked Eliot for introducing him to the charming Arbuses. But the next morning, Allan, whose icy fury could be withering, called Alex to say he would never forgive him for springing Goodman on him unannounced. The hypercritical Allan couldn't help but see shortcomings everywhere, particularly in himself. Even without the embarrassment of the botched reed, the intrusion of the world's most distinguished clarinetist into his home could only spotlight his comparative mediocrity.

Robert Brown had been in the Arbuses' living room that

night, and he was one of the friends who thought Allan might be happier as a clarinetist. He was surprised when, not long afterward, Allan told him that his true ambition was to be an actor, not a musician. Brown's acting career was flourishing, on the stage and in live television. Wanting to sound encouraging, he complimented Allan on his very precise diction.

"I have a recording of Shakespeare that I did," Allan said, and offered to play the tape. As he listened, Robert, who had never thought of his friend as a potential actor, judged that Allan had talent. The iambic pentameter flowed in a sonorous rhythm, yet the meaning of the words emerged clearly. It appeared that Allan's musical capability resided in his speech as well as in his clarinet noodling.

"Allan, this is terrific!" Robert exclaimed. He said that Allan should study acting and proposed finding him the right instructor.

The acting teacher that Robert located in 1957, on the recommendation of his friend Roddy McDowall, was Mira Rostova, a Russian émigré whose most successful student was Montgomery Clift. Rostova taught a personally devised curriculum that emphasized the actor's engaged presence in a scene. The other students in the class, which met once or twice a week in a room on Eighteenth Street off Fifth Avenue, were ten or fifteen years younger than Allan. Their youth was all the more obvious because they were emulating Monty Clift and Marlon Brando, not Maurice Evans and Ronald Colman. His fellow students wondered how serious Allan was. He was a man who was entering middle age and had an established career. He didn't seem to have the passion or flair that an actor needed to succeed.

One of those eyeing Allan skeptically was a young woman who was the acknowledged prodigy of the class. It was apparent to everyone that Zohra Lampert was destined for stardom. She was bookishly intelligent, quirkily pretty and enormously sexy; when she was playing a role, you couldn't look elsewhere. Her offbeat charm was indeterminately ethnic (her ancestry was Russian Jewish, but she could just as easily play Italian) and in perfect regis-

ter with the desire of the time for naturalness and authenticity.
Probably the only one who had doubts about Zohra's future as
an actor was Zohra. She never intended this to be her calling.
A recent graduate of the University of Chicago, she had met her
first husband, the actor Bill Alton, when they were students. She
thought she might become an artist, a philosophy professor or
a librarian; however, her social circle was thronged with the-
ater people. After she helped paint sets for a stage production
of Bertolt Brecht's *The Caucasian Chalk Circle* at a small theater
run by other Chicago graduates in a converted Chinese laundry,
the actress in the leading role of Grusha dropped out. Zohra
was asked to fill in. Her performance earned enthusiastic raves,
and so she continued with other parts, including Marie in Georg
Büchner's *Woyzeck*. The group around the Playwrights Theatre
Club and its successor, the Compass Players, included a number
of people who would advance to distinguished theater accom-
plishments, Mike Nichols, Elaine May, Edward Asner and Tom
O'Horgan among them. But even in such company, Lampert
shone. She thought she might as well continue acting, because it
came easily to her and she had no clear idea of what else to do.
And so, like many of her Chicago friends, she moved to New York,
the theater capital. Alton came, too, but the marriage faltered.
By the time Allan entered Rostova's class, Bill and Zohra were
divorced, and she was living with a roommate in a large walk-up
apartment on Third Avenue and Forty-Ninth Street. Zohra had
missed Allan's first class, probably while out on a casting call. Her
roommate, who was also a Rostova student, told her "a man" had
joined the group. She meant not a kid in his twenties like them-
selves, but a grown-up.

As Zohra would soon learn, Allan was beset by a grown-up
midlife crisis. All joy and enthusiasm had leaked out of him.
While Diane was busy channeling her energy into her craft and
her children, Allan earned a living through deadening labor he
despised. Temperamentally, he found fault in everything, start-
ing with himself. "I'm not bright," he often said. Surrounded by

the glib, glittery poseurs of the fashion world, he felt his own guise was shamefully threadbare. In Curaçao on a shoot, he agonized every evening before heading off in his white dinner jacket to the obligatory predinner cocktails hosted by the worldly art director of *Glamour* Miki Denhoff, who was supervising the story. "How do you know what to say to people?" he moaned to his assistant. "I never know what to say. That Miki Denhoff drives me crazy. What are we supposed to talk about?"

The acting lessons were one way he hoped to break out of his listless, angry mood. Was it enough? Nancy Christopherson thought not. She urged him to embark on a love affair. Diane's best friend was an odd source of such counsel, but the Arbuses had always extolled emotional loyalty, not sexual fidelity. Nancy didn't feel her advice undercut Diane. Besides, Allan didn't need her input. He was already prospecting for lovers.

His first candidate was Gretchen Harris, a cover model who worked for the best magazines. Gretchen was amusing and, of course, beautiful. Allan was captivated. Unfortunately, she was engaged to be married. He got nowhere with her.

Zohra was slow to perceive Allan's amorous intentions, and once she realized, she resisted. He was a married man. They were rehearsing a scene from Arthur Miller's *A View from the Bridge* when he kissed her. "Oh, these American marriages," she quipped. He snorted. To continue developing the scene, they met out of class in his apartment, and she was struck by the vacant majesty of his living room. "I thought it was spooky," she said. "It was grand and spare. It was kind of beautiful, but obviously, people were not at home." Allan poured out his lament of loneliness. He was thirty-nine, with a critical birthday approaching. "Wait till you're forty and see what it's like," he told her. She was twenty-six. Unlike Allan, she was sailing on instinct into her uncharted future.

"There was nothing ungoverned about him," she thought. One day when she showed up at East Sixty-Eighth to rehearse, Allan had just showered and his curly hair was wet and uncombed. She welcomed this bit of unruliness. "It looks nice," she said. He

started wearing his hair that way. Still, she didn't take him seriously when he asked her out on a date. "I got a telegram," she recalled. "I was going out with my parents. I scoffed." One day she was ill and missed class. When he paid a visit to her apartment to express his concern, she was charmed by his solicitude, but she refused his entreaties to become lovers. Rather than reproach her for the rebuff, he empathized. "He sent me a telegram saying he understood and blessed me," she recalled. "It touched me that someone would be so thoughtful to wish you well." She came to accept that he was not a Don Juan. "There was goodness and kindness in him," she decided. "He was looking for warmth and companionship. It was manifest that he was not with his wife. I understood that it was not a one-night stand." She succumbed to his advances: "I was not immune." Allan began spending nights at her apartment, falling into a pattern in which he would return home on the third day.

She expected him to end his marriage. It puzzled her that Diane apparently accepted an arrangement that Zohra found intolerable. She was not the only one baffled by Diane's public attitude. One evening Pati came by the Arbus apartment and Diane said brightly, "Guess what? Allan has a mistress." "I put an end to the conversation by being somewhat shocked," Pati recalled.

Zohra liked to give parties for her fellow students and other friends, and to her intense discomfort, Allan brought Diane to one. The first thing Zohra noticed was Diane's gray-and-brown woven wool sheath, with cap sleeves that exposed her bare arms. Diane, whose fashion sense was a birthright, dressed intentionally for different audiences: when she saw her parents, she chose shabby clothing to emphasize her relative poverty; meeting her husband's younger lover, she looked sexy and glamorous. It was a time when Zohra lacked money to buy expensive clothes, and she took in Diane's idiosyncratic elegance. Even more than her stylishness, Diane's friendliness flabbergasted Zohra. Diane greeted her warmly and affectionately. "She seemed very nice," Zohra recounted. "She was so good-willed I was suspicious of it."

Occasionally, as her relationship with Allan continued, Zohra felt intimations that Diane might be more distressed than she was letting on. One evening when he arrived at her apartment, Allan said that Diane had bid him farewell with her hands extended in silent beseeching. He felt terrible, but he left anyway.

Zohra waited for Allan to resolve the situation. She was impressed by his kindness and constancy. "I saw him as a knight," she said. She was less convinced by his prowess as an actor. All the actors she knew valued in-the-moment technique and natural-seeming emotion over the measured and deliberate. Allan was old school. "He spoke in a very studied way," Lampert said. "I think he wanted to appear in life in a certain way as well."

Her own reputation was growing. In January 1958, she won critical praise when she appeared on Broadway in the very brief run of *Maybe Tuesday*, a comedy about seven career girls who are sharing an apartment and plotting to get married. She was auditioning for roles in other plays and films. But Zohra manifested a lofty disinterest about her acting success. Indeed, it bothered her that Allan seemed dazzled by it. He was striving to succeed, while she regarded herself as a student who was above crass careerism. "Mira thought he was with me just to get ahead," she recalled. "She didn't approve."

Zohra so admired Allan's photography that she failed to understand why he wanted to be an actor; no better did she grasp how he could be beholden to two women at once. "Allan saw life as dark-toned and I saw it as lit," she said. "I didn't expect trouble, I didn't expect misery, I didn't expect harm. He saw differently. He seemed like a sad person." Once he gave her a photograph that she thought was particularly beautiful. It depicted two spired skyscrapers. Between them, a pigeon was flying. The buildings were solid and clear, but the sky was dark. The bird caught between them was indistinct and blurry.

27

Losing Herself

From the time she was a girl, Diane was periodically afflicted by spells of depression. Even more striking were those moments when, in the midst of a conversation, she would seem to disappear within herself, like a diver who submerges for many long seconds and slowly resurfaces. Her mother had been troubled by depressions, too. Regardless of shifting moods, Gertrude's attentions were directed toward herself. All of her children emphasized how detached and unavailable their mother was. It was the governesses whom Diane and her siblings recalled with powerful feelings of affection or distaste. These women served limited terms and left. Gertrude never departed, yet she was never really there. Her attention was unsteady. The children remembered their mother as a vague figure who occasionally entered their domain, sometimes just to say how odd she found her offspring. She was too self-involved to empathize with their frustrations and desires. She was too dependent on the opinions of others to find who she was, and she passed down that trait to her children.

Gertrude was unreliable—not abusive, but not to be trusted, either. She withdrew without warning or apparent reason. Diane felt that Gertrude was the one who required protection, to keep from slipping away into depression. The child had to suppress her

anger and hide her feelings to avoid upsetting her mother. She
sought with passionate intensity her mother's affection, until at
the point of adolescence she turned on Gertrude with guilt-tinged
vehemence. "I hate her," Diane told Alex at fifteen, and contra-
dicted the statement immediately: "No, that's not true." What
was certain is that she had yearnings that Gertrude had aroused
without satisfying. To take up the part, Diane first found Howard.
Renee believed that they were adolescent lovers, and her husband,
Roy, told her he was convinced that they continued their amorous
relationship throughout their lives. Indeed, Roy attributed How-
ard's worsening alcoholism to torment and guilt over the relation-
ship. Diane recounted this incestuous liaison to her psychiatrist
in her last year. But Diane's sexual forwardness wasn't limited to
her trysts with Howard. Her undressing for the voyeur who lived
across the courtyard and her avid watching of exhibitionists on
the subway established at an early age a lifelong preoccupation:
the urge to be seen and to see in an eroticized light.

With great commitment and fanfare, she chose Allan as her
husband, and she retained her childhood belief that love was
eternal. "I always wanted something I could be faithful to for-
ever," she wrote in 1940, the year before her marriage. "I hated
fickle people." Since the age of thirteen she had depended on
Allan's care. Like some fairy-tale enchantress, she drew vitality
from his spellbound state, which was necessary for her emotional
well-being. But it wasn't enough. She needed to acquire new
admirers, which she had done triumphantly when she was fifteen
with her conquest of Alex. Forced years later to relinquish Alex's
ardent devotion, she did so only after bitter struggle. That loss
had been painful. Allan's turning in earnest to another woman
threatened her immeasurably more.

She had no reservoir of self-esteem to fall back on. Having
learned prematurely to defend herself against intrusions and
dangers, of which the most terrifying and baffling were her
mother's fluctuating moods, she never had a place to develop a

coherent sense of who she was. Acutely interested in both the out-
side world and her internal fantasy life, she was unable to secure
her equilibrium between them. She required a cascade of stim-
ulation to ward off collapse into an apathy of nonexistence and
unbeing. "She had to live in a constant euphoria and that was a
dangerous situation," Lisette Model observed.

In the late fifties, as his relationship with Zohra deepened,
Allan didn't hide from his wife how he felt. Diane confided to
Nancy that Allan spoke of Zohra as monomaniacally as he once
practiced the clarinet. "He could not stop talking about it—how
marvelous he felt, how exhilarated," Nancy recalled hearing
from Diane. "He kept talking about it at the breakfast table all
the time. Diane couldn't stand it and she became deeply angry."

But expressing anger directly was a talent that Diane did not
possess. Instead, she sank into a depression. More than a depres-
sion; it was an abyss that swallowed her sense of herself. With-
out Allan's unquestioned attentiveness to serve as her mirror,
she couldn't see herself and she became lost. She described this
ruined state, once she had emerged from it, as "a spiritual auto-
mobile accident." She said it was as if "I lost my face although
everyone pretended I was the same as ever whatever that was."
From day to day, she convincingly mimicked the motions. She
grew accustomed to raising her hand to touch the place where
her face used to be. And the most amazing thing, she declared,
"and the thing that sticks most in the throat and hurts the most is
how easy it is. The joy and terror are both in the swallowing." After
being reduced to a standstill of motionlessness and nothingness,
she came through the ordeal with a stripped-down but functional
identity, "a perfectly decent rudimentary self." She deemed her-
self happy. Nothing much had changed in "the visible palpable
how you say real world," but the changes within her were stupen-
dous. She had "survived invisible holocausts" and "walked into
plateglass doors without cursing or crying, and generally learned
to behave as though nothing was happening which it wasnt." She

wryly observed that the gods had been "divinely ingenious." In the aftermath, she could only be "as they say in speeches humbly grateful even if I would have wished it otherwise."

What happened in the real world was that Allan moved out. It was not his preference, nor was it Diane's wish. If Allan wanted to incorporate Zohra into their lives, Diane was prepared to endorse the expansive arrangement that the Arbuses had followed with Alex. She went out of her way to demonstrate her willingness to embrace Zohra as a friend. But Zohra forcefully made her position clear. She would not continue to be Allan's lover if he was also sleeping with Diane. And it really wasn't comparable to the earlier situation, because Alex, despite his intense infatuation, had made love to Diane only twice, while Allan was spending several nights a week at Zohra's apartment. Diane tearfully told her closest friends in New York that she and Allan were separating. She shared the news with Nancy inside the dank, peeling walls of a Russian steam bath on the Lower East Side and confided in Tina after lunch at the Museum of Modern Art's penthouse terrace restaurant as they lay stretched out on chaises longues and eyed the skyline through the round apertures in the roof.

Looking back after everything that followed, Allan said that the breakup liberated Diane. "I always felt that it was our separation that made her a photographer," he said. "I couldn't have stood for her going to the places she did. She'd go to bars on the Bowery and to people's houses. I would have been horrified if I'd been with her." For Diane, separating from Allan was as brutally disruptive as the splitting of two trees that have intertwined since they were saplings. It was a test of her strength, and she rose to it. "The main characteristic of Diane was courage," Allan said.

The classes she took with Model, and the act of taking photographs, helped to pull her out of her quicksand. Lisette said that by learning how to photograph, Diane gained the power to live. The act of seeing and being seen, memorialized in a photograph, thickened and strengthened her sense of self and her sense of being. She was taking pictures constantly. Indeed, she immersed

herself so deeply that at times she felt at risk of losing herself: in an unending sequence of seeing and clicking, she might reach a point where she could never find her way back. It was "like being in the ocean when the waves make you feel so strong you might swim to Europe," she wrote to friends. "I mean there was some sort of illusion involved, which could prove its own trap."

Around the time that Allan declared his intention to move out, Diane jotted down a dream. In it, she is wandering through an ornate hotel that is adorned with "cupids carved in the ceiling" and other rococo layers of gorgeousness, like a colossal wedding cake. The hotel is on fire, but the flames are invisible, with only a gauzy veil of smoke that hangs in the air and beautifully haloes the electric lights. She needs to save certain things within her room, but she can't find them and she is unsure what they are. Her "whole life is there." With her camera, she proceeds in a kind of rapture to record what is happening. But does she have time to take more pictures before the building comes down? Is there even film in her camera? She is in a state of suspended ecstasy—as if, she thinks, she is giving birth, and just at the point that the baby is emerging, the nurses say to hold back because they are not quite ready. Like a magic amulet, the camera has the power to stop time. Wearing it around her neck, she prowls amid "an emergency in slow motion," like the *Titanic* after the iceberg crash. How many pictures can she snap before everything around her sinks?

PART THREE

BECOMING A PHOTOGRAPHER

The Ground Was Shifting

In August 1959, Diane moved with Doon and Amy to a home that was unlike the ones they had shared on the Upper East Side with Allan. Instead of bleached, austere grandeur, the little carriage house at 131½ Charles Street in the West Village offered welcoming coziness. To reach it, you passed through a portal to the left of 131 Charles, a handsome redbrick town house dating from the 1830s. The landlord lived in the larger house and collected rent from the dependent building.

"It was like a fairy tale," one visitor recalled. "You'd go through an archway, along a dank corridor, across a patio—and then, their carriage house." The Hansel and Gretel atmosphere continued once you stepped inside the cottage, which had originally been a stable reached by a horsewalk. Except for a few hours during the day, the lighting was dim, with only filtered sunlight seeping through the windows that faced the courtyard. On the right side of the ground-floor space was a partition made of weathered wooden planks that Robert Brown had found on a visit to Long Island and brought back for Diane. She pinned images on this screen of boards: photographs taken by herself and others and clippings that she tore from tabloid newspapers. Behind it she placed her mattress, which she put on the floor,

as she and Allan had always done. To the left of the door was a larger space, comprising the heart of the house: a kitchen and a dining table. A stairway led up to Doon's and Amy's bedrooms and the bathroom.

Allan, too, had moved downtown, to an apartment with a skylight and a tile floor on Washington Place in central Greenwich Village, a fifteen-minute walk away. It served by day as his studio and then, with the lowering of an ingenious Murphy bed, which he attached inside a recessed arch on a stone wall at the end of the room, it converted at night into his residence. After Mira Rostova lost her classroom space, the studio also did occasional duty as a weekly acting school.

Although Diane and Allan were sleeping in different homes, they were still bound by innumerable ligatures of affection, history and habit. Allan came by the house frequently, with a standing appointment for Sunday brunch, and he continued to supervise the money in their joint checking account, paying the bills for the entire family, including the rent on the carriage house. A contributor's note in the January 1960 issue of *Glamour* reported that he lived with Diane and their two daughters on Charles Street. Many of their acquaintances, and even Diane's family, did not know they were separated.

Diane would drop off her film—what she called her "experiments"—at 71 Washington Place for Allan's assistants to develop. Lending a personal meaning to street photography, she usually bore the dusty traces of the pavement. Sandals exposed her dirty feet in warm weather. A rumpled figure, she carried a large brown paper bag in place of a purse. Richard Marx, one of Allan's assistants, worried about her custom of leaving a roll of bills at the top of the paper bag. "Diane, do you know I could take some of this money and you wouldn't even know it?" he once asked, thinking he would get her to reform her ways. She looked him in the eye and said sweetly, "But you won't, will you?"

Diane was just as nonchalant when it came to the technical aspects of photography. Although she would always make her

own prints from the processed negatives, the developing of her film she left to Allan's assistants. There was nothing unusual about that. The state of her negatives, however, was haphazard. Cameras in the fifties provided little information and the film was unforgiving, but Diane didn't bother with a light meter. Regardless of the available daylight or the movement of her subject, she would preset the lens opening to two full stops down from the maximum aperture. Generally speaking, that setting produces the sharpest image, but if the light is too bright or dim, the image on the negative will be washed out or overly dark; and if the problem is severe, it must be mitigated in the darkroom or the picture may prove to be unusable. The assistants developing Diane's film tried to compensate by examining it under a green safelight to determine how much time it needed in the chemical bath—what is called "developing by inspection." One evening in 1959 in the Washington Place studio, another of Allan's assistants, Dan Kramer, was developing film after a long day's fashion shoot. When Diane came by to collect her processed film, he admitted that he hadn't yet developed her pictures. Allan looked in later and asked what the problem was. Kramer said that he hadn't done Diane's film because he was still finishing the fashion job. Allan reproved him. "The most important work that goes on here is Diane's," he said.

Although Kramer was surprised by Allan's admonishment, he privately agreed that Allan's studio work was humdrum and that Diane's pictures were "overwhelming." He was just beginning his photography career. "After I saw her Coney Island pictures and her pictures in the bathhouse, I was totally at odds," he recalled. "I didn't know how one photographs anymore." It wasn't her technique, which was rudimentary, that humbled him. As for her strategies, they were creative, but hardly unprecedented. Erich Salomon had made his reputation in Europe between the wars by using a hidden camera—in his case, photographing diplomats in morning jackets rather than immigrant women in towels, but the subterfuge was the same. What captivated Kramer,

and at such a gut level that he would struggle to find words for it, was Diane's use of the camera as an expressive instrument. She was photographing what she saw, without staging or embellishing. Her selection of subjects was not especially exotic: a heavyset woman wearing only panties in a bathhouse, a cheerful elderly woman carrying two prizes she has won at an arcade. Yet the pictures delivered an emotional charge that was peculiarly personal. The photographs expressed Diane's heart and mind along with her eye. They did so in a far more complex way than Model's pictures—and, for that matter, those of other politically minded photojournalists. The documentary photography of the past already seemed dated. The ground beneath the feet of photojournalists was shifting.

The epochal event that sent tremors through the photographic community in the late fifties was the publication—in France in 1958 and in the United States the following year—of Robert Frank's book *The Americans*. Traveling through the United States on a John Simon Guggenheim Memorial Foundation Fellowship, which he won in 1955 with the fervent backing of Walker Evans, Frank shot whatever caught his attention. Later, he selected, cropped and sequenced the pictures to form a book. Far from universally popular at first, *The Americans* stoked up heated controversy and, for the most part, harsh judgments. Many critics thought that the Swiss-born photographer had bleakly and prejudicially misrepresented his adopted country, but they were missing the essence of his work. In the highways, cafés, bars, barbershops, funeral homes, picnic grounds and sidewalks of this multistriped nation, Frank found images that mirrored the landscape of his mind. In some of his photographs, a scene is being seen through a scrim—a transparent flag, a screen door, gauzy curtains—to underscore the self-conscious photographer's awareness that his images are strained through his sensibility. In the manner of Evans, Frank's subjects are often static. Even in those instances when he shot a moving crowd or a couple rushing down the street, the people feel suspended in solution. There is

a stillness to the work, and also, Arbus thought, a "hollowness." She once commented that Frank's pictures are "like a drama in which the center is removed, there's a kind of question mark at the hollow center of the sort of storm of them, a curious existential kind of awe." Frank recorded real dramas that were unfolding in America, but the chilled, detached calm of the hurricane that Arbus detected in the pictures is the reflection of the man who took them. His pictures are like snapshots in which the shadow of the photographer darkens the depicted scene, except that for Frank, the stain of his personality was an intended adulterant.

As part of the small community of New York photographers, Robert Frank was acquainted with the Arbuses; like them, and most of his other colleagues, he relied on fashion photography to help pay the bills. Yet his exceptional talent stood out, and even before *The Americans,* he was a luminary. Along with the Arbuses, he had a single picture in Edward Steichen's *Abstraction in Photography* show at the Museum of Modern Art in spring 1951. But Frank was on a rapid upward trajectory. At the *Postwar European Photography* exhibition that Steichen organized two years later, there were twenty-two works by Frank; only one other photographer received greater display, with most being represented by merely a few pictures.

In April 1954, a year before taking to the road on his Guggenheim project, Frank brought his beautiful, long-haired wife, Mary, to a party given by the Arbuses at their East Seventy-Second Street apartment. It was the first time Mary met Diane. They struck up a conversation and, over time, they became good friends, much closer than Diane ever was to the irascible, sardonic Robert. One thing the two women had in common when they met was that they were both enormously pregnant. Diane would soon give birth to Amy, and Mary, who was ten years younger than Diane, was also about to have a second child, Andrea. Both had defied their parents to marry very young. Mary Lockspeiser was seventeen when she wed Robert, who was twenty-six.

The differences between the two women were just as striking.

A modern dancer, trained by Martha Graham, Mary had started sculpting in wood, beginning what would be a distinguished artistic career. At the time, the Franks were hard up for cash. Mary remarked on the moneyed ambience of the Arbuses' white triplex on East Seventy-Second, a distant remove from the disorderly, underheated Chelsea loft that she inhabited with Robert and their growing family. She also noticed the obviously expensive ribbed white woolen sweater that Diane was wearing, its huge collar framing her head "like a lowered halo."

Robert hated fashion photography. But other than advertising agencies, the only employers for working photographers in the fifties were magazines and newspapers. The pictorial newsmagazines, dominated by *Life* and *Look,* used photos to illustrate the ideas in the text. Celebrated photographers, such as Cartier-Bresson and Brassaï, could count on the freedom that accompanied non-fashion editorial assignments from *Vogue* and *Bazaar.* Their juniors could not.

One showcase for good pictures was the business magazine *Fortune,* which valued fine photography from the time of its founding in 1930. Walker Evans served for two decades, until 1965, as the magazine's only staff photographer. In 1955, he assigned a *Fortune* photo-essay to Frank on the politicians and businessmen aboard the Congressional Limited express train linking New York and Washington. (Three of those photographs would wind up in *The Americans.*) *Fortune* represented the best of the newsmagazine photography tradition. However, it was a tradition that was already old-fashioned.

As the fifties closed, there were inklings of change in the magazine business, as there were in the world of photography and the world at large. One of the most adventurous new magazines was actually an old magazine, founded just two years after *Fortune* but undergoing an exciting process of rejuvenation. A monthly that in its early years published short stories and literary journalism by Hemingway, Fitzgerald and Dos Passos, *Esquire* stumbled after Arnold Gingrich, the founding editor, retired at the close of

World War II; but once Gingrich, persuaded that his abdication was premature, returned in 1952, things began to turn around. Even before the notoriety that greeted the publication of *The Americans,* Frank completed a photo-essay for *Esquire* on smoggy, decaying Hollywood. "It was very hard to get a story that was only photographs into *Esquire*," recalled Robert Benton, the magazine's art director. "Robert Frank wanted nine pages. I sweated blood and got him seven. When *The Americans* came out, he gave me a copy and signed it, 'In the spirit of compromise.'"

It is uncertain how Arbus found her way to *Esquire*. Harold Hayes, a forceful, charismatic young Southerner, was not yet officially the editor of the magazine but was vying to run the show. Decades later, Benton remembered hazily that Hayes asked him to look at Arbus's portfolio; but in Hayes's recollection, he had no acquaintance with her work, and she must have come on her own to the art department, as photographers did. However the overtures were made, she dropped off her portfolio in early May 1959. "Diane and Allan's work was in magazines I had seen, like *Seventeen*," Benton later explained. "I didn't dislike it, but it never interested me." He was caught off guard when he looked with Hayes at the photographs she left behind. "They knocked us over," he recalled. "We said, 'These are unlike anything else. We have to do these.'"

Buy Amy's Present, Go to the Morgue

When Arbus visited the *Esquire* offices, Benton discovered that the woman, like her photographs, contradicted his vague memories and expectations. Although her voice sounded naïve and girlish, her hairstyle, dress and manner looked ragged. "She was like someone who was blowing apart," he observed. "The effect of Allan's leaving her had been very hard. Her hair was shorn. She had become another person." That the breakup of the marriage caused the change was only a conjecture on his part; even after she and Benton became friends, Diane never discussed Allan or the marital split. And despite her struggle for autonomy, she did not appear to Benton to be unhappy. Indeed, over several years of friendship, he never saw her unhappy.

Benton expressed his enthusiasm for Arbus's pictures of movie-house interiors and wax-museum mannequins. In both cases, they were photographs of fantasies, but they differed in their emotional tone. The scenes of sex and horror that the movie screens offered up were dusted with a powdery light that instantly placed them in the realm of dreams. They were, literally and obviously, projections. By comparison, the ax murderers and rapists who were immortalized in the World in Wax Musee at Coney Island were lifelike enough to seem real at first glance,

especially in a black-and-white photograph. That verisimilitude brought them closer to the actors in actual dreams. At once hideous and comical, they provided Arbus with what she had told Lisette Model she was seeking: visible manifestations of evil. She liked a definition she once heard, that horror is "the relationship between sex and death." In the World in Wax Musee, she wrote, spectators tiptoed "nervous and rapt and polite as if they are in church," gazing on a man cutting up the body of his mistress or a strangler tightening a cord around the throat of a hapless, slip-clad woman. Screened off by chicken wire, in one grim tableau after another the murderer and victim struggled silently "for their last lasting time in . . . their hell where nothing ever happens or stops happening." Just as in a photograph, time in a wax museum is suspended. Arbus's photographs of the World in Wax Musee were time-stopped representations of scenes that were themselves frozen eternally in a gruesome moment.

Funny, charming and graced with a generous intelligence that enhanced your assessment of your own, Arbus was the type of New Yorker who made small-town Southerners like Hayes (born in Elkin, North Carolina) and Benton (Waxahachie, Texas) certain they had landed in the right place. Not that they ever had much doubt. New York for them was a carnival array of the smart, talented and industrious (such as themselves) rubbing up against socialites who were planning charity balls at the Plaza, grifters angling for rubes in Times Square, immigrant women dressed all in black as if they were still in Sicily, peddlers hawking their wares off pushcarts, secretaries looking for affluent husbands, married men looking for credulous secretaries—the cavalcade was nonstop and stupendous. Although Diane was a native New Yorker, she shared their grateful amazement at what the city displayed. She surveyed the human exhibits with a child's glee and a taxonomist's sophistication. "People are gardens," she once told her goddaughter, May Eliot, who was dreading relocation from the English countryside to New York. You could live in the city and still be surrounded by gardens, because that's what people are.

Enamored of their adopted city, Hayes and Benton determined that the annual themed issue of *Esquire,* to appear in July 1960, would be a celebration and exploration of New York's riches and squalors. They saw at once that Arbus would be their ideal photographer, and they contemplated asking her to take the pictures for the entire number. "We talked about it, and we chickened out," Benton recalled. "In the end, we said, 'No, we can't do it.'" Her vision was so particular and intense that they feared it would overcolor the mix. Instead, *Esquire* commissioned a photo-essay, asking her to prowl the city's high and low ends, going wherever her hunches led her.

They led her everywhere. At first, Arbus privately thought that photographing social extremes was "sort of a revolting idea," but then she realized "it would be terrific for me, because I could do anything that came into my head." In October 1959, she began bombarding Hayes's secretary, Toni Bliss, with ideas for subjects and requests for help in gaining access to them. She wanted to find interesting places and people, "both posh and sordid." She needed to schedule many, because not until seeing them could she know if they would make good photographs. "The more the merrier," she wrote Benton. "We cant tell in advance where the most will be. I can only get photographs by photographing. I will go anywhere. The Edwardian Room and The Salvation Army."

She scintillated with ideas, and so did her editors. Benton had met recently with Joan Crawford at her Fifth Avenue penthouse apartment opposite the Frick mansion. "Everything in that apartment was covered in plastic," he recalled. "I thought, the person who needs to meet her is Diane Arbus." Hayes tried to arrange a sitting, without divulging that *Esquire* wanted to photograph only the closets in Crawford's luxuriously antiseptic home. But after much back-and-forth, with the movie star's representatives requesting samples of Arbus's work and suggesting the magazine would do better to hire a *Town & Country* photographer whose pictures Crawford liked, Arbus and *Esquire* jettisoned the idea. "Maybe there are better closets," Arbus wrote Benton.

Even when she photographed someone in a public place, Arbus was required to obtain a written consent form from her subject. This troublesome obligation of releases nagged at her throughout her career. She complained that "if people are grand enough they have learned never to sign anything and if they are degraded enough they cant." One day she passed a derelict lying on the steps of a church, beneath a sign that read "Open for Meditation and Prayer." His fly was unbuttoned, with his penis flopping out. "I couldn't ask him to sign a release, could you?" she asked Benton. (In fact, while this was a good argument for her case, she would not really have wanted that picture. She avoided photographing people who were abject and pitiable, and she also shunned the facile irony between signage and subject matter, which many street photographers relished.)

Permissions were only part of the challenge. At other times, access was granted, and then, when Arbus arrived, she quickly perceived that the experience could not be captured on film. Toni Bliss arranged for her to descend into the city sewers, which Arbus, recalling an old Charlie Chan movie that was set in the sewers of Paris, imagined as a picturesque netherworld. She was excited when she arrived at the assigned rendezvous point on Canal Street in lower Manhattan, where the city workers provided her with hip boots. But once she climbed down a ladder into the manhole, she realized that the dim light and short vistas prevented her from taking a good photograph. The personal experience was marvelous. She could describe it to her friends with vivid details. But the photographs of "rotten yellow water" were worthless.

Working feverishly as a photographer, she was also a full-time mother. The different ages and temperaments of her children posed separate challenges. Doon had grown into a precocious adolescent of remarkable independence. At thirteen, she developed an obsessive interest in the actor Anthony Perkins, who played sensitive young men in such plays and films as *Tea and Sympathy* and *Friendly Persuasion*. Doon learned that Perkins shared

the Midtown apartment of Helen Merrill, a German-born woman who loved to nurture talented young gay men such as Perkins. Merrill would one day represent many of them as a theatrical agent, but at this time she was taking portrait photographs for actors and musicians. Perkins, whose career had recently blossomed, kept a small rear bedroom in her floor-through town house apartment on West Fifty-Sixth Street, opposite the City Center stage door, and stayed there when he was in town. Every day after school, Doon traveled to the building and sat on the stoop for hours, regardless of the weather, without saying a word or in any other way making her presence known. As it happened, this behavior was not unique. Michael Smith, a young man who also fantasized about Perkins, recently had done something similar, cruising by repeatedly on his Vespa. Eventually he managed to meet Merrill and he became, as he put it, "part of the household." Smith was just starting out as a theater critic for the *Village Voice*, and some nights after seeing a play he would stop by at eleven to walk Perkins's dog before returning home to the East Fifties.

Like Michael, Doon found her endurance rewarded. On April 4, 1958, which happened to be both his twenty-sixth birthday and the day after her fourteenth, Perkins came down and asked why she was waiting. He walked with her for blocks, whistling and humming and telling her about two buildings that were almost parallel in a manner so mysterious he couldn't determine which was standing right and which was wrong. Then he left to enter a health bar as they wished each other a happy birthday. All of this Doon related to Diane, who found it "marvelous" and took comfort in her moody older daughter's resulting good humor. The bright, engaging girl charmed both Merrill and Perkins, and like Smith, Doon entered the fold. In summer 1959, about the time her mother moved into their new home, Doon spent a couple of weeks with Merrill, Perkins, Smith and a rotating cast of guests at a house in Truro, on Cape Cod, that Merrill rented. The following year, Perkins bought a house on the Cape and Doon once again visited.

Amy was only five years old when her parents separated. Unlike Doon, she required supervision. If babysitters were unavailable, Diane at times tried taking Amy along on assignments. She would do that even before the separation, when Amy was very young. Once in Central Park, pursuing an ultimately abortive photo-essay on urban litter for Tina Fredericks at *Ladies' Home Journal,* she was so focused on two ducks in a pond that she didn't notice where Amy was walking until, sputtering water "like an angry inept mermaid," the toddler rose to the surface, and Diane had to transport her, dripping wet, in a taxi home to East Sixty-Eighth Street. Usually Amy could be dropped off with a friend while Diane went out hunting for pictures. Still, the obligations of motherhood competed with photography. A typical day's appointment book would read "Buy Amy's birthday present, go to the morgue."

The morgue was one of the New York locations that Arbus visited for *Esquire.* She filled the pages of her notebook with the names and locations of possible subjects. She wanted to photograph wealthy children. Perhaps in a chauffeured car? (Portraying the two children of the actress Elizabeth Taylor in a limousine was, she told Bliss, "a splendid thought," but she settled instead for the nine-year-old daughter of Moss and Kitty Carlisle Hart.) Selecting clothing in Bergdorf's or a small shop off Park Avenue? (She did both.) Taking dancing lessons? She located and photographed a Mrs. William de Rham, who with her husband taught ballroom dancing to the children of New York's social elite. All of these must have evoked memories of her own childhood. In the end, *Esquire* used none of them. Nor did the magazine use her pictures of female impersonators at the Jewel Box Revue, pig and cow heads on racks in the Greater New York Packing Company, a flexing bodybuilder who held the title of Mr. New York City, a dog in its coffin in a pet cemetery, or the physical relics of the Catholic saint Mother Cabrini (whose incomplete remains were encased in a glass sarcophagus and supplemented by a waxen image of her head, making Arbus think of Snow White).

Of the six photographs that ran, just two represented the upper classes, and neither showed children. One was of an appealingly proper dowager of the Daughters of the American Revolution standing on an Oriental rug in a genteel living room, wearing a long strand of pearls and a bar pin commemorating each of her Revolutionary War ancestors, her feet in sensible black shoes and pointed at the correct angles, her gloved hands folded. The other "upper" photograph was taken at the Grand Opera Ball, a charity event. In it, slightly out of focus, a beautiful young society matron, with a look both rapt and vacant, gazes at a tuxedoed man who is seen from the rear. Both women could be characters in an Edith Wharton novel: the old-family "aboriginal" survivor, appearing (in the granular light that filters through a sheer-curtained window) like a ghost from a vanished New York; and the blond bewitcher who has won a wealthy husband but now must live with the consequences.

When the time came, as it inevitably does on the layout table of a magazine, to separate the ones that must run from those that are merely good, the nod more often went to Arbus's photographs of the "low": the professional freaks, the misfits, the abandoned. Two of them were regular performers at Hubert's Museum, the sideshow in Times Square. Hezekiah Trambles, known as "Congo the Jungle Creep," was depicted in character, with his hair a snarled nimbus, his gap-toothed mouth in a downward grimace and his wide eyes upturned in a gaze that is both frightened and frightening. A black man from rural Georgia, Trambles was billed as an African savage. He would climb a ladder of swords, screaming all the way up, and then jump off the ladder with a sword sticking out of one foot. He would swallow a lit cigarette, drink water and blow smoke out of his nose and mouth. He would shout voodoo nonsense, stir diabolical potions and belligerently threaten the audience. Arbus's photograph of Trambles had strongly impressed Hayes in the portfolio she dropped off at *Esquire* on her initial visit. In it, the wooden leg of the ladder forms a strong diagonal on the left. Juxtaposed with

Trambles's tormented face, it evokes a powerful and unsettling association with traditional images of Christ carrying the cross.

Wanting to portray a professional freak at home, Arbus pursued Albert-Alberta, a hermaphrodite whom Lisette Model had photographed at Hubert's some fifteen years before. "I am to meet a half man half woman to see if she (it is referred to as she) will take me to her house," Arbus informed Benton. Albert-Alberta exhibited herself in a risqué costume, exposing a hairy chest and thigh on one side and a feminine nipple and shapely leg on the other. "Brother and sister in one body, she could be the father of a child or the mother of a child," the crowd-rousing sideshow "talker" speciously blared. Disappointingly, Albert-Alberta would not admit a photographer into her private quarters. Instead, Arbus went home with Andy Ratoucheff, the midget she would photograph for more than a decade. (The last photographs she made of him were taken in his winter residence in Tampa, Florida, in 1969.) Because Ratoucheff performed late at night, he met Arbus at his rooming house at one in the morning, expressing some embarrassment at escorting a woman to his apartment at that hour. She was amused by his sense of decorum. She placed him toward the far end of the room, a vantage point that exaggerates the breadth of the bed in the foreground and the diminutiveness of Ratoucheff in the rear. In black tie, fedora, scarf and overcoat, he is every bit as dapper as Maurice Chevalier, whom he had just finished impersonating at Hubert's.

The last two portraits in the sequence are extracted from a lower level in the social strata of New York. Walter L. Gregory was a Bowery celebrity who was known as "the Mad Man from Massachusetts," for his custom of engaging passersby by shadowboxing, ranting and roaring. However, compared to the bums sacking out in the neighborhood's flophouses (or the man Arbus had espied uptown sleeping exposed on the church steps), he was respectable—dressing in clean clothing and living in a rented room in a rooming house. Arbus photographed him stripped to the waist and hugging himself tightly, with his tattooed arms

crossed over his chest and his hands tucked into his armpits. His right eye had been lost in some long-ago mishap. The eye socket was puckered—"a small and pretty crescent folded absolutely shut like an eternal wink," Arbus rhapsodized—but his sober left eye stared out unblinking at her camera. Even more cockeyed were the stories Arbus collected about him, such as one about the time he brought a purloined basket of strawberries to a police station and suggested that if the officers stole some cream they could all enjoy dessert. Arbus entertained her friends with such anecdotes, but their narrative content resisted incorporation into a photograph. Less assimilable still was the sad fact that Gregory died in a traffic accident three months after her photograph was taken and four months before it was published. Maybe the editors were subtly alluding to that denouement with their layout. The final photograph in the sequence is of an unclaimed body beneath a sheet in the city morgue, its naked feet, with one tagged toe, pointing at the viewer.

The photographs were published under the title "The Vertical Journey: Six Movements of a Moment within the Heart of the City." The belabored subtitle obscured Arbus's meaning. "The journey was vertical and dizzying like Alice's," she wrote on the April 19 page of her appointment book. New York was her Wonderland, and she was as breathlessly observant as Alice.

30

A Mephistopheles, a Svengali, a Rasputin

Hayes and Benton were delighted by Arbus's work, and by her company. Both men quickly came to treasure her as a friend. Hayes was married, but Benton could freely spend time with her in the evening. Despite his finding her "incredibly sexy," they were never lovers. They were pals. Every so often, they would eat dinner at Downey's Steak House and then stop in for a coffee, wander over to Hubert's Museum or just drift along together with the human waves that washed through Times Square. "She knew how to hang out, something I was not so good at," he recalled. A slight, bespectacled man who drove a vintage Citroën and wore army shirts to the office, Benton laughed as delightedly as Arbus at the absurdities and incongruities they discovered. He identified his sense of humor as "letting humor intrude in places where you don't expect it and perhaps where it shouldn't." He thought this injection of the comic into inappropriate settings was part of his Southern heritage. Regardless of origins, it bore a close family resemblance to Arbus's blackly comic, classically Jewish take on life. Movies like Ed Wood's ridiculous docudrama about a cross-dresser, *I Changed My Sex!*, or the human anomalies at Hubert's would send them into appreciative raptures. "We liked creepy things," he explained.

"We attached a great romance to that world of what other people think of as grotesque." Diane told him secrets about her life, and he reciprocated by telling her even more of his own. "You would sit with her and become a co-conspirator," he said. "It was an intimacy that you responded to and she responded back. You became two people who spoke a private language."

Without a husband to come home to in the evenings, Diane needed to reinvent herself. As Benton noted, the woman with the long pageboy hairdo and the Peter Pan collars had vanished, replaced by a boyish-looking professional photographer. What he didn't quite realize was how she required a full connection with someone who, appreciating this new role, would affirm the reality of the woman playing it. Deprived of Allan's wholehearted devotion, she was in search of an acute, receptive replacement. She found one. Six months after her first visit to Benton at *Esquire,* she was introduced to another magazine art director, and the intimate complicity that developed almost overnight would profoundly affect her career and her emotional life.

When Marvin Israel met Diane in late November 1959, he was not actually working as an art director at a magazine. Short-tempered and allergic to authority, he never held on to a job for too long. The previous year he had left *Seventeen,* which was located in the same building on Madison Avenue as *Esquire.* Since Allan worked frequently for *Seventeen,* Marvin and Diane would likely have crossed paths before, but only now did they recognize their remarkable affinities. Marvin was raised in an upper-middle-class Jewish environment very much like Diane's. Born in Syracuse in western New York State, he came to Manhattan as an infant, growing up in a Central Park West apartment that was about a mile north of the San Remo, where the Nemerovs lived during their Depression-induced comedown off Park Avenue. Marvin's father and uncle owned a small chain of women's clothing shops. His family, which included a brother and sister, was affluent—not on the level of the Nemerovs, but doing well enough to afford live-in help and to send Marvin and his brother to the Ethical Culture School

that Howard and Diane attended. Marvin was a year younger than Diane. They probably would have met as students had Marvin not transferred to another school. He was "not comfortable with the discipline there," his cousin, Lawrence Israel, explained.

From an early age, Marvin wanted to be an artist. His parents, recognizing his talents as a draftsman, provided private lessons with an art teacher, as the Nemerovs had given Diane. Upon graduating from Syracuse University, Marvin continued to rely on his family's largesse, receiving financial support to study art in Paris for two years. While he benefited from his parents' wealth, he disdained their values. In this way, too, he resembled Diane—and not only Diane, but a whole generation of liberal-minded young people in New York, born to well-off parents with conventional artistic tastes and social aspirations who backed their offspring's heterodox ambitions with bemused, at times grudging, generosity. In the early stages of her long relationship with Marvin, when she rejoiced that she had found her ideal intellectual and romantic partner, Diane chortled at the thought that each set of their parents would approve of the other. Running away from their families as fast as they could, they had "come full circle" and collided with each other like cartoon characters. Their bourgeois Jewish heritage was as unmistakable a "stigma" as being born "Negro or midget," she told him, and it was "glorious . . . to see it reflected back and forth in the mirror of each other." He told her: "If we are all freaks the task is to become as much as possible the freak we are."

In the beginning, Diane seemed not to mind that Marvin was already married. And not merely in name: his conjugal knot, rather than being a technicality, was primary. He was committed to a beautiful, extravagantly creative artist whom he admired, protected and never considered leaving. He had fallen for Margaret Ponce, who became known as Margie Israel, when he was a graduate student at Syracuse. A vibrant, voluptuous woman, she was born in Cuba but came as a baby with her parents to New York. Marvin told a story of how they met: in a life drawing class for undergraduates at the university, he asked the instructor

to indicate the most talented pupil. Pointing to a woman in the back of the room who was not paying any attention to the nude model but was concentrating instead on her paper, the teacher said, "This is the most gifted student." In Marvin's narrative, he was drawn to Margie by her artistic creativity above all. They were married in March 1950. That summer, they left for Paris together.

When they returned to the United States two years later, Marvin went to Yale to study under Josef Albers. There he met Alexey Brodovitch, a "visiting critic" in the graphic arts program, who made him appreciate the artistic potential in magazine and book layout. While her husband earned a master's degree in graphic design, Margie stayed in New York, taking a class in ceramics that opened new opportunities for her. It seemed that she could make anything out of clay. In a town house building on far West Fourteenth Street, near the hub of New York's Cuban community, she and Marvin rented two apartments: small living quarters on the top floor and a studio for Margie on the ground level. She filled both spaces with her art. "She was doing decorative work with design and pattern way before anyone else," said Mary Frank, who regarded her as a mentor. "Her whole studio was an installation of the most extraordinary sort. It was deeply poetic." In the upstairs apartment, the chairs were made entirely by Margie of painted ceramic. So were all the dishes, the doorknobs, the toilet paper holder, and even a large round ceramic bathtub that she had glazed and painted. She produced rolls of wallpaper in bright patterns that often featured animals. Her desk was a board supported by stacks of thick medical books and Bibles. She covered every surface of the studio and apartment with her fantasies. She lived inside her mind, and she saw everything through the prism of art.

Upon finishing at Yale, Marvin in early 1955 took a position as assistant art director at *Seventeen,* and advanced the next year to the top spot when Art Kane, the art director, left to pursue photography. For Marvin, committing to his first full-time job was an act of both independence and indenture. At the age of thirty, he would support himself financially and no longer rely on his par-

ents. His dream, however, was to be a painter, not a magazine designer. In the sunset days of abstract expressionism, he was making calligraphic paintings in the style of Franz Kline.

By the time Diane met him, he was producing these pictures in a studio that was even more remarkable than Margie's. Whereas Margie had transformed a prosaic space into something lyrical, Marvin found a setting that was itself magical and made it into a sorcerer's tower. At the summit of a grand, decaying Beaux-Arts building on Fifth Avenue at Twenty-First Street, in a neighborhood that long ago had been the city's fashionable shopping district until the fashionable crowd moved uptown, Marvin occupied a three-story cupola. One of his admiring female students asked how he had found such a wonderful space. He replied that most people in New York walked with their heads down. He walked looking up.

A visitor coming off the elevator would go down a corridor, which was part of the apartment, and be greeted by a rising cacophony. Marvin kept an aviary of noisy parrots and doves in homemade cages and mesh enclosures. For a while, he also housed an even more raucous captive crow, as well as a cat that he called Mouse. The lord of this manor would be shouting "Shut up, Marvin, shut up," as his dog, a vicious stray that he had taken off the street and named for himself, charged against the studio gate in a frenzy.

On the dome's first floor, which was round and radiant with windows in all directions, Israel maintained his painting studio. The furniture was idiosyncratic. A log served as a bench, on which visitors could sip tea served in Margie's cups and saucers. Marvin placed a mattress over what he called his "coffin," the box in which he stored his artwork. He decorated the many windowsills in the circular room with little arrangements. "A plastic chocolate cake next to a miniature dog and a candle—mixtures of found objects and seashells and garbage," Michael Flanagan, a friend, recalled. "It was like a rich little world of objects, magic tricks and old postcards." A spiral staircase led to the second floor, which had small porthole windows like an ocean liner. Marvin did his graphic design work on a table there. A ladder

gave access to the windowless top of the cupola, dark and conical like a wigwam. Feathers floated in the air.

The human Marvin could lash out as unpredictably and fiercely as the canine one. "A fuse burning" is how his friend Lawrence Shainberg, a younger writer, described him. "Marvin wanted to shape careers," he said. "When I didn't go along with what he wanted me to do, he got furious." Ruth Ansel, who worked for Israel as an assistant art director, said, "He inspired me to do my best work. On the other hand, he could make me cry miserably." At the Parsons School of Design, where he began teaching in 1960, he would tongue-lash his students, most of them young women, frequently until they sobbed. "He would say to a student, 'You have no sense of color, no sense of design, you're not an artist, you don't belong here—are you some suburban, stupid-assed kid?'" one of them recounted. "Very cruel and not very constructive." Yet the depth of his passion, that student said, convinced her she was seeing a true artist for the first time, and she was determined to have him acknowledge her. "He got you incredibly excited about stuff," Flanagan recalled. "Opening your eyes, and getting you to see the richness and strangeness of things." He introduced Ruth Ansel to the work of Malaparte. He led Deborah Turbeville, who was photographing mannequins, to read about the animated tailors' dummies in the stories of Bruno Schulz. When Israel took an interest, his concern and advice flowed limitlessly. So did his curiosity. He surprised Patricia Patterson, who enrolled at Parsons in 1959 and was perhaps his favorite student, by showing up unannounced at a Howard Johnson's in New Jersey, where she worked as a waitress on the breakfast shift, and a few years later at a hotel in London, where she was employed as a chambermaid. "Marvin decided very early that I wasn't any good as a fashion illustrator or designer, but that I would be a painter," Patterson said. And that is what she became. He voiced powerful directives on his students' personal lives as well as their artistic choices, making them feel both appreciative and apprehensive. They called him a Mephistopheles, a Svengali, a Rasputin, but

they were flattered to join a brotherhood in which art was all that mattered. With priestly ardor, Israel would tell Patterson that you could be a heroic master or else you were nothing—"there were only two choices, to be Cézanne or a cow."

And should you disappoint or bore him, watch out: his magic wand became a dagger. One time, in the sixties, he decided he had listened enough to the complaints of the artist and critic Manny Farber, who was doing odd carpentry jobs to support himself. Israel had no sympathy for his whining. "Why don't you just kill yourself?" he said. When Benton once invited him over for dinner with Arbus and the photographer Saul Leiter, Israel, even though he had supported Leiter's career and published his pictures, savaged the man. "Marvin was very annoyed with me, because I didn't have the desire that he thought I should—to be famous, to be great," Leiter observed. "He said once, 'You could have been great if you only cared.'" Israel's cruelty at the dinner horrified Benton. "That ended my friendship with Marvin," he said. "I thought, 'He's a dangerous friend.'"

Those who knew him speculated about the sources of Israel's anger. He was a short, balding, unprepossessing-looking man, but he joked about it. "When your father dies and you get all your money, I want to be your stable boy," he told a teenage student, after they became lovers at the end of the school year. (A Jewish girl from Westchester, she was no more Lady Chatterley than he was Mellors.) His Jewishness seemed to irritate him, too, particularly the way his name proclaimed it like a label. Leiter, who was descended from a line of rabbis, recalled that Israel once confided that as a young man he had disliked being Jewish. Yet Israel also laughed about it. He recounted a tale of how, when he went to a small town in the Deep South to spend the holidays with the family of his Syracuse college roommate, the entire population waited for them at the railroad station: none of them had ever seen a Jew before.

Perhaps he was angry at the need to make a living as an art director when he aspired to be a major artist. Here, too, though, he seemed ambivalent. "All my old friends thought I was nuts to

take the job, but it was the best thing I ever did," he told Flana-
gan. "I get to travel, to do all these interesting things." Flanagan
thought he "got high on being a big shot in this world. He ate it
up." Which is not to deny that on other occasions, he seemed to
resent the loss of time and energy that should have gone to his
painting. It irked him that he was recognized as a designer, not
as a painter. There was also the unhappy issue of deference. On
a magazine, he had to answer to an editor-in-chief who exerted
the ultimate authority and whose taste he usually didn't respect.

In all these ways, life fell short of the ideal. But Israel's violent
temper probably fed most voraciously on his bitter sense of inad-
equacy as an artist. "He would confide in me about his worries
about his work, his disappointment in himself," Patterson said.
She recalled that he once told her, "I have to get really depressed
in order to work." He could not find a personally distinctive style.
Time after time, he tried on identities that other artists had estab-
lished. When he was operating as a pedagogue, he pushed people
to amplify what was unique in their approach. He couldn't locate
that spark to ignite in himself. "I think it was very painful for him
that work just flowed out of Margie and didn't out of him," Patter-
son said. Robert Frank said he knew only a few true artists in his
life, people who were obsessed by their art and had to work con-
stantly, and Margie was one of them. (Diane Arbus was another.)
Not merely prolific, Margie was genuinely original. "Marvin was
burdened by sharing his life with a beautiful, extraordinarily tal-
ented woman who was much more talented than he was," Leiter
remarked. Marvin always gently ministered to Margie; and once
he became close to Diane he was similarly tender with her. He
recognized that both women were emotionally fragile. But when
he grew despondent at how his work was going, he would retreat
from human contact, or he would strike venomously at the unsus-
pecting with the suddenness and accuracy of an adder. "He was
not a great artist," Mary Frank said. "He was married to a great
artist and he was involved with a great artist." He was too smart
not to know that.

A Manual of Facial Types

Within weeks of their meeting, Marvin sent Diane a portfolio of photographs by August Sander that were published earlier that year in the Swiss magazine *Du*. The gift demonstrated Israel's talent for nourishing an artist with precisely the right material to deepen her art. Arbus was good at personalized presents, too, but Israel's, in addition to affirming the intimacy of friendship, implied a comprehension that bordered on partnership. It was a form of inspired matchmaking, the pairing up of an artist with a sympathetic predecessor, and it contributed to his charismatic pull, in which he made the beneficiary of his attention feel truly understood. In Sander, he introduced Arbus to the work of a photographer who, more than any other, had produced portraits that resembled the ones for which she would become renowned. Although Sander depicted a very different society, his concerns and ambitions were akin to hers. Like Sander, Arbus in her more expansive moods fantasized about recording each citizen on film. "*I would like to photograph everybody,*" she wrote feverishly to Marvin. She wanted to preserve these specimens in what, she told Howard, "I privately call the butterfly collection." (To Pati, she compared photographing her subjects to "flattening them on the wall like a butterfly impaled on a pin.") She was practic-

ing "a sort of contemporary anthropology," and in this regard, Sander was a soul mate. She responded so enthusiastically to his pictures of the German populace, mostly taken between the two world wars, that she started seeing New York through his eyes. That spring, during the intense period after she and Israel connected, when she was writing to him almost daily, she sent a note, exulting that "everyone today looked remarkable just like out of August Sander pictures, so absolute and immutable down to the last button feather tassel or stripe, all odd and splendid as freaks and nobody able to see himself, all of us victims of the especial shape we come in."

Compared to the flamboyantly individual and self-consciously malleable New Yorkers whom Arbus would memorialize, the Germans posing for Sander's lens were indeed absolute and immutable. By the time Arbus discovered Sander's photographs, his subjects were already historical entities, specimens of human life forms that were swallowed up by the cataclysms of the first half of the twentieth century. In 1959, Sander was nearing the end of a long life. His book *Face of Our Time* had won praise from the writers Alfred Döblin and Walter Benjamin upon its publication in 1929 in Weimar Germany. With the rise of National Socialism, his reputation sank. The Nazis destroyed the half-tone plates and all available copies of *Face of Our Time,* either because they objected to its inclusion of people who deviated from their Teutonic ideal or, equally likely, because of the political transgressions of Sander's son Erich, a Communist sympathizer who died in prison in 1944. That year, as the Allied bombing of Germany intensified, Sander moved to a small village near his home in Cologne, taking ten thousand glass negatives with him but leaving thirty thousand others hidden in his basement. A disastrous fire in 1946 swept through the Cologne basement, incinerating those negatives. Sander, who was sixty-eight when the war ended, produced little photography thereafter. The rediscovery of his work began with his inclusion in the *Family of Man* show at the Museum of Modern Art in 1955. And now *Du,* a sophisticated magazine devoted to culture and

illustrated with high-quality photogravure reproductions, had presented a selection of his pictures.

The people Sander photographed were types—representatives of the crafts, professions, political stations and family positions that had characterized German society for generations. It was Sander's genius to reveal how particular individuals were protected, confined, fulfilled or devoured by their prescribed social roles. He began by collecting and conserving the images of an archaic rural society in Westerwald, near Cologne, the city to which he moved in 1910. From there, his scope widened. As he described it in a 1931 radio broadcast, he wanted "to capture and communicate in photography the physiognomic time exposure of a whole generation." Classifying his subjects by profession and gender, he would organize the pictures systematically to make clear that "all carry in their physiognomy the expression of their time and the mental attitude of their group." By the standards of this project, the sixty photographs in *Face of Our Time* constituted a mere sketch. There was something characteristically German in the grand, methodical ambition and the categorizing mania of Sander's plan to expand on what Walter Benjamin, in an approving critical notice of *Face of Our Time*, called a "training manual" on the reading of facial types.

In all of his photography, Sander was using a small, old-fashioned view camera on a tripod, exposing orthochromatic glass plates. A newer process, employing panchromatic plates, gradually superseded the orthochromatic, but Sander kept with the old way. The orthochromatic plates registered more detail. For the same reason, he employed fine-grained, glossy printing paper that was typically reserved for scientific images. One also senses in Sander's attachment to traditional methods a profound conservatism, which fed his desire to fix and preserve the images of people who were vanishing.

The camera he used required an exposure of two to four seconds, and the expense of the glass plates prevented him from making more than two or three exposures at a sitting. These were

not candid snapshots. The long exposure meant that his subjects
were his collaborators, who were performing as themselves for
his camera. The hod carrier hoisting his bricks, the pastry chef
stirring his copper bowl, the locksmith toting his ring of keys,
the upholsterer brandishing his tack hammer are identified,
like the subjects of Renaissance portraits, by their symbols and
implements. The roles had existed for centuries; by embodying
them, Sander's models assumed some of the same timelessness.
But even without the advent of Nazi tyranny and wartime dev-
astation, Sander's grand scheme to chart the different circles of
German society was chimerical. His theoretical underpinnings
were haywire: he imagined a grand historical cycle of ascen-
dance and decline, in which the vigor of the earthbound peas-
ant degenerated into the flowering and eventual decadence of
city life. He began with farmers and ended with marginal urban
types such as vagrants, gypsies, circus folk, and ultimately the
blind, the dwarfs, the disfigured, the mentally disabled and the
dead. His thinking had much in common with Oswald Spen-
gler's *The Decline of the West,* which colored intellectual discourse
in Germany after World War I. Happily, the dubious mission
was undercut at every step by the truthfulness and humanity of
Sander's eye, which saw vitality in the vagrant and dignity in the
deformed. Photographs are ambiguous. Their truths are at best
partial, their interpretations myriad. Paradoxically, in a manner
that Arbus came to appreciate, Sander's inclusion of sharply ren-
dered and selectively chosen detail amplifies the uncertainty.

Sander did more than inspire Arbus. It appears likely that she
learned specific posing techniques from him. In particular, the
German photographer liked to arrange sisters side by side, wear-
ing the same dress, bodies touching. Favoring frontal stances that
revealed the most information, he showed no interest in formally
adventurous vantage points. He usually placed the older child in
a pair a little closer to his camera, accentuating the larger size.
Arbus, even when she wasn't dealing with twins or triplets, pre-
ferred to locate her teamed subjects at the same distance from

her lens. Sander was indicating the different places of an older and younger sibling; the distinctions Arbus explored were psychological, beyond such conventional gradations. Portraying a twin brother and sister of the upper middle class, about seven or eight years in age, Sander shows a girl whose face is anxious, tentative and eager to please, and a boy with a slight pout, one hand thrust in his pocket, a bored stare of nascent arrogance. They are holding hands, the boy slightly in front. While Sander is attuned to their mental states, such attention is in service to his deeper interest: perceiving in gestational form the haut bourgeois wife and the supercilious businessman that these children will become.

"Entire stories could be told about many of these photographs, they are asking for it," Alfred Döblin wrote in the introduction to *Face of Our Time.* That is indisputable, but it is also true that many, probably most of the stories would miss the target. In collaborative portraiture, the model and the photographer come together to produce a picture that expresses a shared confidence, a secret. Like all confessions, the photograph divulges only a part of the underlying reality, which remains in shadow or outside the frame. A record of a moment in which the photographer and model participated, the picture, Arbus felt, will always hold a private meaning for them into which others cannot enter. "I think it's a secret probably for everybody's pictures, that your own pictures mean more to you than they mean to anybody else," she said. "Because it's that thing of . . . I was there, and I saw that, and you may not believe it, and this is only an *inkling* of what it was like. But it really was. I was there. And it really was like that and now it isn't like that at all." A viewer standing in front of the photograph would have his own relationship with it, imbibing some of its mysteries, but for him, it could be only an evocation, not a souvenir. Each acutely observed and precisely recorded detail opens up new questions. Arbus might have been describing Sander's work as well as her own when she wrote, near the end of her life, "A photograph is a secret about a secret. The more it tells you the less you know."

The Weeping Clown
and Fearless Tightrope Walker

The *Esquire* assignment went so well that Arbus, even before she finished writing her captions, was invited to develop another idea. Over lunch with Hayes and Benton in April 1960, she proposed photographing people she described as "eccentrics." The idea took shape slowly, building on the foundations of work she had already begun. On the advice of the proprietor of the sideshow of Hubert's Museum, she traveled outside New York that spring, visiting small circuses and fairs. A far cry from the Ringling Bros. and Barnum & Bailey megashow, these troupes provided unso-phisticated entertainment in towns and rural communities, con-tinuing a tradition that could be traced back to the Europe of the Middle Ages. Besides offering diversion for the townspeople, the itinerant carnivals supplied the main sustenance for circus and sideshow performers, who prospered in warm weather and then spent the winter in Florida or subsisted on meager paychecks at indoor urban establishments such as Hubert's. Arbus journeyed by train and bus to provincial way stations in New Jersey and Maryland to photograph the touring show people. She was on a quest for material for *Esquire* but thinking constantly of Israel. "We are a circus, breathtaking, dazzling and hushed," she wrote

to him in late March. "You, the fireater, strongman, juggler. Me, the tightrope walker and the lady liontamer. . . . I am the clown who weeps and you are the one who sits rocking in a structure of precarious chairs."

Like a tearful clown, she suffered long dolorous spells. Summers often depressed her. "I was intensely aware of these violent changes of mood," Allan said. "There were times when it was just awful." And then the emotional weather would blow in a different direction and she bubbled over with excitement. Following the appearance of the July *Esquire* that featured her photographs and marked her coming-out as a solo photographer, she thrummed with jittery elation—waking at four or five in the morning "as restless as a jumping bean," going for aimless walks, stopping into movies that failed to hold her attention. Early in the month, she went out to Coney Island for Independence Day, spending the night in a room "the color of blue ice cream" in a brightly painted, slightly seedy Victorian hotel, Tony's Bright Spot, which reminded her of "a merry-go-round in a garden." Ten days later she saw the Miss America preliminary competition in Atlantic City. She filled her notebook with the names of conceivable subjects.

Once the summer ended, in a follow-up letter to *Esquire,* she wrote that eccentricity was an exaggerated style, flaunted without explanation and in defiance of convention. She was seeking true believers in the impossible, people whose madcap missions had left visible marks on their exteriors, human metaphors "who-if-you-were-going-to-meet-them-for-the-first-time-would-have-no-need-of-a-carnation-in-their-buttonhole." Unlike the subjects of her first *Esquire* assignment, who exemplified socioeconomic castes (vagrant, socialite, blue-blooded dowager, sideshow performer) as distinctly as August Sander figures, the eccentrics inhabited a realm of their own making. "These Are The Characters In A Fairy Tale For Grown Ups," she concluded her pitch. "Wouldn't it be lovely? Yes."

Benton and Hayes agreed. They assigned the piece in November. Over the next eight months, Arbus searched out grandiose

characters who mapped their own corner of reality and crafted their identities to fulfill their outlandish visions. They were, in her mind's eye, "fictional characters searching for their stories." In some respects, she identified with them, just as she did with the circus tightrope walkers. The eccentrics were reinventing themselves, and so was she. Like them, she could imagine that, as she told Marvin, "the gods put us down with a certain arbitrary glee in the wrong place and what we seek is who we really ought to be." She was no longer snapping her subjects on the fly or unobserved. "She got herself to go up to people on the street and ask if she could photograph them," Allan said. "One thing she often said was, 'I'm just practicing'—and indeed, I guess she was." A woman with a girlish, self-effacing manner frightened no one. Diane was so recessive that people almost always thought she was smaller than her actual height of a bit more than five feet, six inches.

Flushed with enthusiasm for the prints of Sander, she aspired to emulate him by producing photographs that registered minute particulars with scientific clarity. She concluded that she needed to change her camera. "Whenever she'd get really fed up, she'd have to get a new camera," Allan said. "Then the goddamned thing would come to me and I'd have to test it." Diane had used a medium-format Rolleiflex during their European sabbatical in the early fifties, and she tried one again for photographing an eccentric—but apparently she abandoned the experiment after eight frames. Pursuing another possibility, she borrowed Israel's Nikon rangefinder to determine whether she wanted to buy one like it. On a rangefinder, unlike the single-lens reflex Nikon F she had grown accustomed to using, the photographer focuses by turning a ring that lines up two superimposable images. Arbus complained that the process took so much time it was like fitting her subjects for a pair of shoes before she took their picture. Another drawback was that the rangefinder viewed the scene from a slightly different vantage point than the lens, which meant that she never felt she knew exactly what she was photograph-

ing. However, there were advantages: the rangefinder camera took pictures with greater detail and less distortion. She enlisted Allan to try out different lenses. "I must have tested five lenses," he recalled. "Nothing was sharp enough for her."

Her dawning desire for clarity she later credited to her teacher Model, but to judge from the timing of the shift, Sander may have been the greater influence. In this period of transition, Arbus was still using a 35 mm camera, and her aesthetic aims fluctuated. The overexposed pictures she took in a Coney Island windstorm on July 3, although superb, are gritty and misty in texture. However, she was evolving away from that style; the photographs of eccentrics indicate where she was headed. She showed Michael Smith, who visited her around 1960, a small group of photographs she had collected and tacked to the partition around her bed, of group portraits of graduating classes, military troops, company picnics and the like. She pointed out that each of the tiny heads in the pictures displayed a human individuality. She said she sought that kind of specificity in her photographs.

Finding her subjects was the first challenge. She perused the files at the city's leading tabloid paper, the *Daily News,* to prospect for odd people, and she asked her friends and acquaintances to nominate candidates. Writing to Howard, she said she had heard rumors of a hermit who lived in a cave on the road from Bennington, Vermont, where Howard was teaching; she added, "but, he is very likely dead or reformed." The human anomalies who passed her screening wore their eccentricity on their sleeves (or, in one case, on the skin). The hermit Arbus eventually found in New Jersey—smiling cheerfully and dressed in a short-sleeved undershirt—"was a terrible disappointment" and she didn't use him. But walking the streets of New York with her eyes wide open, she discovered that eccentrics presented themselves.

One day on Second Avenue, she saw a man wearing a woman's full-length fur, what she called a "Joan Crawford coat," with boxy shoulders and a high waistband. In 1961, men in women's fur coats were unusual. "It looked absolutely sensational," she

thought. She approached him. His name was William Mack. Born in Germany, he was seventy-two and living on his pension as a retired merchant seaman. He wheeled an old baby carriage, in which he collected discards, including old bottles, gathering them, he said, not for the redemption value but as a "diversion." At her request, he invited Arbus to photograph him in his room on Third Avenue. Before she kept the appointment, she gave Doon the address. "I really had the sense that he was one of those people, one of those *Daily News* people who like you read the next day murdered somebody," she explained later. His room measured about seven by eight feet and was filled with an astounding assortment of things. She catalogued what was there: nine umbrellas, twenty rings, five hammers, a toy ukulele, a jar of maraschino cocktail cherries, copies of the Koran (he was a Muslim convert) and the Bible, a pair of white nurse's shoes . . . the list was long. Her photograph depicts him, full-bearded, adorned with rings and bracelets, encroached upon from all directions by detritus, gazing in the direction of the lens with a focus that seems inward. He looks uncannily like a low-rent New York reincarnation of Sardanapalus in Delacroix's painting, and Arbus's photographic portrait of him is as Romantic as that archetypal Romantic fantasy.

William Mack she bagged easily. Others required more persistence. Hoping to photograph Jack Baker, who was tattooed from head to toe and called himself "Jack Dracula," she raised the question at a Coney Island sideshow. "No, I don't allow that, not unless you pay me," he said. They crossed paths again at Hubert's and she repeated the request. "I told ya, I don't allow anybody takin' my picture," he insisted. Only when Charlie Lucas, who managed Hubert's, came up and asked him to relent, saying it could be good publicity, did he let her take one or two. She wasn't satisfied. She popped up everywhere he went, imploring him to pose. He always refused. "Sometimes I go back and back and back, it's like I'm rubbing my nose in it," she once explained. "But I like that." After Jack abandoned the sideshow life to open

a tattoo parlor in New London, Connecticut, a navy town, he had even less use for photographic publicity. Although New London was a three-hour train trip from New York, he was not all that surprised to see Diane there one warm day in 1961. "She did the poor-mouth routine," he recalled. "You know, 'This is how I make my living and I can't help it, it's not my choice,' and everything." He was still disinclined to permit photographs without payment, but when she asked to see how he spent his day, he thought he could get her to pay for a bar tab and a meal or two. In addition, she promised to give him some free prints. He let her accompany him to the Harbor Restaurant, where she bought him a couple of drinks and photographed him bare-chested with his arms crossed at a round table. Then she took him to lunch. Afterward, she proposed going to Ocean Beach Park. They were walking for a while when he told her, "We're going to have to take a cab to Ocean Beach."

"How far is it?" she asked.

"Way out," he said.

"Ah, no."

They walked a little farther down Bank Street until she saw a spot with trees and bushes.

"How about here?" she said. He stretched out on his side and gazed coolly and directly at her, a cigarette burning down between the inked fingers of his left hand, as she snapped.

With a two-foot-wide spread-winged eagle across his upper chest and a smaller eagle on his forehead, black spectacles inked over his eyes and a galaxy of stars and doughnut shapes adorning his cheeks and chin (there were 306 tattoos in all, Arbus reported), Baker was a living tapestry. He is the only subject in the series that she photographed horizontally, in what photographers call "landscape format," rather than the vertical "portrait format" that she used otherwise (and which, not incidentally, conforms to the page of a magazine). Tattoos of parrots, butterflies, fishes and flowers summoned up a kind of landscape—in the long process of winning him over, she watched once as he tat-

tooed a small rose on his thigh—and she accentuated the effect by coming in close, until the blades of grass in the immediate foreground are so pronounced that one spike seems to pierce Frankenstein's head on the decorated stomach. A cocky character who boasted of being a lady's man, Baker surveys the camera with swagger but little sexual heat. Arbus wasn't his type. "Diane Arbus was the plainest looking girl and she had no personality whatsoever as far as I could see," he later remarked. She gave him a copy of "In the Penal Colony," Kafka's tale of an instrument that fatally tattoos the transgressed law on the back of a condemned prisoner. She said the story made him chuckle.

He was a bit strange, Jack Dracula, but far from dotty. The same could be said for Polly Bushong, who came from a socially prominent Massachusetts family and liked to put on false teeth and a wig and appear in public as a wacky character she called Cora Pratt, so that, Arbus realized, she could "commit the faux pas she would like to." The circumstances were cloudier when it came to characters like William Mack, or to a man who styled himself as Prince Robert de Rohan Courtenay and laid claim, from his six-by-nine-foot room on Forty-Eighth Street, to the Byzantine Eastern Roman Empire. Or Max Maxwell Landar, an eighty-year-old who was so invested in his Uncle Sam costume that he didn't think of it as a costume, and whom she accompanied in January 1961 to Washington, D.C., where he tried unsuccessfully to be the first man to shake the hand of Dwight Eisenhower once he was no longer president.

The moral conundrum presented itself as a practical matter when Harold Hayes sent Arbus a letter in February 1961, warning that *Esquire*'s lawyers had advised him that "under no circumstances" could she misrepresent the purpose of a photograph to a prospective subject. Hayes said he had sought an opinion after the editorial office received calls from a couple of "distressed people," most recently from the self-anointed Bishop Ethel Predonzan of Astoria, Queens, "wanting to know why we are printing pictures on spiritual subjects." Bishop Predonzan, a beatifically

smiling woman with wavy pink hair and a penchant for damask robes, warbled sweetly about her many previous incarnations (stints as the twin sister of Jesus Christ and the wife of Moses) and professed an ability to heal the sick even over the telephone. Arbus confided to Israel that the bishop, who was on the short list of suitable eccentrics, had phoned her with word that she'd been advised that *Esquire* was not a spiritual magazine, but then the Lord revealed to her that Diane was innocent, and "the bishop prayed over the telephone for the ball of fire to be made manifest in my photographs and she wept and she blessed me and said no one could hurt us and I agreed."

Did Arbus exploit her subjects? The question nagged at her during her lifetime and continues to shadow her work long after her death. Most often it centers on the professional freaks, who, in Susan Sontag's estimation, "are pathetic, pitiable, as well as repulsive," and "appear not to know that they are ugly." But such criticism of those pictures is obtuse. Not know that they are ugly? It is like saying that accountants don't know that people see them as drudges or actors are unaware that they are show-offs. Circus freaks realized very well that they were strange-looking. Their appearance was their talent and livelihood. To be admired for the qualities that set them apart—as Arbus obviously admired them—could only boost their self-esteem. Far more problematic was Arbus's relationship to the self-deluded eccentrics who believed that she shared and endorsed their fantasies. To photograph them, she had to play along. The slippery ethics of this game troubled her, too.

She knew why her subjects invited her photography. "I think you're paying a kind of attention to them that nobody pays, you know, that their own mother wouldn't pay," she explained. "I want to hear everything they have to tell me, and I'll tell them, too." In the presence of the eccentrics, she perceived "a mutual seduction." She found it "amazing that they can make this craziness work and they kind of can crazify you a little bit." She liked wading out to meet them in their depths. One of the peculiar attributes of a pho-

tograph was that, when regarded later, it was a "funny proof . . . that even if you believed them then you don't believe them now." In the fervor of photographing, she could think and become almost anything. Unless a deadline loomed pressingly, she preferred to let days or weeks elapse before she examined the contact sheets, enough time for that emotion to evaporate.

She acknowledged that "for me there's often a big distance between who I want to be with and who I want to take a picture of." On the other side, she was well aware that the people she photographed usually liked her and enjoyed being with her. "I think I'm kind of two-faced," she said. She elaborated: "I'm very ingratiating, it really annoys me. I mean I think I'm that by nature. . . . I'm just sort of a little too nice. Everything is, 'Oooo,' I hear myself saying, 'How terrific,' and here's this hideous woman, you know, making a hideous face, and I *mean* it's terrific. I don't mean I wish I looked like that, I don't mean I wish my children looked like that, I don't mean in my private life, you know, I want to kiss you. I mean that's amazingly, undeniably something."

The Bizarre and the Chic at *Bazaar*

Arbus worked passionately on the photographs of eccentrics through the winter and spring, but *Esquire* rejected them. Aside from the troublesome ethical and legal questions of whether she had misled the people who posed, the editors fretted that her subjects were too similar to the ones in "The Vertical Journey." In a formal letter that marked the end of the assignment, Hayes asked her to "destroy or return, whichever you prefer," the press credentials he had issued the previous fall. A secretary typed the letter, and Hayes signed his name over his title: "Harold Hayes, Articles Editor." In a slightly hurt but playful tone, Arbus replied that she was returning the letter of accreditation and also destroying it, "since I couldn't decide which I preferred," and added that, as she found his letter "somewhat lacking in human warmth," she wondered whether he might be upset with her, and she dared him, and Benton, too, to join her for lunch. She ended the letter with a typed cascade of closings that descended the page in increasing calibrations of warmth: "Yours, Sincerely, Cordially, Truly, Frankly, Fondly, Diane." Under her signature, she typed the word *Diane.*

She could afford to be lighthearted, because the photographs had landed at a home closer to her heart. In summer 1961, Marvin Israel was named the new *Harper's Bazaar* art director, succeed-

ing Henry Wolf, who had departed to help start an adventurous new magazine, *Show*. It was easier for Hayes to reject her pictures because he knew Israel wanted them. Although Nancy White, the editor of *Bazaar*, was as skittish as Hayes when faced with Stormé DeLarverie, a lesbian who dressed as a man and appeared with a line of female impersonators at the Jewel Box Revue (that picture didn't run), photographs of five eccentrics were published, and moreover, they were accompanied by Arbus's text. Her gift for writing, which her friends had long appreciated in her letters, now was publicly revealed. "To me, the writing is as amazing as the photographs," Allan declared. Even more remarkable was the integrity of her sensibility. "She observes and responds and expresses her responses in a way that to my mind is so totally in sync with the pictures," Doon later asserted. Over the next years, Diane's more astute magazine editors would recognize her capacity to complement with words the essence of her photographs. Her friend Marguerite Lamkin, who commissioned her to do a similar piece on soothsayers for *Glamour* three years later, told her that she would have to take reportorial notes, as no one could accompany her to California. Arbus handed in her pages along with her photographs and asked Lamkin to rewrite them. "I'm not going to touch it," Lamkin replied. "It's beautiful." Arbus's story ran much as she delivered it, but without a credit.

Even more than her photographs, Arbus's texts teemed with information, which she liked to itemize in exhaustive lists. She seemed to notice everything. "Diane had an extraordinary eye for detail," Allan said. Once, in the early days of their marriage, they paid a visit to his cousin, who had a long bookshelf that was filled with volumes. Allan said that when they returned a few weeks later, Diane, looking about, remarked, "Oh, you have a new book." In her photographs of the eccentrics, she could depict the extravagance of their personal getups and, in some cases, their bizarrely cluttered home décor, but her written commentary itemized, with a precision and thoroughness that no single picture could, the fantastic plethora of tattoos, hoarded trash and

imaginary titles. Her curiosity about these people exceeded any practical limits. She seemed to want to know everything. Describing them, whether in conversation with her friends or in the text of a magazine, she expressed her viewpoint more definitively than in her photographs. At times, their manias and delusions fatigued her. Mostly, though, they delighted her. The eccentrics were in many respects absurd, but she made fun of them fondly. She pointed out that Jack Dracula named his pet bird Murderer "because of what it did to his other bird," that Mack was "very fond of polite, aristocratic conversation and sometimes goes to Union Square for a good etymological argument," and that Prince Robert didn't actively seek the restoration of his European empire, as he enjoyed "the nightly society of his friends in the 57th St. Automat."

When Israel won acceptance for Arbus's pictures and text in *Harper's Bazaar*—the piece ran under the title "The Full Circle" in the November 1961 issue—she entered an exalted club that was ruled by its star, her longtime colleague Richard Avedon, a photographer who was two months younger and incomparably more successful than Arbus. His story was as unlikely and romantic as a Hollywood fable; indeed, it was the basis for a 1957 film, *Funny Face,* in which Fred Astaire played the role of the photographer Dick Avery. The real-life Dick Avedon had discharged his wartime duty with two years in the photography department of the merchant marine, working at a base in Sheepshead Bay, Brooklyn, where he took thousands of identification mug shots. Upon leaving military service in 1944, he doggedly set out to work for the most influential magazine in fashion, *Harper's Bazaar,* and Brodovitch, its innovative art director. Brodovitch had welcomed many talented photographers into his publication, including Lisette Model. But unlike Model, who urged her students to photograph only things that they cared about ("Don't shoot 'till the subject hits you in the pit of your stomach"), Brodovitch emphasized novelty above all else. "If you look in the camera and you see something you have seen before, don't click the shutter," he said.

Avedon made thirteen appointments to see Brodovitch, show-
ing up in his best suit at the great man's office, only to be brushed
off on each occasion and instructed to reschedule. When he was
finally admitted, Brodovitch riffled through advertising pictures
that the tyro photographer, barely twenty-one years old, had
made for the Fifth Avenue department store Bonwit Teller, and
dismissed them as derivative. One picture caught the art direc-
tor's eye. It was a photograph that Avedon had added impulsively
to his fashion portfolio; taken during his merchant marine tour
of duty, it depicted sailors who were twins, one in sharp focus and
the other blurred. Brodovitch told Avedon that if he could bring
that sensibility to fashion photography, he might succeed. Rid-
ing on this wavelet of grudging encouragement, Avedon enrolled
in the Design Laboratory class that Brodovitch ran at the New
School for Social Research. Evidently, Brodovitch thought highly
of Avedon's progress, because he quickly brought the young man
into *Harper's Bazaar.*

Bazaar was the destination of Avedon's dreams. "That was the
pantheon," he declared. His boyhood hero was Martin Munkácsi,
a Hungarian whose pictures of on-the-move, athletic models
upturned the stultifying decorum that governed fashion photog-
raphy. Avedon said that when he was eleven, he pasted more than
twenty Munkácsi photographs to the walls and ceiling of his win-
dowless bedroom on unfashionable East Ninety-Eighth Street on
the Upper East Side of Manhattan. If so, he was remarkably au
courant, as he turned eleven in 1934, which was only a year after
Carmel Snow, then editor-in-chief of *Bazaar,* brought in Munkácsi.

Avedon's pictures initially appeared in November 1944 in
"Junior Bazaar," which was a section, and for a short time a
stand-alone publication, that provided a showcase for younger
photographers and writers. He excelled. Like Munkácsi, he pho-
tographed active women in fleeting poses—a quizzical smile, a
quick exit from a taxi—that departed drastically from the style of
Louise Dahl-Wolfe, the magazine's reigning photographer, who
made the models look as static and stony as the sculptures she

sometimes positioned alongside them. In January 1947, Avedon had his first cover of the parent *Bazaar*. His rise was meteoric, but unlike a comet, he did not tail off. The relaxed ease and droll humor of his images perfectly suited the expansionist, consumerist mind-set of confident postwar America. In the act of introducing each season's fashions, his photographs redefined fashion photography. Most famous, but not atypical, were two images of Dovima, his favorite model of the fifties, who appeared in the September 1955 *Bazaar* posing in a Dior gown alongside a pair of elephants, the arabesque of her body rhyming wittily with the sinuous line of an upraised leathery trunk. As with most great photographs, these pictures reward close scrutiny. The fetters that restrain the captive elephants (part of the Parisian Cirque d'Hiver) are clearly visible around a leg of each. The elephants are magnificent prisoners; very much like a beautiful, wealthy woman who wears Dior couture, they are performing in someone else's show. Although Avedon isn't known to have made that analogy, such thinking was characteristic of him. Looking at his 1947 photograph of a Sicilian street entertainer on stilts, he told a journalist, "It's a metaphor of the artist; it's me, on shaky feet but above the crowd." Maybe in the pictures of Dovima with the elephants he would have seen himself, too, as a pampered courtier. "Photography for me has always been a sort of double-sided mirror," he declared in 1950 (like Allan Arbus, he was devoted to psychoanalysis). "The one side reflecting my subject, the other reflecting myself."

Immediately upon taking hold as the new art director of *Bazaar*, Israel established a bond with Avedon that was as formative as his connection to Arbus—and which, for the photographer, corrected the lack of direction he had felt following the forced departure of Brodovitch three years earlier. "It was as though we were two brothers who were opposites but of the same cloth," Avedon remarked. "Completely linked, and always at war." Israel shared with Avedon, as with Arbus, an upbringing as the child of New York Jewish proprietors of women's clothing

stores. The differences, though, poked through what they had in common, because Avedon's Fifth Avenue dress store went bankrupt in 1930 during the Depression (Jacob Avedon opened a successor in 1937 in the less prepossessing locale of Woonsocket, Rhode Island), while the Israel brothers' retail shops and, on an even loftier level, Russeks, weathered the downturn.

Unlike Israel and Arbus, who ostentatiously, if inconsistently, eschewed bourgeois trappings, Avedon was climbing the social ladder and disavowed bohemianism. "How can an artist live on Park Avenue?" Israel needled Avedon some years afterward, once the photographer had securely lodged himself on the high terrain of New York society. "Marvin, *easily*!" Avedon replied. Marvin and Diane usually dressed down. Diane wore little or no makeup, which was unusual for a woman in her set at that time. She had a keen understanding of fashion, and the label on her safari jacket in later years was Yves Saint Laurent, but unless she thought elegance would be to her advantage, she preferred to defy the dictates of fashion. After separating from Allan, she stopped dressing like a schoolgirl and transformed herself into a denim-and-leather-clad hipster. Marvin was even more dogmatic in his shabby dress. Patricia Patterson recalled that he most appreciated the Aran Island fisherman sweater that she gave him once it began to unravel. (Diane photographed him wearing that sweater in its fallen state.) "Marvin Israel always had this pretense of being poor or being on the verge of his last meal," said Geri Trotta, an editor who worked with him at *Bazaar*. "He would dress poor and act poor."

But Avedon adopted upper-class style with panache. "Shortly before I left, he moved into a town house at the end of Fifty-Eighth Street by the East River," said Earl Steinbicker, who departed as the studio manager in 1965. "He told me that for the first time he had done something he had always wanted to do—hired a butler." Avedon's usual sartorial mode, although unbuttoned, was casual in the way that Gianni Agnelli relaxed on his yacht: open-necked shirt, expensive sweater, well-tailored

jeans. As he aged, his mane of hair was magnificent and along with his oversize eyeglasses composed a recognizable signature look. His wholehearted appreciation and shrewd perception of glamour contributed to the éclat of his best photographs. "He was a natural," said Frederick Eberstadt, who worked as Avedon's assistant in the fifties. "It's as if he had perfect pitch. One of the reasons it was so much fun in Dick's studio was it was so easy." While he photographed, Avedon danced around the room and occasionally sang.

Behind the camera, he was the director, and his subjects performed for him. Unlike Arbus's protagonists, who stood still and unchanging, the people in an Avedon photograph are on the move. Avedon said he was trying to incorporate "the element of time . . . this fourth dimension." He explained, "People, women particularly, are almost continually in motion. The aliveness, the realness of people can best be captured by capturing some of this motion." He brought a version of cinematic narrative to fashion photography, viewing his models as fictional characters and placing them in stage-set scenes that sometimes, as in his Paris pictures, looked made up but were actually real. Although the creatures who passed before his camera usually glowed with exuberance and energy, Avedon wasn't limited to that emotional bandwidth. In fashion shoots, too, he could bring out the sadness and weariness that he evoked in his portraits of Marilyn Monroe, the Duke and Duchess of Windsor, and Dwight Eisenhower; in one memorable sequence in 1949, he photographed Dorian Leigh disconsolate and damp-eyed in a train car. (To the photographer's regret, his preferred image of her weeping was rejected by Carmel Snow with the acerbic remark, "Nobody cries in a Dior hat, Dick.")

Yet even in his portraits of the downcast, Avedon's subjects seem to be wearing a tragic mask. It may be the impeccable lighting, or perhaps it is something else, something psychological and, on the part of the photographer, artistically intended. Avedon wanted to create a convincing illusion. Again and again he alluded visually to the movies, and his subjects look like very

talented actors, playing their parts to perfection. "We all per-
form," Avedon remarked. "It's what we do for each other all the
time, deliberately or unintentionally. It's a way of telling about
ourselves in the hope of being recognized as what we'd like to be.
I trust performances. Stripping them away doesn't necessarily get
you closer to anything." Arbus, on the other hand, wanted to peel
back the costume wig to expose the hairline. She was fascinated
by the telling discrepancies that inevitably flaw any pretense. And
she differed from Avedon, too, in that she harkened back to the
narratives of eternal myths and legends, not of Hollywood musi-
cals or Italian neorealist dramas. Even when she photographed
images off the movie screen, she was seeking primal scenes, not
cinematic ones.

In Eberstadt's view, Arbus (who was a friend of his wife, Isabel)
coveted Avedon's financial success. Arbus was ambivalent about
commercial acclaim. Yet there was no denying that she was strug-
gling financially, while Avedon was already wealthy and getting
richer. It was hard not to be envious; in every way, he seemed to
be the consummate professional. As Israel's assistant Ruth Ansel
observed, Arbus's admiration for Avedon extended to the tech-
nical mastery of his studio. Visiting the *Bazaar* offices, she would
see his photographs in the layout room and marvel at the per-
fection of his prints, which were produced and retouched by his
staff under his exacting requirements. "Oh God, I wish I could
make prints like these," she would say.

On the other side, Avedon yearned for Arbus's artistic achieve-
ment and growing critical reputation. Like her, he was susceptible
to the sentiment that monetary success and artistic success were
contradictory. "Dick envied her being seen as a serious photogra-
pher," Eberstadt said. "He hated being seen as a decorative artist.
Then the evil genius comes in, Marvin Israel, and he knew how
to play one against the other. He had a really malign influence
on both of these people, especially on Dick. He emphasized with
Dick the feeling that Dick's work was superficial, not profound."
It was a mistake, Eberstadt felt, because it undercut Avedon's gift:

"Dick was a profoundly superficial person." He was brilliant with surfaces. Why would he try to do what Arbus did, to penetrate the surface to expose what lay beneath?

Although Israel gibed and teased Avedon, no one reported his ever acting that way toward Arbus. He encouraged, pushed and dared her. He didn't mock or belittle her. Being married to a psychologically unstable woman, he recognized the need for delicacy. Diane's moods were labile, with giddiness evaporating into depletion. "I been gloomy," she told Howard in the aftermath of "The Full Circle." "Publication, although very splendid, felt a little like an obituary." She realized that she was glorifying these oddballs and misfits, idealizing traits that most people found offputting or repellent. She was looking at the world upside down. It was the way she saw things: when she was in Spain, she had described for Alex Eliot a red-and-black insect, which resembled a comedy mask if held in one direction, a tragic mask in the other, forming "a perfect face both ways." Like that bug, she had a knack for reversing laughter and tears. So shouldn't her frown turn into a smile? "If my illusion is everyone elses disillusion, as it some times seems, why do I feel so sad?" she wrote to her brother. "I think I think I have forgotten what wasnt necessary to remember in the first place." One thing she feared she had forgotten was "how to proceed." Nonetheless, she proceeded.

Freak Show

Hubert's Dime Museum and Flea Circus occupied a site on West Forty-Second Street between Broadway and Eighth Avenue that, in the more fashionable pre-Prohibition era, belonged to the restaurant and nightclub Murray's Roman Gardens. A pleasure palace decorated with marble statuary and black-and-gold mosaics to simulate the resorts of imperial Rome, Murray's, which closed before Diane was old enough to experience it, exuded the nouveau riche opulence and fakery she despised. The straightforwardly vulgar Hubert's was far more to her liking, and for a decade, its sideshow of freaks was one of her favorite hangouts.

To enter the Hubert's wonderland, one went—"somewhat like Orpheus or Alice or Virgil," she wrote—below the surface. By the front door to the building on Forty-Second Street, at a kiosk decorated with glossy photographs of performers past and current, sideshow tickets were on sale for a quarter. (Inflation, inevitably, had recalibrated the dime museum of P. T. Barnum's era.) To reach your destination, you passed through a clamorous arcade that jangled and flashed with pinball machines, Gypsy Witch mechanical fortune-tellers, Skee-Ball games and shooting galleries. Cowboy automatons blared out mockingly to customers too slow on the draw, "You miserable polecat, you didn't even

come close!" Stopping your ears to these sirens and showing your ticket, you went downstairs to the basement, where the acts proceeded on raised stages. The customers were not seated but instead thronged below the freaks and other entertainers, resembling, Arbus remarked, "a bunch of miserable sinners hoping to be converted . . . hushed and polite as if this was our church."

As in all sideshows, there was a distinction made at Hubert's between "normal" performers, such as magicians and contortionists, and the freaks. And among the freaks a further line was drawn between the "made" freaks—including Jack Dracula and Congo the Jungle Creep—and the "born" freaks, such as the midget Andy Ratoucheff. The roster of born freaks who appeared at Hubert's included Sealo the Seal Boy, whose hands grew out of his shoulders and who was, Arbus said, "the most cheerful man I have ever known," and William Durks, with a cleft face, a split nose and a third eye painted in the hole where the bridge of his nose should have been (he was called "the Man from World War Zero").

The born freaks topped the hierarchy of the sideshow. "There's this terrific distinction between born freaks and made freaks," Arbus explained in 1970, four years after Hubert's had closed. "This is all a thing that's sort of historical now, there's much fewer of them. You know, a made freak was like a man . . . who turned himself blue by eating something. Now he had to live blue, the whole rest of his life, it wasn't like he could go back. So it was a kind of big decision." She was fascinated by the arcane induction regimen of a made freak. She once had a long conversation with a man whose parents, both aerialists, had died in an accident, leaving him with the problem of how to earn a living. A "hermaphro" man-woman at the circus ("a fake act," Arbus observed) offered to teach him to become a human pincushion. By the afternoon, he was inserting pins into his arm. "I mean like this whole course of study took about three hours," she said with a giggle. "But that's pretty good, because I couldn't do it." The human pincushion labored to come up with an innovation every season, such as putting pins in his Adam's apple. "This man

had translated everything into pinpricks," she said. His single-mindedness reminded her of her immersion in photography: "If you do anything enough, you want to do it more."

Still, the human pincushion had entered this world by choice. He didn't belong, as Arbus said that born freaks did, to "a kind of aristocracy by birth." Here, too, she drew from her own experience. She thought people went through life "with a kind of anxiety" of anticipating the worst. "Most people know or fear that sometime in their life they're going to have to face some monumental, traumatic experience—so they sort of have this dread hanging in front of them all through life," she said. "But the freaks are born with a situation that is traumatic. They know that nothing much worse or more frightening can happen to them, so they don't have to go through life dreading what may happen, it's already happened. They've passed their test. They're aristocrats."

Arbus said that unlike movie stars, who grow tired of their fans, the freaks welcomed attention. "I just used to adore them," she told a student near the end of her life. "I mean, I still do adore some of them." By which, she quickly added, "I don't mean like they're my best friends." In their presence she "felt a mixture of shame and awe," which she compared to a blend of attraction and repulsion. With her self-effacing, admiring manner, she quickly won acceptance at Hubert's.

She had been photographing there at least since 1957. "She acted like she was very comfortable in that environment," said the magician Richard Del Bourgo, who began appearing at Hubert's as "Richard the Great" at the end of 1959 or early in 1960. Whenever he saw her, she was carrying a camera and a camera bag. The performers didn't automatically regard a photographer as an intruder; indeed, a person with a camera who, like Arbus, was generous about giving prints to her subjects could be very useful. Lending a few eight-by-ten glossies to the kiosk advertising display was a condition of employment at Hubert's. "Nobody saw themselves as freaks, even the freaks," Del Bourgo said. "The freaks saw themselves as entertainers. They were the top-notch

performers, because they were the ones who would bring them in. When I started, my pay was $60.00 a week, which was $48.60 take-home, or about a dollar a show. Some of the freaks would be getting $75.00."

Determining the salaries, and presiding over the ceremonies, was a shrewd and personable African American man, R. C. Lucas, who was known by his middle name of Charlie (although in his youth, he performed as "Woo Foo" in an ostrich-feather costume and a clamped-on ivory nose ring). Lucas's wife, Mary, who used the stage names of Woogie, Sahloo and Snake Princess Wago, was the headline dancer. She typically wore a two-piece bathing suit with decorative fringes and a spectacular, writhing accessory—an African ball python, which resided in a box between shows. The snake would eat only live rodents, so a supply of rats was kept in stock. One day in late December 1960, Woogie left Diane alone with the snake and a rat—"saying," Diane reported to Marvin, "that I should keep my hands well out of the way and call her as soon as the one had swallowed the other." Almost as transported as the fatally interlocked creatures, Arbus watched the rat, its legs "splayed wide in complete abandon," and the snake, "very knowing," with a huge mouth that reminded her of a smile. She told Israel that the tableau resembled "a sexual paradox, a parable to be enacted on Judgment Day, in which the female at last entered the male." What is most remarkable is that even without Arbus's literary annotation, the picture she took of the predator and its prey effuses a sinister eroticism. She photographed from above, using a flash that, in the dark room, highlighted the gaping mouth and the furry body. The snake's mouth extends around the neck of the rat, which is all white except for a black ring on the top of its head. The rat's right eye is brightly visible, and one small white claw is poised, almost coquettishly, against the left side of the open jaws. In Arbus's sexually charged portraits of people, including freaks, it is difficult to separate out how she sees her subjects from how they are responding to her. With the snake and the rat, the photograph—which conveys in purely visual terms her experience

of the sexuality, horror and myth in the scene—is purely a product of her eye, hand and mind.

The rat and snake in her photograph inhabit the same kingdom as the freaks. They look both real and otherworldly. "There's a quality of legend about freaks," she said. "Like a person in a fairy tale who stops you and demands that you answer a riddle." By getting to know some of them, she was able to "enact my childhood fantasies." And they weren't simply creatures out of a distant mythology. With each of her subjects, including the freaks, "there's some sense in which I always identify with them." She understood that she was attracted to photograph someone because of an unconscious identification, but the nature of the magnetic pull became apparent only in hindsight. "I mean you can't say, to yourself . . . 'What am I like, therefore how can I photograph myself out there?'" she said. To complicate matters further, along with the sense of identification with the subject came a feeling of apartness. "There are two things that happen, and one is recognition, and the other is a total other feeling . . . it's totally peculiar and other than you," she explained. She elaborated on that idea: "What I'm trying to describe is that it's impossible to get out of your skin, in somebody else's. . . . What I'm trying to say is that somebody else's tragedy is not the same as your own."

At Hubert's, she was once again far from the first photographer on the scene. Lisette Model, among others, got there much earlier. Acting on the suggestion of a *Harper's Bazaar* features editor, Model had gone to photograph sideshow performers in the forties. Two of these professional freaks—the hermaphrodite Albert-Alberta and the thin man Percy Pape—would later pose for Arbus as well. However, unlike Model, who frequented Hubert's solely to find subjects for her camera and disparaged the notion of photographing freaks, Arbus regarded the sideshow as a playground as well as a hunting ground. Because her photographs of Albert-Alberta have not been published, they can't be compared to Model's monumental portrait of the stocky hermaphrodite, seated before a patterned curtain, with gender-

appropriate nipples and hairy masculine and ankle-braceleted feminine legs, fully exposed. However, the two photographers' portraits of Percy Pape, the Living Skeleton, diverge tellingly. In 1945, Model photographed him from below, seated in a pose that underplays his skeletal peculiarity. She makes him look substantial, even massive. Arbus, on the other hand, shot him in 1961 in Central Park from a medium distance. Near a tree that echoes his needlelike thinness and height, he is a Giacometti sculpture come to life.

A few years after she started going to Hubert's, Arbus saw *Freaks*, an American movie set in the circus sideshow world; she would watch the film innumerable times, often introducing people she knew to its pleasures. "She said she had to see it every time it played," one of these friends recalled. *Freaks* had been a notorious flop upon its release in 1932. Three decades later, when it was screened for a week in October 1961 at the New Yorker Theater, an art-house cinema that had recently opened on the Upper West Side, it received a much more sympathetic response. It was shown the following year at the 1962 Venice Film Festival, and it began an afterlife as a cult film that continues to this day. (The life of its director, Tod Browning, unfortunately ended in the same year as the Venice presentation.)

The first extraordinary thing about *Freaks* is that its cast includes real sideshow entertainers of its time—some of them, like the conjoined twins Daisy and Violet Hilton, of eminent reputation. The second remarkable feature is its screenplay. Although cut and reedited by the studio after a disastrous preview, *Freaks*, even in mutilated form, remains firmly on the side of the sideshow freaks. (However, as with Arbus's morally layered pictures, *Freaks* has divided critics over whether it is sympathetic or exploitative.)

Because of the authenticity of the actors and the brutality of the story line, the film retains its power to shock. In it, Hans, a midget in a traveling circus, is infatuated with Cleopatra, a "normal" trapeze artist. When Cleopatra learns that Hans has inherited a fortune, she conspires to marry and then poison him. The film shows

the freaks engaged in normal, everyday activities: doing laundry, chatting with neighbors, courting members of the opposite sex. These are the offstage domestic settings in which Arbus preferred to photograph sideshow performers, highlighting their uncanny strangeness against the backdrop of a conventional home.

The most memorable scene in the movie is the wedding banquet, at which the freaks toast Cleopatra as "one of us" and she responds with an outburst of uncontrolled disgust. The episode is deeply discomfiting because, even though Cleopatra is a villain, the movie spectator viscerally feels her nausea. At the climax of the film, the freaks uncover the plot and wreak a terrible revenge, attacking Cleopatra with knives and transforming her truly into "one of us"; once more, the audience member ricochets back and forth between revulsion and compassion. Like a nightmare, the movie presses on the anxieties that freaks provoke in normals. "You can't become a freak, but you can be a fan of freaks," Arbus said. Like Arbus's photographs, *Freaks* is about both the ties that bind and the line that separates them and us.

35

Punchy New Journalism

Before Gay Talese, Tom Wolfe or Norman Mailer, Thomas Morgan was writing literary profiles for *Esquire* in the style that would be dubbed the New Journalism. Growing up in Springfield, Illinois, the son of second-generation Polish Jews with no literary interests, Morgan was encouraged by his high school English teacher to take up writing. By writing, she meant fiction, and when Morgan upon graduation from college moved to New York, he won a job at *Look* in the belief that the income would subsidize his novels. After several years, having produced a great deal of journalism but no fiction, he quit *Look,* and with the freed-up time, he succeeded in writing two novels. Unfortunately, he couldn't get them published. In need of income to support his family, he applied to *Esquire,* where he became a favorite of one of the editors, Clay Felker. It was Felker who suggested a profile of Sammy Davis Jr., which ran in the magazine in October 1959, and may have been the first *Esquire* piece of its era to incorporate long ribbons of dialogue, layers of fine-textured detail, and a narrative propelled (in part) by scenes. Morgan was piping his aspirations as a novelist into journalism. "There was a lot to learn from Tom Morgan," said Tom Wolfe. Hardworking and quick, Morgan remained a frequent contributor to the

Hayes *Esquire* after Felker lost an internal power struggle in 1962
and left the magazine.

On May 3, 1962, Tom Morgan and his wife, Joan, bought
the house at 131 Charles Street and with it, the carriage house
behind it. In the small village that New York can sometimes seem
to be, he had serendipitously become Diane's landlord, and upon
seeing her work, he immediately recognized its originality and
power. That month, when the editors commissioned him to cover
a nine-week-long peace march from New Hampshire to Wash-
ington, D.C., he said, "I've got a great idea. Why don't you send
Diane Arbus with me?" She got the assignment.

In light of Arbus's previous work, *Esquire* might have expected
her to provide close-up portraits of the participants. Spending a
couple of days with the marchers in late May 1962, she did take
some pictures of that sort with her 35 mm camera, photograph-
ing the protesters as they slept on floors and interacted with
passersby (although she declined the organizer's offer to collect
his pacifist foot soldiers for a posed group picture). However,
none of these shots were used. In what was her second published
Esquire contribution, the editors selected one photograph, taken
with the medium-format Rollei, and reproduced it, cropped hor-
izontally, over two full pages. It depicts at a distance a single-file
line of eight of the marchers, some of them carrying placards,
with a rich intaglio of wild grasses forming a band at the bot-
tom of the picture and a gray sky filling almost three-quarters
at the top. Against the sweep of the ground and the vastness of
heaven, the people appear very small. In the article, Morgan
described the individuals and their motivations: the bobby-soxer
coed from Illinois, the full-time peace activist from New Jersey,
the haggard forty-year-old tree farmer from Vermont, the white-
haired blind man from Pennsylvania. Arbus was looking for
something different, she told Paul Salstrom, the conscientious
objector who was the leader of the group. She wanted to convey
the atmosphere, the mood, the quixotic spirit of the march. With
her tableau of these innocent crusaders, she achieved what she

was after. Perhaps intentionally, her photograph bears a strong resemblance to the closing dance-of-death scene in Ingmar Bergman's film about two returned medieval crusaders, *The Seventh Seal,* which was released in New York in October 1958.

Arbus befriended Salstrom. They discussed Ethical Culture teachings, among other things. Afterward, she wrote to him in prison, where he served time for draft resistance. Morgan corresponded with him, too. Arbus and Morgan connected with their subjects in a similar way. Morgan confessed that he was "shameless" in his approach to anyone he interviewed, offering up compliments and confidences to gain his subject's trust. "I tell him truths about myself so that he will tell me truths about himself," he explained. "In a short time, he may know more about me than my wife." His conscience was troubled by this. A guilty conscience is an occupational hazard for all journalists but especially for the New Journalists, whose relationships with their subjects resemble friendship. Those reporters who find they are becoming unduly punctilious about whether they are betraying the people they are researching should reconsider their career choice, thought Tom Wolfe. Wolfe varoomed into national attention in 1963 with an *Esquire* piece on customized cars and became a leading proponent of the New Journalism. The writer must believe, Wolfe argued, that what he is doing is at least as important as whatever it is that his subject is doing.

The New Journalist became emotionally involved with his characters because he spent so much time with them. Only by hanging out could he witness the scenes which, meticulously recreated, would drive the narrative of his piece. For a photographer such as Arbus, this waiting for something to happen was familiar. "The Chinese have some theory that you pass through boredom into fascination and I think it's true," she remarked. Being put off and told to wait before she could begin photographing was boring and unproductive, yet it could be a pleasurable experience, too, a trancelike state in which she calmed her nerves and imagined what was going on outside her field of

vision. She could also identify with the New Journalist's ambition to describe not merely what a person did, but what he thought and felt while doing it. The journalist had to interview his characters to find out what was in their minds; for Arbus, the process of getting beneath the façade was more mysterious but similarly time consuming.

Revealing his subjects' thought processes was particularly important to Gay Talese, whom Hayes introduced to Arbus. They were two of the editor's favorite contributors, and as it happened, they made their *Esquire* debuts together in the New York–themed issue of July 1960. Talese was a reporter for the *New York Times* with goals that the newspaper could not satisfy. Along with a few others, notably Wolfe and Norman Mailer, he would be acclaimed a few years later as a pioneer of literary nonfiction. When Arbus met Talese, probably in 1961, she complimented him on his book *New York: A Serendipiter's Journey,* which was published that year. In it, Talese collaborated with a photographer to portray New York characters, including a sideshow performer, Eddie Carmel, "the Jewish Giant." Arbus suggested that they might want to work together someday. They arranged to chat over coffee. One possibility that Talese suggested (although most likely at a subsequent meeting) was a profile of an elegant prostitute who walked her two greyhounds on his Upper East Side block at all hours. "If you could take a picture of this fabulous-looking woman with her dogs and if I could get her story, we would have something," he told Diane. They met with the woman, who seemed interested. She undoubtedly was calculating what might be in it for her, Talese thought; she backed out because he insisted on printing her real name. In the end, he and Arbus never worked together. Instead, they became involved sexually. It was a casual affair, as Talese was married and Arbus was emotionally committed to Israel. They would make last-minute plans to go out for dinner or a movie, and afterward, back at the Charles Street house, she would show him the pictures she was working on. They would go to bed, careful to be quiet lest they disturb Amy upstairs, and

Doon, too, if she was at home. Gay never guessed that Diane was nine years older than he was. She reminded him of an unkempt, grimy little girl. Their connection was affectionate, not passionate. He valued the sex mainly as the prelude to postcoital conversation. He felt they were both preoccupied with their work.

Although Talese didn't know a great deal about Arbus's field of photography, he could see that she and her colleagues were undermining the *Life* photo-essay—much as he and his fellows were rewriting the rules for the magazine article as it had existed at the *Saturday Evening Post* or the recently defunct *Collier's*. In Harold Hayes's view, a successful magazine writer traditionally followed a formula: begin with an anecdote, expand from it into the general theme, include some biographical information on the principal character, and close with another anecdote. A New Journalist, by contrast, could invent his structure fresh every time, often parachuting the reader immediately into the action of the story. Something similar was happening to the *Life* photo-essays—"those goddamned stories with a beginning and an end," as Robert Frank put it. Even in the best hands, those of W. Eugene Smith, a *Life* story followed a predictable trajectory: one of Smith's most famous pieces, "Spanish Village" of 1951, opened with a seven-year-old girl dressed up for her First Communion and closed with mourners attending the corpse of an old man. When a less talented (and less contentious) photographer was behind the lens, the standard-size *Life* container became a pitcher of treacle. The *Family of Man* exhibition at the Museum of Modern Art contained many pictures drawn from *Life* and shared the weekly's sentimentality—not surprisingly, as Edward Steichen's assistant, photographer Wayne Miller, who helped select the show, appeared regularly in the magazine with his celebrations of such all-American ceremonies as the saying of grace before dinner, navy recruitment, the raising of the flag and high school graduation. (With thirteen pictures, Miller was also the best-represented photographer in the *Family of Man* exhibition.)

Smith's immersion of several weeks in a Spanish village or a

small Colorado town resembled what Tom Wolfe called "satu-
ration reporting." Younger photographers emulated Smith, but
too often their sensibility didn't mesh with the editorial gears
that were driving *Life*. Frank's bitterness at the magazine was
fueled by rejection. For more than four years he tried to sell the
editors a photo-essay, offering a series on unnoticed nobodies in
lower Manhattan, bankers in London or a coal miner in Wales.
For the last, adopting a scaled-down version of Smith's tech-
nique, he spent several days living with the miner's family. *Life*
turned down every piece. In hindsight, it is obvious that Frank's
photographs lacked the moral uplift and narrative cohesion that
Life's editors sought. His pictures were too dark in both senses:
shot in available light with a Leica, they typically appeared
grainy and blurry; even worse, they expressed an outlook that
was harsh and sour. All of which made them perfect for *Esquire*.
Frank's portfolio of Hollywood pictures that ran in *Esquire* in
March 1959 conveyed a mood and an attitude, not a narrative.
So did his extraordinary pictures of Pat and Richard Nixon that
appeared in April 1960. His talents nicely complemented the
insurgent New Journalism.

 Esquire didn't pay as well as *Life,* but the magazines weren't
competing on that basis. Another talented young photojournalist,
Bruce Davidson, grew up believing that publication in *Life* was the
ultimate achievement. Even before the completion of his military
service in 1957, he was contributing to *Life* as a freelance pho-
tographer, dreaming of producing pictures like Gene Smith's.
When he went to work for the magazine, to his disappointment
the assignments he received—a women's college going coed, a
society bandleader on tour—lacked emotional resonance. On
his own, he was taking photographic sequences that conformed
to the *Life* template he admired: behind the scenes with the Yale
football team (a series that, predating his military service, was his
first work published in *Life*, in October 1955), a painter's widow
in a Montmartre garret, the daily life of a circus dwarf. Although
some of the individual pictures (especially of the dwarf) are

strong, the *Life* model undermined him. As Arbus once observed, a news photographer for the tabloids embarks on the day's duties without knowing what he will encounter, and he operates on instinct. A photographer for a magazine such as *Life*, in contrast, reads a script and tries to deliver. "It's become very much like the cart before the horse," she said. In that illustrational spirit, Davidson took his photographs of the Montmartre widow passing by young lovers on a bench in the park and a morose dwarf drinking coffee by himself in a diner. However, demonstrating that the boundary between the two magazines was not so sharply defined in the late fifties, Davidson offered the Montmartre pictures to *Life* but it was *Esquire* that published them—including the one of the widow and lovers, with a caption that made the already obvious point absolutely explicit. *Esquire* also printed the pictures of Jimmy Armstrong the dwarf, but only those of him in costume, not the mawkish ones of his lonely leisure time.

Not long after chronicling Armstrong's life, Davidson began consorting with a Brooklyn gang called the Jokers. Its members were only seven or eight years his junior, and for almost a year he would spend time with them and their girlfriends beneath the boardwalk at Coney Island and in their neighborhood drugstore hangout. His photographs are a high-octane blend of adolescent attitude, sexual heat and aspirational violence: bandaged heads, backseat clinches, looking-glass preening. He offered the photographs to *Life*, which showed no interest. But *Esquire* saw the value of these grittily romantic pictures, developed by Davidson in a way that heightened their black-and-white graininess and contrast. The magazine published five of them, splashed large across the page, in June 1960, a month before Arbus's debut. To accompany the photographs, Norman Mailer wrote an appreciative text, extolling the Jokers' display of "courage, loyalty, honor and the urge for adventure" as an antidote to boredom. Unsurprisingly, the report is as much about Mailer as it is about the Jokers. One of the boys, the author notes approvingly, has been trying to read "The White Negro," Mailer's paean to the hipster's quest to

escape from American conformity by means of the "apocalyptic orgasm" and purgative violence. He'd found it tough slogging, Mailer noted.

On the spectrum of New Journalism, Talese occupied one end, in which the reporter avoids using the first person and remains offstage. Mailer represented the other extreme: not content with limiting his role to first-person narrator, he made himself into a third-person character and strode across the pages of his journalism, mouthing opinions that were alternately (and sometimes simultaneously) brilliant and wacky. He was a self-made literary celebrity. When *Esquire* devoted an issue to new fiction, the editors commissioned Mailer to write the lead journalistic piece. The conceit was that he would rate the latest novels by the reigning contemporary American fiction writers; in practice, that meant a slugfest. Because of Mailer's fondness for boxing, *Esquire* elected to photograph him at Harry Wiley's Gym in Harlem, and asked Arbus to take the picture. In the portrait that ran, he stands in the corner of the ring wearing a three-piece suit, looking coolly at the camera. But Arbus wasn't finished. Following him back to his apartment in Brooklyn Heights, she captured Mailer again, still in the suit and tie, but this time leaning back in a velour-upholstered armchair, his legs wide open, like a fighter after the bout. She knew that the prelude in the ring would leave a visible residue outside it.

Brock Brower, a writer for the magazine, saw the at-home picture on Hayes's desk. "I thought, 'Oh my God, she got him,'" Brower recalled. "It was dead on—short, antagonistic. And I'm a Norman Mailer enthusiast." Because the picture emphasized his diminutive stature, Mailer hated it. Hayes was too politic to risk antagonizing a touchy and prized writer with a portrait that made him look like a bantam rooster. In addition, the more anodyne shot was also more apposite: alongside a blurb that read "Norman Mailer vs. William Styron, James Jones, James Baldwin . . ." and so on, it showed Mailer as a boxer. Arbus sold the tougher picture to the *New York Times*, which used it a few months later in the Book Review, alongside an eviscerating review of his

latest book. "Giving a camera to Diane," Mailer told Hayes, "is like putting a live grenade in the hands of a child." Arbus's portrait, which penetratingly documents the discrepancies in her subject's self-presentation, should be grouped with Wolfe's acid-etched depiction of Leonard Bernstein amid the Black Panthers, Talese's profile of Frank Sinatra through the courtiers surrounding him, and Mailer's own description of himself protesting the Vietnam War. Wolfe, Talese and Mailer are the best-known New Journalists because they crafted recognizable styles. Wolfe's onomatopoetic riffs and obsessive recording of what he called "status details"; Talese's careful stitching together of scenes and dialogue into a tailored garment; and Mailer's elevation of the observer into a character, laced with a homemade philosophical brew of two parts D. H. Lawrence to one part Jack Kerouac—their readers never forget that an article is by someone and not just about something, that it records the encounter between author and subject. Arbus's portrait of Mailer, like much of her photography for *Esquire,* is solidly within that tradition. It is a punchy work of New Journalism.

Silver Spoon

Magazine work provided Diane with an income, but it was insufficient, so Allan supplemented their joint bank account through earnings from his fashion photography. Despite their separation, he continued to write the checks for both households; she once explained that he kept paying the bills because she was "a little sloppy about doing something every month." To people on the outside it wasn't obvious that the marriage had ended. Mary Frank was amazed to learn that Diane spoke to Allan almost daily; she knew no other couples that remained so enmeshed after separating. Three years elapsed before Diane's parents discovered, in 1962, that Diane and Allan were living apart; even then, Diane might not have informed them, but Allan's business was suffering and she wanted to ask her father for help. She told Lisette that her parents responded to the news of the separation with "a whole series of delayed hysterical reactions, ranging from poignant to revolting." But her father did give her some money.

Since 1957, the Nemerovs had been living in Palm Beach, Florida, where David, following his retirement from Russeks, moved with Gertrude into the penthouse of a luxurious apartment complex and pursued his long-deferred dream of becoming an artist. He specialized in still lifes of colorful bouquets. At his first show,

held in a Manhattan gallery a year after his relocation to Florida, he sold thirty-one paintings, for as much as $2,500 a canvas. He hadn't lost his intuition for providing what the customer wanted. Diane, who was not an admirer of her father's art, joked with Pati that his process of painting, framing and selling his pictures resembled the hucksterism of "a patent medicine man with his own bowel movements in the bottle." The joke carried an edge, because Diane was earning only $150 a page from the publication of her photographs in periodicals. In 1964, which was an exceptionally prolific year for her magazine work, she made around $5,000 from it. More typically, she brought in about $4,000 annually. Although her parents would respond to her urgent pleas for cash, they felt no obligation to provide regularly for their adult children, all of whom were struggling.

For Diane, the anxiety induced by her precarious financial situation was partly offset by the gratification of earning an income. "I am terribly proud to make money for something I do," she told Lisette, "except when I feel I would give anything not to have done it." Some assignments adamantly resisted her talents. Henry Wolf, the art director who had departed *Bazaar* for A&P heir Huntington Hartford's new magazine, *Show,* brought in Arbus in spring 1962 to photograph a piece on the making of a National Shoes television commercial. Diane rang up Alan Levy, who was reporting it, and told him with a giggle that she was his photographer. On the telephone, she sounded like a teenager. When they met and Alan saw her girlish figure, garbed in a black sweater and brown leather skirt, he thought she looked like one, too. Delighted by her flair for finding things to laugh at, he had more fun working with her than he'd ever had on assignment. She reveled in the many ridiculous aspects of the story, starting with the Dickensian names of several of the principals: the account supervisor was called Guttenplan, the account executive Shambroom, the ad agency head Mogul. She told him that she was someone to whom people with funny names happened.

She had other unusual attributes as well. "I can walk into a room and tell who's sleeping with whom," she remarked. "Sometimes, I can even tell this before it happened. I mean, later they'll make contact and eventually end up in bed together."

She quoted Kafka and Rilke; she urged him to read Borges. The only quarrel between writer and photographer arose at the very end of the assignment, when she saw the four-page layout: it crammed together eighteen of her pictures, many of which were obviously staged, each one accompanied by a long paragraph by Levy to explain the step-by-step process. It was like a bad *Life* photo-essay, as banal as the *Vogue* story that had led to the Arbus entry in Steichen's *Family of Man*. Having thought all that was behind her, Diane announced that she wanted her name off the article. Levy, who was proud of the piece and of their collaboration, pleaded with her to change her mind; not until the afternoon before the magazine went to press did she relent. In the coming months, he would visit her on Sunday mornings and they would try to dream up another assignment. One that might work, they thought, was a piece on fans and buffs, such as autograph hounds who lingered at the stage doors of Broadway theaters or volunteer firemen who were transfixed by flames. Because the longevity of *Show* seemed uncertain, Levy pitched the concept to *Life*. "The right idea but the wrong photographer," he was told. He and Arbus dropped the scheme.

The making of a television shoe commercial, with men in suits crafting a slick product, was as misguided an assignment for Arbus as could be conceived. But most magazine commissions were only marginally superior. Is it true of life in general, or just of magazine journalism, that the best chances come early, and rarely, if ever, reappear? In her first two years as an independent photographer, Arbus published two portfolios of original photographs in general-interest magazines: "The Vertical Journey" for *Esquire* and "The Full Circle" for *Harper's Bazaar*. She never repeated that success.

American magazines, including both *Esquire* and *Bazaar,* trafficked in celebrities. Arbus much preferred working with anonymous individuals who savored her attention, rather than with people who relegated her to the "inane" position of identifying her subjects instantly without ever having known them. "There's this funny thing about them," she remarked, "which is that you know their face even though you've never met them, you know, they're like postage stamps or something like that." Late in her life, she wrote, "It's what I've never seen before that I recognize." Celebrities placed her in the opposite situation, of confronting a polished, deadened, ubiquitous image that precluded any chance of discovery. "I've never taken a picture of a famous person that I think is really good, because the subject doesn't mean anything to me," she said. But at times a famous subject offered her possibilities, especially if it was someone, like a writer or director, who worked behind the scenes and was not a visually identifiable commodity. James T. Farrell, a literary star whom time had eclipsed, made a fine portrait as he stared out at Arbus nearsightedly and stubbornly in his characterless rented room. Less compelling was a depiction of the movie star Marcello Mastroianni, in a suit, tie and overcoat, slouched unconvincingly half on and half off a hotel bed (he is the first published illustration of Arbus's penchant for posing her subjects in a bed) and gazing with an expression of bored, sophisticated politeness at the camera. Hanging on the door at the edge of the photograph is a sign that could serve as an acid title for the portrait: PLEASE DO NOT DISTURB.

Aside from celebrities, there was always fashion. In 1962, Arbus accepted two children's fashion assignments from *Bazaar*— "which was a little bit like an old nightmare," she told Model afterward, "but I got through it." In June, not long after she shot the peace marchers for *Esquire,* she photographed six-year-old Amy looking adorably fetching in Bill Blass outfits with Peter Pan collars, holding pet animals. Later that summer, in a town house garden on the Upper East Side, she photographed little girls in

party dresses. These pictures were better. The odd-looking girls, their gazes wary or averted, look uneasy rather than cute, amid an ominous profusion of zinnias and dahlias.

Arbus despised photographs that illustrated the conventional platitudes of "how charming children are or how tender their play is or how wistful." She photographed children often; not those who satisfy the spun-sugar fantasies of their elders, but the ones harboring secrets from which adults are excluded. Children lived in their own world, briefly. A picture Arbus took in the midfifties of a sensitive-looking boy with big ears, half turning to look at her with dreamy inquisitiveness as he steps off the curb to cross the street, suggests the inevitable adolescent transition. The small boys she chose to photograph often looked like little men— wearing men's fedoras, overcoats or eyeglasses, examining her with a gaze of curiosity and gravity. Similarly, a little girl standing by the Central Park Lake in bonnet and pumps is precociously matronly. With other pictures, as in one of a couple of boys smoking cigarettes in Central Park, the children's self-conscious aping of grown-up habits underscores the discrepancy between the childishness of her subjects and the adulthood they anticipated.

Wanting to photograph something other than celebrities and fashion, Arbus proposed to Israel in April 1962 that she do a more ambitious series on rich children, "who are almost as toomuchblessed as freaks." She remarked that she knew the territory. The chauffeured car, dancing lessons, clothes shopping—these privileges and burdens were part of her personal history. So were the attendant anxieties. In early March 1932, when she was about to turn nine years old, the Lindbergh baby was kidnapped, and she followed with anxious fascination the frenzied newspaper coverage of the crime: the ladder left outside the second-story nursery, the delivery of the ransom notes, the payment of the money and the eventual discovery of the decomposed body. In her nightmares, a ladder rose outside her high window at the San Remo. How much money, she wondered, would her parents be willing

to pay in order to ransom *her*? She thought it was a question that any child might ponder.

Pitching the assignment to the editor of *Bazaar,* Nancy White, she said she wanted to depict the children of "the most distinguished and dazzling people of our time" and explore how they lived, "like princess and pirate (at once) in a predicament as poignant as it is pretty." She suggested the title of "The Silver Spoon." White told her to go ahead.

Forlorn and Angry Children

On the western margins of Greenwich Village, where Arbus now lived, the children she photographed were typically working-class and grubby; and so she headed uptown to her old haunts, in and around Central Park, to search for wealthy children, those who were fastidiously groomed and under the paid, watchful eyes of governesses. "I was a rich child myself, more or less," she observed. Having been gloomy as well as rich, she stalked with extra zeal those pampered children who appeared troubled. "The way some guys spot cute girls she tracked angry kids," said Frederick Eberstadt, who, as it happened, was the father of two rich children himself. A couple of years after receiving the *Bazaar* assignment, Diane would photograph the Eberstadts' nine-year-old son, Nick, who hated the experience and, in the picture, visibly seethed with fury. Nick's little sister, Fernanda, adored Diane and relished the notion of being photographed by her. However, a frolicsome, happy girl wasn't what Arbus had in mind. On a wintry afternoon, the photographer took Fernanda, accompanied by a nanny, into Central Park. Dressed in a brown velvet snowsuit, the four-year-old child was clutching a Japanese painted plaster doll, her favorite. Diane led her to the chosen spot amid drifts of snow and walked away, so that the two were separated by a

distance too great for talk. The little girl smiled with the cheerful expression she knew a photograph required, and she waited. And waited. In the bitter chill, as the minutes crept by, Fernanda began to crumple with a forlorn sense of abandonment—"first feeling puzzled, then bored, then freezing cold, and then finally this utter desolation beyond boredom, beyond cold, that felt like being an orphan in war-time," she recalled. At that point, Diane snapped the picture.

For the project, which ultimately failed to find publication, Arbus took many photographs of privileged kids in the early sixties: some, whom she visited at home, were the offspring of distinguished New Yorkers, such as the lyricist Alan Jay Lerner. (Close to her age and background, Lerner was himself the son of a successful Jewish New York women's clothing retailer; like Howard Nemerov, he had attended Harvard and chosen literary endeavors over the family business.) More than on introductions and appointments, though, she relied on serendipity, especially in the park, to discover her subjects. In that way, she made her most evocative portrait in the series right at the outset, in spring 1962, when she encountered a knobby-kneed, bony-framed seven-year-old boy walking with his nanny after school. He was wearing shorts with suspenders and a patterned short-sleeved shirt with a Peter Pan collar—the kind of outfit, she thought, that was purchased in "one of those archaic shops for the rich." She watched him try to play with some of the tougher boys, and that sight may have stirred a memory of the time, thirty years earlier, when she had witnessed her brother—in an equally "sissified" getup that featured a camel-hair golf cap and roller skates—respond to the overtures of a couple of young roughnecks, only to be robbed for his troubles. (In her nightmares that night, she had relived a more brutal version of the encounter.)

Little Colin Wood (for that was his name) bristled with nervous, violent energy. "If you held me up, I would have walked on the ceiling," he later said. He was both reckless and scared. Like the young Diane, he was a frightened child who despised

his timidity. In the park, he sought out the friendship of older boys for protection, anxious that stronger kids might pummel him. "Overcoming fear was a big part of my growing up—fear of dying, fear of being hurt," he recalled.

His father, the Wimbledon tennis champion Sidney Wood, descended from a lineage of affluent sportsmen, and his mother's family owned hotels. Colin had started out in life sheltered by his parents on Park Avenue at Sixty-Fifth Street. But two years earlier, his father had moved out, and Colin relocated with his mother and younger brother to less fancy digs farther east on Seventy-Second Street. The parents were now going through a divorce, which left Mrs. Wood distraught and distracted. Colin's supervision was assigned to nannies, first a Scottish and then a German one. A maid who couldn't cook prepared his food. He was living primarily on powdered Junket straight from the box, and the diet of sugar added fuel to his manic rage. At his progressive Catholic school, he brought toy guns to class and threatened to kill the other children. He drew pictures of fires, snakes and tanks. Once he convinced a classmate to hold a firecracker party favor and then detonated it with a pullstring. "I wanted anything that exploded or shot," he said. Among his favorite toys were plastic grenades that were sold at the five-and-dime and went off with a bang when, drawing the pin, you popped the percussion cap.

Colin's mother, in selecting his wardrobe, sometimes likened him to Little Lord Fauntleroy. He was a sickly, asthmatic child, and she liked to apply rouge to his sallow cheeks. Her mothering skills were acquired unsystematically from uncustomary sources. "My mom was raised in hotels," he explained. "She never learned to cook or clean. Her idea of what to wear for children was Eloise in the Plaza."

Arbus knew none of these details, but Colin's histrionic intensity attracted her to him. Furthermore, his outfit recalled her childhood. She exposed eleven frames—almost a full roll of 2¼×2¼ film—as the child pranced, smirked and clowned for the camera. In most of the shots, he has his hands on his hips, smil-

ing. But in the one that she printed, a photograph that in a few years' time would seem, prophetically, to capture the impotent rage of youth in the late sixties, he displays one of his prized toy grenades, gripped in his right hand, and extends the left hand in a matching gesture, clawed but empty. His big gray eyes are staring at her and his scowling mouth is a taut, clenched line. A suspender strap has slipped off his shoulder, and one sock is sagging. Everything around him is the essence of tranquil order: his nanny standing at a discreet distance to the rear; a small family group approaching in the far background; dappled light sifting through the leaves of the trees onto the lawn and path; even the perfectly positioned two tree trunks that rise behind Colin's right shoulder and reprise his skinny legs. In this peaceful context, the boy's frustrated impatience vibrates all the louder. "He was just exasperated with me," Arbus said, remarking on what was happening in the photograph. But when Wood, as an adult, considered the portrait, he regarded it differently. "I was impatient," he said. "She saw in me the frustration, the anger at my surroundings, the kid wanting to explode but can't because he's constrained by his background and by this overly clothed babushka in the background. She's sad about me. 'What's going to happen to him?' What I feel is that she likes me. She can't take me under her wing but she can give me a whirl."

Arbus's empathy distinguishes her portrait from other photographs of boys playing at violence. Eight years earlier, William Klein produced a striking picture of a small boy snarling in mock fury and pointing a toy pistol at the camera as an even younger boy, maybe his brother, gazes at him worshipfully. Grainy in texture and compositionally in your face, with the gun barrel and trigger hand magnified in the foreground, Klein's picture resembles a *Daily News* photograph of a hoodlum. It is powerful and memorable. So why hasn't *Minigang, Amsterdam Avenue, 1954* achieved quite the iconic status of *Child with a toy hand grenade in Central Park, N.Y.C. 1962*? Perhaps because Klein's mugging child, pretending to be a thug, is enjoying himself. His rage is a joke.

Arbus's jesting boy is in pain. Why is he suffering? The picture won't resolve that question. The mystery lingers.

Fernanda Eberstadt as a little girl looked desolate and alone in Arbus's photograph. Colin (like Fernanda's brother, Nick) projected a frustrated rage. Just children, they were already molded by a society in which men were expected to voice their unhappiness angrily, women to stifle it in depressed silence. "I am convinced that in the picture I am actually collaborating with her," said the adult Colin Wood. He meant that Arbus recognized in him the bottled-up murderous fury that she at times felt but could not let out. With Colin, the emotion was on the surface, and she expressed it in the photograph.

38

Self-Created Women

Even more than photographing children, Arbus liked to focus on anonymous women. The older ones are typically self-assured matrons with a brashly original style, who reminded her of her grandmother Rose. The women closer to her own age in her photographs tend to be burdened: carrying a child, a heavy package, a big purse, a worried countenance. For Diane, as for many of her friends in New York, being a woman did not resemble the image that was held out to them as girls. Instead of receiving support and protection from their husbands in return for running a household and supervising the children, they were pursuing careers for creative fulfillment and necessary income, and on top of that, they were still bearing full responsibility for the home. Allan was more helpful around the house than most of his peers. Even after he was separated from Diane, he stopped by one night after she gave a dinner party to do the dishes. But just as the financial onus pressed hardest on the man, the family duties resided chiefly with the woman.

Diane was a devoted mother to her two daughters. Doon, who attended the Rudolf Steiner School uptown, had grown into an independent, often recalcitrant teenager, and Diane told several friends that she worried about how to guide her development.

But Amy was still a small child. In between photographic missions, Diane would race to pick up her younger girl at the Little Red School House, a progressive and well-regarded private school in the neighborhood, and take her to play dates with friends. Sometimes Roberta Miller, a divorced book editor who was raising three daughters in a Greenwich Village apartment, would chat there with Diane over coffee at the kitchen table as Amy played with Roberta's middle girl, a classmate. Her camera hanging around her neck, Diane would not remove her shiny black trench coat. Roberta thought of the coat as "a protective shell," but perhaps it was a work uniform that always stayed on, even when she wasn't exactly on duty. Diane was a full-time photographer and a full-time mother, and she pursued both callings with idiosyncratic passion and without clear dividing lines. Her friend and former editor Tina Fredericks, who had divorced Rick and was herself a working mother with two daughters, marveled at how Diane "would take a piece of toast and put peanut butter on it and cut it in little squares and feed her children like a bird." For Halloween one year, she dressed Amy as a doll, cutting off the bottom of a brown paper bag for a dress (the handles were shoulder straps) and painting a red circle on each cheek. When Diane was in the fashion business with Allan, her living room doubled as the studio. Now, in her smaller solo quarters, life and work still overlapped. At night, after the girls were asleep, she would go through her prints and contact sheets—tacking up on the wooden screen by her bed the photographs she liked, and interspersing them with other images, by painters as well as photographers. She believed that if you kept intimate company with pictures, you entered into a changing and charged relationship with them. She lived alongside her children and her photographs, surrounded by her family and work.

Figuring out as she went along what it meant to be a woman in this world, Diane watched with attentive eyes how her friends managed the task. Nancy Christopherson shirked all responsibilities except her self-imposed mandate to lead a creative life. When she

worked, she earned little for it; she relied on welfare payments and parental handouts. After the collapse of her marriage to the art dealer Dick Bellamy, Dick remained the more reliable parent to Nancy's daughter, Poni. At the end of the day, returning from the Steiner School, Poni would feed herself. The provisions she found in the apartment were often moldy bread, half-spoiled produce and other questionable bounty from Nancy's foraging in dumpsters. Nancy had never imagined herself as a mother, and she filled the role like a miscast actress. She renounced every tenet of her Midwestern family's respectable values.

Like Nancy, Pati Hill had not regarded motherhood as part of her destiny. "Diane's feelings about being a mother were different from mine," Hill said. "She felt it was something she had to be." Indeed, one of Pati's tensions with Brayton Marvell arose from his desire for prolific paternity and her reluctance to cooperate. So it was peculiar that, toward the end of their three-and-a-half-year relationship, she took up with another suitor, married him in November 1960, and within a year's time found herself pregnant. Her husband, Paul Bianchini, was the youngest son of a wealthy French family, but he lacked an independent income. Setting himself up as an art dealer on East Seventy-Eighth Street in New York, he took an apartment on East Seventy-Ninth. Weekends, he would go to Stonington, where Pati continued to spend much of her time, in a more modest house than the one she had shared with Brayton. She didn't intend to let marriage overturn her habits. Similarly, she insisted that motherhood would not change her "one whit" and said she doubted she would have accepted her state if she thought otherwise. It irked her that Paul's mother complimented her on the pregnancy but failed to acknowledge that she had two books being published that year. "The more I am perfectly mindlessly, painlessly, uninterestingly pregnant, the more I despise women who give themselves such dignity and pride from being meres de famille," she told Alain. However, Diane, as she contemplated Pati's incipient maternity, became "quite sentimental," and wrote to her empathetically, "I

feel full of the stirrings of motherhood. Suddenly I want to see my children."

Pati feared gaining weight from her pregnancy, and at times she also dreaded the advent of the child. In September 1962, she gave birth in Geneva to a daughter, Paola. (She couldn't say whether her daughter's birthday was the twenty-third or twenty-fourth. Paul neglected to register the arrival at the city hall, and by the time he did, neither parent was certain.) Although Paola didn't have to scramble to feed herself as Poni had done, she grew up in a household with few rules and lax supervision. Pati could never adjust to the idea of a child who depended on her. She was more comfortable providing for cats, allowing them to come and go as they pleased.

While the difficulty of constructing an identity as a modern woman made a fascinating subject, it didn't lend itself easily to photography. The political dimensions of feminism baffled and bored Diane. When she thought of a self-created woman, her mind turned to extremes, both because she preferred the far-out edge to the predictable middle and because the exaggerated lent itself more dramatically to photography. Rather than show the making of a contemporary woman, which as a theme was drearily sociological and not pictorially rich, she looked for more fundamental self-inventions. To display transformation, a photograph, which is the record of a moment, must reveal both what was and what will be. Hermaphrodites such as Albert-Alberta offered a possible way around that conundrum, containing male and female lineaments in the same body; however, the "he-she" smelled strongly of the sideshow, positioned awkwardly between gimmickry and freakishness.

Female impersonators—men who perform onstage as women—afforded a more promising angle. Any ordinary woman could attest to the effort that went into her everyday act of impersonation. As early as 1956, Arbus photographed women primping in the ladies' room of Grand Central Terminal and trying on clothes in a department store. However, those pictures might

have been ripped out of a fashion magazine. The metamorphosis of a man into a woman, with the aid of the makeup, wigs, gowns and high heels that his sisters routinely employed—such an unlikely quest for womanhood (or, as Arbus once described it, "a leap into a new doom") was poignant and funny, maybe even mythic, all the more so in light of the impersonators' penchant for an extreme version of femininity. "Like the greatest living parody, they shriek and bicker and wriggle and smile and languish so splendidly that any real woman looks pale and dubious beside them," Arbus wrote. She felt that anyone of either sex must be "stirred and dizzied and beguiled" by these gender trespassers. "They are a sort of nouveau legend," she concluded, "for, while it may not be as helpful as Prometheus, it is pretty audacious to steal from Venus everything she holds most dear."

At the Jewel Box Revue, a touring show of female impersonators that she began frequenting in the late fifties during its New York engagements, Arbus gained access to the dressing rooms. It was illegal for a man to appear in public outfitted as a woman; the performers would arrive in the guise of one gender and take the stage as another. Diane remarked to Marvin that each man assumed the one-dimensional role of a particular woman, and curiously, once the transformation was complete, the man was unrecognizable beneath his feminine alter ego.

She had scant interest in photographing the female impersonators as they performed before a largely heterosexual audience of tourists and gawkers. On what was probably her first visit, near the end of 1958, she devoted several rolls of film to the show. But that was simply a warm-up before she could insinuate herself backstage. In a dressing room, amid the wig stands and the falsies, using the reflections on tabletop mirrors as a compositional device, she could photograph the men as they crossed the gender line. And later, when the Jewel Box wasn't playing New York, she infiltrated the 82 Club in the East Village, which drew a similar audience for its nightly drag shows. Gaining access to the 82 Club dressing rooms might require a tedious wait of many hours, with

no certainty of admission, but she persisted and succeeded. At
the time that she began photographing female impersonators in
the late fifties, Arbus was also frequenting Coney Island tattoo
parlors to watch as men had the patterns of their choice inked
onto their skin. This, too, was a form of self-made identity. As a
photographic subject, however, it was immeasurably more evoca-
tive to portray a bare-chested man with an eagle tattoo who was
wearing panty hose as he prepared to impersonate a woman.
Like Bernini, who sculpted Daphne as she dendrified into a lau-
rel tree, Arbus in her photographs zeroed in on the revelatory
and dramatic moment of change. (She had a much-thumbed
copy of Ovid's *Metamorphoses* in her library.)

Arbus took a special interest in Stormé DeLarverie, a biracial
woman who was the solitary female in the Jewel Box Revue's pro-
duction number "Twenty-Five Men and a Girl." Late in the show,
in a number called "The Surprise," the audience was astonished
to discover that the one true girl was the emcee—the only cast
member who appeared to be male. Cross-dressing and homosex-
uality were shocking enough that *Harper's Bazaar* rejected Arbus's
portrait of DeLarverie for "The Full Circle" in 1961. (An unexpur-
gated version of her photographs and text came out the following
year in *Infinity,* the periodical of the American Society of Maga-
zine Photographers.) In the photograph, DeLarverie, dressed in
dashing masculine style in a tweed suit, white shirt and dark tie,
sits on a park bench with a cigarette in one hand, arms and legs
crossed, looking with cool self-containment at the camera.

Male cross-dressers were more at risk of arrest than females;
even so, it was courageous of DeLarverie to stay true to her mas-
culine sartorial preferences outside the theater. "She admits
wryly that most people would figure they'd had enough, just
being a mulatto and would be content to sit on the racial fence
without climbing astride the sexual one," Arbus wrote. "But
maybe what is most curious about Stormé is what she is most
curious about: the air of being someone slightly out of context
and most at home there." On one warm spring afternoon as the

two women crossed the street together, DeLarverie, to Arbus's amusement, exclaimed with admiration at the audacity of a man who was sporting Bermuda shorts.

DeLarverie made almost too convincing a man in a photograph. Without the benefit of a caption, many viewers would believe they were seeing a handsome, slightly androgynous, light-skinned black man. In the pictures of female impersonators backstage, the charade was more apparent, but perhaps it was too stagey. Arbus throughout her career explored the theme of self-creation, searching for ways to depict it in photography. If the pretenders, like Gertrude Nemerov, were aping people they considered to be their social betters, she judged the dissimulation pejoratively. But when, like Stormé DeLarverie, they were refashioning themselves in ways that felt more personally authentic, she applauded their temerity, without overlooking the attendant comedy.

Tinseltown

Hollywood was the international capital of make-believe, which made it an irresistible destination for Arbus. Traveling to Los Angeles in July 1962, she held a commission to photograph clairvoyants for *Harper's Bazaar* and a desire to explore a place she had never seen. It was her first big trip since the sabbatical in Europe that ended a decade earlier, and this time, she was on her own, without Allan. In Los Angeles, she would be staying with her friend Robert Brown, who had moved to the West Coast to advance his acting career, and was remarried to a young woman, Mary Elizabeth Sellers, known as Bunny. He had met Bunny, a friend of Nancy Christopherson's, at a dinner at the Arbuses'.

Feeling "not so much summoned as pushed" to make a journey that was "very brave and very pointless," Diane arrived by cross-country bus. Robert had just returned from making a movie in Spain. He had rented out his house during his absence, and until it became vacant, he and Bunny were living in a borrowed oceanfront mansion in Malibu. Uncomfortable amid the extravagant winding staircases and countless chambers, Diane elected to stay in the modest streetside carriage house, sleeping on the floor of the wood-walled room in the garage where the chauffeur might have resided. As the luxuries of the house did not include

a chauffeur, Robert and Bunny took on the responsibility of driving Diane to her appointments. Diane had a fraught relationship with automobiles. She had taken lessons with an instructor in 1950 (Allan hated to teach her), amused to sit in intimate proximity with a stranger who described to her the position of the gears with the confusing gestures of someone indicating a thing that was "palpable but hidden." It reminded her of "the descriptions one gets of a woman's inner genital equipment." Although the instructor complimented her on her prowess, she remained dubious. In Los Angeles, she learned to drive again, even to smoke a cigarette while at the wheel, but her doubts remained.

Indeed, her interaction with all machines, including cameras, was uncertain. She could avoid taking the driver's seat of a car, but as she was a photographer she had to cope with handling cameras. To her mind they were "something of a nuisance." A camera was "recalcitrant" and "determined to do one thing and you may want to do something else"; the photographer's challenge was "to fuse what you want and what the camera wants." Looking into the viewfinder, she sometimes wanted to shake the frame around like a kaleidoscope until it composed into the pattern she wanted. "I'm not a virtuoso," she conceded. "I can't just do anything I want. In fact, I can't seem to do *anything* I want." She credited Lisette with having helped her overcome her womanly insecurity around machinery. Indeed, Allan chuckled over her attitude toward her professional tools. "She was very funny about her cameras," he recalled. "If one didn't work, she would put it aside and then pick it up the next day to see if it had gotten better." She said, "That's my feeling about machines. If you sort of look the other way, they'll get fixed again."

Robert and Bunny took her to the people and places she wanted to photograph, as well as to the must-see tourist sights she would rather not have seen. "How do you avoid sightseeing, and yet see things?" she once asked Pati. Not all the popular attractions bored her. Her Fieldston high school friend Stewart Stern, who was living in Los Angeles, shared the duty of transporting

Diane to photo assignments. Stern made an excellent cicerone. He was a successful screenwriter, having composed the script for the movie *Rebel Without a Cause*. At least as integral to his status in Hollywood was his lineage: he was the nephew of Adolph Zukor, who established Paramount Pictures, and the cousin and close friend of Arthur Loew Jr., whose grandfather cofounded Metro-Goldwyn-Mayer Studios and started Loew's Theatres. Diane wanted to visit theme parks and movie studios to photograph what she called "pseudo-places"—environments that elaborately reproduced sites that never were. Before traveling west, she told Marvin that she was "looking for the faces of places," and at Disneyland, she literally found one, in Skull Rock from *Peter Pan*. Of course, Skull Rock with visitors swarming about it would be a tourist photograph. She informed Stern that she wanted to photograph "emptiness." That required her to enter a park at off hours, and Stern was able to gain her access to Disneyland and Universal Studios when they were closed to the public. She preferred that time of day anyway. Except at dawn and dusk, she found the sun too bright. Shooting in a half-light that would make even ordinary scenes appear unearthly, Arbus sometimes propped up her camera on a tripod, set a long exposure time, then walked away. "What about the camera?" Stern asked her. "It knows what it's doing," she replied.

"I am Cinderella but a little eager for midnight," she quipped. The days were packed with delightful activities, but each day erased the previous one, adding up to she knew not what. "My cup does not run over," she remarked. "It is full but I think it has a hole at the bottom." In a euphoric mood, she sent a telegram to Hayes at *Esquire* proposing that she depict "ruins of Cambodian temples which never existed" (and, indeed, her photograph of Skull Rock resembles a Khmer shrine that has been overgrown by jungle), as well as "deserts littered with bones of animals who never died." She wanted to photograph Sleeping Beauty Castle, but only if it could be done at daybreak. Thanks to Stern, it could be, and, once again, her prospectus is a poetically apt description

of the eventual picture: "black swans swim in the moat of a castle which looks like the advertisement for a dream." (Actually, the solitary swan in the photograph is white, but the dimly lit castle against a night sky, with the reflections of its windowed turrets shimmering in the moat, does indeed look like a huckster's pitch for an impossible bliss.) Another uncanny picture that she made in the dim light at Disneyland shows huge fake boulders resting on flatbeds on wheels, in an arid landscape with a crestline of mountains behind. It evokes Macbeth's all-too-real nightmare of Birnam Wood advancing.

Arbus's dreamscapes, like Shakespeare's ambulatory Birnam Wood, were real. She had little patience for staged surrealist photographs that were devised to simulate dreams. "What I'm saying is that these people want something to be there that they have seen in their heads somewhere else, and they may consider that more real, but I'm not talking about what's more real than reality," she commented. "I'm saying, let's call reality reality, and let's call dreams dreams, or fantasies." She liked her dreams, but she relegated them to their own domain, without trying to convert them into photographs that would be permanent and universally visible. She knew that, just as something specific can be general, so something real can be fantastic.

She disliked the "lack of the unexpected" in constructed photographs. Some years later, when contemporary photographers resuscitated the form of staged narrative pictures that had been popular in the late Victorian era, she wrote to Duane Michals, a leading proponent of the movement, that his Museum of Modern Art exhibition amazed her, because "although there is much in it that goes against my grain I was *fascinated*. . . . The whole fiction of them begins by appalling me but in some I ended by believing your lie." However, as Michals wryly observed, she was full of advice, which, if followed, would have resulted in him producing photographs just like hers. She loved the baseboards and the electrical outlets in the rooms he depicted—the things that were real, not make-believe. She suggested that he photograph his parents

and follow that up with all sorts of people, including "business men, children, old aunts." It would be "very daring," she argued. "The great thing would be to go past your apparent obsessions all the way to the ones you turn up which are even deeper."

On the Universal lot, she photographed a strip of town house façades on a hill, with a grassy slope in the foreground and a sky of dramatically tufted clouds—a composition similar to one she had used for the peace marchers in New Jersey a couple of months previously. Her first teacher, Berenice Abbott, who obsessively ascertained light exposures before selecting the time and vantage point for photographing New York skyscrapers, would have approved of the lighting. Arbus caught the moment when sunlight was filtering through one of the blank windows on the fake street front. Undoubtedly, she accomplished it without Abbott's fastidious preparation, but the result was what mattered. She was literally seeing through the façades.

In Coney Island, Arbus as early as 1957 had taken many pictures of the Tunnel of Laffs and Spook-a-Rama with the lights on and the machinery exposed. These were demystifying photographs, laying bare the apparatus that generated the thrills. The pictures she took in Disneyland and on the Universal studio lot extend the theme, one that she revisited throughout her life. Because the dreams manufactured in Hollywood were grander and more romantic than the oohs and ahs of the Coney Island rides, her Los Angeles photographs gracefully assume a symbolism that the earlier pictures lacked. Along with fairy-tale illusions there are the fake fronts that Diane also knew from childhood, in the readily visible and amusing form of skin-deep buildings and counterfeit rocks.

Adding to the pictures' dreamlike quality is their precision. Early in 1962, Arbus transferred her primary allegiance from the 35 mm Nikon to the 2¼-inch medium-format Rolleiflex. Because the medium-format camera uses film almost four times the size of that in a 35 mm, it can register far more detail. (Even greater definition is possible with a large-format view camera of the sort

that Allan used for fashion shoots, but after her youthful self-portraits taken with their Deardorff during the war, Diane never returned to the cumbersome view camera.) It's not true that all 35 mm pictures are grainy. Arbus photographed the rocks on wheels, for instance, with her Nikon (probably mounting it to a tripod and setting a long exposure time), and the treads on the road and the rough surfaces of the rocks are minutely registered in the picture. Fairer is the converse statement that medium-format photographs are sharp. The quality isn't simply a function of the larger film, but of the camera itself and the way it is used. Unlike a small 35 mm camera (including Arbus's Nikon), which is brought to the eye, the Rollei and other twin-lens reflex cameras are held at waist level. The photographer sees the image mirrored in left-right reversal by one of the lenses onto the matte surface of the ground glass. Focusing and composing are more deliberate with a Rollei, affecting the photographer's relationship to her subject. In the hands of some photographers, a 35 mm Leica camera could be lifted and lowered so quickly and inconspicuously that picture taking went unnoticed. Photographing with a medium-format camera is a more obvious action; if the subject is a person, he will usually be conscious of the act, and willingly or not, he becomes in some sense a collaborator. Since the camera is not hiding the photographer's face, she can make eye contact directly with the subject before shooting. Arbus, shortly before leaving for Los Angeles, had used the Rollei to photograph Colin Wood holding a toy grenade. Unlike her teacher Model, who preferred not to speak with her subjects, Diane thrived on the social interaction that a medium-format camera facilitated and encouraged. To be seen by her subjects at the same time that she saw them nourished her psyche.

Arbus began regularly using a Rollei at the very end of 1961, sometimes photographing a subject with the Nikon as well. She began her self-instruction with people and places that made her feel comfortable: five-year-old Amy naked at home, Nancy Christopherson's eccentrically decorated apartment. It was a bumpy

transition. The old camera had lost its power, but for months the new one seemed beyond her grasp. Not only was the process different; the image itself appeared in a foreign shape. Instead of the rectangular format of 35 mm film, the pictures produced by a Rollei are square. The equilateral frame encourages a photographer to place her primary subject in the center—a tendency reinforced by Arbus's adoption of a Rollei equipped with a wide-angle lens, a model that was introduced by the company in April 1961, and in which the lens was fixed, not interchangeable. The wide-angle lens slightly heightens the prominence of what is central in the frame and subtly exaggerates the distance of the marginal background. These distortions amplify the sense that a picture is intensely focused yet slightly off-kilter.

When she lamented to Model that she no longer believed in the Nikon but found the Rollei intractable, the older woman said that this was a completely normal situation, and she should take the same pictures with both. Using the two cameras in Los Angeles, Arbus carried out her assignments as well as her pet projects. The photographs of soothsayers she took for *Bazaar* (and which would end up in *Glamour)* were shot primarily with the Rollei. She also used the medium-format camera to shoot the writer Christopher Isherwood, a portrait that went unpublished. He is lying in the grass, the same pose in which she had captured Jack Dracula. But in the earlier 35 mm photograph, her subject filled the horizontal frame. Isherwood, in the square format, is lost in the weeds. She was still learning.

One of her grander long-term ideas, which she inaugurated in earnest in 1962, was to photograph the winners and losers of contests. She had explored competitions before. As early as 1957, she visited a Puerto Rican dance-hall contest; she also photographed bodybuilding competitions for her *Esquire* assignment at the end of 1959 and the Miss New York City pageant in July 1960. But now she was thinking about the subject systematically. In her notebook for 1962, she collected information and jotted down piquant possibilities for the future: Miss Fluidless Contact

Lens, Tooth Health Week Queen, Miss Antifreeze. On this trip, in Venice Beach, she shot pageants of a more conventional sort— muscle men and bathing beauties. Using a wide-angle lens on the Nikon, she memorialized the Miss Venice swimsuit contest, in a picture that depicts the backs of heads of youths who are ogling the rear ends of lined-up bathing beauties. It's a witty piece of social commentary with the directness of a joke's punch line, but it lacks the pathos and ambiguity of Arbus's later photographs of winners and losers. In those, she disregarded the judging entirely and isolated a contestant after the outcome was decided.

She tried out that approach upon returning to New York. Covering a Mr. Universe competition on September 15 at the Brooklyn Academy of Music, she asked the winner, wearing trunks, to pose in the dressing room with his prize. In her photograph, the elaborate multitiered trophy reaches as high as the waist of the champion, who stands a diminutive, if bulky, five foot six. She stepped back far enough from the sweet-faced, docile victor to include the scarred walls, bare lightbulbs, scattered papers, used towels and rudimentary wall sink—the grubby backdrop to his triumph. In Arbus's contest pictures, win or lose, there is no glory. She remarked that perhaps people say "you can't win" because following a victory "you have so much to lose."

PART FOUR

KNOWING PEOPLE IN
AN ALMOST BIBLICAL SENSE

40

A Fantastically Honest Photographer

Marvin, with his gift for making connections, introduced Diane to Walker Evans in the fall of 1962. The art director had published a selection of Evans's New York subway portraits in *Harper's Bazaar* a few months before. Although Evans was celebrated, his subway pictures, which date from 1938 to early 1941, were largely unknown. Except for eight that ran in a small literary review in 1956, he delayed releasing them. It was inherent to the project that he couldn't obtain permissions from his subjects. His moral qualms were exacerbated by fear that the unwitting straphangers might sue.

It took someone with Marvin's perceptiveness to recognize that Evans and Arbus, separated by twenty years in age and an even wider chasm of background, gender and temperament, would admire each other's work and warm to each other personally. While Arbus, too, had snapped photographs in New York subway cars, her subjects can be seen looking back at her—with amused curiosity, puzzled suspicion or jaded forbearance. Evans's riders stare as blindly as buildings toward a photographer who reduced himself into invisibility. To take the pictures, Evans hid his camera inside his overcoat, the lens poking out unobtrusively between two buttons, and squeezed a shutter release cable that ran down his

right sleeve. He wanted to capture people after their masks had dropped, "in naked repose." In limbo between their departure and destination, subway riders were innocent of the pretenses that mark all social interaction, even self-regard in a mirror. They were not trying to be anything they weren't. They were unsuspecting quarry. "I am stalking, as in the hunt," Evans remarked. "What a bagful to be taken home."

Captured on the fly and composed accidentally (but carefully revised in the darkroom through cropping), the subway pictures constituted an experiment for the artistically established if financially precarious Evans. His reputation lay elsewhere. He was the first photographer to receive a solo show at the Museum of Modern Art, in 1938, and only the second photographer to receive a Guggenheim Foundation grant, in 1940. Since 1945, he had been the staff photographer of *Fortune*. There may have been other photographers, such as Ansel Adams and Edward Weston, whose prints were more revered by colleagues, but in intellectual and creative circles, Evans reigned uncontested. A true artist, he regarded the world with a stringent, adamantine sensibility. The painters of ancient Egypt used to depict each part of the body in the most readily identifiable and characteristic posture: the nose in profile, the chest fully frontal, and so on. There was something Egyptian in Evans's approach, as he calculated the optimal angle, lighting and framing to elicit the most telling portraits of buildings and people.

A shy man whose genteel Midwestern origins were tinted but not obliterated by youthful exposure to Parisian and Greenwich Village bohemianism, Evans was a self-taught photographer. He despised both the romanticism of Stieglitz and the slickness of Steichen. Asked in later life what photographic work had impressed him when he started out, he mentioned Paul Strand's *Blind Woman*. "It was strong and real, it seemed to me," he observed. "And a little bit shocking—brutal." He appreciated Strand's directness, and, coming from a sheltered upbringing in suburban Chicago, he shuddered slightly in excited appreciation

at this glimpse of what seemed to him to be "real life." For much the same reason, he admired Knut Hamsun's novel *Hunger*, about a starving student.

Arbus shared his fondness for *Hunger* (at least the movie version) and his fascination with the destitute. Unlike Evans, however, she was not (as he described himself) "armed with detachment." Evans enjoyed the distance afforded him by a telephoto lens, yet whatever lens he used, he achieved the same flattened and compressed effect. The photographs that he took during the Depression in Hale County, Alabama, while on assignment with James Agee, imbued his poverty-stricken subjects with a dignity that reveals the still, cool vantage point from which he regarded them. Arbus thought he was "a fantastically honest photographer" who stripped away his personal identity in his work. "It's partly because he sees himself as an historian," she conjectured. Although she observed that all photographers were, in some sense, historians, Evans was unusual because he really regarded himself that way. Arbus thought that "a sterling purity of character" in the man could be detected in his photographs. But by the end of the decade, having experienced the turbulence of the sixties, she would find Evans's pictures "insanely calm, insanely kind of cold, insanely unconflictive, unimpassioned." The times had changed, and even if you shared Evans's temperament and sensibility, it wasn't possible to photograph in the same way.

Knowing that Evans had oenophile tastes and alcoholic tendencies, Israel regularly called on him with a good bottle of red wine in hand. Evans was living in a top-floor brownstone apartment on East Ninety-Fourth Street with his much younger second wife, Isabelle. "Walker was interested to speak with Marvin about getting photographs in *Harper's Bazaar*," Isabelle explained. "We lived from hand to mouth." One evening in September 1962, Israel was there to discuss the possibility of publishing Evans's photographs of street trash. While they were reviewing the pictures and drinking Bordeaux, Israel said he had some photographs he wanted to share. With a secretive air, he pulled out a

portfolio "like the most precious gold, virtually coming out of his overcoat," Isabelle recalled. These were posed portraits of eccentric people, subjects who looked peculiar and a little dangerous, and Evans reacted to them with explosive enthusiasm. "He was totally overwhelmed," Isabelle recalled. "He saw the pictures were posed. He admired that very much—her courage. He saw some of the people were marginal, and he would have photographed them, too, but secretly." Lowering his voice to a confidential whisper, Israel asked if Evans would like to meet the photographer. She was waiting in a car below. In Isabelle's telling, Israel hurried down the stairs but returned alone. "Too shy to come up," he said. He explained that his friend was awestruck by Evans, but he promised to arrange a meeting soon.

Isabelle's account of that evening rang false to some who knew Diane—because Diane, of course, was the woman who, in Isabelle's tale, was waiting in the car. Saul Leiter, for one, scoffed. "Marvin was going to see Walker Evans and Diane was very shy and wouldn't go with him, I read, but that's a lot of crap," he said. "Diane was not shy at all, she was very aggressive, terribly ambitious, interested in doing whatever you have to do to have a career." As Leiter, who was far less success-oriented, observed, Arbus schemed to advance herself professionally, and soon enough, she would be flattering and cultivating Evans as she had done fifteen years before with Stieglitz. But it is also true that she was stricken repeatedly by crises of self-confidence. Her need for recognition was matched by her sense that she didn't deserve it. Intensely competitive, she saw with disheartening clarity the tawdry aspects of victory. During her friendship with Evans, which began that fall and lasted for the rest of her life, his admiration for her photographs and his self-confidence in the quality of his own body of work never faltered. Her appreciation of both his work and her own fluctuated like a faulty compass needle. She could well have refused to come up that evening. Indisputably, however, she climbed the stairs soon afterward.

She visited Evans as part of a larger mission, asking to add

him to her list of references for a Guggenheim Foundation fellowship, the award he had obtained a generation earlier. It came with a stipend she sorely needed. The photographs she showed Evans included her shots of horror movies, amusement park rides, wax museum murderers and female impersonators. But for her project, which was to examine "American Rites, Manners and Customs," she would be averting her lens from the exotic people of circuses and sideshows in favor of the hair salons, dog shows, gambling parlors, dancing lessons, wedding banquets and beauty contests that make up the fabric of American life. Although these mundane activities appeared "random and barren and formless," she wanted "to gather them, like somebody's grandmother putting up preserves, because they will have been so beautiful." In that future perfect tense, their meaning would be revealed. She promised that, by regarding them epically, she would endow these "innumerable inscrutable habits" with grandeur: "for what is ceremonious and curious and commonplace will be legendary."

She pursued the prize as fervently and systematically as she undertook a photography assignment, soliciting testimonials from as many dignitaries as she could collect. Foremost were other photographers—Robert Frank, Richard Avedon, Lee Friedlander, Helen Levitt and Lisette Model, in addition to Evans. On her list of referees, she even added James T. Farrell, the writer who had posed for her *Esquire* portrait, because he was a former Guggenheim recipient. James Thrall Soby, a wealthy art collector and critic who was a trustee of MoMA, endorsed her. Steichen, who was retiring as curator of photography there, surveyed the selection of forty-seven prints she submitted, including two recent medium-format pictures, one of Disneyland and the other of a rich child, probably the boy with a toy grenade. He concluded that she was even more impressive than he had gathered from the pictures of eccentrics (which he saw in *Infinity*), because "she gets [a] feeling of surrealism in her other subjects, too."

Unable to review her application in time was Steichen's chosen successor, John Szarkowski, who had just arrived at the museum.

In late October, Arbus dropped off her portfolio with Szarkow-
ski's assistant so the curator could assess her pictures. When she
returned to pick it up, he happened to come out of his office.
Slightly embarrassed by the awkwardness of the chance encoun-
ter, his assistant, Pat Walker, introduced them. Szarkowski liked
her immediately, impressed by her "lively intelligence." They had
an animated conversation, leading her to ask his opinion of her
photographs, and once again, that was a bit uncomfortable. He
felt the pictures didn't quite accomplish what she intended. They
reminded him of Robert Frank, or maybe William Klein, but he
thought she was seeking something less ephemeral, more "eidetic."

Grainy textures and blurred images suited Frank and Klein,
because they were presenting facts that could be known only par-
tially. "The reduced tonal scale makes it seem like a copy of a
copy, like an old record that's faded and a lot of the information
is gone," he later reflected. "Which is fine for a certain kind of
description where you feel you're not getting everything. In Klein
you never feel you know the people personally. They're types.
It's a much simpler thing than what Diane's people represent.
They're individuals as well as representing a type." During his
initial encounter with Arbus, he pointed to a square, medium-
format picture, one of the few examples of recent work that she
had included in this selection. "That's what you're looking for,"
he said. Instead of the "spotty" and "jumpy" feel of the earlier
pictures, this photograph was "visually completely coherent
from corner to corner, it was one uninterrupted sensation." In
the coming years, once she had produced much more medium-
format photography, he gained a greater appreciation of how her
mature photographs, even if their subject matter was attention-
grabbing, remained "completely at ease."

At this first meeting, he suggested that she look at the photo-
graphs of August Sander and Darius Kinsey. Szarkowski believed
he was introducing her to Sander's pictures. Having just met
this man in a position of authority, she may have chosen to
flatter his masculine ego by letting him think so. But Kinsey's

nineteenth-century photographs, of loggers posing with massive toppled redwoods, most likely were genuinely a revelation. Early in the new year, she wrote to Szarkowski, asking for the name of Kinsey's book and an address in Germany where she might send a letter to Sander.

Even before then, however, during the Christmas holidays, she had taken two photographs that demonstrated how her own "documentary style" photography was becoming as distinctive as Evans's. Her portrait of a young couple on Hudson Street at West Tenth, a few blocks from where she lived, is the greatest of the many pictures she took of youngsters dressed in clothing that is oddly grown-up for them. She shot it near the end of the year, possibly during the daytime hours of New Year's Eve; if so, the adolescents may be wearing the outfits they had chosen to celebrate that night. Arbus would be taking her camera later that evening to the Metropolitan Museum of Art, but these teenagers were not headed anywhere so posh. They stand in front of a brick wall that is chalked with graffiti. The boy, who is wearing a jacket and tie beneath his car coat, drapes his arm over his girlfriend's shoulder. Her double-breasted camel hair coat looks like a hand-me-down—its sleeves are too short—but her shoes are new and stylish. As is almost always the case in Arbus's portraits of couples, the man looks off in a dreamy state, his vision directed elsewhere, and the woman exchanges a knowing look with the photographer (and therefore with us). A trace of a sad smile plays on her lips. In high school, Diane had contrasted the way a woman "closes her eyes to everything but the present" with "the young restlessness of man." The adult Diane had not changed her opinion of gender differences. The photograph, which is a frozen moment in time, feels like a prophecy: not just the clothing but also the expressions and the postures of this young couple provide a glimpse into their future. And yet, as Szarkowski observed about Arbus's dual vision, this is simultaneously a portrait of individuals and of archetypes.

A similar blend of specificity and universality infuses a Christmas scene in the living room of a tract house in Levittown, Long

Island. Arbus had traveled out to the suburban community, where seventeen thousand homes sprang up rapidly on blighted potato fields after World War II, to photograph rooftop holiday decorations. As she looked about the neighborhood, she spied through a picture window a woman who had just finished vacuuming. Proud of her home, the Levittown resident invited Arbus inside to take a snapshot. What the photographer saw and the homeowner intended were not the same. To make the photograph, Arbus stood at the opposite end of the room from the Christmas tree, which was pushed up against the far wall, its top brushing against the ceiling. A pile of gaily wrapped presents filled the space below the tree. Because Arbus believed that placing things up front drew a viewer into the picture, the foreground is indicated by the edges of an armchair and a gauzy curtain. A textured wall-to-wall carpet blandly extends to the holiday tree. The only wall decoration is a starburst clock, its spiky rays rhyming bleakly with the flurry of tinsel that dangles from the tree and the fringe on the bottom of the upholstered sofa. An unlit lamp is between the couch and the tree, its shade covered with cellophane. The human absence is a palpable presence: including the fastidious occupant would have diminished the photograph. This is a living room devoid of any inflections of life, a holiday scene without any provision for joy.

When Evans depicted the possessions of the tenant-farming Burroughs family in Hale County, his appreciation of their stoneware jugs and kerosene lamps is discernible in his photographs. He was, as Arbus said, a historian of vernacular Americana, and he lovingly documented a culture far from his own. Arbus was operating much closer to home. In an unsurpassed image, comic and barbed, sad and barren, she memorialized the cold sterility of middle-class American life in the Cold War years.

Is the Jewish Couple Happy?

Arbus's oscillations between artistically high-flying plans and crushingly self-critical doubts were echoed, in louder and more strident tones, by Israel's ambivalence about his role as a magazine art director. In late 1962, he got into a shouting argument with Nancy White, the editor of *Bazaar.* She hated the cover he had created for the January issue. The model looked like a man in drag, she complained. What may have been worse, the masculine-looking woman with a prominent nose and assertive, red-lipsticked mouth bore a sneaking resemblance to the editor Diana Vreeland, who had committed the ultimate perfidy by defecting to *Vogue* a few months before. White wanted to kill the cover. Israel refused. The cover ran. But over the next months, their bitter bickering continued, until one day in late February 1963, Israel told White to go fuck herself and she told him he was fired.

Israel's dismissal did not dislodge Arbus from her favored position at *Bazaar.* White replaced Israel with his two young female assistants, Bea Feitler and Ruth Ansel, who shared his high opinion of Arbus's photographs. Admiration for Arbus was becoming widespread. On April 15, 1963, she received word that she had won a Guggenheim fellowship. She communicated the news with excited gratitude to her referees, including postcards

written in tiny capital letters to Evans and Model. To Evans, the subordinate penmanship was echoed in the message: "I called to tell you I got it (Guggenheim) and to *thank you*. It is dizzying and if you have further counsel I will gladly listen." But to Lisette, her effusion was more affectionate. "My father told me to thank you," she wrote, "but your eloquence is your own and your friendship is mine so I cannot."

It was some of the last advice from her father that Diane would have the opportunity to disregard. That spring David Nemerov was hospitalized in New York with terminal lung cancer. The family maintained its tradition of avoidance: he was not told the diagnosis. Diane considered the subterfuge to be an insult, but she said nothing, either. Instead, she snapped pictures of her father in his hospital bed, just as she had once photographed her deceased grandmother. As the disease advanced, she watched, "spellbound by the whole process." David in his emaciated state no longer looked like himself, or like any distinct individual. "The gradual diminishment was fantastic," she noted with emotional detachment. She lurked in the corner with her camera—"almost like a creep," she admitted—snapping away. She didn't "adore" him. She was very removed from the weeping and the agitated distress that, in the family, were expressed mainly by his brothers. She simply clicked the shutter. "I photographed him then, which was really . . . tremendously cold," she later said. "But I mean, I suppose there is something somewhat cold in me—although I resent that implication." David died on May 23. At the funeral, she took photographs of the body lying in its coffin.

Diane once came across a list by David of what he hoped to achieve in his life. A chief goal was to make a million dollars. Reflecting with Howard on their father's aspirations, Diane concluded that he failed, because he did not amass enough wealth to provide for his children or satisfy his wife. By the time he died, Russeks was collapsing and little money remained. What there was went to Gertrude. Instead of establishing a fortune, Diane said, he contrived the illusion of wealth, living more

splendiferously than his friends, many of whom were actually richer. When in 1959 the Fifth Avenue flagship store of Russeks closed, David, in Palm Beach, on the sidelines from the business fray, maintained his public posture of unwavering optimism. He told a reporter, "Painting has filled my life with pleasure since I retired from business. I am happier now than I ever was before." Still, he was as driven as Gertrude by what other people thought of him, as much now as an artist as he had been as a retail executive. "When a stranger walks in and pays for a painting of yours, he becomes wonderful indeed," he said. "You see, I couldn't bear to be a failure, not only in my own eyes but in the eyes of the world."

David had exerted his authority in the household through a variety of strategems. He won arguments by marshaling dubious facts with unassailable certainty. When Gertrude started to lose her temper, he would respond in a voice so soft and reasonable that she could only sputter helplessly; it was "a devastating technique which I hated," Diane once said. Gertrude's sole defense was withdrawal into self-obsessed beauty care and shopping, or, in a more extreme measure, deep depression. But, as was true of most couples in their circle, they stayed together. Although their marriage was constructed on a foundation of pretense and conducted as a long-running hidden conflict, they honored the vow of "until death do us part." A photograph that Diane made around the time of her father's hospital stay, titled *A Jewish couple dancing, N.Y.C. 1963,* portrays a married middle-aged duo on the dance floor. The husband's large hand, with a big pinkie ring, engulfs his wife's. Wearing a double strand of pearls around her neck, as well as pearl earrings and bracelet, she smiles sweetly at the photographer. The husband, grinning boisterously, his rows of mottled teeth exposed and predatory, regards Diane with energetic good humor. It is impossible to determine from this picture at a public event whether the Jewish couple is happy, but it appears indisputable that the man and woman are a couple, and will remain so. The tightly clasped hands mark the flash-

lit convergence point at which the woman's bent arm meets her husband. Against a dark background, and exaggerated by the distorting optics of a wide-angle lens, the joined hands and subordinate arm jut out at the viewer.

Diane's marriage to Allan acknowledged that sexual desires could overflow the boundaries of monogamy and that women as well as men should be able to pursue satisfying careers. It seemed more honest than the Nemerovs' marriage. Unlike the older union, however, it had not endured. Or had it? More than three years after they moved into separate quarters, Diane and Allan remained inextricably linked. Even from up close, they appeared to be a happily united couple. In 1962, they visited Amy at summer camp in Maine, sharing the ten-hour drive with Roberta Miller, whose daughter was in the same camp. Once there, they met up with Tina Fredericks, who also had a daughter enrolled at the camp. In the village of Tenants Harbor, they took two rooms, with the three women sharing one, Allan taking the other; but Diane and Allan had Roberta photograph them, posing for the camera together, and when visiting day was over, they dropped Tina and Roberta in Rockland and borrowed the car to travel on their own farther north. Diane had acclimated herself to her husband's extramarital relationship, so much so that when he and Zohra appeared in the movie *Hey, Let's Twist,* she took screen shots of her husband and his lover in early 1962.

The durability of the Arbuses' conjugal ties finally exhausted Zohra's patience. In 1963, she ended the six-year affair. In the course of it, Allan had periodically exulted in how long they had been together, but she couldn't share in the self-congratulatory mood. Ashamed of dating a married man, she mistrusted his avowals as long as he remained wedded to Diane. Every third day, he would go see his daughters and wife. "I didn't think the separation was meaningful," Zohra said. "They were still connected." The relationship ended after Zohra received a Tony nomination for her performance in *Mother Courage and Her Children* in

1963 and refused to allow Allan to escort her to the ceremony at the end of April. "I said I didn't want to be seen with him," she recounted. "I think he was very hurt." It bothered her, too, that he wanted so badly to attend this glamorous event. Suddenly, everything that troubled her seemed to glare in sharp focus. Rather than issue an ultimatum, she simply announced that she was through. "I didn't want to be that anymore," she said. "I didn't want to be an ensemble." Angry and bitter, Allan refused her offer to remain friends and told her that living well was the best revenge. A little while later, he began a relationship with another young actress, Mariclare Costello, whom Zohra had brought to Rostova's class. Mariclare, unlike Zohra, accepted Allan's marital tie, and she became close to Diane, too. Mariclare joined Allan at the brunches on Charles Street. Her romance with Allan would evolve into marriage, and their bond lasted half a century, the remainder of his life.

After David's death, Gertrude returned to her apartment in Palm Beach. For Diane, the resort town lost much of its restorative power with her father's passing. Even though she derided his surface of unflagging optimism, she had taken periodic shelter beneath it. She could repair to her parents when she was windswept by shifting moods. At those times that she felt "tired and a little delicate alternately with being quite strong," she would slip back there into adolescence—"as if on instruction to do it all over again." On a visit to Palm Beach in April 1958, Diane told Pati she had so many things to learn that she hardly dared to open her mouth. She said she felt compelled to go swimming. "I need to submerge and come up again," she explained. "I wish to learn joy." It was vital to remember that her spirits oscillated like a pendulum. Any recognition of her talent, such as the Guggenheim Fellowship, could buoy her briefly, only then to push her down into an even deeper depression. But if she held her breath and waited, she would surface again.

In widowhood, Gertrude could attend sporadically to her

daughter's occasional cries of distress, but she was distracted by her own anxieties and her need to be entertained. She demanded more care than she gave. David Nemerov had assumed a traditional masculine role of reliable strength, for his daughters as well as for his wife. Upon marrying Diane, Allan inherited and extended that shield, and even after the separation, he was still Diane's most dependable ally. Marvin pushed her to take risks. Allan offered reassurance and protection.

And Then You're a Nudist

The first naked person Diane saw in a nudist colony was a man mowing his lawn. She thought, "How terrific!" It was "like walking into an hallucination without being quite sure whose it is."

Diane was in Sunshine Park in early July 1963, thanks to Marvin. He had read in a newspaper that this venerable nudist camp in southern New Jersey was engaged in a lawsuit; along with the news, the article included the name of the director of the park. Diane had secretly wanted to photograph nudists but didn't know how to make contact. Viewed as vaguely disreputable, or at the very least suspect, nudists usually avoided the spotlight. Like members of Alcoholics Anonymous, they addressed one another only by first names and acted dumb if they encountered each other outside their members-only preserves. Now she had a way to enter their circuit. She called the director and asked if she could come out and take pictures. Sure, he said. She arranged to stay for a week.

The director, her Charon into the naturist netherworld, met her at the bus station in his car. On the way over, he warned, "I hope you realize you've come to a nudist camp." Telling the story later, she would giggle and say, "Well, I mean I hope I realized I *had*. So we were in total agreement there." The naturist told her

that the moral tone of the colony was higher than in the out-
side world, because the human body was not so beautiful, and
stripping away its wrapping of mystery lowered lustful passions. If
that were not sufficient, penalties reinforced the elevated mood:
men could be expelled for unruly public erections, and either
sex might be banished for excessive or inappropriate staring. In
other words, you could look, but be discreet about it. All of that
amused Diane, yet, as she approached the entrance, she was ner-
vous. It seemed obvious that the only way she could photograph
nudists was in the nude.

Doffing her garments and working naked proved to be refresh-
ingly easy. "It just takes a minute and you learn how to do it, and
then you're a nudist," she said. While she wasn't able to transform
herself into a freak or an eccentric, this was one thing she could
be. Yet in a sense, she was never a nudist, because her critical
mind observed at a remove. She stood outside any scene, watch-
ing, at the same time as she participated. Perhaps that means she
was as much a nudist as she was anything else. This was another
role for her to play.

Very quickly she recognized that the nudists were not basking
in prelapsarian bliss, either. Even with their clothes gone, iden-
tifying marks of social status remained. The class-ridden nature
of this supposedly egalitarian society both tickled and troubled
Arbus. One of the nudists she met, a Sing Sing guard, told her
that he liked to play a game, an inversion of the pastime of men-
tally undressing an attractive person on the street. Looking at
naked strangers, he would guess what status they occupied in
the outside world. He was mentally dressing them. And he wasn't
going entirely on speech, stature, posture and other immaterial
signs. Notwithstanding their sartorial renunciations, the nudists
wore fashionable baubles. The women sported platform shoes,
rings and earrings. A few even carried pocketbooks. The men
could be seen in hats and shoes, and sometimes they went so
far as to wear socks. As they lacked pockets, they might tuck a
few bills and a pack of cigarettes into a sock. The vulgar style of

undress offended Arbus's fashion sense. "I mean it's really loathsome," she later said.

She had anticipated a hearty, health-oriented culture. Maybe that was true of Scandinavian nudist resorts. What she found in New Jersey was a place where mold proliferated and the grass didn't grow. On her first day there, she went swimming in a sluggish river. The mucky bottom sucked disgustingly at her feet. The water was tinted the color of root beer from fallen cedar needles. Prurient sightseers in speedboats zipped by to have a peek at the naked women. The living accommodations ranged from tents and mobile homes to houses large enough to qualify as mansions. The prevailing mode of interior decoration was laughable. "The pictures on the walls are mostly nudes, the flowers in the vases are mainly plastic, and the magazines on the coffee tables are largely girlie," she wrote.

Before long, she was fretting at how awkward it was to be a nudist. Why of all possible sports did they elect to play volleyball, in which you had to keep jumping up and down, and "if you're any size at all, you're always jiggling"? She considered the racial exclusions to be objectionable, and the inevitable lame witticism—"Why do black people need a tan?"—spread cheesiness over the offensiveness. After a few days in the nudist camp, the way of life began to weigh on her. She joked that she longed to "slip into something comfortable."

On her first visit to Sunshine Park, she stopped by the dining hall, which was built of logs in rustic style, and ordered a Coke from the young waitress working there. Before sitting on a barstool to drink it, she placed a towel over the seat. (One of the quaint customs of the nudist camp was that the residents and visitors carried a towel around with them for this purpose.) The waitress, Lorna Jahrling, had been informed that a New York photographer would be visiting the colony. When Diane asked about taking her picture, Lorna readily agreed. They walked outside, where the sandy ground was littered with bits of wood and cigarette butts. The session didn't last long. Arbus instructed

Lorna to strike several poses. "Step back and put your weight on that leg and the other leg forward," she said. Lorna had recently fallen off a neighbor's porch and suffered a large gash to her left shin. She was keeping the blemished leg back. She advanced it as directed and lowered her arms to her sides. She wore an organdy half apron, which contained a front pocket for her order pad. On her head was a silver headband. That was all she had on. A few days shy of her thirteenth birthday, she was budding small breasts. She had spent several summers with her family in Sunshine Park, and she gazed placidly and unselfconsciously at the photographer. After taking the picture, Arbus recorded Lorna's name and address. "In case I want to use it, I'll need your parents' permission," she said. Like a homeowner mowing his lawn, a teenage waitress in an apron would be a completely unremarkable sight. It was "peculiar," as Arbus perceived, "because it's just like only one thing is missing."

Arbus pitched the nudist idea to *Esquire*. Hayes generously provided an assignment and some expense money, even though, in the midsixties, there was no chance that a mass-circulation magazine would publish pictures with pubic hair and penises. Benton, in a failure of nerve, even backed out of a pledge to accompany her on an expedition to a naturist camp. Intrepidly, Arbus continued photographing nudists in posed and candid situations. The informal ones—of casual family groups, a mother with children, the despised volleyball matches—apparently failed to please her; she didn't print them. An unposed photograph of nudists around the volleyball net or amid their daily rounds might have been suitable for *Sunshine & Health*, the venerable naturist magazine started in the thirties by the director of Sunshine Park. Such a photograph would have documented the scene, and it might even have been funny. But Arbus sought a "peculiar" aspect that required an element of formality. It was essential for the viewer to recognize an established genre, in order to understand how nudity was subverting its conventions. Her picture of a retired middle-aged couple in a sunwashed summer cabin is set up like

any family holiday photograph; unusually for an Arbus picture, the seated subjects are looking at the photographer with composed smiles. But the one missing thing—clothing—makes the picture immediately comical. The man has his legs apart, with his genitals peeking out beneath a potbelly, while his wife has her hands folded demurely over her crotch. The slyest humor of the picture lies in the details. A picture of a nude pinup girl hangs on the wall. Two small family snapshots in frames on the television set depict the husband and wife individually—and, of course, each is naked.

What fascinated Diane about nudism was its banality. Although the photograph of the retired man and his wife is a comic triumph, Arbus's greatest nudist pictures evoke not the homey trappings of middle-class American life but the classics of Western art. As the gap between the nude pictorial ideal and the naked everyday truth is that much wider, the effect is more powerful. On a visit to a camp in Pennsylvania two years after her introduction to nudism, Arbus photographed an overweight family of three, sprawled on the grass by an empty stretch of road. The fin of their large car protrudes into the right edge of the frame. They are evidently part-time nudists, because the whiteness of the woman's exposed, lumpy torso contrasts with her tanned arms. She is wearing dark glasses. Her left leg is crooked upward, unintentionally bracketing the penis of her husband, who is just behind her. To their left (on the right of the photograph, closest to the car) is the daughter, the only one who is modest enough to be wearing shorts. The scene is a version of a fête champêtre, a theme that was lyrical when painted in sixteenth-century Venice by Giorgione, bracingly modern when reimagined in mid-nineteenth-century Paris by Manet and ludicrously contemporary when presented in mid-twentieth-century America by Arbus, who has drained the subject of all eroticism and grace.

Arguably her nudist masterpiece is a picture she took in New Jersey during her first week as a naturist, at Pine Forest, a camp a few miles down the road from Sunshine Park. Evoking both

biblical scripture and the Western pictorial tradition, *A husband and wife in the woods at a nudist camp, N.J. 1963* depicts a nude couple standing in an arboreal grove, with a few rustic cabins visible behind the trees. Compared to the nudists in Arbus's other pictures, they are fit and attractive. The woman's belly slightly protrudes, perhaps in early pregnancy. The man's body is smooth and athletic. Neither is looking at the camera. His gaze is steady and affable, hers is as unfocused as a dazed deer's. In dappled light and wooded setting, the nude couple, their hands clasped, recall Adam and Eve in a Renaissance painting. Indeed, Arbus once owned a postcard of a painting on this subject by Lucas Cranach the Elder, an artist she greatly admired, and the woman's convex stomach suggests the feminine contour favored by Cranach. But whenever Cranach depicted Eve, he showed her in the *contrapposto* stance, placing most of her weight on one leg—a posture that, since classical times, has been used to suggest balance and poise. It is the position that Arbus coached Lorna Jahrling to take.

This time, the photographer wanted something different. Her Eve flat-footedly faces the camera. On her feet she is wearing sandals, and on her fingernails, shiny polish. Further inspection reveals that Adam is holding a pack of cigarettes in his right hand, and the ground around the couple is littered with discarded wrappers. Reflecting on the tossed-away bottles and scattered bobby pins, oozy swimming-hole bottoms, puerile humor and flabby bodies that she encountered at the nudist camps, Arbus later wrote, "It is as if way back in the Garden of Eden, after the Fall, Adam and Eve had begged the Lord to forgive them; and God, in his boundless exasperation, had said, 'All right, then. *STAY*. Stay in the Garden. Get civilized. Procreate. Muck it up.' And they did." Her picture states her position as clearly as her words, and yet the frankness of the man's look, the far-off preoccupation of his wife, the affection of their clasped hands, the tenderness of the light—all the specifics of the photograph drape the message with strands of ambiguity.

It's Not Like You're Acting

In the Roman Catholic church on Fifth Avenue, everything was comme il faut for Paola Bianchini's baptism in fall 1963. As a ritual of the social elite, the ceremony fell nicely within Diane's Guggenheim project; but this was an intimate family occasion, and Pati did not welcome Diane, who had not been invited, intruding with a camera—especially if Diane arrived with a preconceived premise, as Pati believed. For the ceremony, Pati wore a plain gold dress; her husband, Paul, was totally outfitted in Brooks Brothers; and the godparents, too, were handsome models of upper-class propriety. "Paul and the priest were the only Catholics, but we all did as well as we could," Pati remarked. Officiating, the priest donned a surplice and held the blond child, her arms outstretched, above the basin. The only discordant element was the babysitter, a girl from Puerto Rico or Cuba who was dolled up in florid exuberance, as if she were attending her *quinceañera*. Although the babysitter wasn't participating in the baptism, Pati cunningly invited her to join the family on the dais. Diane took some pictures, but Pati could detect her friend's dissatisfaction. Eventually, Diane inquired whether the girl might be asked to step down and sit in a pew for a minute. "No, I can't do that, it would hurt her feelings," Pati said. The babysitter never left the group.

Inwardly, Pati exulted in her victory. The scene made her think of a studio sound stage in which a character from the set of a movie musical had mistakenly wandered into a staid drama, noisily clacking her heels. "It ruined the picture of this New England family having its picture taken and each one playing the part perfectly," she judged. The photograph Diane wanted "was a picture made in heaven, but it was a sociological picture." It was, to Pati's mind, like the portrait that Diane connived to take of her wearing a Burberry raincoat outside Central Park, but this time, the intended prey thwarted the raptor.

Arbus was busy. In addition to the ceremonies and rituals she was recording for her Guggenheim Fellowship, she executed frequent assignments from *Esquire* and *Harper's Bazaar.* Although Benton left his position as the *Esquire* art director around the end of 1963 to take up screenwriting, his departure didn't diminish Arbus's popularity there any more than Israel's dismissal had harmed her at *Bazaar.* In a mere three years she had established a reputation as a journalistic portrait photographer of uncommon originality and depth. Sam Antupit, who succeeded Benton, said that Arbus was one of two photographers the *Esquire* editors considered for virtually every story. "Sometimes she couldn't do it and we would have to find someone else," Antupit said. "Then we would never assign it in that kind of vein. We never looked for someone to do an Arbus kind of photograph. We would just rethink the thing." When she came by the office, he or another editor would float an idea past her. "And she wouldn't say, 'I would like to photograph that,'" he recalled. "But if her eyes lit up, she got it. If they didn't and they glazed over, we passed by." In retrospect, he thought that reflexively going to Arbus was "so guaranteed a success that it was laziness."

Doon left home that fall to attend Reed College, a liberal arts college in Portland, Oregon, known for its bright, independent-minded students and its atmosphere of nonconformity, rebellion and permissiveness. To help look after nine-year-old Amy, Diane gave Doon's vacated bedroom to Suzanne Victor, nicknamed

"Sudie," a recent student of Howard's who had moved to New York to start an entry-level job at Random House.

Diane's work required her to travel. In early February 1964, she visited New Orleans and photographed Mardi Gras, although the only picture she printed was of a New Orleans lady bartender whose astounding hairdo—blond bangs, horizontal braid and exuberant beehive—is echoed drolly by a ruffled poodle figurine on a baker's rack. Arbus particularly enjoyed drawing out a likeness between a subject's signature style and some rococo tabletop tchotchke. For *Harper's Bazaar* in 1965, she photographed Mrs. T. Charlton Henry, an elderly Philadelphia socialite who boasted an even more extravagant bouffant coiffure, on an order of sumptuousness rarely seen since pre-revolutionary France. The picture was shot in Mrs. Henry's grand home, where Arbus placed her, gloriously adorned by strands of pearls around her neck and wrist and a beaded Balenciaga dress. Positioned between a cut-glass vase with two frilly peonies and a venerable Chinese figurine lamp with a fringed parasol shade, Mrs. Henry looks as antique—tasseled, lacquered and bloodlessly refined—as her bibelots.

Arbus had made her greatest portrait of a person possessed by her possessions earlier, without an assignment. In spring 1963, she discovered Betty Blanc Glassbury, a widow who lived near Carnegie Hall. Mrs. Glassbury was an upper-middle-class alter ego of William Mack, the hoarder of street finds who appeared in "The Full Circle" in *Harper's Bazaar.* An artist, poet and one-time president of the ASCAP music licensing association, she inhabited a spacious apartment that she had filled to overflowing with her collection of primarily Asian art. Chinese screens and floor-to-ceiling drapes blocked the light from the windows, a huge Buddha kept vigil by the grand piano, and Tibetan paintings hung on the walls. In her bedroom, she sat for Arbus's photograph between an enormous Chinese vase on a wooden stand and an ornate dresser that was crowded with figurines and painted dishes. Amid all these treasures she also kept old radios and cheap wastebaskets. Arbus loved this ecumenical atti-

tude toward her things. Mrs. Glassbury was an affluent woman who took her meals at the Automat. She was a woman guided by her own tastes. In that, she was the opposite of Gertrude Nemerov, who was widowed at about the time—perhaps in the same week—that these photographs were made. Arbus said she was "terrifically moved" that Mrs. Glassbury did not care that some of her things "are valuable and some come from the Five and Ten." Yet Betty Glassbury seems as defined by what she owns as Mrs. Nemerov. In the photograph, she wears a shiny lamé dress, matching high-heeled shoes, a heavy bracelet and necklace, and a stiff bouffant hairdo. Awkwardly seated, she looks uneasy. But who could relax in this bedroom? Everything is on display.

From the beginning, Arbus was drawn to photographing gewgaws and trinkets. Her earliest experiments with a Rollei, around January 1957, were of cheap glistening merchandise in a store window; she was probably investigating a larger format in order to register greater detail in these baubles. She had a more complicated ambition now that she was incorporating a person's possessions into a portrait, and her goal was very different from what August Sander had in mind. Sander would include a pastry chef's mixing bowl or an industrialist's massive desk to communicate the social position that the person occupied. In an Arbus photograph, the details of a home setting are more apt to comment on an individual's unique identity.

In February 1964, on the way home from New Orleans, she stopped in Baltimore for two *Esquire* commissions. In one, she photographed the outspoken atheist Madalyn Murray standing with a forthright expression in her Victorian bedroom, her mouth half-open and her right index finger pointing, evidently in the midst of imparting a strongly held conviction. Also in Baltimore, Arbus met Tom Morgan to photograph Blaze Starr, a stripper he was profiling for *Esquire*. "We talked and talked and talked," Starr recalled. "She just kept shooting." The magazine published two Arbus pictures. One shows Blaze at the club, her wrapper open to reveal one breast. Her face, divided between

light and shadow, is even more nakedly exposed than her body. Of the many photographs taken during her show business career, this would be Blaze's all-time favorite. The other picture *Esquire* ran is of the stripper at home. Starr took Arbus into her walk-in closet for suggestions on what to wear. "Whatever you're comfortable with," Diane said. "Just be yourself, be natural. That's what I like about you. It's not like you're acting." Within those parameters, as Blaze explained, "I wanted to make sure I looked good, so I wore skintight clothing." In stretch gold lamé pants and clingy white blouse, she strikes the same pose as she had in the burlesque joint, but this photograph—of the entertainer, her pet toy poodle (which wandered unsummoned into the frame) and a large statue of the Buddha, all on a vast, foliage-patterned carpet—is like a campy illustration in a manual on how to keep passion alive in a marriage. Just as Madalyn Murray was always talking, Blaze Starr was always posing. Counterintuitively, she was viewed in a stagy stance at home and in an introspective state at the club. The Starr photographs cinched Arbus's status at the magazine. "We used to talk about doing somebody 'in the Blaze Starr style,'" Antupit said. "Which is really absurd because it's just two pictures, it isn't a style."

Starr and Murray were independent women whom Arbus evidently liked. Shortly after she returned to New York, *Esquire* brought her in to photograph a less appealing subject: the mother of President Kennedy's assassin, Lee Harvey Oswald. The shooting in Dallas had occurred a few months before. The passage of time would reveal it to be a harrowing overture to years of turmoil, violence, iconoclasm and uncertainty; it might be said to have inaugurated the sixties in America. Arbus's only pictorial comment on the assassination at the time was this oblique one—a portrait of Marguerite Oswald. Mrs. Oswald puzzled her. Instead of portraying the matronly figure at home, where she might have recorded some information about her tastes and interests, Arbus saw her in the magazine offices, with only a half hour at her disposal. Mrs. Oswald had sold the magazine the rights to a series of

letters that Lee had written to her from Russia, and her portrait would illustrate the piece. Arbus couldn't understand why she seemed so smug and self-satisfied. Looking into the viewfinder, she observed that a smile never left Mrs. Oswald's lips. "What does she have to be so pleased about?" Arbus wondered. Mrs. Oswald's look of pride and authority reminded the photographer of the mother played by Angela Lansbury in the 1962 movie *The Manchurian Candidate*. It was as if, like that character, Mrs. Oswald had manipulated her son into pulling the trigger.

A subject who would not drop the mask of imperturbable good cheer was Arbus's deadliest antagonist. At least with Mrs. Oswald, the incongruity of the smile said something. Things were worse on an earlier *Esquire* assignment with Tom Morgan, photographing the Random House publisher and quiz show panelist Bennett Cerf. Arbus was so discouraged by her first sitting that she "did this kind of dumb girl business" and begged for a second opportunity. "It *is* one advantage to being a woman," she remarked. When Cerf granted her request, she showed up in the morning at his town house and waited while he ate his breakfast with the newspaper in front of him. At last, he was ready for her. He lowered the paper and looked out, with the implied command: "Now!" Helplessly, she regarded his face, which she thought "was incredibly like it was his ass, because it was so sort of round and blank." Her picture was unedifying, but it was no worse than Morgan's profile of the self-congratulatory, exuberant, pun-happy Cerf, whom Morgan described, unpromisingly, as being averse to "any public inference that he might have a profound or painful thought." After publication, Morgan admitted, "I still don't know what makes him tick." Neither did Arbus.

What she most sought (and Cerf resolutely refused to provide) was a glimpse of a hidden truth, particular or transcendent. The picture of vacant-eyed, bare-breasted Blaze had it, and so, in a different way, did the portraits of the New Orleans bartender and of the elderly Mrs. Glassbury and Mrs. Henry. In each of these photographs, Arbus, by looking very closely, penetrated the

exterior to bring out an underlying reality—or, to put it more accurately, brought to the surface a reality that she could then capture. Sometimes a flicker of the mythic was lying out there in plain view for anyone with eyes to see it. Arbus was in the lobby of a New York building very soon after returning from Baltimore in early 1964, and noticed a reproduction of a fifteenth-century Flemish portrayal by Robert Campin of Christ delivering a blessing. Brightly lit, the face of Christ gleamed in this incongruous setting, and his raised index finger might have been poised to turn the page of an open book on the ledge below him. Even more strangely, a reflection of the image shimmered on an adjacent shiny wall, as otherworldly as the outline on the Shroud of Turin. Both comical and eerie, Arbus's photograph is a counterbalance to her Levittown Christmas scene. In that celebration of Jesus's birth, not a religious element enters; yet here, amid chilly Manhattan marble, she located a spark of the divine.

To Know People,
Almost in a Biblical Sense

Returning to Southern California in August 1964, Arbus photo-
graphed two over-the-top women who, on divergent paths, were
in pursuit of the divine.

She stayed again with Robert Brown and Bunny Sellers, back
now in their Malibu home. Sellers, acting as primary chauffeur,
drove Arbus up to Santa Barbara to visit the self-styled bishop
Ethel Predonzan, who had moved from Astoria, Queens, in the
belief that God would appear in California on December 4. Pre-
donzan's ingenuous inquiry about *Esquire*'s interest in spiritual
matters had led Harold Hayes to drop Arbus's assignment on
eccentrics a few years before, but that incident did not rupture
the tie between the two women. Sellers marveled at Arbus's ability
to relate to Predonzan, who spoke effusively about her previous
lives and her religious prophecies. "It was hard to know how to
talk to her," Sellers said. "Diane had a thousand cameras around
her neck and seemed weighed down. Her stance was very sub-
missive. At the same time, there was such dignity about her. She
was able to go beyond the language. Much of what she did was
without words." On a flower-dotted cliff overlooking the Pacific,
Arbus photographed the blissfully smiling bishop in floor-length

damask, sporting a tiara and holding a large foam cross. Predon-
zan also posed at home, hands clasped and eyes raised, beneath
a wall hanging of Jesus with his hand lifted in the same blessing
position as in the Campin painting (although rendered without
the magisterial prowess), and in her bedroom, which was so fem-
inine that even in black-and-white it reads as pink.

Watching Arbus with Predonzan and other eccentric subjects,
Sellers, who in later life worked as a psychotherapist, observed how
she established instant intimacy. Diane behaved with these odd
folks as she did with everyone—indeed, as she had put Sellers at
ease the evening they met in the Arbus kitchen. Diane made the
people posing for her "feel that they were wonderful and every-
thing about them was important." She also resorted to certain
ploys. She would, for instance, ask an unexpectedly specific ques-
tion that presumed a preexisting familiarity and an overarching
concern. "Have you always worn glasses?" she would say, and her
new acquaintance felt as if she really wanted to know the answer.

Yet, beyond a palpable respect and a few basic techniques,
Arbus evoked a response from her subjects, especially the social
misfits, in ways that seemed like sorcery to other photographers
who watched her work. The previous summer, Joel Meyerowitz,
who had been photographing for only a year, drove her to the
Catskills to spend a day shooting in the Borscht Belt hotels that
catered to a New York Jewish clientele. At Grossinger's, after
checking out the shuffleboard players, the mambo and tango les-
sons, and the swimming pool with an underwater window, they
took advantage of Meyerowitz's prior connection to the steward
and went into the kitchen for a staff lunch. As they ate at a long
refectory table, a man took a seat opposite them and, with his
head down, shoveled food into his mouth. Almost immediately
he began talking to Diane, discussing his astrological sign and
revealing that he was planning to conceive a child on a specific
date because he wanted a baby boy who was born under an aus-
picious planetary influence. "I realize Diane is staring at him in
total absorption, she is drinking him in," Meyerowitz recalled.

"She has a way of listening or being that is so vulnerable that people will want to tell her something. Whispering, nodding, letting the other person know she understood." When lunch was over, she asked if she could photograph him. "He just got up and went with her and he was available and docile and open," Meyerowitz said. "She barely connected with him then, he was already in her web." She looked down at the Rollei. The important work had taken place; now she simply clicked the shutter. "She was an emissary from the world of feeling," he said. "People opened up to her in an emotional way and they yielded their mystery."

Perhaps the absence of her own direct feelings gave her the space or the need for exceptional empathy. Certainly, establishing a special connection was the key to her portraiture. She faced a daunting challenge when she went to photograph the notorious woman who, along with the bishop, brought her to Los Angeles in the summer of 1964.

Mae West was the lady in question, and the job came from *Show*, the magazine that had furnished the less fertile assignment of a shoe commercial a couple of years previously. Learning that Henry Wolf had left *Show*, Arbus, without an appointment, paid a call on the new art director, Nicky Haslam. He looked up to see "a beautiful waif, slinging her sandals." She sat on his desk and said, "I'm Diane Arbus. I worked for Henry Wolf and I'd like to work for you." She charmed him. He assigned her the Bishop and Mae West.

To produce pictures that were telling and surprising, rather than the standard shots of a sassy temptress, Arbus needed to peek behind the caricature that West had invented. The living legend lived by the ocean in Santa Monica, not far from the Browns in Malibu. Robert drove Diane to her appointments on two days and waited for her at the house while the women created the pictures. Having just celebrated her seventy-first birthday, West still displayed her trademark blond tresses, lacy lingerie and knowing smirk, but her face was spiderwebbed with wrinkles, and each furrow and fret was highlighted on Arbus's black-and-white film by the merciless Southern California light. Shooting

in color as well, Arbus showed West in her large off-white bed, dressed in pink froufrou beneath a pink satin canopy, grinning as she played with one of a pair of pet monkeys.

Emerging from the house on the first day, Arbus was breathless with excitement. "You know what we did most of the time?" she told Brown. "She's got a locked room with models in plaster of all the men she's had sex with—of their erections. She's got these things in cement." After the next day's session, Arbus emerged and said, "Drive away fast." She opened her hand and showed him two or three hundred-dollar bills. "She tipped me," she said. "I can't take it. She thinks they're going to be glamorized." And of course, they were not. According to Allan, West hated the pictures when they were published, "because they were truthful."

Providing *Show* with text as well as pictures, Arbus portrayed a sex goddess in her sunset years. "Men are my kind of people," West proclaimed in her brassiest manner. "I was once asked what ten men I'd like to have come up and see me sometime. Why ten? Why not a hundred, a thousand?" She said there was "a man for every mood." Arbus, perhaps in the afterglow of the bishop's oratory, inquired about West's spiritual side. The actress said that she occasionally heard voices and discerned visions, and one time had detected a deep manly voice speaking to her in the diction of a bygone day; but she characteristically spiked the admission with a joke. "I knew that in some marvelous way I had touched the hem of the unknown," she said. "And being me, I wanted to lift that hemline a little bit more."

Arbus noted, with what sounded like envy, that West through-out her many love affairs "seems never to have suffered or yearned or pined like most people do." Having recently turned forty-one, Arbus lacked the impregnable confidence in her own appeal that was radiated by this woman thirty years her senior. West took for granted that her charms were irresistible. Arbus, who required continual reassurance, had placed herself in the punishing position of falling in love with a man committed to his marriage. That she had entered into her relationship with

Marvin fully aware that he had a wife about whom he spoke with pride and affection did not insulate her from feeling neglected.

Diane's uneasiness at her lover's unreliable attention had deepened when Margie Israel suffered a mysterious and persistent psychological collapse in 1961 and required Marvin's care. In the summer of 1963, he took Margie with him on a fashion shoot in Paris and then traveled with her to the Aran Islands, where his former student, Patricia Patterson, was living. Urging Patterson to resume her painting in New York, the Israels brought her back with them, installing her for three months in Margie's ground-floor studio to get settled. To earn a little money, Patricia sometimes tended the children of Robert and Mary Frank. Margie was admitting virtually no outsiders during this period, and Mary was one of the friends she avoided. "You could babysit for her, but I don't want you to bring her here," she said. Mary, who liked and greatly admired Margie, would ask Marvin about his wife's condition. He rebuffed all inquiries. "He would make it clear that he was not going to say anything about her or tell you how she was," Mary recalled. When Margie did eventually emerge from this self-imposed purdah, she seemed to have changed. "It was impossible to refer to anything with the slightest sadness in her presence," Mary said. "If you started to begin a sentence that was going to be about something that was not okay, she wasn't there." She hid behind a protective wall that Marvin diligently maintained. Diane was always sharply aware of Marvin's wife, but Margie—as far as any of her friends could tell—was ignorant of her husband's love affair with Diane.

Although Diane lost Alex when he fell in love with Jane, she did better with the other central men in her life. She outlasted Allan's six-year affair with Zohra, and settled into a friendly relationship with Zohra's successor, Mariclare. Despite everything, Allan remained under her sway. And so, too, did her older brother. Howard would move from Bennington to several other colleges and then to a professorship, held until retirement, at Washington University in St. Louis, where he lived with Peggy

and their three sons. His reputation was rising. He eventually garnered almost every accolade an American poet can receive, including a Pulitzer Prize and an appointment as poet laureate of the United States. Yet he hugged to his shoulders a cloak of melancholy, dwelling on disappointments rather than triumphs, exuding what his son described as "a guilt and sorrow wont to cover the world in snow and ice." His drinking became more copious, his philandering more obvious. His connection with Peggy appeared to be both enmeshed and detached. One of his students would see them go bird-watching hand in hand. Clearly they were close, but she wondered how to square that with Howard's well-known extramarital affairs, which were much talked about on campus. Peggy, an innocent lower-middle-class Englishwoman when she married, had parachuted into terrain that was as foreign psychosexually as it was socioeconomically. But as far as her sister-in-law was concerned, she manifested ignorance. She denied that Howard regarded Diane with special affection. She told a writer, after the siblings were dead, "We didn't know her, we never saw her, there's nothing there. Howard never thought about her or cared about her." It was a willful refuting of a confluence that ran like an underground stream.

Yet it mattered little that Allan and Howard remained in Diane's thrall if Marvin, having commandeered the dominant place in her life, stubbornly eluded her. There was no denying that his chief allegiance was to Margie, and regardless of how Diane rationalized the situation in her mind, it still burned corrosively. Mary spent a day with her in Coney Island when Diane was obviously depressed, and although she talked indirectly, Mary understood that it was Marvin's unavailability that made her unhappy. "A desire to be cared for, if not taken care of, is a very human instinct," Mary remarked. "Marvin could not have given Diane that feeling."

Instead, he provided a deep comprehension of her talent and goaded her onward. "Marvin was manipulating her to go further and further into dark subject matter," said Deborah

Turbeville. "The more strange, the better, for Marvin." When he interacted with his many protégés, Marvin was always directing, but at the same time—and this was particularly true of his relationship with Diane—he was leading in a dance, not pulling the strings of a puppet. Even before meeting Marvin, Diane wanted to explore forbidden territory. Sharing that desire, Marvin could supply encouragement, offer suggestions and make telling criticisms. "When an artist discovers someone who understands her work that well, she becomes dependent on him," Turbeville said. "She has to."

The similarity between erotic adventures and photographic assignments was something Arbus remarked on. She said that when she first took up photography, she thought of it as "a sort of naughty thing to do" and "very perverse." Going off to photograph a stranger reminded her of heading off on a blind date. She was queasy until she arrived at the rendezvous. And then a different feeling took over. Walking into a strange house that had a preexisting history always thrilled her. It was exciting whether she was there to take a picture or, tiptoeing past the wife's slippers in the bathroom, to engage in a sexual tryst. The titillation of being somewhere she shouldn't and seeing what was secret powered her photographic and erotic missions alike. "I tend to think of the act of photographing generally as an adventure," she said. "I mean my favorite thing is to go where I've never been."

One of the street characters she befriended was Moondog, a long-bearded beggar musician who stood on Sixth Avenue and Fifty-Fourth Street in a horned Viking helmet with cape and hood of scarlet velvet and a six-foot iron spear, holding a hollow moose hoof to accept donations. Blinded by an accidental explosion when he was sixteen, Louis Hardin Jr. was a gifted, pioneering composer (his minimalist music was much admired by younger musicians, including Philip Glass and Steve Reich), but his most original creation may have been his own persona. His costume, his reverence for Norse culture, his choice of the name Moondog—he made all of these decisions with careful

deliberation. He was a blind visionary, and Diane could not help but be impressed. As she told Marvin, "Moondog's faith is other than ours. We believe in the invisible and what he believes in is the visible." She knew Moondog well enough to introduce him to Mary Frank. Indeed, she knew him better than that, because in the summer of 1964, he allowed her to accompany him home one night to take pictures. He lived at the stinking, derelict Aristo Hotel on West Forty-Fourth Street at Sixth Avenue. Before reaching his cockroach-infested room, which was barely big enough for a mattress, you could expect to climb over two or three passed-out drunks. In the end, it was too dark and Arbus got an adventure in Moondog's room rather than good photographs.

However, simply crossing the fence of decorum didn't satisfy her. She needed her trespass to provoke a response, and her photographic portraits and sexual assignations were alternative ways of achieving affirmation that she was alive and real. Because of his blindness, Moondog wasn't an ideal subject for Arbus. He couldn't engage in the reciprocity she sought, in which she was seen as well as seeing. She was shooting with a Rolleiflex held at waist level, her face open to view. And because her presence was so seductive, her photographic subjects, like sexual conquests, respond: lustful, bashful, curious, leering, complicit, knowing, uncomfortable— the reactions vary, but the pictures are erotically intimate. For the viewer, coming up this close to the people Arbus photographed can be, as Szarkowski said, "shocking, in the best sense of the word." He explained, "She wanted to know people, almost in a biblical sense. It was knowledge she wanted, not just to make a good picture. The picture was a proof of the knowledge."

An Element of Torture

During the fall of 1964, Arbus was photographing young Puerto Rican women, in their neighborhood on the Lower East Side or at the Puerto Rican Day celebrations in Central Park (which she had been attending at least since 1962). In their faces, she often saw anger and hostility. Like many women of her background, Arbus had difficulty expressing those emotions, so she may have been intrigued by a culture in which female fury simmered on the surface. Rage viewed in close-up in a photograph is disconcerting. It appears to be directed at the spectator. Distorting the features of a beautiful person, the anger is also unexpected, like a lubricious leer by someone ugly or deformed.

Arbus was pursuing pretty Puerto Rican women as part of an ongoing project she called "ethnic beauties." In American society at the time, membership in a minority group cast a shadow over beauty; it was like an asterisk affixed to a record-breaking athletic season. Furthermore, in whatever form it came, great physical attractiveness could be a stigma, Arbus suspected—"an aberration, a burden, a mystery, even to itself." (The same might be said of enormous wealth.) In August 1965, under the catchier name of "Minority Pin-ups," Harold Hayes approved Arbus's story proposal and assigned her to do the photographs and text for an

Esquire piece on ethnic beauties. Along with the Puerto Ricans, she photographed a girl named Sharon Goldberg, who was wearing a Star of David pendant ("so the boys will know I'm Jewish," Diane reported her saying). Although Sharon was a pretty girl, the flash of Arbus's camera mercilessly illuminated the coarse dark hair that covered her bare arm from shoulder to wrist and the meticulously manicured long fingernails that gleamed like talons.

Arbus had borrowed, probably in 1964, a Mighty Lite handheld flash from the photographer Larry Fink, another former student of Model; she kept it for the rest of her life. When Fink used flash, the contrasts between the inky blacks and brilliant highlights are harsh and graphic. In Arbus's hands, Fink said, "the flash would come out in very silvery ways," but it exposed details with forensic zeal.

In her photographs from this time, Arbus also focused on privileged subjects who do not, in her portrayals, inspire envy. *Harper's Bazaar* awarded her numerous commissions to depict the well-off. "It was clear that she was always hard up for money," said Ansel, the co–art director. "We always tried to give her assignments so she could have a paycheck." Rather than assign her the fashion stories that were the magazine's heart blood, *Bazaar* had Arbus do feature subjects. Often, she worked for Turbeville, later to become an innovative fashion photographer, who was editing a section called The Fashion Independent that highlighted personalities, not clothing.

The first Fashion Independent assignment from Arbus that *Bazaar* published was on young heiresses. The category fit within her amorphous "Silver Spoon" series. "She came and said she wanted to do debutantes," Turbeville recalled. "They were anything but. They were all strays." In fairness, they were pedigreed strays, such as the model Penelope Tree and the actress Sally Kirkland; but still, they were offbeat rebels, not the usual society girls. The editors preferred Arbus's pictures of more conventional young ladies, although they did publish a full-page portrait

of Mia Farrow seated at the edge of a bed, wearing lingerie and looking exquisite.

Turbeville, who accompanied Arbus on some of her photo shoots, found them interminable. They dragged on so long that she and her assistant would surreptitiously remove some rolls of film from Arbus's camera bag to bring things to an end. "She would try to wear people down," Turbeville said. "They just stood there looking wilted." Along with exhausting her subjects, Turbeville thought Arbus was also stoking up her own enthusiasm. "Diane had to make things interesting for herself and make these people more of an icon than they were," Turbeville explained. "She would build up a story about them. That's why it was so frustrating to be on a sitting with her. It was an endurance process, while she tried to get herself excited and then to get a response from them. She would ask them questions. She would reveal something about herself and hope these people would react and then she would go from there and get more and more intimate until she'd slam a home run. She was trying to get as passionate as she could about the subject matter before her." It was a mutual seduction that took time to unfold.

Bazaar had her photograph a group of accomplished married couples in late 1964 and early 1965. She scheduled those sittings in between sessions with parents and children that she was doing for *Esquire.* Her attention was so directed toward families that there was a certain coherent logic, however accidental, when Robert Benton, who was getting married, asked if she would take the pictures at his wedding. "It was my idea, because I loved her and I thought, whatever it is that was true of me that I wasn't aware of, I was going to see in those photographs," Benton recalled. The ceremony took place at the Little Church Around the Corner, a Manhattan house of worship that had a reputation for welcoming actors and other slightly disreputable congregants. Despite those bohemian credentials, Benton's wife, Sallie, was unprepared for the pictures that Arbus delivered. Although Diane fastidiously

chronicled all the stations on the nuptial path, everything seen
by her wide-angle lens and her off-kilter eye appeared a bit awry.
"She took a picture of us coming down the aisle, right after we
were married," Benton said. "Sallie thinks we look like dwarfs,
but we don't. It's just that she shot us from above. She caught this
sort of smile on our faces." It was an intimate moment, witnessed
drily. "Sallie didn't know Diane or Diane's work," he said. "What
I expected is what I got. I don't think I ever braced her for the
work." Sallie hated the photographs.

The married couples that Arbus captured for *Bazaar* were a
mixture of people she knew and celebrities or socialites that the
editors proposed. The conductor Herbert von Karajan with his
pretty young wife fell into the second class. She photographed
him in haughty aquiline profile, hair swept back and nose jutting
forward, with the blond Eliette facing the camera, doe-eyed and
smiling. "Diane hated von Karajan," Turbeville said. "It's subtle,
but I think it's there." The photographer's viewpoint is more obvi-
ous in her portrait of Howard Oxenberg and his wife, the former
Princess Elizabeth of Yugoslavia. "Marriage has to have its impos-
sible moments," Elizabeth Oxenberg is quoted as saying, in the
picture caption. "Otherwise, it would be a crashing bore." The
Oxenbergs are shown seated together on a sofa, Howard in black
tie, holding a brandy snifter, looking intensely at the camera with
faint displeasure, and Elizabeth, in chiffon, staring with glazed
ennui. Undoubtedly they had been posing for hours.

The magazine editor Clay Felker, who had left *Esquire* for the
New York Herald Tribune, recalled outlasting Arbus as he stood with
his wife, Pamela Tiffin. "It took a long time and I knew what she
was attempting to do and I refused to cooperate with her," he said.
Arbus asked them to hold a position and keep smiling. He felt that
she was waiting for them to relax and rearrange their expressions.
It became a battle that he reckoned he won, because *Bazaar* did
not run the picture, which he hadn't wanted in the first place.

Arbus was greeted with greater cooperation when she arrived
at the East Village parlor-floor apartment of another couple she

knew, the journalist John Gruen and his wife, the painter Jane Wilson. Even though Gruen would need to make an appearance at his office at the *Herald Tribune* on West Forty-First Street, Arbus asked to come at eleven in the morning. As an artist, Wilson understood that the light in the room, which faced Tompkins Square Park, was best at midday. They asked beforehand how to dress, and Arbus said, "Very glamorously." Gruen put on an English suit, and Wilson, who modeled part-time, chose an elegant Geoffrey Beene gown with polka dots and ameboid shapes. Arbus arrived in a white cable-knit sweater, with her Rolleiflex around her neck. Her voice was a whisper, requiring them to listen closely. "Very unintimidating," Wilson thought. "Not a shred of glamour or pretense." Arbus asked the couple to stand close to her, between the two tall, sun-flooded windows, with an empty side chair placed in front of each window. She kept telling Wilson how beautiful she looked. She asked her to move close to Gruen and to shift their positions. Once she was satisfied, she had them hold the pose for fifteen or twenty minutes, which is a very long time to stand in place. After a short break, she would say, "Okay, assume the same pose, please," and have them maintain it for a quarter hour more.

The session went on and on. They took a time-out for lunch, which Wilson served, and then went back to it. The afternoon advanced, and Gruen was becoming worried. "Diane, I have to go to work," he said.

"Oh, John, this won't take much longer," she said. "Can you call to say you will be a little late?"

It felt sadistic. His wife was tired, and he was going to be missed at his office. "There was an element of torture in photographing us," he reflected. "It came out after three or four hours. She seemed so nice. Why was she doing it to us? And why were we allowing it to happen?" He thought of it as a kind of strange drama or, in psychoanalytical terms, a reenactment in which each was playing a part. "She seemed so passive," he said, "and when she came to see us, we were utterly passive and she was aggressive."

She acted the same way when she visited Frederick and Isabel
Eberstadt, whom she knew even better than the Gruens. Indeed,
Isabel was a good friend. The Eberstadts invited her to lunch
at their apartment at Seventy-Fourth and Park, with Freddy
interrupting his normal routine to come home from his West
Fifty-Sixth Street photography studio. He was already annoyed
at the inconvenience. His ire increased when she wouldn't leave.
"Finally, I was pushing her out of the house and she kept snap-
ping," he recalled. "The last one she took is the one she used. I
looked frustrated and Isabel looked drunk and perhaps embar-
rassed by my behavior." Arbus had chosen from Isabel's closet a
pale Courrèges pantsuit for her to wear. "Isabel's skin was very
white, and it looked even whiter against that color," Turbeville
recalled. "She looked like Morticia." Freddy hated the picture.
He has a glass of wine in his hand and a stony expression on
his face, while Isabel, her gaze blurry and apologetic, tilts into
him for support. "It caused a good deal of trouble," Eberstadt
recalled. Arbus had excavated the truth—or *a* truth—as she saw
it, but in Freddy's view, the portrait did not accurately depict the
Eberstadts.

In contrast, the Gruens, having suffered through the process,
marveled at the result. In the picture, Jane leans into John with her
hands grasping his elbow, while John looks straight ahead, his left
hand holding a cigarette by his side and his right extending across
his waist. They often stood that way when they were alone.

"I thought it was very elegant and very telling and more reveal-
ing than I would have liked it to be," Jane said. "She could connect
to the inner motivations. She had this instinct to dig into what con-
nected two people. She got it by moving people around physically
until they fell into a position for the camera that showed what she
was feeling, that felt like an instinctual relationship, not a pose."

"She wasn't telling the greatest love story ever told," John said.
"We do love each other, but there are some other floating feel-
ings that we harbor toward each other, and she wanted to find
that out. Things that are not voiced come out."

Arbus would do whatever was necessary to produce a photograph she desired. As Harold Hayes had intuited when he requested the return of her press credentials, she didn't scruple when it came to obtaining access. While doing the project on married couples for *Bazaar,* she enlisted Turbeville's assistant, Mary Louise Mullin, to call Jayne Mansfield's agent to arrange for a sitting. By that time, having descended from glamour into bathos, Mansfield was not a subject that the editor of *Bazaar* would ever assign. "She said, 'I need to have a magazine behind me to go to her,'" said Turbeville, who did not learn of it until after the session. "Diane did them for her own portfolio." For her part, Mansfield, thinking the session would approximate Bert Stern's erotic shots of a tremulous Marilyn Monroe in *Vogue,* was perplexed but compliant when Arbus had her put on an old nightgown. A poignant picture of Mansfield, her eyes heavily made up to resemble Elizabeth Taylor as Cleopatra, with a big black bow on her head and her arms around her daughter, would eventually appear in Arbus's feature on parents and children in *Esquire.*

When *Bazaar* wanted a picture of Turbeville and Mullin to run on the contributor's page, Turbeville thought of asking Arbus to take it. Diane suggested that they all drive up to Connecticut and she would photograph the two young women swimming. Discussing it, Debbie and Mary Louise decided they were uncomfortable with that idea, so they took the picture themselves, a double portrait in profile, with their heads and eyes raised. "I love the portrait you took of yourselves!" Diane said when she saw it. "You look like noble heroines. That's how I wanted to portray you." She was very gracious about it, Turbeville thought.

People on Plinths

"Are you Jewish?"

The fifteen-year-old girl wasn't, but it didn't matter. By asking the personal question, Diane had struck up a connection to this teenager from Queens, with ironed straight hair, cotton skirt and sandals. Like many who had fled the orthodoxies of middle-class parents in the outer boroughs and flocked to Washington Square Park in Greenwich Village, the girl had adopted, with avid conformism, the manners of the burgeoning folkie and hippie counterculture.

Washington Square Park, a fifteen-minute walk from where Arbus lived, was a collecting pool for young misfits. The folk music clubs and coffeehouses were nearby on Bleecker and Mac-dougal Streets, and there were book and record stores selling Ginsberg and Dylan just to the north on Eighth Street. Within the park, paved paths radiated from a round central plaza with a fountain. Sitting on the park benches, coming down from LSD trips, swigging wine, or high merely on the excitement of being where they shouldn't be, the truants and rebels passed their days. Circling them with her camera, Arbus observed the different cliques. There were the "young hippie junkies." There was a cadre of "really tough, amazingly hard-core lesbians," some wear-

ing men's button-down shirts and chinos, some smoking cigars.
There were the black men with Afros and bottles of cheap red
wine, often in the company of white girls from the boroughs.
Each group occupied a territory with firmly demarcated bound-
aries that Arbus mapped out in her mind like a mandala. "There
are worlds and they've got rules," she once explained, discuss-
ing the various subcultures she loved to infiltrate. "And there's a
game, and you kind of try and play the game. You're never really
part of it, but you just by hook or by crook try and figure out what
their rules are."

In her mythopoeic imagination, adolescent wayfarers wanting
to pass from one circle into the next were faced with obstacles
worthy of a contemporary Odyssey. For instance, a girl from the
Bronx who was eager to join the drugged-out hippies could cross
into their quarter only by first sleeping with the winos. And while
this was perhaps not literally true, in fact the African American
alcoholics often did pair off with the young girls who came to
the park. Marilyn Curry, the refugee from Queens whom Arbus
greeted (but did not photograph) had taken up with a twenty-
eight-year-old man with a large Afro and a gold tooth who
accosted her the first time she entered Washington Square Park.
They never went beyond kissing and petting, but they would
spend the day together. To those in the park who knew them,
they were a couple.

Choosing among the sitters on the park benches, Arbus pho-
tographed solitary people (usually young women) and couples,
throughout the spring and summer of 1965. It took courage to
approach some of them. She found it "very scary." When photo-
graphing nudists, she had been able to become a nudist with-
out any trouble. Whatever these people were, she could never be
one of them. They were lost, addled, aimless, runaways or out-
casts. Most of all, they were young and unformed. Some days,
she lacked the strength to make contact. On other occasions, she
found that she could, and then she would keep going. "There are
times when you can and times when you can't," she once told Pati,

who was complaining about being unable to write. "So you do something else." It was what she had learned from Lisette: "She told me to take pictures when I felt like it, to enjoy it. She told me to take photographs when it was fun and when it was easy."

In a curious way, the people felt like sculptures to her. Seated on benches, they might have been mounted on plinths. And negotiating a route through Washington Square, she was mapping a spectator's sequence, much like wending her way through the Metropolitan Museum of Art. However, these were sculptures that required her interaction. Unlike Walker Evans's subway riders, the Washington Square subjects knew they were being photographed. "I was very, very keen to go very, very close to them, so I had to ask them," she explained. "You can't go this close to somebody and not say a word—although I have done that." She would return from a day of shooting and drop off huge fishnet bags of film to be developed at Allan's studio, conveniently situated on the western border of the park. Like Evans, she would be giddy with her bag of trophies. "She was usually in very high spirits afterward," Allan's assistant said. "There was a real exuberance."

Not satisfied with depicting her subjects in the public park, Arbus wanted to follow them home. This had been her approach from the start of her career, as when she persuaded William Mack to invite her to his Lower East Side room. Depicting people in their bedrooms would become one of her hallmarks. Welcomed by one lesbian couple into their apartment, she took a picture in which the two enact a scene out of Norman Rockwell: a conventional American mother (a large woman with upswept hair, pleated skirt, and eyeglasses) has draped her arm around a small, scrawny son. However, the rumpled sheets on the double bed suggest something less maternal, and a closer scrutiny reveals the true gender of the "son." Arbus also photographed the couple, fully dressed, frolicking in the bed, and she shot them in the park wearing men's white shirts and flat-front trousers.

She chose her subjects intuitively. "I think it's a mysterious sort of body thing," she once said, fumbling to explain why she was

drawn to photograph certain people and not others. Sometimes there was an intriguing incongruity in the Washington Square Park couples she selected. A pregnant wife, adorned by a huge beehive hairdo, black eyeliner and rhinestone cat's-eye glasses, looked like a woman from Queens (at least, so thought Marilyn Curry). She made a highly unlikely mate for her husband, an androgynous African American man with conked hair. Often, the boys in the couples Arbus photographed seem dazed, spaced out or clueless, while their girlfriends look shrewd, canny and knowing. This, too, could have triggered a gut response in Arbus, as it was characteristic of the portraits of couples she made throughout her career. And then, some subjects simply possessed that quality that film directors cite: the camera loved them. A blond lesbian smoking a cigar had sultry star magnetism, while the homosexual young men might be softly feminine or, alternatively, sharply manic. There was an edginess to the scene in Washington Square Park, a vague but jittery sense that youths on speed could be volatile, even violent, and that the racial tensions splitting the nation might play out with sudden aggression on this small stage. By the end of the decade, the paranoia of the drug-fueled counterculture and the anger of racial animosity that were so palpable in this Greenwich Village microcosm would pervade the mood of New York.

Although Arbus's portraits in Washington Square in some ways resemble Evans's subway pictures, the personal exchange that took place between photographer and subject before the shutter clicked recalls the work of August Sander. So does the pattern of picture taking. Mindful of the cost of glass plates, Sander took no more than two or three images of any subject. Arbus, too, a trophy hunter in the park, would shoot once and move on. But the differences between Arbus and Sander are revealing. Most of Arbus's pictures in this series are taken outdoors, not at people's homes. There is nothing in her settings to correspond with the visual cues, especially on occupation, that Sander provides. But then, most of the people in Washington Square Park

had no occupations. They were loitering, not working. More profoundly, they had no reliable identities. In his portraits of young Germans, Sander lets you see how a malleable adolescent can be shaped by a role: the bland, scarred duelist from a Nuremberg student corps, or the proud, simple Hitler Youth member in his new uniform. Even the tramps in Sander's Germany are playing a part. Arbus's young people in Washington Square Park are operating without a script. They may be conformists when choosing their clothing or their hairstyles, but these preferences supply a temporary group membership card without leading toward a destiny. Sander was seeking to create a contemporary atlas of German society. Arbus was responding to strangers who reminded her of herself or of people close to her, people looking for self-definition and emotional regeneration.

47

Teaching Younger People

Even though she much preferred observing young people to instructing them, Diane in the fall of 1965 began teaching a small class on Tuesday afternoons at the Parsons School of Design, where Marvin was on the faculty. She needed the money. After the completion of the Guggenheim year, she had only magazine work to support her. Her journalism career was thriving, with as many assignments from *Esquire* and *Bazaar* as she could handle. Still, the magazines paid the full (piddling) amount only if the photographs were printed. Many of Diane's stories sank on the way, leaving her stranded with a fractional kill fee. It was a very insecure living.

She was insecure, too, about teaching. As photography was, to her mind, a faintly disreputable vocation, the concept of offering college courses on the subject seemed preposterous. Besides, what did she know about it, anyway? "I have to teach today and I don't know what I will say," she complained to Howard late in the semester. "Suddenly they all remind me of me but I don't at all remind me of them." Yet the introduction of the subject into the university curriculum meant that photographers, like poets, had a better chance of survival, through inculcating the idealistic young with the values and practices of their poorly paid calling.

After her first class, Arbus went out to a late lunch with Marvin and Michael Flanagan, one of Marvin's former students, who was auditing her class. Flanagan had first met Arbus two years before, while searching futilely for good pictures of Norman Mailer to complete an assignment in Israel's illustration course. "It happens that a good friend of mine has just taken some photographs of Mailer," Israel told him. Flanagan called Arbus, who invited him over and generously loaned him her Mailer contact sheets and proofs. Some time later, when Allan needed a new assistant, Diane recommended Michael, who had become one of Marvin's protégés. And now, he was developing her film in Allan's studio and attending her course at Parsons. In advance of the lunch, Marvin warned him not to comment on Diane's teaching. Michael nonetheless blurted out an unsolicited review, a critique on the order of "Maybe you were too shy." Marvin called him that evening and verbally lashed out at him, so viciously that by the end of the conversation Michael felt flayed.

Apologetic about her dearth of technical knowledge, Arbus referred all questions on film developing to her colleague Benedict Fernandez, who was working as the darkroom technician and would advance to become the director of the photography program. She always deprecated her abilities with cameras and chemicals. Flanagan remarked that compared with Allan, who was "an incredible stickler, a real pro and technician," Diane proceeded on feelings and instinct. She printed her pictures in the darkroom "like a cook—very intuitive," Flanagan said. "She made it seem like a lark." Similarly, her classes appeared to be designed to deepen students' self-knowledge, not to hone skills. "She gave these fabulous assignments that pulled out what there was of you at that very young age," said Paulette Hunsicker, who enrolled in her Parsons class. The first task she set for the students was to photograph one another. She paired them off. Teamed with Flanagan, Hunsicker shot him in his bedroom, in the belief that in this private space, "your soul comes out more, you become more defensive, more vulnerable." For another assignment,

Arbus brought in photography books for the students to peruse, with each selecting one style to emulate.

Arbus was a nurturing teacher. Unlike Marvin, she did not provoke through intimidation. She brought grapes or other snacks to class for the students to munch. On the evening of November 9, which fell on a Tuesday, an electrical blackout immobilized New York City, along with much of the Northeast. Diane held the class at her home. The students sat around the kitchen of the Charles Street carriage house by candlelight as she read them ghost stories. In the quaint cottage, they felt transported into a storybook.

Three thousand miles away at Reed College, Doon was as ambivalent about being a student as her mother was about teaching. As with many adolescents, going off to college marked her first prolonged separation from her parents, and she cultivated the gap. Diane complained to Marvin's friend Patricia Patterson that Doon never wrote letters home. "But I have my pride," she said wryly. "I'm not going to beg." Once an angelic-looking child, Doon had matured into a striking young woman, with a nimbus of curly hair that darkened with age and a fiercely forthright manner that stayed brassy. And although Diane was now in her early forties, you wouldn't have guessed it. Youthful in appearance, she had a speaking voice that accentuated her girlishness. Visiting New York from Reed, Doon was invited with Diane to dinner by May Eliot, Alex's daughter, who was living with her boyfriend in a downtown loft. "Which is the mother?" May's boyfriend said when they entered.

Doon's absence from New York ended ahead of schedule. She dropped out of Reed a year short of her class's graduation, and in the late fall of 1965, she was back in her hometown, looking for commissions as a magazine writer and supplementing those assignments with positions as a secretary, personal assistant and waitress. She "has gone in a flash from unspeakable sloth and bog to a succession of undertakings worthy of Eleanor Roosevelt," Diane told Howard. In contrast to Doon's energetic flurry, Diane was mired in a black mood, paralyzed in "utter immobility" as if

she had forgotten how to take a photograph. "Each thing I begin to do I pile impossibilities in front of till I cannot clamber over," she lamented. Despite her doubts and depression, however, she kept working.

She spent time that summer and fall with Bruce Davidson, who lived near her in the West Village. As he emerged from the wreckage of a failed marriage, Davidson, too, was in need of emotional support. Wavering in his faith in photography along with everything else, he had conducted a workshop the previous winter for ten students in his one-room apartment, and he invited guests, including Avedon and Kertész. One evening the speaker was Arbus. After her appearance, he went out with her for a pizza. They became friends and, for a short time, lovers. He traveled with her one summer day to Atlantic City to see a burlesque show and then, driving back in his Volkswagen bug, they stopped at a house with a front lawn that was peopled with white-painted figurines for sale. They got out of the car to take a picture, but the woman who lived there emerged and shouted at them. They ran away, laughing.

"You're better when people aren't looking at the camera, and I'm better when they are," she said jokingly to him once. Ten years younger than Diane, Bruce questioned what he could offer her. "She instructed a lot of photographers," he thought. "Avedon picked up on her. I'm sure that I did. I'm sure everybody did." He felt that way at the time. Afterward, he would go even further. "Arbus was a giant," he concluded. "If you could make a series of bridges in the history of photography, in taking what the medium can do to another departure point, you might have Atget, Cartier-Bresson, Robert Frank, then Arbus." Her approach wasn't something that other photographers could readily imitate, at least not successfully. "There were not many people who would want to come close to a dwarf, a female impersonator," he said. "She went so close that she became them, and back again." It was impressive, but he also found it unsettling. "I think she was the most influential person at that time for me," he explained. "And she made me appreciate things that I had done, like the circus

pictures. She once told me that she liked that part of me, that I was able to go into places and work emotionally."

But there was a gap that divided them, one that stretched even further than the difference in years. "I was kind of a naïve kid," he said. "I felt Diane wasn't mine. It was whoever she wanted to have. It wasn't healthy or comfortable for me to have an intense relationship with her. That's what my instinct told me—stay away from all that stuff, it's not a Midwestern boy's way of looking at things." He let the relationship cool. And then, when her elder daughter appeared in town, he had an idea. "I felt I didn't belong where Diane was," he calculated. "I thought Doon was more my age. I tried to shift over from Diane to court Doon. Doon was intelligent and beautiful and she had a lot of her mother's outlook. So I thought, 'I'm not really dropping Diane.' There were other people in her life. I thought it was better for me to be more with people my own age. I thought I'd like to get to know Doon better." With Diane, he felt out of his depth. "Diane may have gotten to be too much for me to handle," he reflected. He told himself, "I should be with Doon." He didn't regard it "as an awkward or immoral situation with a mother-daughter."

Nothing came of his overtures. Looking back on it, he thought, "I was probably pretty clumsy about it."

Davidson wasn't the only young man who, at least in his own mind, wavered between Diane and Doon. After first meeting Diane, Michael Flanagan fantasized about this attractive woman who was twice his age. "I would sit on her bed looking at pictures with her," he recalled. "She was very seductive. She just exuded it." And then, one day when he was visiting at Marvin's studio and no longer working for Allan, she joined them. He felt something had changed.

"Drop by," she said.

But he never did. "It didn't seem comfortable," he realized. "I wasn't a kid anymore and I didn't have a way of being in an adult friendship with her."

Instead, he developed a crush on Doon—and like Davidson, he struck out.

This Is the Whole Secret

Diane came up with the idea that Doon might write a piece on James Brown, the rhythm-and-blues singer whose electrifying performances and propulsive hit singles made him a crossover star. In March 1966, Brown would be performing for the first time at Madison Square Garden. (Unlike Doon, Diane had seen Brown in concert live, in Harlem at the Apollo.) The mother-and-daughter team pitched the idea to Clay Felker, the onetime *Esquire* editor who was now at the top of the masthead of *New York*, the Sunday magazine of the *Herald Tribune*. He bought it. The story ran on the day of the concert, with two pictures taken by Diane at the end of 1965 or start of 1966. The larger one depicts Brown in black tie, with a showman's smile, in the glare of a strobe. The more memorable one, like so many Arbus photographs, portrays a transformation: the wrists and hands of an unseen stylist are primping the hair of the entertainer. His broad-planed head is upturned in weary repose, and his kimono hangs open to reveal a silver pendant over a bare chest.

Many of Arbus's photographs showed performers offstage, often in the private process of assuming a public persona. This was a clandestine world. Indeed, Doon underlined the privileged quality of the backstage space when she ended her piece

on Brown by relating an exchange between the singer and his orchestra conductor. The bandleader wants to hear Brown's definition of *soul,* but indicates that he will wait until the reporter has departed and the two men are alone. Brown apologetically admits to Doon that his friend has a point. "I mean like *this,* baby, this is *the whole secret,*" he says.

The secret rituals and subterfuges that go into the making of public identity were the subject of a classic study by sociologist Erving Goffman, *The Presentation of Self in Everyday Life,* which came out in book form in 1959. Arbus owned a later volume by Goffman, *Stigma,* on social deviates, which discussed some of her typical photographic subjects, such as people with physical deformities, unorthodox sexual preferences, mental disabilities and eccentric religious zeal. Whether she also knew *Presentation of Self* is uncertain. One indication that she might have read it is an unusual phrase of hers, "shame and awe," which also appears in that book. When Goffman uses it, taking the concept from another sociologist, he refers to the notion that the same feats that inspire awe in a mystified audience are liable to generate feelings of shame in a performer who is consciously deceiving his onlookers. (Like Arbus, Goffman was considering all people who assume a public identity, not just professional entertainers.) "A mixed feeling of shame and awe" for Arbus describes something very different—the contradictory blend of emotions with which she (and, she presumed, everyone else) regarded sideshow freaks, simultaneously mesmerized by their extraordinary bodies and embarrassed by the fascination that led her, a "normal," to stare.

Of all the entertainers she photographed, the freaks at Hubert's remained high on her list of favorites; she frequented the establishment regularly enough that she was almost part of the company. And so she shared the performers' dismay—and a sense that an era was ending—when Hubert's announced that it would be closing down in 1966. She took her Parsons class to the Times Square dime museum (Parsons at that time was located in the snootier environs of East Fifty-Fourth Street, near Sutton

Place) so they could see it before it was gone. "You don't think you see people like that in New York," Paulette Hunsicker remarked. Freaks for Arbus were real-life legends, thrilling refutations of the middle-class proprieties she flouted. She was hardly alone as a fan of freaks. But social attitudes were changing. The gee-whiz excitement at seeing a dwarf or a bearded lady was yielding to a consensus that their marvelous attributes were actually disabilities, to be averted or alleviated rather than exhibited. Along with the dwindling audiences came a diminishing supply of freaks. "Medical Science being what it is they don't hardly make 'em like that anymore and the laws prevent pretending or people are rich enough nowadays to hide their relatives away instead of selling them to the Carnival, like they used to," Arbus wrote in the text for an unpublished magazine piece.

Fond as she was of sideshow freaks, her connection to them was complicated. Asked once if she developed close relationships with her subjects, she said, "Well no, I try not to. Sometimes I do. I mean, they're not my *friends.*" Any New Journalist who has spent hours sharing the hospitality and companionship of a story subject would recognize the confusion. The demarcation between the freakish and the normal could be similarly unclear. Indeed, one of the things Arbus loved about freaks was how they possessed typical attributes that she recognized—so that, for example, the red hair and stinginess of a lady dwarf reminded her of her grandmother Rose. She would reveal those aspects photographically: a portrait of a freak caught you off balance when this person whom you would have shunned as profoundly "other" displayed features that were unexpectedly familiar.

And the reverse was also true. She observed the bizarre aspects of lives that were ostensibly normal, even in families—or especially in families—that resembled her own. In January 1966, *Esquire* sent her to suburban Boston to photograph Brenda Frazier Kelly Chatfield-Taylor, an unhappy society matron who, after achieving celebrity as a debutante in 1938 on the cover of *Life,* had suffered two failed marriages and multiple failed suicide

attempts. (By the time she died of bone cancer in 1982, she had tried, by her psychiatrist's reckoning, to take her life at least thirty-one times.) Brenda routinely started her day with Great Western champagne and kept an alcoholic beverage in her hand until bedtime. In addition, she relied on bottles of pills. Anorexic and bulimic, she was unhealthily thin, and her maquillage of white face powder, false eyelashes and dark red lipstick added to the unnaturalness of her appearance. Like Gertrude Nemerov, she ran the household from her bed, smoking cigarettes and indulging in long telephone chats with her friends. Like Gertrude, too, she had a strained relationship with her daughter. But she also felt, like Diane, neglected by her own mother and had depended in her childhood on a French governess she called Mademoiselle, whose dismissal left her inconsolably forlorn.

Esquire assigned Arbus to photograph Brenda Frazier after Bernard Weinraub, who had proposed the subject, returned from his reporting and wrote the piece. Before flying up to Boston on January 6, 1966, she telephoned Weinraub to find out what Brenda was like. Listening without saying much, Diane talked in a slow monotone, "as if she was underwater." Although she was friendly, she made Weinraub a little uncomfortable. "She listened, but she was very quiet," he recalled. "It was like she was off somewhere. Long pauses and I didn't know what to say next." He told her that Brenda lived in a big house with servants, reminding him of Norma Desmond in *Sunset Boulevard*. In the refrigerator was bottle after bottle of Great Western champagne and nothing else, not even an apple.

Arbus's photograph, which ran uncropped in square format on a page and a third in Esquire, shows Frazier propped up against a rose chintz headboard with the billows of a white duvet covering her from the waist down. She is wearing a white fur bed jacket and holding a lit cigarette between long-nailed fingers. Her makeup is exaggerated but immaculately applied. A large glass is prominent on her night table. Although she is only forty-four, two years older than Arbus, the furrows in her forehead and the lines from her nose to the sides of her mouth are

gouged deep. Her kindly expression is rueful and world-weary. She evokes memories of fictional characters: Norma Desmond, certainly, and also Miss Havisham.

Weinraub was astounded when he saw the photograph. "I thought, that picture totally erases the piece," he said. "It blew me away. It was devastating, but it caught her." Byron Dobell, an *Esquire* editor, reacted differently. Feeling that Arbus was "deceptively nice" and "came off as sweetness and light," he challenged her on the Brenda Frazier portrait. "Don't you think this is a rather cruel picture?" he said to her in the magazine offices. He later explained, "It upset me, to the extent that the person who was alive and saw these pictures would be hurt by them." Diane seemed taken aback by the charge that she treated her subjects harshly. "I love them," she said. "I really seek out the beauty in them." Dobell was disgusted by what he considered a disingenuous response. Many of Brenda's friends also thought the picture was unconscionably cruel. However, as Weinraub recognized, the photograph and the article conveyed the same message.

"She really studied the person," said Antupit, the art director. "She didn't just give us back a photograph. The pictures that she gave us, you could sit and look at the photograph of the person for as long as you could read the article, and get just as much out of looking at the picture as you could get out of reading the article." That was usually true of Arbus's *Esquire* photographs: she intuited quickly the story that the reporter might need more time to uncover. Brenda Frazier had been a national figure since her teens, chronicled in gossip columns and memorialized in song lyrics. The photograph could be regarded as a backstage look at an entertainer, away from her audience, worn by her efforts, catching her breath. And, if, as Freddy Eberstadt said, Diane regarded her mother's style as a tinny mirroring of WASP glamour, here was the tarnished silver prototype in its original setting.

Mysteries of Sex

Sex, which fascinated Arbus from girlhood until death, eluded her camera. The problem was that it didn't look the way it felt. When experienced, sex was "wet and hairy," nothing at all like romantic shots of couples kissing. Diane said that the best and most accurate depiction of sex on film that she knew was in the movie *Hunger*. Through a keyhole, a starving writer watches his middle-aged landlady hitch up her skirt as her husband thrusts. A quick glimpse of an abrupt movement, and then the camera cuts away. "It's really beautiful, and there's nothing pretty about it, you know?" she said.

Sex held out the promise of direct feeling. The more intense, the better: she told Marvin that she envied her sister, Renee, for having been raped as a teenager. In early 1966, Arbus started photographing at orgies and depicting couples in bed, before and during sex. The photographs posed a challenge artistically and provided an opportunity personally, but they would never earn her any money. They were unpublishable.

At one of the first "swingers" parties she attended, she was amused to discover sexual favors exchanged as blandly as Tupperware. (The introduction of the term *swinging* to replace *wife-swapping* was said at the time to reflect the rising status of women.)

Between giggles, she told Benton and Hayes at *Esquire* that the gathering was held in a spick-and-span middle-class home, of the sort she had photographed in Levittown. The hostess served soda and potato chips to allow the congregants to socialize a bit before getting down to business.

She found she could be a swinger as easily as she was a nudist. Actually, she wouldn't have referred to herself as a swinger, because the term was associated with suburbanites who mixed up their car keys in a jar and fished out the identity of that night's partner. In New York, the free-love events were group-sex parties or orgies. A book she owned, *New York Unexpurgated,* which was published in 1966, irreverently catalogued the opportunities the city offered to those seeking casual sex—pickup bars, dirty bookstores, flagellation clubs, orgies, sex toy stores, apartment houses with active swimming pools, and much more. Arbus availed herself of many such opportunities. To a woman friend, she described a pool party she attended, in which she had sexual intercourse with one man after another. Walking on the Upper West Side with the actress Estelle Parsons, who had commissioned a portrait of her twin daughters, she remarked that it would be droll if she ran into one of the men whom she knew only from orgies; how would he respond to her in an unfamiliar context? She told Freddy Eberstadt that she had slept with any man who ever asked her, and while he regarded that admission as (untaken) bait to lure him into confessing his own secret sex life, he had no cause to doubt her. She confided to Gay Talese that she took Greyhound rides as far as Boston and sat in the rear of the bus to indicate her willingness for sex—not to take pictures, just for the experience. She went to Forty-Second Street grindhouse cinemas with the screenwriter Buck Henry, who watched, astonished, as she lent a hand to masturbating patrons. Even in the sexual revolution of the sixties, this kind of libertinism divorced from emotional attachment was unusual for women.

While the swinger debauches appear to have brought her some satisfaction and excitement, in artistic terms they were a

disappointment. Arbus's sex photographs might be stills from a cheaply produced pornographic movie. In one of them, a naked man and woman, their faces obscured, sprawl beneath a hanging paper lantern on a mattress plunked on the floor of a run-down apartment; in the center of the picture is the woman's rapidly moving hand, stroking the man's erection. Certainly, the photograph avoids the coyness of the "incredible romantic" and "poetic" love scenes that Arbus disparaged. Unfortunately, it is not erotic or sensual, either. It is merely grim and tawdry. Also, as Arbus recognized, such images raise the question of how the photographer came to be there, and that nagging uncertainty adds another layer to the alienation felt by the viewer of the picture. The fact that, at least for some orgies, Arbus was there because she was participating is information that rests outside the frame of these portrayals of preoccupied lovers. It does enter the picture when the swingers are looking directly at the camera; yet in those cases, too, their expressions of mischievous complicity convey nothing of the sensation of sex. There was more libidinal heat in the photographs Arbus took of fully clothed couples on the benches of Washington Square Park. Those pictures marked the culmination of a potent (if quick) seduction by the photographer. At an orgy, there was whoopee without wooing.

Sex was such a vast subject, and for Arbus such a compelling one, that she contemplated the task of approaching it scientifically, along the encyclopedic lines of Sander. One dream project she described with enthusiasm but never pursued was an atlas of penises; she marveled at the inexhaustible variations in them, as she did in the individuality of noses. "Nothing is ever alike," she wrote. "The best thing is the difference." She once asked the photographer Melvin Sokolsky, who was a bodybuilder, a series of questions about the sexual endowment of musclemen. (He told her that although he was not an expert, he didn't think there was any relationship in size between a man's biceps and his genitals.) Documenting sex organs would be looking at sex directly, without sentimentality. And yet, despite her overall campaign to strip

away pretense and euphemism, when it came to sex she was not just debunking. She could also sound uncharacteristically reverential. The word she applied again and again to describe her sexual encounters was "mysterious."

Howard published his own musings on sex (and other matters) at the end of 1965, in the form of a psychoanalytically informed, freely associative journal that he had maintained while struggling without success to produce a novel in the summer of 1963. In this book, which he called *Journal of the Fictive Life*, he wondered at one point if there was a psychological explanation for his inability to write, in poetry or fiction, about sex and love. He thought the block might relate to "some experience having to do with a picture, a statue, a photograph, in which art and sex are related. Note that art photographs is euphemistic for feelthy pictures. Rodin's 'Le Baiser' reproduced in bronze on the edge of a jade ashtray in the living room." These disjointed, private associations contributed to Diane's strong emotional response to the book. Only she knew firsthand of the "sexual experimentation" inspired by the ashtray replica of Rodin's lovers, or could follow the train of thought that led there from photography. She wrote Howard that "it hits me with a kind of contagion, not precisely as though it were my book but I recognize so nearly everything in it, like I am possessed." She read with tacit recollection and comprehension his argument that photography pries after secrets, which might yield to the pen but resist the fundamental superficiality of the camera. "The silent dialogue we have had all our lives on these matters is the more extraordinary for what we seem to have heard," she told him. She bridled only at his characterization of her photographs as "spectacular, shocking, dramatic" in their focus "on subjects perverse and queer (freaks, professional transvestites, strong men, tattooed men, the children of the very rich)." She said it "read like a dirty catalogue."

In fairness to Howard, many of the subjects Diane pursued were, by the standards of the time, perverse and queer. Homosexual men fascinated her, the more flamboyant the better. The

previous year, she had photographed gay youths in Washington Square Park, some of them so cranked up on drugs that they were barely in control. More established, but equally theatrical and outrageous, was Monti Rock II, a self-created, cocaine-loving Puerto Rican celebrity hairdresser with showbiz aspirations, whom Diane cultivated as part of a never-completed project on "Homosexuals." Monti did hair styling for models, including work for Avedon, who may have provided the introduction to Arbus. Monti and Diane had known each other at least since 1964, when he let her come along in a rented vintage Buick limousine, driven by a chauffeur who was wearing livery and sporting a cocaine-filled amulet, to the wedding in Millbrook, New York, of Timothy Leary and the model Nena von Schlebrügge. Arbus squeezed into the backseat of the limo, an anchor of smiling sobriety between Monti and a fashion editor friend of his, both of whom were chemically aloft.

In the course of multiple sessions, Diane photographed Monti in a suit and bare-chested with jewelry. Her apparent delight in his antics charmed him. "I was like a crazy kid that wanted to be a star," he recalled. "She was like a cheering section." Arbus didn't talk much. "She was a very good listener," he said. "She was absolutely disarming because she just liked me." Responding to her unqualified approval, he dropped his guard: "There were certain people I allowed to see the real me, and she was one of them."

Arbus was on the alert for people who dreamed of being stars. On the subway one day in 1966, she noticed a young woman with teased bouffant black hair, exaggerated penciled eyebrows and heavy eyeliner. "She's one of those people who is always told that they look like Elizabeth Taylor," Arbus remarked. "I mean, she does sort of, but it's her kind of fatal destiny." Approaching this replica of Elizabeth, Arbus learned that she came from Brooklyn, was married with children, and would be happy to be photographed. She was a little cautious—the telephone number she gave Arbus was her mother's. But an appointment was arranged for mid-May and Arbus went out to her home, which was in the

Bronx. There she discovered that Marylin Dauria, for that was her name, had three children, and the eldest, a boy, was severely mentally impaired.

Only twenty-one, Marylin had married when she was sixteen. "Everyone was doing it, the whole crowd," she said. She and her husband, whose name was Richard and who worked as a garage mechanic, had met in high school. Actually, when asked about these prosaic facts a couple of years later, Arbus was a touch uncertain. She recalled instead the sex manual, *Ideal Marriage,* on the Daurias' understocked bookshelf and Marylin's admission that she was not Irish but had dyed her hair black to appear as if she were. They were an "incredibly rudimentary" family, Arbus felt.

She devoted several rolls of film to them. She took the picture that best captured her view of their elemental connectedness just before the Daurias got into their car for a Sunday visit to one of their parents. Marylin is encumbered with Dawn, the baby daughter, along with a fake leopard-skin coat, a pocketbook, and an inexpensive Brownie camera. Her eyes are unfocused, as if she is daydreaming. Richard is facing Arbus with a frank gaze and the hint of a soft, earnest smile. He is holding nothing but the small hand of Richard Jr., who is dressed in a white V-neck tennis sweater. Cross-eyed, mouth agape, body twisted, Richard Jr. is lost in his own universe. Baby Dawn, bundled up in a hooded jumpsuit in her mother's arms, reaches out, projecting forward from the other three, while Richard Jr. stands between his parents, making physical contact with both, like a human glue that binds them. "They were undeniably close in a painful sort of way," Arbus said of the husband and wife. Her photograph exposes the gulf that yawns, profound and dark, between tinsel fantasies and real-life obligations. Richard and Marylin were "like two children who had suddenly played Truth and Consequences and got stuck with the consequences, you know, for sort of forever," she said.

I Think We Should Tell You, We're Men

Diane learned in March 1966 that her application for a second Guggenheim Foundation fellowship was successful, and she would be receiving the full $7,500 she had requested. Despite her magazine work and her Parsons teaching job, she lived in constant financial anxiety. Actually, it was Allan, paying her bills along with his own, who directly felt the tension of the ledger, but Diane struggled to contribute her share. She knew that the grind of fashion photography—much of it these days for catalogues and second-tier magazines like *Glamour* and *Seventeen*—was wearing Allan down. The Guggenheim stipend would provide them with a little space. For her, the breathing room was artistic as well as financial. Independent of editorial demands, she could afford, at least some of the time, to go wherever she chose.

She had devoted the first months of the year to magazine commissions, including Brenda Frazier and James Brown. A big assignment from *Harper's Bazaar* on contemporary American painters and sculptors occupied her for much of the spring; along with a host of art-marquee names, including Frank Stella (grinning to reveal the row of missing front teeth that he lost in a boyhood fight) and Roy Lichtenstein, she managed to slip in a portrait of Marvin among the thirteen "not to be missed." During this period, she was also

learning to use a new camera, the Japanese-made Mamiya. Like the Rolleiflex, the Mamiya was a twin-lens reflex camera, which the photographer held at waist-level and focused by looking down into the ground glass. The Mamiya's chief advantage over the Rollei was that it used interchangeable lenses. Instead of being limited to the fixed wide-angle of her Rollei, Arbus could also photograph with a telephoto or a normal lens.

Richard Avedon dispatched his studio assistant Gideon Lewin to teach her how to use her new camera. "She came across very meekly, unsure about technical stuff," Lewin recalled. "Once she got the hang of it she was fine. Some photographers are so obsessed with the functionality of the camera that they spend too much time on it and they miss the image." The camera was heavy, and with a flash attachment, it was cumbersome, but Arbus seemed not to mind the weight of her equipment. "I never carried anything like what she carried," said the photographer Garry Winogrand. He thought she welcomed the burden in the belief that if photographs came too easily they would be inferior. This seemed to him a fundamental misunderstanding. Certainly it underlay a basic difference in their photography: Winogrand's on-the-run, off-balance shots and Arbus's classically composed, psychologically observed studies. When she recommended Winogrand for a Guggenheim, Arbus described him as "an instinctive, nearly primitive ironist." In all sorts of ways, she carried more baggage.

Things were advancing, if never easily, at least encouragingly. And then, in early June, just a month before the planned start of her fellowship, she collapsed with hepatitis. Probably it was hepatitis B, which in the United States tends to be contracted through sex. Right up until falling sick, she had been photographing—and often participating in—orgies and other erotic sessions. At the dawn of the sexual revolution, with effective birth control available to ward off pregnancy and antibiotics on hand to cure syphilis and gonorrhea, hepatitis lurked as a furtive danger. Although sex is the usual pathway, the hepatitis B virus can also

be transmitted through repeated household contact: Allan, Doon and Amy, as well as Marvin, needed prophylactic injections of gamma globulin. The illness incapacitated Diane for a large part of the summer, draining her energy and darkening her mood. She could not supply the Guggenheim Foundation with a doctor's certification of good health until the end of July—and so, to add to her worries, the first installment of the stipend was delayed.

When her strength returned in the late summer, Arbus went back to work, taking photographs for the Guggenheim project. "The Fellowship enabled me to go far enough to find the way to go further," she had written in her application, describing her achievements using the first grant and her plans should it be renewed. "I have learned to get past the door, from the outside to the inside." That year, she followed home several transvestites and photographed them making up their faces or sitting half-undressed in women's clothing. Washington Square Park was a good place for her to meet them. Unlike her subjects at the Jewel Box and the 82 Club, these transvestites were not entertainers. You might say they were performers, but only in the sense that we are all acting in public. Backstage at the drag shows, Arbus had been illuminating the artifices of femininity. At home with cross-dressers, she was charting the construction of identity. A young man setting his hair in curlers and holding a cigarette daintily between manicured long-nailed fingers, whom she photographed in 1966 in his Chelsea apartment as he prepared for an annual drag ball, is etched as sharply as a Sander portrait. His projected image is derived from gender, however, not occupation, and his trappings are self-made, not inherited as a social legacy.

Riding her bicycle up Third Avenue one day, Arbus saw what she thought were two very large lesbians getting out of a police car and entering a diner. She followed and asked if she could photograph them. They gave her an address and told her to come by the next morning at eleven. When she arrived on schedule, they were just returning home. "I think we should tell you," one of them said. "We're men." Cross-dressers, they had

been jailed overnight for female impersonation and prostitution. Diane acted unperturbed. Secretly, she was pleased.

Called Vicky and Jean, they were naturally tall; in the interest of acquiring ample flesh to simulate a womanly bosom, they were intentionally fat. Diane would go out with them sometimes, to a restaurant or the movies. Despite their aggressive ugliness, men would greet them with catcalls and whistles, responding to their sashaying walk and flaunted sexuality. "I mean, everyone smells it," Arbus said. It amused her that Vicky and Jean thought that *she* was peculiar. When they saw her that first time on the bicycle, one said to the other, "Dig that, Mondo Cane," an allusion (to the 1962 documentary film) that was their private code for anything odd.

She befriended them, especially Vicky, who came to view Diane as her personal photographer. Vicky once called to obtain portraits to send to a man in San Diego who was in search of a wife. Arbus supplied them. (The pictures did not net Vicky a husband.) Unlike Arbus's usual subjects, who rarely bothered to thank her for prints, Vicky never failed to send a gracious, ladylike note. She gave Diane presents, too, notably a music library that she had acquired by repeatedly joining a record-of-the-month club and moving before the bill arrived. They met for the last time in 1969, when Vicky invited her to come over for a birthday party. Vicky was living in a residential hotel on Broadway and West 100th Street that Diane, a veteran of many squalid lairs, declared the nadir. The lobby evoked Hades, populated by loitering human wrecks with corrupted complexions and livid eye whites. The elevator was broken. Climbing the stairs to the fourth floor, Diane had to step over three or four people on each flight before arriving in Vicky's quarters, brightened for the occasion by balloons fixed to the walls and a birthday cake on the bed. The only guests were another transvestite prostitute and Vicky's pimp. Diane took a photograph of Vicky lying on her bed in a negligee, her mouth open in laughter, revealing a missing tooth. Along with the party decorations on the wall are a pinup calendar and a few birthday cards. A box of Kotex is displayed

prominently on the dresser, to provide a ready-made explanation to any client who demanded services that Vicky could not deliver.

Diane read up on transsexuals and transvestites, and she understood, at a time when many people were confused about such things, the distinction between gender identity and sexual orientation. Although she photographed gay men in sexual encounters, her deeper interest was in men who chose to live as women. *Esquire* gave her a welcome assignment to depict a man who had become a woman, to run with an article on transsexuals. The art director, Antupit, said the editors "felt that she would be the least threatening" and "the subject wouldn't be uncomfortable" before her camera. In the article, all of the transsexuals were veiled by pseudonyms. "To locate someone who would agree to be photographed was half the battle with that," Antupit said.

With the assistance of Dr. Harry Benjamin, a pink-cheeked, German-born endocrinologist in his eighties who invented the term *transsexual* and was the author of a pioneering book that Arbus relied on, she found what she sought, a subject who wasn't an entertainer (like Christine Jorgensen) or a pretty homosexual youth, but just an ordinary guy—except for this one distinguishing thing. Stanley, whom she photographed at home, had undergone surgery to become female and was residing on the Grand Concourse in the Bronx, sharing an apartment with his common-law husband. Measured by geographic coordinates, he hadn't journeyed far from where he had lived with his former wife, who still visited and continued to call him Stanley. His life story—which Arbus could recount as a winding, engrossing and hilarious tale—was a comedy of errors in which Stanley, on the eve of traveling to Milan to meet up with a transsexual acquaintance and undergo the operation, headed to the Catskills for "sort of a last fling," and there proceeded both to lose the scrap of paper with the address of the rendezvous in Milan and also to meet an innocent woman whom he decided to marry. Neither the awarding of a Silver Star for combat during World War II nor the fathering of two children and the subsequent birth of three

grandchildren diminished his belief that he was truly a woman, a state he finally achieved, legally and medically, after thirty years of marriage.

Of course, none of these details can be parsed from the photograph. Even so, Arbus's portrait of the affable matron in her knee-length dark dress and four strands of pearls, one leg daintily extended and the other crossed beneath it to rest on the sofa cushion, provides a vivid sense of a transsexual's embrace of traditional femininity—a more compelling glimpse than the four brief lives that the reporter, Tom Buckley, provides along with much background on transsexualism in the accompanying article. Arbus dismissed her portrait as "not a very good picture." Perhaps she denigrated it because it did not pry beneath the mask—and yet, in this instance, the mask is the meat of the matter. Arbus recognized the former Stanley, who was now the wife of a "very sort of Jewish" husband, as a sister beneath the skin to the women she had encountered in the Hollywood film industry and, earlier, in the Seventh Avenue garment business. These women absorbed their notions of correct comportment from stage and screen; that was how Gertrude Nemerov, who named her daughter for a character in a Broadway melodrama, acquired her standards. Their brand of the feminine mystique was tinged with the flavor of the forties. Diane observed that, just like Gertrude, this demure transsexual in the Bronx wore high-heeled shoes but, when seated, didn't quite lower the heel to the floor.

Transsexuals and transvestites never came out of costume, and as far as Arbus was concerned, they *were* women. Or so she said. But when she looked at cross-dressers, or for that matter, when she passed anyone on the street, she searched for the signs that exposed the lie, for the holes in the disguise: "what you notice about people is the flaw." Compared with the photographs that Peter Hujar (whom Arbus knew) took of his friends in drag a few years later, hers are not portraits of exuberant, glamorous, stylish cross-dressers. Arbus's transvestite subjects are overweight, homely, or just too obviously men. Her photograph of Vicki sit-

ting on a couch shows the dark hairline below the blond wig. And yet, that is not all it reveals. It also conveys the fleshy, carnal eroticism that made men whistle. It shows Vicki as she was and as she yearned to be. Arbus's portrait of Stanley, while it may be less vivid, does the same.

Transvestitism and transsexualism are manifestations of a more general human desire to be what one is not. One of Arbus's memorable depictions of that longing is a landscape in which no person appears. Like many New York street photographers, she had no interest in nature and rarely if ever photographed it. When Howard asked in early 1967 if she had a photograph of a natural scene that he might use for the cover of his next book of poems, *The Blue Swallows,* this was the only candidate she could suggest. It was a picture she took at the end of 1966, of a waterfront graced with birch trees and a quaint cottage. It takes a moment to discern, from the electrical outlet and a seam at a corner of the room, that this picturesque scene is in reality a picture: a wallpaper mural. A Manhattan lobby trying to be a sylvan European cove—as in the portraits of transvestites that she was making at this time, she presented the attempt as both funny and affecting.

Nancy and Pati in Middle Age

A woman artist was typically forced to choose between precarious independence and stifling domestic obligations. To be reminded of that, Diane needed only contemplate the lives of her two closest female friends.

She still saw Nancy, but their friendship was fraying. Nancy despised Marvin. On her intuitively drawn map of the universe, Marvin shone as a star of malevolence, and she feared that by falling under his influence, Diane was becoming a force of darkness herself. Nancy had once thought that she and Diane were closer than sisters, more like conjoined twins. In her eyes, their twinship was over.

Nancy's marriage to Dick Bellamy, which was consecrated in 1952 on her parents' farm in Ohio, ended in a separation within two or three years, although they were never legally divorced. Lacking any visible income other than checks from her mother, Nancy lived in bohemian poverty in a rambling top-floor apartment on Amsterdam Avenue and West 107th Street, a Hispanic neighborhood south of Harlem. Happily, the Thalia Theater, a repertory cinema, was located nearby. She briefly worked in its box office, but holding a regular job was not within her interests or powers. Instead, over the long run, the Thalia was a place where Nancy

could indulge her passion for poetic foreign films, such as *Children of Paradise* and *L'Atalante*. One night, she insisted to a close friend that they put on rubber gloves and, just as in a Jean Cocteau film, walk through a ten-foot-high antique mirror on the wall. When they failed, she blamed him for not believing enough.

Like her former squat on West 10th Street, the 107th Street apartment was more an art installation than a residence. Nancy furnished it with unusual pieces that she bought in thrift shops or scavenged on the street. One cherished possession was a dressmaker's dummy of the upper half of the body, which Diane photographed on the stove. Nancy also displayed favorite quotations, such as Pascal's "You wouldn't be looking for me if you hadn't already found me," and an equally oracular line from J. A. Baker's 1967 nature chronicle *The Peregrine*. She covered all the walls, and even the refrigerator, in deep reds and other dark colors. Her bedroom was a tint between purple and morning-glory blue. She treated the walls as if they were paintings: on careful scrutiny, you detected that various shades of a pigment had been applied in subtly modulated shifts. The rooms were dimly lit, and red or blue lightbulbs in the lamps cast moody shadows. One room was hung with purple velvet curtains. Another chamber was a television room; when a set broke, she would get a new one and place it on top, until she had assembled a tower. A window opened onto a fire escape, and up and down the metal steps she planted an extraordinary container garden, with vines that climbed to the roof in a thick profusion of greenery.

Nancy's artistic career, which was too sporadic and idiosyncratic to deserve that name, took its most cohesive form for a few years in the midsixties as she worked as a costume designer of effusive originality at the Poets' Theater of the Judson Memorial Church in Greenwich Village. With the arrival of the charismatic Reverend Al Carmines in 1962, the church broadened its progressive outreach to include theater, and it became home to one of the city's most adventurous and admired avant-garde stage groups. Under Carmines, who was a composer and lyricist as well

as an ordained minister, and his colleague, director Lawrence
Kornfeld, who had worked with the Living Theatre, the Judson
Poets' Theater produced musical comedies and other plays. It's
uncertain who brought Christopherson into this fluctuating,
tightly interwoven group. She said that she dreamed of Carmines
entertaining at the circus the night before she came to see him
and knew it was predestined.

Nancy found many of her costume materials on the street. For
a sailor who drowned in the course of *San Francisco's Burning,* a
1967 musical that was one of the Judson's most ambitious pro-
ductions, she collected the plastic netting that binds purchased
Christmas trees and draped it over the actor like moss. She used
egg crates and chicken wire, too, fastening everything together
with safety pins. "She had wonderful ideas for costumes, but she
had to be there and sew you into them," said Lee Guilliatt, who
designed the sets. For each costume, she imagined an intricate
backstory of who the character was and what meaning accom-
panied a color. When she made the costumes for *Song of Songs*
in 1967, she took inspiration from the masques that are staged
in John Fowles's *The Magus,* a novel that excited her at the time.
As if reenacting one of the ceremonies in that story, she had the
characters in Carmines's musical wear clothes from different his-
torical periods (very loosely speaking—one was in purple lamé
with an egg-crate headdress) and cross the centuries to meet.

Jumping boundaries of time and place, or fact and fantasy,
came naturally to Nancy. Her deep love of mythology led her to
iconographic and anthropological studies of folklore. Several of
her standby books were in Diane's collection, most likely there
on Nancy's recommendation: Robert Graves's *The White God-
dess* (feminist spirituality and goddess worship were particularly
close to Nancy's heart) and Sir James George Frazer's *The Golden
Bough.* Two books by Isak Dinesen, another great favorite of Nan-
cy's, were in Diane's library as well. But Diane in her later years
showed more enthusiasm for books that Marvin relished and
Nancy would have abhorred: Céline's vituperatively savage *Death*

on the Installment Plan (of which she had three copies) and *Journey to the End of the Night* (two); Jean Genet's homosexual prison novel, *Our Lady of the Flowers;* three volumes of plays by Harold Pinter; and Tommaso Landolfi's *Gogol's Wife and Other Stories,* a collection with a scabrous title story that comically recounts a man's fatal sexual passion for an inflatable doll.

Nancy sometimes boasted to her Judson friends that she had shaped Diane as an artist. "She took credit for showing Diane how to see," one of them recalled. "The appreciation of the wonders of human beings and the oddities of human beings and the freakiness of human beings." For Nancy, seeing was an intensely active occupation. "She was interested in so much," another Judson friend said. "Nothing escaped her attention. She really was observant in a way that most of us are not."

Nancy's high point as a costumer was the Carmines musical *Peace,* a resetting of the Aristophanes play that transferred the story to the United States in the Civil War era. For one character, she devised a surprisingly durable wig composed of wood shavings. Her collaborators regarded her with awe and a touch of nervousness. "Her costumes were totally eccentric and amazing," said the stage and puppet designer Ralph M. Lee. "No other costume designer would have done it." The director Kornfeld believed he saw her ideas in *Vogue* a few months after they surfaced on the stage at the Judson.

Nancy cast a spell—or so she might have said—at her first meeting with Albert Poland, who produced *Peace* off-Broadway. She and Albert began seeing each other regularly, and, despite being gay, he fell in love with her. She reciprocated his feelings, and he moved into her apartment. He was amazed by the fecundity of her imagination and touched by her unstinting generosity. She made all his clothes out of China silk, which she thought created a "lunar" look. (*Lunar* was one of her favorite words.) She was an inspired cook, constructing strange but delicious salads by adding one ingredient after another. "With Nancy, more than with anyone else in my life, and I've known many dazzlingly

gifted people, I really came face-to-face with my limitations," Poland later said. "She lived every moment as an artist." Being with someone who stopped to gaze at the cracks on the sidewalk and the palimpsests of peeling posters and blistering paints on building walls could get exhausting, however. And the fervent belief that nothing was as it seemed, that small details carried immense importance and that each entity conveyed multiple and symbolic meanings could slip from artistry into paranoia. One night, as Albert slept in his customary place on the living room sofa, he woke to find her standing over him with a candle, saying, "Who are you? What do you want of me?"

When she drank, as she did more and more, Nancy grew angry and vindictive. Indeed, she told some people she was schizophrenic. Her insatiable ardor for Albert frequently brought her to tears, her emotional need and her sense of entitlement exhausted her friends and her psychological fragility interfered with her work. The last Carmines musical that she costumed was in December 1969. It may have been internal politics and company bickering that drove her away. It could have been rumblings within her head. "She didn't have any tough skin," Ralph Lee said. "After having this amazing flowering of creative ideas there for a couple of years, she withdrew from it all and became a recluse." She was estranged from her daughter, who was living in Germany. Gaining weight, drinking excessively, feeling too anxious to answer the telephone or doorbell, she grew to resemble the red-faced woman who had accosted her with Diane on the long-ago excursion in Central Park, when Nancy predicted that this loud-talking drunk might embody her future.

Long before Nancy's sharp decline, her disinclination to discriminate between fantasy and reality had alienated Pati and dissolved that connection. Like Nancy, Pati detested Marvin. "I didn't like him from the first moment," she recalled. "He was very combative." But she didn't permit this antipathy to interfere with her friendship with Diane. They communicated primarily by telephone. Pati was living in Stonington, and, at the outset

of her marriage, Paul's tenure at the New York gallery during
the week allowed her time to write productively. Although her
subsequent books never matched the originality of *The Nine Mile
Circle,* they twinkle with the sly charm of her personality. In 1962,
she published a novella, *One Thing I Know,* which chronicles the
dating exploits of a teenage girl who speaks in a voice that evokes
J. D. Salinger's Holden Caulfield and, much like its author, takes
up with one boy after the next without much fuss or afterthought.
Pati dedicated the book to Diane and sent the manuscript to her
to read and to offer suggestions; although Diane's praise fell short
of the extravagant accolades with which she had greeted *The Nine
Mile Circle,* she was still generous. Doon—who was about the age
of Francesca, the narrator—also liked the book, Diane reported.
Contemplating a fictional adolescent girl in the company of a
real one made Diane wistful. Paraphrasing Kierkegaard, she told
Pati, "I think life has absolutely to be lived backwards and there
is no convenient shortcut like forwards."

Pati's life changed with the birth of Paola in September 1962.
While Paul was off in New York, helping to advance the careers of
Roy Lichtenstein, Claes Oldenburg and Andy Warhol, Pati found
herself burdened with the solitary drudgery of motherhood. "You
were right, I should not have had a child and I wouldn't have if I
had known," she wrote Alain from Stonington in early 1968. "But
I didn't. And now, of course, there's no regretting. Except not to
have two lives." More oppressive than the chores was the weighty
responsibility for another human being. Paola was "dependent
on me to an extent I could not accept," Pati reflected.

She couldn't write, and she wasn't mothering very well, either.
In 1967, when her daughter was four or five, she suffered a ner-
vous breakdown. She wept and would not stop weeping. Not
knowing what to do, Paul looked for a psychiatrist. In Pati's past,
perhaps in as prosaic a place as her address book, he found the
name of Dr. Heller. Knowing nothing of their private history of
seduction and betrayal, Paul brought Pati to see him. Her depres-
sion was so severe that Dr. Heller had her hospitalized; at the

Payne Whitney Clinic, she was sedated and probably given elec-
troshock therapy. "That was the comeuppance of Dr. Heller," Pati
later judged. Although she viewed this regimen as revenge, the
depression did eventually lift. Before it did, while she was still in
a state of cloudy partial awareness, Diane visited and reminded
Pati that she had wanted very much to have a baby when she was
pregnant. Pati didn't recall that.

As usual, Diane wore a camera around her neck. "It was a little
threatening," Pati thought. "I had enough of a brain in my head
to know I didn't want to be photographed in a nuthouse." She
asked Diane to refrain from taking her picture. Diane reassured
her that she wouldn't think of doing so, but later, Pati wondered if
she had been telling the truth. It was a reasonable doubt, because
Diane sometimes denied to a person whom she was photograph-
ing that she was doing what, in fact, she was doing. In this case,
though, she seems to have been telling the truth. There are no
photographs in her archive of her half-crazed friend in the psy-
chiatric ward.

Each with a Tiny Difference

Arbus attended a Christmas Day party in 1966 that was held by the Suburban Mothers of Twins and Triplets Club of Roselle, New Jersey. It wasn't her first time prospecting for human multiples on the other side of the Hudson. Three years earlier, she had shown up at a similar event in New Jersey seeking subjects for her camera. That time she met the Slota family and received an invitation to follow them home to Jersey City and photograph their girl triplets. She posed the sisters at the dining room and kitchen tables, in their parents' bedroom, on the living room sofa and, many times, including the image she selected, in their shared bedroom. Dressed identically and primly in buttoned-up white shirts, white headbands and long dark skirts, they sat together on the middle bed in a room with three close-set identical beds and a wall decorated with a repeating pattern of diamonds. The girl on the left folded her hands and looked earnest. The central one appeared placidly content. The sister on the far right gazed with a faintly troubled expression and lightly gripped the shoulder of the triplet in the middle. Against the machine-made repetitions of the surroundings, each girl projects willy-nilly a human individuality. For Arbus, the triplets embodied a symbolic psychological narrative. "They remind me

of myself, my own adolescent self," she said, "lined up in three images, each with a tiny difference."

The triplets photograph was such a success that Arbus wanted to explore the theme further. Attending the 1966 Christmas party in Roselle, she found the event "terrific" and "phenomenal," but it didn't provide her with the lineups of identical twins and triplets that she had envisioned. The children weren't all identical, and the ones that were didn't compose themselves in uniform groupings. She needed to pose them, even though she claimed she never did. "I don't like to arrange things," she said. "If I stand in front of something, instead of arranging *it* I arrange *myself*." But that professed stance was in itself a pose, a pretense, an exaggeration. She wasn't a street photographer, prowling with a Leica to catch a picture in motion. Covering competitions, she had learned that the contestants, judges and spectators usually wandered here and there, failing to fall into place within the viewfinder. Depending on the requirements of the photograph, to a greater or lesser degree she arranged her subjects. Yet, as she frequently emphasized, she wasn't a fashion photographer, either. When she directed people, it was to bring out their own qualities—or, at least, the qualities that she saw in them.

At the party in Roselle, in a Knights of Columbus hall, she encountered twins and asked to photograph them side by side. She got them to stand shoulder to shoulder and depicted them frontally against a blank wall. There was nothing innovative in their pose or her camera position. In particular, a striking formal similarity exists between these photographs and those that August Sander made of paired subjects—sometimes of siblings, including twins, who wear the same clothing and stand close enough to overlap. Arbus likely found inspiration there. But the differences from Sander, in her aims and results, are telling. When Sander photographed two farm-girl sisters dressed identically, he created a portrait of distinct individuals who had been cast in the same role. Looking at Sander's portraits of children, you see the youngsters as seeds. With individual bumps

and wrinkles, they will sprout into recognizable specimens of their society.

The socioeconomic position and future of the twin girls who are the subjects of what would become Arbus's most famous photograph cannot be surmised or teased from their image. Nothing in the picture would let you know that Colleen and Cathleen Wade were two of the eight children of a white-collar worker in the employee relations division of the Esso Research and Engineering Company (later rebranded as Exxon). You could, perhaps, correctly conjecture that the dresses the sisters are wearing, with big, flat white collars and white cuffs, were made by their mother. But that is not where the picture takes you. What it indelibly evokes is the duality of a human sensibility. Because the twins are so alike—even the two bobby pins that fix in place their white headbands are arranged in precisely the same way—a viewer focuses on the subtle distinctions between them. The one on the right smiles angelically. Her eyes are bright, her bangs are neatly combed, and her stockings are drawn up. The sister on the left is a bit less carefully pulled together. Moreover, her expression is slightly off. Her eyes are hooded and her mouth is pursed. She appears to be a hidden personality of the first girl, a baleful doppelgänger. For an artist who, from early adolescence, had agonized over the presence of "evil" within herself, the photograph could represent the visualization of a darker alter ego. Diane's psychological motivations aside, the portrait delves deeply into the mysteries of human identity.

"What's left after what one isn't is taken away is what one is," Arbus wrote in her notebook in 1959, early in her independent career. This tenet on the essential kernel of every individual had a practical corollary: to reveal the fundamental, a photographer must exclude what is extraneous. More than a decade later, she made the same point to her students: "I mean we've all got an identity, you can't avoid it. It's what you've got when you take everything else away." Eliminating all distractions, the photograph seems to plumb the nature of the two girls. As the

backdrop of a light-colored wall and a dark brick floor fades into insignificance, the eye of the spectator searches to make distinctions between the identical twins wearing identical outfits. A keen observer—and there is no eye sharper than Arbus's—will notice that despite the congruence of tiny details ("*Look* at those bobby pins!" she exclaimed) the clothes aren't precisely the same. For one, there are slight differences in the hems of the dresses. "And then there's this incredible thing," the artist said gleefully when discussing the picture in public, "which is they're wearing stockings that are very, very similar, but different." Yet if those subtle variations help bring life to the portrait, in the way that an orchestra conductor's tiny modulations enhance the performance of a symphony, the overall impression remains that the girls are identically dressed. A modernist architect or designer would approve. All superfluous ornaments have been stripped away. The structures are expressed on the surface, the facts of personality and character exposed.

And yet, if the portrait of the Wade sisters, like that of the Slota triplets, suggested merely the changing states of a single personality, the photograph would not exert such force. It would not have become, through its evocation in Stanley Kubrick's film *The Shining* and countless other reproductions, an image almost as iconic as Edvard Munch's *The Scream*. Its chief quality is instead something otherworldly, a haunted stillness and strangeness. A believer in the supernatural might imagine the girls—or, at least, the twin on the left—to be possessed by an evil spirit. They might have walked out of one of the ghost stories that Diane read to her class during the New York City blackout. Unlike surrealist montages and manipulated images, which Arbus scorned, her portrait of the Roselle twins is as clear and direct as a family snapshot. Nonetheless, the girls' parents disliked the print when Arbus sent it to them, and they put it away. "We thought it was the worst likeness of the twins we'd ever seen," Bob Wade admitted.

Freud, in his essay on "The Uncanny," describes how artists introduce devices that successfully evoke an impression of what

in German is called the *unheimlich,* or, literally, the "unhome-like." One way is by creating doubt in the mind of a reader as to whether a figure in a story is living or inanimate—such as the doll, Olympia, in E. T. A. Hoffmann's story "The Sandman," and in Offenbach's opera that is derived from Hoffmann's tales. Photographers, from the early days of the medium, have known that a living person can seem dead in a picture, and conversely, a photograph of a sculpture can appear to be alive. Arbus's photographs of the murderers in the wax museum exploit that ambiguity. But another ploy that Freud cites, and one that particularly comes into play in her photograph of the Roselle twins, is the appearance of an identical double who arouses dread—in Hoffmann's novel *The Devil's Elixirs,* for instance, and in Edgar Allan Poe's story "William Wilson" (which Freud does not mention). From his psychoanalytical perspective, Freud regarded the uncanny as the emergence of something familiar that has been repressed. Its appearance elicits recognition, and, at the same time, fear or horror. He emphasized that if the overall setting is fantastic, as in a fairy tale, the effect does not arise. It is only when the odd occurrence is inserted into an otherwise conventional and realistic background that the uncanny flicks its feathery brush and our spines tingle. Arbus had three books by Freud in her library, but not this essay, which she may never have read. Nonetheless, she understood, as she put it approvingly, that "a fantasy can be literal." Unlike surrealist artists who attempted to represent what they saw in their minds, she found her fantasy by looking closely at the world around her. Reality is what confronted her camera. "I mean reality is reality," she once said, "but if you scrutinize reality closely enough . . . or if in some way you really, really get to it, it seems to me like it's fantastic."

THE CRYSTAL-CLEAR VISION OF A POET

53

Desperate to Be Famous

John Szarkowski indicated in his first exhibition how the Photography Department of the Museum of Modern Art would change under his direction. Pointedly titled *Five Unrelated Photographers,* the show, which opened on May 29, 1963, was just that—a display of the work of five distinct artists without any curatorial attempt to thread them together. It departed abruptly from the style of Steichen, his predecessor, who used photographs as blocks to build a narrative. As Szarkowski saw it, in the *Family of Man* show "the personal intentions of the photographer are subservient to a larger overriding concept." He promised that he would take his lead from the photographers and not impose his ideas on them.

It was his taste, of course, that dictated which artists he considered important. He distinguished between the "realists" whose photographs, he later wrote, opened a window on the world and those "romantics" who held a mirror to their own personality. Not that it was possible to draw a firm line, but differences in attitude could be discerned. Although Szarkowski never openly declared where his sympathies lay, his predilection clearly was for windows over mirrors. As a professional photographer—a career interrupted by his museum appointment—he used the camera to depict urban streetscapes and natural landscapes. The photographers he

championed in his new role as a curator did the same. He adjusted easily to the fact that he was now in New York, where people constituted the majority of the scenery, and not in his native territory of northern Wisconsin, where trees and lakes prevailed.

Szarkowski, who was two and a half years younger than Arbus, hesitated only briefly when asked to succeed Steichen at the Museum of Modern Art. Arriving on July 1, 1962, he served twenty-nine years as the director of the department. In his first few years there, he brought attention to Jacques-Henri Lartigue and André Kertész, two photographers who were not yet widely known. In *The Photographer's Eye,* which in the summer of 1964 inaugurated the photography galleries in the museum's renovated building, he audaciously included anonymous vernacular pictures taken by amateurs and workaday pros. A good picture was good, he maintained, regardless of its provenance; and recognition of that fact was a sign that photography was shedding its defensiveness and maturing as an established art form. Among Szarkowski's other major shows in those early years were an examination of American landscape photography and the first full retrospective of Dorothea Lange, whose pictures, he noted, were "directed not toward esthetic delight, but toward social relevance."

Of his many exhibitions, the show that left the greatest mark of Szarkowski's long tenure was one he began preparing in 1966. With it, he aimed to portray how documentary photography had progressed since Lange and her colleagues depicted the Great Depression for the Farm Security Administration. The New Deal photographers depicted the need for reform and the ways in which government programs helped the poor. Lange was proudly political, but even the politically disengaged, such as Walker Evans (who worked for the FSA's predecessor, the Resettlement Administration) and Berenice Abbott, recognized that their labors served a political end.

Times had changed. Instead of wanting to improve the world, the new generation sought to understand it. Or so Szarkowski argued. The three photographers he selected for the exhibition—

Lee Friedlander, Garry Winogrand and Diane Arbus—worked in very different idioms, but each had reshaped the form to suit a personal agenda. What made their photographs, in Szarkowski's view, "like absolutely the first breath of spring air coming through this smoggy city" was the depleted state of documentary photography, which "had gotten so leaden, tired, boring, dutiful, automatic and Pavlovian" that it was "dreary" and "distasteful to look at," as uninspired and uninspiring as a campaign speech. These three photographers were using the documentary form "to explore their own experience and their own life and not to persuade somebody else what to do or what to work for," Szarkowski said. Looking through windows, they were seeing what was happening around them, but they were also recording a self-reflective image.

He called the exhibition *New Documents*. One could argue, and Szarkowski undoubtedly would have agreed, that the two foremost living documentary photographers in the United States, Walker Evans and Robert Frank, also disavowed the power of photography to reform society. Were the artists in *New Documents* really novel? Winogrand grew out of Frank, Friedlander bore deep resemblances to Atget, Arbus learned much from Sander. By lumping these three photographers under one rubric and declaring them "new," Szarkowski was committing, at least in peccadillo proportions, the sin he denounced in Steichen. Yet it would have been misleading had he gone too far in the other direction and presented "three unrelated photographers." Each of these artists took a personal slant on a disturbingly unsettled moment in American history. Winogrand—whom Szarkowski would later judge to be "the central photographer of his generation"—typically tried to compress the maximum of chaos within a frame without collapsing into incoherence. Friedlander mediated his images with cool, cerebral irony. Arbus infused individual portraits with her psychological preoccupations, erotic longings and mythic fancies.

When Szarkowski approached Arbus about the exhibition, she responded with a characteristic blend of elation and doubt.

She had been cultivating the curator since the time she dropped off her photographs for his review in 1962. They had become friends, although it was a measured friendship, delimited by a subtle formality and reserve in which she revealed herself only obliquely, by way of jokes or coded allusions. Szarkowski compared their interaction to the dance steps of partners at a masked ball. He attributed this "ceremonial sensitivity" on Arbus's part to the majesty of her artistic ambition and the emotional remove it imposed. Notwithstanding the grandeur of her aims, she wasn't above flattery and charm to propel her career forward. She was adept at plumping up masculine self-esteem. "I'm glad you are where you are (and I am not the only one)," she wrote to him. "The museum has never seemed so humane or intelligent or delightful. really." She pressed him to say which of her prints he would like as gifts, presumably for the museum collection; and, after dining informally at his apartment, she provided a personal photograph she took of him playing a duet with his wife, Jill. (Szarkowski, like Diane's earlier and most important photography mentor, Allan, was an enthusiastic amateur clarinetist. Her picture of Szarkowski blowing on his clarinet would have carried a secret significance for her.)

The museum had obtained seven Arbus photographs for the permanent collection in fall 1964 and displayed two of them in a *New Acquisitions* group exhibition the next summer. However, the prospective show invited a completely different level of scrutiny. "Diane was not at all eager to exhibit her work," Szarkowski recalled. He thought her qualms were complicated. Unlike Winogrand, who recorded passersby, or Friedlander, who liked shooting inanimate objects or family members, Arbus typically photographed people she engaged intensely but who were not part of her inner circle. She thought of herself as a "spy" who carried out "photography projects that are somewhat Mata Hari-ish" and unearthed secrets. Exhibiting or publishing these secrets raised ethical questions, and Szarkowski felt she wished to ensure that the public exposure was not "in violation of her personal, moral

commitment." She was also aware that her project was singular; she didn't want to air it until she felt it was complete. "I always thought that I'd wait until I'm 90 to have a show or write a book, because I figured I was good for only one shot—that I wanted to wait until I had it all done," she said. "But then I decided perhaps that was even more pretentious than having a show now."

Her trust in Szarkowski's judgment helped convince her to participate. "I wouldn't have done it for anyone but John Szarkowski—he's wonderful," she told an interviewer; yet, in the same moment, she admitted "it impresses me tremendously to have a show at the Museum of Modern Art." Her anxiety alternated with her excitement. The museum could display about thirty pictures. Did she have enough good ones? She compiled a roster before falling ill with hepatitis in June 1966. When her health returned, so did her apprehensions. She wrote to Szarkowski in early November, asking to meet over a meal to reconsider which photographs to include. She suspected that the pictures she had been taking recently were superior to some earlier ones she no longer liked—although, as she had yet to print the new ones, she couldn't be certain. Of the thirty-two they chose, only three were shot with the 35 mm camera, before her conversion to the medium-format square image. At Szarkowski's suggestion, she printed four of her photographs larger than the others, making prints on sixteen-by-twenty-inch paper for the first time, so that the faces in two of them, close-up portraits, were approximately life-size.

In years to come, such a prestigious exhibition would boost sale prices of a photographer's prints, but in 1967, there was no art market for photography, and the impending show did nothing to alleviate Arbus's financial worries. The prints in the show were available for purchase: the ten-by-fourteen-inch size at fifty dollars, the large ones at seventy-five. Arbus was unable to support herself that way, and a few months before the opening, she accepted, with gratitude and dread, a commission to photograph a children's fashion supplement for the *New York Times Magazine*.

Patricia Peterson, who was the fashion editor at the *Times*, knew Arbus's work for *Harper's Bazaar* and especially liked her fashion feature of odd-looking children amid oversize blooms in an Upper East Side garden. She telephoned Arbus and said, "I want children to look like children. I don't want children to look like dolls." On that they could agree. Because the supplement showcased summer clothing, Peterson planned to stage the shoot on the island of Jamaica shortly after Christmas. Diane asked if she might bring Amy. Pat said that if mother and daughter shared a room, the arrangement was fine. She would include her young son, Jan, on the expedition.

In Jamaica, Peterson saw a small camera case Arbus was carrying, in which Allan had pasted the settings instructions that accompanied Kodak film. "I don't really know how to do color," Diane told her. The Mae West assignment for *Show* was her only previous experience. But the sessions proceeded professionally. Peterson prowled the island to find child candidates to propose to Arbus. "Do you like this one?" she asked about one of the children.

"You choose," Arbus said. "Just bring them to me."

It was a job, but with it came perks. Thanks to Peterson's artful management of the *Times* budget, they could go to hotels and gorge themselves at the buffet tables. "Amy has never seen the expensive side of life," Diane told Pat. The two women went skinny-dipping, and Diane shared confidences. She told Pat that she had experienced at least one lesbian relationship; Pat inferred that it was with Bea Feitler, the co–art director of *Bazaar*. Pat also observed that Diane was conducting an affair with a handsome black waiter on the island. Looking to bring back souvenir gifts, editor and photographer each bought a hand-painted crown from a local artist, who was visibly distressed, despite the need for money, to part with his creations. On the plane ride back to New York, Diane moved Pat deeply by revealing that, in empathy with the artist's sense of loss, she had revisited him and returned her crown.

Back in New York, Diane included Pat on her guest list for the *New Documents* opening. The roster of names that she sent

to the museum reprised the high-to-low "vertical journey" of her first magazine assignment for *Esquire*. Among those invited were Gloria Vanderbilt (with husband Wyatt Cooper) and the impoverished eccentric who called himself Prince Robert de Rohan Courtenay. (She described him as "a slimy prince.") Between them she mined every stratum of New York society: the Norman Mailers, the Robert Bentons, the Saul Hellers, Monti Rock II, Timothy Leary, Charlie and Woogie Lucas, the Leonard Bernsteins, and the artists Ray Johnson, Richard Lindner and Frank Stella. At the top of her list she placed, in descending order, Allan Arbus, Marvin Israel, Howard and Peggy Nemerov, Nancy Christopherson, and Pati Hill and Paul Bianchini. "I'm not greedy," she wrote. "I just want it to be a good party." She was delighted when Howard, who was teaching at Brandeis University, said that he would come down from the Boston suburbs, where he and Peggy lived.

The photography exhibition space of the museum comprised two rooms on the ground floor, connected by a long hallway. The larger room was allocated to Winogrand and Friedlander, with their pictures displayed separately; the smaller one went to Arbus. Before the show was hung, the formidable director of the museum, René d'Harnoncourt, suggested to Szarkowski that they divide Arbus's room with a partition. Recognizing that d'Harnoncourt wanted to segregate the edgier pictures, such as those of transvestites and nudists, Szarkowski demurred. One of the central assumptions underlying Arbus's art was a denial of any distinction between the so-called freaks and normals. Gently but firmly, d'Harnoncourt persisted. At last, the curator urged him to raise it directly with Arbus. Szarkowski looked on amused as the diminutive photographer and the authoritative six-foot six-inch director discussed the matter. At the end of the conversation, d'Harnoncourt gave up and dropped his proposal.

About 250 people attended the opening, which was held on the evening of February 27, 1967, in the two ground-floor galleries and the sixth-floor Founders Room reception area. Like

a warrior on the eve of battle, Diane armored herself before-
hand with an angular helmet cut, the signature hairstyle at
trendy Vidal Sassoon on Madison Avenue. Next door, a friend
who worked at the Paraphernalia boutique did her makeup. The
gamine mod style suited her. "Diane looks old," Pati reported to
Alain de la Falaise. "And pretty. *Sexy*, if you can imagine it." Diane
also bought a new frock, which drew mixed reviews. Mary Frank
described it as "an appalling green dress" that was "the most ugly
thing you could put on her." But others agreed with Szarkow-
ski, who thought that when Diane arrived fashionably late to the
party, she glowed as radiant as a movie star of the thirties. Avedon
was waiting for her with a big bouquet of yellow roses. This was
her moment, her coming-out party as a photographer; yet Arbus,
unlike Winogrand and Friedlander, could not relax and enjoy
it. Or so Szarkowski judged, and the evidence supports his view.
A picture shows her watching unobserved as Howard chats with
Allan and Allan's girlfriend, Mariclare Costello. On the edge of
the crowd of well-wishers, Diane seems alone.

In the wake of the official opening, she made up postcards
of the Roselle, New Jersey, twins and sent them out to everyone
she could think of, urging them to see the show if possible: Rob-
ert and Evelyn Meservey, Stewart Stern, Paul Salstrom and many
others. Even Elbert Lenrow, her English teacher at Fieldston,
received a card, with the information that her photographs were
on display at the museum—"I really want you to see them"—and
the signature, "Diane (Nemerov) Arbus (Fieldston '40 I think)."
To Michael Smith, she mailed a contact print of the nude teen-
age waitress with a note saying she hoped he'd come by the
museum. During the couple of months that the exhibition ran,
Diane devoted much time to spying on spectators of her photo-
graphs, shadowing them as she had her guests at the party. She
loved hearing the comments. "She was desperate to be famous,"
Saul Leiter felt. "Her whole life was aspiring to fame." Pati, too,
believed that Diane had a continuing "desire for attention and
fame" that served as her "assurance." The photographer Tod

Papageorge, a young friend of Winogrand, witnessed Arbus's regular attendance at the exhibition. Sometime thereafter, when he ventured to criticize a couple of her pictures for satirizing too easy targets, he was flustered by her thin-skinned reaction. "How could this sophisticated woman credit my opinion at all?" he wondered. He concluded that "Diane's whole being was tied up in her work. The value of her work as she saw it was imperceptible from her view of herself."

Arbus's photographs dominated the notices of the exhibition. "The press was all about Diane, it was as if Garry and Lee didn't exist," Papageorge commented. He thought Avedon was manipulating the journalists behind the scenes. Certainly Avedon was a master of public relations, but even without intermediary maneuvers, Arbus's work tugged at spectators as the work of the other two did not. *Newsweek* devoted two-thirds of its review to Arbus; the writer credited her with "the sharp, crystal-clear, generous vision of a poet" and quoted Avedon's remark, "She has taken photography away from the sneaks, the grabbers, the generation created by *Life, Look* and *Popular Photography* and returned it to the artist." (As "sneaks" and "grabbers" were unflattering names for street photographers such as Winogrand and Friedlander, this comment—coming from a fashion and portrait photographer—was heavily loaded.) The photographer David Vestal, writing in *Infinity,* declared that having Arbus in the first room you enter was "hard on the other two photographers" because "she is the one whose vision and craftsmanship most effectively work together." In *The Nation,* Max Kozloff remarked on how the "urgent complicity" of Arbus's subjects evoked a "characteristic shiver" in the viewer. Other critics reported being "most impressed by the penetrating lens of Miss Arbus" or praised her because, "unlike her colleagues," she rarely lost "sight of the fact that documentary, in order to communicate, must strive for the quintessential." Writing to Diane privately, Norman Mailer stated that "there was not a single weak photograph in your show, and I have a hard eye for dull photos."

In the *New York Times,* Jacob Deschin judged that Arbus had received her own room "because her work is so individual." To accompany the review, the newspaper published only one photograph, Arbus's wide-angle 35 mm shot of the Venice Beach beauty contest. It was uncharacteristic of her pictures in the show. Winogrand might have taken it, or Elliott Erwitt. In it, she juxtaposed a symmetrical array of girls in swimsuits in the background with the randomly placed and variably sized heads of boys up close. Its formal composition is more complex than usual, reminiscent of Cartier-Bresson. It is as if an abstract artist of great originality were to be represented by a nude life study, to demonstrate that he could be a superb draftsman if he wanted to be, and to present the public with a work familiar enough to be assured of respect. (That may be why it was also the sole Arbus picture that had been included, under the imprimatur of Lisette Model, in a small show of established photographers and the emerging artists they sponsored, held two years earlier at the University of Wisconsin in Milwaukee.)

For a while, the adulatory attention brightened Arbus's self-regard. Along with Winogrand, she attended a session of a master class that Avedon and Israel led. Deborah Turbeville, who was taking the class, barely recognized in this beautifully dressed woman the bedraggled "beatnik bohemian" she knew from her *Bazaar* days. Gideon Lewin, who also attended, was similarly surprised to hear Arbus speak assertively, with a confidence far from the tentative tone she'd taken when he had shown her how to operate her new Mamiya. She agreed with Israel's characterization of the exhibition as an exclamation point in her career. When Israel turned to the other *New Documents* photographer present and asked if he felt the same, Winogrand shrugged. It was more like a comma, he said.

As always, Arbus knew that her mood was unstable. To gain a respite from the excitement, she went to Florida for ten days in mid-March, visiting her mother and photographing such risible attractions as lady wrestlers and "an authentic Italian Miami

palazzo." She prowled the big Miami Beach hotels, especially admiring the glass-sided pool that allowed spectators to catch underwater views of the swimmers at the Fontainebleau. She dearly wanted to do a feature on the hotel for *Harper's Bazaar;* while Ansel and Feitler loved the idea, the editors didn't, and the piece was not assigned. Regardless, she was enjoying herself. "Ionesco would be pleased here but my hotel is for Beckett," she wrote Israel. As usual, her handwriting conveyed her mood. She was bubbly, and she inscribed his address in penmanship as loopy and ornate as the decorative filigree in the original Fontainebleau in France.

On the last day of the *New Documents* exhibition, a twenty-two-year-old Brooklyn-born photographer, Stephen Salmieri, visited. He reacted so strongly to Arbus's photographs that he went to the corner phone booth, found her number and dialed.

"No one called me," she said, in her little-girl voice. "You're the only one who called."

"I'd like to come by and show you my photographs," he replied.

"Sure," she said. "You're gonna come by now?"

He stopped at his Upper West Side studio, gathered his portfolio and took the subway down to the West Village. She greeted him affably. He noticed sixteen-by-twenty-inch work prints, still wet, tacked up on her wall. She looked at his pictures.

"Oh my," she said, "you look like you know what you're doing."

He was using the same Mamiya C33 camera as Arbus, equipped like hers with three lenses: 105 mm telephoto, 55 mm wide-angle and 80 mm standard.

She interrogated him with her characteristic persistence. She was the acclaimed artist, he was just a kid, but her questions, of disarming naïveté, might have been asked by a novice. "I never know what the difference is between a wide-angle lens and a telephoto lens," she said. "Why do you go from one to another?"

Using a flash posed additional challenges. She had wrapped hers in plastic, on the advice of Israel—whom, it turned out, Salmieri knew, having studied with him at the School of Visual

Arts. She remarked that Marvin hated a cold, hard flash in a person's face. "I have a lot of problems when I use flash, with setting the right exposure," she said. She would come right up to a person without remembering to close down the lens aperture, and then when the flash went off, the film would be blasted with light. "I get so excited, I forget," she said. The diffusion provided by the plastic added to the difficulty in determining a correct exposure. Sometimes she would miss the shot.

When not exploring technical tips, she spoke emotionally about the experience of *New Documents*. She told Salmieri that she enjoyed eavesdropping on museumgoers to catch their responses to her photographs, but she worried that some of her subjects would be distressed if they saw their portraits in the exhibition. She had told them she was taking the pictures for her own use. That duplicity disturbed her.

The exhibition would prove to be the most significant display of Arbus's photographs in her lifetime. It closed on May 7. Later in the month, Pati reported to Alain, "Diane had a show at the Museum of Modern Art and a near breakdown, one on top of the other."

Peace and Love

Diane teetered in the wake of the exhibition. "I've been jumpy," she wrote Howard. "Going in fits and starts since the show."

A traditional documentary photographer could turn to the next newsworthy event without pause. Bruce Davidson, who energetically documented the civil rights struggle of the sixties, epitomized the politically motivated photographer. He traveled to the South to photograph the Freedom Riders, and he didn't lose his footing when he returned to New York. In addition to covering sit-ins and protest marches, he devoted two years with a large-format view camera to the people living on run-down East 100th Street in Spanish Harlem. He embarked on that project in 1967, fully in the spirit of the Great Depression documentary photographers.

Szarkowski supported Davidson's work: he exhibited forty-three of the East 100th Street pictures at the Museum of Modern Art in 1970. But there was no denying that Davidson was old guard. The *New Documents* exhibition, opening at the time that Davidson inaugurated the East 100th Street project, presciently caught scent of a wind that would change the shape of documentary photography in America. The news and feature magazines that had been its mainstay were declining. Concurrently, there

was a widening conviction that reportage should be personally expressive, rather than nakedly partisan or putatively objective. People thought, perhaps wrongly, that if subject matter is overly charged with newsy power, any competent photographer can get the job done, and the work of one cannot be distinguished from another. The terrain was shifting from the common outer world to the photographer's unique inner sensibility. Arbus was the pivotal figure in the move.

And yet, even the three photographers in *New Documents* couldn't avoid the tumult of their times. Winogrand shot peace marches, including some of the violent confrontations; he was attracted to the frenetic activity. Friedlander photographed television sets on which news reports were playing; these refracted images of the primary events gratified his love of complication and obliqueness. Arbus photographed television sets, too, but in her pictures they are usually turned-off appliances, part of the room's furniture. And when she did depict the projections on TV or movie screens, she selected mythic or gothic images, not the scenes of war, protest and assassination that unfolded on the nightly news. Along with classical music and haute cuisine, politics held scant appeal for her.

When she asked Ben Fernandez, her colleague at Parsons and an old-school documentary photographer, if she could go with him to some protest marches, she didn't aim to compile a historical record. She was looking only for people who stood on the fringe. She told another photographer, who said he admired how Sander portrayed individual representatives of German society, that she preferred to look for people at the edges. She said they also opened a window on their time. In her circles, demonstrators for political change represented the establishment—a left-leaning consensus supporting equal rights for women and blacks and opposing the Vietnam War. They were the ones she could relate to politically. But the people she wanted to photograph were those with whom she identified more deeply: the lonely, zealous campaigners for right-wing causes, the champions of

what already seemed a forlorn hope. They were the people who were left out, neglected, scorned.

She accompanied Fernandez to a party hosted by a leader of the Manhattan chapter of the American Nazi Party, at an apartment on the Upper West Side, near the West Side Highway. She wore her camera, but instead of photographing, she sat and chatted with the other guests. Fernandez was taking pictures when he suddenly thought, "I wonder if she's Jewish? If she starts saying something, I'm dead." He looked around for the door or a window with a fire escape, plotting an emergency exit. But Diane ingratiated herself with the group, even arranging a return visit to photograph the chapter commander with his mother. Departing the festivities and walking down the stairs, Fernandez looked at her and said, "Diane . . . ?" Without his needing to say another word, she smiled and nodded yes. Later that evening he took her to a gathering of Vietcong sympathizers. She fit in there, too. He thought she was "very businesslike."

Arbus attended a huge peace demonstration down Fifth Avenue on April 15, 1967. She came away with no good pictures. A month later, she tried again at a pro-war march, and this time she captured two specimens. Each is a portrait of a young man against a wall, close up, wearing a button that (uncharacteristically for Arbus) helps carry the punch of the picture. One youth is dressed immaculately—indeed, anachronistically, as if he has walked out of the 1890s—in a straw boater, striped bow tie and jacket with a vest. He is holding an American flag with the pole perfectly upright, and he is looking sweetly at Arbus. On his lapels are a bow tie–shaped pin of stars and stripes, a large button in support of the American troops in Vietnam, and a smaller button, in almost the center of the square image, that reads BOMB HANOI. The payload of the photograph lies in the discrepancy between his placid gaze and bellicose sentiments. With his big ears, thin lips and prominent Adam's apple, he is painfully young. He seems untouched by experience, oblivious to reality, eerie in his incongruous calm; it is easy to imagine that in a few

years he will be wading through a rice paddy, awakened too late
to the consequences of ignorance. The other portrait is crueler.
A disheveled young man, his hair tousled, the collar askew on
his cheap iridescent shirt, is staring cockeyed and half smiling.
His complexion is bad. His flag is crooked. His teeth are jagged
and his mouth gapes slightly. Illuminated by a harsh flash, which
leaves a dark shadow on the wall behind him, he wears a button
that, as in the other photograph, functions as an ironic caption:
I'M PROUD. Although in some ways Arbus related to these naïve
young men, she was also mocking them.

Around the same time, she made use of the Mamiya with flash
for portraits, usually of women she encountered on or near Fifth
Avenue and in Central Park. Accosting them, she would ask if she
might take their picture. As Avedon said, she was not a sneak or
a grabber. Some of her subjects smile at her. She continued this
informal series for more than a year. Seen in tight proximity in
the glare of a flashbulb, anyone will look uncanny or freakish. A
young blond woman with shiny lipstick appears waxen. A smiling
middle-aged woman, wearing a silk turban, a net half-veil, large
pearl earrings, a sheer chiffon scarf and a white fur, is, as Arbus
said, a "lady on Fifty-Seventh Street, but she looks sort of tribal."
Even babies turn bizarre. The round, bald, sleeping head of
Anderson Cooper, the infant son of Gloria Vanderbilt and Wyatt
Cooper, fills most of the frame of the photograph. Wearing a
white terry-cloth bib that obscures his neck, he evokes a colossal
Olmec stone sculpture.

Following the klieg-light visibility of *New Documents,* Arbus
worried that her celebrity would be a liability: magazine art direc-
tors could easily stereotype her as a photographer of eccentrics
and limit her assignments. Her apprehension turned out to be
warranted. A year later, she told a friend she had attained such
renown that editors avoided her in the belief that she was a diva.
Maybe she was like Goldilocks's porridge. She would always be
judged "no good or too good," and never "just right." As another
downside of fame, her need to approach subjects without arous-

ing suspicion might be compromised if she became recognizable. (She asked *Newsweek* not to publish a picture of her for that reason.) A reputation that got too large became confining. Pati Hill once remarked to her that anyone aiming to be famous had to consent not to change. "Yes," Diane said, "you have to agree to give yourself up. You have no further right to yourself."

Coming to the end of her Guggenheim Fellowship, restless, seeking new subject matter, she turned her mind toward California; but instead of the dream factory of Los Angeles, she elected to explore San Francisco, which had become the capital of the counterculture and was celebrating what was being called the Summer of Love. It seemed a natural extension of photographing acid-dropping teenagers in Washington Square Park.

Paul Salstrom, the leader of the peace march she covered for *Esquire* in 1962, had served three years in prison for draft resistance. When he was released in 1965, he continued to work for progressive causes, eventually moving to San Francisco. She wrote to ask if she could come visit. He welcomed her. He was residing in a big Victorian house on the eastern edge of Haight-Ashbury, the epicenter of the Summer of Love. One of the group's leaders had just left to live with his girlfriend in Berkeley, and Salstrom installed Arbus in the newly vacated sunny room, the best in the house.

Not long after arriving in San Francisco, Diane told Paul that she slept with most of the people she knew. "I told her I was going with someone and that wasn't something I was interested in," he recalled. "Not that I was going with someone. But you think you'd get to know someone better first." As Diane later told Pati, Paul was "a very monkish young man."

She disliked San Francisco. The hippie counterculture wasn't something she cared to photograph. Images of long-haired boys and bell-bottomed girls saturated the magazines. What could she add to that profusion? *Newsweek* tracked her down, but she didn't accept an assignment. "There were plenty of people sitting along Haight Street, but she didn't take any that I know of," Salstrom recalled. "There wasn't any individuality." In the lingo of the

day, hippies were known as "freaks." As a longtime fan of freaks, Arbus seemed offended by the usage. "These aren't freaks, Paul," she said. "These are imitators."

She was drawn more to the topless dancers of North Beach, where Carol Doda morphed into a national celebrity by exposing her silicone-enhanced breasts at the Condor Club. North Beach had been the home of the beat movement, but little except the City Lights bookstore remained. As the beatniks faded, freewheeling North Beach became known instead for blondes with breasts that defied easy credence. Wearing a Rudi Gernreich monokini, Doda doffed pasties and gyrated through the first nationally publicized topless dance on June 22, 1964. The acclaim (and, at least initially, the tacit acceptance by the authorities) led to many rivals. The picture Arbus made in San Francisco that she chose to print and keep was of Doda's chief rival, who performed under the name Yvonne d'Angers at a club called the Off Broadway. Unlike Carol, Yvonne claimed that her assets were God-given, not man-made. Seated in her dressing room, with her large breasts and long legs protruding from a feathered-and-sequined gown, Yvonne gazes out in Arbus's photograph with a cool, amiable expression. Her belongings surround her: a floor fan, several pairs of slippers, street clothes hanging on high. But the most curious of her possessions is easy to miss. On the dressing table, half hidden by her coats and dresses, is a huge coffee table book on Leonardo da Vinci. The cover is a detail of the Last Supper, showing Jesus with one of his disciples. Yvonne's clothing hides most of the book, so that, except for a hand, Jesus is not visible. What you see instead is Doubting Thomas, his index finger pointed upwards in disbelief.

Feeling "queasy and repudiated," Arbus longed to leave San Francisco after a couple of weeks. Her depression may have resulted in part from the letdown following *New Documents*. When she told Salstrom that she was ready to depart, he responded that he needed to visit his family in Rock Island, Illinois, and they might drive together for part of the journey. To obtain a

car that they could drop off, they first needed to go to Los Angeles. Salstrom had an aunt and uncle, Marv and Evelyn King, who lived in Lake Elsinore, about an hour's drive southeast of the city. The uncle operated a tractor in the apricot orchards, and the aunt cleaned rooms in a motel. Paul and Diane stayed with them, sleeping outside in the yard to catch a breeze in the intense heat. Arbus photographed Evelyn, asking her where she would like to pose. Evelyn, an overweight woman with a love of Hollywood, was very proud of her large television set, and Diane photographed her with an arm draped over it. Paul asked Diane if she would also like to take a picture of his uncle. Marv had a huge goiter on the side of his neck. Diane said that she didn't want to photograph him because she felt sorry for him. He was not a professional freak. He was disfigured.

At some point on the trip, Diane coaxed Paul, who was seventeen or eighteen years her junior, into a disappointing sexual encounter. Happily, the denouement did not unravel the friendship. In Oklahoma, he left to hitchhike to Illinois. She drove the car to Dallas, dropped it off and caught a bus back to New York, reading short stories and Marshall McLuhan to pass the time. "I will not apologize or thank you," she wrote to Paul. "It is all too mysterious." Getting into the city at five A.M., she walked the streets all day, relieved to be back where she felt she belonged. "But nothing really delights me," she told Pati. "I dont work. I am restless and indolent and lazy. The only nice thing is Im alone and I dont have to see anyone." Most of her friends didn't know she had returned. She drove about in her "irrational automobile," a Renault she had purchased for $200 earlier that year. She believed that the wise thing was to do whatever you wanted, but she confessed that most of the time, she was unsure what that might be. "I seem to have forgotten the main reason but I guess it will come back in the nick of time," she mused.

An English Connection

Michael Rand was one of the many visitors to *New Documents* who left amazed by Arbus's photographs. He thought the pictures were suffused with a paradoxical blend of sympathy and cruelty, "the sort of work I'd never seen before." Unlike most, he was in a position to act on his enthusiasm. As the art director of the *Sunday Times Magazine* in London, Rand aimed for a blend of "grit and glamour" that would define the publication's character. He called Arbus to see if she might be interested in working for his magazine. On the phone, she was "a little bit little-girlish" and "evasive," but she seemed receptive to the opportunity.

A few months after his return to London, an occasion arose for him to think of her. The *Sunday Times Magazine* had asked the reporter Hunter Davies, who was traveling to New York for a book project, to do a piece on a camp in upstate New York for overweight girls. The magazine sent a photographer who worked for the *Sunday Times* newspaper, but Rand, who regarded the magazine as a showcase for superlative photography, was unhappy with the pictures and wanted to redo them. He thought of Arbus, telling Davies that she was "good on freaks and ugly people." Accepting the assignment, Diane photographed the girls doing calisthenics, playing baseball, and displaying photographic por-

traits of themselves. The campers are wistful, sullen, earnest or graceless—awkwardly adolescent. The subject was close to her heart. Thirteen-year-old Amy, who was away at another camp that summer, also struggled with her weight. Writing from Charles Street to express how much she missed her younger daughter, Diane noted with puzzlement that she had dreamed that Amy took down "all the pictures off my wall" because she "needed the tape." Was this guilt that so much of the time and energy she might have bestowed upon her daughter was devoted to her photographs?

Diane was a deeply engaged mother. She took Amy, sometimes with a friend, on many of her photography jobs. "Life is made up of your work and your laundry," Doon later said. "And unless you have segregated places for these things, which this kind of photographer typically doesn't, they tend to swim around together." When Amy attended camp during the summers, Diane wrote her long, affectionate letters, which were maternal without being condescending. She had done so even when Amy was a young child. "The counselors who read them to Amy said they'd never read such loving letters," Allan recalled. But she was not a full-time mother, and as a woman dedicated to her art, without a husband at home, Diane felt deficient. She fretted anxiously over Amy's adolescent journey of self-definition.

At the same time, she was racing after work. Although she was dissatisfied with the pictures she took in the summer camp for fat girls, Rand was not. He spoke rapturously about her *New Documents* pictures to Peter Crookston, a *Sunday Times Magazine* assistant editor who was about to visit New York.

So when he arrived in the city in late October 1967, Crookston followed Rand's instructions and phoned her. "Come down and see me," Arbus said. Crookston was only thirty years old, with choirboy looks that made him appear younger. When he traveled downtown in the morning to examine Arbus's photographs, she sat next to him on her bed, the surface in her cramped quarters that she usually chose for portfolio reviews. "I did get the feeling

it was a bit closer than one could have sat," he recounted. "It was a warm thing, and it seemed a bit flirtatious." He thought she was sexy, and took her to be six or seven years younger than she was. "She had this little-girl voice and such a good figure," he explained. While they were looking at pictures, an attractive young woman with a head of abundant curly hair came down the stairs. Diane introduced him to Doon, who then left the house. "What a charming girl," Peter said. "Yeah, yeah, we're quite competitive," Diane replied, with a giggle.

Crookston was scheduled to fly to California, but he arranged to meet Diane on his return. On November 5, he came down to Greenwich Village to pick her up for dinner. He admired a photograph of a bodybuilder, pinned up on the plank screen around her bed. She took it down and said, "You can have it." The phone rang. Peter could hear Diane murmuring, "No, I don't think so," and, "Maybe . . ." Having hung up, she said, "You don't want to go to an orgy, do you?" He did not. Instead they went to eat in a small Italian restaurant nearby. Afterward, she offered to give him a lift in her Renault to his hotel. They ended the night in bed. "You looked at me as hard as I looked at you as if we were England and America at the Signing of the Treaty," she wrote to him about six months later. "Its so mysterious." For the remaining four years of Arbus's life, Crookston, who was married ("but it was the sixties," he explained), would be an occasional sex partner, an affectionate friend and, most importantly, a sympathetic and loyal editor.

He admired her as a naturally gifted journalist. "I never thought of her as an artist," he said. "She talked all the time about ideas, ideas, ideas." Following her San Francisco excursion, she had begun photographing people with their dogs and babies—subjects that were "terribly odd," she wrote to Howard, but she liked the feeling of "starting over again." Far more often than dogs, she was portraying babies; in many cases, such as with Anderson Cooper, the future newsman, whom she shot late that summer, she obtained the best results when she posed her sub-

ject alone. The portrait of the Cooper infant appeared in *Harper's Bazaar;* others, including the ones she took of Jason Solotaroff—the son of the progressive lawyer Shirley Fingerhood, a friend of Diane's since Fieldston—were done without an assignment. She told Crookston that babies, like great beauties, "can take the most remorseless scrutiny."

In August she had combined her long-standing attachment to contests and her newfound preoccupation with babies by visiting the Diaper Derby, an event staged in a New Jersey amusement park. Parents hoping to win a twenty-five-dollar U.S. savings bond and a queer sort of glory would enter their toddlers in an annual crawling race. "By the rules of this game, the contestants have to be too young to know what a race is," Arbus explained. "They can't even walk so they can't very well know these other things." If they stood up, they were disqualified. A parent was allowed on the track, holding some article that the baby loved, such as a keychain or a bottle. Perspiring in the summer heat, sensing their parents' anxiety and suffering from hunger or thirst, the babies would all be crying. "The whole thing is just absolutely miserable," Arbus said. She loved it. She photographed the juvenile participants in the unforgiving light of her flash, snot clogging their tiny nostrils, tears streaming down their cheeks. In the most memorable of the series, a knit-browed baby, teething, with a thread of spittle suspended from his lower lip, looks out in consternation. The flash also illuminates, a bit less prominently, the damp, shiny forehead and nose of his mother, whose scarily avid gaze contrasts with his forlorn one. Her forceful fingers press into the bare skin of his chest alongside his softly splayed hand.

Arbus said that in a photograph of the Diaper Derby, "you just get a little tiny bit of this terrific thing." She was delighted when Crookston assigned a reporter to come to New York to write pieces on the Derby and on another of her subjects, Mrs. Betty Glassbury, the widow who lived in an apartment crammed with Asian art. Arbus went with the reporter to see Mrs. Glassbury, whom she had photographed nearly four years earlier. "Just look

at them limbs," Mrs. Glassbury said, pointing appreciatively to Arbus's shapely legs. Mrs. Glassbury was very proud of her own limbs, which Arbus in her portrait had placed front and center, shod in elegant high heels.

The *Sunday Times Magazine* allowed Arbus to pursue her hunches and fantasies; American publications were driven by their own demands. The English weekly didn't pay very much, only $150 a page plus expenses, but even that was hard to come by in New York. "American magazines are not so rich either, except the ones I dont work for," Diane wrote to Peter. (She approached the mass-circulation, pictorially oriented *Look*—less for higher pay than greater clout—hoping to photograph prisoners on death row but got nowhere.) Assignments at *Harper's Bazaar* were drying up. It was not the fault of the art directors, Ansel and Feitler. They pushed for her. "She was always struggling for money, and we were always trying to throw her things," Ansel said. However, *Bazaar* was less interested in the artistic and the offbeat than it had been in the past. The magazine would publish only five pieces with Arbus photographs during 1968 and 1969, and none thereafter. At *Esquire,* the period when her name came up for almost every subject had passed. Art director Antupit, who would leave in 1969, tended to assign her pieces where her mild manner would soothe skittish subjects or her uncanny eye would highlight what was odd or grotesque. There was not an abundance of such stories.

She took mundane jobs for money. Jody Bradley, who worked in the photography department at the Museum of Modern Art, needed pictures for the society pages to mark her engagement to Jonathan Bush. "Being snotty about photography, I thought Diane could take our picture," she said. Not knowing how much to pay, Jody readily agreed when Diane suggested they make it the day rate set by the American Society of Magazine Photographers: the modest sum of $150.

At the end of November 1967, after Crookston had returned home, Arbus wrote that she was tentatively planning to accom-

pany Israel on a trip to London for two weeks in January. The prospect made her giddy. Everything was going so strangely and surprisingly well that she felt as though someone had stepped in to turn around her life and reveal it to her in a completely new light. However, she was still following Gertrude's regimen of emotional abstinence: it's better not to wish, because wanting something makes you less likely to get it. She and Marvin never spoke of the trip. Despite these superstitious precautions, the trip was canceled by mid-December. "Plans changed and oddly Im not disappointed really," she told Crookston. There was too much going on. "I couldnt have taken more in."

The Heart of the Maelstrom

Finding a new apartment was the most urgent task confronting Diane at the end of 1967. Thomas Morgan and his wife had decided to sell their Charles Street residence and carriage house, which meant that Diane, Doon and Amy had to move to new quarters. Relying on Allan to provide a second opinion, Diane trudged off to inspect apartments in the unrelenting rain. She contracted a cold and also "a dislike for all dwelling places and a sort of blankness about christmas" that exceeded even her "normal scroogeness." Still, she yearned for "a fresh start."

She located a new apartment sooner than she expected—two apartments, actually, one above the other, on a pretty block in the East Village. The lower-floor flat provided three small bedrooms, one for each member of the family, and a shared bathroom. Above it was a separate apartment with a living room, kitchen and bath. Now she had the herculean labor of packing up the past: cleaning out the home where she had lived for almost a decade following her separation from Allan. Sorting her possessions, she felt as if she was giving away more than she retained. It was a full-time job, leaving no opportunity for photography. "I am pure housewife and I hate that its so barren and obsessive but I look forward to the new beginning like a bride," she told Peter.

Once the move was over, however, and the family was installed
at 120 East Tenth Street, she slipped into a "terrible funk" as
she sought her footing. "The old house fell apart and the new
wont fall in," she complained. "My incompetence looms like a
middle name." In keeping with the spiky clothing style of denim
and leather that she had adopted, she furnished the apartment
with hard and uncomfortable banquettes made of plaster over
chicken wire. "These weren't like the architecture of a house,
it was like they were dug into a wall," Pati remarked. She felt
that Diane was burrowing deep within a cave. Saul Leiter lived
across the street with his companion, Soames Bantry; like the
Arbuses, they inhabited two small apartments on different
levels. He thought Diane's home was dark and depressing. It
reminded him, too, of a cave. "It was like someone creating a
stage set that was totally weird," he said. Diane would indulge
on many afternoons in confessional conversations with Soames.
"Soames said if I had heard some of Diane's stories, they would
have made my hair curl," he recalled.

Although geographically not so far removed, Arbus's new
neighborhood contrasted vividly with the old. The West Village
at that time offered a full range of housing options from run-
down tenements to renovated single-family town houses, with a
correspondingly motley group of residents of varying incomes
living in them. It was stable, family-oriented and neighborly. Jane
Jacobs, who resided there a short walk from Arbus (and was pho-
tographed by her for *Esquire*), rhapsodized in 1961 in *The Death
and Life of Great American Cities* that Hudson Street—the site of
Arbus's memorable photograph of a strangely old-looking teen-
age couple—served as an outdoor setting for a daily "intricate
human ballet." At predictable times, people emerged from their
homes to put out their garbage, walk their dogs, set off for work
and perform other routine tasks, greeting their neighbors as
they did so.

The nonstop theater of the East Village featured a colorful
traveling cast in a different genre: gritty, seedy, garish. St. Marks

Place, the East Village's counterpart to Hudson Street, was sit-
uated two blocks away from East Tenth Street. It was the High
Street of the East Village in more ways than one. As Arbus told
Crookston, St. Marks Place had become "one of the great cor-
ners in the city where just standing still you feel in the heart of
the maelstrom." Like Haight Street in San Francisco, St. Marks
magnetically drew drug-befuddled young people and other dis-
affected dropouts from the Great Society. Arbus persuaded some
to let her take photographs in their crash pads, but the pictures
were lackluster. She couldn't connect to these people. As she had
complained to Salstrom in San Francisco, she despised imitation
freaks. She was after the weird and depraved, the long-term den-
izens of the fringe, those who were either natives of the social
margins or permanent settlers there. She prowled her new terri-
tory in search of material. She would accost the journalist John
Gruen, whom she had photographed for *Bazaar* with his wife, a
block east of where she was now living on Tenth Street. "Hi, John,
how are you, how's beautiful Jane? Say, do you know any dwarfs?"
She kept her eye out for freaks that met her definition. "There are
some amazingly flamboyant bewigged and empurpled whores
who hang out on one particular place," she reported.

Resuming photography after a long furlough helped to dis-
pel the "queasy" feeling of being "strange to myself." Along with
changing her address, she was also crossing the threshold of
"some odd new thing" in her approach to photography, she told
Crookston. She didn't specify what it was. She had written to Amy
that rather than wait for people to look her in the eye before pho-
tographing them, she suddenly decided not to: "Its as if I think I
will see them more clearly if they are not watching me watching
them." She was also shedding her enthusiasm for "remorseless
frontal" portraits illuminated by flash. The brilliant strobe light
revealed some things that the naked eye would not notice, but it
hid others. Because the flash dazzled the photographer as well as
the subject, the picture remained invisible until it was developed
in the darkroom. Only then could she see the person's expres-

sion, and even more, the play of light and shadow, that had been present at the instant she pressed the shutter.

Arbus's first magazine assignment following the move to the East Village illustrated the hazards of photographing people who were freakish but not professional freaks: the pictures could be *too* grotesque. She was sent by *Esquire* to illustrate a story on Donald E. Gatch, a white Southern doctor who treated poverty-stricken patients in rural South Carolina. His practice consisted mostly of illiterate African Americans and inbred whites, living in isolated settlements, ravaged by malnutrition, hookworm, rickets and other afflictions thought to be foreign to this affluent country. Their wooden shacks and the hardscrabble countryside raised obvious comparisons with the landscape of the Depression. The *Esquire* editors felt that way. They titled the piece "Let Us Now Praise Dr. Gatch," in a bow to the reportage of James Agee and Walker Evans among tenant farmers in Alabama in 1936.

Between Agee's idiosyncratic slant and the *Esquire* journalist's conventional approach there can be no confusion. A casual viewer, on the other hand, might lump together the photographs of Arbus and Evans, which depict poor people in humble dwellings. Yet, in fact, they are very different. Evans found a home-spun dignity in his sharecroppers. His classical compositions and direct frontal angles engage his subjects straightforwardly, like the clasp of a handshake. Arbus slides into the messiness and filth of Dr. Gatch's patients, producing asymmetrical, densely detailed images that are reeking of squalor quite unlike the soiled yet orderly shanties memorialized by Evans. Arbus liked clutter (witness Mrs. Glassbury), but clutter acquires a rancid air when it is composed of tubs of lard and torn cartons of evaporated milk. Exuding hopeless defeat, Dr. Gatch's patients possessed nothing of value, not even the self-possession of Evans's Burroughs, Tingle and Fields families. "I never saw poverty like that," Arbus said, "I mean I'd never been in homes like that." These were people she could only feel sorry for, like Salstrom's deformed uncle whom she had declined to photograph. When

the affinity to Evans came up, she conceded there was a slight similarity but suggested that the better analogy was to the photographs of tenement dwellers taken by Jacob Riis.

The degradation that accompanied poverty, imbecility and disease was a suitable subject for a muckraking documentary photographer of the old school, such as Riis, but inappropriate for Arbus. Degradation associated with eccentricity was more to her taste. The assignment she undertook immediately upon returning from South Carolina was for *New York,* which in the aftermath of its parent newspaper's demise was starting a stand-alone life under its editor, Clay Felker. The subject was Susan Hoffmann, better known as Viva, a recent and high-profile recruit to the Andy Warhol coterie. Unconventional-looking, with frizzy hair, angular features and a bony body, Viva was either beautiful or ugly depending on one's point of view. Speaking nonstop about such outrageous subjects as masculine sexual performance in a voice that dripped with languid hauteur, Viva was a natural for Warhol, who cast her in his movies and anointed her as one of his "superstars." Felker thought Arbus would be the perfect choice to photograph someone he regarded as a "decadent Andy Warhol figure."

Warhol in early 1968 moved his headquarters, the Factory, downtown to Union Square West. Arbus had photographed at the glittery old Factory on East Forty-Seventh Street, a building that came by its name rightfully, as a facility for the manufacture of hats, but took on a different character once it was decorated by an amphetamine-fueled Warhol acolyte with abundant aluminum foil, Mylar, silver paint and mirrors. In 1964, during the production of an early Warhol-produced film, *Batman Dracula,* Arbus took pictures of a couple of the actors: Baby Jane Holzer, whose wealthy Jewish parents knew the Nemerovs in Palm Beach, and Gerard Malanga, a handsome fledgling poet who had corresponded with Howard Nemerov and who helped run Warhol's studio when he wasn't appearing in films. As artists, Arbus and Warhol took opposite routes: she infused with profundity an art form devoted to surfaces, while he embraced the superficial as the subject of

his art. Yet in some ways they were alike. Each endowed every-
day sights with an archetypal, eternal quality. They surrounded
themselves with people who were out of the mainstream: sexually
ambiguous, histrionically self-dramatizing, either opulently rich
or extremely poor. Both were accused of exploitation. Both were
openly fascinated by sexual secrets. And on the days that Arbus
photographed at the Factory, they may have been two of the few
people in the building who were not high.

To Arbus, the Factory was a showroom for colorful subjects
whom she could select to photograph in their homes. In 1966,
she arranged with Malanga that she would come by the East Vil-
lage apartment where he lived, the home of the Warhol movie
director Paul Morrissey. It was about nine or ten in the morn-
ing when she arrived, and Malanga was just waking up after a
night dancing onstage at a performance of the Exploding Plas-
tic Inevitable with the Velvet Underground. He leaned back
on a Victorian sofa, dressed only in houndstooth bell-bottoms.
He looks sleepy-eyed and sultry, his bent arm supporting his
reclining head, his pillowy lips half-parted, his hairy chest and
armpit inviting an erotic intimacy that was real and tactile, not
airbrushed and plastic. The sharp focus of the body hair and the
slight blur of the face combine the specificity of carnality with
the haze of desire. When Diane asked if he would remove the
trousers, he said no. In the published picture, she limited her
frame to above his waist.

She would find a more compliant model two years later in
Viva. In what became a notorious photograph, Viva also posed
bare-chested (and, in a second picture, completely nude), but to
very different effect. "It was a picture of a naked woman where
the issue of sexual attractiveness doesn't even enter into the
consideration," said Milton Glaser, the art director of *New York*.
Arbus visited Viva more than once. The two photographs that
were published in *New York* she took during her last session in
Viva's ramshackle East Side apartment, having already seen her
there in the company of Barbara Goldsmith, the reporter for the

piece. Viva overslept. She had forgotten their appointment. Even if she hadn't, Arbus might have arrived early, to catch her subject unprepared. Naked and wrapped in a sheet when she answered the door, Viva told Arbus that it would take just a few minutes to dress. No need, Arbus said, these would only be head shots, nothing would show. That is what Viva recalled, and it, too, was a promise that Arbus sometimes made but failed to keep. However, in Viva's recounting, Arbus instructed her to roll her eyes up into her head. That seems implausible, because it was the kind of direction that Arbus avoided. She preferred to wait out her subjects until they revealed what she judged to be their true selves. Both Goldsmith and Jane Holzer remembered the eye roll as an expression of derisory incredulity that was part of Viva's repertoire of facial expressions. It was the instant Arbus seized.

When he reviewed the take with Glaser on the layout table, Felker reacted violently. "Clay almost fainted," Glaser recounted. "He was appalled. There was a Midwestern Puritanism about Clay." Leaning back on the sofa, her face framed by an aureole of frizzy hair, her breasts and nipples exposed, a tuft of hair peeking out of one armpit, Viva stared inwardly in an unfocused gaze that could have been drug-induced. It might also have been the rapture of Saint Teresa as depicted by Bernini—or the aftermath of ecstasy, with the thin sheen of perspiration on Viva's dazed face contributing to a sense of postcoital exhaustion. Adding to that possible interpretation were the other pictures in the take, depicting Viva, naked, in sexual congress with a young actor and his wife. "These are Diane's photographs," Felker said to Goldsmith. "You're supposed to be the reporter. Where were you when these were taken?" (He added a parenthetical sentence to the piece: "For this story Viva was photographed having sexual relations with Marco St. John and his wife Barbara.")

Although Felker had been angling for an image of depravity, the photographs—and especially the one of Viva with her head thrown back and her eyes rolled up—were far stronger than anything he had anticipated. For half an hour, the editors discussed

what to do. The issue was closing and they didn't have much time. "All the fashion magazines were running naked models," Glaser said. "But this was not a nude, this was something else. What you experienced was not sexuality but anguish. The fact that you could see nipples in it wasn't the point. It looked like someone receiving the stigmata, someone in a state of religious fervor." With trepidation, Felker agreed to publish the picture.

It appeared in the fourth issue of *New York*. "Clay wanted a response, saying no one else would do something like it," Glaser recalled, "and he was also anxious for that reason." When the magazine came out, the vehemence of the reaction stunned Felker. Advertisers were furious. "They were so outraged, they didn't want to be associated with us," Felker said. "Somebody said it looks like Buchenwald people. They didn't like the nudity, they didn't like the hair under her arms, they didn't like the sheer absolute decadence she revealed." He later blamed Arbus's photograph for the loss of $500,000 in advertising, which constituted half the first year's ad revenues. He said the cancellations almost smothered the newborn enterprise.

"I think Clay after that felt the magazine had to be cutting-edge and new and different, but there was also a place beyond which he didn't want to go," said George A. Hirsch, the publisher. "He wanted an audience. He was also very conscious of advertisers. With this one, he felt he had put his fingers on a hot stove." Coming between the murders of Martin Luther King Jr. in early April and Robert F. Kennedy in early June, the scandalous pictures of Viva left little permanent impression. The political events that Arbus characteristically overlooked took precedence. Less obviously, her arresting photography benefited the magazine in the long term. "We had not quite found a voice," Glaser explained. Was *New York* going to be a civic booster, a consumer guide or something tougher, sharper, bolder? Goldsmith's article on Viva—and even more, Arbus's photographs (two were published, including a cheerier full-length nude)—signposted a path of provocative and fearless coverage that would shape the

publication's identity. "Mostly we heard from the advertising sales guys," Glaser recalled. "The reader response was so mixed. A lot were thrilled we ran something so transgressive."

"The article is harsh and humorless but there are lots of fascinating pictures," Arbus told Crookston. "It was something of a cause celebre, much mail and cancelled subscriptions and pro and con phone calls and whatnot, even a threatened lawsuit." The threat of a legal action against the writer, photographer and magazine came from Viva, but, in her telling, Arbus "begged" her to forgo it, and both Warhol and Paul Morrissey, the director of the movie she had just filmed, advised against it. She didn't proceed. However, unlike Arbus, who seemed amused by the uproar, Viva felt shamed and horrified. It "ranks up there with the worst things that ever happened to me," she later said. Felker was deeply shaken, too. And for Arbus it had consequences that were unexpected and undesired. The photographs of Viva were her last published work in *New York*. The controversy strengthened the impression that she turned her subjects into freaks, a stereotyping that made it more difficult for her to attract magazine assignments.

57

Fantasy Made Actual

Ever since the move to her new apartment, Diane had been lacking energy and motivation. She had been feeling "grim" when she photographed Dr. Gatch and Viva early in the year. And then, late in the spring of 1968, the grayness gave way to brightness. "I am so happy, so excited suddenly," she wrote Crookston. "For months my chin was on the ground and my mind was sodden and driven and afraid." All at once, she was juggling more ideas than she could handle: sex clubs, vigilante women, returned runaways, prisoners, and inmates of mental institutions. The list rolled on. "I have a train of thought and it might go anywhere and nearly everything delights me," she exulted. Two-thirds of her ideas for photographic subjects she knew would come to nothing, but she didn't care. Roaming Washington Square Park, she photographed baby after baby "like I was everybodys mother." Yet even as she rode the wave of exuberance, she couldn't forget that she would inevitably crash. "I hope this elation is not misguided not just More American Hysteria and when it leaves it doesn't leave me flat," she wrote. "I don't worry but that is because I don't understand."

If she was truthful in saying that she did not worry about a collapse in her mood, it was one of the few things she did not fret about. Money ranked high on the list of nagging concerns.

Although the *Sunday Times Magazine* was quickly becoming her primary employer, it paid in dribs and drabs, according to a fee rate that did not conform to her understanding of their arrangement. She told Crookston that "part of my snobbery is to act excessively casual about money as if I didn't care if I ever got any." She needed to generate more income, yet the relentless obligation conflicted with her privileged mind-set. Acquaintances almost invariably assumed that Diane was well off. More than merely her style of speaking or carrying herself, it was the way she behaved. Like her mother, she had the air of someone who does as she pleases. Diane recognized this more clearly in her mother than in herself, reacting to Gertrude's propensity to gratify her impulses with a mixture of amazement and dismay. She was feeling that way with unusual sharpness in June, because her mother was about to take another husband, who, Arbus reported to Crookston, "looks like a dentist." (The marriage lasted less than a year.)

One day in April or May, as she was walking on Macdougal Street near Washington Square, she heard someone calling to her: "Photographer!" Turning, she recognized a small-time grifter she knew from the park, a cross-dresser who shoplifted occasionally and who, in his masculine guise, provided sexual favors to a woman who helped pay his bills. He was also a raconteur, telling tales that Arbus relished. He said he had been cross-dressing since he was three. When looking for work, he preferred to apply as a woman. It was, Arbus recounted with amusement, "a female liberation sort of thing": as a woman, "you don't have to lift such heavy things and you can always pretend that you have your period." He had engaged in all possible sexual permutations, with both men and women, as both a man and a woman, but what thrilled him most was to dress convincingly in feminine attire and sit at a bar with ordinary housewives, indulging in girl talk—"whether they use Duz or Tide," as Arbus summed it up. He allowed her to photograph him on a bench in the park, dressed as a woman, and later, as a man. He was so convincing in either

guise that a sequence of pictures might seem required to convey the transformation. Unlike Duane Michals, who at this time was producing series of still photographs that unfolded into a narrative, Arbus sought something far more difficult to capture: a moment that laid bare a process. She accompanied her subject to his apartment, where he posed for a picture she titled *A naked man being a woman, N.Y.C. 1968.*

One of Arbus's greatest photographs, *A naked man* can be read as a primer on her artistry. As much as any fashion picture, it is a collaboration between the model and photographer. Arbus snapped pictures of the cross-dresser (whom she referred to as "Catherine Bruce" or "Bruce Catherine" according to his gender presentation) in the process of undressing. Seated on his bed, which was recessed in an alcove behind half-drawn drapes, he stripped down to his bra, girdle and slip as Arbus pressed the shutter button. He removed every article of feminine clothing until he was completely naked. And then he struck a pose. Crucially, he was not acting out the fantasies of the person behind the camera, as was true, say, of the naked Sicilian boys imitating classical statues in the homoerotic photographs of Wilhelm von Gloeden. Diane may have guided or coaxed him, as she had done for the models in the studio that she once shared with Allan, but she was no longer a fashion photographer imposing the pose. She was serving his vision, not hers.

It was the familiar *contrapposto,* adopted by the young nudist waitress who was an earlier Arbus subject, in which one knee is bent and the other, straight leg supports most of the body's weight. A device of classical sculpture, the *contrapposto* was revived in the Renaissance by painters as well as by sculptors. One of its most famous appearances is in Botticelli's *The Birth of Venus,* in which the goddess stands with counterpoised legs on a giant scallop shell and covers her breasts and groin in a demure gesture. Although he replicated the Venus leg pose almost precisely, to the detail of raising the toes of his right foot off the floor, "Catherine Bruce" was less modest than Botticelli's model. He didn't

bother to place his hands over either his chest or his crotch. His body hair is trimmed close but not shaved, his genitals are tucked tightly out of sight between his legs, his coiffure is short and masculine. Even without his penis showing, anatomically he is clearly a man. The discarded garments that allowed him to maintain the illusion in the park are strewn across the bed and the floor. Other clothing is folded more neatly on a chair in the foreground. Only his makeup remains in place. The chair is crude, the wall paint is stained, and a can of Schaefer beer sits under the bed. But the graceful posture and ladylike demeanor of "Catherine Bruce" rise above the shabby surroundings. Framed by the open-curtained alcove, which was a bed-sit version of the *baldacchino* familiar from Renaissance paintings, "Catherine Bruce," devoid of almost all props, here in the privacy of his home has become a woman.

The supposition that fantasy could be made actual buoyed Diane that spring. As it did for "Catherine Bruce," the conundrum of sex—what she called "the purple passages"—excited her. "It is all so urgent so ordinary so mysterious and profound," she wrote to Crookston. "Some people compare it to eating but eating may be more necessary and as ordinary but it never even *seems* revealing. Just filling." She was newly infatuated with Crookston, a handsome, considerate man, who responded to her ardently and admiringly. She seemed to be on the verge of . . . it wasn't clear what, but she was on the cusp of *something*. "Oh peter," she wrote him in June, "somewhere at the end there is a joke and even though I forget it there are moments where I have fancied I knew for just a second what the punch line was." More optimistically still, she told him, "I wish for what may be the first time I could stay around to see how it all Comes Out."

A Family on Their Lawn in Westchester

When Jackie Sheresky introduced June Kelly Tarnopol to Diane at the Doubleday Book Shop on Fifth Avenue, June was wearing a custom-tailored, knee-length gray dress, with a matching jacket and a white top, bought at Tape Measure, a boutique on Madison. June had come in to the city from her home in Purchase, less than an hour away in Westchester County, as she did once or twice a week, to meet a friend for lunch and indulge in some shopping. June's former husband had introduced her to Jackie, who was about ten years older but very beautiful—"a stunning woman, almost Eurasian-looking," June thought. Although that first marriage ended, her friendship with Jackie continued. Now, in the early spring of 1968, June was the wife of Nat Tarnopol, a handsome Jewish record-company executive in his midthirties who had a thriving career built on his passion for African American R&B music.

Jackie was highly gregarious, so June thought nothing of it when she came up and said, "I've met an old girlfriend from Fieldston and she wants to meet you." But when Jackie brought over Diane, June noticed the incongruity of the two women. Alongside the vivacious, elegantly dressed Jackie, Diane was "very shy, very introverted, looking more than talking," and "dressed kind

of down" for Fifth Avenue, like "a very artsy person." She was so slight and girlish that June didn't take in at first that Diane was actually Jackie's age, not her own. They chatted, a little awkwardly because Diane didn't say much, and then they waved good-bye and June returned to Westchester.

She was surprised when Jackie called a few days later and said, "Diane wants to photograph you." Although June was rather stunning herself, with blond hair bleached blonder, high cheekbones and a curvy figure, she wondered why Diane would have chosen her over Jackie. And while Diane had mentioned at Doubleday that she was a photographer, June hadn't thought much of it. "Everybody took photographs," she said. "Jackie explained she was a fledgling photographer and it was a great way to take pictures." June asked Nat if it would be okay if this friend of Jackie's took pictures of them. Being in the record business and familiar with publicity shots, he was concerned about the commercial angle. "They're not going to be sold, are they?" he asked June. When she spoke with Diane on the telephone, June asked that question. "Oh no, never," Diane replied.

They would certainly not be sold as publicity shots. Unknown to June, Diane was also communicating with Crookston in London, who informed her that the *Sunday Times Magazine* was devoting an issue to "the family." "I have been wanting to do families," she responded enthusiastically. For some time, she had been producing portraits that could make up a book she provisionally titled *Family Album.* Aside from the name and a vague concept, she hadn't done anything but snap the pictures she would have taken anyway, gathering up her subjects with "a sort of sweet lust . . . like picking flowers or Noah's ark." She was insatiable: "I can hardly bear to leave any animal out."

The cartoonist Charles Addams had used her prospective title as the subtitle of his 1959 compendium *Dear Dead Days: A Family Album,* which Diane owned. In his grab bag, Addams included photographs and drawings of things that tickled his fancy and spiked his art: sideshow freaks, natural disasters, surgical instru-

ments, murder weapons, babies playing with handguns or bear cubs, hearses, embalming fluids, rat hunts, bordellos and catacombs. Arbus shared Addams's black sense of humor and jaundiced view of the family. She loved the quote Crookston sent her from the anthropologist Edmund Leach, who, in that year's annual Reith Lecture on BBC radio, said: "Far from being the basis of the good society, the family, with its narrow privacy and tawdry secrets, is the source of all our discontents."

She told Crookston that she was on the trail of several likely families. She had recently accosted two elderly sisters on the street, and she was planning to visit three generations of Jewish women in Brooklyn (the youngest was already pregnant). "And especially there is a woman I stopped in a Bookstore who lives in Westchester which is Upper Suburbia," she wrote Crookston. "She is about 35 with terribly blonde hair and enormously eyelashed and miniskirted like a former show girl and booted and probably married to a dress manufacturer or restaurateur and I said I wanted to photograph her with husband and children so she suggested I wait till warm weather so I can do it around the pool!" Although she hadn't met them yet, she was confident that they were "a fascinating family."

"I think all families are creepy in a way," she told Crookston. "I have started to think about incest and my dead father and why I thought he preferred me to my mother and why I disliked him. Very like The Homecoming which I found really extraordinary." The Harold Pinter play had opened to sensational acclaim on Broadway earlier in the year, and it's not surprising that Arbus loved it. The family in *The Homecoming* consists of three grown sons and their widower father, who is by turns threatening and mawkishly sentimental. They are bound together, in mutual loathing and understanding, by hinted-at secrets of childhood sexual abuse and maternal unfaithfulness. The drama turns on the erotically provocative behavior of the wife of the oldest brother. She has traveled with her husband from America (where he escaped to become a university professor) to meet his family

in the working-class North London home in which he was raised. The atmosphere is thick with incestuous and animalistic sexuality.

At one point in *The Homecoming,* the middle son, who is a pimp with intellectual leanings, taunts his father with a line of interrogation. "It's a question I've been meaning to ask you for some time," he says. "That night . . . you know . . . the night you got me . . . that night with Mum, what was it like? Eh? When I was just a glint in your eye." To Arbus's mind, the shadowy violations of *The Homecoming* and the "tawdry secrets" of Professor Leach were ultimately mysterious. If you pared away at secrets, layer by layer, eventually you arrived at an impenetrable kernel: "none of us can ever I don't think imagine the scene of our own conception and it's probably the most tempting of all secrets," "the most bedrock question there is." She told Crookston, "As for the family again: growing up is a process of becoming contemporary with one's parents in one's head. (Once in the middle of lovemaking I thought I was forgiving them for conceiving me.)" While many people find the notion of their parents engaged in sex to be "creepy," not so many would follow Arbus's logic to conclude that whatever issued from that creepy act was creepy in its own right.

A couple of months elapsed between the Doubleday meeting and Diane's appointment on June 16 to photograph the Tarnopol family in Purchase. She came up on the train. Meeting her at the station, June saw "a tiny person with all this gear—tripods and cameras," and was shocked by the transformation in the short time since their initial encounter. "She was very emaciated-looking," June recalled. "She said she had been ill. She was reluctant to discuss it." Her color was bad, and her eyes, "you could just look at them and know she had been ill." She seemed so frail—as if she "couldn't even be standing"—that June helped load the equipment into the car. When they got to the house, June introduced her to Nat, and Diane reacted with a jolt, her eyes opening wide. June was baffled. She had no way of knowing that her husband, with his dark, Eastern European Jewish good looks and his ever present cigarette, not only emitted a powerful sexual charge

but also bore an unexpected resemblance to David Nemerov. It was "a family that was like my family," Arbus later said.

Diane arrived at about eleven thirty. After some initial work, they broke for lunch, and then she resumed shooting. She asked the family—the Tarnopols had two sons, ages five and eight, and a two-year-old daughter—to pose in the four-acre yard behind the large, midcentury ranch house. She was facing north, with the house to her back, and on this beautiful early summer day, the abundant light was, if anything, too bright. From time to time, she and June would go into the house to rummage through June's closet for a change of costume. In many of the shots, a single child appears.

The day stretched on, and Diane showed no signs of getting ready to leave. Nat grew impatient. He put on his bathing suit, as he normally would on a Sunday, but Diane didn't want him by the pool. A swimming pool "really gives a place the look of *nowhere*," she thought. She had the lawn chairs moved before Nat and June lay down on them, so the pool would not be visible in her frame. She could see a glider chair and a seesaw rocker way in the background, and in the middle distance, a little inflatable pool in which the children kept baby ducks that spent nights in a bathtub in the maid's room. The sky was mostly obscured by a line of dark trees. Describing the eventual print, Marvin Israel said the trees were "like a theatrical backdrop that might at any moment roll forward across the lawn."

As the afternoon dwindled into evening, June stretched out on one chaise longue, wearing an elegant white swimsuit that she had purchased in Acapulco four months before. Her makeup was elaborate enough for a stroll up Fifth Avenue. On his chair, Nat was also in a white swimsuit, with his bare chest and legs exposed to the fading sun. His arm was raised, with his hand over his eyes, in a characteristic gesture of annoyance. "You know when your partner is like, 'This is enough, when is it going to be over?'" June explained later. "It was getting awkward. That was the reality of the scene at the time." Between their two chairs, a

round redwood Adirondack table bore an empty glass and an ashtray. Farther back, oblivious to the undercurrents of tension, Paul, the younger son, leaned over the little blow-up pool. Diane clicked the shutter.

When she came home to the East Village at the end of the long day, in a state of overwhelming fatigue, Arbus was unsure whether she had obtained what she needed. Before she left, the Tarnopols had said she could return in August to photograph a party they were hosting, and she planned on doing so. But she fell grievously ill that summer, and could not go to any parties, or even print her pictures, until September. Only then, when she looked at her contact sheets, did she realize that she had it. "I don't know how that picture happened," she said. "I mean, it was the only good one."

In this photograph, *A family on their lawn one Sunday in Westchester, N.Y. 1968,* which Crookston published and which later became one of her most famous, she merged the specific and the universal. Had she included the modern house or the swimming pool, the photograph would have been a social document, the sort that ran in *Life* to illustrate a story on the affluent lifestyle of the American suburbs. Instead, the setting is stylized—as Israel said, like a stage set. The three characters play out their drama as the points of an Oedipal triangle: a sexually provocative mother, a potent, angry father, and at the apex, their young son in his abstracted universe. It was a personal reading of the dynamic of the Tarnopol family, and it was also a retelling of the Nemerov family history: the fashion-obsessed, self-involved mother, the distracted businessman father, and the child adrift in her own fantasy world—the little girl who thinks her father prefers her to her mother. Diane told Pat Peterson that the cold, distant separation in the picture was how she saw her own childhood. The image subsumed both families because it was an archetype. The photograph was "so odd," Arbus told Crookston, "nearly like Pinter but not quite." Perhaps it was "more like Charles Addams"—that is to say, Gothic, but haute American Gothic, with the genteel surface

of a cartoon in *The New Yorker*, and not proletarian English Gothic, reeking with a pervasive odor of perversion. The photo reminded her of the Leach quote strongly enough that she thought it could serve to introduce the issue. In words as poetic as the photograph, she wrote: "In the picture the parents seem to be dreaming the child and the child seems to be inventing them."

Long after Arbus's death, June Tarnopol questioned the photograph's accuracy as a depiction of her family. But whether or not it conveyed the truth of the Tarnopols (and sidestepping the issue of who could answer such a question), the photograph told a story powerful enough to lodge in the memory. Arbus recognized the force of the image immediately. Adhering to the philosophy of her teacher Model, she knew that a photograph does not document some external reality. "I really think a photograph exists alone," Arbus said. Or, as Model put it: A photograph is "living its own independent life and projecting, if we like it or not, its magic."

A Frightful Zombie

The deterioration June Tarnopol detected in Diane's physical appearance between April and June was no illusion. Something was wrong. Climbing the stairs to her apartment, Diane needed to catch her breath on the landing. When she reached her bedroom, she would collapse in exhaustion for fifteen minutes. Psychologically, too, she felt "oddly out of sorts." She told Crookston, "I seem to be undergoing some subterranean revolution in which the surface hardly stirs but I sleep and dream a lot and once in a while signs erupt that seem portentous to me at least." For months she had been consulting doctors, who told her the problem was psychosomatic, menopausal, or both, and there was nothing medical science could do. Finally, a few weeks after photographing the Tarnopols, she went to a doctor who recommended hospital tests. She balked, thinking he resembled a "shyster lawyer" rather than the attentive physician he proved to be, but he insisted. She felt too dreadful to keep resisting.

On July 18, she checked into Doctors Hospital, a fashionable establishment that overlooked the East River on East Eighty-Seventh Street. Allan procured for her an air-conditioned private room, leaving until later the question of how they would pay for it. (In emergencies, Diane was in the habit of appealing to

her mother.) Doctors Hospital catered to wealthy patients who wouldn't permit the insult of inferior accommodations to compound the injury of illness. The entrance lobby might have been the foyer of an Upper East Side hotel, decorated with rugs on the floors and Chinese lamps on mahogany tables, and pleasantly devoid of any antiseptic odor that could expose what went on within. Walker Evans had entered Doctors Hospital for tests of his own a few years before, and approvingly told his future wife Isabelle that it was "like a hotel" which "friends can visit any time of day, until late." He even kept a bottle in his room to entertain visitors. Diane went him one better. Later, after the worst of the ordeal was over, she told Peter that she and Marvin had made love in her hospital room.

She stayed there for almost three weeks. She was subjected to a series of barium enemas, and the doctors warned that if her gallbladder was diseased, it would need to be removed.

A specialist came in one day and announced he would need to perform a liver biopsy.

"What is the liver for?" she asked him cheerily.

"Well," he replied, "let's just say you couldn't liver without it."

As they exchanged puerile banter, she groaned with the "indignity" of pretending not to be scared when she was in fact shivering with apprehension. For a day after the biopsy, she couldn't feed herself, requiring the nurse, with "a total lack of imagination" and "that brutal disregard for how long it takes to chew something," to spoon food into her passive mouth. Her doctor's assurances that a cancer diagnosis was highly improbable made her realize belatedly this was something else she should be worrying about. Unless, that is, the doctor was being "melodramatic" in posing the suggestion. Or was she the one being melodramatic, in making the unwarranted inference? She bounced between deep gloom, brought on by the pain, weakness and uncertainty, and diffuse contentment. These were "weeks of alternate distress and delight like someone in a repertory company playing every conceivable role."

She regressed to a childish dependence. Too enervated to read, she indulged in watching daytime television, with its non-stop raucous procession of political tirades and hokey confrontations. Reporting to Pati, who was spending the summer in France with Paul and Paula, she exulted, "It was like a vast injection of contemporary mythology and I was truly grateful."

She was even more grateful when the tests produced a diagnosis that was "the least awesome and dire of all the possibilities." Her liver had never recovered fully from the hepatitis of two years before. Furthermore, the doctors suspected that she had aggravated the liver ailment with medication: birth control pills and "various antidepressants I was taking because it was depressing me so." The antidepressant prescribed for her was Vivactil, one of the tricyclic compounds that were frequently administered in the United States beginning in the early sixties. Unusually among the tricyclics, Vivactil boosts energy levels. It is uncertain how long before her hospitalization Arbus had begun taking the pills, but to judge from her quip, it was only in the last few months, when fatigue overtook her.

She slowed to the suppressed rhythms of illness, until "in the oddest way the hospital became salutary and glorious" and she would have preferred not to let any visitors intrude on her serenity. The prospect of walking out of her room and down the hall to take a hot bath beckoned as an utter delight. Awaiting her recovery, cut free of the attachments to everyday life, she shed all responsibilities—and with them, her familiar identity—as a mother and a photographer. In the wake of the illness, she wrote, "My own personality began to recede or else it was jettisoned by my fear or because I hurt." Like her previous breakdowns, this crisis emptied her of all inner sense of who she was. Usually, that negation terrified or paralyzed her, but this time, perhaps because the physical incapacitation had already immobilized her in a protective cocoon, she appeared to welcome the inner void. She maintained that the effacement of self was as beneficially cathartic as the colon-cleansing enemas: "Like seeing yourself

from a great distance and learning how comical it is after all."
Chiefly, it was not having to take photographs that liberated her.
"When I was most sick and scared I was no longer a photographer
(I still am not and something about realizing that I don't Have
to Photograph was terribly good for me)," she wrote, shortly after
leaving the hospital.

But was the freedom not to photograph a blessing? The per-
petual searching for and taking of pictures operated as a motor
that kept Arbus running. "I photograph, I can't even really figure
out what the reason is," she said a year and a half later. "I don't
know what else to do. It became a thing, really, that the more I
did it the more I could do it." How would she live if the engine
shut off? The only other activity that she pursued with the same
compulsive fervor was sex, and the recurrence of hepatitis sug-
gested that, rather than being just an alternative to taking pic-
tures, promiscuous sexual encounters could interfere with the
photographic endeavor. During her convalescence, Diane asked
Nancy Christopherson in a telephone conversation whether
she thought the disease could have been contracted through
group sex. Nancy, for whom sex constituted a sacrament, was too
appalled to reply. It would be their last talk.

Upon her release from Doctors Hospital at the beginning of
August, Diane spent a day in the stifling hot city, pried out of the
comfortable capsule of enforced quiet but lacking the strength
to move forward. Being in the city for just a single day gave her
"the creeps." She marched about "like a frightful zombie," afraid
and vaguely ashamed that she would never recover her health.
The next day she traveled out to East Hampton on the East End
of Long Island, where Tina Fredericks, divorced from Rick and
embarked on a very successful new career in real estate, lived
full-time with her two daughters. A capable, considerate hostess
who was a friend of two decades' standing, Tina provided Diane
with a reliable refuge in a beautiful pastoral setting. The country-
side was a big yawn for Diane; under the circumstances, that was
exactly what was called for. She wasn't permitted to exercise, have

sex, sunbathe or take long walks. Since she was so weak, these proscriptions were superfluous. She fell asleep several times a day. On waking, she could begin to read again, and simply watching chipmunks, pheasants, rabbits and squirrels cross the lawn gave her pleasure. She followed her doctor's instructions to eat a pound of meat a day—"which isn't easy," she observed—and swallow numerous vitamins. Out in the country, "sitting is more possible" than in the city, and she was "excused from all demands." She began to walk more normally, "not so horribly S L O W L Y," she wrote to Pati. "And if I am very good and obedient it seems and eat like a cannibal I will be better in a couple of months."

Although she had not fully recuperated, in mid-August she returned to the city and in September she resumed photography. She told her goddaughter, May Eliot, that she needed to begin all over, like climbing a mountain. She alternated between running and collapsing; walking had yet to return to her repertoire. Ever since the start of her convalescence, she was visited nightly by a strange "rage," which typically would come on at about four A.M. She felt like a werewolf, she wrote Crookston, and she couldn't figure out how to convert the "raw wild power" into energy that would fuel her work. There was never any doubt, however, that her place was not among the trimmed lawns and birdsong of rural Long Island, but back in the roiling, throbbing maelstrom.

60

An Ideal Woman

A photographer, especially one employed in fashion, journalism or advertising, belonged in New York. Opportunities for actors resided in Los Angeles. In February 1968, Allan turned fifty, miserably chained to a faded career in fashion photography. If ever he hoped to practice his chosen calling, he needed to make his move.

His longtime friend and former neighbor Robert Brown had succeeded in Hollywood. Following years of steady guest appearances and supporting parts, Brown landed a starring role in an ABC series, *Here Come the Brides,* as a Seattle lumber mill owner who imports marriageable women to cheer up his lonely loggers. The show first aired in September 1968. Visiting New York on a publicity tour in advance of the premiere, Robert urged Allan to make the leap. "I've got a plan," he said. "I've got a house in Brentwood. You can stay with me. I have an extra car. I'll get you an agent. I can get you into the Screen Actors Guild."

"Can you do that?" Allan said. A plan began to take shape in his mind. He would move to Los Angeles and secure a base. Once he did, Mariclare would join him there.

Diane hailed the scheme with generous encouragement and quiet trepidation. Aside from the prospect of geographical separation from the man who had been a supporting pillar of her life

since she was thirteen years old, the closing of Allan's photogra-
phy studio would cut off an income stream that helped her stay
afloat. Writing to Crookston in early June, she remarked that her
finances were "confusingly and delightfully wed to my husbands
and he seems to be perhaps planning to marry a very nice girl
although I may be over anticipating."

Aside from Allan's support, she was perpetually conscious of
the need to bring in money. One indication was her continuing to
teach. When Cooper Union asked her at the last minute, shortly
before the commencement of the September term, if she would
give a class, she reluctantly but pragmatically acceded. Still, what-
ever she earned was never enough, and Allan's contributions as a
photographer helped. Furthermore, in a show of feminine help-
lessness, she had shunted off to him the chores of paying the
bills and balancing the accounts. If she were "to be supporting
my small self soon," she told Crookston, "I should know some-
thing about how much I make." Allan's potential move to the
West Coast required other practical adjustments as well. Without
his studio, she would need to develop her film, a task that Allan's
assistants had always performed for her.

That fall, as she tried to recover her health while contemplat-
ing an uncertain future of financial autonomy, Diane considered
her own Hollywood offer. In monetary terms, it sounded (and
probably was) too good to be true. Mike Nichols, a close friend
of Avedon, was going to direct a film of Joseph Heller's absurdist
World War II novel, *Catch-22*. He would be shooting part of the
movie on location in Mexico, with a little time in Rome, and a
unit photographer was needed to record the process. Executives
at Paramount, the Hollywood studio making the movie, called
Arbus with honeyed overtures ("considerable insertions of flat-
tering words like genius," Diane reported to Howard) and liberal
promises (she could bring Amy to the set, make her own sched-
ule, shoot what she wanted). Avedon advised Arbus to ask for a
weekly salary of $3,000. Perhaps Avedon could have commanded
that exorbitant sum, as he was the most glamorous photogra-

pher in the world, and the ensuing publicity would have justified it; maybe he maintained gallantly that Arbus could and should receive the same. However, even with inflated Hollywood budgets, the producer was unlikely to allocate so much for a unit photographer. The executives found the proposal "rather high and so did I," Diane wrote Howard, "but I wd [would] easily dwindle."

The producer of *Catch-22* was an unusual one. In Hollywood, his colleagues regarded John Calley more as a thinker and reader than as a profit-driven businessman (even though he astutely watched the bottom line), and appreciated him as a conversationalist who entertained with hilarious anecdotes. He was also a charmer attractive to the opposite sex, and he took full advantage of that. In all these ways, except for the business acumen, he resembled Diane. John was "rather fun," she told Peter in advance of an evening get-together at which she was planning to discuss the job with her potential employer. Apprehensively, she suspected she would "blow the whole thing probably out of some deep snobbery which is quite uncalled for under the circumstances," or from an unwitting but unerring tendency to dash any chances for financial gain.

When the meeting took place in late October, Diane found it excruciatingly artificial. Although she liked John, discerning a core of diffidence beneath his shrewd and assured surface, the smooth conversation rang false. She longed to brush away all the clever business conversation and sophisticated repartee by striking a direct, honest human connection. Rather than talking, she wanted to tumble into his arms. As the fakery of the encounter continued, she felt inside her a coil of tension tighten to a degree that became unbearable. She yearned to reach out and touch him, but did she dare? The terror of making a seductive gesture battled with her queasy distaste for the situation until, as always, the loathing of her fear won out and she did it. A few hours later, leaving his bed to return home, she felt happy, exhausted, courageous and relieved. She had wiped away the anxiety, but wondered: Had she thrown away the deal?

She waited for the studio to decide. The calls from Hollywood ceased but a script mysteriously arrived in the mail. Surely that was a good sign. She realized that in the wake of her impulsive sexual forwardness, most of her ambivalence about the position had receded. More than simply a bounty that would bankroll her for a year, she thought that photographing the workings of a big movie in production would be "fun." But she did not land the job. What she did acquire was an ongoing sexual relationship with Calley, who joined a roster of men—including Marvin, Howard and Peter—who were primarily engaged elsewhere and only sporadically available.

Diane had lost weight during her illness. She looked gaunt. As a woman who accentuated her youthfulness so skillfully that younger men (Calley was seven years her junior) seemed unaware of her age, she was finding this sleight of hand more difficult to pull off. Her appearance varied as radically as her handwriting. On some days she was beautifully turned out, on others she looked dirty and disheveled. But she was making drastic modifications. Since childhood, she had been bothered by her jutting teeth, especially the prominent cuspids. Doon told her she resembled Dracula and a friend, Barbara Jakobson, would try to avert her eyes from the "snaggle teeth" with their "odd assortment of shapes." At the time of the *New Documents* opening, Diane had the canine teeth removed and wore braces for four months to realign her mouth.

The sudden aging brought on by illness sapped her self-confidence. Although she would not have called herself a feminist, Arbus was exquisitely attuned to the self-presentation of women in a sexist culture. Did the double standard make her angry? How could it not—at least, once she lacked the resources to play the game successfully. American society discounted aging women, in particular those who relied on their powers of seduction.

In mid-November, as she waited to hear whether she would be named the *Catch-22* unit photographer or would, as usual, be "dashing off everywhere for $100 at a time," Diane went prospect-

ing with her camera to a fancy-dress party at the Biltmore Hotel. The Artists and Models Ball was one of the charitable dances that marked the New York fall season. Arbus attended many of these events. When people wore formal outfits or elaborate costumes, she could explore the incongruity between their individuality and their uniforms. She captured memorable images at masquerade parties, drag balls, mummers' parades, Puerto Rican festivals, and most often, black-tie affairs. On the other hand, at shabby gatherings like the Human Be-In that she had photographed in Central Park the previous Easter, she found nothing worth keeping among the beaded and bearded celebrants. Subjects who let it all hang out did not appeal to her.

One of the prosperous guests at the Artists and Models Ball that night was Marilyn Neilson, who attended with her husband, Rulon. Although Marilyn was accustomed to photographers, Arbus stood out in that starchy setting. Most society photographers were men. More than that, her appearance was slovenly, with "black and droopy" clothes and "stringy hair." "She didn't even smell very good," Marilyn recalled. Unlike her fellow New Documentarians, Winogrand and Friedlander, who also photographed at parties around this time, Arbus did not grab shots in the crowd. Her male colleagues were conveying a sense of what it was like to be at these gatherings: giddy, silly and sexy for Winogrand, disjointed and alienating for Friedlander. Arbus was more like the man with a camera on the deck of a cruise ship. She was producing portraits. When she came up and asked permission to take a picture, Marilyn and Rulon were talking to two of their close friends: Roland Gammon, a religious writer, and George Masone, an owner and breeder of Kentucky horses. She and Rulon had been married for a year and a half. It was the first marriage for each, even though Rulon, an oil company founder, was twenty-seven years older.

Marilyn was accustomed to attracting worshipful or lustful male glances. When she was still Marilyn Hanold, she had posed as a Playboy Playmate of the Month and for a Gil Elvgren pin-up of a

witch on a broomstick, and then leveraged her physical assets into starlet roles in Hollywood. She was a tall, buxom woman, often described as statuesque. At the Artists and Models Ball, her high-necked fitted tunic and long skirt concealed her skin but not her curves. Almost two months pregnant, she was not yet showing. Her hair and makeup were elaborate and impeccable. She wore a large Kenneth Jay Lane rhinestone choker and sparkly earrings.

After receiving permission to take a few pictures, Arbus asked the group not to look at her and to go back to what they were doing. The men resumed their conversation and ignored the camera. Marilyn could not forget that she was being photographed. "Even when I go to the symphony, I'm aware that people are watching," she later said. "I think it becomes ingrained." In the picture Arbus printed, the men are holding drinks and smiling as they talk. Marilyn is standing still and straight, a slight smile on her lips, her eyes focused on something imaginary in the distance. She is interacting with Arbus as strongly as if staring at her. She is posing. And the perfection of her coiffure and maquillage in combination with the lack of animation in her face creates a curious effect. It was around this time that Arbus visited the Museum of Famous People on West Fiftieth Street, where she took pictures of dioramas of vinyl figures: Harry Thaw murdering Stanford White, Charlotte Corday confronting Marat in his bathtub, the panicked young women in the Triangle Shirtwaist Factory fire. She devoted most of her film to a representation of the Last Supper. Photographing in a museum of replicas, she endeavored to make the mannequins look weirdly lifelike. Working as a party photographer, she has done the opposite. Marilyn seems to be made of wax or china, a life-size doll, literally a trophy wife. Decorative and silent, she represents a bygone womanly ideal. Fittingly, the white wall behind the foursome is blank but for two electrical outlets: available female receptacles.

A Political Year

In 1968, the most political of years, the "police riot" outside the Chicago Democratic convention, the collapse of Eugene McCarthy's insurgent campaign and the election of Richard Nixon followed upon the assassinations of King and Kennedy. Inevitably, Arbus was asked to photograph some political figures. *Harper's Bazaar* sent her to Atlanta in early October to do a portrait of Coretta Scott King, the widow of the civil rights leader. Although Diane enjoyed the trip, she judged her photographs "awful." The one that was published, of Mrs. King looking heavenward with her hands clasped in front of her waist, is almost as saccharine as the Paul Engle poem that accompanied it. Arbus's best portraits are a discomfiting blend of barbed compassion. That approach would not work for Mrs. King. National revulsion at the crime was so great and racial tensions ran so high that an admissible portrait could only be anodyne. "It is quite extraordinary how I cannot seem to take a photograph of a person that makes them look good," Diane wrote to Howard a month later. "I dont think I ever have and the few times Ive made a special effort the photograph was rotten." In Atlanta, Mrs. King informed Diane that she had asked her young son for his feelings about the assassin, James Earl Ray, and the boy had replied, "I think Daddy would

have forgiven him." Recounting the incident to Crookston, Arbus commented, "Thats what I mean about her. It gives me the creeps but you arent allowed to say why."

She had better luck with McCarthy, whose mordant Irish wit and intellectual bent came much closer to her own sensibility. She visited him for *Esquire* in his Senate office on the evening of the presidential election. When he peered up at her as if his dentist had just entered the room, and made "that curious gesture of looking like he was about to give me his face to photograph managing all the while to avoid inhabiting it," she smelled incipient disaster. Her lodger, the former Suzanne Victor, now married and known as Suzanne Trazoff, had advised Diane that McCarthy loved and wrote poetry. Recognizing that she had to act swiftly, Diane (as she later explained to Howard) delivered "my schoolgirl piece about my brother the HowardNemerov and the whole climate changed." McCarthy expounded on one of Howard's poems, searched in vain for a book of Nemerov verse (Diane would send one once she returned to New York) and invited her to stay. They chatted amiably. She remarked on the Mathew Brady portrait of Lincoln on the wall, and he regaled her with off-color Lincoln anecdotes. As the night drew on and the election results became clear, she watched him telephone Humphrey with condolences and compose comic versions of a congratulatory telegram to Nixon. Late in the evening, when she was ready to use her camera, "he was terribly open and curiously willing," she reported to Howard, "although in the photograph he looks haunted." She liked the results. He resembled, she told Crookston, "a defrocked priest."

However, the McCarthy picture was not published. Other political projects also withered before fruition. A vague scheme by Crookston at the beginning of the year to depict what Arbus described as "baroque Republicans" went nowhere. Another plan, to photograph Nixon's running mate, Spiro Agnew, for *Esquire,* fell through when the magazine decided to use a caricature instead of a photograph. Fearing it would sound like "sour

grapes," Arbus refrained from telling the editors that she felt Agnew was already a caricature, with a physiognomy so vulgar that the drawing defied belief and looked "awful." One built-in advantage of a photograph is that it is demonstrably portraying (however skewed the perspective) something real.

No matter. She preferred photographing the obscure over the celebrated, the victims of power rather than its agents. They went before her camera with fewer defenses, and the humble burdens they carried aroused her empathy. In fall 1968, John Berendt, an editor at *Esquire,* read a newspaper item on Iva D'Aquino, who was better known as Tokyo Rose. Convicted of treason on dubious evidence, D'Aquino had served six years in prison. Through her lawyer, Berendt learned that she was living in Chicago. For the first few phone calls, she pretended to be her sister, but eventually she admitted her identity and agreed to a portrait. Berendt asked Arbus to take it. "Diane was the perfect choice for photographer, not only because of the bizarre subject matter, but because Diane was a reassuring presence which is useful for skittish subjects," he later explained. "Diane was delightful, very gentle, friendly, benign, but her eyes would light up at the mere suggestion of oddity, deformity, depravity."

Iva D'Aquino was an ordinary-looking middle-aged woman with an extremely odd history. An American citizen born to Japanese immigrants, she was visiting a sick aunt in Japan when the United States declared war on that country. Detained by the authorities, she refused to take Japanese citizenship or to broadcast anti-American propaganda. However, she accepted a part-time job playing music on an English-language radio station. There were a number of women who, speaking in English over the Japanese radio network, were collectively christened as "Tokyo Rose" by their audience of American GIs. Only D'Aquino was prosecuted. Years after Arbus's death, she would receive a presidential pardon.

In the photograph, Arbus emphasized the ordinariness of D'Aquino's life. Aside from a shoji screen that lends a faint Jap-

anese flavor, the living room of this notorious figure is breath-takingly typical, from the lace doilies on the armchair to the blank screen of the centrally placed television set and the plant in a foil-wrapped pot on the windowsill. In the midst of it all is primly dressed Tokyo Rose, looking at Arbus with a sweet smile, as respectable and unremarkable as everything else in her home. She "looks as innocent as most of us," Arbus told Crookston, and "is just a pleasant, cheerful lady living in Chicago now." Although Arbus disparaged the assignment as "a very dumb story," she believed with mild indignation that D'Aquino had been "wronged."

As in her portrait of the nudist retired couple in their bungalow, the conventionality of the pose in the Tokyo Rose photograph underscores the peculiarity of D'Aquino's situation. "Diane liked the middle-class banality of it," Berendt explained. "And the opacity of the dead [TV] screen." The plan was for Arbus to take notes that Berendt would convert into a text block, but when she was back in New York, Diane asked to write it herself. Berendt happily consented. Arbus described the composite Tokyo Rose who emanated over the airwaves, harping on destroyed American ships and urging the Yank soldiers to go home, as being like "Betty Grable and Peter Lorre rolled into one." The quotes from D'Aquino underlined the comic absurdity of her misfortune: "Isn't it funny?" "It was eeny meeny miney mo, and I was It." "I could have done without all this, but it's a lot of water under the bridge now." Berendt was pleased. Diane performed the task "very nicely," he judged.

Back from Chicago, attempting in vain to ignore the dreaded advent of Christmas, Arbus was feeling "rather ornery" but brimming with ideas. She wanted to photograph "double twins"—twins who were married to twins—but was having trouble tracking them down. She was thinking about cosmetic surgery and beauty queens. She obtained permission and traveled to Englewood, New Jersey, to take pictures at a retirement home for

old actors. She told Crookston that she longed to photograph the mentally disabled. She knew someone who could help her.

None of that brought in income.

Luckily, Pat Peterson at the *New York Times* hired her once again to do the magazine's children's fashion supplement, which was being shot this year in Saint Croix, in the U.S. Virgin Islands. The pay was generous: $5,000. And the output the last time had been more satisfactory than Arbus anticipated. She'd stipulated that the credit "Arbus Studio" appear on the first supplement, but for this, and the one subsequent edition that she photographed, "Diane Arbus" is identified as the photographer.

Flatland

Bestowing quirky gifts on her friends delighted Arbus. She gave Tina Fredericks old tin letters that spelled out TINA (and were made of a metal with a name like Tina). After Fredericks had moved out to the East End of Long Island, Arbus brought her a heavy Swedish waffle iron in the shape of a heart. Sometimes her choices were more mysterious. Following one of the fashion shoots for the *Times* in the Caribbean, Arbus mailed an editorial assistant who had been on the trip a metal puncher that would emboss writing paper and envelopes with the young woman's address. The gift puzzled its recipient.

A present that Arbus delivered to many people, apparently bewildering them all, was a book entitled *Flatland: A Romance of Many Dimensions,* a mathematical fantasy that was published in 1884 without fanfare, only to be discovered by enthusiastic readers long after the death of its author, Edwin A. Abbott. Both a satire of Victorian values and a speculation about dimensions beyond the three we know, the little book came into vogue in the sixties, and Arbus was not alone in recognizing its charms, even if it perplexed her friends. "It baffled me and has again in subsequent attempts to read it," Pati Hill admitted. The documentary filmmaker Emile de Antonio felt the same way when

Arbus brought him a copy around 1969. He recognized that she never made such a gesture "without some definite meaning or purpose," but after glancing through it, all he could think was: "What the hell does Diane mean by this?"

Flatland is a fable narrated by a character named A Square. (The author's full name was Edwin Abbott Abbott, which a mathematically inclined thinker might playfully express as Abbott to the second power, or Abbott (A) squared—a detail that was just the sort of clever transposition Diane appreciated.) A Square dwells in Flatland, a two-dimensional universe, and, as his name suggests, A Square is a square. In Flatland, the population consists of male polygons—triangles, squares, pentagons, and so on. The more sides you have, the more august you are. At the very bottom of the pecking order are the women, who are merely lines—"the Thinner Sex," they are called. Barely above them, as you ascend in society, you find the lowly isosceles triangles. With their sharp-angled points, these male ruffians are almost as dangerous as women, and comparably expendable. In geometry, the more sides to a two-dimensional figure, the wider are the angles where those sides meet. In Flatland, therefore, a high-ranking man with many sides also has very wide angles. Once the sides are so numerous as to be virtually continuous and the angles are so wide as to be no longer detectable, the polygon is revered as a Circle, one of the rulers of the land.

Confined as they are to two dimensions, the people in Flatland can't directly see each other's entire form. (That would require rising above Flatland, not residing in it.) When they come face-to-face with each other, what they glimpse is a side of a polygon, that is to say, a line—or, more informatively, the place where two sides of a polygon meet, and those two lines form an angle. That's enough. If all the sides of the polygon are equal in length, one angle tells them everything they need to know, because the angles between those sides will also be equal, and from the size of that angle you know how many sides are contained in the polygon. In other words, you can infer the whole

form in front of you from a single angle of a "regular" polygon. But what if the sides are unequal, which would mean that the angles vary as well? In Flatland, these "Irregulars" are scorned by society, including their families, and closely policed as they grow up. If at maturity their margin of deviation exceeds a specified level, they are destroyed. Otherwise, they are permitted to toil in a life of supervised servitude.

One begins to see the reasons for Arbus's appreciation of this social satire. But it gets better. The lower orders in Flatland perceive each other's angles through "Feeling." Among the more highfalutin Flatlanders, however, "'Feeling' is discouraged or actively forbidden." These socially superior beings are educated to read each other's angles through the subtle way light bounces in the foggy atmosphere. They are unable to feel, only to see.

Consumed by snobbery, the regular polygons dream that their offspring will ascend in rank through the rapid acquisition of more sides and wider angles. In a normal generation, a son will have just one more side than his father. That pace is not fast enough. Frequently, the status-crazed polygons will subject their infant sons to a high-risk procedure known as "fracturing." Most die, but the few survivors acquire so many new sides that their glorious success tempts many other parents to send their sons to an almost certain doom.

If *Flatland* did nothing else but lampoon a culture in which women and feelings are subordinated, regularity is mandated, freaks are despised, and social climbing is the overriding passion of the privileged classes, Arbus could have giggled at the depiction of what might well be called Nemerovland. In the second half of the book, however, Abbott tackled his more ambitious project, which was to introduce a way of imagining a fourth dimension. A Square has a dream, in which he meets the monarch of a one-dimensional world called Lineland. The monarch believes that his kingdom, which consists of a straight line, comprises the entire universe. "Not being able either to move or see, save in his Straight Line, he had no conception of anything out

of it," Abbott writes. Because A Square is invisible to him, the king believes that the questions the polygon poses are sounds emanating from his own intestines. He is the sort of odd, colorful solipsist that Arbus pursued. And he greets the questions of A Square, which are predicated upon an experience totally foreign to him, with the dismissive arrogance that Arbus knew from the eccentrics she photographed: "Can anything be more irrational or audacious? Acknowledge your folly or depart from my dominions."

The dream prepares A Square for an experience that he is comparably ill equipped to comprehend. A Sphere comes to visit him—a three-dimensional emissary from Spaceland. Gradually, through visual demonstrations that can't be explained without assuming the presence of an additional dimension, the Sphere is able to convince A Square that he is not talking nonsense. Before long A Square is jeopardizing his own safety by speaking provocatively of other dimensions and quoting an old sage who declared, in words that might have come from Arbus's own magazine writing, that "prophets and inspired people are always considered by the majority to be mad."

Abbott's aim is to make an abstruse mathematical concept comprehensible to nonmathematicians. He is demonstrating that the existence of a fourth dimension, although as far from our intuitive grasp as a third dimension was to A Square's, can be postulated through an extension of the same logical reasoning.

But for Arbus, although not for most of the friends upon whom she pressed copies of *Flatland,* another more mundane concern might have come to mind. What the Sphere needs to do for A Square is transform the three-dimensional world into a legible two-dimensional version. As a photographer, that is what she did every day, by both seeing and feeling.

And unlike some of her contemporaries, whose on-the-run photographs conveyed a glimpse of things that were rapidly changing, Arbus did not try to capture the presence of what is conventionally thought of as the fourth dimension: time. Rather,

she sought to banish it. "What's definitive is always calm, because it is detached from time," stated the narrator of another book she loved, Italo Svevo's *Confessions of Zeno*. "One of the wonderful things about Diane's pictures is, despite the fact that on some grounds they're startling, they also have this wonderful placidity," MoMA's Szarkowski observed. Three dimensions have been converted into two, and the fourth dimension is at such a remove that it's not perceptible, or even imaginable. Edwin Abbott Abbott would have understood, even if Arbus's friends did not.

63

Swinging London

Allan pressed forward with the plan to change his life. In Los Angeles, he would pursue an alternate career, set up a second household, and, eventually, start a new family. As a preliminary step, he needed to formalize the ten-year separation from Diane. The time had come to obtain a divorce.

In 1969, the simplest, quickest and cheapest way for a New Yorker to dissolve a marriage amicably, free of accusations, was to travel to Mexico, where only one spouse had to be present. As the border with Mexico represented a minor detour on the way to California, Allan added the stop to his itinerary. Diane joked with him about it, but her apprehension bubbled close to the surface. "This isnt exactly total divorce," she wrote him at one point; and then, a week or so later, she added, "If you want more total divorce lemme know."

Their initial split in 1959 had hollowed her out. The legal divorce, and more powerfully, the geographical separation, would undermine her once again. Ever mindful, Allan set up a darkroom for her at 29 Charles Street, a few blocks east of the carriage house where she had initially landed after their separation. He arranged for his former assistant to teach her how to develop

film, which she had never done, and he supplied instructions on developers. "Its arduous but good to be learning," she told him in midsummer, when she was fully immersed in the process. "I feel like I am making my own shoes." The loss of his physical proximity, however, he could not correct.

With the singular exception of Marvin, the men Diane relied on tended to be kindly, protective and (compared with her women friends) straightforward, pragmatic and prosaic. They recognized both her superior talents and her emotional lability. Sometimes their bond with her included sex and other times not, but the relationships, irrespective of erotic components, were fundamentally fraternal. Howard set the mold. Allan perfected it. Outsiders often remarked that Allan and Diane seemed like brother and sister. Later, Alex Eliot, Robert Brown, and now Peter Crookston assumed the brotherly role.

In February 1969, Crookston left the *Sunday Times Magazine,* where he had risen to deputy editor, to become the editor of *Nova. Nova* was founded in 1965 as a women's magazine. However, its hard-hitting reportage (life in a women's prison) and steamy photographs (how to strip for your husband) were thought to attract as many male as female readers. Story topics might be sensational, but the treatment was tough-minded, the design artistic and the contributors often top flight. Crookston brought with him to *Nova* his *Sunday Times Magazine* colleague David Hillman as art director. Like Michael Rand, Hillman admired Arbus's work, so he gladly endorsed Crookston's initiative to employ her as much as possible. The better American photographers usually declined jobs for British monthlies, which paid poorly and lacked visibility at home. Hillman assumed that Arbus photographed for *Nova* because of her relationship with Crookston.

That was partly true. "I like to work for you because you are daring dashing fair decisive formidable and even rather wise," she had written him coquettishly the previous spring. (She added as a postscript: "do you find me tough and ruthless? or arrogant and unreasonable? or feminine? or what? or funny?") Aside

from her fondness for Crookston, Arbus was in urgent need of any paying assignment.

Erotic seduction and keen scrutiny, coiled tightly, charge Arbus's most characteristic work. But those strands were starting to unravel, as the sex and the photography proceeded separately, without either furnishing her much satisfaction. Soon after Crookston took over at *Nova*, Arbus included among her story suggestions one on Eberhard and Phyllis Kronhausen, married sexologists who were collectors of erotic art, campaigners for sexual freedom and live-in therapists for private patients. The Kronhausens were very willing to be profiled; indeed, their ardor for publicity troubled Arbus, but she thought, given their sexual expertise, they might at the very least steer her in useful directions. A few months before writing to Crookston, she had arranged to call on them at seven A.M. in an Upper East Side apartment they were occupying on a visit to New York. She set up her tripod in the bedroom, but before she could start to take pictures, a conversation sprang up about group sex. Like Arbus, the Kronhausens not only observed, they participated. Diane revealed that she had joined in orgies she attended to photograph. The question hung heavily in the air: Was this to be one of those occasions? The ambiguity of the situation might have excited Arbus to snap away furiously. Instead, their knowingness unnerved her. Who was seducing whom, and to what end? She failed to take any pictures. According to Eberhard, she suddenly announced that she was too aroused to photograph and wanted to climb into their bed and make love. Although Arbus was never bashful about recounting her sexual exploits to Crookston, she gave him a different explanation of why the session did not work out. The encounter was "too verbal," she told him, and left her with "a funny eerie sense of mutual exploitation." On second thought, she would rather not photograph the Kronhausens, not for *Nova* or anyone else. And she never did.

She delightedly accepted Crookston's offer to photograph in England, a trip he financed by splitting the assignments (and the

costs) with the *Sunday Times Magazine*. He proposed two possibili-
ties: the rock band The Who and the wives of famous men. In the
weeks leading up to her April 16 departure to London, Arbus was
terrifically busy. She flew to Houston for *Sports Illustrated* to shoot
the rotund, flamboyant Roy Hofheinz, a "terrible Texan" who
owned half the Ringling Bros. and Barnum & Bailey Circus and
leased the Astrodome. She posed him grinning with a showgirl and
a clown. She returned home, going out to New Jersey for Easter
on an exciting long-term project that she had recently begun. And
then she was off to London. "I have always thought it had the dirti-
est secrets in the world," she wrote gaily to Crookston. "Does it?" He
didn't know what she meant. For starters, she had heard there were
clubs in which secretaries performed stripteases during their lunch
hours. "Show and tell me everything," she implored him.

When she arrived in London, Diane was wobbly. It may have
been the pressure of too much work or the strain of too little
money. Ever since the hepatitis relapse, her health had been pre-
carious. Allan's impending departure churned up deep anxiet-
ies. And even without a clear cause, her mood could fluctuate
extremely. Whatever the reasons, her spirits were low, and she
burst into tears without warning. Crookston was struck by her
gaunt face, which bore the marks of a serious illness. She seemed
so frail, both physically and emotionally, that he feared the trip
would be a disaster. Then she began to photograph, and Diane's
demeanor changed. "As soon as she started working and the work
began going well, she became happy," he recalled.

The story lineup had shifted from the original plan. Because too
few wives of the great and powerful agreed to be photographed,
that piece was dropped. And instead of The Who, Arbus would
be shooting Lulu, a twenty-year-old singer who had precociously
released several hit records. A portrait of a pop star was a standard
magazine assignment; even so, Arbus's lead photograph of wide-
eyed, vacuous Lulu pushed, if it didn't transcend, the genre.

The most original idea of the trip was hers, and it was a char-
acteristic one: "people who think they look like other people."

Desired and imagined resemblances, with their built-in ironic double take, supplied Arbus with some of her favorite material. She found ingenious ways to illustrate the theme, from Valentino look-alike contests to scenic wallpapers in public lobbies. In London, to find suitable candidates for her scrutiny, the *Nova* editors advertised in the press; many self-proclaimed celebrity doppelgängers responded, so many in fact that the staff had to winnow a short list of a dozen of the best prospects and let Arbus choose among them. Most were women who imagined they bore an uncanny resemblance to Elizabeth Taylor. The young Brooklyn mother, Marylin Dauria, had thought the same; it was a popular delusion of the time. Arbus photographed four Liz pretenders. Two other women imagined they could be mistaken for Sophia Loren, and a seventh made herself out to be a twin of Zsa Zsa Gabor. The best of the lot, however, was a surgeon's widow who believed she resembled not a film star but a queen. Norma Falk really did look something like Queen Elizabeth II, at least when viewed from the right angle and quavering with emotion. Seated in a pose that was demure and stately, Mrs. Falk merited the lead position, on a full page. Acting on Arbus's inspired notion, the magazine sent out the picture to be hand-colored, so it resembled the sort of old-fashioned postcard that was sold at the time of Elizabeth's coronation. After disliking the first attempt, Arbus told the colorist, Maxine Kravitz, a former Parsons student who had also taken classes with Marvin, that she wanted pink and aqua tints like the pastel sugar coatings of Jordan almonds.

Arbus sympathetically propped up the fantasies of these subjects. "Oh, you *are* like Elizabeth Taylor!" she would exclaim, leaving the hearer to feel, as one put it, "really special" and "marvelous." However, her greatest success in charming the natives—and her favorite work generated by the trip—came in the seaside town of Brighton, where she went to photograph another variety of pretender. Writer Peter Martin, who hailed from a working-class district of Brighton, had already written a story on a gang of young motorcycle riders and their girlfriends. Like the Brooklyn

Jokers that Bruce Davidson had photographed a decade before, the leather-clad "rockers" were powered by testosterone, frustration and bluster. Both they and their sworn adversaries, the sharp-dressing dudes called "mods," emulated the styles of film and pop stars. (The rockers especially admired Elvis Presley on his Harley-Davidson.) But unlike the pliable women who modeled themselves on Elizabeth Taylor, bands of mods and rockers disrupted seaside resorts such as Brighton with their brawls. Many people feared the rockers, but Peter Martin wasn't one of them. He thought they were "really sweet kids." Crookston asked if he would escort Arbus to Brighton and introduce her to them.

He met her at Victoria Station and they went down in the Brighton Belle, a Pullman train done up in Ye Olde fashion with gilt lettering on the brown-and-cream cars. Inside, the windows were curtained, the lamps shaded and the seats velvet. "She was amused and a little delighted," Martin thought. He was only twenty-four. In her leather jacket and tight trousers, she seemed like a very hip American lady, but he felt comfortable talking with her. "She looked as if she hadn't had the easiest sort of life," he remarked. She responded merrily to anything quintessentially English. For Sunday brunch, they went to a seafront restaurant in which the waitresses wore lace aprons, and she pointed out with amusement the excessively bright oranges and greens of the carrots and peas that accompanied the roast lamb. She adored English food—the way it looked if not the way it tasted. On another day, she marveled to Crookston about the windows of the Kings Road pastry shops. "I love those cakes with cream oozing out of them," she said.

The rockers' hangout, a roadside café on the outskirts of town called the Day-Go, was as much a stage set as the Brighton Belle. It was a place where young men could feign a tough worldliness. Dressed in her customary black leather jacket and acting a part of her own, Arbus spent the first couple of hours without any film in her camera, pretending to take pictures while she developed a rapport with the bikers and their girlfriends. She confided

that subterfuge to Martin on the train back to London; at the time, he believed she was photographing all along. He watched as the rockers gradually relaxed—in response to her sexiness, he thought. "It wasn't sleazy sexuality," he observed. "She was just very sexy, very seductive." She was regarding them with fully appreciative attention, and they returned her open gaze. Later, seeing a photograph of a young couple posing on a motorcycle, he was startled. "I hadn't realized how beautiful they were until I saw the photo," he said. "It wasn't what she did with the camera. It was the way they had begun to relate to her." The young man and woman, with artfully tousled long hair, had become attractive because they sensed that she found them so. Beneath the girl's eye makeup and the boy's confrontational stare, their child-like innocence—what she called their "donquixoteness"—shines through. Here was a rare instance of Arbus taking a picture that made people look good. On the train ride back to London, she seemed drained of energy and didn't talk much to Martin. She was reading an encyclopedia on sideshow performers, with the provocative word *freaks* in full view on the cover. "This book in front of her was almost getting in the way of the conversation," he explained. "I found her easy use of the word 'freaks' so potent."

Because she saw the rockers as a kind of family, Arbus suggested laying out the pictures in the format of a "family album." She added that the art director could crop the images, even writing the rockers' comments under or across the photographs, so that they resembled snapshots. Although Crookston appreciated her journalistic selflessness in service of the story, Hillman did not deface her photographs. When the piece came out in September, Arbus told Crookston she liked it "more than any published thing in a long time." (Unfortunately, more than five months after her trip she had not received any payments from *Nova* except for expense reimbursement.)

Although it helped subsidize Arbus's travel expenses, the *Sunday Times Magazine* published nothing. "It was difficult to find subjects for her," recalled Rand, the art director. The magazine

proposed a story on a hospice in the countryside, and she went out one day with the writer Francis Wyndham, neither of them feeling any enthusiasm for the assignment. The sight of the terminally ill patients dismayed her. She always shied away from photographing people who were painfully afflicted, and at the hospice she took no pictures. Wyndham was moved by her empathy.

One evening, she took an overnight trip to a village near East Grinstead, in the countryside south of London, where Alex Eliot had moved with his wife, Jane; their two young children; and his daughter May. Diane hadn't seen Alex in years. The friendship was quiescent, but the link, forged so early, endured. After a Guggenheim Fellowship took him and his family to Spain in 1960, Alex had quit his *Time* position in search of a less stressful, more gratifying life. The Eliots had become world wayfarers, living in Greece, Italy, Japan and now England. When Alex and May went to the train station to fetch Diane, they saw on the platform only a young man with his back to them. As the youth turned, they realized in the fading light that it was Diane—cropped hair, leather jacket, lean figure. That night they all talked until very late. Diane described what she was photographing—in particular, the woman who thought she was a double for Queen Elizabeth. She said that she coaxed the woman to the verge of tears, because in that state, she looked more like the queen. When Jane admired an unusual silver ring on Diane's finger that was shaped like an insect, Diane took it off and gave it to her, placing it on her hand with a solemn look. She left the next morning on a very early train back to London, concluding a visit that felt to the Eliots disturbingly like a valediction.

While in England, too, Diane crossed the Channel to pay a call on Pati, who was in the country compound that the Bianchini family owned outside Paris. Although the purpose of the visit was for the old friends to catch up, Diane was so tired that she dozed away much of her time in a lawn chair. Then, at the Bianchinis' large kitchen table, she announced that this was her "prescription" and produced from a brown paper package a slab of raw

liver, which to the horrified astonishment of Pati's four young nephews and nieces she wolfed down. When she finished, she bared her teeth in a bloody smile. Pati realized for the first time that Diane had suffered a serious illness.

On her last evening in London, Arbus rewarded herself for a successful mission by stopping at a trendy leather shop on the Kings Road. There was a piece of clothing she really wanted, but once there, she realized she was about twenty-five pounds short of the price, and there was no time to retrieve funds from her hotel room before closing time. Would they trust her to take the garment if she promised to send over the amount due in the morning? To Crookston's astonishment when she told him the tale and asked him to deliver the money, they did trust her.

Arbus impressed people as being reliable. Margaret Pringle, a writer who worked with her on the look-alike story, was surprised to receive in the mail a package from Diane in New York containing a duplicate of that silver insect ring she had been wearing in London. Like Jane Eliot, Pringle had admired it. Arbus had promised to send her one, as people do and then forget. She remembered. (Both rings broke very quickly; the wiry legs caught in fabric and snapped.) With the exception of those times that she promised that an aspect (usually nakedness) of a subject's appearance would not show in the photo, or implied that the marvelous way a subject looked was a variety of what is commonly understood as beauty, Arbus usually kept her word. This was one reason that the people she photographed placed their trust in her. Sometimes it seemed that the only person who lacked confidence in Diane was Diane.

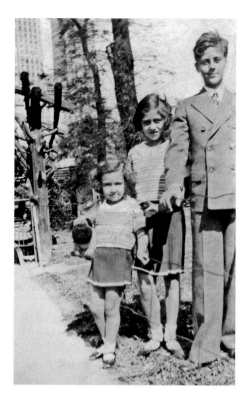

The Nemerov children, circa summer 1931, when Howard was eleven, Diane eight, and Renee almost three. The two elder children had a special bond. "It was them against the world," Renee said.
Courtesy of Alisa Sparkia Moore

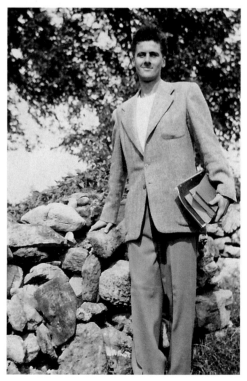

Bookish Howard preceded Diane at the Fieldston School. His English teacher, who considered him to be "exceptionally brilliant," was astonished to find Diane "far more brilliant than Howard" and "totally original."
Courtesy of David Nemerov

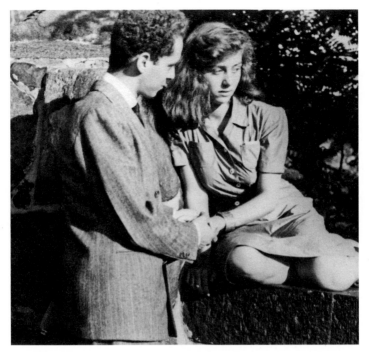

In 1936, when Diane was thirteen, Allan Arbus came to work at Russeks, her parents' department store, and she quickly decided that she would marry him. They often went together to Central Park, as here in the summer of 1939.

Courtesy of Alisa Sparkia Moore

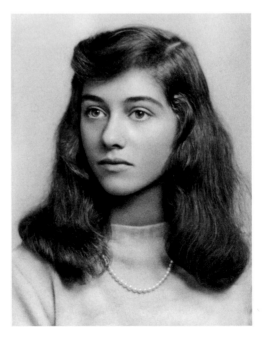

Diane's high school graduation picture in 1940 was also used that year for her engagement announcement.

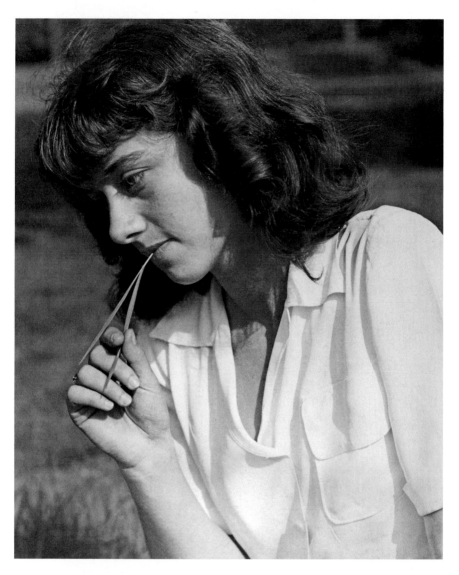

Diane in Central Park, circa 1939. This picture was owned by Howard throughout his life and is likely the image of Diane that he carried in his Bristol Beaufighter when he flew bombing missions during World War II. *Courtesy of Alexander Nemerov*

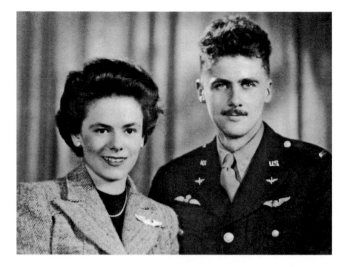

In London during the war in 1944, Howard met and married Peggy Russell. He sent her to New York to stay with the Nemerovs. Their wealth astonished her. Their chilly welcome unnerved her. *Courtesy of Alisa Sparkia Moore*

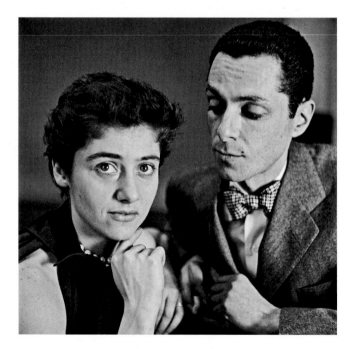

Diane and Allan in the early years of their marriage posed for *Glamour*, a magazine that hired them regularly to take fashion photographs. "What matters love? If only 'Glamour' loves our next picture," Diane commented acidly.
Frances McLaughlin-Gill/(c) Condé Nast

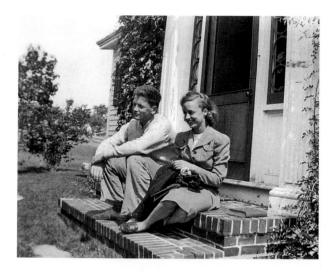

Alex Eliot's obsession with Diane contributed to the breakup of his first marriage to Anne Dick, seen with him here, circa 1940.
Courtesy of May Eliot Paddock

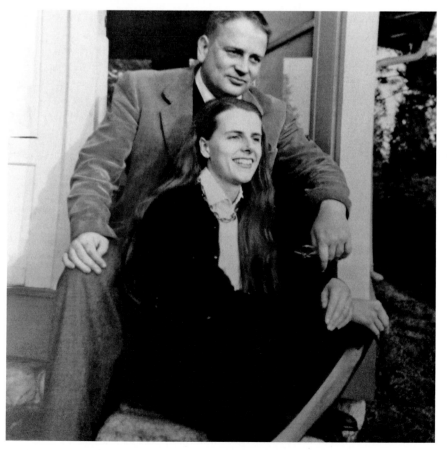

Alex's second wife, Jane Winslow Knapp, with him here on their honeymoon in 1952, knew the history and astutely ensured that it would not repeat itself.
Courtesy of Winslow Eliot

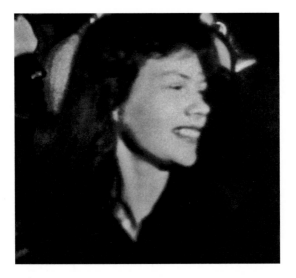

Nancy Christopherson, who was one of Diane's
closest female friends, appeared in Maya Deren's
1946 avant-garde film, *Ritual in Transfigured Time*.
"She lived every moment as an artist," said one of
Nancy's intimates. From *Ritual in Transfigured Time
by Maya Deren*, 16mm, 1946.
*Courtesy of the Estate of Maya Deren and Anthology Film
Archives, New York*

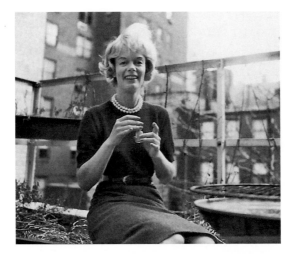

Pati Hill was Diane's other close female friend,
photographed here as she applied nail polish on
her Upper East Side terrace, circa 1956. "I've told
you everything and you are still full of secrets,"
Pati once complained. "I need my secrets," Diane
replied. *Paul Berg,* St. Louis Post-Dispatch

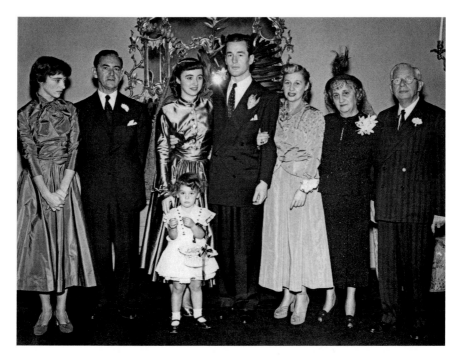

The Nemerovs gathered for Renee's wedding to Roy Sparkia in 1947. *(From left to right:)* Diane, David, Renee, Roy, Gertrude, Rose and Frank, with flower girl, Doon, in front. "Diane still captures all the family first-run love and attention," Roy later groused. "Ren gets the fondness of a second-rate pet." *Courtesy of Alisa Sparkia Moore*

After David retired from running Russeks, he and Gertrude moved to Palm Beach, where he fulfilled his dream of becoming a painter. Diane compared the creation, framing and selling of her father's flower paintings, which he successfully exhibited and sold for as much as $2,500 a canvas in 1958, to the hucksterism of "a patent medicine man with his own bowel movements in the bottle." *Courtesy of David Nemerov*

The Viennese-born photographer Lisette Model, seen here circa 1970, was Diane's teacher and friend. "Three sessions and Diane was a photographer," said Allan, describing the effect of Model's instruction. *The Estate of Irene Fay/Courtesy of Barry Singer Gallery, Petaluma, CA*

Painter and graphic designer Marvin Israel, in his studio in spring 1964 with his cat, Mouse. Diane's married lover and devoted collaborator, Israel loved to push and provoke. "The more strange, the better, for Marvin," said one of his protégées. *The Estate of Michael Flanagan/Courtesy of Sharon Cooke*

Zohra Lampert with Allan, circa 1960. "There was nothing ungoverned about him," she thought. In 1963, she ended their six-year love affair. "I didn't want to be an ensemble," she said.
Courtesy of Zohra Lampert

Diane with her younger daughter, Amy, in 1963. Amy's summer camp counselors told Allan that "they'd never read such loving letters" as the ones Diane wrote.
(c) Lee Friedlander/Courtesy of Fraenkel Gallery, San Francisco

The *New Documents* group exhibition at the Museum of Modern Art in 1967 was Diane's most important show during her lifetime. During the installation, she and Garry Winogrand, who with Lee Friedlander filled out the three-artist exhibition, worked the telephones. Once the show had opened, the reviewers devoted most of their attention to Diane. *(c) Tod Papageorge*

At the exhibition's opening on February 27, 1967, Diane watched intently as Allan and his girlfriend, Mariclare Costello, chatted with Howard. Her invited guests ranged from Gloria Vanderbilt to a sideshow snake dancer. *(c) Avery Architectural & Fine Arts Library, Columbia University*

Diane spoke at a workshop hosted by Richard Avedon and Marvin
Israel in 1967, the day after the opening of *New Documents*. With
her Vidal Sassoon haircut and modish dress, she appeared
unusually elegant and spoke with uncharacteristic assertiveness.
(c) Gideon Lewin

Diane attanded a peace march in Central Park on April 15, 1967, but came up with nothing she liked. She had better luck at a pro-war demonstration a month later. *(c) The Estate of Garry Winogrand/Courtesy of Fraenkel Gallery, San Francisco*

At the October 16, 1969, opening of an exhibition of thirty years of modern and contemporary New York art held at the Metropolitan Museum of Art, Diane chatted with the artists Claes Oldenburg and Hannah Wilke, Oldenburg's girlfriend at the time. *(c) The Estate of Garry Winogrand/Courtesy of Fraenkel Gallery, San Francisco*

Although known by reputation as a photographer of sideshow freaks, transvestites and other marginal characters, Diane took many more pictures of conventional women and children. She had a two-part process. First she charmed her subjects, then she lowered her head to the viewfinder and captured them. *(c) Tod Papageorge*

London magazine editor Peter Crookston, seen here in 1972. After meeting Diane in the fall of 1967, Crookston became both her occasional lover and her constant journalist collaborator and commissioning editor.

Courtesy of Peter Crookston

Constantly pressed for money, Diane taught classes in the late sixties. She hated doing it, but her students found her fascinating.

Courtesy of Alisa Sparkia Moore

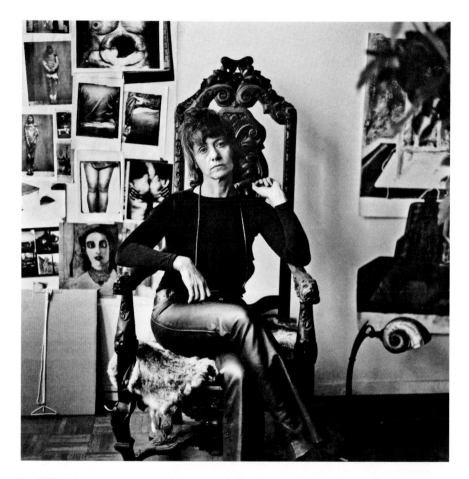

In 1971, Diane was gaunt and depressed. She lamented that her work no longer gave her anything back. In her Westbeth apartment, she posted photographs that depicted people with deformities and victims of horrific violence. *(c) Eva Rubinstein*

Shortly before her death, Diane asked a friend, artist Nancy Grossman, to make a rubbing of her hand. "It will hurt," Nancy objected. "I don't mind," Diane said.
(c) Nancy Grossman

The 1972 posthumous Arbus retrospective at the Museum of Modern Art was a blockbuster. The director of the photography department at MoMA, John Szarkowski, who was Diane's most important backer, chatted with Doon at the November opening.
(c) The Museum of Modern Art/Licensed by SCALA/Art Resource, NY

HAPPY EVEN THOUGH THEY DON'T HAVE ANYTHING

PART SIX

HAPPY EVEN THOUGH THEY
DON'T HAVE ANYTHING

64

Asylum

The Easter celebrations that Arbus attended in New Jersey before traveling to London marked the early stages of a project she hoped would resurrect her career. By the standards of criticism, if not of commerce, her work was going well; and yet it was the artistry more than the money that bedeviled her. She feared she was repeating herself and others were copying her. It is hard to say which she dreaded more. Her style of square-shaped medium-format photographs, printed with a black edge on fiber-based, warm-toned Portriga paper, felt as personal as her fingerprints. But nothing stopped other photographers from adopting the same procedures. "Everyone is turning to Rolleis and Portriga and printing with black borders," she complained to Allan that spring. Her own recurring patterns disheartened her, too. She was growing tired of photographing at nudist colonies and carnival sideshows. She was becoming bored with the hyperclarity of strobe-lit close-ups.

As she had informed Crookston six months earlier, she was dreaming of something new, unlike anything she had done. Through connections, she was maneuvering to gain entry to institutions in New Jersey for the mentally disabled. Arbus had an enormous network of friends and acquaintances. Carlotta Mar-

shall, a delicately beautiful blonde who was of Doon's generation (and whom Doon and Diane had met in September 1959 through the *Village Voice* critic Michael Smith), was living on the Upper East Side with another young woman, Adrian Condon, and Adrian's husband, Robert. Diane would go there for dinner sometimes, and quickly Adrian felt as if they were longtime intimates. Robert Condon had been brought up by his aunt Mary Baird; she in turn was a cousin and confidante of the eccentric patrician legislator Millicent Fenwick of New Jersey. Today, the legal waivers and consent forms to photograph inside a state institution for the developmentally handicapped would be ferociously difficult to obtain. As the inmates lacked the mental capacity to grant permission, their guardians would need to sign off. Indeed, that was true then as well, but if you approached under the aegis of an important person, the custodians might sidestep the regulations. This was Arbus's angle of entry.

The first center she visited, in March, was located not far from New York, in Woodbridge, a small town north of Perth Amboy and due west of Staten Island. Woodbridge was a coed facility. To judge from Arbus's photographs, it was also a grim one. In a room with cinder-block walls and linoleum floors, she depicted the residents. Whatever they might be doing—holding a handkerchief, tumbling with a chair on the floor—the setting determined the tone. Very quickly she realized that to avoid making pictures that documented human degradation and transcendence in an asylum (as Avedon had done in 1963 at the East Louisiana State Hospital and Mary Ellen Mark would later accomplish in Ward 81 of the Oregon State Hospital), she required a more generic backdrop. She must eliminate the cinder block and linoleum, as she had avoided the swimming pool of the family on their lawn in Westchester.

The pictures she took on Easter Sunday, shortly before her trip to London, resolved the problem with a simple stroke. She would photograph her mentally disabled subjects outdoors. Trees and lawns were universal. In addition to Woodbridge, that day she

visited another institution, located in Vineland, in the southern part of the state near Atlantic City. Established in 1888, the Vineland Developmental Center, with about two thousand female residents in a rural setting, would be the backdrop for most of the pictures Arbus took in this project, which she was just beginning and which would engage her for the rest of her life.

Formally and technically, her photographs of the institutionalized women and girls constituted a new phase of Arbus's career. That became apparent later. More obviously, the pictures represented a shift in subject matter. The starting point on this trajectory may have been a portrait she took in 1968 for *Harper's Bazaar,* of a writer she much admired, Jorge Luis Borges. She shot him in Central Park with a medium-format camera; nothing unusual about that. But Borges, who was blind, could not return her scrutiny. Like the residents of the New Jersey centers for the mentally handicapped, he was immune to Arbus's seductive gaze. Although the portrait was good, visually the exchange was one-sided, and such engagements left Arbus without the replenishment she needed to project her charm on the next subject. When she photographed the blind musician Moondog in 1964, she had been flush with assignments and energy. But now she was on a downward spiral of depletion. She said in 1970 that the "ultimate photograph," which she had clipped from the Press section in *Time,* was one taken by a photographer who shot a gunman at the moment the assailant shot him. "It was extraordinary," she said, "because it was the proof that he was shot." The photograph recorded and verified an instant of intense mutual recognition. Her own pictures weren't doing that for her.

Yet photographing in Vineland provided her with a sort of asylum from the turmoil of life in New York. Although she had absorbed strength from her London assignments, once back home, "marvelously exhausted by the trip," she became rickety again. "I had a marvelous time," she wrote Crookston. "I mean I think all my tears in the beginning just made it all better in the end. You sustained me. I am indebted." In New York, she was "out

of whack," rising at dawn in a state of disquiet. The edginess of the city seemed to be seeping into her psyche. Violence was something she had never personally experienced, she confessed a little wistfully, but these days everyone was talking about violence. It was in the air. On a spring afternoon soon after her return to New York, she saw one man bleeding and another who was "totally ashen" and black in the face with decay. By Bethesda Fountain in Central Park, she informed Crookston, she watched people "devour each other with their eyes." A gawking crowd gathered around a girl who was lying on the ground in the spasms of an epileptic fit. They were pushing and straining for a better view. "The city is very tense," Arbus reported. She had been sitting on a bus next to an attractive, well-dressed young African American woman when a stout middle-aged white lady passed toward the exit door and with her umbrella touched the woman's knee. Reacting to the look of annoyance, the white woman said, "I'm sorry," but Arbus's seatmate did not respond. "I said I'm sorry, what more can I do than that?" the woman repeated, in a loud, angry, querulous voice. The black woman shrugged with sour apathy. Everywhere Arbus looked, she saw people who were furious, sullen, unable to communicate. The energy and hopefulness of the midsixties had curdled into a morass of resentment and paranoid suspicion.

Her sanctuary was her new darkroom, which she reached through the door of an apartment building, past a courtyard, and beyond another unmarked door. A plumber and carpenter were renovating it according to Allan's specifications. Thirteen years after she quit the fashion business, the brass plate, DIANE & ALLAN ARBUS STUDIO, was finally retired.

In anticipation of his absence, Allan was still taking care of her, as best he could. Without the income from his photography studio, however, he could do little to support her financially. Diane needed to stand on her own. More than that, she wanted to help cushion Allan's transition to an acting career. Over the last decade, he had toiled unhappily in a job he detested, earning an income that sub-

sidized her artistic development. It was her turn now to return the generosity. That seemed only fair. But was it feasible?

In late May, following barely a month in New York, during which she printed the pictures for *Nova,* Diane traveled to Florida. Gertrude, her second marriage in ashes, still resided in Palm Beach, but a daughterly visit was not Diane's priority. She was in Florida to make money. The Office of Public Affairs of the Social Security Administration had selected six photographers to depict a representative selection of the agency's constituency. Each got to choose a locale. William Gedney, for example, went to Hays, Kansas, and Duane Michals to San Antonio, Texas. "It was romantic," Michals thought, because of the commission's resonance with the Depression photographs made under the auspices of the Farm Security Administration. Some of his Texas pictures, of farmworkers harvesting onions and collard greens, evoke those hallowed images. The ones taken by Arbus, who opted for the retirement mecca of St. Petersburg, across the state from Palm Beach, look less like the FSA and more like Arbus. One of the people she photographed there was Andy Ratoucheff, the Russian-born midget in her first *Esquire* story, who was now living in retirement with a friend. In the week she spent there, Arbus also shot the nation's oldest dance instructors and the world's oldest softball player.

In Florida, she had another assignment, this one from Rand at the *Sunday Times Magazine,* to photograph the bodybuilding legend Charles Atlas, who kept an apartment in Palm Beach. The writer, Philip Norman, had already reported the piece. When Arbus's photographs came in (one taken from above showing Atlas bare-chested in a weight lifter's bench press, the other posing him as Rodin's *Thinker* against the elaborate window treatment and gilded furniture of his home), there was a note from her to Rand describing Atlas as "wondrously dense." Norman, who liked Atlas, objected to her tone of condescension. Yet a reader of his story—in which Atlas praised Michelangelo as "a fine artist, it's too bad he passed away," explained that he had

exchanged his Sicilian moniker for a surname he lifted from a
Rockaway Beach hotel and described preserving his purity by
resisting the advances of lustful, wealthy widows—might see how
Arbus arrived at her opinion.

In between St. Petersburg and Palm Beach, Arbus went to
Gainesville, where the photographer Jerry Uelsmann, who taught
there at the University of Florida, had invited her to be a guest
lecturer. Uelsmann recognized that she was doing it only for
the $400 fee, but he respected her work and reputation, and he
wanted to import distinguished photographers to the campus.
Uelsmann was a radically different photographer from Arbus. As
it happened, the Museum of Modern Art staged a small exhibi-
tion of his work at the same time as *New Documents,* and he had
met her then. In this period before photographs could be manip-
ulated digitally, Uelsmann printed with multiple negatives to cre-
ate montages in which an uprooted tree might float in the sky or
a woman's lips materialize on a country road. They were dream-
scapes, the kind of surrealist photography that bored Arbus. At
the end of her visit, with three hours to spare before her flight,
Uelsmann asked, "Would you like to see some of my work?" He
left her with a stack of about fifteen prints. In the space of two
minutes, she emerged from the room. "I'm ready to go to the
airport," she said.

In rural Florida, Arbus stood out. At her lecture, she wore a
very short skirt and a thin gray blouse with no bra underneath. "It
was a bit shocking in that town at that time," one faculty member
recalled; he characterized the intimacy of the personal details
she shared in her talk as "almost an aggressive vulnerability."
She began with her childhood. At her family's department store,
she said, the mannequins seemed alive to her, and she recap-
tured that sensation in her photographs of wax museums. She
explained how in the midfifties she had begun a kind of street
photography, but instead of blending into the background, she
would wear outrageous clothing, like fake leopard-skin coats, that
called attention to herself. Then the pictures from the nudist col-

onies appeared. Uelsmann, who had invited the dean and other important guests, listened nervously as she described taking off her clothing and feeling the surprising coldness of the camera against her naked body. A picture of a naked potbellied man in his trailer with a big smile on his face and his legs spread wide open came up on the screen. "Jerry, is that in focus?" she called out. Uelsmann adjusted the projector. She giggled. "There's something I should tell you about what happened with this guy," she said to the audience. "No, no, I shouldn't." The moment dragged on, the suspense built and Uelsmann squirmed as Arbus debated with herself whether to share her secret. Finally, of course, she did. "At the time, I was menstruating," she said. "I had to be nude. When I was photographing this man, I was having my period and this man noticed my string was hanging out. And he said this was not correct in the context of the nudist colony."

Diane told Allan afterward that her speech was "lousy" and accepting the payment made her feel "fraudulent." The best part of the Gainesville sojourn was a day she spent out of town with Uelsmann's wife, Marilynn Schlott, who was a social worker. As part of her job, Schlott paid house calls on clients in rural Bradford County to verify their eligibility for Medicaid. Some she had come to like so much that she visited even without a specific purpose. Arbus asked if she might come along. They drove in Schlott's Volkswagen bug into a terrain of dirt roads and small cabins, where directions consisted of "turn left at the palm tree or a burned-out barn." Schlott was particularly fond of a pair of old ladies who called each other "sister," even though they were not related. Living in houses fifty yards apart, one cultivated vegetables, the other flowers. The vegetable grower chewed tobacco constantly. They had electricity but no indoor plumbing. "Would you mind if I took your picture?" Arbus asked. They didn't mind at all. She photographed them together, on the porch of one of their shacks. (As they were pensioners, she included their photograph in her Social Security submission.) For the rest of the day, she and Schlott visited other impoverished households: an old

couple with a pecan grove and a cow pasture, a little old man who lived alone in a cabin lined with newspapers and blackened with grease, another tiny man who lived in a trailer and tended cattle that belonged to someone else. "It was a source of fascination to Diane that these people didn't have anything but they were happy," Schlott recalled. "They had no education. Most hadn't finished high school. The majority were religious."

In Starke, the main town in the county, she photographed in a nursing home. At an old-fashioned lunch counter, they stopped for a sandwich. "She observed everything and everybody as they came in and out," Schlott said. But she didn't say much. "She was not withdrawn, just private," Schlott felt. It was evening when they returned to Gainesville. On the forty-five-minute drive back, they talked a little about what they had seen. These people owned nothing—maybe a bowl of cereal to offer or something fried or from the garden. And yet, the amazing thing was, they seemed content.

"They're really happy even though they don't have anything," Schlott said.

"Yes, I'm surprised they're so happy," Arbus replied. "I wouldn't mind a little spot that I would go to that was so peaceful."

Art and Money

Back in New York, Arbus found a letter waiting for her from Jean-Claude Lemagny, a recently appointed young curator in Paris at the Bibliothèque nationale de France. Charged with expanding the French national library's extensive photography collection, Lemagny was particularly eager to acquire contemporary American prints. Might he buy about twenty of Arbus's "best and most famous photographs"? She could make the selection, although he did note in passing his admiration for the "marvelous" portrait of the Roselle, New Jersey, twins. Apologetically, he added that because of his pinched budget, he would be unable to "purchase photographic portraits at their real price." She responded that she was overburdened with work and didn't know when she might print so many. Perhaps they could start with five. What was he thinking of paying? Her usual price was $100. She also wondered what other photographers were represented in his collection. "I wish we were closer so I could see yours and you could see mine," she wrote him.

Recognition of photography as an art and of Arbus's exceptional achievement in the field had been growing since *New Documents*. Lacking, unfortunately, was a way to convert the prestige into cash. The support system for art photography had yet to be

constructed. A few New York galleries, most famously those run by Stieglitz, exhibited photographs as well as paintings in the first half of the century. Julien Levy, a young Harvard graduate who was an admirer of Stieglitz's enterprise, opened an exhibition space in 1931 devoted primarily to photography, but after disappointing sales, he shifted his emphasis to surrealist painting and sculpture. In 1954, Helen Gee, who was a friend of Lisette Model's, inaugurated Limelight, a Greenwich Village coffeehouse that exhibited and sold photographs; relying more on a trade in pastries and espressos than pictures, it squeaked along unprofitably for seven years. Not until 1969 did a collector and enthusiast named Lee Witkin open the first New York gallery that succeeded solely through the sale of photographs.

In October, Witkin took on consignment six Arbus photographs, offering them at a price of $175 each, which included his 40 percent commission. He sold two, to a young photographer, Bevan Davies, who admired her pictures at *New Documents* so sincerely that he began copying her style. Davies saved up to afford to buy the portraits of three Russian midgets at home and the pimple-faced, wild-eyed boy at the pro-war parade. Eventually, he took courage and telephoned Arbus to ask if he could show her his portfolio. She invited him to come down to her new darkroom. Looking at his photographs, she seemed to him "bothered" by the blatant imitation, but she was gracious. She told him that while photography renders reality marvelously, it was up to the photographer to bring something personal to it. She was more candid about her feelings when she complained to Allan of "people wanting to see me and show me pictures just like mine and museums wanting prints for no money."

From the outset, Witkin expressed the desire to give Arbus a show. She hung back. She had voiced similar objections to Szarkowski, but he had pushed her gently yet firmly to win her consent. Without a major institution behind him, Witkin lacked leverage, which was too bad, because the attention might have lifted her spirits. Although museums were acquiring her photo-

graphs, the honor was too abstract for her to savor; she needed to experience firsthand the response to her work, as she had by eavesdropping on the visitors to *New Documents*. Providing prints for the permanent collections of museums obligated her to spend hours in the darkroom without that emotional payoff—and without much of a monetary reward, either, as museums, pleading budget stringency, would not supply even the modest $100 standard rate she charged for a picture.

At the beginning of 1969, she agreed to sell to the Metropolitan Museum in New York three photographs at the price of $75 each. Payment still had not arrived when she returned from Florida. Calling to inquire, she found that the museum, on reconsideration, felt it could afford to buy only two. "So I guess being broke is no disgrace," Diane joked to Allan. The Smithsonian Institution in Washington acquired five prints for a total of $125. Over in Paris, Lemagny reacted with embarrassed dismay when he learned her rates. He told her he could pay no more than $20 or $30 for a photograph. In the end, after much haggling back and forth, she informed him in late October that because a collector had fortuitously placed an order for prints with the intention of giving them to a museum, she could produce his at the same time and supply twenty pictures for the cut-rate sum of $600. (The Los Angeles dealer Irving Blum had approached her, with the Pasadena Art Museum being the intended repository; the deal never came off.) Lemagny gratefully agreed, although not without brazenly adding that if she saw fit to donate a few more, "I'll pray the Good Lord for you during all my life!" Despite his effusions of gratitude, the discounted but desperately needed check did not reach her until the end of March the following year.

She might have fared better by exhibiting in a gallery. However, just as she thwarted overtures from Witkin, she turned down an offer from Blum. A dealer who in the early sixties introduced Andy Warhol and showcased other pop artists at the Ferus Gallery, Blum had run his own exhibition space in Los Angeles since 1967, concentrating on East Coast painters. He had never

shown photographs, but he would have made an exception for
Arbus. She told him she wasn't ready.

Arbus's deep ambivalence about praise, which she both craved
and mistrusted, was matched by her conflicting feelings about
money. "I've always literally been somewhat ashamed of making
money," she said in 1968. "And when I make money on a photo-
graph I immediately assume it's not as good a photograph. . . . I
can't believe that money is any sort of proper reward for art. . . . I
mean art seems to me like just something you do because it makes
you feel good to do it or because it seems to excite you or you learn
something by it or it's like your play that's your education."

There was a division in her mind between the work she under-
took to eke out a living—magazine assignments and privately
commissioned portraits—and the subjects she pursued on her
own. As with most such dichotomies, the line was indistinct, and
she could on occasion find welcome in a magazine (especially an
English one) for a picture she had created independently. Con-
versely, she might even produce a picture on demand that she
genuinely loved (but this happened less often). In June, she took
another job from the *Sunday Times Magazine,* to photograph some
of the leading feminists in America. The elder stateswoman of
the group was Betty Friedan, whom Arbus shot in close-up from
below, using a wide-angle lens and flash. Although the portrait
is animated and vibrant, Friedan hated it. She thought it made
her ugly and exaggerated the size of her nose. The other women
are depicted doing karate, holding political newspapers, or just
looking dumpy and frowzy in their unattractive rooms. Like Frie-
dan, they disliked the pictures, complaining that Arbus turned
them into "freaks." The exception was Ti-Grace Atkinson, who,
notwithstanding her politically motivated celibacy, wore a sexy
leopard-print skirt that exposed her shapely legs. She loved the
pictures. "I knew almost all of the women Diane photographed
and it was uncanny the way she plucked out the essence of each
of us at that particular time, in that particular context," Atkinson

recalled. "When I saw the one of myself, I burst out laughing, since she really got me: off in la-la-land abstractions, my skirt riding up my thigh."

Seeing the pictures, which were published in mid-September 1969, Atkinson, who had earlier studied painting and worked as a critic for *ARTnews*, felt she was in the presence of work that was "super-special spectacular." Arbus was less pleased. Soon after the shoot, she fell into a bleak depression and destroyed most of the negatives. With Allan departed and Marvin maintaining his independent distance in the face of her intensifying despair, she found it hard some days to perform the most basic tasks. She said that she was "shaky and going around in circles." Irma Kurtz, who had reported the *Sunday Times Magazine* feminists story, returned to New York and rang up to see if they might get together. When Irma arrived, Diane was lying in bed and remained there throughout their talk, explaining she was too depressed to get up. "I feel like I hang by a thread," she told Crookston. "Probably I will go somewhere and lie down. Till the spirit moves me again."

She made a quick trip to Los Angeles that summer. *Harper's Magazine,* a new (and just onetime) employer, assigned her to photograph Jacqueline Susann, whose Hollywood potboiler *Valley of the Dolls* had been an enormous bestseller a few years earlier. Susann was now promoting a follow-up novel, *The Love Machine,* with the help of her husband, Irving Mansfield, who was a press agent. Jackie and Irving kept a suite at the Beverly Hills Hotel, which is where Diane photographed them, in bathing suits and matching ankh necklaces. (Susann featured the ancient Egyptian symbol in her novel, and the publisher made it central to the advertising campaign.) The couple shared an armchair, with Jackie's long legs extended across Irving's lap. Perfectly made up, Jackie gazes at the camera with the ferocious self-assurance of a Beverly Hills gorgon. As is typical in an Arbus portrait of a heterosexual couple, the male half, Irving, seems mild-mannered,

uncertain and a bit sheepish. He later said that he was embar-
rassed by the "undignified" pose; he had objected but Jackie was
too obliging, and Arbus assured them she wanted the picture for
herself and would not publish it. The photograph, like the com-
panion article by Sara Davidson, drips with distaste for the vul-
garity of the couple and their tawdry literary enterprise. Asked
the following year how she got the shot, Diane said that as soon as
she photographed the Mansfields at the pool, she knew they were
the kind of people who would wear their bathing suits indoors,
and that the pose would be "terrific."

She took another picture in Los Angeles, intended for the *Sun-
day Times Magazine* but not used, of a man who was mad for Joan
Crawford (a "middleaged super fag Joan Crawford fan," as she
put it to Allan). She viewed him in profile while he contemplated
a Crawford mask in his hand. With a stark flash, she created
a shadow—a third profile—on the white wall of the bare, no-
frills apartment. Perhaps she was thinking drolly of Rembrandt's
Aristotle with a Bust of Homer, a painting that the Metropolitan
Museum purchased to much fanfare in 1961. But the picture is
not very witty. It feels contrived and cruel, lacking in empathy.
In a letter she wrote to May Eliot at this time, Arbus wondered
whether it was "a certain intransigence in my nature that makes
me inwardly partly sabotage anything anyone else wants me to
do." Because she felt she was "so little rebellious," she reckoned
that this form of passive aggression would be operating uncon-
sciously. Probably it was "more complicated" than that.

She devoted much of the summer of 1969 to unremunerative
projects. She had tried to interest Crookston when he took over
at *Nova* in a story on two baton-twirling competitions to be held
in August. Along with her pitch she mailed him an *Esquire* piece
written several years earlier by Terry Southern that depicted in
deliciously acerbic prose the Dixie National Baton Twirling Insti-
tute on the campus of Ole Miss. What particularly moved her
was the nunlike, all-consuming devotion to a supremely useless

art that must be relinquished the moment a girl turned twenty-one. Because the careers of the students were so abbreviated, instructing them seemed as far-fetched and fanciful as "raising butterflies, or training fleas." She failed to persuade Crookston, but nevertheless she spent three days in Syracuse in upstate New York, photographing girls twirling batons, individually and in groups, in a project as idealistic and impractical as their own.

Fantastic and Real

On the campus of the center for the mentally disabled in Vineland, Arbus watched the residents as they played Simon Says. In this setting, the game took on challenges and pathos out of the ordinary. If the leader commanded "Touch your head" or "Pat your belly," the contestants, many of them pear-shaped, struggled to comply. Arbus looked on rapt as one girl crouched on the grassy field in slow-motion obedience to a called-out instruction. "Everyone knew it was important," Diane reported to Amy. "She bent her head to her knees and with an odd shiver somehow the rest of her followed in what looked like the First Somersault." More miraculous than the feat is how Arbus conveys in a picture her ceremonial vision of it. In the photograph, a girl on the left holds her arms at her sides stiffly and stares at the ground. On the right, another girl has thrown her head back in laughter, her limp arms pointed down. They stand as upright bookends while, slightly off center in this oddly archaic and lyrical trio, an upside-down girl assumes a crablike posture more sculptural than human and braces her arms as she prepares to tumble in the direction of the camera. The trees behind the field compose a backdrop similar to the one in the photograph of the Westchester family on their lawn. And the trancelike suspension of the

figures also recalls the mood of that earlier picture. *A family on their lawn one Sunday in Westchester, N.Y. 1968* is the forerunner of what became known posthumously as the "Untitled" pictures of the mentally disabled. In this series, Arbus demonstrated again that in her hands, an undoctored photograph could be at least as dreamlike as a surrealistic montage.

In the summer of 1969, she traveled to New Jersey as often as she could to photograph the handicapped. Even before her first visit, she knew that she wanted to portray "idiots, imbeciles and morons (morons are the smartest of the three), especially the cheerful ones." She wasn't seeking out suffering, but rather joy in the face of terrible adversity. By artistic standards, a photograph of a severely disabled person with a smiling face would usually be more moving and mysterious than a conventional documentation of the afflicted and downtrodden. But her motives were not entirely aesthetic. As when driving through the hardscrabble backcountry of Florida, she questioned how people with so little could be this happy. Happiness perplexed her.

In the enervating summer heat, her mentally disabled subjects—whom she found "the strangest combination of grownup and child"—provided solace. Her pictures of their parties and processions convey a sentiment of acceptance and contentment. These people had stopped fighting fate. They had surrendered any pretense of control. And they seemed happy. Not all of them, of course. Some were angry or distraught. But those were not the ones she usually chose as subjects.

The residents behaved according to their own rules. Previously, when she had photographed groups she either told them where to stand or waited until they coalesced on their own into a tight composition. "I think my pictures are often too narrow, too zeroed in," she fretted in 1967, during the *New Documents* show. Now, in unconscious empathy or unavoidable accommodation, she relinquished control, too. And because she was unable to impose guidelines on her human subjects, she needed to be more skillful, or at least luckier, when it came to her camera set-

tings. Despite her avowals of technical incompetence, she knew that for these photographs the correct lighting, focal lengths and exposure times were crucial to achieving her desired effect. She experimented. Since giving up the Nikon seven or eight years earlier, she had become unaccustomed to photographing movement. When she did depict, say, people in a ballroom—as in *A Jewish couple dancing, N.Y.C. 1963* and the marvelous *The Junior Interstate Ballroom Dance Champions, Yonkers, N.Y. 1963*—the dancers halted in midswing because they were aware of her camera.

Arbus's usual working approach approximated amateur snapshots, traditional portraiture or pre-Munkácsi fashion photography. She relied on stillness and posing. At Vineland, more or less for the first time since her days with a 35 mm camera on the Coney Island boardwalk, she was having to learn how to portray people in motion. The mentally disabled people moved slowly, which helped, but they weren't stationary. Since Arbus wanted to view them within a landscape, she had to slow down the shutter speed to a sixtieth or thirtieth of a second—otherwise the shallow depth of field would have obscured the detail in the background, deepening its contrasts and making it "too violent and lit and nightlike." At such a slow speed, moving figures will blur or leave a ghost. That was fine, as she wanted to soften the sharp edges—a little, but not too much. "I am like someone who gets excellent glasses because of a slight defect in eyesight and puts vaseline on them to make it look more like he normally sees," she told Allan.

Then there was the flash. She had mastered its use for close-ups, when she aimed to erase the background so that all you saw was a giant head. Now she was using flash in a completely different manner, to illuminate the foreground subtly on a gray day. Not knowing in advance what she was after, she recognized her wished-for result only upon obtaining it. The photographs thrilled her, not least because they were "very different" from what she had done before. Also, unlike her full-frontal strobe-lit portraits, these pictures would be tricky or impossible for others to replicate.

She was determined to outrun the photographers she felt were copying her. As part of that campaign, she changed her method of printing. For the past four years, she had been producing prints with a black border. The style had evolved gradually out of a makeshift solution to a technical difficulty: when she switched to medium-format film in 1962, the negative carrier on Allan's enlarger was too small for it. Her remedy was to file away the aluminum brackets that held the film, so that the entire image would be visible. At first, she created crisp borders by using the edges of the masking frame that held the paper in place. Then she changed her method, moving back the metal blades to reveal not only what she had photographed but also the clear border of the negative, which in printing came out black. She liked the effect—probably because, thought Peter Bunnell, a curator at MoMA and a friend, it emphasized that the picture wasn't a glimpse through a window; this was a photograph, the product of penetrating observation and organizing intelligence. "That black edge is what defines the edge of the picture and the sheet of paper," he explained. "You're making pictures. You're not looking through a peephole."

However, now that "everyone" was printing with black borders, as she lamented in peeved hyperbole, she felt compelled to stop. In late 1969, she came up with a new technique. Using thin strips that she cut from the cardboard boxes in which the negative sleeves were packaged, she fashioned soft brackets that she taped around the opening on top of the negative carrier, to give a blurred and irregular edge to the image on the print. She had to keep changing the cardboard, smoothing its fuzzy fringe with her spit. Each print therefore was slightly different. As a lover of irregularity, she appreciated that.

The soft edge was especially appropriate for the photographs she took at the residential institutions. She rightly characterized the pictures as "tender," and in many of them, the tonal palette was modulated in gentle grays. She exulted over the photographs she made at Halloween of the residents of the Vineland facility

in masks and costumes. The lighting (not in all, but in more than enough) had come out perfectly, although she was unsure whether that was because the strobe had gone off or because it hadn't. Some of the pictures were too blurred, but others were "gorgeous," she judged. "FINALLY what I've been searching for." They were "JUST like snapshots only better." She was learning to savor the weak, watery light that arrives in late afternoon at the end of autumn and the beginning of winter. Illuminated in this filtered sunshine, figures and landscapes evoke the finely gradated tonal range of an aquatint etching. Many of these photographs recall particularly the aquatints of Goya's *Disparates*, in which a towering ghost appears to sleeping soldiers, or groups of women huddle on branches or toss male dolls on a blanket. Women with beaky noses, imbecilic grins and disguising masks appear in both artists' visions. The specificity of realistic detail in fantastic and mysterious scenes, at which Goya excelled, also characterizes Arbus's photographs in this series. She, too, was creating tableaux that seem to emerge from dreams or nightmares. As in Goya's drawings and etchings, her figures, when they are in motion, move in a deliberate and stately fashion, a modern minuet. They could be illustrating parables, as in Goya, or in other painters, too: her photograph of a procession of women dressed for Halloween, holding hands and looking in various directions, strikingly resembles Bruegel's depiction of the blind leading the blind. At Vineland, the women's faces were so unguarded and open, even under their masks, that they served as a reminder of the more concealing masks people ordinarily assume. And the things scarcely noticed in quotidian existence loomed large here. "Their pocketbooks seem to keep them alive," Arbus observed. Looking at her photographs, one sees what she meant. The women, who have so little, hold their bags with a childlike seriousness.

People would ask Arbus if she wanted to publish a book. It's what her peers were doing. The Museum of Modern Art issued Winogrand's book on zoo animals in 1969. Friedlander self-published a book of self-portraits the following year. Even

Daniel Kramer, who had processed film for Diane when he was Allan's assistant, put out a book of his photographs of Bob Dylan in 1967. Diane sent him a postcard congratulating him and saying she couldn't imagine doing one herself. When Robert Delpire, the French photography connoisseur who in 1958 was the first to publish Frank's *The Americans,* invited her to do a book, she begged off, explaining she wasn't ready. Yet now, later in the same year, she could envision compiling a volume on the mentally disabled women.

She had previously mentioned to Crookston her vague desire to write a book on "the family," but that concept was so baggy almost anything could be included. It would not really be about anything, merely a package to drop her favorite pictures into. A book on Vineland would be more sharply defined. She wrote to Allan at the end of November that the prospect excited her. For the first time, she was not simply looking for the best shot of a particular subject, but for many images on a related theme. When she was photographing at sideshows and carnivals and Coney Island, she hadn't thought of "multiplicity" as the goal. In Vineland, she did. "And I ought to be able to write it," she remarked, "because I really adore them." She filled her notebook with their comments, the sorts of things that she couldn't photograph but would be able to write. One girl told her, "I've got a boyfriend. He says I'm beautiful. I told him you haven't seen the pretty parts." Another wore a key around her neck in memory of a girlfriend who had given it to her; she told Diane that it was good to remember those who have died. Including a text along with her pictures would give Arbus an opportunity to come closer to the people in them, which was her paramount goal. "I think the subject of the picture is always more important than the picture, and more complicated," she once said. "It has to be of something, and to me that's sort of just terrific, and what it's of is always more remarkable than what it is."

Those to whom she showed the Vineland photographs usually responded with effusive praise. Doon and Amy lauded them.

Mary Frank was "stunned." Pat Peterson found them "fantastic." Pati Hill loved them and thought they were untainted by the judgmental cruelty that she privately deplored in Arbus's work. Diane at first shared their enthusiasm, but her self-confidence never lasted long. Any intimation of disapproval unsettled her. And of course, not everyone loved the pictures. May Eliot, for instance, believed "she had missed the whole beauty of these retarded people," even though she knew that Diane "thought she had found the beauty and something good in them." Diane told Ti-Grace Atkinson that it upset her the most when people derided her mentally disabled subjects as freaks. "She said she was drawn to them because there was a special beauty there, and she wanted to capture that," Atkinson recalled. "She thought she had succeeded, but if people couldn't see it, what does that mean?" Diane may have been ambivalent, too, about her newly adopted recessive photographic stance. Lisette Model remarked to Eva Rubinstein, a photographer who studied with both Arbus and Model, that Diane confided, "I hate those pictures because I can't control these people." If Diane indeed said that, it would have been when she was submerged in the depths of unhappiness and fearing she could do nothing right. She told a friend that one of the women, aboard a bus, touched her with an affectionate little hand. The exchange moved and depressed her. She loved these people, but they could lend her no strength.

A Dowsing Rod for Anguish

When not balancing requests from the world's leading museums, Arbus was telephoning magazine editors during the last months of 1969 to elicit work so she could pay her bills. She called Pat Peterson at the *New York Times Magazine* and, graciously, Peterson said that this was an extraordinary coincidence, as she was just about to invite Arbus to return over Christmas to the Caribbean (the destination was Barbados) to photograph another children's fashion supplement. Five thousand dollars! It was, Diane told Allan, a "godsend." In another success, she convinced Clay Felker at *New York* to assign her a piece on department store Santas, which was a revisit of sorts to a subject she had explored for the *Saturday Evening Post* back in 1964. However, for the earlier piece, which was suggested to her by her friend Alan Levy, she'd traveled upstate to a school that trained prospective Santas. The multiplicity of white-bearded, portly men in costume was droll. A grown woman sitting on Santa's knee, as Arbus shot her for *New York*, was less amusing. Noting that Susann and Mansfield had struck the same pose in Los Angeles, Diane wryly commented to Allan that perhaps she would use that format for all future magazine pictures. The *New York* Santa photographs never ran.

Even more pedestrian than the magazine assignments were

the private commissions. Konrad Matthaei, a television actor and theater producer, was best friends since Yale with Jonathan Bush, whose wife, Jody, had hired Arbus to shoot her engagement picture. Konrad wanted photographs taken of his family at Christmastime, when his relatives would be visiting from Michigan. Jody suggested three photographers, and from that list, Gay Matthaei, Konrad's wife, selected Arbus. The Matthaeis lived with their two daughters, nine and eleven, and their son, not quite three, in an Upper East Side town house that was decorated with the moneyed taste Arbus recognized from her childhood. Indeed, the Matthaeis outdid the Nemerovs, who never, for example, owned a six-and-a-half-foot-long Monet painting of Giverny water lilies. This was a job Arbus needed but not one to make her rejoice. Instead of waiting to be gently clobbered by the image, she clicked the shutter again and again, determined through incessant repetition to accumulate enough prints to satisfy her clients.

Exposing 325 frames of film in the course of two days, she took many of the standard shots that such commissions demand: the affectionate little boy in the arms of his father, the candlelit meal, the gregarious grandmother, the gloriously decorated tree. But she also followed her personal playbook. Returning to the device that had won her and Allan a place in *The Family of Man*, she sat Marcella, the older daughter, next to Konrad Jr. on the sofa, sharing a book. ("I would not have naturally decided in my party dress to sit on the couch and read a book to my brother," Marcella later remarked.) She posed Gay and Konrad on their bed. And her best photographs, characteristically, depicted the unease of the Matthaei daughters. Marcella, her brow impregnably defended by thick, long bangs, stares with pained discomfort at the camera. Her body is rigid. Her arms hang down straight, as do the drawstrings on her crochet dress and the tresses of her long hair. She looks as if she might cry, or as if she has dissociated mentally from where she is and what she is doing. Perhaps Arbus had her stand against the wood-paneled wall for a long time, as

she had done with little Fernanda Eberstadt in snowy Central Park and the Gruens in their East Village apartment. With her headdress-like hairdo and pharaonic posture, Marcella could be an Egyptian tomb figure.

The shots of her younger sister, Leslie, are memorable, too. A flaxen-haired child with almond-shaped eyes, Leslie had the delicate Pre-Raphaelite beauty that Diane admired in her friend Carlotta Marshall. In a few of the pictures, Leslie is laughing. More often, however, she appears distressed, wild-eyed, downcast or hostile. In three frames, she is on the sofa with her siblings, obviously miserable to be there. While Marcella and Konrad Jr. cuddle in the center, Leslie is at the very end of the couch, as far from them as possible, glowering. The Monet painting, that trophy of wealth and status, occupies half the frame of the photograph and looms above the children. Much later, Marcella saw in these pictures the foreshadowing of a rupture that came two decades after Arbus snapped the portraits. "Anyone looking at the photographs would see how alienated she was from the family, even at that age," Marcella said. "It wasn't acknowledged or addressed or of particular concern to the family at the time." Arbus saw and captured it.

She was a dowsing rod for anguish. On her regular prowls through Central Park that fall, she spotted a perfectly turned-out middle-aged woman who was wearing a three-strand necklace and a sleeveless knit dress, the matching jacket removed, sitting alone on a bench. Diane asked if she might take a picture. In the photograph, this elegant matron, her bouffant hair as hard as a helmet, her eyes squinting slightly into the sun, casts a morose, questioning look of profound disillusionment. She might be asking, "Is that all there is?" in a mood of reserved, proper, polite despondence. Arbus's shadow falls on the woman's arm like a dark cloud. Seeing the portrait years later, Diane's friend Adrian Condon reacted with shock, because she knew this Upper East Side lady—but she hadn't known her at all. "I had never seen this woman look like that before," she recalled. "She was always

laughing, smiling, covering up what was underneath." Not long after her portrait was taken, she committed suicide.

Arbus's own despair that autumn was intense. Things were bad enough that she started in September to see a psychiatrist, a step she had resisted in the past. It was Marvin, overwhelmed by her neediness following Allan's departure, who convinced her. Neither Marvin nor Diane thought much of psychiatry. In 1960, when Allan had been in analysis for more than a decade, Diane confided to Marvin that she hated the idea of "motivation and the whole notion that one does something BECAUSE of something and all of psychologic continuity and maybe historical continuity too." The axioms that underlie psychotherapy infuriated her; or, if they didn't make her angry, they made her laugh. Back when Pati, depressed and indecisive, elected to see Allan's analyst for help with her problems, Diane turned the engagement into a ferociously entertaining sport. Things had gone badly between Dr. Heller and Pati. In any case, it would have been inappropriate for Diane to see Allan's former therapist. She looked to Marvin for a referral, even though he distrusted psychotherapy, too. Only half joking, he told friends how he once took Margie to a psychiatrist and the man was so frightened by her brilliance that he broke a leg to avoid seeing her again. But Marvin could not cope with Diane's demands, and he wanted outside assistance. He turned to David Shainberg, a psychiatrist and the older brother of his friend Larry, who in turn recommended Dr. Helen Boigon, with an office on the Upper East Side. David had been close to Helen's husband, also a psychiatrist, who, not yet fifty, had died of a brain hemorrhage at the very beginning of the year.

As a follower of Karen Horney, Dr. Boigon would seem to be a promising candidate to help Arbus. One of the first women psychoanalysts, Horney, who immigrated to the United States from Germany in 1930, rejected or adjusted some of Freud's gender-biased theories. She countered female "penis envy" with male "womb envy" and framed the development of women's personalities and sexual feelings in the context of a culture dominated by

men. Like Arbus, Horney tracked the source of human discontents to the family. In neurotics who have grown up with cold and unreliable parents, she observed a compulsive and indiscriminate need for affection, excessive longing to be liked and aversion to solitude. In Horney's view, an insatiable hunger for sex often had less to do with physical cravings than with a soothing of anxiety and yearning for human contact. She identified the "basic conflict" for neurotics as the split between ambition and the need for love. To alleviate the tension provoked by this dilemma, a person might refute or disbelieve all signs of talent and success and instead cloak her competitive urges in convictions of inferiority. Much of Horney's theory drew on her personal history, which bore many resemblances to Arbus's. Raised in a prosperous family, she developed an erotic fixation on her older brother, married young and suffered serious, at times suicidal, depressions. She progressed from lover to lover, typically trying to retain her ties to several at once because each fulfilled different needs or desires. Both men and women described her relations with men as "very seductive" and driven by a need for sexual conquests. Perhaps Horney would have been ideally suited to treat Arbus, but she died in 1952. Boigon would prove to be sadly ineffective in what was, to be fair, a very difficult case.

Boigon was an outgoing woman of Arbus's age but from another social background, as was immediately apparent from her fashion choices: she favored showy jewelry, iridescent mascara and false eyelashes. Her patients came to an office that contained a couch for those undergoing psychoanalysis as well as an armchair, and she sat facing the door with her feet elevated on a stool because of poor circulation. At their first session, Diane got down on the floor and began stroking Boigon's knee and outstretched leg with what the psychiatrist described as a "slimy" expression on her face. Boigon told her gently but unequivocally to stop—she could say whatever she liked, but she was not to make physical contact. It never happened again. But Arbus was too restless to confine herself to the sofa or chair. She

walked back and forth, looking through the windows at the street or examining the objects on a table, gesturing with her hands as her thoughts jumped about. She spoke conversationally, as if she were at a cocktail party, Boigon felt. And most of what she talked about was sex and work. She was zealously pursuing both and deriving little satisfaction from either. "She was obsessed with sex the way a fat person is compulsively obsessed with food," Boigon recounted. "He stuffs himself and stuffs himself and is never satisfied, gets no gratification. Diane was like that but worse, she could not connect with anyone or anything. That was what she wanted to be able to do—reaching out trying to connect. But she didn't feel anything."

Arbus described going up to strangers on the street and propositioning them for sex. She spoke of answering ads in swinger magazines and bedding physically unattractive couples. She recounted sexual escapades on Greyhound buses and at orgies. She detailed episodes of sexual intercourse with sailors, women, nudists, and the Jamaican waiter. Most startling of all, she said in an offhand way that she slept with her brother, Howard, whenever he came to New York. It perturbed Boigon that Arbus told these tales without a trace of shame or remorse. The psychiatrist was mystified, much as Anne Eliot had been when Diane offered no apologies for having made love with Alex. Arbus viewed sex with moral neutrality. Boigon wondered how she could lack "any comprehension that some of the things she talked about or did were offensive." About four months into the therapy, Arbus gave her a print of the Roselle twins, which Boigon hung in the office without much liking it. Not knowing for sure what was meant by the gift, she suspected that Arbus—who enjoyed hearing about other patients' reactions to the photograph—was alluding to the duality of her nature and asking her therapist to accept both sides.

Sex was compulsive but empty. Work was worse. She complained tearfully to Boigon that people were coming to her as if she were some kind of expert, requesting lessons, showing their

photographs, wanting her to judge competitions, asking her to give lectures—when in fact she knew nothing. She could not satisfy their demands or expectations. What's more, her work no longer provided her with anything. It had become meaningless. Why did she feel nothing, nothing at all? Why had she felt so little throughout her life? She had tried to be a wife, mother, sister, daughter, and what she received in return was a void. Childbirth and menstruation were two of the only experiences that had provided her with the sense of being connected, almost the sole experiences that had bestowed upon her a twinge of joy.

Sending Diane to a psychiatrist was Marvin's attempt to deflect her demands. Yet as the therapy proceeded, Arbus spent much of her time with Boigon angrily bemoaning her relationship with Israel. She raged that he was not there for her as much as she wanted. And Marvin, even though he had engineered the therapy, grew to doubt the psychiatrist's acuity. Deborah Turbeville was once in his studio, working on a project, when Marvin excused himself to take a call from Diane. Although Turbeville could not hear what was said, she could tell it was a troubled conversation. Mostly, Marvin listened. He was engaged for a long time. When he returned to Deborah, he said, "Why do brilliant people go to mediocre people for advice?"

At the end of the year, having seen Boigon for a few months, Arbus was uncertain whether she was benefiting from therapy. Her mood was low when she traveled to Barbados, right after photographing the Matthaeis. Compared to the photographic assignments she dreamed up on her own, shooting children's fashions for the *Times Magazine* ranked in the same dreary category as recording a rich family's parties. Three months after her return, when asked in a lecture how the *Times Magazine* commission ranked with her other work, she explained, "It's not half as much fun. I mean, it's okay. I don't compromise, I do the best I can. I just don't like doing it. I don't like photographing people in not their own clothes, not their own place, not doing what they want to do. Those kids didn't like me and I didn't like them.

I mean, some of them were terrific, but—you know, the whole situation is just a complete bore." In Barbados, she was more subdued than she had been on the two previous trips. She told both Peterson and the assistant, Andrea Skinner, that she was struggling with the lingering effects of hepatitis. When she wasn't photographing the children, she rested in her room. "She was sad a lot," Skinner said. She perked up a bit when she photographed one geeky little boy with glasses. "I love that boy, because I can see Marvin as a child like this," she said. (Although, in fact, she had chosen to photograph mannish little boys before she met Israel.) Once when Peterson stopped by, Arbus was thumbing through a book of German primitive paintings of children. Usually, though, she was composing postcards and letters to Marvin. "I really don't like the children," she wrote in one of them. "I long to be with you."

Wild Dynamics

A couple of months earlier, in mid-October, John Szarkowski had proposed over lunch a museum project that he believed would engage Arbus's talents and passions. It would also pay her a stipend. He knew that she was hard up for cash, although he did not realize that the financial stress was contributing to an enveloping black melancholy. As far as he knew, Diane was happy, or at least unhappy in an ordinary and manageable way. "She was a very lively person," he recalled many years after her death. "She had a very vivacious mind. She was never a depressed person in my presence." Just as she dressed to suit the occasion, Arbus, even in extremity, pulled up her spirits when engaging with people who might further her career. In regard to professional advancement, no one could be more helpful than Szarkowski.

On his side, Szarkowski shrewdly recognized that Arbus would be uniquely useful for the scheme he had in mind. As part of his promotion of vernacular photography, he wanted to mount an exhibition on tabloid pictures. He believed that the term *news photography* was misleading, because most of the pictures that appear in newspapers are timeless. They portray subjects that recur, such as captured criminals, disconsolate children, and beauty contests. There are good reasons for that. Unlike a news

story, which can be reported and reconstituted after the event, a photograph must be taken as the incident unfolds. In a future era when nearly everyone would carry a camera device in his pocket, such photography would be more feasible. But in the late sixties, and even more in the golden period before the advent of television, most news photographs were produced by professionals, waiting to cover a scheduled event or summoned to record the aftermath of an unplanned one. The greatest of the tabloid photographers, who called himself Weegee, lamented that he always saw the victim lying on the ground alongside a fallen gray fedora but never witnessed the crime. He wrote, "Some day I'll follow one of these guys with a 'pearl gray hat,' have my camera all set and get the actual killing."

"The project is based on the premise that much of what is in fact newsworthy is not photographable," Szarkowski wrote, "and that what *is* photographable is generally concerned less with news than with the vicarious sharing of a few basic and constant human experiences." He tentatively titled the show *Iconography of the Picture Press* but aimed to come up with something "less ponderous."

As he knew from his familiarity with both her photographs and her fellowship applications, Arbus was a connoisseur of competitions, pageants, rites and bizarre occurrences. Beyond that, as he wrote when soliciting funds to pay her wage, she was "a person of acute intelligence" who had "demonstrated through her own work a profound understanding of the central qualities of the news photography tradition." There was no one better qualified to peruse the files of newspapers and agencies and make a preliminary selection of five hundred to a thousand photographs, which he and his curatorial colleagues would winnow down to a manageable show. Diane contemplated his offer. She loved the subject and she surely preferred photo research to teaching. Three weeks after their lunch, she wrote Szarkowski to accept the job, asking if she could delay starting until February, when the bad weather would prevent her photographing outdoors. Museum bureaucracies proceed more slowly than struggling art-

ists might wish. At the end of February 1970, about two months after Diane's return from Barbados, the museum obtained a grant for $4,000 from a foundation run by the family of the manufacturer of Life Savers candies. Szarkowski had estimated four months of work. At Arbus's request, so that she could keep taking photographs, the labor and the stipend would be doled out in four segments over eight months. Not until the second half of June was the first portion of the money released. By that point, Arbus had commenced putting in two days a week of work and the bad weather had long receded.

Szarkowski secured permission for Arbus to work freely in the picture library of the New York *Daily News,* which supplied most of the photographs (and the primary sponsorship) for the exhibition. Because several cooks collaborated on the stew, Arbus's contribution can't be definitively determined. Nevertheless, her sensibility is stamped all over the show, which opened in 1973 under the title *From the Picture Press.* Szarkowski divided the 228 photographs into eight categories that recall Arbus's first Guggenheim application on the "ceremonies of our present": ceremonies, winners, losers, disasters, alarums and conundrums, good news and the good life, contests and confrontations, and heroes. To be sure, some of the titles also recall the categories used by Weegee in *Naked City,* his best-selling and groundbreaking 1945 book, and many of the losers in *From the Picture Press* were criminals or corpses, a terrain that Arbus never much explored. (She had tried once, in 1962, riding around New York with a couple of detectives as they reconnoitered the Greyhound bus terminal, collared a couple of pickpockets, and brought the culprits to the police station for booking. Another time, wanting to take murder photographs, she accompanied police officers to a supermarket robbery, arriving after the culprits had fled. She enjoyed herself but produced no photographs.) Sports also provided many tabloid photo opportunities that she had neglected to pursue. But when the view shifted to rituals and competitions—the proud cat owner holding her best-in-show fluffy champion along with

an armful of ribbons, or the scantily dressed "Miss Frankfurter Queen 1952" displaying a weenie—she was on her home turf.

Writing to Crookston, she delightedly described a photograph she had come across of a woman lathered up, seemingly for a shave, between a doctor and nurse. The caption read "All for Beauty's Sake," and disclosed that a Miss Harriet Heckman was undergoing plastic surgery because she would risk even death rather than continue "with a body and face that have made me miserable." (The picture didn't make it into the exhibition.) A requisition by Arbus for twenty-eight pictures on approval from the Underwood & Underwood News Photos agency indicated her predilections: she asked for only three pictures of criminals or dead bodies, but four of stunts, seven of demonstrators of odd-ball inventions (such as an automatic flapjack machine), and thirteen of pageants, contests or weddings (including one of Siamese twins with their brides). She created a taxonomy of news pictures, including such categories as "people hiding their faces" in police custody. When *From the Picture Press* opened, her role in its initiation was proclaimed in the press announcements and the catalogue. Reviewers of the show saw her hand in the photo selection, while acknowledging that the styles of the exhibited prints diverged from hers. A picture of three little girls in swimsuits who are competing to be "Pint-sized Pin-up 1956" is a worthy Arbus subject, except (as one critic perceptively observed) she would have posed the little contestants against a neutral background, rather than the crowded and painted miscellany that muddles the image, and she would have eliminated the banner they are holding that too literally states the theme.

Weegee, the master of the news photograph, had died in December 1968, less than a year before Szarkowski proposed the show. For Arbus, one of the most rewarding avenues of research led to the Hell's Kitchen town house owned by Wilma Wilcox, Weegee's partner during his last years, who allowed her to examine about eight thousand of his prints. Wilcox was a

prim Midwestern psychologist and social worker for the Salva-
tion Army—"cultivated" and "sterling," Arbus thought, and curi-
ously the very opposite of the unpolished, self-promoting tabloid
genius, who was born Usher Fellig in what is today the Ukrainian
city of Lviv. Having resettled as a child with his Jewish parents in
New York in 1910, Weegee never lost the immigrant's enthusiasm
for his adopted home. He adored it, high and low, but especially
low. And once he discovered photography, he loved all aspects of
the process, teaching himself to capture a promising subject, to
print rapidly and expertly, and to perform every step in between.

His rivals marveled at his seeming prescience in arriving at a
crime site. Nonetheless (and in keeping with the theme of *From
the Picture Press),* even when he was the first journalist to show up,
Weegee arrived late on the scene, after the shot was fired, the
blaze ignited, the car crashed, the criminal handcuffed. As if to
underline that position, he included other spectators in many of
his best photographs. "People pushing, shoving, screaming, bits
of extraneous events thrust into the main one," Arbus remarked.
In a classic Arbus picture the subject is responding to the pho-
tographer; in a quintessential Weegee the action radiates around
someone who is dead or in shock, and the onlookers share the
photographer's lively interest in what has happened. As his prowl-
ing time was mostly nocturnal, Weegee of necessity became a
master at lighting the darkness with his flash. The strobe attach-
ment, starkly illuminating what is close and leaving in obscurity
what lies behind, also establishes where the photographer is
standing; it places him. "With a flash on a camera, the way that
the intensity falls off so rapidly, it almost has the quality of look-
ing through a keyhole, because it identifies the position of the
photographer," Szarkowski observed.

Arbus also used flash to further her goals, which were differ-
ent from Weegee's. "I think flash is something that she learned to
use with more and more confidence," Szarkowski remarked. "The
baby pictures, for instance, is flash used as intelligently as Weegee

did it." Most of the time, she was working during the day, and the flash inflicted unblinking scrutiny on her subject. It produced other effects as well. The harshness of the light, if raked from the side, could cast dark shadows. The brightness highlighted sweat and grime. Being unnatural, a strobe could make the ordinary appear lurid. Paradoxically, in a brightly lit Arbus photograph, the underlying narrative is mysterious; in a dark Weegee, it is as blatant as the entry in a police blotter. Even so, Weegee's best pictures, compressing a vulgar exuberance within a powerful composition, crackle with life—and when something is alive, it is also mysterious. The quality of Weegee's work varied, but at his peak during the thirties and early forties he was unmatched at what he did. "He was SO good when he was good," Diane wrote to Allan. "Extraordinary!"

He was also in the vanguard. As Arbus waded through his files, she could see that Weegee photographed Coney Island before his colleagues of the Photo League, Sammy's on the Bowery before Lisette Model, a Brobdingnagian Thanksgiving Day balloon before Robert Frank, kids playing in the street before Helen Levitt, and the dwarf Jimmy Armstrong before Bruce Davidson. In several areas, he anticipated Arbus's idiosyncratic choices, too. His photograph of smiling children holding rabidly anti-Japanese placards during World War II prefigured her mild-mannered young man with a BOMB HANOI button; and, using infrared film, he captured movie theater audiences gawking and necking long before she stalked the cinemas with her camera. In his later career, from the midforties to the midfifties, he was also photographing couples on benches in Washington Square Park. Yet there is no confusing a becalmed Arbus picture for a Weegee, charged with what she lauded as its "wild dynamics." Like Model (who also admired his pictures), he was attracted to vigor and vitality. Arbus knew Weegee's photographs (she owned both *Naked City* and its sequel, *Weegee's People,* published in 1946), but it is easier to see why she praised them than to say how she

might have learned from them. The main overlap between the two photographers is in subject matter: both studied people on the edges of society. The characters in Arbus's first *Esquire* assignment, "The Vertical Journey," might have posed for Weegee, who once said that he covered everything from "debutante balls to hatchet murders." However, Weegee was at his best as a voyeur of raw emotions in situations of extremity. He was a caffeinated flaneur on the lookout for melodrama. Even when sleeping, his people feel more restless than Arbus's posed subjects, who are frozen in time and also, as Szarkowski noted, "eidetic"—by which he meant that they appear to be aspiring to or embodying an ideal form, as well as manifesting a particular personality.

Although she recognized Weegee's artistry and thought that he merited and would inevitably occasion a one-man retrospective, Arbus also savored anonymous and amateur photographs of things singular, perverse, uncanny or painful. The content came first. Photographs of people who were about to die particularly intrigued her. In a lecture, and pinned with other favorite photos in her home, she displayed a picture of Jews lined up with their arms raised at the wall of the Warsaw ghetto; she said that it portrayed "Jews about to be executed." She tore out a photograph of an engaged man and woman sitting on their sofa, taken shortly before they were killed, and others of a homicidal teenage couple clowning in a hotel room. Time advanced, people died, but the photograph remained as mute testimony. For Arbus, there was something profound in the way "the photograph goes forward and backward in time by just staying there," in how it was "so goddamn still when everything else moves."

She valued many of the tabloid pictures that she collected, even knowing that their obscenely violent content would disqualify them from Szarkowski's show. Coming over for dinner, Ruth Ansel reacted with shock to the photographs of mutilated bodies that Arbus had hung up in her bedroom. "Huge blown-up photos of exploded stomachs were lining the walls," she recalled.

"Something was wrong with someone who could be sleeping in the same room as these images and not be affected by it. It was really shocking. Exploding pieces of flesh."

By the time of Ansel's visit, Arbus had moved into the West Village apartment where she would reside for the remaining year and a half of her life. Her new home, like the curatorial job, was arranged for her by Szarkowski.

An Urban Palace

"This is a palace you got for me," Arbus wrote to Szarkowski. She exulted that she had "never felt such homely bliss" and urged him to come visit and see for himself.

The home she moved into, on January 22, 1970, was located three blocks north of her former Charles Street carriage house. But while that venerable brick dwelling had been a vestige of old New York, her new loft apartment pointed toward downtown's future. The duplex was perched high up in a concrete-and-steel fortress that once housed the Bell Telephone Laboratories, where the transistor was invented and the first talking movie was screened. When Bell moved its research facilities to New Jersey, it abandoned the group of thirteen buildings, which filled a square block and abutted the Hudson. On the southern edge of the Meatpacking District, in a neighborhood where nights belonged to the butchers unloading carcasses and the streetwalkers and gay men hunting for sex, the redevelopment of the former labs into apartments pioneered what would become known as adaptive reuse. It was the brainchild of Jacob M. Kaplan, a self-made and progressive-minded philanthropist, and Roger L. Stevens, the head of the National Council on the Arts. Manhattan was becoming too expensive a place for artists to live or for compa-

nies to expand. Superimposing these two limitations, Kaplan and Stevens saw an opportunity.

The architect Richard Meier and his colleagues carved out 384 apartments, half of them large enough to be deemed suitable for families. Westbeth, as the project was called, admitted only artists of low or moderate income. Because there were at least twice as many applicants as apartments, an advisory committee of distinguished arts professionals and community advocates was appointed to make recommendations. The goal was to assemble a vibrant and varied roster of creative types, ranging from poets to filmmakers. On the committee, which included the directors of the Whitney and Metropolitan Museums, curators, theater directors, movie directors and musicians, there was just one photography expert: Szarkowski. To sift through applications, the committee engaged two women, the poet Thalia Selz and the art writer Eleanor Munro. Selz, whose former husband had been the curator of painting and sculpture at the Museum of Modern Art, knew Arbus already. That didn't hurt, but it probably didn't matter. Although every applicant submitted three peer references, Szarkowski on his own would have been able to usher through a candidate in photography. Arbus was understandably grateful to him.

And her delight in her new quarters was genuine. "Best place I ever had," she told Crookston. Owing to her custodianship of Amy and the temporary presence of Doon (who would inherit a small Upper West Side rental once Mariclare joined Allan in Los Angeles), Diane finagled a coveted duplex, on the ninth and tenth floors, with a fine view from the upper level of tugboats cruising the river and gulls and helicopters crossing the sky. Entering on the ninth floor, you were in a relatively small room with a wavy concrete ceiling that was ten and a half feet high, from which Diane hung a pod-shaped rattan chair like a swing. She installed a small desk on the right. This was Amy's domain. The sole bathroom was in the back, with a window that looked out on an interior courtyard and the other apartments that ringed it. A raw

concrete stairway on the left led up to an airy open space with a ceiling that was thirteen feet high. Big windows to the left overlooked the Hudson. On one side of the room was an alcove in which Diane placed a single bed resting on a three-drawer white Formica platform for storage. She hung a transparent curtain in front of it. That was where she would sleep. A larger bed in the room, more centrally positioned, had a foam mattress covered with black nylon sheets and a throw she pieced together from remnants of fur—among them, badger, otter, mink, and even fox with heads attached; as part of her Russeks legacy, she knew her way around the fur district, and how to gather leftover pieces of pelts that were sold cheaply by weight. On the wall opposite the windows she hung a Plexiglas frame, which held a photographic print that she could change. She also had a big wall, on which she pinned up rough prints of photographs, either hers or others', including many torn out of the tabloids. The gory ones that horrified Ansel were displayed there. The small kitchen was to the right of the staircase. It was walled off (the only other enclosed space was the bathroom downstairs) and you entered by going into the dining area alongside it.

Saul Leiter found Diane's new home much brighter and less "creepy" than the cavelike dwelling on East Tenth, although he thought the pinned-up *Daily News* photos conveyed some of the mood of the old apartment. "The sheer creepiness of them appealed to her," he said. When she needed a portrait of herself, she asked if he would take it, saying that she wouldn't be afraid to be photographed by him. He thought that was droll, "considering that she did what she did and was what she was—was the truth something she reserved for herself?" But he understood her meaning. Leiter was on the lookout for unexpected beauty. Arbus was after a different prize. "She had a taste for the unsavory," he said. "She had a gift for ignoring a large part of the world that is beautiful." When he took her picture, he posed her by the photomontage in her apartment. "The screen was a biography of her and her interests," he remarked. "There were pic-

tures of all kinds of weird things. If you wanted to have a portrait of her, you would just photograph the screen and it's all there." What Leiter regarded as ugly Arbus thought of as true.

Even the whimsical items that she giddily purchased for her new home were a bit ghoulish. She installed an ant farm, so she could watch industrious insects when she wasn't working. She bought a transparent female anatomical model with inner organs to be inserted or removed. She acquired gag toys—an ice-cube mold in the shape of a woman and some fake worms. Relishing the disgusting look-alike, the bizarre disaster, the sexually vulgar and the unabashedly freakish, she might have been doing Christmas shopping for the Addams family.

In its early months, Westbeth vibrated with a frontier spirit of adaptation to the unfamiliar. Construction in unfinished parts of the complex continued after Arbus moved into her apartment. The original distinct buildings were stitched together to form an integrated but confusingly incoherent edifice, with the labyrinthine corridors painted in different colors—lime green, shocking pink, taxicab yellow—to help the disoriented find their way. Arbus negotiated her path surefootedly. She not only managed her own move, but she engineered one for her friend Mary Frank. Mary was recently separated from Robert, who had fallen in love with the artist June Leaf, soon to be his second wife. The Franks' was an acrimonious parting, made still more difficult after Mary fell seriously ill with pancreatitis. Robert stopped by Larry Shainberg's apartment one afternoon, when Marvin Israel and the painter Robert Beauchamp were over to watch football on television. Frank's teenage daughter, Andrea, accompanied him. He explained that Mary was in the hospital. "Why?" Marvin said. "Are you spiking her tea?" Andrea, crying, ran out of the room, and the furious Frank blamed Shainberg, not Israel. The wires that bound these competitive male friends were barbed and electrified. "He's never forgiven me for having an affair with Margie," Frank once told Shainberg, to explain Israel's anger. On another occasion, Israel bragged to Shainberg that he had fon-

dled Andrea's leg while they were seated together in the back of a car. She was thirteen or fourteen at the time.

By comparison, the women in these circles had nurturing relationships. When Lisette wouldn't apply for a dearly needed Guggenheim Fellowship back in 1964, Diane had taken the initiative and gone to the office of the foundation to procure the forms—and then, to judge from the distinctive writing style, she composed the successful proposal, too. Now, once more aware of a friend's financial hardship, she took it upon herself to help out. There was a backlog of artists hoping for admission to Westbeth. Through her connection with Thalia Selz, Diane enabled Mary to jump the queue. Mary had never heard of Westbeth. When she emerged from the hospital, Diane presented her with an apartment. "She acted as if it was sort of nothing," Mary recalled. "It was an amazing thing. It affected my life a lot."

A Modern-Day Ingres

After *Newsweek* approached Ti-Grace Atkinson to be the cover subject for a story on the much-in-the-news women's movement, she consulted her radical collective. Would this picture foster a retrograde cult of personality, or was any mainstream attention to revolutionary feminist ideology a positive development? It wasn't an easy call. Perfectly obvious, however, was the reason that the editors asked her. Unlike many of her colleagues, Atkinson, who had broken with her affluent, Republican Louisiana family, was highly photogenic in a manner that conformed to traditional standards of feminine beauty. The *New York Times* dubbed her "softly sexy": her image might be expected to sell well on the newsstand. Atkinson later said that she feared the publicity would strip her of physical anonymity. She was persuaded to cooperate, she said, by other members of The Feminists, a group she had organized the previous year upon resigning as the New York chapter head of the more moderate National Organization for Women. If so, it may not have taken that much cajoling: her critics within the fractious movement thought Atkinson was a media-oriented self-promoter. Having decided to proceed, she called the *Newsweek* photo editor with one condition. "I'll only do it if you hire Diane Arbus to do my portrait," she said. The

editor sounded confused. "She does freaks," he replied. Atkinson was unswayed. "And I want her to have a kill fee," she continued. "What I'm getting out of it is a portrait by Diane Arbus. But you may not like it."

Having concluded from the *Sunday Times Magazine* photos of feminists that Arbus was an "artistic genius," Atkinson looked forward to an extensive collaboration. On the phone, they arranged to fly together to Providence, Rhode Island, where Atkinson, having committed to give a lecture, could reserve blocks of unscheduled time. They would shoot the color cover portrait there, with supplementary black-and-white candid shots. It was February, soon after Arbus's move into Westbeth. They met at the airport, and as they waited to board the plane, Diane looked at Ti-Grace and said, "Why did you ask for me? Do you want to have sex with me?" It was clear that Arbus didn't object to the idea. But her tone was strangely disembodied, making the words sound like neutral curiosity rather than an attempt at seduction. Ti-Grace, who thought Diane was "desperately looking for feeling," was dumbfounded. It's true, she was a divorced woman who vehemently denounced the power imbalance in heterosexual relationships, but her chosen recourse was celibacy, not lesbianism. "Diane, you're a great artist, that's why I wanted you to do my portrait," she sputtered. With that settled, the question of sex between them never came up again.

They checked into a motel room with two beds. Over a couple of days, Arbus trailed after Atkinson with a camera, capturing her speaking in public or primping in the bathroom. Atkinson felt that Arbus was emotionally attuned but politically disconnected. "Diane found feminism puzzling," she said. Arbus talked about the discrimination she had faced as a woman, particularly when she was starting out in partnership with her husband. "She really resented that she would do all of the background work and the setting up, and he would get all of the credit," Atkinson recalled. "She talked about that a lot, as sex discrimination." They discussed how women in the art world were financially and emo-

tionally dependent on men. To Atkinson, Arbus seemed angry but not self-pitying. Indeed, she was disgusted by women who felt sorry for themselves. After Atkinson's lecture, a few members of the audience, too reticent to air their problems in public, came to the motel room to talk privately. Arbus was able to fade into invisibility, a talent she often employed when taking pictures. As she lay quietly on the other bed, the local women shared their heartaches with Atkinson. The typical complaint would be that a middle-aged husband had run off with a younger woman, leaving his unprepared and bewildered wife to cope alone. After one woman with such a tale exited the room, Arbus spewed acid exasperation. Atkinson was surprised and puzzled that instead of being moved, Arbus was bored, even mocking. She could not empathize with a self-identified victim. In Atkinson's estimation, she felt that "to make your anguish public was contemptible."

She talked openly about her financial woes. People lined up to see her exhibitions, but they wouldn't buy any photographs. She was compelled to take detestable jobs for money. She had even been forced back to the fashion photography she loathed, remarking that the recent feature on children's attire was as bad as it gets. That was the work she was paid for, while the photographs that meant most to her were completely misunderstood. At least as bad as her artistic and monetary struggles was her romantic predicament. She said little if anything about Allan, her former husband, or his plans to marry a younger woman. She concentrated with burning intensity on Israel. "She spoke bitterly of her relationship with Marvin," Atkinson said. "His attentions were divided, and he didn't spend enough time with her. It made her doubt the importance of the relationship to him." She begrudged the time he gave to his wife.

All of these problems Arbus related calmly and objectively as she trained her camera on Atkinson and admitted that she had little experience with color film. Atkinson aspired to be depicted as "Everywoman." Even though her complexion was very pale, she did not want to use makeup. How could a radical feminist wear

powder or rouge? In the diluted winter light, augmented by the artificial lighting in the room, Arbus struggled to produce an expressive photograph. She feared that everything she was taking would be washed-out and overexposed.

On their second and last night, they stayed up late and went to sleep discouraged. "We worked very hard and we weren't getting it," Atkinson recalled. They rose early the next morning to try again. Thinking of impressionist and post-impressionist painters, particularly Pierre Bonnard, Atkinson suggested that maybe if she got into the bath, the light-reflecting water and mirrors would accentuate the planes of her face. Arbus liked the idea. By Atkinson's calculation, she snapped more than a hundred photographs there. Being nude before Arbus didn't trouble Atkinson. She was as relaxed as she would have been with one of her four sisters. What alarmed her was the clicking camera. "These are just head shots, right?" she asked nervously. "Oh, yes," Arbus said soothingly, and Atkinson choked down her anxiety. "She was so into it, and I didn't want to interfere with her concentration," she explained. All the time, Arbus was carrying on an intense conversation without being distracted from her camera. Atkinson, who was photographed often, had never encountered that ability in anyone else.

That morning Arbus talked about suicide. She asked whether Atkinson ever contemplated it. Atkinson said that she had thought about suicide, but it was not a path she could seriously consider. The choice to end her life would be interpreted publicly as a negation of feminism and all of her political beliefs. Arbus retorted that she found every aspect of life unsatisfactory. "She was very natural in the way she talked about it," Atkinson said. "She was really fed up. She had been thinking about it for some time. She was tired of hardship." The stoicism in her manner reminded Atkinson of the ancient Romans. "I've had it," Arbus said evenly. "If this doesn't improve, I'm not going to take it anymore." How long should you wait if you can't tolerate being alive? She indicated that she had a deadline in her mind. "I've got about three more years," she said. In Atkinson's understanding,

that meant she would give it until she turned fifty. Although she described her new Westbeth apartment with enthusiasm, nothing seemed able to decelerate her downward vortex of dejection and exhaustion. "There was something you felt was almost physiological," Atkinson recalled.

They proceeded from the bathroom back into the bedroom. Atkinson had wrapped a white sheet around herself. Soon they would have to leave for the airport. Indeed, they were already late. "Let's get dressed," she said. Arbus asked her to pose one last time, sitting on the bed. They continued to talk. Perhaps the seriousness of their conversation imprinted itself on Atkinson's face. Maybe Arbus finally mastered the challenge of watery light on chalky skin. It could have been luck. "This is it," Arbus said, as she pressed the shutter repeatedly. They kept talking. The sheet slipped, exposing Atkinson's breasts. "Nothing shows, right?" she said. "No, nothing shows," Arbus replied.

When they packed up and left the motel, Arbus was so elated that her high spirits were contagious. "I think we got it," they both said, hugging in excitement at the airport. Back in New York, Arbus turned in her film to *Newsweek*. Atkinson waited to hear from the magazine on the choice of cover. When several days had gone by without any word, she called the *Newsweek* editor in charge of the cover photo.

"I'm not sure what the message is," he said guardedly.

Atkinson reacted with confused dismay, guessing what he meant.

"I think you should see them," he said. He sent over a set of contact sheets by messenger to Atkinson's basement apartment at Park and East Seventy-Ninth.

When she opened the package, she found to her horror that about two dozen of the pictures showed her bare-breasted, sitting on the bed. As Diane had predicted, these last shots were by far the best of the group. In their dignified emotion and restrained color palette, they reminded Atkinson of Ingres. She thought, "It's really my face that's naked."

She knew that the *Newsweek* editors expected her to be mortified. And they were right: she was "dying of embarrassment." But she refused to admit it. "If you've got the guts to use it, I've got the guts to do it," she told the cover photo editor. She also spoke by phone with Arbus, who came right over to examine the sheets. "Diane, you said nothing was showing," she protested, but she quickly realized that the complaint was pointless. Right away Arbus started marking them up. "Oh, I like this one," she said. "And I like this one."

Newsweek didn't like any of them. The magazine rejected the take. When Arbus heard, she was upset. "Oh, I've cost you the cover of *Newsweek,*" she moaned to Atkinson, who reassured her. "Are you mad at me?" Arbus asked. She insisted that they go out to Central Park, near Atkinson's apartment. "I know what they want," she said. She had Atkinson stand, holding a poster, in a formulaic pose of protest. She noted that she wouldn't want a photo credit if the picture ran.

The picture did not run, and Atkinson did not appear on the cover. *Newsweek* used a high-contrast conceptual photograph of a nude woman raising her arm in a power salute and breaking the circle of a female gender symbol. One small black-and-white Arbus photograph of Atkinson in front of a microphone ran inside.

Three weeks after the magazine appeared on the newsstands, The Feminists issued a statement that deplored the media desire to create "stars" and the consistent identification of Atkinson as the group's "leader," "spokeswoman" and "theorist." In the future, whenever a journalist insisted on communicating with a "spokeswoman" for The Feminists, that woman must be chosen by lot. The statement warned, "Anyone who flagrantly or consistently violates this rule will no longer be a member of The Feminists." Two days later, Atkinson quit the group she had founded.

The Jewish Giant, too, reported that Diane had made sexual overtures toward him. "You know her?" he asked Michael Flanagan, Marvin's friend and Allan's former assistant, when they were introduced backstage at the circus. "What's with her?" Eddie Carmel said that Diane "came on" to him. If so, it would have been in pursuit of an experience, not a picture, because the photograph of Eddie that Arbus sought, and which she achieved a little more than two weeks after immortalizing "Cha-Cha-Cha," is of a son, not a lover. Like *A family on their lawn one Sunday in Westchester, N.Y. 1968,* this picture, which she called *A Jewish giant at home with his parents in the Bronx, N.Y. 1970,* was a photograph about a family, in which the subjects are relating (or not relating) to one another, rather than to Arbus.

Eddie was known professionally as "the Jewish Giant." In his line of work, ethnic or national identification was customary: the sideshow circuit showcased a Kentucky Giant, a Nova Scotia Giantess and so on. But Arbus was drawn to Eddie's real-life role as a Jewish son. To bring that to the surface, she needed to photograph him with his parents, and for two years, she had been hoping to arrange it. When Crookston initially proposed his feature on the family, she suggested the Carmels to him. Although she had photographed them once, she couldn't find the negatives. "He is tragic with a curious bitter somewhat stupid wit," she told Crookston. "The parents are orthodox and repressive and classic and disapprove of his carnival career." Eddie demanded to be paid before allowing Diane to photograph him again, but she thought twenty-five or fifty dollars would satisfy him. To her mind, the family's exceptional tragedy only highlighted the ordinariness of the Carmels' predicament. "They are truly a metaphorical family," she told Crookston. "When he stands with his arms around each he looks like he would gladly crush them." Although she wanted very much to schedule a shoot, she was unable to contact Eddie. It was the late spring, and the Jewish Giant was probably on tour with the circus.

From her first encounter with Eddie, she "always thought he

was on the point of dying and there was something very touching about it." Yet he could be irritating, too, "the kind of class clown that everybody had in high school." One of his tricks was to compose a poem on demand. "You just give him a word or a sentence or several things you want in the poem and he'll just do it right away," she explained. "But it's a kind of inane rhyme sort of thing." She allowed that he was "very greedy for money" and "a little bit sophomoric." On the other hand, she admired how he refrained from complaining about his plight. When she invited him to the *New Documents* opening at MoMA, she described him to the staff as a "very touching boy." His belabored drollery was coarse but also brave. Once he was touring in a small town and his companion, a carnival barker, entered the bar first. "Stand aside, folks, a giant is coming," the straight man proclaimed. Eddie followed, arms extended. "Fee fi fo fum, I smell the blood of a virgin," he bellowed. The two men drank all night for free. On another occasion, a young man confronted him at a sideshow on Coney Island. Why did the sign on the tent say that he measured nine foot four when Eddie had just said he stood eight foot six? "Son, that was done before my operation," Eddie quick-wittedly replied.

Arbus was uncertain how tall Eddie was. "They say eight foot nine, they say nine foot two, it's hard to say," she commented. "He really isn't so tall, he's more—you know, his hands are fantastic." When he was lying down, he reminded her of Lewis Carroll's Alice after she swallows the "Eat Me" cake. "I mean, there's something extraordinary about the way he fills a couch, I don't know, he's like a mountain range," she said. Like other sideshow freaks, who pretended they came from Eastern European royalty or were plucked out of the African jungle, Carmel propagated a mythology of his origins. He told Gay Talese, who included him in a book on New York published in 1961, that his grandfather, at seven foot six, was known as the Tallest Rabbi in the World, and that he, Eddie, measured seven feet at the age of eleven. A decade later, he was spinning even taller tales. "I first noticed that I was unusual when I was six years old and I was a little over six feet

tall and I was already being approached for basketball scholar-ships," he said. The truth was sadder and more ordinary. Born in Israel, Eddie came with his parents to New York as a small child, to enable his mother to care for a sick relative. His parents showed Diane his childhood pictures. "He was this sort of beau-tiful blond curly-headed baby and little two-year-old, and just at the age of three or something, this uncontrollable thing started to happen," she reported. That was not quite correct. The pitu-itary gland tumor that provoked Eddie's excessive growth—the medical term for his condition is acromegaly—did not emerge until he reached the age of fifteen. From then on, his height accelerated mercilessly.

He tried to lead a normal life, matriculating at City College as a business major. He was a bright student. But normal life becomes impossible if you are well over seven feet tall. The one place he could find regular employment was the sideshow. The unsavory nature of Eddie's employment infuriated his father, Yitzhak, an insurance salesman, who was always impeccably dressed in suit and tie. Father and son regarded each other with smoldering rage. Although Yitzhak longed to return to Israel, the parents could not abandon their ill son. Eddie's condition was deteriorating. In the earlier photographs that Arbus took of him, in 1960, when he was performing as "the world's tallest cowboy," Eddie had been strapping and handsome. By 1970, he was crippled with arthritis and relying on one or two canes to stand. He wore orthopedic shoes that were built up to adjust for his unevenly sized legs. He was spending much of his time liv-ing unhappily in his parents' home in the South Bronx. Arbus contacted him there and arranged to photograph him on April 10. She had the family pose together, and in many of the shots, Eddie again wraps his arms around his parents' shoulders as he had done in 1960. But one picture was different. "Marvelous," she exulted to Crookston after she reviewed the contact sheets.

The marvelous photograph portrays the family dynamic that Arbus had discerned and hoped to reveal. The father and son

"really can't endure each other," she said. The mother was "very sweet and she's right in between them because she makes peace with both of them." Arbus suspected Miriam Carmel harbored "a kind of sneaking admiration" for Eddie. In the one glorious image in the sixty or seventy frames Arbus shot, Eddie, unkempt and unshaven, leans on a cane and bends toward his parents, towering over them. He is a little closer to Arbus than they are, which, amplified by the wide-angle lens, further exaggerates the disparity in stature. Even though Eddie is stooped, his head scrapes the ceiling. Yitzhak, formally dressed as always, glares in his son's direction. Miriam, in a soiled housedress, gazes up at him in what seems like wonder. Detailing the mundane particulars of the Carmels' home life, the photograph transcends them. The curtains are drawn shut over the windows, the lamp shades are protected with cellophane, and the upholstery is shielded with fabric covers. A talismanic picture of the holy city of Jerusalem hangs on the wall. Every precaution has been taken to defend against possible danger, and yet, as in a fairy tale, a monster has materialized in the room.

Curiously, the photograph has a formal composition that is almost identical to *Xmas tree in a living room, Levittown, L.I. 1963.* Arbus has positioned herself in the same spot, so that the truncated arms of a chair protrude into the frame on the lower right, and two walls of the room converge on the upper left, where the tallest figure in the room stands: in Levittown, the tree, and in the Bronx, Eddie. In each photograph, a sofa establishes the slanted angle of the left wall. But the Carmel apartment is much more claustrophobic than the Levittown house, mainly because it is more cluttered but also because of Arbus's technique. Probably unintentionally, she has allowed the light to fall off in the four corners of the frame, producing an effect that is called "vignetting" and is a common, usually undesired artifact of flash employed with a wide-angle lens. In this picture, though, the sense of observing through a keyhole subtly intensifies the hermetic closeness of the scene.

Eddie very much liked the picture. "Why did it have to happen to me?" he joked. "My luck, I have to have midget parents." He seems to have liked Arbus, too. Appearing on a talk show six months after her death (and, as things turned out, six months before his own), Eddie asked to be given a subject for one of his spontaneous poems. The moderator proposed "Diane Arbus." Eddie grimaced for a moment and then said,

> A long time ago I had a real strange pal,
> A truly strange and wonderful gal.
> In a world that's growing quickly and seems to
> be in some kind of weird stir,
> Here was a marvelous gal, a photographer.
> Who would suddenly open up her little eyes
> and mutter,
> And quickly snap her camera shutter.
> Diane Arbus is now not with us anymore,
> And it's a tragedy that suddenly we have faced
> a closing door.
> Of a wonderful gal, a talented one,
> Affectionately known as a lovely dear old son
> of a gun. Diane Arbus.

Had she heard the poem, it almost certainly would have made her giggle.

PART SEVEN

HEARTBREAKING AND DIZZYING

72

Almost Like Ice

To allow Arbus to sell her photographs without agonizing over an exhibition or exposing her subjects to unrestricted scrutiny, Israel in the fall of 1969 came up with the idea of a portfolio of prints. Marketing her work directly, she would also avoid sharing the proceeds with a dealer. She embraced the scheme, pursuing it in parallel with her foggy notion of a book on the mentally disabled. Israel proposed collecting about ten prints—the number would depend on Arbus—in a Plexiglas box. If hung on the wall, the clear receptacle could double as a borderless frame. The photography department at the Museum of Modern Art used Lucite frames designed and manufactured by Robert Kulicke, and Kulicke's firm was retained to fabricate Arbus's box. In March 1970, she consulted with curator Bunnell at MoMA. Once she had made her selection, she prepared a flyer, with two strips of 35 mm copies of the prints that she chose for the portfolio, and Bunnell spent two days compiling a list of curators around the country who might be interested in buying it. She mailed out the flyer to some of the names on the list.

She decided to make the prints on sixteen-by-twenty-inch paper, which was larger than her customary size. Technical difficulties plagued her. For example, the big prints, which were not

mounted, rippled as they dried. After obtaining Allan's counsel, she corrected the problem by using a blotter roll, a basic procedure for flattening prints that she had never been interested enough to learn. When printing, she softened the edges of the image in the style she had recently adopted.

Israel discussed the idea of a boxed portfolio with Avedon, too, for an edition of prints on still larger twenty-by-twenty-four-inch paper, in conjunction with a forthcoming retrospective of Avedon's work at the Minneapolis Institute of Arts. Israel, who was earning an income as a book designer as well as a teacher when he was not painting, had agreed to collaborate with Avedon on the Minneapolis installation. Sharing the results of their research on the Plexiglas box, Avedon instructed his studio manager, Gideon Lewin, to help Arbus develop a prototype. She loved the finished version, which she described as "almost like ice." She wanted to pay Lewin for his labors. "No, no, you can't accept any money," Avedon told him. "She doesn't have it."

More important than constructing the box was determining what to put in it. Arbus mistrusted the value of her inventory. She had suffered the same doubts as the deadline for *New Documents* approached, petitioning Szarkowski to change the lineup. Two months before the show opened in 1967, she'd captured the hypnotic image of the Roselle, New Jersey, twins, which she then selected for her invitation postcards. Once again, as she pondered how best to represent her art, she concluded that she needed to add new work. In the spring of 1970, she took several pictures, including those of Lauro Morales and Eddie Carmel, which she ranked, like the twins, among her best. The passage of time has confirmed her judgment.

Finding herself "in financial straits," she called up Harold Hayes at *Esquire* and pitched him two ideas that he accepted— one on old age, the other on girl revues at carnivals. Adding to the good news, he increased her rate, so that instead of the $250 per page she was receiving in 1965, he paid her $371 for the one photograph that eventually ran. (The odd total included a

small amount, probably $21, for film and processing.) The published picture accompanied a grim article on old age in America. Although the piece was set in San Francisco, where its writer lived, the indignities it chronicled—loneliness, diminished physical capabilities, shabby domiciles, joyless time-filling activities, increased suicide rates—were universal. On May 22, in New York Arbus photographed Yetta Granat, seventy-two, and Charles Fahrer, seventy-nine. They were not a couple. Indeed, they had never even met until, in a random drawing, they were proclaimed to be king and queen at a Friday-night dance for senior citizens. Bedizened in jewel-encrusted crowns and fake ermine capes, holding scepters and wrapped party gifts, they stared glumly at the camera. Granat wore a leopard-print dress much like the one Ti-Grace Atkinson had on when Diane first photographed her, but the legs revealed on this occasion were far less comely. Presiding over a wintry domain, Yetta and Charles could be the queen and bishop who frowned on the young betrothed couple in Howard's poem "An Old Picture." Alternatively, their gaudy trappings might be the terminal trophies for the youthful pair who won the 1963 Yonkers ballroom dancing competition. It is the bleakest of Arbus's many pictures of contestants. Allan thought the photograph was "heartbreaking" and "dizzying." Diane liked it, too. She included it in the portfolio.

As the end of June drew near, Arbus eagerly anticipated the opening of Avedon's Minneapolis exhibition. Ted Hartwell, the founding curator of photography at the Institute of Arts, had organized the show, which was the first large-scale look at the photographer's achievement. Against the inclinations of the museum director, Anthony Clark, Hartwell deferred to Avedon and excluded all fashion pictures from the show. "We extended tremendous control to him as a living artist," Hartwell recalled. Avedon and Israel made all the curatorial decisions. They insisted on it. In a period when photography's status as an art was uncertain and fashion photography was particularly suspect, this large-scale exhibition, aimed at confirming Avedon's place as

an artist, would confine itself to his portraiture. (It was a choice that played to Avedon's insecurities rather than his strengths; some critics—including Gene Thornton in the *New York Times*—considered the fashion pictures to be the acme of Avedon's art.)

The photographer and the designer laid out the galleries as if they were creating pages in a book, paying close attention to the sequencing and sizing of the images. Whenever they changed their minds, they would call Lewin, the studio manager, in New York and procure a new print. Most of the photographs were displayed in aluminum-edged Kulicke frames, but in the sixth and final gallery, which was painted black and screened off with a curtain, they hung life-size prints, unmounted and unframed, of the Chicago Seven defendants. Playing on a sound system were taped remarks, elicited and recorded by Doon, from the antiwar activists whose portraits were on the walls. At Israel's suggestion, Doon had started working with Avedon the previous summer, conducting interviews that, after a long incubation period, would eventually be incorporated alongside the photographs into the book *The Sixties*. She had been doing similar work as one of four contributing editors of the counterculture magazine *Cheetah,* interviewing such groovy celebrities as Dustin Hoffman and Michael J. Pollard, until the publication folded after the appearance of its eighth issue in May 1968. She kept long hours in the Avedon studio and was popular with the staff, but the studio assistants regarded her as Dick's friend rather than as one of them. She was easy to get along with. "She was a lot more open, a lot more jolly" than Diane, thought Peter Waldman, one of the assistants.

With her mother, Doon flew out to Minneapolis to see the show, which also drew many of the fashion editors and models in Avedon's New York constellation. Diane was fizzy with excitement. At Marvin's painting exhibitions at the Cordier & Ekstrom gallery in New York, Margie attended the openings as the artist's wife. But Margie, in delicate health, wasn't coming to Minneapolis. The role of Marvin's consort would be played by her understudy, Diane. Arriving in Minneapolis three days before

the July 2 opening, Diane pitched in energetically with the prepa-
rations. She loved the show, especially the huge prints, which
loomed as "presences." No one had ever seen such a photography
exhibition. And to be with Marvin at his moment of triumph, sur-
rounded by friends in a celebratory mood, was thrilling. Marvin
was "funny and splendid," she declared. "Everyone felt it."

It was like a big country-house weekend. All the New York
guests were staying in a suburban motel that was two stories high
and built around a domed courtyard with a swimming pool. In
a characteristically provocative gesture, the New York visitors—
not satisfied with the prominent positioning of a print of the
naked, hairy lovers Allen Ginsberg and Peter Orlovsky—further
pinpricked the shell of Midwestern respectability by distribut-
ing, in a district of transient hotels and dive bars, opening-night
invitations to colorful people who might show up for free food
and drink. After the festivities at the museum, the New Yorkers
and other friends of the photographer drove back to the motel
for an after-party. Lewin had crafted Avedon stick masks, and
there were balloons stamped with Avedon's likeness. When the
guest of honor belatedly arrived, he saw to his horror a sea of
Avedons. He caught his breath for a moment. Then he jumped
fully dressed into the pool. A little later, boisterous interlopers
crashed the party, taking off their clothes and jumping into the
water. Diane and Marvin retreated to a nearby deli. When they
returned, things had quieted down. The night ended when a sud-
den thunderstorm pealed overhead, pelting the dome above the
pool—where Diane and others swam—with droplets of rain. It
felt like "a benediction," Arbus proclaimed.

Returning to her life in New York, Diane was as deflated as
last week's party balloon. She felt "sort of lousy" and "fell into
a most terrible funk" for several months. Marvin's friend Larry
Shainberg later speculated that she suffered a painful letdown
from the elation of sleeping next to Marvin in an overnight inti-
macy that her lover had up until then denied her. In the after-
math of Minneapolis, Arbus began calling Shainberg, which she

had never done, two or three times a week, for conversations that were half an hour or forty-five minutes in duration. At the time, he did not connect her despair to any unhappiness over Israel. "I was moved and overwhelmed that she would be coming to me for help," he recalled. "She would say, 'I don't feel I can go on.' I remember being very tough on her. I felt like she was giving in to the infantile part of herself. She was expressing this incredible hopelessness, and she was even more halting in her speech than usual."

Despite the depression, she pushed herself to keep working. Carrying out her other *Esquire* assignment, she traveled to a carnival in Hagerstown, Maryland, in late July. She had photographed there nine years before, including shots of strippers, when she was still using a 35 mm camera. The trip in July resulted neither in a published piece nor in a photograph that she judged quite worthy of the Lucite box. Her pictures of the burlesque dancers, which were the ostensible reason for her visit, she seems not to have liked well enough even to print. Instead, she selected an image of a seated circus fat man in a two-piece satin costume that exposed his lightly hairy chest and midriff. His elephantine legs extend from a short skirt, and a dimple in his chin accentuates the roll of fat below it. He looks like a big, chubby baby. A hermaphrodite in her trailer, with a small dog resting its head on her hairy thigh below a tattooed forearm, could be a small-town housewife. Better still is a man, bare-chested, from the waist up entirely tattooed. Arbus stood close to him when taking the picture, using a flash in the descending dusk, and she managed to achieve the softness of light that she had savored in her photographs of the institutionalized women. As he looms before her like an apparition, with a skull emblazoned on his forehead, his pale eyes are as strange and mysterious as those of the "mythic" dog that used to visit her on Martha's Vineyard during that memorable summer more than twenty years before. Unlike her earlier portrait of the tattooed Jack Dracula, who was an eccentric, this man seemed to have emerged from a dream.

But the standout picture from the Hagerstown sojourn was an image even more mythic. It was in keeping with other photographs—melding sex, suffering and religiosity—that Arbus was producing in the spring and summer of 1970. Despite her Jewish background, she was powerfully attracted to Roman Catholic iconography, especially its darkly erotic forms. She giggled and gaped at masochistic piety. Visiting the Gallery of Erotic Art, which an enterprising enthusiast named Robert Rosinek had set up in his living room on Park Avenue at Ninety-Sixth Street, Arbus shot a performance artist, Carlin Jeffrey, who painted his body silver, tied himself naked to a cross, and, with his back exposed, faced a wall between two large windows from the hours of eleven A.M. to six P.M., with a break for lunch. A little better than this unremarkable photograph were the shots she took elsewhere of a dominatrix with a naked middle-aged client, who groveled at his mistress's feet in one picture and embraced her in another.

As Arbus knew from her disappointing attempts at shooting orgies, when people are engaged in blatantly sexual activity they usually appear grubby, theatrical or both. While in Hagerstown, she stumbled on a way to elevate the allure of eroticism, masochism and Christianity out of comedy and into legend. Sandra Reed was an albino sword swallower who was working at the fair. Approached by a mild-mannered woman in a blue denim jacket, Reed at first thought Diane was an autograph seeker. Arbus sat with her and talked for a while, questioning her on the touring life. They discussed how Reed swallowed the sword. "Although she thought it was remarkable, she didn't seem to be shocked or surprised," the sword swallower recalled. Unbeknownst to Reed, Arbus knew all about sword swallowing from Estelline Pike at Hubert's, and probably from others as well. Reed asked about Arbus's photography. "She wasn't fancy, she was a very plain, down-to-earth person," Reed thought. After an hour or two, Arbus asked if Reed would be willing to dress in full costume and be photographed swallowing the sword. The performer happily obliged, going through her

whole routine, which took between forty-five minutes and an hour. "When I do my act, I do not watch anyone, I'm focused on what I'm doing," Reed said. "The rapport that went on between her and I happened before she started photographing."

Once she began, Reed had to continue without stopping. "If the sword's halfway down and the picture isn't right, sometimes they say, 'Take it out, the light's not right,'" she explained. "But she was right on the money every time. She followed me with her camera and snapped the picture. She was the best one I ever had." Reed loved the resulting photograph. "I thought it was extraordinary," she said. "It made me look better than what I really looked like." In an embroidered white blouse and dark peasant skirt, Reed, who is performing against a tent, extends her arms as if she is being crucified. Her head is thrown back ecstatically, with none of her face visible but the pale skin and hair and the dark open lips. The point of the sword, unsupported and erect, is in her mouth or throat, and the grip, guard and blade form a perfect crucifix. You might even think, if caught up in the Christian spirit, that the two posts of the tent evoke the crosses of the thieves at Golgotha. It's a magnificent image, which Arbus considered including in the portfolio. A collaboration between photographer and subject, the photograph is nonetheless unlike most of her celebrated pictures, because Reed, after agreeing to cooperate, was oblivious to Arbus's presence. She had to concentrate on what she was doing. Her survival depended on it.

73

Storms

July thunderstorms diverted the flight that brought Arbus to State College, a town in central Pennsylvania. Marc Hessel was waiting at the Black Moshannon airport to pick her up as scheduled and drive the twenty miles to Pennsylvania State University, where a summer arts festival was in full swing. He returned to the campus alone. She would be landing at Altoona, sixty miles in the other direction from Penn State.

When the airport limousine from Altoona arrived in town, Arbus wasn't on it. The opening time passed for the reception in her honor, and Hessel called to cancel it. He walked to the arts building, wondering what he should do. Arbus was scheduled to judge two photography exhibitions, one for professionals and the other for amateurs. She was also slated to deliver a talk. When he opened the door to the arts building, a voice greeted him from the top of the stairwell.

"Are you Marc?"

"Diane?"

Down the stairs came a woman in a white linen dress and white pumps, carrying a white pocketbook. "Yes," she said.

He wondered how she'd managed to get there. She explained

that on the flight, she had befriended a television producer. Since he was heading for State College, he offered her a lift.

With the welcoming reception called off, they had time to go downtown to the Corner Shop café to chat over coffee. Arbus fascinated Marc. He had first seen her work when he was studying at the University of Iowa and a traveling exhibition of photographs by recent recipients of Guggenheim Fellowships came to town. Her images mesmerized and mystified him. He had thought at the time that he would love to meet her.

After graduating from Iowa, Marc was hired in the photography department at Penn State. He started in the summer of 1969. One of the tasks assigned to him was to chair the next summer festival, which included an exhibition in which a distinguished visiting artist awarded prizes. In the past, the shows had featured paintings. He decided to dedicate this exhibition to photography and to invite Arbus to judge it. He obtained her number from the telephone directory and called a few months before the July event. She spoke into the telephone "in a childlike, timid voice," he recalled, "like a child left at home with no babysitter who had been told by her parents, 'We'll be back soon, but don't answer the phone.'" Once he identified the reason for his call, her tone changed. He explained the position, which came with a $750 honorarium. "Well, I don't have enough magazine assignments this month to cover my rent, so I'll do it," she said.

When Arbus remarked to John Szarkowski that she would be visiting State College, he told her to be sure to look up the photographer Henry Wessel. Szarkowski didn't know that Henry had recently ended his teaching appointment and no longer lived there. However, returning from a trip, Wessel happened to stop by the town. In a booth at the Corner Shop, he saw his friend Marc Hessel with a woman who looked familiar. When he walked over, she stood up, introduced herself and shook his hand. A little later, when Marc excused himself to go to the bathroom, she grabbed Henry's arm and said, "Are you going to be here all

day?" He said he was. "Come around with me," she said. "We can talk and have a good time."

Sitting in the booth of the diner, Marc asked Arbus which photographers had influenced her. He expected her to cite August Sander. But when an artist acknowledges her sources of inspiration, she may choose not those whose work obviously resembles hers, in ways that can be oppressively close, but others who, although on first glance are very different, offer lessons and insights that she has absorbed and made her own. Arbus thought for a while. "Robert and Walker," she said, meaning Robert Frank and Walker Evans. She also discussed her journalism. She said that if she had anything to impart to his students, it would be to encourage them to work for magazines, because they would be paid to travel and have adventures. "My assignments have been dwindling lately, because they think they know what I'll do," she admitted.

Marc and Henry kept her company throughout the day. In one of the studios in the arts building, she fulfilled her first obligation, delivering a speech that went on for over an hour. "It wasn't much of a talk," Henry thought. Marc was more impressed. "She spoke of anything that came to mind," he recounted. "She would say something and get really quiet for the longest time. And then she would emerge somewhere that was a connection in her mind but was not evident on the surface. Each point was a brilliant point of light or insight—little encapsulated thoughts that would dissolve and emerge as other encapsulated thoughts."

Accompanying her through the exhibition, Henry never doubted that she was there only for the stipend. "I'm so broke," she said. "We're trying to put together this portfolio of ten prints. But I don't have ten photographs I like enough to put in." She mentioned only three. The one she seemed particularly proud of was the photograph of the family on the lawn in Westchester. "Nobody can steal that photograph from me," she said.

As she reviewed the photography contestants, she quickly

eliminated anything that resembled her own work. A Nebraska photographer's frontal shots of prison inmates, for example, she put right to the side. The professional picture she selected for first prize, *The Recital,* was a panoramic view of two women, a singer and a pianist, performing for an audience of staid middle-aged ladies in a bourgeois living room. The photographer, Anne Noggle, greatly admired Arbus. In later years, her work would show an obvious influence; had she presented such photographs at the exhibition, Arbus no doubt would have passed them over. Henry thought Diane seemed bored by all the photographs submitted by professionals. "It looked to me that she wasn't interested in any of them, and this was the least uninteresting to her of that group," he recalled.

The amateur award provoked more controversy. One of Marc's students had printed on eleven-by-fourteen-inch paper a shot from his parents' honeymoon cruise, taken at a bon voyage party on deck in the bright sun. The newlyweds are wearing hats that shadow their faces, and they are holding cocktail glasses, with the woman leaning forward and sipping from hers. "It caused a stir, because the student hadn't taken the photograph," Henry said. "I remember very clearly that it was a photograph I was also very interested in. I think anyone who had looked at Szarkowski's *The Photographer's Eye* was open to the idea of how interesting vernacular photography was." Arbus made it clear that she was not prepared to fight for her opinion. "Look, if you think something should be in that I haven't included, put it in," she said to Marc. "And if you don't like that one, take it out."

Although a room at the inn had been reserved for her, she said she needed to get back to New York. She never intended to stay over; she hadn't even brought an overnight bag. Hessel volunteered to take her to Black Moshannon. They arrived early. In the waiting area, there was a machine that dispensed flight life insurance, a regular feature of airports of that era. She bought the largest policy offered, filled it out and handed the envelope

to Hessel. "I don't have a stamp," she said. "Will you mail it for me?" It was addressed to Allan Arbus in Los Angeles.

Waiting with her for the plane to board, Marc nervously grasped for topics of conversation. Having come out of the Iowa Writers' Workshop, he knew very little about photography.

"Are you aware of the work of Les Krims?" he said.

It was the wrong thing to ask. She turned to him with an agitated expression.

Les Krims was a young photographer who staged pictures, usually for comically lurid effect. He shared some of Arbus's interests but came at them from a very different starting point. He photographed unclothed women, sometimes as bound and bloody victims or in other poses of degradation. He placed a legless man on a plinth, instructed him to scream, and titled the picture *Human Being as a Piece of Sculpture Fiction*. His tableaux enraged feminists and other progressive-minded critics, and earned him notoriety. He also had his champions. Bunnell at the Museum of Modern Art, for instance, recommended him for a teaching position at the Rochester Institute of Technology and also brought him to the attention of Lee Witkin, who gave him a show in 1969. The following year, Krims had embarked on a project that featured dwarves and midgets, after obtaining permission to photograph at the convention of the Little People of America. To her distress, Arbus had written a formal request to the organization and was turned down. She complained to a friend that she was falsely stereotyped as a sensationalist. Someone, in brief, like Les Krims.

With passion and anger, she told the surprised Hessel what she thought of Krims. He exploits his subjects, she said. He doesn't care about these people at all. He just uses them. Hessel guessed that some critics might have associated Krims with Arbus, although she never said that. He focused on maintaining eye contact as she delivered her rant. When she stopped, he looked around. The waiting room had emptied. He turned to

gaze out the window. The plane was on the runway. The airstair was lifted. The pilot had begun his taxi.

"I've got to get on the plane!" Diane cried.

Hessel dashed through the gate and out the door, waving his arms for the plane to stop. Arbus was running behind him. The pilot saw them and turned the aircraft around so Diane could board. She threw her arms around Marc in a grateful hug and was gone.

It's All Chemical

During the summer and fall of 1970, Arbus repeatedly took to the road to fulfill magazine assignments that she had procured to earn money and now unhappily needed to complete.

Some, like the carnival story for *Esquire,* at least resulted in excellent pictures, but disappointed financially, earning only a kill fee and not a page rate. Other outings fell short on both money and art. She accepted jobs that earlier in her career she might have declined, as she took on work for start-ups rather than for top-ranked magazines like *Esquire* and *Harper's Bazaar.* In summer 1970, *Essence,* a magazine for African American women that had begun publishing that May, assigned her three stories. She knew John Gerbino, the art director, from his tenure about five years before as a young assistant art director at *Harper's Bazaar.* On many of the lackluster *Essence* pictures, probably at her request, she received no credit. Two were local assignments: one on young black activists and another on a middle-aged feminist. For the third story, she traveled to Detroit to photograph the pastor of the Shrine of the Black Madonna, on a visit she described as "a nightmare." She may have disliked the black separatist minister, whose celebrity sprouted from his claim that Jesus was black. Or he may have disliked her. She photographed him

gazing at the camera with hostile suspicion in his hooded eyes. Adding to the dismal experience, *Essence* was very slow in paying its modest fee. She had to enlist the help of a lawyer friend to extract the $1,000 owed her, not receiving it until the beginning of February.

In a tender pas de deux of mutual consideration, either Allan or Diane consistently extended a hand to the other whenever his or her personal footing seemed less slippery. In June 1969, responding to what Diane later deprecated as her "hysteria," Allan mailed her a check, which she tore up. Toward the end of 1970, perceiving that Allan was stretched to the squeaking point, she sent him a check for $500 on the joint account that they retained, along with a number of blank checks, which she instructed him to use as needed. Although neither may have drawn on this line of reciprocal credit, it seems to have fortified them emotionally.

To maximize her time and reduce her employers' expenses, Arbus arranged the visit to Detroit as a stopover on her way back from California, where she traveled on a more auspicious assignment. Peter Crookston had been fired as the editor of *Nova,* which, the management grumbled, was becoming too serious and text-driven, departing from its racy, visually oriented identity. Welcomed back by the London *Sunday Times Magazine,* Crookston promptly assigned Arbus a piece on two planned communities in Southern California—Sun City for affluent white seniors and South Bay Clubs for affluent white singles. Connecting by phone with the reporter, Ann Leslie, Arbus said she didn't want their visits to coincide, but, as Leslie would be stopping in New York on her way back from California, she would like to receive some guidance. At Arbus's suggestion, they met at the MoMA café. As always, Arbus had a camera around her neck, which Leslie found off-putting. Even more off-putting was Arbus's wordless stare in response to the list of names and contact information Leslie proffered. Later, upon seeing the published photographs, she complained that she didn't recognize the "cheery pensioners" in these portraits of "surreal grotesques" that were "imag-

inative projections" of the photographer's "own tortured self." The old people in Arbus's photographs are not such gargoyles, however. (The preening, suntanned young swingers are more ludicrous.) Arbus didn't regard her pictures as unflattering. She asked Crookston if he might send copies to her subjects: "I think they might all be pleased."

The problem with the pictures isn't their mocking tone but their predictability. And for those familiar with Arbus's previous work—which none knew better than Arbus—there was something dishearteningly repetitive about another person sprawled on a bed, another hapless subject on a sofa beneath a framed picture, another vulgarian in a bathing suit disporting indoors. The same stale odor clings to another assignment she completed in Los Angeles, this one for *Esquire*, on Ozzie and Harriet Nelson and the families of their sons, Ricky and David. Inevitably, the piece explored the discrepancies between the idealized image of the all-American family on the television series *The Adventures of Ozzie and Harriet* and the tense, discordant real-life Nelsons. Each of the three families was different. As she went from house to house, all in the same day, Arbus noticed that she was adapting her personal attitudes and speaking style, unconsciously, to match each of theirs. But she did not adjust her pictorial approach. In the photographs, any variations have been ironed out by the blandness of their smiles and the conventionality of their poses. They are not responding to Arbus. And she is not responding to them.

For Diane, the best part of the Los Angeles sojourn was the chance to see Allan for the first time since his move. Their geographical separation had undermined her more deeply than she had anticipated. "I guess it was oddly enough the finality of Allans leaving (for Calif) that so shook me," she wrote to her friend Carlotta Marshall that autumn. "He had been gone somewhat for a hundred years but suddenly it was no more pretending." On the brief Los Angeles visit, his solicitousness soothed her. She brought some of her recent work to show him, includ-

ing the Jewish giant at home: "The father looking, 'What have I wrought,' the mother looking awestruck," as Allan described it with admiration. During much of her brief stay, she was in a precarious mood. Driving in his car alongside him, she said, "I took a pill before we left and I feel much better. It's all chemical."

Her internist wanted to put her on a regimen of antidepressants, but Dr. Boigon, the psychotherapist, didn't believe in them. Diane described bemusedly how each side had staked out a position with no resolution in sight. Whether the antidepressants available in that era would have alleviated her depressions or only accentuated her mood swings can't be determined now. She did not rely on them. Once she was back in New York, she sent a letter to Allan in early October, expressing her thanks. "Your generosity to me had some effect, some enormous reassurance I cant explain," she wrote. "I don't think we are good for each other in the sense that we tend to remind each other of our own sadness, but there will always be something you do for me that nobody else in the world can."

Old Photographs, New Camera

Avedon bought the first finished box of ten photographs and gave it to a friend, the director Mike Nichols. He purchased a second box for himself and, as a lagniappe, Arbus added an eleventh photograph, of a mentally disabled woman in a wheelchair holding a Halloween mask to her face. Bea Feitler, the co–art director of *Harper's Bazaar*, purchased a third box, which came with a different bonus photograph.

As Diane acknowledged to Allan, Avedon maneuvered the first three sales, and now she had to start peddling the portfolios on her own. She promoted the box during her visit to the Avedon opening in Minneapolis, and Ted Hartwell tried, without immediate success, to persuade the museum director to buy it. Hoping for magazine publicity, she paid a call on Alexander Liberman, the editorial director of Condé Nast, who had terrorized her and Allan at *Vogue* a lifetime ago. He was grayer and brittler, as if "Dracula has been at him," yet still brimming with enthusiasm and gallantry. The meeting was fruitless. "I played my cards wrong," she told Allan. Still, she described the "sentimental journey" as being "really fun," because in this fresh encounter with the potentate of her old country, she knew that she "had nothing to lose and even less to gain."

She asked many people to call on her in Westbeth to see the portfolio and consider laying out $1,000. A remarkable bargain in hindsight, it was a significant sum at the time. Feitler's colleague Ruth Ansel was one of the people Arbus approached, but unlike Feitler, Ansel did not come from a wealthy family and couldn't afford it. (Instead, Arbus presented her with the gift of a print of the Roselle identical twins.) Arbus solicited the actress Estelle Parsons, whose children she had photographed. Parsons, too, couldn't spare the cash. Diane and Marvin went together to visit Pati Hill's husband, Paul Bianchini, at this point a private dealer working out of his East Seventy-Ninth Street apartment. After they left, Paul told Pati he hated the work, which he called "gloomy" and "Germanic." Arbus phoned Barbara Jakobson, a Museum of Modern Art trustee, whom she had met serendipitously in Central Park in the late fifties, chatting while their toddlers played in the sandbox. Despite many amiable encounters over the years, Jakobson, who collected art, had never received a phone call from Arbus before. She detected an undertone of urgency and might have bought the portfolio, but at the time, she was distracted by a family medical emergency. She failed to make the trip to the West Village.

The art dealer Irving Blum, who had previously expressed interest in Arbus's work, accepted a few boxes on consignment. He recalled that he disposed of one to Jasper Johns, whom he encountered in Los Angeles at Gemini G.E.L., supervising an edition of prints. Although Arbus at the time reported that an art dealer brokered the sale, Johns remembered buying it from her directly, through an ad in *Artforum*. However the transaction came about, it was the fourth and final box to be sold during Arbus's lifetime, and the only one not bought by a friend. She delivered each box personally. A fifth was later purchased by the Fogg Art Museum at Harvard, in a transaction she began but didn't complete.

She devoted enormous care to the production of the box. For a title page, she experimented with writing in different scripts on

a sheet of vellum. Although she worked in a mechanical medium, Arbus glorified the handmade. "She would always give a present to you in wrapping paper that was like a page from the telephone book, but she made it look good," Pati Hill said. She likewise prized the accidental defects that appeared on her negatives, and rarely if ever manipulated tonal contrasts through dodging and burning to beautify a print. In 1971, William Burback, a curatorial intern at the Museum of Modern Art, arranged to buy, for $125, *A family one evening in a nudist camp, Pa. 1965* (a photograph Arbus seriously considered for the box), in which a flaw on the negative results in a dark ragged blot in the sky on the print. Arbus warned him that while it would be easy to retouch, she loved the imperfection and was not going to correct it.

For each box, she formulated simple captions that she would inscribe on the back of each print and repeat on vellum papers between the photographs. They were summaries without tonal inflections or poetic flights, garnished with a fact or two. For example: "A young family in Brooklyn going for a Sunday outing. Their baby is named Dawn. Their son is retarded. N.Y.C. 1966." The pictures that made the cut—in addition to the Brooklyn family, the Mexican dwarf, the Jewish giant and the senior king and queen—were the pro-war boy in a straw boater (she contemplated but eliminated the wild-eyed I'M PROUD protester), the Westchester family on the lawn, the identical twins, the retired nudist couple in their bungalow, the transvestite in hair curlers and the Levittown Christmas interior. Arbus was an astute critic of her own work, and this selection, which she probably made in consultation with Israel, comprises many of her finest photographs. Some are missing, but there was room for only ten. Conspicuously absent is the child with a toy grenade, and various admirers will point to different lacunae, including any sample of her depictions of the institutionalized; but the Box of Ten provides an excellent abridged edition of her achievement.

The act of reviewing her archive seems to have goaded Arbus to strike out for new territory. As a child she went through a

period of believing that anything became untrue the moment she said it. As a mature photographer, she held something of the same attitude about pictures she had taken. Once she did something, she lost faith in it. The photographs that became too famous she grew especially to doubt. (The portrait of the Roselle twins was an exception.) Although the unposed group portraits of the mentally disabled, many taken in natural light without flash, constituted a departure, she aimed to break even more radically from her past. She began to fantasize about a new camera.

The photographer Hiro, whose studio occupied part of Avedon's East Fifty-Eighth Street town house, had received a strange new contraption from his native Japan, with an invitation to try it out. The Pentax 6×7 resembled a pumped-up 35 mm Leica—or, as Arbus described it, a camera discovered in Wonderland by Alice or brandished by a circus clown who pops a bird out of it instead of a picture. Weighing close to three pounds, it was much heavier and clunkier than the Nikon she had used at the onset of her professional career, yet it promised to combine the traits she missed in the former camera with the qualities she valued in the medium-format models. The Pentax was held to the eye to focus (like a Nikon), but with a film frame of 6 cm by 7 cm, four times the size of 35 mm, it had the capability of producing extremely sharp images (like a Mamiya). "The large-scale film in a camera that you could use like a Nikon or a Leica intrigued her," said Paul Corlett, who was Hiro's assistant. "The proportion must have appealed to her, too." The Pentax used the same film as the Rollei or Mamiya, and the frame occupied the identical width, but instead of a square, it was a rectangle—with a proportion of 1:1.25, compared to the 1:1.50 of 35 mm film. (Because of the increased vertical dimension, a roll of film allowed for only ten exposures with the Pentax rather than twelve with the Mamiya.) She thought it was a "marvelous shape."

Borrowing Hiro's Pentax, Arbus became infatuated with its novelty and possibilities. "What it could do is make the pictures more narrative and temporal, less fixed and simple and complete

and isolated, more dynamics, more things happening," she wrote to Allan and Mariclare. With the aid of this new mechanical device, she could travel further in the direction she was heading with her lyrical photographs at Vineland. She might also infuse her pictures with the energy that she admired in the press photographs in the *Daily News* archive, and in particular in Weegee's work. The Pentax made a loud thud when you pressed the shutter release. It was cumbersome to carry and to lift. The awkwardness did not dissuade her. It may even have pleased her. Back in February 1969, she had written to Crookston, "For a long time I didnt think it counted unless it hurt but not now." Despite the avowal of reform, she would always mistrust what came painlessly.

Although hardly the sort of camera you could pluck from your pocket and use invisibly, as she had seen Cartier-Bresson do while walking down Fifth Avenue with his Leica, the Pentax would not only extend a new path but would also allow Arbus to revisit her beginnings as a street photographer. Unlike the Nikon, it was slow to load, so if you had to fire off more than ten shots quickly, it wouldn't do. Another drawback was that it synced with flash only at very slow speeds. But Arbus was tiring of using flash outside; in November 1970, when her light attachment broke, she confided to Allan, "I begin to suspect I am sick of strobe." She was appreciating the subtle variability of natural light, and praising the virtues of darkness and obscurity in the prints of Bill Brandt and Brassaï. In general, she was searching for what would appear more natural or more true to life. The square format of the Mamiya imposed a symmetrical formality on a photograph, with everything radiating around the bull's-eye at the center. The oblong frame of the Pentax, she thought, suggested "a greater degree of reality."

If she wanted the camera—and she did, badly—she needed to raise about $1,000 to buy one.

Blood

Since his dismissal from *Harper's Bazaar* in February 1963, Israel had been able to dedicate himself primarily to his painting while earning an income as a freelance designer. His approach shifted radically over the years. The gestural, thickly brushed, semi-abstract nudes of Margie from the early sixties, which were heavily influenced by de Kooning and other abstract expressionists, feel sensual and playfully erotic, with luscious paint applied in swirls like cake frosting. That period was behind him. Now he made hard-edged, flat-textured pictures in a commercial style, which resemble advertising art, except for their disturbing content.

The paintings he produced in 1969 and 1970 seethe with menace. Highly theatrical, they feature long shadows, electrical wires and disconnected telephones within domestic interiors in which acts of erotically tinged violence seem either recent or imminent. In one, in a room pocked by bullet holes, a man's shadow extends ominously over a floor on which a woman's undergarments lie strewn. In another, splayed female legs are on the floor in the foreground, with a heap of purple lingerie on a round blue table and four modern Chippendale-style chairs completing the ensemble. Once again, an unseen man casts a shadow over the room. A 1970 pastel drawing titled *The First Time* depicts

a dog tearing into the leg of a seated woman; in another, *The Second Time,* from the same year, a dog rears upright between a woman's bare open legs. Reviewing Israel's October 1970 show at the Cordier & Ekstrom gallery, Hilton Kramer in the *New York Times* remarked that the artist was staking out territory between Francis Bacon, who portrayed agonized human forms in stylized modern interiors, and Richard Lindner, who employed a brightly colored illustrational mode to paint cartoonish women wearing lewd outfits. "The atmosphere is one of sinister quiet, pervaded by the zany energy of some kinky sexual hanky-panky," Kramer wrote. Although he noted that this "novelistic" approach to painting was unfashionable, he judged that "it seems to work." John Gruen in *New York* found the show "chilling." In his reading of Israel's paintings, "devastating loneliness leads a cast of characters to enact scenes of strange erotic content."

During this period, Israel was also creating shoebox-size dioramas, to similarly dark effect. He bought plastic dollhouse furniture at B. Shackman, a manufacturer of novelty items with offices near his studio, for assembly into nasty tableaux. Once again, telephones off the hook were a recurring motif. For one diorama, he cut out Arbus's portrait of the Adam and Eve nudist couple from a contact sheet and placed it in a round frame on the wall as part of the décor. In another, a woman has been felled by a dropped birdcage. In a third, a man stretches supine over two chairs as another man in a pig mask stands at his feet. Nancy Grossman, a young artist who was showing her sculpture at Cordier & Ekstrom, recalled seeing, in 1970 or early 1971, a particularly macabre diorama by Israel in the office of Arne Ekstrom, the gallerist. It depicted a woman lying in a bathtub that was filled with blood.

Israel, who was always on the lookout for talent, in 1969 befriended Grossman and her roommate, Anita Siegel, an artist who cut up printed illustrations to create ingenious collages. The two women, friends since art school, shared a loft on Eldridge Street on the Lower East Side. At night, they would sometimes

prowl the neighborhood for pieces of wood, scraps of metal, and other urban castoffs that Grossman would use in her sculptures. Through Israel they met Avedon, who photographed them, and Arbus, who befriended them. Grossman respected Israel's intelligence, but his unceasing provocations distressed her. "He hated feeling afraid of things," she said. "Especially taboos." He was very sharp in his manner and confident in his judgments. Arbus, on the other hand, could make Grossman feel uncomfortable by receding into near invisibility and soaking up the reactions of friends as a way to materialize. Their initial meeting proved typical. Nancy and Anita were visiting Marvin's studio. "She came creeping in," Nancy recalled. "Like she was sneaking up on us." Diane preferred to observe before she was noticed. Nancy didn't know her photographs. She was struck instead by "a lack of self-definition" that confused her. "She was always more absorbing and taking in," Grossman said. "It was a way of having herself back from your response. She could only have herself through other people. The more formidable the person, the more validating it was."

At the opening of Israel's October 1970 show, which was his third at Cordier & Ekstrom, Arbus floated about the room with her camera. She seemed to disappear behind it. "I never realized it was such an indirect way of being aggressive," Grossman recalled. "She could see everything and you couldn't see her." Grossman attended a dinner at the Isle of Capri restaurant in Israel's honor after the opening. Avedon was there in a suit made entirely of denim, unheard of at the time. Israel wore a striped gondolier's shirt under his suit, which was almost as unconventional. But where was Diane, Nancy wondered. Then she realized that, of course, at the opening Marvin would be with his wife.

But usually, since Margie didn't enjoy social occasions, Marvin would be seen in public with Diane. Marvin's prickliness vexed many of those who were closest to Diane, including Allan. Michael Flanagan, Allan's studio assistant, was a protégé of Marvin's, and he could blather on about his hero. One time the name

of a photographer came up. "Marvin thinks he's really great," Michael said. To which Allan replied, "I don't think everything Marvin says is so great." Aside from his own feelings, Allan believed that Marvin often irritated Diane. "From my outside viewpoint, I sensed without any particular evidence that it was not easy for her," Allan recalled. However, he judged that "it was a relationship that was very important to her and very helpful to her." Thanks to Marvin, she joined "certain circles that she wanted to be in."

Some of the doors Marvin opened for Diane were professional, such as the introduction to the pages of *Harper's Bazaar.* Others were social. Marvin frequented the club Max's Kansas City, a bohemian hangout near Union Square that opened at the end of 1965 and welcomed different elements of the city's artistic and raffish subcultures. The front room was an updated descendant of Greenwich Village's romanticized Cedar Tavern, where in the fifties the abstract expressionists drank, caroused and bickered. At Max's, the artists, along with models, writers and uptown society figures, congregated in the front by the large bar. Whiskey and rivalry fueled their contentious talk. The back room became a clubhouse for Andy Warhol and his retinue from the Factory, a speed-amped bunch of art assistants, hustlers, musicians, renegade rich kids and colorful Warhol-anointed stars. The middle section, near the kitchen, was the in-between zone, attracting a blend of artists, photographers and celebrities. That was where Marvin and his friends sat. Their regular booth, which was intended for four but could squeeze in a couple more, often included Avedon, Richard Lindner, and Larry Shainberg, along with Marvin and Diane. (Margie never went.) Even if Diane had her camera around her neck, she didn't photograph at Max's. The hangout had an off-the-record feel to it, and only a few trusted friends of the proprietor, Mickey Ruskin, were allowed to take pictures. Besides, Arbus was no paparazzo. If she saw someone whose looks struck her, she would leave the table and introduce herself, trying to schedule a photography session in the future.

A waitress who worked at Max's from 1966 until mid-1967 recalled that Diane was "considerate, not a snob," but "always looked like she was on the verge of tears." Another young woman employed there, Abigail Rosen, the bouncer at the door, chatted sometimes with Diane, who would linger outside, perhaps eyeing the arrivals as potential subjects. Abigail, too, sensed that Diane was unhappy and thought the explanation lay in her unsatisfactory relationship. Marvin established the boundaries. "He didn't want any endearments in their conversation," Shainberg said. "He told me that he wanted to keep it under control. He didn't want them to be too attached to each other, too amorous with each other." Although it was not a subject Diane discussed directly, her friends could see that Marvin's imposed limits pained her. By 1970, the pain was a constant anguish.

Although she complained at times about the shortfalls in her sporadic intimacies with the "Hollywood type" (Calley) and the "Englishman" (Crookston), these men were stand-ins for the protagonist of her melodrama. Marvin had become her obsession. Diane deeply envied Margie's priority for Marvin's attentions. But she also, notwithstanding her disavowal of bourgeois monogamy, resented other women in Marvin's life. Maxine Kravitz, the photograph colorist who had been a student of Marvin's, entered into a sexual relationship with him following her graduation from Parsons. She knew that Marvin and Diane were friends, but nothing more. She had never seen them together. So she was startled and upset when Diane said to her one day, without preamble or context, in a low voice: "I don't trust you."

The emptiness that had troubled Diane since girlhood now threatened to swallow her up. "She was so vulnerable sometimes that without the big glass eye of her camera, she would disappear," Grossman felt. As if to verify her existence, dating back to her adolescence, Diane had often dwelled on an incontrovertible bit of physical evidence: her monthly flow of blood. Like Diane's other women friends, Grossman was startled by her frank and exuberant discussions of her menstruation. Women didn't talk

about their periods. And it wasn't just women that Arbus caught off guard. The young photographer Tod Papageorge, who hardly knew Arbus, was in Central Park with his camera when he ran into her. "God, here I am, I'm out here having my period and I don't have my Tampax," she said. He was speechless. Grossman was at a loss for words, too, when Arbus described a time she was teaching a class and felt a sudden heavy flow of blood running down her leg. "I would be horrified," Grossman said. "She was laughing. She was delighted." Once, when she and Anita were walking with Diane along the West Side Highway, they saw a poster for a new product, a Tassaway disposable menstrual cup. "She told Anita and me that she had tried these things," Grossman recalled. "She squealed with excitement. She loved her period, and she wanted to make it public." But in 1970, when Diane saw the poster, she was forty-seven years old. Her periods would soon be in her past.

Aging

"She hated losing her looks," Pati Hill said. "That was very hard for her." Pati had once quipped, "Diane, we are middle-aged ladies," amused by how unlikely that seemed. "You can be a middle-aged lady," Diane said. "I'm not." Pati was surprised by the asperity of the retort, until she realized that Diane, unlike Pati, was looking middle-aged. Walking behind her, Pati saw, to her alarm, that Diane's hair was thin and patchy, and she had an unpleasant epiphany: "I felt suddenly that she had dropped into another world."

On some days, Nancy Grossman observed, Arbus could look twenty years younger than her age, but on other meetings, "she was like Granny, so haggard." The effects of the hepatitis relapse lingered. To cover up the deep lines in her face, she tried applying thick white face powder, which she accented with black pencil around her eyes. Pati thought she resembled Isak Dinesen. Encountering her on the street near the Museum of Modern Art, Bruce Davidson was reminded of a Pierrot in clown makeup, off to a sitting with Nadar. In her youth, Arbus had worn little makeup other than eyeliner. As Robert Brown, the actor, remarked, she started using pancake powder only when she got "crinkly." It was "a bit theatrical," Mary Frank felt, "but not to hide anything."

Losing the capacity to play her old roles, she was experimenting with new ones. She had reached a stage of life where, when she was seen in the company of her older daughter, no one would ask which was the mother.

Oddly, though, if a friend of Diane's telephoned the apartment and Doon answered the phone, there could be confusion. "You'd talk on the phone and you couldn't tell whether it was Diane or Doon," Ruth Ansel recalled. "There was something in their demeanor that was interchangeable." Beyond a similarity in voices, their personal styles overlapped. "If I called and got Doon—you often mistake a child for a mother, but it was the physical gestures and ways of speaking that were also so alike," Frank said. "I found it disturbing way before anything else."

What eventually disturbed Mary Frank deeply, and disconcerted many of Diane's friends, were the rumors that Doon and Marvin were sleeping together. "It was so horrible that it was always unspoken but understood," Frank said. "I never asked more from people who knew Diane and who knew Doon and knew Marvin. It was horrible and you didn't want to know." She was particularly shaken because this wasn't a mother and daughter who were distant, but a pair who appeared inextricably close, even symbiotically attached. Tina Fredericks recalled that as a teenager, Doon was so beautiful that Diane said she felt "jealous almost" as she aged in advance of her daughter. The mother of two girls, Fredericks responded with dismay to the reports of Doon's romance with Marvin.

Yet could it have happened without Diane's connivance? "Diane was always putting herself in danger," Nancy Grossman said. "She was addicted to it." In Diane's worldview, and in Marvin's, taboos existed to be broken. Pushing boundaries and transgressing proprieties led to higher knowledge and deeper feeling. "Diane had this attitude—maybe it was a part of the times—that she would be able to put up with any social sexual system that was being played out," Mary Frank said. But the emotional repercussions could not be foretold. "She gave me the impression of want-

ing to be able to be in situations that would be out there, and that she wouldn't be affected by that," Frank said. "These situations wouldn't be able to hurt her. But the impression I got is it really did hurt her." Diane said nothing to Mary about Doon's relationship with Marvin. She discussed it briefly with Saul Leiter. "She talked about it," Leiter said many years afterward. "I think she had a conversation with me and she blurted it out. Which was not like her to do." He felt she was distraught over it.

Doon was very close to Avedon, her employer, and that, too, seemed to distress Diane. In public and private, Diane expressed her esteem for Avedon's photography. "I do terribly admire Avedon's work," she told the *Newsweek* reporter at the time of *New Documents*. "It's influenced me terrifically." Deborah Turbeville, who didn't revere Avedon quite as much, found Arbus's panegyrics a little wearisome. "She was absolutely in adoration of Dick," Turbeville said. "I think she thought he was the greatest photographer." Once, in a class, after Avedon demonstrated how he worked with a model, Arbus turned to Turbeville and said, " 'Isn't that the most incredible thing you've ever seen?' " When Turbeville disagreed, she felt Arbus "didn't like hearing that" because she was "so defensive of Dick." On his side, Avedon frequently proclaimed his admiration for Arbus's work. He told Ted Hartwell in Minneapolis several times that he considered her to be the greatest living photographer. He also recommended her for jobs, such as the one on the *Catch-22* movie set. In spring 1969, he landed her an advertising commission for a series of portraits of cameras by the greatest photographers in the world—a "bad dream" of an assignment, which, she gratefully acknowledged, was too lucrative to refuse.

Yet in 1970, attending art openings with Ti-Grace Atkinson, Arbus "seemed to have a contempt for Avedon's work," Atkinson thought. "He was concerned with appearances," Atkinson understood her to mean. "He wasn't trying to do something more." Arbus told Atkinson she felt "betrayed" and "bitter" that Doon had become Dick's assistant.

In her weekly psychotherapy sessions with Dr. Boigon, how-
ever, Arbus reserved her invective for Marvin. She never talked
about Allan. She talked sometimes about her daughters, always
affectionately. Although she was concerned for Amy's well-being,
she expressed nothing but confidence in her older daughter.
"Doon was the person she seemed to care about most," Boigon
felt. Doon was assertive, direct and combative. The therapist
thought that Doon represented something Diane wished she
could be.

Song and Dance

To raise the money to buy a Pentax 6×7, Arbus offered a private class at Westbeth. Her willingness to teach signaled how badly she wanted the camera. Playing the part of instructor made her feel like a total impostor.

But where else was the money to come from? Pat Peterson at the *New York Times Magazine* did not assign her a children's fashion supplement to shoot over Christmas as she had in the previous two years. In late February 1971, Arbus applied for a grant from the Ingram Merrill Foundation to photograph what she called "the quiet minorities." It was a project that could result in a book of photographs on subcultures, including people who were fat, freckled or handicapped; people of a certain age, class or ethnicity. She did not get the foundation grant.

Holding the class in Westbeth eased the burden of teaching. Grander opportunities she wouldn't even consider. In the fall of 1970, Walker Evans, in his midsixties, was seeking his successor at Yale, where he had taught since 1965. Photography fell under the domain of the graphic design department, founded by Alvin Eisenman, the husband of Howard Nemerov's high school girlfriend Hope Greer Eisenman. Alvin Eisenman was actively engaged in the search for someone to take up the position once

Evans retired. He last knew Arbus when she wheeled his baby
daughter in a doll carriage at Fort Monmouth, but he was famil-
iar with her photographs and shared Evans's admiration for
them. "It occurred to us both simultaneously that she was the
only photographer of the level of the other people in the depart-
ment," Eisenman recalled. "So we were very interested in trying to
establish a relationship. And she on the other hand could hardly
believe that anybody wanted poor little her. Walker thought she
was the perfect successor to him, and he was the most distin-
guished teacher of photography in the world. The only other per-
son within smiling distance was Diane as he thought—but not
as she thought. She thought that was humorous beyond belief,
that she was being asked to take Walker's place." She professed
that she had nothing to impart to students. She told Eisenman
she had taught the previous spring at the Rhode Island School of
Design in Providence, and it had been awful for her.

A class in her housing complex was less intimidating. She
advertised with posted flyers and through word of mouth, largely
attracting young photographers who worked for Hiro, lived at
Westbeth, contributed to the fashion magazines or had a con-
nection to the Museum of Modern Art. To preserve the privacy
of her apartment, she found an available room at Westbeth in
which she could give the course. On January 7, 1971, she inter-
viewed applicants, asking them to bring portfolios of their work.
The selection process crystallized her misgivings. Defending her
judgments about other people's photographs made her uneasy.
She had opinions, certainly, but she seemed to find it more con-
genial to assess the achievements of her peers than to gauge the
promise of those starting out. Their pictures confused her. On
one level, their photographs were proficient and "werent after
all so wildly different from Good pictures, except there was that
mysterious thing." They bored her. She had the discomfiting
sense that the ailment might be contagious and before she knew
it she would be taking boring photographs, too. Unsure of how to
choose among applicants, she concluded that she would accept

them all. Instead of the expected twelve, she admitted more than double the number—twenty-eight at one count, in early February. The increased enrollment would bring in that much more money for the same amount of time.

Unhappily, the overcrowding impeded the students' ability to learn. "People would crowd around when she had the contact sheets up and she'd say, 'That's good,' but nobody knew what she was talking about," recalled one student, Eva Rubinstein. It didn't seem as if instruction was the point. Arbus was a teacher who believed that photography was an intuitive art that could not really be taught. In a class with Lisette Model, Rubinstein sat before the other students as Model shone a light on her in different ways, indicating the effects of illumination on a face. Arbus's exercises were far less technical and vocational. "I all but sing and dance," she told Allan and Mariclare. She had the students describe an incident from their lives that could not be photographed. She asked them to bring in an object from home that they particularly loved. Discussing the tabloid press, which was on her mind more than usual as she worked on the Museum of Modern Art show, she exhibited some sensational photographs and asked the students to take a picture in that style. Coming into the next week's session, Deborah Turbeville, Arbus's onetime editor at *Bazaar* who, with Marvin's encouragement, was at the outset of a notable career as a fashion photographer, revealed that she had not fulfilled the assignment. When Arbus asked why not, Turbeville said she wasn't interested in the tabloids. "Your work is fake," Arbus responded testily. "What you do is fake." Turbeville had enrolled in the course only because she wanted Arbus's recommendation to supplement those of Israel and Avedon for a Guggenheim Fellowship. Israel told her that if she was going to ask, she should at least take the class. Grudgingly, Turbeville did. After this exchange, she did not return.

But most of the students seemed to enjoy their time with Arbus. Some, like Norman Bringsjord, were "in awe" of her. He resented only that there were so many cool-seeming people in the class

that he couldn't get more of her attention. Hiro's assistant, Paul Corlett, having recently arrived in New York from Minneapolis, was thrilled to be in her presence and hardly minded that "in some instances it didn't have anything to do with photography, it was more about what was going on in your head." Anne Wilkes Tucker, a curatorial intern at the Museum of Modern Art, was wavering in her ambition to take pictures anyway. "I was mostly interested in her," she said. For her part, Arbus seemed to be more interested in the students than in their photographs. She told Barbara Kruger, who would later achieve artistic distinction as an image-and-text conceptual artist, that she talked like Dorothy Parker and should think of becoming a writer. Having grown up in Newark without literary advantages, Kruger didn't know who Parker was.

Some of Arbus's lessons did require the students to take pictures. One week she teamed them up, in male-female pairs, with the task of photographing each other. For another assignment, she had them photograph something awe-inspiring or frightening. Rubinstein said she wanted to make a portrait of Arbus. After blinking a few times, Diane said, "Okay." She arranged a meeting in her apartment for early one morning, before a dentist appointment; perhaps she thought she would group the two unpleasant chores together. Rubinstein passed Amy coming out of the bathroom and drying her hair; upstairs, she noted the gruesome photographs of body parts and deformities pinned to the wall. She set up her tripod as fast as she could, knowing time was short. Over her shoulder, she glimpsed Arbus adjusting her hair. "The idea of her primping amazed me," Rubinstein recalled. It shouldn't have. Arbus readily admitted that, like most people, she shuddered in the face of the camera's unwavering eye. She thought a camera lens was "a little bit cold" and "harsh," inflicting an "extra kind of scrutiny which we don't normally give each other." Being photographed was slightly painful. "I think it's very hard to submit to that kind of scrutiny," she said. "*I* hate looking at pictures of myself. I don't mean that they're necessar-

ily good or bad or something. I mean, I just don't like—eew. You know?" She believed that one's physical manifestation was "some kind of signal . . . mysterious to us" to be received by others. Your appearance belonged to the world and not to you. Ideally, she said, she would never let her subjects see their portraits.

The class met for ten sessions, ending with a party in Arbus's apartment in late March. Sometime afterward, Turbeville sent Arbus her Guggenheim recommendation form. It came back in the mail unmarked, except for the scrawled words, "The same to you." Turbeville fretted over the lingering animosity and wished to dispel it. A few months later, she went to see Arbus and lied. She said she had dropped out because she was having boyfriend problems and was too distraught to attend the classes. Arbus's hostile demeanor changed completely. "Anything to do with that, I understand," she said.

"Love"

For an encyclopedic series on "the art of photography" aimed at amateur shutterbugs, Time-Life Books asked Arbus if she would illustrate, in return for $500, the concept of "love." Like "high and low New York" or "the family," it was an editorial category so vague that she could steer it in whatever direction she wished. She had ideas on the matter. She believed that love blended "understanding with misunderstanding" in "a peculiar, unfathomable combination." The challenge would be to display that in a photograph without becoming the kind of hack who went out on assignment for *Time* or *Life* to reproduce a preconceived picture in his head. Love wasn't usually visible. And "if they're performing as if they love each other," she remarked, "they really get to look like they don't."

She explored possible subjects during the weeks that she was teaching the Westbeth class. As usual, she was a sleuth overly blessed with leads. She visited a bridal fashion show, in which young women tried on gowns for their mothers and fiancés. She photographed a wedding. She depicted a blind couple and a gay couple. She found a pair of middle-aged identical male twins who had never spent a day apart. They lived together with their spouses, and when one of the wives died, the widower's brother moved into

his bedroom to comfort him. Eleven years later, he was still there, with his wife occupying their old bedroom on her own.

As with so many of the people she depicted, she collected stories about them. Some aspects of life were unphotographable, but she gathered them up with the same voracity that guided her camera. She described, with wonder, a dance for the handicapped to which she had been invited by a woman who was herself slightly crippled. It was a prospecting mission, because Arbus wasn't permitted to take pictures and hadn't brought her camera, but she kept a written record of an "incredible heart-stopping retarded couple"—a very tall man and a "radiant" midget with curly red hair. Mostly, though, it was dreary. She sampled the dismal food, "all sort of pale white to pale beige," and was having a miserable time until someone asked her to dance, followed by another and another; before long she felt like the belle of the ball and was enjoying herself immensely. Her host pointed out a shy man, about sixty years old, and urged her to invite him out on the floor. He was someone so ordinary-looking that she would never have wanted to photograph him. But she approached, and as they started dancing, she asked about his life. He lived with his father on Coney Island and wheeled a Good Humor ice cream cart. She coaxed information from him, all the while worrying that she would utter a stupid remark that highlighted his disability. Then, very slowly, he said to her something like, "I used to worry about being like this"—there was a long pause as he reached for words—"but now"—and his face brightened—"now I don't worry any more." It was an "incredible sentence," she thought. She found it "totally knockout." Unfortunately, it was not a photograph.

One day she heard about a New Jersey housewife who outfitted a stump-tailed macaque monkey in a snowsuit and bonnet. When she was a new mother, Diane had laughed at how much the infant Doon resembled a little monkey. Here was a promising look-alike opportunity. She contacted the woman, who agreed to be photographed at home. Arbus shot her with the monkey in two rooms: in the kitchen, and, more effectively, in a dark, wood-

paneled den in front of an askew venetian blind, on a couch with a bold floral-pattern slipcover, holding the well-dressed infant-size simian in her lap. Afterward, making rough prints in the darkroom, Arbus thought she had come up with all botches. She would have to return and try again. And then, as she looked at the prints, one image arrested her eye. "There was something wrong in all of them, but there was one that was just sort of peculiar," she told her Westbeth students. "It was a terrible dodo of a picture, maybe it came because I'd been talking to you about dumb photography, you know, you can't tell where those things come from. But it was incredibly . . . it looks to me a little as if the lady's husband took it, you know. It's terribly head-on and it's kind of ugly and there's something terrific about it . . . and I've gotten to like it better and better. And now I'm secretly really very sort of nutty about it."

Notwithstanding the square shape, the photo has a Kodak Instamatic aesthetic. It indeed looks as if the husband could have taken it. Because Arbus had placed the flash attachment close to her Mamiya, its glaring light left a sharp black shadow behind the woman's head. The woman's expression is grave and concerned as she looks penetratingly at the camera lens. Arbus referred to the photograph as a Madonna and child. She loved it so much that she added it to the box of ten photographs that Bea Feitler purchased, as the bonus eleventh.

In late February, Israel had a show in Hannover, Germany, and invited Arbus to join him. After much vacillation, confessing to Allan that she was feeling "jittery" about it, she agreed. To help subsidize the trip, she arranged to photograph the retired boxer Max Schmeling for *Esquire*. A hero whose time had passed, he might have made a good picture, but the plans fell through before she left. Instead, she won an assignment from *Harper's Bazaar* for a portrait of Günter Grass. That also was canceled, but she recouped with a commission to photograph Bertolt Brecht's widow, Helene Weigel, who directed the Berliner Ensemble. Although the picture turned out well, it never ran, and *Bazaar*

balked at paying her expenses. Arbus was in tears. To obtain the money owed her, Israel had to intervene angrily with Ruth Ansel.

Marvin supported Diane, but always at a slight remove, bestowing affection tinctured with acidity. Upon their return on March 8, he sent her a postcard: "Dear Diane, it sure sounds like you had a terrific time in Germany. Boy, are you lucky. It is difficult not to be extremely envious of you. As ever, Marvin." Six days later, he made an eight-page card to mark her forty-eighth birthday; in it, he included two candles and a cut-out clipping on the shape-shifting sea god Proteus, who, as the printed paragraph explained, would assume only under extreme duress "a single form, the form most his own, and carry out his function of prophecy." The card confirmed again that, as Diane often told friends, Marvin was the person who best understood her sensibility and her art.

However, an appreciation of her photography was building in the art world at large. Ted Hartwell urged her to do a show like Avedon's in Minneapolis, designed by Israel. She put him off, saying she wasn't ready, although she was open to returning to the city to lecture or teach once the weather in New York turned bad in late November. She did accede to a much smaller exhibition, a group show at the Fogg Art Museum at Harvard University, from mid-April to mid-May, for which she supplied seven prints. Even with such a small number, lining up releases added to her headaches. More than give her a show, she hoped the Fogg would buy a portfolio. This time, she was the one who was put off. The curator said he would love to make the purchase, but would have to wait to hear about a pending grant before committing.

The most gratifying acknowledgment of her as an artist came not from a museum but from a magazine. Through Henry Geldzahler, the contemporary-art curator at the Metropolitan Museum, Arbus arranged a meeting with Philip Leider. The founding editor of *Artforum,* an influential monthly art magazine that championed modernism, Leider regarded the sculptor and land artist Robert Smithson as the most significant artist of the day. He had never featured a photographer in his pages. He

didn't believe photography mixed with painting and sculpture; he wasn't even convinced that it was an art form. But he agreed to meet Geldzahler in Arbus's apartment and look at the pictures in her portfolio.

Even though he was very aware of Arbus by reputation, he didn't know her work well. The box of ten photographs astounded him. He wanted to reproduce all of the pictures in his magazine. Arbus offered him stacks of other photographs, which he looked through as she chatted with Geldzahler. A central tenet of modernism, as formulated most forcefully by the critic Clement Greenberg, is that a painter or sculptor should respect and exploit the capacities and limitations of the form in which he works. Since a canvas is flat, for example, a painter mustn't resort to trickery that would suggest otherwise. He should emphasize the flatness. Studying Arbus's pictures, Leider concluded "that Diane's work accomplished for photography what we demanded be accomplished, under the needs of Modernism, for all arts: it owed nothing to any other art. What it had to offer could only be provided by photography." He committed himself to publishing her work. He ended up not being able to use all ten of the photographs, but he did take six, giving each a full page. Indeed, for one of them—the pro-war demonstrator in the straw boater—he went a step further. He placed it on the cover. To jump from never including a photographer to assigning one the most prominent place in the magazine was a huge leap. The showcase for Arbus in the May 1971 issue of *Artforum* marked a key moment in the recognition of photography as more than a handmaiden or stepsister of art. Fully fledged, photography had flown the nest. It was a grown-up art form, with Arbus clearly a leader.

The editor gave her a page to write a brief statement on her work. She told Allan that she "sweated" and Doon helped. Eventually, she produced five short stand-alone paragraphs, each poetic and gnomic. The first recapitulates the dream she had when she and Allan separated, in which she was photographing in slow motion inside a burning hotel, elated amid the destruc-

tion. In this version, the hotel has become an ocean liner and its resemblance to a wedding cake, formerly implied, is now stated. In a second paragraph, she recounts a joke she loved, in which a man points out that a bartender has a banana in his ear. "Speak louder," the bartender replies. "I can't hear you because I've got a banana in my ear." The jest makes a nice rejoinder to the criticism that was already being voiced, and which Susan Sontag later formulated in print, that the professional freaks who posed for Arbus had no notion of their ugliness before she proclaimed it.

The other three statements were expressions of her credo, an evolution of the desire she had as a child to treasure a motto all her life. (The one she chose, "In God We Trust," lifted off the Lincoln copper penny, didn't endure.) Lapidary, counterintuitive and slightly impenetrable, they discuss the falseness of preconceptions, the beauty of tiny disparities, and the mystery at the heart of a mute photograph.

Nothing is ever the same as they said it was.
It's what I've never seen before that I recognize.

Nothing is ever alike. The best thing is the difference.
I get to keep what nobody needs.

A photograph is a secret about a secret. The more
it tells you the less you know.

Carelessly, the magazine omitted mention of the availability of the box of ten photographs. To make amends, the apologetic editor republished as a free advertisement in the June issue the picture of the Jewish giant and his parents, with instructions on how to contact Arbus directly to buy the portfolio for $1,000. Using her contacts, Arbus arranged to have the same photograph and purchase information reach a more demotic readership in the Best Bets column of *New York*. Both magazines were on the newsstands at the end of May. With the possible exception of Jasper Johns, the promotional copy resulted in no sales.

80

A Woman Passing

An elegant middle-aged woman, wearing a ribbed pillbox hat and a coat with a broad white fur collar, walks down the avenue. Her gloved hand, emerging from a wide cuff, clutches a pocketbook close to her waist. Her eyes are cast downward. Her thoughts lie elsewhere. Unobserved, Arbus snaps her picture.

With the Pentax, borrowed from Hiro as she waited for the camera she ordered to arrive from Japan, Arbus returned to street photography. The pedestrians who caught her eye, most of them women, resembled those she had portrayed a decade earlier. But the change from posed shots to grabbed shots was fundamental. An elderly, well-dressed woman in a rococo floppy hat, standing by the curb, is not so different in appearance from another woman in a millinery extravaganza of giant fabric roses, whom Arbus had photographed at the end of her Nikon period in 1963. Even the vertical proportions of the portrait are comparable. However, the woman in the rose hat is standing against a wall, facing the camera and strobe with white-gloved hands raised in a mildly pugilistic stance. The woman in the floppy hat, captured in profile in available light, is as unaware of the photographer as were the subway riders bagged by Walker Evans. She does not return Arbus's gaze.

"It will change things," Arbus wrote to Crookston. "I am awk-
ward with it at first, but its very thrilling. Nobody understands
but me what a difference it might make." In 1971, there was a
marked shift in her work, which the new camera facilitated.
Arbus was seeking people she could photograph surreptitiously.
Not exclusively so: using the rectangular format, she also utilized
her time-tested frontal pose with some of her traditional sub-
jects, such as a blond girl holding a hot dog in Central Park and
an odd-looking young man in a trench coat. But those portraits
she could have composed with the Mamiya. With the Pentax 6×7,
she was able to indulge in anonymous street photography like
Frank and Winogrand.

Beyond the street, she located other places and ways to pho-
tograph without engaging in visual dialogue as she had before.
She continued to travel to Vineland, where the mentally disabled
women observed her but reflected back her scrutiny dimly, as in a
fogged mirror. For the Time-Life assignment on love, she visited
blind couples, who couldn't see her at all. She aimed to go even
further. She told an acquaintance, Richard Lamparski, that she
would like to take pictures of people sleeping in the same bed.
They could be spouses, lovers or children. The important thing
is that they would not interact with her, either before or during
the taking of the picture. Supplied with a key, she would creep
into the bedroom and photograph them in slumber. "They won't
meet me," she emphasized. Although Lamparski responded with
an enthusiastic offer to help, nothing came of the project.

She took the Pentax to photograph in movie theaters, as she
had done with the Nikon in the late fifties. Back then, she made
screen shots of screaming victims, scary monsters and alluring
actresses, and she also recorded the silhouettes of the movie-
house patrons, who congregated in churchlike devotion beneath
a cone of white light that streamed with Old Testament force.
Now she visited the Elgin cinema in Chelsea during off hours and
photographed the vacant theater and the blank, empty screen.

She was starving psychically, and her work supplied scant nour-

ishment. She told Nancy Grossman that she received no gratification from photography. Lisette Model responded to Arbus's lament that she was unable to take pictures by urging her to photograph a chair and find in it all the people who ever sat on it. The exceptionally long gaps before Arbus spoke alarmed Model, who feared that her friend's brain was deteriorating. Helen Boigon listened to incessant complaints from Arbus in therapy sessions that work "gave her nothing back" and "appeared meaningless to her." Out in Los Angeles, Bunny Sellers received a couple of phone calls in January. "She was in so much pain and really struggling with what the meaning of her life was," Sellers said. "I had never felt her to be as fragile and unsure. She was feeling alone. She was always at once devoted to and loathing of photography. She was always wondering not was it good enough but was it true enough, always wanting to understand that kernel. There was that whole sense that there is a secret, and once you get that secret, that's such a triumph. Only to find that there is another secret."

To neighbors, she seemed very depressed. Thalia Selz, who had overseen Westbeth admissions, informed her friend Sonia Gechtoff, another tenant, that Diane was deeply distressed. Gechtoff knew Arbus less well, but also discerned a weary sadness in her large pale eyes. When Athos Zacharias, a painter who lived across the hall and was recuperating from a hospital stay, received an invitation to come over, Arbus baked a banana as a snack. "She would go in and out of the conversation," he recalled. "Two- or three-second pauses, and then she would come back." She talked often about her need for money. Another neighbor, David Gillison, was a documentary photographer who taught at Lehman College in the Bronx. He asked if she would be interested in speaking to his class. "Yes, if I get paid," she replied. He arranged for a $200 honorarium and she came up with him in his car. He felt her to be "very depressed" and "very fragile." His colleagues were impressed that he was bringing such a well-known photographer, and the class went smoothly, except when

one student said, "I want to make it as a photographer in New York. How do I do that?" Gillison perceived a flicker of pain cross her face. "Forget about making it," she said. "Do what you want to do." The student was unhappy with that response, and the exchange sputtered on for a while at crossed purposes.

Arbus very reasonably felt that she was the last person to offer advice on how to obtain money. She was careening up and down the freelancer's roller coaster. She congratulated herself in April, with the tuition money from her Westbeth class in the bank and a promised assignment from the *Sunday Times Magazine* on the way. She was on "easy street." A month later, the assignment had fallen through, and she calculated, to her panicked dismay, that she owed $1,800, not counting her normal monthly outlays and her taxes. "This is the point at which I usually get sick but I wont this time," she assured Allan.

That spring, she received several assignments from John Gerbino, who, having left *Essence,* was art directing what Diane described to Allan as "a terrible new magazine called NEW-WOMAN." Gerbino asked her to photograph Barbara Hackman Franklin, a businesswoman with a position in the Nixon administration, and Paul Lepercq, a French-born investment banker. They were boring assignments that resulted in boring pictures. A more promising subject was Germaine Greer. An Australian, six feet tall and arresting in appearance, Greer was the author of a stylish feminist screed, *The Female Eunuch.* A couple of weeks earlier, she had jousted with dazzling repartee to discomfit Norman Mailer in an uproarious debate at Town Hall in midtown Manhattan. An overnight celebrity, she was confident in manner and fiercely outspoken, especially when it came to sex. Not quite two years had elapsed since Arbus photographed the American feminist leaders for the *Sunday Times Magazine,* impressing Ti-Grace Atkinson with her remarkable ability to carry on an animated conversation while simultaneously disappearing into near invisibility behind the camera. In that time, her style had changed.

She was depleted and desperately determined. Calling on Greer at the Chelsea Hotel, she said very little, only an occasional snippet of words in an apologetic murmur. But she was far from invisible. Clicking shot after shot, she maneuvered Greer into lying back on the bed, straddling her and thrusting the Mamiya close to her face. The session dragged on interminably. "I knew that at that distance anybody's face would have more pores than features," Greer recounted. Afterward, Diane told Allan that Greer "was fun and is terrific looking but I managed to make [her] otherwise." With a little less candor, she wrote an enthusiastic postcard to Gerbino, in which she extolled Greer as "bold lusty funny outrageous radiant silly"—so many things that perhaps the magazine might run more than one photograph. But when the magazine's publisher interviewed Greer, she recoiled at the feminist's brashness. The piece never ran.

Unlike that *New Woman* assignment, which she deprecated as "a lousy page," the *Sunday Times Magazine* piece that fell through had been Arbus's idea: a far more substantial series of portraits of world leaders who were out of power. The editors couldn't round up enough of them. Winners becoming losers—"ex-champions" or "heavyweights," as she called them —were natural subjects for Arbus. She displayed in her apartment a framed print, given to her by Avedon, of President Dwight Eisenhower, whom Avedon had photographed four years after he left the White House. Looking wistful, seemingly burdened with the sad wisdom that comes with age, Eisenhower casts his gaze inward. Avedon liked the photograph so much that he chose it for the banner outside the museum during his Minneapolis retrospective. As a portrait of a disillusioned politician, it could have hung alongside Arbus's of Senator McCarthy.

Losing such a promising story was a disappointment, but Crookston presented a dubious substitute that Arbus gamely accepted. On June 12, Tricia Nixon, the elder daughter of the president, was to be married at the White House. Arbus agreed

to join the press squadron memorializing the nuptials. Covering the wedding required her to spend two nights in Washington. She anticipated darting in and out of the action with the mobility of a guerrilla, capturing candid shots of the attending dignitaries. She was naïve.

The festivities proceeded with the precise control of a military campaign. On her first day, she was given detailed instructions and maps. Reviewing the "battle plans," she realized how remote her vantage point would be. She protested futilely. The photographers gathered that evening for what was billed as a chance to view the wedding cake, but the matrimonial gâteau on exhibit turned out to be an uninteresting aggregate of tulle and sugar—"something like the hat of the cake," in her estimation. On the next day, she reported to the press tent, which was "rubbery, soggy, humid, like a shower stall the size of an airplane hangar," and listened with hundreds of other journalists to periodic updates by junior press attachés. When the time came, the flock was shepherded in the steady rain to the east gate of the White House, to be corralled behind a rope, jostling for position. She watched how the photographers who were experienced with this sort of work maneuvered their tripods and their ridiculously long lenses and took positions as carefully as snipers. They had the chilly demeanor of assassins, too—"if they had to slit your throat later they didn't want to pal around too much in advance to make it sticky." The fashion reporters who called out questions about the designers of dresses as the celebrities made their way down the red carpet were at odds with the photographers, because the reporters' shouts often caused heads to turn away at the crucial moment.

On this dispiriting day, the best chances came at the end, as the wedding party left the White House. Arbus stood on a small riser with only a few other photographers, truly seeing the principals for the first time. She thought that Tricia was "very pretty really but something like a paper doll." The president appeared to be wearing makeup. She sent the film to London, not knowing

how the pictures looked. She never did find out. The magazine didn't run them. The current whereabouts of the negatives, if they still exist, are unknown.

She remarked to Crookston that her stay in Washington was "funnier in retrospect." Back in New York, she told Estelle Parsons, whose children she was photographing for a second time, how much she admired her for running in the park every day, and fretted that she, Diane, lacked all discipline, having just returned from an assignment in the White House where she was unable to function. To Atkinson, she called the experience at the Nixon wedding a low moment and a turning point.

You Can't Come In

Allan Porter, the editor since 1965 of the Swiss magazine *Camera*, called Arbus in early June while visiting New York. He had phoned a year before and was told, "Perhaps we will meet some time when we are both old and dying." When he rang up this time, she said, "I don't want to be around people." Porter, who knew both Israel and Model, persisted until she consented to give him fifteen minutes in her Westbeth apartment. He brought her a collection of August Sander's photographs, the book edition of pictures that *Camera* had published in gravure. "You have no idea of how much I love this and wanted this book," she exclaimed. She said gravure reproduction was what Sander would have wished. Her resistance melted. Instead of fifteen minutes, they talked for three hours, with Arbus reeling him back several times after he exited her door to show him something she had overlooked.

They sat side by side on her fur-covered bed in the large upstairs room, looking at her photographs. They began by speaking of Sander. She acknowledged the strong affinity that her work bore to his, even though she had begun photographing long before she knew of him. She asked Porter to describe why he liked her work. She posed question after question. Her interrogation often struck him as ingenuous, but her responses

were sophisticated. He had arrived with the purpose of selecting a group of her pictures to publish in *Camera*. To his surprise, rather than gathering information and material from an artist, he felt he was the one being interviewed. Seeing her wall of photographs of professional freaks and other human anomalies, he asked if it was inspired by a photograph that Robert Frank took in the late fifties of the poster wall at Hubert's Museum. That photograph, which includes Arbus's portrait of Congo the Jungle Creep, became famous a year later when it was used for the cover of a Rolling Stones album, *Exile on Main St.* "It impressed me very much," she said of Frank's photograph. "It gave me ideas."

Warm, humid breezes stirred the fishnet curtains. The telephone rang four or five times, and she told each caller that she was unable to come for dinner, arrange a meeting, or do whatever they might be asking, but she would get in touch when she felt better. She seemed to Porter to be profoundly unhappy. She alluded to difficulties with friendship and to heartaches over boyfriends. Yet she said that whenever she wanted something from Israel, she could always rely on him.

They heard a knock on the door. Diane went downstairs to check. It was Doon. "You can't come in," Diane said. When she came back up, she explained, "My friends are my friends and not her friends." Porter found it to be "a very strange situation." At the time, he guessed that Diane resented Doon's closeness to Avedon, which he judged to be flirtatious. "That disturbed her," he believed. However, as was typical of a conversation with Arbus, he was connecting the dots of inferences. She did not explain herself or make direct avowals.

When he finally departed to head uptown to a Witkin Gallery photography show opening, Porter invited Arbus to come along. She declined, saying she didn't want to be around so many people. Besides, she remarked, after their intimate talk, the persiflage of a cocktail party would be tiresome.

She had lost the patience for small talk, but her need for income confounded her desire for seclusion. On June 20, she

began a week of teaching at Hampshire College in Amherst, Massachusetts, in a photography program run by Jerome Liebling, a longtime friend of Szarkowski. For the summer program, in which Lee Friedlander also conducted a class, she handed out some of her standard assignments, such as "Photograph something that is embarrassing for you," or "Go off with someone in the class you don't know and photograph that person in an uncomfortable situation." Often the discomfort involved nakedness. Hampshire was an alternative college that had just concluded its first academic year. In the countercultural atmosphere, nudity flourished. Bill Dane, older than his fellow students at thirty-two, would skinny-dip in the college pond and don a towel on emerging. He saw Arbus there every day, sunning in a black one-piece suit on the sandy beach. They would talk. One day, as he stood in waist-high water, she waded out to him, steadily and deliberately, until, when she was about seven feet away, she stopped her advance and started to chat. He stood there, embarrassed and uncomfortable, stationary to preserve his modesty, waiting for her to leave. Eventually, she went back to the beach. A day or two later, she told him, "I just wanted to see what you would do, since I was clothed and I'm a woman." She was groping for diversions. "This is pretty awful, there is nothing for me here," she told him on another day. He took that to mean that she could find nothing she wanted to photograph. As someone who suffered from depression, he divined a familiar darkness in her withdrawn demeanor. "I got to get out of here," she confided. "I'm glad I'm only here for a week."

During that week, she received a short visit from Amy, who was residing in Woolman Hill, a progressive school in nearby Deerfield. Amy had been unhappy at the Elisabeth Irwin High School, which was the upper-grade complement to the Little Red School House; researching the possibilities, she resolved to attend the Study, Travel, Community School in Bowdoinham, Maine, an educational institution that was even more alternative than Hampshire College. Calling it a school, Diane joked, was a "euphemism." But she endorsed Amy's decision. "I fall apart so

easy," Diane wrote to Allan at the end of August 1970. "I think its important to get Amy away." As a core part of the curriculum, after helping to dig a well and construct a communal kitchen, Amy built her own dwelling, a yurt. Journeying up there in early May, Diane photographed her daughter and classmates inside and out of their circular homes. "She sounds happier than in years," Diane reported to Carlotta Marshall. Perhaps in keeping with the Mongolian nomadic spirit, the short-lived school was itinerant, and its students had decamped to Woolman Hill for the summer.

After Diane's Hampshire College class was over, Doon came in a car and picked her up at the pond to take her back to New York. In the steamy city, Diane didn't take many photographs. She would go to Marvin's studio and sit quietly, watching him paint canvases of men and women, women and women, dogs and women, and men and dogs, kissing with bloody, snarling mouths, scratching into flesh with blood-flecked fingernails and claws.

Loose Ends

One evening in the middle of July, in the Lower East Side loft that she shared with Anita Siegel, Nancy Grossman heard the downstairs bell ring. It was Diane. Nancy buzzed her up, surprised that she was visiting without Marvin. Diane was obviously distraught. Nothing that the two women said comforted her. Sitting on a mattress on the floor, she bemoaned the barren harvest of her work. Nancy was roasting a chicken, and she invited Diane to join in the meal. Devouring the chicken hungrily, Diane seemed slightly restored, but she was still as needy as an inconsolable child. Anita, whose body was soft and bosomy, cradled her. "I wish I could go to bed with both of you," Diane exclaimed. The remark unsettled Nancy. Years later, she would come out as a lesbian, but at the time she was dating men. Anita was heterosexual. And wasn't Diane, with her passion for Marvin, heterosexual, too? "I found it very threatening," Grossman recalled. "I felt there was a lack of self-definition in the fact that Diane said that. It was like either/or would be fine, but not in between. It wasn't like that at that time." Neither Nancy nor Anita responded to Diane's outcry. "She wasn't being seductive," Grossman explained. "She was so upset. We tried to ask her what was wrong."

That day, Grossman had been making rubbings of zippers and

leather straps, positioning them in different places beneath a paper before pressing down with a graphite stick so that the impressions coalesced into a design. Arbus examined the rubbings.

"How does it work?" she asked. Nancy showed her, making a rubbing of a pair of scissors.

"Make one of my hand," Diane said.

"No, I have to press down hard," Nancy said. "It will hurt."

"I don't mind," Diane said. "Try."

Nancy made an impression of Diane's small hand on a piece of paper. The pangs of the process and the residual proof when it was over seemed to lift Diane's mood. She had felt something, and she had left behind some physical evidence that she existed. The meal, too, provided sustenance. When she said good-bye, she appeared to be less despondent.

That July in New York was like an oven, with the daily high averaging 84 degrees; on July 8 the temperature spiked to 96. "Diane couldn't bear the summers," Grossman recalled. "She would get really depressed." Doon later told one of Diane's friends that "summers in New York could be bad and *that* summer was worse." Fighting back her blues, Arbus pushed herself to work. For the *Sunday Times Magazine,* she traveled to Grand Rapids, Michigan, to do a piece on a weekend convention of twins, looking especially for pairs of adult twins. She completed a *Vogue* assignment on the actor Cliff Gorman, who was playing the taboo-defying stand-up comic Lenny Bruce in the Broadway show *Lenny.* Without an assignment, she covered the Puerto Rican Day Parade, as she did most years. She ignored the politically motivated violent clashes, in which nineteen policemen were injured, and focused on drum majorettes and young women on floats, precisely the frivolous spectacle that the radicals were protesting. She worked on another government job, probably for the Social Security Administration, taking pictures at a picnic hosted on July 10 by the Federation of the Handicapped, devoting special attention to a crippled female dwarf. With the exception of a portrait of

Gorman in a cardinal's costume as Bruce, none of the photographs that she took in June and July have been published or exhibited.

She was tying up loose ends and taking care of things she had been putting off. A bit mysteriously, she asked if Pati Hill wanted the letters she had sent to Diane during their long friendship. There was a particular letter that Pati valued highly, one she had written on lined paper many years ago. She had composed it while waiting, in 1949, in Diane and Allan's empty apartment (they were on Martha's Vineyard) for the ship that would take her to Europe and inaugurate a new act of her life. In those pages, she had recounted in detail much of her previous history. But the time for revisiting those years was off in the future, when she might be inclined to write a memoir of her youth. She had no need for old letters now.

Diane had known Tina Fredericks almost as long as she had Pati. Invited to stay with Tina in East Hampton, in the house she had visited while recuperating from the hepatitis relapse, Diane called to ask whether Tina would appreciate it if Diane photographed her daughters. "Of course!" Tina said. Diane brought her camera equipment with her on the train. Tina had two children—Devon, twenty-one, and Stacey, nineteen. Stacey was relaxed and accustomed to being photographed. Her older sister was not. Devon later described herself as "a lost and unhappy person at that time." At the end of the day, sunburned from the beach, Diane photographed the sisters separately out on the lawn. She took seventy frames of Stacey, and more than twice as many of Devon. Unlike the conventionally smiling portraits of Stacey, those of Devon look like Arbus photographs, with the young woman biting her lip or showing a bit of cleavage beneath her leotard. "I didn't recognize the pictures when I first saw them, but I did grow up to be that person," Devon said. "I think I looked provocative, much sexier than I certainly felt at the time. I look womanly in them, in a way I didn't feel then. I

think she captured something that it took me a long time to get comfortable with."

Diane sent Tina all the contact sheets and selected proofs in a manila envelope, postmarked July 16. With it, she enclosed a note:

> DEAR Tina
> You are really something.
> There were so many things I wanted to say to you
> and couldnt. . . . Come see me in the city.

She added that she would be happy to make finished prints of any pictures that Tina liked.

Back from the beach, which followed her week in the sun in Massachusetts, Diane was looking tanned and fit. John Lotte, a young photographer who regarded Arbus as a mentor—over a period of three years, he brought his pictures on several occasions for her to review—came to see her that July. Lotte had never considered Arbus to be depressed. Even so, he found her unusually animated. He thought she looked different, too. She was wearing a long white dress instead of her usual short black skirts, and the fashion change attractively emphasized her suntan. Lisette Model also saw her in July and marveled at how well she seemed—"in bloom and strong and coming from the beach and looking magnificent." Model had secretly worried for years that Arbus might harm herself. Later, looking back on what had happened, she told Peter Bunnell that she interceded once to prevent Arbus from committing suicide, and Israel intervened on another occasion. Seeing her in July so vigorous and healthy, Model felt with relief that, at least for the moment, vigilance was unnecessary. "And that was my mistake," she said. "And my mistake was that I did not know that people commit suicide when they are strong, and not when they are weak."

Like Hamlet and Medea

"Are you afraid of dying?" Pati asked Diane. Pati was in Stonington and they were talking by phone. It was one of the last times they spoke.

"No," Diane replied. "I'm afraid of *not* dying."

When she discussed death, which she did frequently throughout her life, it was in the cool, ironic, measured tone with which, as a schoolgirl, she postulated that Hamlet and Medea achieved contentment only once they were dead.

That year, there had been two suicides in Westbeth. The first was a young woman who didn't live in the building but took classes from a printmaker there. She found her way to a roof and threw herself off. The second was Sheldon Brody, a documentary photographer in his forties who taught at Yale. He jumped, too, and landed in the courtyard. Kids in the hallways joked that their apartment complex should be called "Deathbed." "It was a time when you didn't want to live here," David Gillison recalled.

Soon after her return from East Hampton, Diane bicycled to Adrian Condon's apartment on the Upper East Side to see Carlotta Marshall, who was making one of her regular visits to New York following a move to Holland. At the time that Arbus was hospitalized for the hepatitis relapse, in 1968, Marshall had been

critically ill with encephalitis, and she was later diagnosed with multiple sclerosis. After visiting with her several times on this sojourn, Arbus was paying a last call before Marshall sailed back to Europe on July 17. They stayed up talking until the early hours of the morning. Carlotta had seen Amy frequently during this visit, and she told Diane how wonderful Amy was. Diane confided that she was concerned that Amy had not yet determined a path in life. Doon, by contrast, was in Paris, holed up in a hotel on the Left Bank, fully engaged on a project for Avedon.

They talked of suicide, as they sometimes did. Arbus introduced the subject, but it didn't jar or perturb Marshall. "It was maybe hypothetical," Marshall said later. "I didn't go away thinking, 'That was odd she brought that up. I wonder why she did.'" Marshall had contemplated suicide herself from time to time. "So I just didn't pay special attention to the fact that she brought it up," she explained. "It wasn't a morbid discussion when we were talking about death."

Howard also came through New York in July, and he and Diane went out for dinner. One of the adhesive bonds in their special relationship was competitiveness. Each struggled to produce work that would stand up against the highest historical achievements in their respective arts, regardless of the passing judgments of the present day. As much as they deprecated celebrity and honors, Howard and Diane nevertheless craved recognition. Each measured individual progress against the accomplishments of colleagues. Each, despite conflicts and reservations, longed for fame. Furthermore, each vied with the sibling who had served as the earliest measuring rod. Howard, in the *Journal of the Fictive Life,* vigorously argued that a great writer explored depths that no photographer could fathom. He regarded photography with distaste. He hid the print Diane gave him of the Roselle identical twins in a desk drawer, along with his children's crayons. Yet as his son Alexander, an art historian, would observe, Howard wrote an essay comparing Wordsworth with Blake, and he bestowed the laurels on Blake. Like Wordsworth, Howard was

a nature poet; like Blake, Diane was a visionary. In Alexander's assessment, Howard acknowledged that Diane's talents and ambitions surpassed his.

Diane was at least as insecure as Howard. Always dubious of the merits of what she produced, she seemed when they met in July to be particularly downcast. "I'll be known as Howard Nemerov's sister," she said to him. After dinner, as she reported to Dr. Boigon, she and Howard went to bed together once more.

Margie Israel had undergone intestinal surgery that summer, an operation that reportedly improved her mood as well as her digestion. Marvin was especially attentive to his wife as she convalesced. On the weekend of July 23, Avedon lent the Israels his Fire Island house so they could relax on the beach. Marvin invited Larry Shainberg and his wife, Andra Samelson, and the lawyer Jay Gold to join them.

Although she lived with Shainberg in an apartment on Sixth Avenue in SoHo, Samelson kept a painting studio in Westbeth. Before departing for the weekend, she paid a call on Arbus. She mentioned that she and Larry were going to Fire Island with the Israels. "Who cooks?" Diane said, punctuating the question with a little laugh. Samelson had just been in Paris at the Bibliothèque nationale, examining a group of prints by Rogi André. The purpose of her neighborly visit now was to see if Arbus would develop and print the film she had brought back. André, who before World War II instructed Lisette Model in the art of photography, befriended Samelson much later in life. When André died in 1970, all of her possessions were discarded, except for the photographs. Samelson had used a cheap automatic camera to make a copy of a picture that André took in 1944 of the painter Wassily Kandinsky on his deathbed, dapper in an elegant suit on a white-sheeted sleigh bed beneath one of his abstractions. She wanted the photograph as a memento of André. Sometime that weekend, in the darkroom on Charles Street, Arbus processed the film, printed the surreal image and left the picture in a manila envelope under Samelson's door in Westbeth. On the

envelope, she wrote, "It's a little crude lookin. Couldn't make it any softer. D."

Arbus saw Dr. Boigon for her Saturday appointment. She appeared less depressed than usual, the psychiatrist thought. Rather, she was angry. She was furious with Marvin for not being available to her, and wanted to know how she could get back at him for his neglect. Uncharacteristically, she was enraged with Allan, too, for having deserted her. But mainly she was agitated about Marvin. She spent most of the session complaining that Marvin said he had to take better care of Margie. How could she retaliate for this abandonment?

On Sunday night, Lee Guilliatt, the artist who had worked with Nancy Christopherson at the Judson and now lived at Westbeth, encountered Arbus in the elevator. "Why don't you come up and have a drink?" Arbus said. "I can't, maybe next week," Guilliatt replied. Arbus didn't seem distraught, or at least she didn't appear any more troubled than usual. She always looked sad to Guilliatt.

On Monday, July 26, Arbus placed her appointment diary, with the words *Last Supper* inscribed as that day's entry, on the concrete steps that led from Amy's room and the bathroom to the more spacious upstairs of the apartment. (She may have written an additional message; someone later neatly cut out that page and the two subsequent pages of the diary. They were never recovered.) She left her copy of the *I Ching* open to a hexagram that was interpreted to mean "time to move on"—most likely number eighteen, an ideogram of three maggots and an urn, which represents decay. Wearing a red shirt and blue denim shorts, she consumed a handful of barbiturates and lay down in the tub that occupied the full width of the small bathroom. She slashed across her wrists with a razor blade, three times on the left, twice on the right, so deeply that she severed tendons.

What she meant by "Last Supper" remains ambiguous. The phrase evokes at least two associations. Seated at the Passover table shortly before his arrest and crucifixion, Jesus Christ broke

unleavened bread with his disciples and said, "This is my body, which is given for you," and drank from a cup of wine and said, "This is my blood of the Covenant." In Christianity, the ritual consumption of wafers and wine is a communion in eternal life with Christ. For a woman taking fatal tablets and spilling her blood, the analogy was blackly self-mocking and keeningly grandiose.

Also at the Last Supper, Jesus said that one of those closest to him would be guilty of betrayal. Of that traitor, Jesus added: "It would be better for him if he had not been born."

84

Runes

Back in New York at the conclusion of the weekend, Marvin tried to contact Diane by telephone. When he was unable to reach her for two days, he went down to Westbeth on the evening of July 28 and used his key to open her door.

The phone rang in the Shainberg apartment at dinnertime. Larry and Andra were about to leave for a restaurant in Chinatown. Andra couldn't reach the phone before the answering machine switched on. She picked up the receiver, laughing.

"This is not a funny time for us, Andra," Marvin said. "Diane has killed herself." Larry got on the phone and said he would taxi right over while Marvin waited for the police to arrive.

Israel also called Avedon and reached him in the studio. Avedon conveyed the news to his stunned employees. "It was quite difficult to comprehend, to believe," said Peter Waldman, a studio assistant. Avedon left immediately. The third person Israel called was Jay Gold. All three reached Arbus's apartment before the police showed up, with the body conspicuously present but out of sight in the bathroom. When the officers entered, Marvin went upstairs to talk with them while the three friends clustered uneasily in the small room below. "I'm going in there," Avedon

said to Shainberg, striding over to the bathroom. "And you're coming in with me." Shainberg declined.

In her apartment in Westbeth, Sonia Gechtoff heard a frantic ringing at her door. It was Thalia Selz, too agitated to speak. In the cellular beehive of Westbeth, she could see from her apartment into the bathroom of Diane's. She had witnessed the arrival of the police and had gone out to investigate the commotion.

"Diane Arbus, Diane Arbus," she repeated. And then she managed to say, "They found her body in the tub. She killed herself."

The news pulsed quickly through Westbeth. "There was a lot of sadness in the air that night," Athos Zacharias said. Along with the sadness was an undercurrent of terror. If an artist of Arbus's stature found life futile, what about those who had accomplished so much less? This anxiety would unsettle a number of Arbus's photographer colleagues when they learned of her suicide. "If she was doing the kind of work she was doing and photography wasn't enough to keep her alive, what hope did we have?" Joel Meyerowitz recalled thinking. "Photography back then was the bastard child of painting, and it had to be defended all the time. We were always driving each other on, saying we were doing something with high purpose. She was one of a handful of people to be celebrated and taken seriously, and then she kills herself. It was devastating."

Allan was in Santa Fe shooting an independent movie, *Greaser's Palace,* with Robert Downey directing. It was his first big role, as a Christ figure in a striped zoot suit stuck in a Western town, trying to sing and dance his way to Jerusalem. He flew to New York when he learned the horrible news.

In St. Louis, the telephone rang, with the midsummer sun still aloft in the evening sky. Howard, ashen, came out of his study to the garden, and told his three sons—the eldest was twenty-one, the youngest six—that Diane had taken her life. Later that night, he went over to the home of his friends Stanley Elkin, the writer, and Stanley's wife, Joan. He had never discussed Diane with them. Indeed, Joan had known him for five years when she happened to

mention to a friend that she admired Diane Arbus's photographs and was told, "That's Howard's sister." Howard didn't ever speak of Diane, not even with his closest friends, Al and Naomi Lebowitz. That night at the Elkins', Joan recalled, Howard wasn't talking about Diane, either. He was getting "stinking drunk."

He was drunk when he telephoned Renee in Michigan. Renee and Roy routinely went to bed early. Their daughter, Alisa, answered the phone and woke her mother up. Renee became hysterical, throwing herself on the floor, kicking her feet in the air. Years later, she said the news was gut-wrenching but not unexpected. "It didn't surprise me when she killed herself," Renee said. "Horrifyingly, no."

Gertrude, too, recognized that her three children, like their mother, suffered from depression, and that Diane was the one most afflicted. Over the last year, Diane several times had called Gertrude, crying. She would ask her mother to describe how she had emerged from the darkness that enveloped her when Diane was a child, as if the telling might now help Diane discover a path out.

Avedon took it on himself to inform Doon in person. He flew to Paris and they returned together to New York. Larry and Andra, who had a house in Vermont not far from Deerfield, drove Doon to Massachusetts to speak to seventeen-year-old Amy. They all stayed overnight in the Shainberg home and went the next day to New York. "It was a terrible thing for Amy," Allan said three decades later. "She's never gotten over it."

The funeral was held on Sunday at the Frank E. Campbell funeral chapel on Madison Avenue, the socially preferred mortuary of New York. The services were sparsely attended. On a summer weekend, many people who knew Diane were out of town. Moreover, a large number didn't find out that she had died until later. In the aftershock of the suicide, Marvin withdrew completely, taking no role in the funeral arrangements.

Howard delivered the eulogy. "This is a sorry occasion," he began. Like everyone there, he said, he had assumed that Diane

would always be a living presence in his life. "I was close to Diane, ever so close . . . and yet I realize how little, really, I know of her," he said. He spoke of her kindness, beauty, charm, "and a sort of radiant, sudden humor that was hers alone, an angle of vision that for a moment would illuminate the world, making it new and strange." It was a mystery, he said, how with the mechanical device of a camera, she could produce work that was "absolutely distinctive, uniquely her own."

In closing, he read the last verse of "Runes," a poem he published in 1959. A meditation on mysteries and secrets, "Runes" describes the esoteric processes that unfold in nature: the tightly compressed packet of a seed, the water that can flow in runnels or lie still in pools. By choosing to recite these lines, Howard—who once bitterly wrote, "I hate intelligence, and I have nothing else"—encapsulated the tragedy in an aestheticized and distancing frame. The poem ends:

> Knowing the secret,
> Keeping the secret . . .
> . . . it is not knowing, it is not keeping,
> But being the secret hidden from yourself.

Diane was a connoisseur and gatherer of secrets, storing them up, doling them out. Like the custodian of a museum-quality collection, she would trade some of hers to acquire the treasures of others. "She was genuinely fascinated with these confessions," Allan reflected. "I never thought I knew all of her secrets." But he judged that she "probably" knew all of his.

Leaving the service, Richard Avedon turned to Freddy Eberstadt, who had worked for him in the fifties.

"I would give anything to have her talent," Avedon said.

"No, you wouldn't," Eberstadt replied.

Lucas Samaras, an artist whom Diane had photographed for *Bazaar* but who did not know her well, was invited to attend, probably by Avedon. He wouldn't have gone—he avoided funerals—

but the friend he was with that day persuaded him that he should. What impressed him most was the sequel. Shortly after he exited the chapel, the heavens opened in a torrential thunderstorm. "The sky was knowledgeable of what happened," he thought.

In a sonnet, "To D—, Dead by Her Own Hand," which he published in 1972, Howard recalled a game in which a child runs along a ledge; at a certain point, afraid of losing balance, the child jumps. The poet wrote that Diane had refused to keep playing the grown-up version of the game, in which you never look down and never leap off. Other than in the eulogy and the sonnet, Howard didn't discuss Diane's death publicly. However, Pamela Hadas, a former student who taught with him during summers at the Bread Loaf Writers' Conference, said, "All that he was interested in was Diane. We would go on walks in Vermont, and he would point out things Diane would take pictures of." At Bread Loaf, Howard befriended another young poet, Judith Ortiz Cofer, who was an amateur photographer. He told her once that she reminded him of his sister, but never revealed who that sister was. With Hadas, he said more. She sensed he felt remorse that he didn't help Diane when he saw how emotionally distressed and financially strained she was two weeks before her suicide.

Marvin didn't attend the funeral. The suicide, and the oblique but incisive jab of the "Last Supper" note, conveyed with awful power Diane's sense of Marvin's abandonment and betrayal. But Marvin, in his guilty distress, could freely reapportion the blame. Wasn't Allan, by moving three thousand miles away, equally at fault? And what about Diane's brother, with his tweedy WASP manners and his lofty, sanctimonious airs? The day after the funeral, Marvin mailed a one-page note to St. Louis:

> Howard
>
> I am enraged at what you have helped to make. You—with your Temple-Emanuel voice and your complete indifference. If I could condemn you I would.

I wanted to meet you Sunday. But each time I
thought my dark thoughts the thunder increased the
rain and I was certain it was Diane scolding me.

I wanted to tell you about Diane, to show you her
work, to explain to you, to have you see, feel, why
Diane is dead.

I want you to know because you do not want to
know.

You have been here and you have gone and you
have been no place.

Marvin

In the days that followed, Marvin kept to himself in his stu-
dio, obsessively reading Louis L'Amour Western romance novels,
which he had always loved, and chain-smoking cigarettes. Two
weeks after the suicide, he turned away Michael Flanagan, who
arrived, as usual, unannounced. From the far side of the metal
gate, Flanagan observed that Israel had painted the walls of his
studio black and had even erased some of his pictures with black
paint. On another day, Shainberg, too, saw that Israel was sur-
rounded in self-imposed blackness.

Israel later told Maxine Kravitz that he felt guilty about Arbus's
death. She understood him to mean that he wished he had been
more available during Arbus's depression. But when Israel told
Saul Leiter over lunch that what he had done was wrong, Leiter
interpreted the regret differently. "I guess what he meant was to
be involved with the daughter after the mother was wrong," Leiter
said. In time, Israel developed a narrative that explained Arbus's
suicide. "The thing about Diane is, she could never refuse a dare,"
he told Shainberg. To Flanagan he said it was an ultimate act of
theater. "The point came where he forgave himself for not recog-
nizing the signs," Flanagan explained. "A lot of people hated him
and blamed him. I'm sure he blamed himself plenty and then got
over it and was able to talk about it, as he did with me."

The women who knew both Diane and Marvin tended to be

less forgiving of him than his male friends. His desertion infuriated Andra, who couldn't excuse how he abdicated all responsibility for the funeral. Nancy Grossman bitterly regretted that she didn't learn that Diane was dead until after the services. She reviled Marvin for neglecting Diane. "We wanted to wring Marvin's neck," she said. "We felt murderous towards him."

Mary Frank was staying in a borrowed house in rural Massachusetts. The first thing that came to her mind upon learning of the suicide was the relationship of Marvin and Doon.

Tina Fredericks, when she was told of Diane's death, thought the same. "I believe he behaved very badly towards her," she said. "When she found out he was doing Doon, what choice did she have? That's what I feel happened."

Doon telephoned Pati to inform her of Diane's suicide. Pati was furious, too, but not with Marvin and certainly not with Doon. She directed her anger at Diane. "I was absolutely enraged that she would do that," Hill said. "And I was furious with myself because I had refused to listen to what I saw." Doon, in the course of their conversation, said, "It's *all right*," but Pati was not reassured.

From a certain vantage point, Diane's self-annihilation could be viewed not as a dramatic gesture or a daredevil stunt, but as an act of generosity. A few years after Arbus's death, May Eliot's mother, Anne, also committed suicide. She had suffered from recurring and debilitating depressions. "My mother was so sick, and in this way, she freed me up from her unbelievable illness and desperation," May said. "Doon and I had a talk after my mother died. I felt my mother had done it for my sake. She said the same was true of her."

Out in California, Robert Brown received the news of the suicide with sickening incomprehension. He had never considered Diane to be in a psychologically precarious state. Now, as he sought to make sense of this catastrophe, he questioned whether by encouraging Allan to relocate to Los Angeles he had inadvertently sent Diane reeling. "That pulled the rug out," he thought.

Nancy Christopherson, when told of the death of the woman

who had once been her closest friend, maintained that Diane had not committed suicide. She declared that Marvin had murdered Diane because he was sleeping with her daughter.

Alex Eliot was "absolutely shattered" by the suicide. He remained desolate and miserable until Diane appeared to him in a dream and said with a giggle that it made her laugh to see him cry. "She's right, she's released," he thought. He stopped crying.

Lisette grieved that she had failed to save this fragile woman she loved. She wept bitterly, and she was not a woman accustomed to shedding tears. "Why are you crying?" her husband said. "You wouldn't even cry for me." Compounding the hurt, a greeting card arrived in the mail. Emblazoned alongside blue morning glories and pink and yellow daisies were the words "Goodbye and Good Luck." When Lisette opened the card, she saw, within the outline of a flower, a printed message in bright cheerful pink: "Be happy!" At the bottom, penned in a neat cursive script, was the signature: Diane.

Things That Nobody Would See

Anne Wilkes Tucker, the MoMA photography curatorial intern, reported to her colleagues in the fall of 1970 that her husband's boss had won a Nobel Prize. Immediately afterward, his rejected scientific papers were published and his government salary soared. "There's nothing in the art world that will do that for you," Tucker remarked.

"Yes, there is," Szarkowski replied. "Dying."

Arbus knew it, too. "The irony is that when I'm dead, my work will skyrocket in value," she had told Ti-Grace Atkinson in Rhode Island in 1969. She was very clear about that, Atkinson remembered. And very bitter.

When the report of her suicide reached the department, Szarkowski entered his private office and closed the door. "John did not speak of his emotions," Tucker noted. "He was a Midwesterner." Instead, he began to conceive a posthumous retrospective of Arbus's work. The exhibition opened fifteen months later. On a museum's timetable, that is virtually overnight.

Death, by concluding a catalogue raisonné and rounding off an open-ended life, burnishes an artist's reputation. Suicide brings an added spooky luster. Particularly when the art is perceived to be self-lacerating, this ultimate act of despair stamps

the artistic products with a seal of emotional authenticity. Like Vincent van Gogh, Mark Rothko and Sylvia Plath, Arbus after her suicide was widely thought to have recorded her pain in her art. Even more, she was said to have sacrificed her emotional well-being by looking too unblinkingly at the anguished, abject and misshapen, at those frightening and horrific aspects of the world from which most of us avert our eyes. During her lifetime she had been accused of betraying her subjects. She was now said to have died because she felt their pain too acutely. These contradictory simplifications had one thing in common: they reduced and obscured her achievement.

She had been so reluctant to show her pictures that her work was only sketchily known. Aiming to change that, Szarkowski resolved to issue a book along with the exhibition. In 1967, when *New Documents* opened, the museum had just inaugurated its new building. Money was scarce, and no catalogue accompanied that show. For an artist's retrospective, Szarkowski felt he had to produce a permanent record. Marvin Israel agreed. In addition to the artistic testament, he hoped a book might bring in royalties. Doon and Amy needed money. Israel thought an outside publisher could sell more copies than the museum.

After Diane's death, Marvin and Doon socialized and traveled together as a couple (although Marvin continued to live with Margie until a heart attack ended his life in 1984). They promptly set about selecting prints for a monograph and located a book packager who was enthusiastic about the project. But after holding it for almost a year, the packager announced in July that he couldn't sell it, and returned the property. As soon as he learned of that disappointment, Szarkowski went to the MoMA publishing division to explore what might be possible. He was told that at this late date, the best the museum could do was a sixteen-page brochure. The institution wasn't geared for speed.

Szarkowski went to lunch with Michael Hoffman, the executive director of Aperture. Founded in 1952 by photographers and

critics, the nonprofit Aperture Foundation publishes a magazine and books that are dedicated to the art of photography.

"Why are you so despondent?" Hoffman asked.

"We are opening a Diane Arbus exhibition and we can't do a book," Szarkowski said. "It's too late."

"It's extremely late," Hoffman said.

"It's not too late?"

"It's extremely late," Hoffman repeated. He paused. "The trouble is, I don't like the work."

But he agreed to publish a book.

Explaining his decision to the photographer Paul Strand, Hoffman confided that Arbus's suicide had compelled him to reconsider her photography. Previously believing that she "preyed on her subjects," he now regarded her connection to them as one of "near total identification and sympathy"; and even though the book was "one of those very difficult projects which few people will comprehend," he judged that it was "very worth doing." He told another friend that he was impressed by the mock-up that Doon and Marvin brought him—not only by the pictures, but also by the text, drawn mainly from a taped interview with Diane by the Chicago journalist Studs Terkel, some unpublished articles for magazines, and a recording of her Westbeth class by Ikko Narahara, a Japanese photographer who had feared he wouldn't understand the sessions on first hearing.

Proceeding on separate parallel tracks, the organization of both the book and the show were well advanced by the time Aperture signed on. "Okay, in order to avoid a lot of committee meetings, you do the book and I do the exhibition," Szarkowski had told Israel, "and after we finish our edits, we'll show them to each other and see what comments we have." When eventually revealed, their visions of Arbus's accomplishment matched nicely. Of the 80 photographs that Marvin and Doon chose for the book, all were made with a medium-format camera. Szarkowski could accommodate a larger selection, of 112 prints, but he

too favored the later pictures. He included only 8 examples of
the 35 mm work, out of the hundreds of rolls Arbus had taken on
the streets of Manhattan, in the dressing rooms of female imper-
sonators, in Times Square movie houses, and on the boardwalk
and beach of Coney Island. These pictures, many of which are
superb, would have to wait for recognition.

While the MoMA exhibition and Aperture book were being
developed, another showcase of Arbus's photographs was under-
way. Walter Hopps—the charismatic cofounder of the defunct
Ferus Gallery in Los Angeles, the former director of the Pasadena
Art Museum and now the director of the Corcoran Museum of
Art in Washington, D.C.—had been appointed to select the artists
for the United States Pavilion at the thirty-sixth Venice Biennale,
opening in June 1972. In the past, the places had gone exclusively
to painters and sculptors, but Hopps, like the editor of *Artforum*,
saw Arbus as a true artist. He had approached her to participate
in this exposition, the most prestigious in the international art
world. During Arbus's tirades in Dr. Boigon's office, when she
despairingly enumerated the outsize things that people expected
of her, Hopps's overtures ranked high on her list of terrors.

Dead artists are easier for curators to deal with. Although
Hopps gave Arbus only part of the pavilion, shared with four
painters and (another first) a video artist, when the biennale
opened in June it was the ten large Arbus photographs—the
ones she had chosen for the boxed portfolio—that the critics sin-
gled out for praise. (These enthusiastic notices may have influ-
enced Hoffman's change of heart a month later.) Hilton Kramer
in the *Times* proclaimed Arbus's photos to be "by far the most
audacious thing" in Hopps's exhibition, possessing "a power that
nothing else in the American show—and very little else in the
biennale as a whole—can match." They were, he wrote, "the over-
whelming sensation of the American Pavilion." Less than a year
had elapsed since Arbus's suicide, yet she already enjoyed a "semi-
mythical status." He noted that the Venice exhibition provided
only a small sample, but her "extraordinary achievement" was so

evident that he eagerly anticipated the wider range that would be on display at the Museum of Modern Art in the fall.

He wasn't alone. When the Arbus retrospective opened at MoMA on November 7, 1972, it was clear that this would be the most popular photography exhibition since *The Family of Man*. Lines stretched down the block. Szarkowski had placed an advance order of five thousand copies of the Aperture monograph. "We thought they would be on our hands for years," he said. Instead, the monograph became one of the best-selling photography books of all time. Within a month of the opening, the publisher supplemented the first printing of eleven thousand with a second of ten thousand. Over the first four decades, Aperture reprinted the monograph twenty times in hardcover and twenty-two times in paperback. Sales have been estimated at about half a million copies.

The crowds filing through the museum behaved differently from the usual visitors. "The tone in the exhibition was absolutely quiet," Szarkowski recalled. "A complete hush. It felt like church. It was like people going to communion." He associated the dolorous mood with a disillusionment that pervaded America during the bitter winding-down of the Vietnam War. "People were understanding it was not just a mistake," he said. A few years after the exhibition, he wrote that the Vietnam War "brought to us a sudden, unambiguous knowledge of moral frailty and failure. The photographs that best memorialize the shock of that new knowledge were perhaps made halfway around the world, by Diane Arbus." For the cover of *Mirrors and Windows: American Photography since 1960,* in which those words appear, Szarkowski chose a photograph that Arbus shot in 1969 of a middle-aged man saluting a Veterans Day parade; his beige raincoat is soiled, he clutches a dark hat to his breast and his expression is one of sorrowful dignity in the face of defeat.

Reviewing the MoMA exhibition, Hilton Kramer argued that Arbus met her subjects on a common ground of empathy, with a "completely relaxed acceptance." His *Times* colleague, the pho-

tography critic A. D. Coleman, praised her "humor" and "tender-
ness." Peter Bunnell wrote that Arbus "was not a voyeur" but "a
partner" of her subjects. Robert Hughes in *Time* believed that her
photographs represent "sympathy at the end of its tether."

But there was another way of looking at the work. During her
lifetime, and increasingly after her death, some spectators main-
tained that the pictures were mean-spirited and exploitative.
Asked by an audience member at a lecture in March 1970 if she
thought her photographs were "cruel," Arbus said, "I don't think
so. I think the process is sort of cruel. I think I plug into that
cruelty a little bit." She denied that she was displaying human
specimens she found repellent. "You may say I'm telling you these
people are ugly," she said. "I'm not. *I* don't think I am. *You* may
think they're ugly." She insisted that she wasn't judging.

After she died, she could no longer respond to these charges.
Among critics of the posthumous retrospective, Susan Sontag
inflicted the heaviest and most enduring blow. She equated the
exhibition, in its consistency of vision, to Steichen's *Family of Man*,
the only difference being that instead of aiming for uplift, this
show was a "downer." By traducing hideous people who were
ignorant of their "ugliness," or by using the tricks of the cam-
era to make ordinary folks appear monstrous, Arbus excavated
pain that could embody her maimed psychological state. She
then aggressively assailed her viewers with repellent images, in a
bombardment that desensitized them to society's injustices and
limited their capacity for compassion. First published in *The New
York Review of Books* in November 1973, Sontag's essay reappeared
in a book, *On Photography*, which came out four years later. Israel
marked his copy of the chapter in three colors of ink, with vocif-
erous crosses next to the parts he found objectionable. The
paragraph that most aroused him, warranting three red X's, was
one in which Sontag suggested, "Her suicide . . . proved the pho-
tographs to have been dangerous to her." Marvin knew better.
"Diane was absolutely delighted by the people that she met," he
said after her death. "And perhaps the one thing that gave her

total enthusiasm and energy was the possibility of finding more of these people."

Lisette Model disdained Sontag's book, too. Picking up a copy that was lying in the loft of Eva Rubinstein, she thumbed through the pages and then said, "This woman, she knows everything but she understands nothing."

In what other artistic medium would a work be disparaged as too personally expressive? Photography has yet to overcome its origins (or its creation myth) as a form of documentation. For political reasons, some critics have chastised Arbus for deflecting the social goals of documentary photography to personal aims. Within that framework, this is a coherent criticism. It resembles the attacks on Bob Dylan in the midsixties, after he went electric and autobiographical and deviated from the politically progressive folk music of Woody Guthrie and Pete Seeger. Such critics bemoan the distance traveled between Lewis Hine's *A Madonna of the Tenements,* a sympathetic portrait of a poor but dignified immigrant with her two children, and Arbus's photograph, sixty-five years later, of a housewife with her dressed-up monkey.

Photography's documentary legacy also raises ethical dilemmas for any practitioner. By purveying a seemingly direct vision of "truth," the photographer invades dangerously on a subject's privacy. A sketch artist sitting surreptitiously next to Walker Evans on the subway would not have suffered the same anxieties over legal retribution. Unlike painters, photographers are required to obtain releases; in fact, after the posthumous MoMA show went up, two portraits were withdrawn because the subjects protested. One of the subtracted pictures was the print *Superstar at home, N.Y.C. 1968.* Szarkowski took it down after Viva called up and, in his telling, threatened vindictive vandalism if he refused to comply. Legally, the museum might have defied Viva, because the picture was taken with her cooperation as part of a journalistic enterprise, and it had already been published. The other case was clear-cut. The photograph depicts two girls, one sultry and beautiful, the other hapless-looking and homely, in identical trench coats in Central

Park. Most likely, Arbus had stopped the pair, asked if she could take their picture, and then left without indicating that this was anything more than a private snapshot. At the behest of lawyers, the photograph was removed not only from the show but also from subsequent editions of the monograph.

Arbus's approach could be ruthless. She possessed a great artist's unswervable determination. She sometimes misled and dissembled. But once you take the long view and regard her photographs as works of art, it matters less whether she took advantage of her subjects—either those who were deviant and deformed, or those (usually depicted more harshly) who were well-off and fatuous. No one much cares today whether Manet manipulated Victorine Meurent, who sat as his Olympia, or whether Proust maligned Robert de Montesquiou in composing the Baron de Charlus. Although the scandal stirred by the portrait of "Madame X" lingers in the historical memory, critics judging Sargent's painting don't base their verdict on whether the artist betrayed Madame Pierre Gautreau. All of these real-life figures are long dead and mostly forgotten. The fictional renditions survive. For Arbus, too, any controversy should be over the photographs, which exist independently.

The mistake is to imagine that she entirely empathized with her subjects or despised them, that she regarded these people either as soul mates or as repugnant. Like a photograph, life isn't just black and white. It comes in an infinite gradation of grays. This ambiguity allows Arbus's photographs to retain their fascination, their mystery and their unmatched capacity to generate discomfort. Her giggle in the face of calamity was a form of courage. When at the beginning of her career she imagined portraying grainy figures to achieve something universal, she might have been thinking of K. and Josef K., because, like Kafka, she wanted to create real-life parables. In her mature work, she demonstrated that a photograph could be allusive, funny, moving, intelligent and profound.

"Naturally, I like Diane Arbus' pictures," said Robert Frank,

the postwar artist who, like Arbus, reimagined the possibilities of the medium. "She's certainly had a tremendous influence on other photographers." Her impact is most significant when it is not obviously apparent. "After Diane became famous, you would see at least one portfolio a week of people who thought if you confronted a subject up against a wall with a flash that you created a Diane Arbus," Szarkowski said. But much of what distinguished an Arbus picture transpired before she clicked the shutter. To ape her formal devices marked a photographer as slavishly derivative—shameless, like an artist who dripped and poured paint on a horizontal canvas.

Yet as Jackson Pollock, style aside, demonstrated that the process of making art could become art's subject matter, so Arbus, too, altered a mind-set, steering the course of photography away from street photography and the decisive moment, into a domain of collaboration and staging that would characterize the work of Cindy Sherman, Jeff Wall, Thomas Ruff, Rineke Dijkstra, Mary Ellen Mark, Robert Mapplethorpe, Nan Goldin, Judith Joy Ross, Catherine Opie, Katy Grannan, and many other younger artists. She led the charge of photographers, which began in the early seventies, over the ramparts and into the castle of fine art. (And the market followed: In 2015, a print of *Child with a toy hand grenade in Central Park, N.Y.C. 1962,* once owned by Pati Hill, would sell at auction for $785,000.) She showed how photography could allude to myth and iconic images and also reveal truths about individuals and the present day. And she did it within the boundaries of her medium: a single frame, processed with minimal intervention in the darkroom. She ended up with art that could have been produced only by a camera, but which photography was not thought capable of achieving.

Beneath her protective veil of self-deprecation, she acknowledged that what drove her as a photographer was the awareness that she produced pictures unlike anybody else's. Contrary to common perception, the choice of odd subject matter is not what distinguished her. It was something bigger, deeper and subtler.

"I do think I have some slight corner on something about the quality of things," she said in an interview in 1968. There were times when she contemplated giving up the camera, relinquishing her subjects to others. "I mean, when I was very gloomy I thought that I could let somebody else photograph them," she said. "You know, just call some very good photographer up and say why don't you photograph this or this." But gradually she had abandoned that notion. Her take on the world was unique, and she knew it. "Although I can't defend this position," she said, "I think I maybe do it because . . . there are things that nobody would see unless I photographed them."

SOURCES AND ACKNOWLEDGMENTS

I have endeavored in this book to tell the story of Diane Arbus with the detail and clarity that she prized in her photographs. In no instance have I invented dialogue or scenes. All quotations came from someone present—either as recounted directly to me, or in a letter or conversation to one of my informants. Whenever possible, I have supplemented and corroborated these first-person reports with the testimony of other witnesses.

In 2007, the Metropolitan Museum of Art in New York received the archive of the Estate of Diane Arbus as a gift and promised gift from Arbus's daughters, Doon and Amy. The archive, which is undergoing cataloguing and conservation, is closed indefinitely to outside researchers. Along with finished prints, the holdings of Arbus's photography include approximately 7,500 contact sheets and most of the corresponding negatives. In the first stage of Arbus's independent career, she was using a 35 mm camera; typically, each of those contact sheets, constituting about 1,500 in total, contains thirty-six frames. Later, when she employed a medium-format camera, a contact sheet usually comprised twelve frames. Sometimes she marked more than one contact sheet with the same number and the letters *A* and *B,* and there are occasional gaps in the numerical sequence. In the fifteen years that she was numbering her contact sheets, she exposed more than

100,000 frames. Most of these photographs she considered not worth printing.

Because the Arbus Estate did not authorize publication of Arbus photographs in this book, I have referred in the endnotes to books in which they may be seen. Although *Revelations* contains the greatest number, there are some available only in *Diane Arbus: An Aperture Monograph*, *Diane Arbus: Magazine Work*, or *Diane Arbus: Untitled*.

Along with the photographic legacy, the Diane Arbus Archive contains the artist's journals and appointment diaries, her library, unpublished texts, and many of her letters, including those she wrote to the most important people in her life: Allan Arbus, Marvin Israel, Doon Arbus and Amy Arbus. There are also revealing letters she sent to a good friend, Carlotta Marshall, and an important body of her correspondence, from 1967 to 1971, to Peter Crookston. Copies of the letters to Crookston exist in his personal holdings, in the Patricia Bosworth Collection in the Howard Gotlieb Archival Research Center, and in my possession. Arbus's other writings in this archive are available only as excerpts published under the auspices of the Arbus Estate, primarily in *Revelations* and, to a much lesser extent, in *Magazine Work*.

The most important collections of letters by Arbus that are not in the Diane Arbus Archive were written to Alexander Eliot (often jointly to both Alex and his second wife, Jane) and to Pati Hill. The Eliot correspondence is in the Alexander Eliot Collection, now part of his estate; copies are also owned by the Arbus Archive and by me. Before his death, Eliot provided me with unpublished memoirs that recount his friendship with Arbus. Another significant body of Arbus letters is correspondence with Pati Hill. Fifteen letters and one postcard, dating from 1949 to 1968, constitute the Pati Hill Collection, which was bequeathed to me by Hill. Except for two letters, one of them transferred to Doon Arbus by Hill and therefore not part of the collection, Arbus's correspondence with Hill was not previously known. Also in my possession are unpublished manuscripts by Hill that recall her long connection

with Arbus. Duane Michals, the late Michael Flanagan and the late Tina Fredericks also furnished me with copies of unpublished correspondence from Arbus. When I have had access to original documents, I indicate if they are "reprinted" in a book; when I must rely on the printed version, I use the word "published."

There are three main records of Arbus's conversations. A taped interview made by Studs Terkel in 1968 is in the collection of the Chicago History Museum. (A short excerpt from that interview appears in Terkel's 1970 book of oral histories on the Great Depression, *Hard Times,* with Arbus identified by the pseudonym of Daisy Singer.) A recording of a talk that Arbus gave to the International Fund for Concerned Photography on March 26, 1970, is in the collection of Benedict Fernandez, who graciously allowed me access to it. The class that Arbus gave at Westbeth in February and March 1971 was taped by one of her students, Ikko Narahara. A transcript is in my possession. In addition, *Newsweek* reporter-researcher Ann Ray Martin filed a summary of an interview she conducted with Arbus as background for a story about the *New Documents* exhibition in 1967. After Arbus's death, *Newsweek* presented a copy of Martin's ten-page report to the Museum of Modern Art. Although not a tape or transcript, it constitutes a fourth record of Arbus in conversation.

Phillip Lopate kindly allowed me to use quotations from Lisette Model in the unpublished manuscript that he prepared as an introduction for the Aperture monograph on Model's work. Model reviewed his essay, softened some of her quotations, and in the end refused to authorize its publication. In some cases, which I have indicated, I have quoted Lopate's original transcriptions of Model's words, not her revisions.

For the most part, Arbus's contact sheets have not been seen by independent researchers. However, around 1980, Diana Hulick, who was at the time a graduate student at Princeton University, catalogued all of Arbus's contact sheets. She generously provided me access to her descriptive roster of the images, thus furnishing me with irreplaceable insights into the entirety of Arbus's inde-

pendent photographic career. Among other benefits, Hulick's research has allowed me to correct some misdatings of Arbus photographs. The Spencer Museum of Art of the University of Kansas holds the contact sheets of Arbus's *Esquire* work. Those images can be viewed online at the museum website. Marcella Matthaei showed me all 325 frames on the contact sheets that Arbus made in 1969 for the Matthaei family. Many of the best were suppressed from Anthony W. Lee and John Pultz's *Diane Arbus: Family Albums,* the catalogue that accompanied a traveling exhibition in 2003 that centered on this commission. Jeffrey Fraenkel and Frish Brandt of the Fraenkel Gallery allowed me to see many Arbus photographs, some of them unique prints, which I would not otherwise have known. Paul Richert-Garcia at the Robert Miller Gallery also showed me some early Arbus prints.

Although several books, in English and French, have been written about Arbus since her death, there is only one previous biography based on original research, by Patricia Bosworth in 1984. Bosworth's research materials are deposited in the Howard Gotlieb Archival Research Center at Boston University. She generously allowed me to quote from her interviews with important sources who are now dead, including Gertrude Nemerov, Howard Nemerov, Dr. Helen Boigon, Nancy Christopherson and Elbert Lenrow. Thomas Southall kindly loaned me the taped interviews he conducted while researching *Diane Arbus: Magazine Work* and permitted me to quote from them. Alisa Sparkia Moore allowed me to read and quote from the journals of her father, Roy Sparkia, and provided me with family photographs. Alexander Nemerov answered many questions, sent me a copy of a portrait of Diane in his father's possession and permitted use of his parents' writings. His brother David supplied me with photographs and memories.

Among the many friends of Diane Arbus who gave liberally of their time, I am particularly indebted to the late Pati Hill, whose phenomenal powers of recall (independently verified by me in many instances), evocative writings and trove of Arbus letters have immeasurably enriched this biography. She was an extraor-

dinary woman, and her friendship, experienced over frequent e-mails and phone calls and five visits to her home in France, enriched my life as well as my book. Her professional associate and friend Nicole Huard has also generously assisted me. I am deeply grateful to the late Alex Eliot for speaking with me many times and sharing with me both his memoirs and his letters from Diane. His children—May Eliot Paddock, Winslow Eliot and Jefferson Eliot—have been enormously helpful. Although I owe much to all the people who spoke with me, I want to give special thanks to Robert Brown, Peter Crookston, the late Michael Flanagan, Mary Frank, the late Tina Fredericks, Nancy Grossman, Zohra Lampert and Larry Shainberg.

This book was supported by a fellowship from the Dorothy and Lewis B. Cullman Center for Scholars and Writers at the New York Public Library. The camaraderie of the fellows and the assistance of the librarians, as well as the generous stipend, were all hugely helpful to the completion of my book. At the Cullman Center, I am grateful to Paul Delaverdac, Marie d'Origny, Julia Pagnamenta, Caitlin Kean and, particularly, my good friend Jean Strouse. Among the extraordinary librarians there, I owe a special debt to Clayton Kirking. Another home away from home has been the New York Institute for the Humanities, and I am grateful to Eric Banks, Stephanie Steiker and Melanie Rehak, and to the New York University librarians. At other libraries, Rick Watson of the Harry Ransom Center of the University of Texas at Austin; Jessica Ficken at the Harvard Art Museums; and Peter Trepanier, Philip Dombowsky and Cyndie Campbell of the National Gallery of Canada were especially accommodating.

Many photography curators have encouraged and helped me. I am extremely grateful to Peter Bunnell, Peter Galassi, Sandra Phillips, Elisabeth Sussman, Ann Thomas and Anne Wilkes Tucker. I am indebted also to David Benjamin, Susan Kismaric, David Little, Jane Livingston, Sarah Meister, Jeff L. Rosenheim and Joel Smith. Among museum administrators, I want to thank Annie Philbin, Betsy Ennis and Kim Mitchell.

Shelley Dowell was my invaluable guide to the legacy of Marvin Israel. Stephen Salmieri helped me understand the mechanics of medium-format cameras. He also took my author photo with a Rollei, using a flattering telephoto lens rather than the wide-angle that Arbus favored.

This project was originally proposed to me in 2003 as a *New York Times Magazine* article by Jynne Martin, who was then at Random House, and assigned as a cover story by Adam Moss. When I decided to expand that magazine piece into a full biography, my astute agent, Elyse Cheney, and her associate Alex Jacobs propelled the project forward. My editor at Dan Halpern's stalwart Ecco, Hilary Redmon, read the manuscript with a degree of sensitivity and care that I had thought existed only in a bygone golden age of publishing, making innumerable suggestions, large and small, that greatly improved the book. Her colleague Gabriella Doob was extremely solicitous and efficient. Mark Holborn, my editor at Jonathan Cape, was an eloquent advocate.

I have been guided to people I might not otherwise have interviewed by longtime friends, recent acquaintances and professional colleagues: Elisabeth Biondi, Marie Brenner, Alix Browne, Jody Bush, James Gavin, Philip Gefter, Tom Hayes, Joe E. Jeffries, Joe Lelyveld, Tom Lovcik, M. C. Marden, Larry Mark, Olivier Renaud-Clement, Andrea Schwan, Judith Stein, Carol Sternhell, Gene Stone, Annalyn Swan, Andy Tobias, and Richard Torchia. Philippa Polskin gave wise advice. Harriet Shapiro proffered enthusiastic encouragement. I have benefited from discussions with Jane Berentson, Fred Bernstein, Tim Bush, Gwen Kinkead, Tom Moore and, especially, Mark Stevens.

Helen Hershkoff gave a scrupulously close reading of the manuscript and provided sage counsel. David Hollander has been supportive in many essential ways. Wendy Lesser reviewed these pages with her customary acumen and listened to my tales of setback and triumph. To Jason Royal, who made room in our home for Diane Arbus over the last twelve years, goes my deepest gratitude.

NOTES

Memoirs, Talks and Interviews

1934 Autobiography Diane Nemerov, September 29, 1934, Autobiography. Howard Nemerov Papers, Washington University Libraries, St. Louis, MO.

1940 Autobiography Diane Nemerov, 1940 Autobiography. Howard Nemerov Papers, Washington University Libraries, St. Louis, MO.

Ann Ray Martin Ann Ray Martin interview with Diane Arbus, March 4, 1967. *Newsweek* research report.

Studs Terkel Studs Terkel interview with Diane Arbus, 1968. Chicago History Museum recording.

IFCP lecture Diane Arbus lecture, International Fund for Concerned Photography, March 26, 1970.

McQuaid/Tait Jim McQuaid and David Tait interview with Lisettte Model, 1977. Lisette Model Archive, National Gallery of Canada, Ottawa.

Westbeth class transcript Transcript of the class Arbus gave in Westbeth in February and March 1971, recorded by Ikko Narahara.

Thomas Southall recordings Taped interviews conducted by Thomas Southall in connection with *Diane Arbus: Magazine Work.*

Archives

Harold Hayes Papers Harold Hayes Papers, Special Collections, Z. Smith Reynolds Library, Wake Forest University, Winston-Salem, NC.

Nemerov Papers Howard Nemerov Papers, Washington University Libraries, St. Louis, MO.

Gotlieb Archive Patricia Bosworth Collection, Howard Gotlieb Archival Research Center, Boston University.

Lisette Model Archive Lisette Model Archive, National Gallery of Canada Library and Archives, Ottawa, Ontario.

Hubert's Museum Archive Hubert's Museum Archive, Miriam and Ira D. Wallach Division of Art, Prints and Photographs, New York Public Library.

Walker Evans Archive Walker Evans Archive, Metropolitan Museum of Art, New York.

Books by Diane Arbus

Diane Arbus: An Aperture Monograph *Diane Arbus: An Aperture Monograph.* New
 York: Aperture Foundation, 1972.
Magazine Work *Diane Arbus: Magazine Work.* New York: Aperture Foundation, 1984.
Untitled Diane Arbus, *Untitled.* New York: Aperture Foundation, 1995.
Revelations Diane Arbus, *Revelations.* New York: Random House, 2003.

Other Books

Bosworth, *Diane Arbus* Patricia Bosworth, *Diane Arbus: A Biography.* New York:
 Alfred A. Knopf, 1984.
Fictive Life Howard Nemerov, *Journal of the Fictive Life.* New Brunswick, NJ:
 Rutgers University Press, 1965.
Collected Poems *The Collected Poems of Howard Nemerov.* Chicago: University of
 Chicago Press, 1977.

Name Abbreviations

AA	Allan Arbus
AE	Alexander Eliot
DA	Diane Arbus
DN	Diane Nemerov (before marriage to Allan Arbus)
GN	Gertrude Nemerov
HN	Howard Nemerov
MI	Marvin Israel
PB	Patricia Bosworth
PC	Peter Crookston
PH	Pati Hill
RS	Renee Nemerov Sparkia Brown

Chapter 1: The Decisive Moment

3 *"I can't do it anymore" . . . "pin the dress"* AL interview with AA, New
 York, NY, August 14, 2003.
 "Boy" and "Girl" AL phone interview with Robert Brown, August 13,
 2003; AL interview with PH, Sens, France, January 23, 2011.
4 *"bag lady"* AL interview with AA, New York, NY, August 14, 2003.
 "hate fashion photography" Ann Ray Martin.
 "love secrets" Ibid.
5 **slink along the sidelines** AL phone interview with Dolores Hawkins
 Phelps, May 2, 2012.
 "Allan was stunned" AL phone interview with Robert Brown,
 August 19, 2003.

Chapter 2: Stage-Set French

7 *"hard, sad"* 1940 Autobiography, reprinted in *Revelations,* 127.
 "outside world" Studs Terkel. "I stood there with my governess on the
 rim looking down at it," she said a year earlier. "So now I think I use my
 photography to be all those ten thousand other things. I do it in order
 not to be exempt or immune." Ann Ray Martin.
8 **twilight gloom** *Fictive Life,* 90.
 reproduction eighteenth-century Studs Terkel.
 Chinese wallpaper AL interview with RS. Ventura, CA, March 3, 2011.
 bookmaker earnings Bosworth, *Diane Arbus,* 3.
 relocate to a longed-for Fifth Avenue "F. Russek Is Dead, Store Official,
 73," *New York Times,* December 11, 1948, 15.

8 *devoutly pious man* "Meyer Nemerov, Jewish Leader, 76," *New York Times,* November 20, 1939, 19.
 "my father and his religion" *Fictive Life,* 165.
9 *twenty-one weeks later* Ibid., 84. Gertrude Russek and David Nemerov wed on October 5, 1919. "Nemerov-Russek," *New York Times,* October 6, 1919, 17. Howard was born on February 29, 1920.
 Russeks enterprise continued "F. Russek Is Dead, Store Official, 73," *New York Times,* December 11, 1948, 15.
 David Nemerov also progressed "David Nemerov of Russeks Dies," *New York Times,* May 24, 1963, 26.
 first New York merchants "Spring Fever from France Grips U.S. Fashion World," *New York Times,* March 18, 1960, 28; Sharon Zukin, *Point of Purchase: How Shopping Changed American Culture* (New York/London: Routledge, 2004), 131.
 were taken along *Revelations,* 123. 1934 Autobiography, 5–6.
 Mrs. Nemerov typically . . . "I wonder where" AL interview with RS, Ventura, CA, March 1, 2011.
10 *named for the leading character* Doon Arbus, "Diane Arbus: Photographer," *Ms.,* October 1972, 52. The play opened on Broadway at the Booth Theatre on October 30, 1922, and ran for 683 performances; Ken Bloom, *Broadway: Its History, People and Places, An Encyclopedia* (New York and London: Routledge, 2004), 76; Austin Strong, *Seventh Heaven* (New York: Samuel French, 1922).
 "front would have to be maintained" Studs Terkel.
11 *Howard used the tickets* AL interview with Hope Greer Eisenman, July 2, 2011.
 "terribly artificial" AL interview with RS, Ventura, CA, March 2, 2011.
 "very scathing" AL interview with Frederick Eberstadt, New York, NY, February 1, 2011.
 "a sad person" AL interview with PH, Sens, France, January 20, 2011.
 "clung to me . . . never confided" PB interview with GN, St. Louis, MO, June–July 1979, Gotlieb Archive.
12 *grocery and shopping lists* Entry in Roy Sparkia Journal, November 1, 1952. Alisa Sparkia Moore Collection. In addition to describing what he has been told about Gertrude's depression and her response to the psychiatrist's questions, Sparkia describes her tearing up lists. He also relates Gertrude's refusal to sip a drop of alcohol to her "fear of uninhibiting herself." Gertrude Nemerov talked about the psychiatrist in Bosworth, *Diane Arbus,* 36–37.
 awkwardness of cutting back Studs Terkel.
 "Mr. Nemeroff" Transcript quoted in Defendant-Appellant's Brief, submitted in *People v. Jelke,* 1 N.Y. 2d 321 (1956), in Julian Jawitz, "The People of the State of New York Against Minor F. Jelke," 215, available at https://books.google.com/books?id=yo2V3kMLhOUC&dq=minot+f.+jelke&source=gbs_navlinks_s.
 no one else had noticed DA to HN, n.d. [c. November 1965]. Nemerov Papers. For the dating of this letter, see *Revelations,* 336 n. 232. The scandal is discussed in *Fictive Life,* 92, 98.
 "loathsome movie" Studs Terkel.
 "bowed slightly . . . mockeries" DA to MI, March 4, 1960, reprinted in *Revelations,* 124.
 leering The main floor of Russeks housed "the leeringest manikins ever." Ibid. Douglas Prince recalled her saying at a lecture at the University of Florida in June 1969 that the mannequins at Russeks

would appear to become animated when she visited. AL phone
interview with Douglas Prince, April 9, 2013.

12 *"never felt adversity"* Studs Terkel.

13 *"trickster"* . . . *bravery* DA to AE and Jane Winslow Knapp, Paris,
August 8, [1951], Alexander Eliot Collection.

Chapter 3: Them Against the World

15 *three cents* PB interview with HN, July 21, 1979, Gotlieb Archive.
"illusory future" Studs Terkel.
sucking his thumb PB interview with HN, July 21, 1979, Gotlieb
Archive.

16 *"I have a cold"* *Fictive Life*, 69.
A Tale of Two Cities PB interview with HN, July 21, 1979, Gotlieb
Archive.
white scar *Fictive Life*, 74. Diane refers to the injury—she writes "I cut
myself with a china doll"—in her 1934 Autobiography.
"against the world" AL interview with RS, Ventura, CA, March 1, 2011.
"faraway expression" PB interview with GN, St. Louis, MO, June–July,
1979, Gotlieb Archive.
"very arrogant" PB interview with Victor D'Amico, July 29, [n.y.],
Gotlieb Archive.

17 *"exceptionally brilliant"* PB interview with Elbert Lenrow, n.d. Gotlieb
Archive.
"more original and striking" PB interview with HN, July 5, 1978, Gotlieb
Archive.
"peeking around in the hall" AL phone interview with Hope Greer
Eisenman, July 2, 2011.
a nonlinear thinker Studs Terkel.
his father caught him *Fictive Life*, 138.

18 *experimented sexually* Ibid., 79.
indulged in their secret PB interview with RS, Traverse City, MI, March
12–14, 1979, Gotlieb Archive.
little gold replica Unpublished manuscript by Alexander Eliot. Howard
Nemerov refers to this ashtray in *Fictive Life*, 85, 90, 169.
"An Old Picture" "An Old Picture" in *Collected Poems*, 129–30. He writes
about "betrothed royalties" in *Fictive Life*, 77–78, where he asserts that
he had not realized the connection to this painting while he was writing
the poem.

19 *last went to bed with him* PB interview with Dr. Helen Boigon, New
York, NY, August 13, 1981, Gotlieb Archive.

Chapter 4: Mysterious, but Not Blurry

21 *portrait of a mother* . . . *"representational"* AL phone interview with
Stewart Stern, August 11, 2003.

22 *"inanimate objects"* PB interview with Victor D'Amico, July 29, [n.y.],
Gotlieb Archive.
cigarette break PB interview with Phyllis Carton Contini, April 15, 1980,
Gotlieb Archive.
Russeks' illustrator Bosworth, *Diane Arbus*, 33.
"highly individual" *Revelations*, 126.
"horrible thing" . . . *squishy* 1940 Autobiography.

23 *more fundamentally* "She was painting in high school and she became
very disgusted with it, because as soon as she finished something, she'd
show it and they'd say, 'Oh, Diane, it's marvelous, it's marvelous.' She

said somewhere, 'If it's that easy, it can't be any good.'" AL interview with AA, New York, NY, August 14, 2003.

23 ***wasn't worth doing*** Studs Terkel.

 ashamed . . . "hot and frightened" 1940 Autobiography.

 window ledge Marvin Israel, "Diane Arbus," *Infinity* 21 (November 1972): 8.

 "I like danger" Ann Ray Martin.

24 ***exhibitionists*** Studs Terkel.

 Western classics Elbert Lenrow to Catherine Lord, October 31, 1977. Nemerov Papers. The excerpts from Diane's papers are included in this letter.

25 ***"nothing blurry"*** AL phone interview with Stewart Stern, August 11, 2003. Renee Nemerov Sparkia Brown also thought Diane was "stiff and not comfortable, awkward and tense as a dancer." AL interview with RS, Ventura, CA, March 3, 2011.

 placed an ashtray AL interview with RS, Ventura, CA, March 2, 2011.

26 ***exchange confessions of unhappiness*** 1940 Autobiography.

27 ***"doesn't paint as well"*** DN to AE, November 12, 1938, Alexander Eliot Collection. A slightly abridged version appears in *Revelations,* 126.

 "Vegetable, you're Mineral" Catalogue Note, Property from the Collection of Alexander Eliot and Jane Winslow Eliot, Lot 169, Sotheby's, Photography Auction, 2005. See also the slightly different wording in Alexander Eliot, "Looking Again Through Dark, Avid Lens of Diane Arbus," *Washington Times,* January 3, 2004. The painting is reproduced in *Revelations,* 126.

Chapter 5: Enter Allan

29 ***through his uncle Max Weinstein*** AL interview with AA, New York, NY, August 14, 2003; Catherine Lord, "What Becomes a Legend Most: The Short, Sad Career of Diane Arbus" in Richard Bolton, *The Contest of Meaning: Critical Histories of Photography* (Cambridge, MA: MIT Press, 1989), 112; "Max Weinstein, 71, Russeks Head, Dies," *New York Times,* February 1, 1950, 29; "Mrs. Max Weinstein, Aide of Hospital, 73," *New York Times,* April 13, 1958, 83.

30 ***"Mister Nobody"*** AL interview with AA, New York, NY, August 14, 2003.

 "Allan always looked like Howard" PB interview with Rick Fredericks, May 5, 1980, Gotlieb Archive.

 "tremendous allies" *Revelations,* 126.

31 ***"touch each other"*** AL interview with RS, Ventura, CA, March 2, 2011.

 "virgin vessel" AL phone interview with Stewart Stern, August 11, 2003.

 went to college Elbert Lenrow to Catherine Lord, October 31, 1977, Nemerov Papers.

 her Fieldston yearbook *Revelations,* 126.

 "To-day the clouds" "Ben Jonson Entertains a Man from Stratford" in Edward Arlington Robinson, *The Man Against the Sky: A Book of Poems* (New York: Macmillan, 1916), 61–62.

32 ***Allan once told*** Bosworth, *Diane Arbus,* 46.

Chapter 6: A Friendly-Looking Beard

33 ***Alex Eliot removed*** Alexander Eliot, "The Mythic Adventure," unpublished manuscript, 181.

 engraved inscription *Revelations,* 128.

 in place of an engagement ring Except where stated otherwise, this account is based on an unpublished memoir by Alexander Eliot, which includes all of the quoted dialogue.

33 *"wide green eyes"* Alexander Eliot, "Looking Again Through Dark, Avid Lens of Diane Arbus," *Washington Times,* January 3, 2004.

34 *"posing for you"* AL phone interview with AE, March 9, 2011.

Chapter 7: Weddings

39 *piece of the same carpet* Bosworth, *Diane Arbus,* 43.

40 *"I'm nothing"* AL phone interview with AE, March 17, 2011.

 "Allan is bad enough" Ibid., March 15, 2011.

 "close as brothers" Bosworth, *Diane Arbus,* 46.

 desperately in love Ibid., 45.

 "He is good" DA to AE, "Tuesday, 6:30 p.m." n.d. [c. early 1939], Alexander Eliot Collection.

 announced the engagement "Engaged to Wed," *New York Times,* March 4, 1941, 26.

41 *"did something wrong"* 1940 Autobiography.

 if it was evil Bosworth, *Diane Arbus,* 53. AL phone interview with AE, October 6, 2013.

 "I had the feeling" Elbert Lenrow to Catherine Lord, October 31, 1977, Nemerov Papers.

 Perturbed, the teacher "I had hoped that her successes with both family and profession had given her such support and assurance as she may have needed in resolving her conflicts. (You may remember that you and I had talked of Diane's problems back in 1940.)" Elbert Lenrow to HN, October 11, 1971, Nemerov Papers.

 at the beachfront estate Alexander Eliot, "The Poetry of Life Itself," unpublished manuscript, 161.

 story of her broken engagement Ian Hamilton, *Robert Lowell: A Biography* (New York: Random House, 1982), 30–32, 39–41, 49–50.

42 *"both on the rebound"* AL phone interview with AE, October 11, 2011.

 Anne was too depressed Ibid., October 6, 2013.

 three-week honeymoon *Revelations,* 129.

43 *first night* AL phone interview with AE, March 9, 2011.

 peck on the cheek Bosworth, *Diane Arbus,* 54.

 four legs Ibid., 55. AL phone interview with AE, October 6, 2013.

 walk-up apartment The address was 325 East 37th Street, New York City Telephone Directory, Manhattan White Pages. December 1941–June 1942.

 "hateful to me" AL phone interview with AE, October 6, 2013.

 "used to meet" *Revelations,* 129.

44 *"good wife to Allan"* AL interview with AE, Venice, CA, August 24, 2010.

Chapter 8: Living, Breathing Photography

45 *Graflex* *Revelations,* 129. "You are a painter and you don't want to paint anymore," he said. "This will be more useful to you than a race car." Violaine Binet, *Diane Arbus* (Paris: Bernard Grasset, 2009), 59.

 on holiday . . . view camera *Revelations,* 129.

 "living, breathing" AL interview with AA, New York, NY, August 14, 2003.

46 *"flash of recognition"* Berenice Abbott, *The World of Atget* (New York: Horizon Press, 1964), viii.

47 *since 1939* "Rent Apartments over a Wide Area," *New York Times,* August 7, 1939, 31.

 "As I was looking" AL interview with AA, New York, NY, August 14, 2003.

 "quite a shine" Ibid.

 admired Cartier-Bresson Ibid.

47 *"Diane's father was so great"* Ibid.
48 *"paces up and down"* PB interview with HN, St. Louis, July 5, 1978,
 Gotlieb Archive.
 "the apple of his eye" Studs Terkel.
 "I was wary" AL phone interview with Alvin Eisenman, July 8, 2011.
 "very secretive" AL phone interview with Hope Greer Eisenman,
 July 2, 2011.
49 *"what the human eye observes"* Berenice Abbott, *A Guide to Better
 Photography* (New York: Crown, 1941), 59.
 a whale washed up AL telephone interview with Hope Greer
 Eisenman, July 2, 2011.
 a small apartment in the East Fifties *Revelations*, 130.
 simple ceiling fixture *Room with lamp and light fixture, N.Y.C. 1944*,
 reproduced in *Revelations*, 19.
50 *"picture has a good 'composition'"* Abbott, *A Guide*, 92–93.

Chapter 9: Floating Weightless and Brilliant

51 *at Julius'* PH e-mail to AL, July 8, 2011.
 at the Tenth Street Studio AL interview with Pam Barkentin Blackburn,
 Westport, CT, April 27, 2012.
 chain-smoking Pam Barkentin Blackburn e-mail to AL, April 20, 2012.
 votive candles Pati Hill, "Top Dogs," unpublished manuscript. This
 is the source for the account in this chapter of the early friendship of
 Arbus and Hill, unless otherwise noted.
53 *"questions she asked"* AL interview with PH, Sens, France,
 January 20, 2011.
 "rearranging their words" Pati Hill, "Fear of Not Dying," unpublished
 manuscript.
 "happen spontaneously" PH e-mail to AL, July 28, 2010.
54 *"very career always"* Ibid., July 21, 2011.
 she admired the scarlet walls Ibid., July 12, 2011.
 part of her destiny AL interview with PH, Sens, France, January 20, 2011.
55 *"I've told you everything"* Ibid., January 21, 2011.
 "She saw in me" Ibid., January 20, 2011.
 "thinking, doing, saying" DA to AE and Jane Winslow Knapp, n.d.
 [c. late May 1951], Alexander Eliot Collection, reprinted in part in
 Revelations, 130.
56 *"most prying person"* AL interview with PH, Sens, France, January 24,
 2011.
 "bunch of briars" Ibid., January 22, 2011.
 "to be pejorative" Ibid., January 20, 2011.
 made love Ibid., February 2, 2014.
 "that word 'seductive'" Ibid., January 21, 2011. See also Israel, "Diane
 Arbus," *Infinity*, 8.

Chapter 10: Doon Is Born

57 *confronted and raped* AL phone interview with Alisa Sparkia Moore,
 January 9, 2014.
 cuddled and mothered AL interview with RS, Ventura, CA, March 1,
 2011.
58 *keep it as their secret* AL phone interview with Alisa Sparkia Moore,
 January 9, 2014.
 wallet-size photograph Alexander Nemerov e-mails to AL, August
 23 and September 9, 2011; December 4 and 5, 2015. Although it is

possible that Howard had a different portrait of Diane with him when he flew, this is by far the most likely.

58 *wrote a poem* "The Photograph of a Girl" was included in Howard Nemerov's first published collection of poems, *The Image and the Law,* in 1947, and is reprinted in *Collected Poems,* 42–43.

Howard's ideal Alexander Nemerov e-mails to AL, August 23 and September 9, 2011.

"not nearly as quiet" Peggy Russell Nemerov to HN, March 29, 1945, Nemerov Papers.

59 *"not talk easily"* PB interview with Peggy Russell Nemerov, St. Louis, MO, July 20–23, 1979, Gotlieb Archive. Renee also said that Diane did not want the pregnancy. PB interview with RS, n.d., Gotlieb Archive.

photograph that she mailed *Self-portrait pregnant, N.Y.C. 1945,* published in *Revelations,* 15.

doctor had instructed PB interview with Peggy Russell Nemerov, St. Louis, MO, July 20–23, 1979, Gotlieb Archive.

"That Peter Pan collar" AL interview with PH, Sens, France, January 21, 2011.

"played at submission" Pati Hill, "Back, Now, to Then," unpublished manuscript.

sexually seductive Rick Fredericks, for example, said, "She was a great one for batting her eyes at men and she could be very seductive— whispering to you almost conspiratorially in her little-girl voice." Bosworth, *Diane Arbus,* 73.

conscious of the image Studs Terkel.

60 *modeled in the nude* Bosworth, *Diane Arbus,* 76.

went into labor The source for this account is Peggy Russell Nemerov to HN, April 3, 1945, Alexander Nemerov Collection.

"love our lack of connection" DA to Alfred Stieglitz, April 8, 1945, Alfred Stieglitz/Georgia O'Keefe Archive, Beinecke Rare Book and Manuscript Library, Yale University Library. The letter was first located and published by Joel Smith, "Diane Arbus to Alfred Stieglitz," *History of Photography* 20 (Winter 1996): 338–39. It is quoted in *Revelations,* 130.

61 *frequenting his gallery* The visits took place "before and after the war— and during, briefly." AL interview with AA, New York, NY, August 14, 2003.

bower of enchantment Bosworth, *Diane Arbus,* 59. The source for this anecdote was Patricia Bosworth's interview with a Fieldston friend, Phyllis Carton Contini, on April 15, 1980, Gotlieb Archive.

"funny subliminal thing" Westbeth class transcript, 27.

too small-breasted AL interview with RS, Ventura, CA, March 2, 2011.

62 *"under such pressure"* Bosworth, *Diane Arbus,* 61, has a slightly different version. I have relied on Patricia Bosworth's notes from her interview with Peggy Russell Nemerov, July 20–23, 1979, Gotlieb Archive.

Chapter 11: Mr. and Mrs. Inc.

63 *"Walk very slowly"* AL interview with PH, Sens, France, January 20, 2011.

before finding an apartment *Revelations,* 130.

David Nemerov also agreed Ibid., 131.

64 *photographer William Klein* Jane Livingston, *The New York School: Photographs 1936–1963* (New York: Stewart, Tabori & Chang, 1992), 313.

on contract for **Vogue** Martin Harrison, "Introduction," *Shots of Style:*

Great Fashion Photographs Chosen by David Bailey, ed. David Bailey (London: Victoria and Albert Museum, 1985), 45.

64 *drop off portfolios* AL interview with Tina Fredericks, East Hampton, NY, March 23, 2011.

 only twelve . . . Liberman Isabel Carmichael, "Designing, Selling, Building," *East Hampton Star*, November 5, 2009; "Tina Fredericks, 93," *East Hampton Star*, May 14, 2015.

65 *Warhol* AL interview with Tina Fredericks, East Hampton, NY, March 23, 2011; Bob Colacello, *Holy Terror: Andy Warhol Close Up* (New York: HarperCollins, 1990), 22.

 "became a zealot" "Mr. and Mrs. Inc," *Glamour*, April 1947, 170.

 "very fun" AL phone interview with Tina Fredericks, August 20, 2003.

 "Diane was the only one" AL interview with AA, New York, NY, August 14, 2003.

 six-page portfolio AL interview with Tina Fredericks, East Hampton, NY, March 23, 2011; "Fair and Cooler: $20 Below," *Glamour*, June 1947, 84–89.

66 *furled newspaper* "About the Size of It," *Glamour*, February 1949, 118.

 art nouveau staircase "Switzerland," *Glamour*, March 1948, 120.

 striped façade "Black for Now for Later on For Always," *Glamour*, July 1947, 36–37.

 rows of telephone booths "What Makes a Woman Smart?" *Glamour*, February 1950, 84–87; "Translated from the Greek," *Glamour*, January 1950, 67, 71.

 old-fashioned photographer's "A Picture in Your Graduation," *Glamour*, May 1948, 104–7; "Who Makes a Man Well-Dressed . . . Usually a Woman," *Glamour*, February 1948, 68–69; "The Love Letter Dress," *Glamour*, February 1948, 89.

67 *first* **Vogue** *pictures* "People and Ideas," *Vogue*, October 1, 1948, 184–87.

 cross-country album "Fashion: Cross-Country Album," *Vogue*, February 1, 1949, 194–97, 226.

 Christmas gift "Fashion: 27 More Christmas Ideas," *Vogue*, November 15, 1950, 120–25.

68 *"fundamental mistake"* AL interview with AA, New York, NY, August 14, 2003.

69 *"Was it false"* AL interview with PH, Sens, France, January 20, 2011.

 "acted-out devotion . . . just walk out" PH e-mail to AL, September 28, 2011.

 reason they hired her AL interview with PH, Sens, France, January 21, 2011.

 "desperately, to make use of life" DA to AE and Jane Winslow Knapp, July 26, [1951], Alexander Eliot Collection; a shorter version is published in *Revelations*, 131.

Chapter 12: A Mystical Friendship

71 *sequence of rooms* This description of the house comes from Anaïs Nin, "A Child Born out of the Fog," (New York: Gemor Press, [1947]) and AL interviews with PH, Sens, France, January 20 and 22, 2011.

 a visitor recognized AL interview with PH, Sens, France, January 22. 2011.

72 *expectant mother . . . father taught* AL phone interview with Jeanne Christopherson, February 18, 2011.

 Nin's telling Nin, "A Child." In the story, which was self-published as a chap-book, Nancy is called Sarah and the daughter's name is misspelled

as "Pony," but the other details conform to the version Nancy related to her niece, Jeanne Christopherson, and to the account in *The Diary of Anais Nin, Vol. 4* (New York: Harvest Books, 1983), 141, 144–45.

72　　*black boy excluded*　AL phone interview with Jean Rigg, August 2, 2011.

73　　*equal partnership*　AL phone interview with Jeanne Christopherson, February 18, 2011.

　　　"loved the looks"　AL interview with PH, Sens, France, January 21, 2011.

　　　"negative space"　AL interview with Charles Atlas, New York, NY, July 27, 2011.

　　　"one of those gods"　AL phone interview with Jean Rigg, August 2, 2011.

　　　"I could tolerate her"　AL interview with PH, Sens, France, January 21, 2011.

74　　*"Diane was fascinated . . . fakery nor reality"*　Ibid., January 22, 2011.

　　　"extraordinary presence"　PB interview with Nancy Christopherson, New York, NY, March 6, 1979, Gotlieb Archive. A briefer account appears in *Revelations*, 131. Bosworth, *Diane Arbus*, 77, describes this episode, with different details, and the pseudonym "Cheech McKensie" for Christopherson.

75　　*"lived partly in her head"*　AL interview with PH, Sens, France, January 22, 2011.

　　　the I Ching　AL phone interview with Jean Rigg, August 2, 2011; AL interview with Charles Atlas, New York, NY, July 27, 2011.

76　　*"most critical person"*　AL phone interview with AE, June 20, 2011.

　　　"that fiend"　AA to AE and Jane Winslow Knapp, December 18, [1951], Alexander Eliot Collection.

　　　"who cannot distinguish"　*Revelations*, 143.

Chapter 13: A Long-Awaited Consummation

77　　*"horrible shape" . . . crabs*　DA and AA to Tina and Rick Fredericks, n.d. [summer 1948], Tina Fredericks Collection.

78　　*Houdini's techniques*　AL phone interview with May Eliot Paddock, March 20, 2011.

　　　"one rests . . . awful pain"　DA and AA to Tina and Rick Fredericks, n.d. [summer 1948], Tina Fredericks Collection.

　　　stray mutt　Westbeth class transcript, 19.

79　　*empty bottle of pills*　AL phone interview with AE, October 11, 2011.

　　　when soused　AL phone interview with May Eliot Paddock, March 20, 2011.

　　　foursome took a car trip　PH e-mail to AL, October 14, 2011.

　　　"underrated beverage"　AL phone interview with Carlotta Marshall, August 8, 2003.

　　　"what matters love?"　DA to PH, October 12, [1949], Pati Hill Collection.

80　　*self-portrait, pregnant*　Eliot sold a print of this image at Sotheby's, November 10, 1986, Lot 295. The photograph was dated February 1945 by Arbus.

　　　photograph that Allan had taken　Eliot sold two prints of this image at auction: Sotheby's, November 10, 1986, Lot 295; and Sotheby's, April 27, 2005, Lot 170. Eliot dates the photograph as 1944. Allan Arbus was shipped overseas in the summer of that year.

　　　"love to make Howard happy"　Alexander Eliot, unpublished memoir, Alexander Eliot Collection.

　　　sardonic artist . . . no more than smile　DA to PH, n.d. [posted September 7, 1949], Pati Hill Collection.

　　　"about a boy"　Pati Hill journals, October 22, 1951, Pati Hill Collection.

81 *Alex read a chapter . . . took the news calmly* Bosworth, *Diane Arbus,*
 82–83; DA to PH, October 12, [1949], Pati Hill Collection.
 homosexual affair AL phone interview with AE, June 7, 2012; AL
 interview with Zohra Lampert, New York, NY, June 12, 2015.

82 *Anne could not forgive* AL phone interview with May Eliot Paddock,
 March 20, 2011.
 "almost no guilt" DA to PH, October 27, [1949], Pati Hill Collection.
 entered psychoanalysis He began analysis on about September 30, 1949.
 DA to PH, October 27, [1949], Pati Hill Collection.
 "the tellings" DA to PH, October 27, [1949], Pati Hill Collection.
 "sick of my own dullness" Ibid., October 12, [1949].
 "Utter inarticulateness" Ibid., October 27, [1949].

83 *two-sided photograph* Sotheby's, November 10, 1986, Lot 297. AL
 phone interview with AE, September 22, 2013. Although the catalogue
 identifies Diane as the photographer of the portrait of Anne, Eliot said
 that Allan later informed him that he, not Diane, took it.
 Time *sent him* Pati Hill, "Alex in Wonderland," unpublished
 manuscript, Pati Hill Collection. Although Hill in this memoir dates the
 episode in September, it may have occurred in early October.
 accosted Picasso . . . "looking ahead" Pati Hill journals, October 14,
 1949, Pati Hill Collection.

84 *"obvious cure"* AE to PH, n.d. [late October or early November 1949],
 Pati Hill Collection.

Chapter 14: Central Park Prophecy

85 *"just like a cowboy movie"* Except where noted, the source in this
 chapter is unpublished manuscripts in the Pati Hill Collection.

86 *another woman . . . Rockefeller Center* Alexander Eliot, "The Poetry of
 Life Itself," unpublished memoir, Alexander Eliot Collection.

87 *"'Paul Jones' mixer"* Arbus raised the idea in DA to PH, October 12,
 [1949]. She described how Hill, after waiting almost a year to write
 back, was "throwing back that Paul Jones thing at me . . . just as it was
 more pertinent and painful" than it would have been previously, in DA
 to PH, July 18 (?), [1950], Pati Hill Collection.

Chapter 15: Out the Prison Door

93 *wedding on skis* *Life,* February 10, 1947, 35–36, 38.
 Auden poems Pati Hill, "Polar Bear World bis," unpublished
 manuscript.

94 *"You should be here"* DA to PH, n.d. [mid-August 1950], Pati Hill
 Collection. This letter contains the list of guests.
 "how utterly I have lost" DA to AE and Jane Winslow Knapp, August 8,
 [1951], Alexander Eliot Collection.
 "vaguely separated" Pati Hill journals, November 30, 1949, Pati Hill
 Collection.
 soon move . . . visited her there on weekends AL interview with PH, Sens,
 France, January 23, 2011.
 "enormously complex" DA to AE, n.d. [spring 1951], Alexander Eliot
 Collection, reprinted in *Revelations,* 130.
 "terrifying tyrannical" . . . "open and willing" DA to AE and Jane
 Winslow Knapp, n.d. [c. late May 1951], Alexander Eliot Collection.
 "Im curious to know" DA to PH, n.d. [September 7, 1949], Pati Hill
 Collection.

95 *should go to bed* Ibid., October 27, [1949].

95 *"trying to get the rest of Diane"* Robert Meservey to PH, n.d. [1950], Pati Hill Collection.
 "so disgusting" DA to PH, October 12, [1949], Pati Hill Collection.
 "really running away" *Revelations,* 134.
 camera store and psychoanalyst AA to AE and Jane Winslow Knapp, December 18, [1951], Alexander Eliot Collection.
 six weeks working AE to Elisabeth Sussman, "First day of spring," [March 20], 2002, Alexander Eliot Collection.

96 **difficult to talk to** AL interview with AE and Jane Winslow Eliot, Venice, CA, August 24, 2010.
 Abstraction in Photography "Abstract Photography of Many Types to Be Shown at Museum," press release, Museum of Modern Art, May 1, 1951. A typo in the press release lists the photographers as "Diana & Allan Arbus."
 angling to land AL phone interview with AE, December 6, 2011.
 Paris assignment from Tina DA to AE and Jane Winslow Knapp, June 13 [1951], Alexander Eliot Collection.
 black circles Bosworth, *Diane Arbus,* 104. Although Meservey is identified in the book as the source, according to the archival notes it was Rick Fredericks. PB interview with Rick Fredericks, May 5, 1980, Gotlieb Archive.
 "marvelously cheerful" DA to AE and Jane Winslow Knapp, n.d. [early May 1951], Alexander Eliot Collection.

97 *"an image in a mirror"* . . . *"falling in"* DA to PH, n.d. [postmarked May 17, 1951], Pati Hill Collection.
 "People were interested" AL phone interview with John Szarkowski, August 6, 2003.

98 *"true indigestibleness"* DA to AE and Jane Winslow Knapp, n.d. [c. late May, 1951], Alexander Eliot Collection, reprinted in *Revelations,* 101. (Original punctuation restored.)
 "the world seemed" Studs Terkel.
 unfamiliar with such blissful contentment PH e-mail to AL, August 14, 2011.
 asked her psychotherapist PB interview with Helen Boigon, August 13, 1981, Gotlieb Archive.
 bitten by leeches Bosworth, *Diane Arbus,* 79; PB interview with Nancy Christopherson, March 6, 1979, Gotlieb Archive.
 rarely felt anything PB interview with Helen Boigon, April 2, 1982, Gotlieb Archive.

Chapter 16: Hermitage Seductions

99 **for three months** AL interview with PH, Sens, France, January 21, 2011.
 "What does it feel like" Ibid., January 20, 2011.
 sporting an outfit Pati Hill, "*Le Dejeuner sur l'Herbe,*" unpublished manuscript. This is the source of the dialogue in this chapter.

100 **Doon reluctantly contributed** AL interview with PH, Sens, France, January 21, 2011.
 "magical child" Ibid., January 20, 2011.
 "sullen cabbage" Pati Hill, "*Le Dejeuner sur l'Herbe,*" unpublished manuscript.
 "dear in their own element" PH to Alain de la Falaise, September 8, 1957. Pati Hill Collection. This letter was written more than six years later, when the Arbuses visited Hill in Connecticut, but in it she said "it was almost as bad as at Montacher except that this time I was able to retire to my shed."

101 *inflated with rare enthusiasm* AL interview with PH, Sens, France, January 20, 2011.
"very good for Diane" Ibid., January 21, 2011.
this character, Linda Pati Hill, *The Nine Mile Circle* (Boston: Houghton Mifflin, 1957), 129, 131.

102 *Pati pacing back and forth . . . "feel wonderful"* DA to AE and Jane Winslow Knapp, n.d. [c. late May, 1951], Alexander Eliot Collection.

103 *She confessed that she* Ibid., July 26, [1951].

104 *"Technically she is Alain's mistress"* Ibid., n.d. [early summer 1951].
Her sketch in words Ibid., July 26, [1951].

105 *"I think your book"* AA to PH, February 16, [1952], Pati Hill Collection. Hill's pleased reaction to his comments is in *"Le Dejeuner sur l'Herbe,"* unpublished manuscript.

Chapter 17: A Spanish Impasse

107 *"rich and bitter"* DA to AE and Jane Winslow Knapp, n.d. [c. late May, 1951], Alexander Eliot Collection.

108 *"too remote, flat"* Ibid., June 13, [1951].
"bigger and bigger" Ibid.

109 *"separately embittered" . . . to bed with Jane's fiancé* Ibid.

110 *"I get very empty"* Ibid.
top of the Eiffel Tower Ibid., [July] 24, [1951].
details of the chapel Ibid., July 26, [1951].

111 *learned from Tina Fredericks* Ibid., June 13, [1951].
"crazily familiar" Ibid., July 26, [1951]. Diane is reporting in her own words both her and Allan's impressions.
even more "nightmarish" DA and AA to AE and Jane Winslow Knapp, August 8, [1951], Alexander Eliot Collection.
"dammed up" DA to AE and Jane Winslow Knapp, [September] 30, [1951], Alexander Eliot Collection.

112 *She wasn't pregnant* Ibid., August 8, [1951].
"where the edges" Ibid., March 10, [1952]; ellipsis in the original.
continuous loop played DA and AA to AE and Jane Winslow Knapp, December 18, [1951], Alexander Eliot Collection.
six art pieces AL phone interview with AE, December 6, 2011.
"dumbstruck" DA and AA to AE and Jane Winslow Knapp, August 8, [1951], Alexander Eliot Collection.

113 *"so very peace-full" . . . "I always do"* DA to AE and Jane Winslow Knapp, July 26, [1951], Alexander Eliot Collection.

Chapter 18: Italian Street Photographer

115 *soaking her feet* DA and AA to AE and Jane Winslow Knapp, December 18, [1951], Alexander Eliot Collection.
"cosy, anonymous" DA to PH, January 11, [1952], Pati Hill Collection. The month in Florence is mentioned in *Revelations,* 135, and in DA to AE and Jane Winslow Knapp, [September] 30, [1951], Alexander Eliot Collection.
passed through Rome DA and AA to AE and Jane Winslow Knapp, December 18, [1951], Alexander Eliot Collection.

116 *"a little dampened"* DA to AE and Jane Winslow Knapp, [September] 30, [1951], Alexander Eliot Collection.
Vogue *assignments* DA to GN and Rose Russek, January 27, 1952, reprinted in *Revelations,* 136.
picturesque place DA to AE and Jane Winslow Knapp, [September] 30, [1951], Alexander Eliot Collection.

117 *balletic movements* AL phone interview with AE, December 6, 2011.
 immobile and timeless See the photographs reproduced in *Revelations*,
 134–36.
 "funnyugly misshapen thought" DA and AA to AE and Jane Winslow
 Knapp, December 18, [1951], Alexander Eliot Collection.
118 *"flexing the muscles"* DA to PH, January 11, [1952], Pati Hill Collection.
 war photographers Jeff L. Rosenheim, *Photography and the American Civil
 War* (New Haven, CT: Yale University Press, 2013), 96–97. Susan Sontag
 related the posing in the studio and the composition on the battlefield
 in *Regarding the Pain of Others* (New York: Picador, 2004), 53, quoted in
 Rosenheim, 98.
119 *"new vision of life"* Abbott, *A Guide*, 59, 76.
120 *at the time of the winter solstice* Hank O'Neal, *Berenice Abbott, American
 Photographer* (New York: McGraw-Hill Book Company, 1982), 4.
 notably by André Kertész "It was perhaps André Kertész who first
 demonstrated the enormous photographic richness of the street." John
 Szarkowski, *Looking at Photographs* (New York: Museum of Modern Art,
 1973), 178.
 credit himself to Martin Munkácsi Pierre Assouline, *Henri Cartier-Bresson:
 A Biography* (London: Thames & Hudson, 2005), 60–61.
 "between intention and effect" Westbeth class transcript, 4.
121 *"everything grownup"* DA to AE and Jane Winslow Knapp, August 8,
 [1951], Alexander Eliot Collection.
 young Italian nun . . . other pictures The photographs are reproduced in
 Revelations, 134–36.
122 *noticeable lack of interest* AL interview with PH, Sens, France,
 January 20, 2011.
 the "doomed" hog DA to PH, January 11, [1952], Pati Hill Collection.

Chapter 19: Modish and Empty
123 *assignment fell through* DA to PH, February 16, [1952], Pati Hill
 Collection, reprinted in *Revelations*, 136.
 eventually be published "New Kind of Collection: The Private Museum
 of Cesare Zavattini." *Vogue*, January 1, 1953, 126–27.
 only new job DA and AA to AE and Jane Winslow Knapp, March 10,
 [1952], Alexander Eliot Collection.
 "or Central Park" DA to PH, February 16, [1952], Pati Hill Collection,
 reprinted in *Revelations*, 136.
 state of dejection DA and AA to AE and Jane Winslow Knapp, March 10,
 [1952], Alexander Eliot Collection.
 "gloomy and haunted" . . . "my own imagination" DA to AE and Jane
 Winslow Knapp, [September] 30, [1951], Alexander Eliot Collection.
124 *"comfortable hugging"* DA and AA to AE and Jane Winslow Knapp,
 December 18, [1951], Alexander Eliot Collection.
 "the one thing" Ibid., March 10, [1952].
 on April 7 *Revelations*, 137; ibid.
 At first, Allan said . . . "crassly, coarsely" DA and AA to AE and Jane
 Winslow Knapp, March 10, [1952], Alexander Eliot Collection.
125 *earthy satisfactions* Ibid.
 Jane shunned . . . even Alex AL phone interview with AE, June 7, 2012.
 The configuration of the apartments was described in AL interview with
 Robert Brown, Ojai, CA, March 2, 2011.
126 *painter Alfred Leslie* AL phone interview with Alfred Leslie,
 October 21, 2015.

126 *"high note of hysteria"* . . . *"first one in a year"* DA to AE and Jane Eliot,
 May 20, [1952], Alexander Eliot Collection.
 ruined amphitheater DA and AA to AE and Jane Winslow Knapp,
 December 18, [1951], Alexander Eliot Collection.
127 **Diane would dare** Doon Arbus, "Diane Arbus: Photographer," *Ms.*,
 October 1972, 52.
 giggling with Nancy PB interview with Nancy Christopherson, New
 York, NY, March 6, 1979, Gotlieb Archive.
 "blowing up the very balloon" DA to AE and Jane Eliot, n.d. [May 1952],
 Alexander Eliot Collection.
 "undulated wearisomely" Ibid. [c. June 1952].
128 *"making $2,300 a year"* PB interview with HN, St. Louis, MO, July 21,
 1979, Gotlieb Archive.
 Diane mainly noticed DA to AE and Jane Eliot, n.d. [c. June 1952],
 Alexander Eliot Collection.
 "worshiped" Diane AL interview with RS, Ventura, CA, March 1, 2011.
 "fortune-hunting husband" Entry in Roy Sparkia journal, February 4,
 1952, Alisa Sparkia Moore Collection.
 pitching stories to **True Confessions** Ibid., November 23, 1952.
 "lived in Diane's shadow . . . *self-pampering tantrums"* Ibid., July 22,
 1953.
129 *apartment of James Goold* AL interview with Robert Brown, Ojai, CA,
 March 2, 2011. This is the source for the following account.

Chapter 20: Circus

131 *circus was coming* "Ringling Barnum Routes, 1950–1959," Circus
 Historical Society, last modified July 2009, http://www.circushistory
 .org/Routes/Ringling50.htm.
 Robert was eating AL phone interview with Robert Brown, August 13,
 2003.
132 *group of midgets* Midgets distinguished themselves from dwarfs,
 emphasizing their skills as entertainers over their sideshow
 appearances. Robert Bogdan, *Freak Show: Presenting Human Oddities for
 Amusement and Profit* (Chicago: University of Chicago Press, 1988), 175.
 a clean-cut performer T. Robinson and Russell Maloney, "The Talk of
 the Town: Ratoucheff," *The New Yorker*, January 16, 1943, 10–12.
133 *"anonymously famous"* IFCP lecture.
 preferred the word **Lilliputian** Robinson and Maloney, 10.
 Paying a call IFCP lecture.
 best photographs The best known of these pictures is *Russian midget
 friends in a living room on 100th Street, N.Y.C. 1963*. It is reproduced in
 Revelations, 100. In a caption that ran with the photograph in 1971,
 Arbus provided the information that the three friends had belonged
 to "a troupe of midgets who first came to America in 1923 with a
 circus." Time-Life Books, *The Art of Photography* (New York: Time-
 Life Books, 1971), 219. The present author is presuming that the
 two women Arbus described in her IFCP lecture are the ones in this
 picture. The building at 100th Street and Madison Avenue is part of
 a housing project.
134 *experienced a letdown* AL interview with Frederick Eberstadt, New York,
 NY, February 1, 2011; AL interview with PH, Sens, France, January 20,
 2011.
 "smaller and smaller" DA to PH, n.d. [May 1957], Pati Hill Collection.
 "sadly ailing" DA to AE and Jane Eliot, May 30, [1952], Alexander

Eliot Collection, reprinted along with the photograph of the corpse in *Revelations*, 139.

134 *"rather vulgar"* DA to Walker Evans, New York, NY, September 20, 1962, Walker Evans Archive.

135 *divided into nine apartments* http://daytoninmanhattan.blogspot .com/2010/06/house-that-scandal-built-18-east-68th.html.
"fabulous, crumbling" Entry in Roy Sparkia journal, September 21, 1957, Alisa Sparkia Moore Collection.
"acres of manicured lawn" Ibid., July 22, 1953.

136 *"what femininity constituted"* Studs Terkel.
"woman spends the first" Ann Ray Martin.

Chapter 21: Out of Fashion

137 *"technical guy"* . . . *"not vertical"* AL interview with Daniel Kramer, New York, NY, August 1, 2012.

138 *fashion photography was treacherous* Westbeth class transcript, 23.
middlebrow approach For a summary of this critique, see Fred Turner, *"The Family of Man* and the Politics of Attention in Cold War America," *Public Culture* 24 (Winter 2012): 56–57.
magazine photo-essay This criticism was made influentially by Russell Lynes, *Good Old Modern: The Museum of Modern Art* (New York: Atheneum, 1973), 325. See Turner, "The Family of Man," 60–61. One critic traces the show's genealogy to the *Ladies' Home Journal* photo-essays that photo editor John G. Morris produced in 1947 under the rubric "People Are People the World Over." Christopher Phillips, "The Judgment Seat of Photography," *October* 22 (Autumn 1982): 48 n. 49.

139 *"first serious fashion photographs"* Edward Steichen, *A Life in Photography* (New York: Doubleday, 1963), n.p.
Liberman showed Martin Harrison, *Appearances: Fashion Photography since 1945* (New York: Rizzoli, 1991), 46.
"final reduction" Steichen, *A Life.*

140 *picture was her own* AL interview with Roberta Miller, New York, NY, January 26, 2012.
appeared in **Vogue** "The Well-Built Sunday," *Vogue*, March 1, 1953, 144–45, 176. The following account relies additionally on AL interviews with Jonathan Gates, August 30, 2012, and with Ada Gates Patton, August 30, 2012, as well as e-mail from Peter Gates on September 6, 2012. The photograph appears in *The Family of Man* (New York: Museum of Modern Art, 1955), 53.

142 *relatively interesting* **Vogue** *assignments* "The Drive-in Movie—with a Young Broadway Audience," *Vogue*, February 1, 1953, 198–99; "Jimmy Brownell and His Chili Con Carne," *Vogue*, March 1, 1953, 154–55; "People Are Talking About: Jacques d'Amboise," *Vogue*, August 1, 1953, 152–53.
Mostly, however Among such assignments were "Retouching the Figure," *Vogue*, February 15, 1953, 120–24; "The Summer Figure Based on White Cotton," *Vogue*, May 1, 1953, 134–35, 150; "Vogue's 20-Page Christmas Package," *Vogue*, November 1, 1953, 124–30; "Young Choice: The Short Dancing Dress," *Vogue*, November 1, 1953, 144–45, 175; "The News—On the Dot," *Vogue*, February 1, 1954, 167–69. Although most of these are unremarkable, the Arbuses photographed the February 1, 1954, feature on dresses with dotted fabrics by having the male companions of the posing women move their heads (but not their bodies), and the exposure was long enough to render their faces

a blur. Allan had experimented in this way photographing traffic cops in Italy.

142 *"taken out and washed"* AL interview with PH, Sens, France, January 21, 2011.

Diane tearfully decided *Revelations,* 139. In this account, Diane is in tears and Allan suggests she end the collaboration and she agrees. In interviews with AL, cited in Chapter 1, both Robert Brown and Allan described the scene slightly differently.

bloomer dresses "Bloomer Girl—1956 Version," *Vogue,* May 1, 1956, 150–51.

143 *"terrifying for me"* . . . *"other things"* AL interview with AA, New York, NY, August 14, 2003.

Chapter 22: Finding Her Spot

145 *fascinated by the* **I Ching** *Revelations,* 142.

before making any decision AL phone interview with Albert Poland, February 22, 2011.

146 *hands-off approach* AL phone interview with Wendy Clarke, August 7, 2013. Clarke, who counted Poni as her best friend in the late fifties, said, "Nancy was very removed. Poni really took care of herself. Nancy did not take care of Poni. Poni had to make her own food."

beautiful Puerto Rican Pati Hill, "Back, Now, to Then," unpublished manuscript.

described the crime thriller DA to PH, July 18?, [1950], Pati Hill Collection.

147 *Nancy thought she had influenced* AL phone interview with Jean Rigg, August 2, 2011.

fascinated by the differences Pati Hill, "Fear of Not Dying," unpublished manuscript.

"photography tends to deal" Westbeth class transcript, 7.

Baby Doll *Carroll Baker on screen in "Baby Doll" (with silhouette), N.Y.C. 1966* and *Kiss from "Baby Doll," N.Y.C. 1956, Revelations,* 21, 29. Photographs of *Baby Doll,* taken in December 1956, appear as nine frames on Contact Sheet 81, Hulick Photo Roster.

148 *"her own instantaneous putrefaction"* . . . *"nightmares to beguile"* DA to Walker Evans, September 20, 1962, Walker Evans Archive.

began the numbering *Revelations,* 139.

149 *twenty-four frames* The first contact sheets from a Rolleiflex, 86A and 87, are from January 1957, with twelve exposures in each of the two sheets. She didn't use the Rollei again until Contact Sheet 1044, from March 1961, when she experimented for eight exposures of William Mack. In both instances, she might have been seeking a sharper record of the extravagant volume of objects. The Wide Angle Rolleiflex with a Zeiss Distagon lens that Arbus used was introduced in 1961. Four thousand units were produced until it was discontinued in 1967. The serial numbers run from 2490000 through 2493999. "Rolleiflex Wide Angle: Rolleiwide," http://pacificrimcamera.com/pp/rolleiflexwide .htm. Arbus's camera bears the serial number 2490579, confirming that it was issued early in the run. E-mail from Beth Saunders, curatorial assistant, Department of Photographs, Metropolitan Museum of Art, New York, NY, to AL, December 1, 2014.

Coney Island occupied Two of the best chroniclers of Coney Island among the Photo League photographers were Sid Grossman and Leon Levinstein. Some of their work is reproduced in Livingston, *The New*

York School for Grossman's sensual bodies, 8–11, 28–35; for Levinstein's monumental figures, 173, 179. A classic Weegee of the Coney Island beach mob is on page 3. A rare Arbus photograph of Coney Island appears on pages 4–5, along with another on page 225. Other Arbus photographs of Coney Island appear in *Revelations*, 56, 139, 142, 152 (related to the one published in *The New York School*, 4–5), 153 and 238. Arbus's teacher, Lisette Model, took two of the most celebrated examples of the genre of monumental Coney Island bather. For more on the Photo League, see Mason Klein and Catherine Evans, *The Radical Camera: New York's Photo League, 1936–1951* (New Haven, CT: Yale University Press, 2011).

149 **half-naked elderly women** *Women on a sundeck, Coney Island, N.Y. 1959*, *Revelations*, 56; *Coney Island bath house, Brooklyn, N.Y. 1960*, collection of the New York Public Library.

large-nosed, hirsute *Masked boy with friends, Coney Island, N.Y. 1956*, *Revelations*, 255. Contact Sheet 183, Frame 183, Hulick Photo Roster, places this circa May 1957, the information in the title notwithstanding.

boy in blackface *Kid in black-face with friend, N.Y.C. 1957*, *Revelations*, 30. Contact Sheet 322, Frame 28, Hulick Photo Roster, establishes the timing as Halloween 1957.

Chapter 23: Raincoat in Central Park

151 **Raincoat in Central Park** The account in this chapter is based on PH, "Back, Now, to Then," unpublished manuscript, and on AL interview with PH, Sens, France, January 20, 2011. The photographs appear on Contact Sheet 73, Frames 4 to 33, taken in December 1956, Hulick Photo Roster.

having divorced PH journal, September 10, 1951, Pati Hill Collection.

met him long ago PH to Alain de la Falaise, October 19, 1955, excerpted in PH journal, Pati Hill Collection.

"sail a boat" PH to Patricia Guion Hill Wichmann, August 20, 1956, excerpted in PH journal, Pati Hill Collection.

152 **"life of leisure"** Ibid., June 6, 1956.

Houghton Mifflin agreed PH journal reports on October 31, 1956, that Houghton Mifflin has bought the book.

set up house PH to Alain de la Falaise, December 11, 1956, excerpted in PH journal, Pati Hill Collection.

Pati should seduce AL interview with PH, Sens, France, January 21, 2011.

153 **sixteen years older** "Dr. Saul I. Heller, 80, Is Dead; Neurologist and Psychiatrist," *New York Times*, November 23, 1985.

pursued Pati AL interview with PH, Sens, France, February 2, 2014.

a little party Pati Hill, "Back, Now, to Then," unpublished manuscript.

medicine bottles blazed Ibid.

154 **"What about Mrs. Auchincloss"** Ibid.

Chapter 24: A Tiny Woman with a Grand Manner

157 **"calling me on the phone"** Phillip Lopate, "Portrait of Lisettte Model," unpublished manuscript, 80.

briefly in 1955 *Revelations*, 13.

drinking heavily Adrian Condon Allen, who began working with Brodovitch at *Harper's Bazaar* in 1951, said he began to "go downhill" in 1956. AL interview with Adrian Condon Allen, New York, NY, August 12, 2003. Brodovitch was fired from *Harper's Bazaar* in August 1958, partly because of his heavy drinking. Kerry William Purcell, *Alexey Brodovitch* (New York: Phaidon, 2002), 104.

158 *"instill in Arbus"* AL phone interview with Peter Bunnell, August 22, 2003.
"She didn't make a single lecture" Episode Six. Jim McQuaid and
David Tait interview with Lisettte Model, 1977. Lisette Model Archive,
National Gallery of Canada, Ottawa.
"something went wrong" David Vestal, "Lisette Model," *Popular
Photography* 86 (May 1980): 114.

159 *"You must be crazy"* Ibid. The former student was Hanns Eisler, a
composer who was at the time collaborating with Bertolt Brecht.
"Never photograph anything" Ann Thomas, *Lisette Model* (Ottawa:
National Gallery of Canada, 1990), 44.
"People didn't move" Lopate, *Portrait,* 23.
"I appeared to be" Lin Harris, "A Last Interview with Lisette Model,"
Camera Arts 3 (June 1983): 16.

160 *preferred not to speak* AL interview with Rosalind Fox Solomon, New
York, NY, January 14, 2016; Thomas, *Lisette Model,* 46.
she would approach Thomas, *Lisette Model,* 78.
she would crop it Ibid., 47.
"extreme people" Carol Squiers, "Lisette Model," *Interview,* January
1980, 37.
"my husband couldn't" Lopate, *Portrait,* 23. This is the original version.
At Model's direction, Lopate corrected it: "Evsa was not a very practical
man: though later on he taught and sold some of his paintings, on
the whole Lisette took over the burden of supporting both of them in
America."
"you must be crazy" Vestal, "Lisette Model."
Model disavowed "I am never critical," she told a journalist,
discussing these photographs. "I try to understand." Squiers, "Lisette
Model," 37.

161 *more vitriolic text* Thomas, *Lisette Model,* 50; Lise Curel, "Cote d'Azur,"
Regards 4 (February 28, 1935): n.p. Thomas's research revealed this
prior publication, about which Model did not speak.
few attempts Thomas, *Lisette Model,* 99.
"poor man's Stork Club" Weegee, *Naked City* (New York: Da Capo Press,
1973 [1945]), 138.
"rarely two figures" Lopate, *Portrait,* 38.
"grotesques" Model said, "I am looking for faces that are *not* hidden—
where everything is suddenly pushed to the surface. They are intense
and exaggerated faces. But they are not grotesques." Ibid., 55.
"When I was painting" Ibid., 52. In the manuscript, this has been
crossed out because Model objected to it.

162 **Coney Island Bather** The picture appeared in *Harper's Bazaar,* July
1941, 52, and the two versions are reproduced in Thomas, *Lisette Model,*
25, 163.
"You stupid people" Harris, "Last Interview," 92.
she tried to buy Lopate, *Portrait,* 80.
group exhibition "Exhibition of Photographs of New York City on View
at Museum," press release, Museum of Modern Art, November 27,
1957. See also *Revelations,* 141.
a card praising it DA to Lisette Model, postcard, n.d. [postmarked
September 13, 1961], Lisette Model Archive.
"Dear Lisette. . . . Diane" DA to Lisette Model, n.d. [postmarked
August 3, 1967], Lisette Model Archive.
"losing her sense" Lopate, *Portrait,* 82.
Evsa believed Ibid., 83.

163 *Model sought those* In a teaching notebook, Model wrote of her
 subjects: "I feel that these are people of great strength and vitality—
 whose life experience is not held back but comes strongly to the surface
 of their bodies and expression." Thomas, *Lisette Model*, 126.
 "You are only attracted" Vestal, "Lisette Model," 114.
 the McCarthy period Ann Thomas, "Un contexte de production, Lisette
 Model et les années McCarthy" in Sam Stourdzé and Ann Thomas,
 Lisette Model (Paris: Editions Léo Scheer, 2002), 17–28.
164 *first tried teaching* Thomas, *Lisette Model*, 112.
 time and energy Lopate, *Portrait*, 74.
 feeling depressed Thomas, *Lisette Model*, 131.
 "I've been a balloon" DA to PH, n.d. [postmarked April 5, 1958], Pati
 Hill Collection.
 "She looked like" . . . balloon flying up Lopate, *Portrait*, 80.
 falling leaf *Falling leaf with bare branches in background, N.Y.C. 1956,* is
 published in *The Plot Thickens* (San Francisco: Fraenkel Gallery, 2014),
 Plate 44.
 newspaper blowing Exhibited at *The Unphotographable,* a show at the
 Fraenkel Gallery in San Francisco that ran from January 3 to March 23,
 2013, and was accompanied by a catalogue. Arbus may have taken this
 picture as part of an abortive assignment to photograph litter that was
 commissioned by Tina Fredericks, who was at this time working at the
 Ladies' Home Journal. Revelations, 142.
 more than a dozen pictures Contact Sheets 62 and 63 for the
 newspapers, 50 and 52A for the leaves, and 62 and 63 for the doll,
 Hulick Photo Roster.
165 *Diane said that she could not go . . . "not responsible for morally"* Lopate,
 Portrait, 80.

Chapter 25: What She Learned

167 *"that was Lisette"* AL interview with AA, New York, NY, August 14,
 2003.
 "nothing but grain" *Revelations,* 139, 141.
 smitten with the dots Westbeth class transcript, 17–18.
168 *"Lisette talked to me"* Ann Ray Martin, reprinted in Sandra S. Phillips,
 "The Question of Belief," *Revelations,* 330 n. 5.
 "And I remember" Westbeth class transcript, 6.
169 *Brodovitch cropped . . . Cartier-Bresson* Purcell, *Alexey Brodovitch,* 80;
 Peter Galassi, *Henri Cartier-Bresson: The Modern Century* (New York:
 Museum of Modern Art, 2010), 17.
 clicking the shutter Thomas, *Lisette Model,* 47.
 Arbus would lurk AL phone interview with Richard Marx, February 15,
 2011.
170 *"I do what gnaws"* "Best Bets," *New York,* May 31, 1971, 45; AL interview
 with Stephen Salmieri, New York, NY, July 28, 2015.
 an uncanny resemblance *Woman on the street with her eyes closed, N.Y.C.
 1956, Revelations,* 25. For the resemblance to Rose, see Arbus's
 photograph in *Revelations,* 133.
 attire that was unusual *Woman in a bow dress, N.Y.C., 1956,* Robert Miller
 Gallery. This photograph is not included in *Revelations.*
 she zeroed in *Woman carrying a child in Central Park, N.Y.C. 1956,*
 Revelations, 230.
 hoisted high *Boy above a crowd, N.Y.C. 1956, Revelations,* 284. This is
 probably on Contact Sheet 60, which is recorded as "Demonstration:

invasion of Hungary" and dates from November 1956, Hulick Photo
Roster.

170 *on the subway, holding* *Boy in the subway, N.Y.C. 1956,* Robert Miller
Gallery, New York.
man's overcoat and fedora *Boy reading a magazine, N.Y.C., 1956,* Fraenkel
Gallery, San Francisco.
by cropping the image An example of her cropping of a photograph in
1956 appears in *Revelations,* 139.
then she stopped Phillips, "The Question of Belief," 52.

171 *curiously bisected photograph* *Woman and a headless dummy, N.Y.C. 1956,*
Revelations, 52.
couple at a diner *Couple eating, N.Y.C. 1956, Revelations,* 141.
"I don't press" DA to MI, February 4, 1860, published in *Revelations,* 147.
A Jewish couple dancing *A Jewish couple dancing, N.Y.C. 1963,*
Revelations, 97.
Lady in a tiara *Lady in a tiara at a ball, N.Y.C. 1963, Revelations,* 22.
Masked man *Masked man at a ball, N.Y.C. 1967, Revelations,* 107.

172 *"Diane could learn"* Lopate, *Portrait,* 83.
"I've never seen anyone" Vestal, "Lisette Model," 139.
"When I photograph, you" Lopate, *Portrait,* 81–82.

Chapter 26: Notes of Unhappiness

173 *Allan would take out* AL interview with Daniel Kramer, New York, NY,
August 1, 2012.
"Allan was sequestered" AL interview with Tina Fredericks, East
Hampton, NY, March 23, 2011.
"We felt that" AL phone interview with AE, March 23, 2013.

174 *Alex called up Allan to ask* AL interview with Robert Brown, Ojai, CA,
March 2, 2011.
he would never forgive him AL phone intervew with AE, March 23, 2013.

175 *"I have a recording"* AL interview with Robert Brown, Ojai, CA,
March 2, 2011.

176 *doubts about Zohra's future* The following account of Zohra Lampert's
relationship with Allan Arbus is based on AL interviews with Lampert,
July 20, 2011, and September 22, 2011, New York, NY. Information on
the Playwrights Theatre Club is found in Janet Coleman, *The Compass:
The Improvisational Theatre That Revolutionized American Comedy,* 57–58.
"I'm not bright" AL interview with Zohra Lampert, New York, NY,
July 20, 2011.

177 *in Curaçao* AL interview with Daniel Kramer, New York, NY, August 1,
2012.
She urged him PB interview with Nancy Christopherson, New York, NY,
March 6, 1979, Gotlieb Archive.
His first candidate AL interview with Zohra Lampert, New York, NY,
July 20, 2011.

178 *"Allan has a mistress"* AL interview with PH, Sens, France, January 21
2011.
she chose shabby clothing "Dianne [*sic*], in periods of little money,
seems to have gone out of her way to dress like a frump when visiting
her parents, as if to point up to the whole world that that is the
economic relationship between the Nemerovs and their daughter. Only
during times of Allan's personal success does she dress at all decently—
and efforts of the parents to gloss over appearances by giving Dianne
clothes are rebuffed by Dianne—either by her selecting cheap little

dresses on the level she wishes to brand herself with, or by giving away more expensive things." Roy Sparkia journal, December 28, 1953, Alisa Sparkia Moore Collection.

179 ***won critical praise*** "Theatre: Bachelor Girls," *New York Times,* January 31, 1958, 18; see also Craig Hamrick, *Big Lou: The Life and Career of Actor Louis Edmonds* (Bloomington, IN: iUniverse Star, 2004), 34–35.

two spired skyscrapers Probably it was *City Bird,* the work included in the *Abstraction in Photography* show at the Museum of Modern Art in 1951.

Chapter 27: Losing Herself

182 ***Renee believed . . . and her husband, Roy*** AL interview with Alisa Sparkia Moore, Ventura, CA, November 10, 2012.

belief that love was eternal AL interview with PH, Sens, France, January 24, 2011; PB interview with RS, August 24, [n.y.], Gotlieb Archive.

"faithful to forever" 1940 Autobiography, reprinted in *Revelations,* 127. The specific referent of this comment is her desire for a motto to call her own; given the date of the writing, it is more than likely that her fiancé was on her mind.

against intrusions and dangers The source for this approach to Diane Arbus's mental state, and of these sentences in particular, is M. Masud R. Khan, "Ego Distortion, Cumulative Trauma, and the Role of Reconstruction in the Analytic Situation," *International Journal of Psycho-Analysis* (1964): 45, 272–79. Khan was a prominent (and controversial) protégé of D. W. Winnicott.

183 ***"constant euphoria"*** Lopate, *Portrait,* 81.

"could not stop talking" PB interview with Nancy Christopherson, March 7, 1979, Gotlieb Archive.

"spiritual automobile accident" DA to PH, n.d. [May 1957], Pati Hill Collection.

184 ***Russian steam bath*** PB interview with Nancy Christopherson, March 6, 1979, Gotlieb Archive. Recounted with a pseudonym in Bosworth, *Diane Arbus,* 153–54.

penthouse terrace restaurant AL interview with Tina Fredericks, East Hampton, NY, March 23, 2011.

"it was our separation" AL interview with AA, New York, NY, August 14, 2003.

gained the power to live AL phone interview with Peter Bunnell, March 27, 2013. Bunnell referred to his notes from a conversation he had with Model on October 19, 1973.

185 ***"like being in the ocean"*** DA to Robert and Evelyn Meservey, n.d. The first of the two sentences is reprinted in *Revelations,* 141. A copy of the letter is in the Gotlieb Archive.

Diane jotted down a dream The dream is recounted in the first in the series of notebooks that Arbus began keeping in 1959. This notebook predates the marital split-up and Diane's move to Charles Street, as it is inscribed in the front with the 18 East Sixty-Eighth Street address. The description of the dream is reprinted in *Revelations,* 17. In this initial telling, the dream is set in "an enormous white gorgeous hotel which is on fire, doomed," and she compares it to the *Titanic.* She published a shorter, revised version of the dream as part of the brief text that accompanied the publication of five of her photographs in *Artforum* in May 1971. Diane Arbus, "Five Photographs by Diane Arbus," *Artforum* 9 (May 1971): 64. In this second version, the hotel has become a ship,

much like the *Titanic*. And she makes explicit the sense of marital combustion that was already suggested by the description (and the cupids) in the original telling: The ocean liner is "rococo as a wedding cake."

Chapter 28: The Ground Was Shifting

189 ***To reach it*** AL visit to 131 Charles Street, November 19, 2014, courtesy of Judith Stonehill.
 "like a fairy tale" AL interview with Michael Flanagan, Lyme, CT, March 13, 2011.
 wooden planks . . . placed her mattress AL interview with Robert Brown, Ojai, CA, March 2, 2011.

190 ***heart of the house*** AL phone interview with Carlotta Marshall, August 8, 2003.
 skylight and a tile floor AL interview with Zohra Lampert, New York, NY, July 20, 2011; AL interview with Daniel Kramer, New York, NY, August 1, 2012.
 Allan came by *Revelations*, 144.
 paying the bills Studs Terkel.
 contributor's note *Glamour*, January 1960, 62.
 even Diane's family DA to Lisette Model, n.d. [postmarked September 25, 1962], Lisette Model Archive, reprinted in *Revelations*, 144.
 roll of bills AL phone interview with Richard Marx, February 15, 2011.

191 ***preset the lens opening . . . "overwhelming"*** AL phone interview with Daniel Kramer, July 25, 2011.

192 ***selection of subjects*** *Coney Island bath house, Brooklyn, N.Y., 1960* and *Woman with prizes, Coney Island, N.Y., 1960* are both in the Hubert's Museum Archive.
 backing of Walker Evans Sarah Greenough, *Looking In: Robert Frank's The Americans* (Washington, DC: National Gallery of Art, 2009), 36–37; Jeff L. Rosenheim, "Robert Frank and Walker Evans," in *Looking In*, 150.
 selected, cropped and sequenced Greenough, *Looking In*, xix.
 harsh judgments Ibid., 314–15.

193 ***"hollowness . . . like a drama"*** Westbeth class transcript, 32. Quoted in *Revelations*, 342 n. 499.
 relied on fashion photography Greenough, *Looking In*, 21.
 a single picture "Abstract Photography of Many Types to Be Shown at Museum," press release, Museum of Modern Art, New York, May 1, 1951.
 twenty-two works Stuart Alexander, "Robert Frank and Edward Steichen" in *Looking In*, 49.
 Mary Lockspeiser was seventeen Anne Wilkes Tucker, "It's the Misinformation That's Important" in *Robert Frank: New York to Nova Scotia*, ed. Anne Wilkes Tucker (Boston: Bulfinch Press, 1986), 91.

194 ***a distant remove*** AL interview with Mary Frank, New York, NY, April 23, 2012. Upon returning from Europe in 1953, the Franks rented an apartment at 130 West Twenty-Third Street. Tucker, *Robert Frank*, 9.
 Walker Evans served Belinda Rathbone, *Walker Evans: A Biography* (Boston: Houghton Mifflin, 1995), 197.
 Congressional Limited express "The Congressional," *Fortune*, November 1955, 118–22.

195 ***decaying Hollywood*** "A Hard Look at the New Hollywood," *Esquire*, March 1959, 51–65.

195 *"It was very hard"... remembered hazily* AL interview with Robert
Benton, New York, NY, January 24, 2012.
in Hayes's recollection Thomas Southall interview with Harold Hayes,
November 22, 1982.
"Diane and Allan's work" AL interview with Robert Benton, New
York, NY, January 24, 2012. The month of the meeting is identified in
Revelations, 142, 144.

Chapter 29: Buy Amy's Present, Go to the Morgue

197 *"blowing apart"* AL interview with Robert Benton, New York, NY,
January 24, 2012.
expressed his enthusiasm *Revelations*, 144.
World in Wax Musee The World in Wax Musee opened in 1926,
and featured tableaus in dimly lit rooms, typically of "grisly
dismemberments, executions, and gang murders." Charles Denson,
Coney Island: Lost and Found (Berkeley, CA: Ten Speed Press, 2002), 187.

198 *"between sex and death"* Westbeth class transcript, 10.
"last lasting time" DA to Walker Evans, September 20, 1962, Walker
Evans Archive, reprinted in *Revelations*, 158.
"People are gardens" AL phone interview with May Eliot Paddock,
March 20, 2011.

199 *"we chickened out"* AL interview with Robert Benton, New York, NY,
January 24, 2012.
so particular and intense Thomas W. Southall, "The Magazine Years,
1960–1971" in *Magazine Work*, 155.
"sort of a revolting idea" IFCP lecture.
"posh and sordid" DA to Robert Benton, n.d. [c. October 1959],
Harold Hayes Papers, reprinted in part in *Revelations*, 144.
"covered in plastic" AL interview with Robert Benton, New York, NY,
January 24, 2012.
pictures Crawford liked Office correspondence between Toni Bliss and
Harold Hayes ends with Hayes's handwritten note, "Let Crawford go.
Will get someone else." November 13, 1959, Harold Hayes Papers.
"there are better closets" DA to Robert Benton, n.d. [c. October 1959],
Harold Hayes Papers.

200 *"if people are grand"* Ibid.
shunned the facile irony In her very early work, Arbus, like many street
photographers, did exploit visual puns, such as the incongruity between
the words in a movie marquee and what was happening below. Diana
Hulick found many examples in 1958. Diana Emery Hulick, "Diane Arbus's
Expressive Methods," *History of Photography* 19 (Summer 1995): 110. Arbus
quickly abandoned that approach, and later, when she did incorporate
such witticisms, they are subordinated to the point of being almost hidden.
"rotten yellow water" IFCP lecture.

201 *Doon traveled to the bulding* AL phone interview with Michael Smith,
July 14, 2014.
found it "marvelous" DA to PH, n.d. [postmarked April 5, 1958], Pati
Hill Collection.
engaging girl charmed AL phone interview with Michael Smith, July 14,
2014.

202 *"angry inept mermaid"* DA to MI, n.d. [spring 1960], reprinted in
Revelations, 142.
"Buy Amy's birthday present" AL interview with Elisabeth Sussman, New
York, NY, July 31, 2003.

202 *filled the pages* For Mother Cabrini, see DA to MI, March 13, 1960,
 published in *Revelations,* 146. The dog in its coffin is on Contact Sheet 689,
 the pig heads on racks on Contact Sheet 69, the cow heads on Contact
 Sheet 802, and the Mother Cabrini shrine on Contact Sheet 836, Hulick
 Photo Roster. The other unused pictures are described in caption material
 for "The Vertical Journey," March 25, 1960, Harold Hayes Papers.
203 *bar pin* Arbus identifies the bar pin in an undated note to Hayes,
 Harold Hayes Papers. *Flora Knapp Dickinson, Honorary Regent of the
 Washington Heights Chapter of the Daughters of the American Revolution,
 N.Y.C. 1960,* reproduced in *Magazine Work,* 11.
 young society matron *Mrs. Dagmar Patino at The Grand Opera Ball, N.Y.C.
 1960,* reproduced in *Magazine Work,* 9.
 climb a ladder This description comes from AL phone interview with
 Richard Del Bourgo, June 22, 2011. Del Bourgo began working at
 Hubert's in late 1959 or early 1960. He places Trambles's origins in
 Georgia, contradicting Arbus's caption information, which identifies
 him as Haitian. *Hezekiah Trambles, "The Jungle Creep," N.Y.C. 1960,*
 reproduced in *Magazine Work,* 8.
 strongly impressed Hayes Southall, "The Magazine Years," in *Magazine
 Work,* 155.
204 *a hermaphrodite whom Lisette* Thomas, *Lisette Model,* 164–67.
 "I am to meet" DA to Robert Benton, n.d. [c. October 1959], Harold
 Hayes Papers.
 "Brother and sister" AL phone interview with Richard Del Bourgo,
 June 22, 2011.
 his winter residence "SSA Program Circular, Public Information No.
 235, Section 39-01. December 1, 1970," courtesy of Duane Michals. The
 photograph is reprinted in *Revelations,* 199.
 at one in the morning, expressing Caption material for "The Vertical
 Journey," March 25, 1960, Harold Hayes Papers.
 vantage point that exaggerates The photograph is reprinted in *Magazine
 Work,* 10.
 stripped to the waist The photograph is reprinted in *Magazine
 Work,* 12.
205 *"small and pretty crescent"* DA to MI, January 29, 1960, published in
 Revelations, 147.
 died in a traffic accident DA to Toni Bliss, n.d. [early March 1960].
 Caption material for "The Vertical Journey," March 25, 1960, Harold
 Hayes Papers. He was hit by a bus on the night of February 28, 1960.
 an unclaimed body Reprinted in *Magazine Work,* 13.
 published under the title "The Vertical Journey: Six Movements of a
 Moment within the Heart of the City," *Esquire,* July 1960, 102–7.
 journey was vertical *Revelations,* 147.

Chapter 30: A Mephistopheles, a Svengali, a Rasputin

207 *"incredibly sexy . . . hang out"* AL interview with Robert Benton, New
 York, NY, January 24, 2012.
 "letting humor intrude" Harold T. Hayes, "Robert Benton: From Out to
 In," *New York,* March 14, 1977, 76.
 "liked creepy things" AL interview with Robert Benton, New York, NY,
 April 3, 2012.
208 *late November 1959* *Revelations,* 144.
 frequently for **Seventeen** Martin Harrison says that Israel knew Diane
 Arbus "slightly" beginning in 1956, when he employed Allan regularly

at *Seventeen.* Martin Harrison, *Marvin Israel* (New York: Twining Gallery, 1990), 8.

208 *Marvin was raised* AL phone interview with Lawrence Israel, March 18, 2011.

209 *"come full circle"* DA to MI, January 19, 1960, published in *Revelations,* 144.
"If we are all freaks" Arbus copied this in her 1960 Notebook. Phillips, "The Question of Belief," in *Revelations,* 54.
story of how they met AL phone interview with Lawrence Israel, March 18, 2011; Rose C. S. Slivka, *Margaret Ponce Israel: A Recollection* (New York: Twining Gallery, 1989/90), 14. The author's interview with Lawrence Israel is the source of the information on Marvin's family and upbringing; he was probably also the source for Slivka's account of this incident. Slivka is the source for some of Margaret Israel's biography.

210 *When they returned* For the dates of Marvin and Margie's meeting, their Paris sojourn and their careers upon returning to the United States, see Harrison, *Marvin Israel,* 2–4.
"doing decorative work" AL phone interview with Mary Frank, August 23, 2003.
the upstairs apartment . . . paper holder AL phone interview with Andra Samelson, February 25, 2011.
round ceramic bathtub AL phone interview with Mary Frank, June 12, 2015.
wallpaper . . . Bibles AL phone interview with Patricia Patterson, June 6, 2012.

211 *walked looking up* AL phone interview with Maxine Kravitz, January 13, 2015.
off the elevator . . . frenzy AL phone interview with Michael Flanagan, August 25, 2003.
placed a mattress AL phone interview with Patricia Patterson, June 6, 2012.
"plastic chocolate cake" AL phone interview with Michael Flanagan, August 25, 2003.

212 *"A fuse burning"* AL phone interview with Lawrence Shainberg, August 25, 2003.
"inspired me to do" AL phone interview with Ruth Ansel, August 23, 2003.
began teaching in 1960 Harrison, *Marvin Israel,* 8.
they sobbed . . . acknowledge her AL phone interview with Susan Doukas, June 4, 2013.
"incredibly excited" AL phone interview with Michael Flanagan, August 25, 2003.
work of Malaparte AL phone interview with Ruth Ansel, August 23, 2003.
stories of Bruno Schulz AL interview with Deborah Turbeville, New York, NY, November 17, 2011.
surprised Patricia Patterson AL phone interview with Patricia Patterson, June 6, 2012.
Mephistopheles AL interview with Lawrence Shainberg, New York, NY, May 2, 2012.
Svengali AL interview with Deborah Turbeville, New York, NY, November 17, 2011.
Rasputin AL phone interview with Nancy Grossman, November 29, 2011.

213 *"Cézanne or a cow"* AL phone interview with Patricia Patterson, June 6, 2012.
"just kill yourself" Ibid. This remark was heard directly at Max's Kansas

City by Lawrence Shainberg. AL interview with Lawrence Shainberg, New York, NY, May 2, 2012.

213 *"could have been great"* AL interview with Saul Leiter, New York, NY, March 14, 2012.

"ended my friendship" AL interview with Robert Benton, New York, NY, April 3, 2012.

"your stable boy AL phone interview with Susan Doukas, June 4, 2013.

disliked being Jewish AL interview with Saul Leiter, New York, NY, December 16, 2011.

in the Deep South AL phone interview with Susan Doukas, June 4, 2013.

"thought I was nuts" AL phone interview with Michael Flanagan, August 25, 2003.

214 *irked him* AL phone interview with Lee Marks, February 9, 2015.

"would confide in me" AL phone interview with Patricia Patterson, June 6, 2012.

Margie was one William S. Johnson, ed., *The Pictures Are a Necessity: Robert Frank in Rochester, NY, November 1988*, Rochester Film & Photo Consortium Occasional Papers, no. 2 (January 1989): 140, 144.

Diane Arbus was another Eugenia Parry Janis and Wendy MacNeil, ed., *Photography within the Humanities* (Danbury, NH: Addison House Publishers, 1977), 59.

"Marvin was burdened" AL interview with Saul Leiter, New York, NY, December 16, 2011.

"not a great artist" AL phone interview with Mary Frank, August 11, 2003.

Chapter 31: A Manual of Facial Types

215 *Swiss magazine* Du Arbus referred to the portfolio in a January 24, 1960, postcard to Israel; *Revelations*, 148. The portfolio appeared in *Du*, no. 225 (November 1959).

"to photograph everybody" DA to MI, n.d. [c. late January 1960], published in *Revelations*, 145.

"the butterfly collection" DA to HN, n.d. [c. November 1965], Nemerov Papers.

"flattening them" DA to PH, January 11, [1952], Pati Hill Collection.

216 *"contemporary anthropology"* Artist Record, Museum of Modern Art, Department of Photography, October 5, 1964. [Artist questionnaire filled out by Arbus.]

"everyone today looked" DA to MI, n.d. [c. spring 1960], published in *Revelations*, 147; see also 333 n. 102.

nearing the end He lived from 1876 to 1964. For biographical information on Sander, see Ulrich Keller, "August Sander: A German Biography," in *August Sander: Citizens of the Twentieth Century*, ed. Gunther Sander (Cambridge, MA: MIT Press, 1986), 12–22.

rediscovery of his work Susanne Lange, *August Sander, 1876–1964* (Cologne: Taschen, 1999), 115.

217 *1931 radio broadcast* Ulrich Keller, "Conceptual and Stylistic Aspects of the Portraits" in *Sander: Citizens*, 24.

"training manual" Walter Benjamin, "Little History of Photography" (1931), in *Walter Benjamin: Selected Writings, Volume 2, 1927–1934*, eds. Michael W. Jennings, Howard Eiland, and Gary Smith (Cambridge, MA: Belknap Press of Harvard University Press, 1999), 520.

Sander was using Keller, "German Biography" in *Sander: Citizens*, 15, 27.

217 *exposure of two to four* Keller, "Conceptual and Stylistic Aspects" in *Sander: Citizens,* 27.

218 *his collaborators* Ulrich Keller emphasizes the collaborative nature of Sander's photographs in *In Focus: August Sander* (Los Angeles: J. Paul Getty Museum, 2000), 115, 126, seconded by Hilla Becher, 126.

219 *twin brother and sister* The photograph is reproduced in *Sander: Citizens,* 172.

"Entire stories" Lange, *August Sander,* 103.

"I think it's a secret" IFCP lecture.

"a secret about a secret" Arbus, "Five Photographs," 64. The comments are dated April 1, 1971.

Chapter 32: The Weeping Clown and Fearless Tightrope Walker

221 *she proposed photographing* DA to MI, n.d. [April 20, 1960], published in *Revelations,* 148.

the advice of the proprietor *Revelations,* 148.

"breathtaking, dazzling" DA to MI, March 27, 1960, published in *Revelations,* 150.

222 *Summers often depressed* AL phone interview with Nancy Grossman, November 29, 2011.

"intensely aware" AL interview with AA, New York, NY, August 14, 2003.

"jumping bean" DA to Doon Arbus, n.d. [c. July 1961], published in *Revelations,* 156–57.

"blue ice cream" Ibid., July 4, 1960, published in *Revelations,* 153. Tony's Bright Spot was the only Coney Island hotel open to tourists. It was also an SRO residence. Arbus photographed there on several occasions, in late spring 1971 for the last time. Contact Sheet 7289, Hulick Photo Roster.

Miss America preliminary DA to MI, July 15, 1960, published in *Revelations,* 153–54.

in a follow-up letter DA to Robert Benton and Harold Hayes, n.d. [c. September 12, 1960], Harold Hayes Papers, reprinted in *Revelations,* 155. Although the book's caption identifies the letter as dating circa November 1960, a handwritten draft as it appeared in Arbus's notebook, reproduced on the same page of *Revelations,* is dated September 12, 1960.

assigned the piece in November Harold Hayes issued the official accreditation letter on November 17, 1960, Harold Hayes Papers.

223 *"fictional characters"* DA to MI, January 12, 1961, published in *Revelations,* 154.

"gods put us down" DA to MI, November, 13, 1960, published in *Revelations,* 153.

"She got herself" AL interview with AA, New York, NY, August 14, 2003.

five feet, six inches Her height is recorded in the autopsy report. *Revelations,* 225. Meeting her in 1967, *Newsweek*'s Ann Ray Martin judged her to be "not much more than five feet tall." Ann Ray Martin. Renee Nemerov Sparkia Brown said, "Actually, D wasn't as tiny as she appeared. She was five feet six, but it was her manner that made people think she was petite." PB interview with RS, n.d., Gotlieb Archive.

"really fed up" AL interview with AA, New York, NY, August 14, 2003.

during their European sabbatical An example is reproduced in *Revelations,* 134.

after eight frames Contact Sheet 1044, Hulick Photo Roster. The pictures are of William Mack, taken circa January 1961.

223 ***borrowed Israel's Nikon*** DA to MI, n.d. [c. November 1960], published in *Revelations,* 336 n. 116.

 she never felt she knew DA to MI, n.d. [c. November 1960], published in *Revelations,* 154.

224 ***"I must have tested"*** *Revelations,* 154.

 Coney Island windstorm *Coney Island, N.Y. 1960 [windy group], Revelations,* 152. Other grainy, overexposed and wonderfully expressive Coney Island pictures from that time include *Woman shouting, Coney Island, NY. 1960, Revelations,* 153; and *Couple arguing, Coney Island, N.Y. 1960, Revelations,* 238. The windstorm is discussed in DA to Doon Arbus, July 4,1960, published in *Revelations,* 153.

 she showed Michael Smith AL phone interview with Michael Smith, July 14, 2014.

 perused the files Harold Hayes to Robert Shand, November 18, 1960. Harold Hayes Papers. In this letter to the managing editor of the *Daily News,* Hayes requested access for Arbus to the newspaper's library files. The letter is marked "OK by phone 11-21-60."

 rumors of a hermit DA to HN, n.d. [c. November 1960], Nemerov Papers.

 "a terrible disappointment" Westbeth transcript, 1. Although dated the following year, the unsatisfactory photograph would seem to be *Smiling hermit on lily frond path in N.J., 1962,* Fraenkel Gallery, San Francisco. My description of the hermit is derived from that photograph.

 wearing a woman's full-length fur . . . "murdered somebody" IFCP lecture; *William Mack, Sage of the Wilderness, N.Y.C. 1960,* reproduced in *Magazine Work,* 15.

225 ***astounding assortment of things*** The list appears in Arbus's article, reprinted in *Magazine Work,* 16–17.

 called himself "Jack Dracula" This account of Jack Baker's life and his interaction with Arbus is drawn from the videotape of an interview with him conducted in spring 2010 by Daniel Schwartz and posted on YouTube, as well as from two articles that appeared in *The Day* (New London): Kenton Robinson, "The Marked Man: Jack Dracula's New London Years," December 13, 2009; and Kenton Robinson, "Jack Dracula Fades Away," January 29, 2011. Baker's comment on Arbus being plain-looking is in the Schwartz tape, as are most of the details of her pursuit of him and their day together in New London; *Jack Dracula, the Marked Man, N.Y.C. 1961,* reproduced in *Magazine Work,* 14. The place name is erroneous.

 "rubbing my nose" IFCP lecture.

227 ***a copy of "In the Penal Colony"*** "The Full Circle," reprinted in *Magazine Work,* 16.

 "commit the faux pas" DA to PH, n.d. [c. July 1961], Pati Hill Collection; *Miss Cora Pratt, the Counterfeit Lady, 1961,* reproduced in *Magazine Work,* 21.

 Prince Robert *His Serene Highness, Prince Robert de Rohan Courtenay, 1961,* reproduced in *Magazine Work,* 18.

 Max Maxwell Landar *Max Maxwell Landar (Uncle Sam),* reproduced in *Magazine Work,* 19.

 a letter in February 1961 Harold Hayes to DA, February 16, 1961, Harold Hayes Papers, reprinted in *Revelations,* 156.

228 ***a beatifically smiling woman*** Diane Arbus, "The Bishop's Charisma" in *Magazine Work,* 48–52.

 "the bishop prayed" DA to MI, n.d. [c. 1961], published in *Revelations,* 156.

228 *"pathetic, pitiable"* Susan Sontag, *On Photography* (New York: Farrar,
 Straus and Giroux, 1977), 33, 36.
 "I think you're paying" IFCP lecture.
 "mutual seduction" . . . *"don't believe them now"* Westbeth class
 transcript, 46.
229 *preferred to let days* Ibid., 10.
 "often a big distance" Ibid., 1.
 "two-faced" . . . *"undeniably something"* Ibid., 47. This is reprinted in
 Diane Arbus: An Aperture Monograph, 1, with a few differences. The one
 significant change is the deletion in the monograph of both uses of the
 word "hideous."

Chapter 33: The Bizarre and the Chic at *Bazaar*

231 *editors fretted* Southall, "The Magazine Years," in *Magazine Work,* 157.
 "destroy or return" . . . *the word* **Diane** Harold Hayes to DA, August 25,
 1961; DA to Harold Hayes, August 28, 1961, Harold Hayes Papers. The
 letters are excerpted in *Revelations,* 157.
232 *easier for Hayes* DA to Doon Arbus, n.d. [c. July 1961], published in
 Revelations, 157.
 photographs of five eccentrics Diane Arbus, "The Full Circle," *Harper's
 Bazaar,* November 1961, 133–37, 169–73, 179. The text and pictures
 were reprinted with the addition of the Stormé DeLarverie suppressed
 picture, in *Infinity* 11 (February 1962): 4–13, 19, 21.
 "To me, the writing" AL interview with AA, New York, NY, August 14,
 2003.
 "so totally in sync" AL interview with Doon Arbus, New York, NY,
 August 9, 2003.
 friend Marguerite Lamkin AL phone interview with Marguerite Lamkin
 Littman, August 7, 2003.
 "extraordinary eye" AL interview with AA, New York, NY, August 14,
 2003.
233 *delusions fatigued her* Of William Mack, she wrote, "He is given to
 saying things like that moses wasn't a jew and shakespeare didn't write
 any plays which make me quite tired to hear. . . . But he is very splendid
 looking." DA to MI, January 12, 1961, published in *Revelations,* 154.
 Israel won acceptance "If it wasn't for Marvin, Diane's 'Last Circle' [*sic*]
 would never have been published in *Bazaar,*" said Israel's assistant. AL
 phone interview with Ruth Ansel, August 23, 2003.
 "pit of your stomach" "Berenice Abbott about Lisette Model,"
 Camera 56 (December 1977): 4. Model described how she explained
 the difference between her approach and Brodovitch's to Arbus:
 "Originality means coming from the source, not like Brodovitch—at
 any price to do it different," *Revelations,* 141.
 "don't click the shutter" Purcell, *Alexey Brodovitch,* 124.
234 *thirteen appointments . . . Brodovitch thought highly* Winthrop Sargeant,
 "A Woman Entering a Taxi in the Rain," *The New Yorker,* November
 8, 1958, 49–84; Purcell, *Alexey Brodovitch,* 81; Charles Michener, "The
 Avedon Look," *Newsweek,* October 16, 1978, 71; Penelope Rowlands, *A
 Dash of Daring: Carmel Snow and her Life in Fashion, Art, and Letters* (New
 York: Atria Books, 2005), 331.
 Bazaar *was the destination* David Ansen, "Avedon," *Newsweek,*
 September 13, 1993, 56; Jane Livingston, "The Art of Richard Avedon"
 in Richard Avedon, *Evidence 1944–1994* (New York: Random House,
 1994), 56.

234 *when he was eleven* Livingston, *New York School,* 337.
a year after Carmel Snow Rowlands, 165–66.
appeared in November 1944 Carol Squiers, "Let's Call It Fashion':
Richard Avedon at Harper's Bazaar" in *Avedon Fashion 1944–2000* (New
York: Harry N. Abrams, 2009), 156; *Harper's Bazaar,* November 1944,
108–10.

235 *his first cover* Squiers, 'Let's Call It Fashion,' 161.
two images of Dovima *Dovima with Elephants* in *Harper's Bazaar,*
September 1955, 214–15.
"metaphor of the artist" Ansen, "Avedon," 52.
"double-sided mirror" "Photography in Fashion—Fashion in
Photography," *Portfolio* 1 (Winter 1950): n.p.
"two brothers who were opposites" Livingston, "The Art of Richard
Avedon,"35. In the same communication with Livingston in March
1993, Avedon said that he and Israel experienced an "instantaneous
recognition." He continued, "After Brodovitch, I felt that overnight my
editorial work slipped. It wasn't until Marvin that I got back on my feet.
We were completely united in our goals and in the belief that wherever
a photograph appeared on a wall or a page or a billboard, it was an
event." Brodovitch was fired in August 1958, partly because of his heavy
drinking. Purcell, *Alexey Brodovitch,* 104.

236 *dress store went bankrupt* "Avedon," *Camera* (November 1974): 4.
disavowed bohemianism In an interview published in French, he told
Nicole Wisniak, *"Je n'ai rien d'un bohème. Je sais que je suis responsable de
ma famille. Et je l'ai su très tôt."* ("There is nothing bohemian about me.
I know that I am responsible for my family. And I knew it very soon.")
Richard Avedon—Nicole Wisniak, "Un Portrait est une Opinion,"
Egoiste, no. 9, 50.
"Marvin, easily!" Ansen, "Avedon," 48.
Yves Saint Laurent AL interview with Pat Peterson, New York, NY,
February 1, 2011.
fisherman sweater AL phone interview with Patricia Patterson, June 6,
2012. The photograph was published in the July 1966 issue of *Harper's
Bazaar* and is reproduced in *Revelations,* 179.
"pretense of being poor" AL phone interview with Geri Trotta,
August 11, 2003.
"hired a butler" AL phone interview with Earl Steinbicker,
September 12, 2012.

237 *"He was a natural"* AL interview with Frederick Eberstadt, New York,
NY, February 1, 2011.
danced around the room AL phone interview with Earl Steinbicker,
September 12, 2012.
"the element of time" Richard Avedon, "Time for Motion . . . The
Fourth Dimension," *Commercial Camera* 2, no. 2 (1949): 9, 14.
stage-set scenes Vince Aletti, "In Vogue and After" in *Avedon Fashion
1944–2000,* 270; Squiers, " 'Let's Call It Fashion,' " 187; Livingston, "The
Art of Richard Avedon," 50.
"Nobody cries in a Dior hat" Richard Avedon interview, *American Masters,*
February 1, 1995, quoted in Squiers, " 'Let's Call It Fashion,' "168.

238 *"We all perform"* *Camera* (November 1974): 13.
"Oh god, I wish" AL phone interview with Ruth Ansel, August 23,
2003.

239 *"profoundly superficial"* AL interview with Frederick Eberstadt, New
York, NY, February 1, 2011.

239 *"I been gloomy"* DA to HN, n.d. [c. December 1961], Nemerov Papers, reprinted in *Revelations*, 159.
 red-and-black insect DA to AE and Jane Winslow Knapp, n.d. [c. late May 1951], Alexander Eliot Collection.
 "my illusion" DA to HN, n.d. [c. December 1961], Nemerov Papers, reprinted in *Revelations*, 159.

Chapter 34: Freak Show

241 ***Murray's Roman Gardens*** Lewis A. Erenberg, *Steppin' Out: New York Nightlife and the Transformation of American Culture, 1890–1930* (Chicago: University of Chicago Press, 1981, 1984), 44–45.
 "somewhat like Orpheus" "Hubert's Obituary," *Magazine Work*, 80.
 clamorous arcade . . . "even come close" AL phone interview with Richard Del Bourgo, June 22, 2011. Del Bourgo, a magician who began working at Hubert's in late 1959 or early 1960, is the source for these descriptions of the place and the performers. At Coney Island, and to a lesser extent at Hubert's, Arbus would routinely photograph the geometrically patterned target of the shooting gallery. These very similar images, photographed straight on and taken from 1958 to 1960, appear in four frames in Contact Sheet 362, one in Contact Sheet 388, one in Contact Sheet 397, one in Contact Sheet 606, and four in Contact Sheet 839 (these were taken at Hubert's), Hulick Photo Roster.
242 *"bunch of miserable sinners"* "Hubert's Obituary," *Magazine Work*, 80–81.
 a distinction made Rachel Adams, *Sideshow U.S.A.: Freaks and the American Cultural Imagination* (Chicago: University of Chicago Press, 2001), 255–56, n. 12.
 "most cheerful man" "Hubert's Obituary," *Magazine Work*, 81.
 William Durks Gregory Gibson, *Hubert's Freaks: The Rare-Book Dealer, the Times Square Talker, and the Lost Photos of Diane Arbus* (New York: Harcourt, 2008), 29.
 "distinction between born freaks and made freaks" . . . "want to do it more" IFCP lecture.
243 *"aristocracy by birth" . . . "kind of anxiety"* Ibid.
 "Most people know" . . . "aristocrats" Ann Ray Martin. A heavily edited version is published in *Diane Arbus: An Aperture Monograph*, 3.
 "unlike movie stars" Ann Ray Martin.
 "adore them" . . . "shame and awe" Westbeth class transcript, 12. Arbus also described the "mixed feeling of shame and awe" that audiences experience in a sideshow at a lecture the previous year. IFCP lecture.
 at least since 1957 The first photographs of Hubert's catalogued by Hulick appear on Contact Sheet 127 from 1957. The first photographs of freaks at the circus appear about the same time, on Contact Sheet 111. Because the numbered contact sheets do not begin until 1956, they would not include any of Arbus's earlier pictures. While Arbus was already photographing backstage at the circus in 1957 in Contact Sheets 112 and 114, her first backstage shots at Hubert's do not appear until the following year, in Contact Sheet 576, Hulick Photo Roster.
 "very comfortable" AL phone interview with Richard Del Bourgo, June 22, 2011.
 eight-by-ten glossies In late 1959, Charlie Lucas was asking potential performers to supply at least five eight-by-ten photographs, which would be returned to them at the end of the engagement. Box 6, 110PH007.563, Hubert's Museum Archive.
 "Nobody saw themselves" AL phone interview with Richard Del Bourgo,

June 22, 2011. Del Bourgo's recollections of the general pay scale are corroborated by contracts in Box 6, 110PH007.563, Hubert's Museum Archive.

244 *performed as "Woo Foo"* Bogdan, *Freak Show,* 196.

Woogie left Diane alone DA to MI, n.d. [c. November 1960], published in *Revelations,* 149. The letter may have been written earlier; the photographs in the numerically contiguous contact sheets were taken at Coney Island in late summer 1960. Arbus snapped three pictures; the photographs are on Contact Sheet 928, Frames 12 to 14, Hulick Photo Roster.

highlighted the gaping mouth The photograph, *Snake eating a rat backstage at Hubert's Museum, N.Y.C. 1960,* is in Box 2, 110PH007.011, Hubert's Museum Archive.

245 *"quality of legend" . . . "childhood fantasies"* Ann Ray Martin.

"there's some sense" Westbeth class transcript, 16.

"two things that happen" Ibid., 5.

Acting on the suggestion Thomas, *Lisette Model,* 96. The editor was Dorothy Wheelock, who was in charge of personality features.

disparaged the notion She said, with typical nonchalance regarding the truth: "For example, I have never photographed homosexuals. I have never photographed lesbians. I have never photographed freaks. [This] is not what I was interested in." Janet Beller interview with Lisette Model, Port Washington, NY, July 27, 1979. In Thomas, *Lisette Model,* 149.

have not been published They first appear in 1959 on Contact Sheet 649, 655, 658, 662, 666, 674A, 679A, 680A, and repeatedly thereafter, Hulick Photo Roster.

Model's monumental portrait It is reproduced in Thomas, *Lisette Model,* 166.

246 *portraits of Percy Pape* In ibid., the Model picture is on page 154, the Arbus photo on page 153.

"she had to see it" AL phone interview with Nancy Grossman, May 14, 2013. Grossman said they saw it on Forty-Second Street. Michael Flanagan said they saw it together in Greenwich Village, at the Bleecker Street Theater. AL interview with Michael Flanagan, Lyme, CT, March 13, 2011.

notorious flop David J. Skal and Elias Savada, *Dark Carnival: The Secret World of Tod Browning* (New York: Anchor Books, 1995), 223–24. This account states without documentation that Arbus first saw the movie in a New York art-house screening in 1960. It seems much likelier that she saw it at the New Yorker Theater, which screened it for a week, beginning October 12, 1961. Toby Talbot, *The New Yorker Theater and Other Scenes from a Life at the Movies* (New York: Columbia University Press, 2009). The reproduced ledger of movie bookings appears as the final appendix, not paginated. Another book, David J. Skal, *The Monster Show: A Cultural History of Horror* (New York: Penguin, 1994 [Norton, 1993]), 15, contains an unsubstantiated account of Arbus "holed up" in the New Yorker watching *Freaks* for three consecutive nights while smoking marijuana.

cut and reedited Skal and Savada, *Dark Carnival,* 174–75.

divided critics Angela M. Smith, *Hideous Progeny: Disability, Eugenics, and Classic Horror Cinema* (New York: Columbia University Press, 2011), 94; Skal and Savada, *Dark Carnival,* 176–78.

247 *revulsion and compassion* For reaction to the wedding banquet, Smith,

Hideous Progeny, 90, 115–16. On the mutilation of Cleopatra, John
Thomas, *"Freaks," Film Quarterly* 17 (Spring 1964): 60–61, cited in Smith,
Hideous Progeny, 109.

247　　*"can't become a freak"*　Ann Ray Martin.

Chapter 35: Punchy New Journalism

249　　*in Springfield . . . Clay Felker*　Thomas B. Morgan, *Self-Creations:
13 Impersonalities* (New York: Holt, Rinehart and Winston, 1965),
9–10; Marc Weingarten, *The Gang That Wouldn't Write Straight: Wolfe,
Thompson, Didion, and the New Journalism Revolution* (New York: Crown,
2005), 47–48.

　　　　first **Esquire** *piece*　Thomas B. Morgan, "What Makes Sammy Jr. Run?"
Esquire, October 1959, 91–97. Marc Weingarten writes: "*Esquire* had
never run a profile as formally inventive or as revealing as 'What Makes
Sammy Jr. Run?' As a thwarted novelist, Morgan wanted to get as close
as he could to the richness of fiction with his nonfiction, and in so
doing he elevated his reportage into literature." Weingarten, *The
Gang,* 49.

　　　　"a lot to learn"　Marc Weingarten, *Who's Afraid of Tom Wolfe? How New
Journalism Rewrote the World* (London: Aurum, 2005), 45.

250　　*bought the house*　Deeds, New York County, Block 632, Lot 30, courtesy
of Judith Stonehill.

　　　　"I've got a great idea"　Thomas Southall interview with Thomas
Morgan, February 1982.

　　　　photographing the protesters　Contact Sheet 1375, Hulick Photo Roster.

　　　　declined the organizer's offer　AL phone interview with Paul Salstrom,
August 7, 2003.

　　　　she told Paul Salstrom　AL phone interviews with Paul Salstrom,
August 7, 2003, and April 3, 2012.

　　　　With her tableau　Thomas B. Morgan, "Doom and Passion Along Rt. 45,"
Esquire, November 1962, 103–6, 168–71. The photograph appears on
pages 104 and 105. It is reproduced in *Revelations,* 161, with a caption
stating that it was taken in May. Morgan reported the piece in June.

251　　*discussed Ethical Culture*　AL phone interview with Paul Salstrom,
August 7, 2003.

　　　　she wrote . . . Morgan corresponded　Ibid., April 3, 2012.

　　　　"I tell him truths"　Morgan, *Self-Creations,* 16.

　　　　The writer must believe　Tom Wolfe, *The New Journalism: With an
Anthology* (New York: Harper & Row, 1973), 21, 51.

　　　　"Chinese have some theory"　Westbeth class transcript, 27, 34.

252　　*important to Gay Talese*　"The New Journalism," *Writer's Digest,* January
1970, 34; John Brady, "Gay Talese: An Interview," *Writer's Digest,* January
1973 and February 1973, reprinted in Ronald Weber, *The Reporter as
Artist: A Look at the New Journalism Controversy* (New York: Hastings
House, 1974), 98–99.

　　　　sideshow performer, Eddie Carmel　Gay Talese, *New York: A Serendipiter's
Journey* (New York: Harper & Brothers, 1961), 73–76.

　　　　elegant prostitute　Arbus shot five rolls of twelve-exposure film on
Marilyn the prostitute, late in 1964. Contact Sheets 3775 to 3779,
Hulick Photo Roster.

　　　　"If you could take" . . . preoccupied with their work　AL phone interview
with Gay Talese, September 13, 2011.

253　　*Harold Hayes's view*　"The New Journalism," *Writer's Digest,* 33.

　　　　"goddamned stories"　Eugenia Parry Janis and Wendy MacNeil, eds.,

Photography within the Humanities (Danbury, NH: Addison House Publishers, 1977), 56.

253 *"Spanish Village"* "Spanish Village," *Life,* April 9, 1951, 120–29.

shared the weekly's sentimentality Fred Turner, "*The Family of Man* and the Politics of Attention in Cold War America," *Public Culture* 24 (Fall 2012): 60.

all-American ceremonies Many are reprinted in *The Fifties: Photographs of America* (New York: Pantheon Books, 1985), n.p.

best-represented photographer Abigail Solomon-Godeau, "*The Family of Man*: Refurbishing Humanism for a Postmodern Age" in *The Family of Man 1955–2001,* eds. Jean Back and Viktoria Schmidt-Linsenhoff, (Marburg, Germany: Jonas Verlag, 2004), 35.

Smith's immersion Glenn G. Willumson, *W. Eugene Smith and the Photographic Essay* (New York: Cambridge University Press, 1992), 46, states that Smith spent three weeks in Kremmling, Colorado, for one of his most famous pieces, "Country Doctor," *Life,* September 20, 1948, 115–25. For his masterpiece, "Spanish Village," he devoted at least as much time. Willumson, *W. Eugene Smith,* 107.

254 *Frank's bitterness* Greenough, *Looking In,* 30–33.

portfolio of Hollywood pictures "A Hard Look."

pictures of Pat and Richard Nixon They illustrate Joseph Kraft, "Ike vs. Nixon," *Esquire,* April 1960, 84–86.

young photojournalist, Bruce Davidson Details of Davidson's life are drawn from Bruce Davidson, *Photographs* (New York: Agrinde Publications, 1978), 8–12.

255 *"cart before the horse"* Westbeth class transcript, 7. At *Life,* once a story was approved, a researcher prepared a "picture script," and the picture editor, having selected a photographer, explained what would be needed. "This discussion of the shooting script established the scope of the story." Willumson, *W. Eugene Smith,* 21.

widow and lovers "Widow of Montmartre," *Esquire,* October 1958, 138–41. The caption on page 140 reads, in part, "Madame Fauché hobbles away from a pair of lovers whose embrace recalls her romantic youth."

pictures of Jimmy Armstrong Bruce Davidson, "The Clown," *Esquire,* January 1960, 71–75.

Brooklyn gang Livingston, *New York School,* 329.

magazine published five Bruce Davidson and Norman Mailer, "Brooklyn Minority Report," *Esquire,* June 1960, 129–37.

256 *She knew that the prelude in the ring* AL interview with Ti-Grace Atkinson, Cambridge, MA, May 20, 2013. Arbus recounted the story to Atkinson.

Brock Brower . . . Mailer hated it AL phone interview with Brock Brower, November 18, 2013.

it showed Mailer The formal title of the piece, printed in small type, was "Some Children of the Goddess," *Esquire,* July 1963, 63–69, 105. Arbus's full-page picture appears on page 63. The setting of Harry Wiley's Gym is specified on page 64.

an eviscerating review John Kenneth Galbraith, "The Kennedys Didn't Reply," *New York Times Book Review,* November 17, 1963.

257 *"putting a live grenade"* Harold Hayes, "Editor's Note," *Esquire,* November 1971, 216. Hayes said that Mailer was not alluding to Arbus's photograph *Child with a toy hand grenade in Central Park, N.Y., 1962,* which he most likely had not seen. Thomas Southall interview with Harold Hayes, November 22, 1982.

Chapter 36: Silver Spoon

259 *"a little sloppy"* Studs Terkel.

Mary Frank was amazed AL phone interview with Mary Frank, August 11, 2003.

"delayed hysterical reactions" DA to Lisette Model, n.d. [postmarked September 25, 1962], Lisette Model Archive, reprinted in *Revelations*, 144.

dream of becoming an artist "Nemerov Makes First PB Showing April 5," Palm Beach *Daily News*, March 31, 1961, 1. Contradicting *Revelations*, 142, which states that the Nemerovs moved to Palm Beach in 1958, this article dates the move a year earlier.

260 *he sold thirty-one paintings* "The Desk Set," *Time*, November 24, 1958, 80.

"patent medicine man" DA to PH, n.d. [postmarked April 5, 1958], Pati Hill Collection.

around $5,000 Southall, "The Magazine Years," in *Magazine Works*, 166.

about $4,000 *Revelations*, 176.

"terribly proud" DA to Lisette Model, National Gallery of Canada Library and Archive, reprinted in *Revelations*, 163.

rang up Alan Levy . . . did she relent Alan Levy, "Working with Diane Arbus: 'A Many Splendored Experience,'" *ARTnews* 72 (Summer 1973): 80–81.

261 *Levy pitched the concept* Alan Levy, "Remembering Deeyann," *International Herald Tribune*, March 14, 1980, 7W.

She never repeated Although *Bazaar* in December 1963 did publish a portfolio of four of her photographs of children under the title "Auguries of Innocence," these were pictures she had taken previously, not for the purpose of a new editorial assignment.

262 *working with anonymous* IFCP lecture.

"like postage stamps" Westbeth class transcript, 9.

"what I've never seen" Arbus, "Five Photographs," 64.

"picture of a famous person" Westbeth class transcript, 45.

James T. Farrell Richard Schickel, "James T. Farrell: Another Time, Another Place," *Esquire*, December 1962, 156–57, 272–75. The photograph, which appears on page 157, is reproduced, uncropped and in the square Rolleiflex format, in *Magazine Work*, 26.

Marcello Mastroianni "Europe's Uncommon Market," *Show*, March 1963, 67, reproduced in *Magazine Work*, 26–27. It appears on Contact Sheet 1543, Hulick Photo Archive. Arbus could find no telltale crack in the persona that would reveal the man. See Leo Rubinfien, "Where Diane Arbus Went," *Art in America* 93 (October 2005): 69.

"an old nightmare" DA to Lisette Model, n.d. [postmarked September 25, 1962], Lisette Model Archive, reprinted in *Revelations*, 163.

photographed six-year-old Amy "Bill Blass Designs for Little Ones," *Harper's Bazaar*, September 1962, 252–53. The pictures, taken with a Rolleiflex, appear on Contact Sheets 1383, 1384 A through D, 1385 A through F, 1386 A through E, and 1387 A through C. Amy in different frames is holding a rabbit, chameleon, guinea pig, frog and turtle. The sheets are dated June 1962.

town house garden AL phone interview with Ray Crespin, May 9, 2012.

263 *odd-looking girls* "Petal Pink for Little Parties," *Harper's Bazaar*, November 1962, 186–88.

"how charming children are" IFCP lecture.

263 ***sensitive-looking boy*** *Boy stepping off the curb, N.Y.C. circa 1956,*
reproduced in *Revelations,* 20.
looked like little men *Boy reading a magazine, N.Y.C. 1956,* Fraenkel
Gallery; *Boy above a crowd, N.Y.C. 1956,* reproduced in *Revelations,* 284;
Boy in a man's hat, N.Y.C. 1956, reproduced in *Revelations,* 139.
bonnet and pumps *A girl in a hat at Central Park Lake, N.Y.C. 1962,*
reproduced in *Revelations,* 160.
boys smoking cigarettes *Two boys smoking in Central Park, N.Y.C. 1962,*
reproduced in *Revelations,* 90.
"toomuchblessed" DA to MI, n.d. [c. April 1962], published in
Revelations, 160.
In her nightmares IFCP lecture.
"like princess and pirate" *Revelations,* 334 n.142.
264 ***White told her*** Ibid., 165.

Chapter 37: Forlorn and Angry Children

265 ***"a rich child myself"*** Editors of Time-Life Books, *The Camera* (New York:
Time-Life Books, 1970), 222.
"she tracked angry kids" AL interview with Frederick Eberstadt, New
York, NY, February 1, 2011.
On a wintry afternoon Fernanda Eberstadt e-mails to AL, June 11, 2011,
and January 7, 2014.
266 ***lyricist Alan Jay Lerner*** *Revelations,* 166.
son of a successful Jewish "Alan Jay Lerner, the Lyricist and Playwright,
Is Dead at 67," *New York Times,* June 15, 1986.
"archaic shops for the rich" Time-Life Books, *The Camera,* 222.
equally "sissified" getup StudsTerkel.
"walked on the ceiling" AL interview with Colin Wood, Glendale, CA,
November 9, 2012. Unless otherwise noted, this is the source of all the
information about Colin Wood.
267 ***his outfit recalled her childhood*** AL phone interview with Douglas
Prince, April 9, 2013. Prince attended Arbus's lecture at the University
of Florida in Gainesville, in June 1969, and recalled her remark.
exposed eleven frames The contact sheet is reproduced in *Revelations,*
164. It is Contact Sheet 1341, Hulick Photo Roster. *Child with a toy
hand grenade in Central Park, N.Y.C. 1962,* is reproduced in *Revelations,*
104–5. Another marvelously strange photograph from the same series,
Man and a boy on a bench in Central Park, N.Y.C. 1962, is reproduced in
Revelations, 76.
268 ***"exasperated with me"*** IFCP lecture.

Chapter 38: Self-Created Women

271 ***anonymous women*** "A survey of Arbus's contact sheets shows that most
subjects are women or female impersonators followed in numerical
order by children and men. Fewer male figures are seen close up
and many of the men are transvestites or appear as aged, debilitated,
androgynous, or as young, erotic and emotional, as stripped of
traditional male status." Diana Emery Hulick, "Diane Arbus's Women
and Transvestites: Separate Selves," *History of Photography* 16 (Spring
1992): 34.
older ones Examples reproduced in *Revelations* include *Lady in a bus,
N.Y.C. 1956,* 51; *Woman with white gloves and a fancy hat, N.Y.C. 1963,* 59;
Lady in a tiara at a ball, N.Y.C. 1963, 22; *Woman in a mink coat, N.Y.C.
1966,* 74; *Woman in a rose hat, N.Y.C. 1966,* 113; and *Woman in a floppy*

hat, N.Y.C., 1971, 67. A photograph of Rose Russek appears on page 133.

271 **closer to her own age** Examples reproduced in *Revelations* include *Woman carrying a child in Central Park, N.Y.C. 1956,* 230; *Woman on the street with parcels, N.Y.C. 1956,* 262; *Woman with two men, N.Y.C. 1956,* 51; and *Woman with a briefcase and pocketbook, N.Y.C. 1962,* 163.

stopped by one night AL phone interview with Ruth Ansel, August 23, 2003.

told several friends AL phone interview with Tom Morgan, June 28, 2011; AL interview with Charles Atlas, New York, NY, July 27, 2011. Atlas said this was told to him by Nancy Christopherson. AL interview with Roberta Miller, New York, NY, January 26, 2012; Pam Barkentin Blackburn e-mail to AL, April 19, 2012.

272 **Sometimes Roberta Miller** AL interview with Roberta Miller, New York, NY, January 26, 2012.

"a piece of toast" AL phone interview with Tina Fredericks, August 20, 2003.

dressed Amy as a doll AL interview with Roberta Miller, New York, NY, January 26, 2012.

intimate company with pictures Westbeth class transcript, 27.

273 **welfare payments and parental handouts** AL phone interview with Jeanne Christopherson, February 18, 2011.

Poni would feed herself AL phone interview with Wendy Clarke, August 27, 2013.

moldy bread AL phone interview with Jeanne Christopherson, February 18, 2011.

"Diane's feelings" AL interview with PH, Sens, France, January 20, 2011.

one of Pati's tensions PH e-mail to AL, June 6, 2011.

took up with another suitor PH to Alain de la Falaise, March 5, 1959, excerpted in Pati Hill journals, Pati Hill Collection.

married him "Pati Hill Is Married to Paul Bianchini," *New York Times,* November 4, 1960, 36.

Setting himself up PH e-mail to AL, March 12, 2011.

motherhood would not change PH to Alain de la Falaise, March 19, 1962, excerpted in Pati Hill journals, Pati Hill Collection.

"quite sentimental" DA to PH, n.d. [August 1962], Pati Hill Collection.

274 **dreaded the advent** Pati Hill journals, May 1962, Pati Hill Collection.

neither parent was certain PH e-mail to AL, June 7, 2011.

Pati could never adjust Ibid., June 15, 2011.

political dimensions Ti-Grace Atkinson e-mail to AL, October 8, 2012; AL interview with Ti-Grace Atkinson, Cambridge, MA, May 20, 2013.

primping in the ladies' room Contact Sheet 77, Frames 13 to 18, Hulick Photo Roster.

trying on clothes Contact Sheets 80 and 81, Hulick Photo Roster.

275 **"leap into a new doom"** DA to MI, March 17, 1960, published in *Revelations,* 147.

"greatest living parody" DA to Walker Evans, September 20, 1962, Walker Evans Archive.

illegal for a man "Linda," "Backstage at the Jewel Box Revue," *Transvestia* 15 (1962), 55–57; Joe E. Jeffreys, "Who's No Lady? Excerpts from an Oral History of New York City's 82 Club," *New York Folklore* 19, no. 1–2 (1993): 191; Laurence Senelick, *The Changing Room: Sex, Drag and Theatre* (London/New York: Routledge, 2000), 384; Esther Newton,

Mother Camp: Female Impersonators in America (Chicago: University of Chicago Press, 1972, 1979), 130.

275 **one-dimensional role** DA to MI, March 17, 1960, *Revelations,* 147.
largely heterosexual audience Newton, *Mother Camp,* 117; Senelick, *Changing Room,* 380.
devoted several rolls Contact Sheets 564, 565, 572, 577, Hulick Photo Roster. Hulick incorrectly situates these pictures at the 82 Club; they were taken at the Jewel Box Revue. Diana Emery Hulick, "Diane Arbus's Women and Transvestites: Separate Selves," *History of Photography* 16 (Spring 1992): 35. Diana Hulick e-mail to AL, January 16, 2014. In the 1972 MoMA retrospective, the later photograph that is now known as *Two female impersonators backstage, N.Y.C. 1961* is titled *Two female impersonators, Apollo Theater, New York City, 1961.* The Apollo was a venue frequented by the itinerant Jewel Box Revue. The confusion between the Jewel Box Revue and the 82 Club is perpetuated in *Magazine Work,* 153–54, where the photograph is also misdated. Performers who worked at the 82 Club attest that the elaborate dressing rooms in the Arbus backstage photographs did not exist there. The 82 Club dressing rooms had mirrored walls but no framed mirrors. AL interview with Rick Colantino, New York, NY, January 23, 2014; AL interview with Henry Arango, Queens, NY, January 13, 2014; AL interview with James Bidgood, New York, NY, January 16, 2014.
tedious wait Westbeth class transcript, 34.

276 **Coney Island tattoo parlors** Contact Sheet 205, Frames 9–19 and Contact Sheet 211, Frames 11–14, of tattoo parlors precede this work. But Contact Sheet 606, Frame 15, in which a boy looks at Arbus, seemingly startled, in the process of being tattooed, is contemporaneous with it. Hulick Photo Roster.
bare-chested man *Smiling female impersonator with an eagle tattoo, N.Y.C. 1959,* Fraenkel Gallery, San Francisco; *Female impersonators in mirrors, N.Y.C. 1958,* is reproduced in *Revelations,* 147. The former photo appears on Contact Sheet 668, Frame 10, Hulick Photo Roster. The latter photograph is misdated, as the earliest shots by Arbus of female impersonators backstage are on Contact Sheet 650 and date from 1959. Although Hulick wrote that Arbus began concentrating on impersonators applying makeup and getting into costume in 1961–1962, the photo roster indicates that the shift occurred much more rapidly, within a few months of her first pictures at the club. Hulick, "Diane Arbus's Women and Transvestites," 35.
much-thumbed copy Phillips, "The Question of Belief," 51–52.
Stormé DeLarverie Elizabeth Drorbaugh, "Sliding Scales: Notes on Stormé DeLarverié and the Jewel Box Revue, the Cross-Dressed Woman on the Contemporary Stage, and the Invert" in Lesley Ferris, *Crossing the Stage: Controversies on Cross-Dressing* (London/ New York: Routledge, 1993), 123.
unexpurgated version Arbus, "The Full Circle," *Infinity,* 7. The Arbus photograph *Stormé DeLarverie, the lady who appears to be a gentleman, N.Y.C. 1961,* reproduced in *Revelations,* 156.
courageous of DeLarverie Senelick, *Changing Room,* 381.
"She admits wryly" . . . Bermuda shorts Arbus, "The Full Circle," 13.

Chapter 39: Tinseltown

279 **commission to photograph** *Revelations,* 160.
He had met Bunny AL interview with Robert Brown, Ojai, CA, March 2, 2011; AL phone interview with Bunny Sellers, August 21, 2003.

279 *"not so much summoned"* DA to PH, n.d. [August 1962], Pati Hill
 Collection.
 borrowed oceanfront mansion AL interview with Robert Brown, Ojai, CA,
 March 2, 2011.
 sleeping on the floor DA to PH, n.d. [August 1962], Pati Hill Collection.
280 *responsibility of driving* AL interview with Robert Brown, Ojai, CA,
 March 2, 2011.
 position of the gears DA to PH, July 18 (?), [1950]. Pati Hill Collection.
 smoke a cigarette Ibid., n.d. [August 1962].
 "something of a nuisance" Westbeth class transcript, 25.
 "recalcitrant" . . . "the camera wants" Ann Ray Martin.
 like a kaleidoscope Westbeth class transcript, 3.
 "not a virtuoso" . . . credited Lisette Ann Ray Martin.
 "She was very funny" AL interview with AA, New York, NY, August 14,
 2003.
 "my feeling about machines" Westbeth clas transcript, 25.
 must-see tourist sights DA to AA, n.d. [August 1962], published in
 Revelations, 161.
 "avoid sightseeing" DA to PH, n.d. [postmarked September 7, 1949],
 Pati Hill Collection.
281 *"faces of places"* DA to MI, n.d. [c. April 1962], published in
 Revelations, 160.
 Skull Rock *A rock in Disneyland, Cal. 1962*, reproduced in *Revelations*,
 162.
 photograph "emptiness" AL phone interview with Stewart Stern,
 August 11, 2003.
 the sun too bright DA to PH, n.d. [August 1962], Pati Hill Collection.
 propped up her camera AL phone interview with Stewart Stern,
 August 11, 2003.
 "I am Cinderella" . . . "My cup does not" DA to PH, n.d. [August 1962],
 Pati Hill Collection.
 "ruins of Cambodian temples" . . . "advertisement for a dream"
 The notes are in her 1962 notebook, which is reproduced in *Revelations*,
 162, and identified as the draft of a telegram to Harold Hayes. No copy
 of the telegram has survived in Hayes's papers, so it is uncertain that
 she sent it. *A castle in Disneyland, Cal. 1962*, reproduced in *Revelations*,
 288–89.
282 *huge fake boulders* *Rocks on wheels, Disneyland, Cal. 1962*, reproduced in
 Revelations, 248–49.
 "What I'm saying" Westbeth class transcript, 23–24.
 "lack of the unexpected" Ibid., 2.
 she wrote to Duane Michals AL phone interview Duane Michals,
 April 20, 2015; DA to Duane Michals, postcard, n.d. [c. mid-October
 1970], courtesy of Duane Michals. *Stories by Duane Michals* was exhibited
 at the Museum of Modern Art in New York, from October 7 to
 December 6, 1970.
283 *façades on a hill* *A house on a hill, Hollywood, Cal. 1962*, reproduced in
 Revelations, 344–45.
 Tunnel of Laffs Contact Sheet 184 from early summer 1957 seems to be
 the first. Hulick Photo Roster.
 laying bare the apparatus *The House of Horrors, Coney Island, N.Y. 1961*,
 reproduced in *Revelations*, 110, is an example.
284 *photographed the rocks on wheels* Contact Sheet 1463, Hulick Photo
 Roster.

284 *in some sense a collaborator* Phillips, "The Question of Belief," 59.
 very end of 1961 *Revelations*, 333 n.138, reproduces as an example of a
 subject shot in both formats: *Girl on a stoop with baby, N.Y.C. 1962*. These
 appear in 35 millimeter on Contact Sheet 1244A and in medium format
 on Contact Sheet 1258, Hulick Photo Roster.
 began her self-instruction Contact Sheet 1170 for Amy and 1173 for
 Nancy's apartment, Hulick Photo Roster. *Nancy Bellamy's bedroom,
 N.Y.C. 1961* is reproduced in *The Plot Thickens* (San Francisco: Fraenkel
 Gallery, 2014), Plate 10.

285 *old camera had lost* DA to Evelyn and Robert Meservey, n.d. [c. January
 1962], reprinted in *Revelations*, 159.
 introduced by the company in April 1961 http://www.rolleigraphy.org
 /rolleigraphy.html.
 wide-angle lens slightly heightens Phillips, "The Question of Belief," 59.
 completely normal situation *Revelations*, 159–60.
 photographs of soothsayers Contact Sheets 1402, 1403, 1406, 1407, 1412,
 1428, 1431–34, 1436–39, 1444–48, 1452, 1467, 1471, 1473, 1475–77,
 1482, Hulick Photo Roster. The photographs were originally published
 in *Glamour*, January 1964, 67–68 and *Glamour*, October 1964, 131. The
 photographs are reproduced with Arbus's unabridged text in *Magazine
 Work*, 36–37.
 writer Christopher Isherwood Contact Sheets 1435, 1443, 1474, Hulick
 Photo Roster. The picture is reproduced in *Magazine Work*, 25.
 Puerto Rican dance-hall contest Contact Sheet 119, Hulick Photo Roster.
 bodybuilding competitions Contact Sheet 698, Hulick Photo Roster.
 Miss New York City pageant Contact Sheet 901, Hulick Photo Roster.
 Diane described the pageant to Marvin in a letter on July 15, 1960,
 which is published in *Revelations*, 153–54.
 piquant possibilities *Revelations*, 160.

286 *memorialized the Miss Venice* *Miss Venice Beach, Venice, Cal. 1962*,
 reproduced in *Revelations*, 58–59.
 Mr. Universe competition *Muscle man in his dressing room with trophy,
 Brooklyn, N.Y. 1962*, reproduced in *Revelations*, 260, Contact sheet 1515,
 Hulick Photo Roster; "Former Mr. Universe Eiferman Dies at 76," *Sun*
 (Las Vegas), February 14, 2002; Gord Venables, "Backstage at the 1962
 IFBB Mr. Universe—Mr. America Muscle Battle," *Mr. America Magazine*,
 February 1963, 46.
 "you can't win" Diane Arbus, "1962 Notebook (No.8)," published in
 Revelations, 246.

Chapter 40: A Fantastically Honest Photographer

289 *subway pictures* Gilles Mora and John T. Hill, *Walker Evans: The Hungry
 Eye* (New York: Harry N. Abrams, 2004), 220; Sarah Greenough, *Walker
 Evans: Subways and Streets* (Washington, D.C.: National Gallery of Art,
 1991), 21; Walker Evans, "Rapid Transit: Eight Photographs," *i.e. The
 Cambridge Review* 5 (March 1956): 16–25. In 1966, Evans wrote that he
 had delayed book publication until the passage of twenty-five years
 insured "anonymity" of his subjects. The book was published in late
 November 1966. Greenough, *Walker Evans*, 39, and Walker Evans,
 "Twenty Thousand Moments under Lexington Avenue: A Superfluous
 Word." Draft text for maquette of "Lex. Ave. Local" (1966), 127.
 Arbus had a copy of the original 1966 edition of *Many Are Called* in her
 personal library. Doon Arbus, *Diane Arbus: The Libraries* (San Francisco:
 Fraenkel Gallery, 2004), n.p.

289 ***delayed releasing them*** Walker Evans, *Many Are Called* (Cambridge, MA:
 Riverside Press, Houghton Mifflin, 1966).
 her subjects can be seen *Boy in the subway, N.Y.C., 1956.* Robert
 Miller Gallery, New York. As early as December 1956, Arbus was
 photographing people in subway cars with a 35 mm camera. Contact
 Sheet 78, Frames 22 to 28; Contact Sheet 86B, Frames 16 to 20, Hulick
 Photo Roster. She continued to do so in 1957: Contact Sheet 110,
 Frames 20 to 22; Contact Sheet 121, Frames 2 to 23; Contact Sheet
 123, Frames 2 to 13; Contact Sheet 173, Frame 11; Contact Sheet 215,
 Frames 27 to 28; Contact sheet 354, Frames 12 to 29; Contact Sheet
 356, Frames 10 to 15. Her subway portraits continue until she adopts
 the Rolleiflex in 1962.
 Evans hid his camera Greenough, *Walker Evans,* 18; Evans, "Twenty
 Thousand Moments," 127.
290 ***their masks had dropped*** James Agee, "Introduction," in Walker Evans,
 Many Are Called (New Haven: Yale University Press, 2004), 16. Agee,
 who was Evans's close friend and sometime collaborator, wrote this in
 October 1940.
 "in naked repose" Walker Evans, "The Unposed Portrait," *Harper's
 Bazaar,* March 1962, 122.
 "stalking, as in the hunt" Evans, "Twenty Thousand Moments," 127.
 artistically established Greenough, *Walker Evans,* 16.
 self-taught Paul Cummings, *Artists in Their Own Words* (New York:
 St. Martin's Press, 1979), 87.
 despised both Greenough, *Walker Evans,* 13.
 "strong and real"* . . . *starving student Cummings, *Artists,* 88.
291 ***shared his fondness*** Westbeth class transcript, 11.
 "armed with detachment" Evans, "Twenty Thousand Moments," 127.
 Evans enjoyed the distance Jerry L. Thompson, "Walker Evans: Some
 Notes on His Way of Working" in *Walker Evans at Work,* ed. John T. Hill
 (New York: Harper & Row, 1982), 12.
 "fantastically honest" Westbeth class transcript, 28–29.
 "sterling purity" Ibid., 10.
 "insanely calm" Ibid., 33.
 Israel regularly called The apartment is described in Isabelle Storey,
 Walker's Way: My Years with Walker Evans (Brooklyn: powerHouse Books,
 2007), 123. His custom of bringing expensive bottles of claret is on
 pages 171 and 176.
 "hand to mouth"* . . . *a meeting soon AL phone interview with Isabelle
 Storey, October 9, 2014. The interview amplified, and in one instance
 corrected (Arbus was waiting not in a taxi but a car), the account in
 Storey, *Walker's Way,* 176–77.
292 ***"a lot of crap"*** AL interview with Saul Leiter, New York, NY,
 December 16, 2011.
293 ***included her shots*** DA to Walker Evans, September 20, 1962, Walker
 Evans Archive.
 "American Rites, Manners"* . . . *"legendary" Diane Arbus proposal
 for 1963 Guggenheim Foundation grant, reprinted in *Revelations,*
 41. She sent the proposal to Walker Evans when she requested his
 recommendation. DA to Walker Evans, n.d. Walker Evans Archive.
 soliciting testimonials *Revelations,* 334 n. 158.
 "feeling of surrealism" Handwritten note by Edward Steichen to Grace
 Mayer, October 26, 1962. Photography department archive, Museum of
 Modern Art, New York.

293 ***Unable to review her application*** DA to John Scarkowski [*sic*],
 September 23, 1962. A handwritten note, presumably by Szarkowski to
 his assistant Pat Walker, reads, "Pat: wont be back before October 15
 deadline." Photography department archive, Museum of Modern Art,
 New York.

294 ***Szarkowski liked her*** AL phone interview with John Szarkowski,
 August 6, 2003. This interview is the source, except where noted, of all
 the material in this section.

 "That's what you're looking for" Forty years later, Szarkowski recalled
 that the picture he praised was *The Junior Interstate Ballroom Dance
 Champions, Yonkers, N.Y. 1963,* but, according to both the Arbus Estate
 and the Hulick Photo Roster, that picture was taken the next year. She
 would probably have shown him *Child with a toy hand grenade in Central
 Park, N.Y.C., 1962* as it was taken the previous spring, and it is most
 likely the "first of a series on rich children" that she showed Steichen.
 DA to Grace Mayer, n.d. [October 1962]. Photography department
 archive, Museum of Modern Art, New York.

295 ***asking for the name*** Patricia Walker to DA, January 14, 1963.
 Photography department archive, Museum of Modern Art, New York.
 The Kinsey book that Szarkowski recommended was Ralph W. Andrews,
 "This Was Logging!" Selected Photographs of Darius Kinsey (Seattle: Superior
 Publishing Company, 1954). Although less obviously relevant to Arbus,
 Kinsey would have been on Szarkowski's mind, for he was featured in
 a show in progress, *The Photographer and the American Landscape,* which
 opened at the museum on September 24, 1963.

 young couple on Hudson Street Although the geographical coordinate in
 the picture's title is only "Hudson Street," Arbus referred to it as "Boy
 and Girl (on 10th St.)," *Revelations,* 340 n. 408.

 "closes her eyes" Elbert Lenrow to Catherine Lord, October 31, 1977,
 Nemerov Papers. The excerpts from Diane's papers are included in this
 letter.

 frozen moment in time *Teenage couple on Hudson Street, N.Y.C., 1963* is
 reproduced in *Revelations,* 102. Despite the year in the title, the Hulick
 Photo Roster indicates that the photograph was more likely taken
 on New Year's Eve, 1962. Contact Sheets 1644 and 1645, with Arbus's
 selection being 1644, Frame 8. Hulick Photo Roster.

 living room of a tract house *Xmas tree in a living room, Levittown, L.I.
 1963,* reproduced in *Revelations,* 92–93. Despite the year in the title, the
 Hulick Photo Roster reveals that the photograph, Contact Sheet 1630,
 Frame 2, was taken in late December 1962. The year is correctly stated
 in Arbus, "Five Photographs," 64.

296 ***spied through a picture window*** IFCP lecture.

 foreground is indicated Her friend Stephen Salmieri said, "She talked
 about how putting things in the foreground draws you into the
 picture." AL interview with Stephen Salmieri, New York, NY, July 28,
 2015. Hardly a device unique to Arbus, this inclusion of a partial
 foreground detail in close-up was also used occasionally by Walker
 Evans, for instance, in *Fireplace, Burroughs House, Hale County, Alabama,
 1936,* published in Greenough, *Walker Evans,* 62.

 occupant would have diminished For other photographs of Levittown, see
 Margaret Lundrigan Ferrer and Tova Navarra, *Images of America:
 Levittown: The First 50 Years* (Charleston, SC: Arcadia Publishing,
 1997), 7–8. Alternate photographic visions of Levittown interiors
 are proffered in the homey interiors on pages 83–87. Illustrating

another outlook, too, is a fond reminiscence of growing up on Cornflower Road in Levittown in Susan Kirsch Duncan, *Levittown: The Way We Were* (Huntington, NY: Maple Hill Press, 1999). Barbara Gallucci, *Ranch 50: The Levittown Interiors* (Berkeley, CA: Palm Press, 2006) shows how different homeowners personalized a room; the interiors are cluttered but obviously lived-in. How the "richness of 'irrelevant' detail" in this photograph stands in for the "mundane factuality" of contemporary Christmas is discussed in Linda Nochlin, "The Realist Criminal and the Abstract Law," *Art in America* 61 (November–December 1973): 102.

296 *stoneware jugs and kerosene lamps* Some examples can be seen in Maria Morris Hambourg et. al., *Walker Evans* (New York: Metropolitan Museum of Art, 2000), Plates 90–93.

Chapter 41: Is the Jewish Couple Happy?

297 *shouting argument* Samira Bouabana and Angela Tillman Sperandio, *Hall of Femmes: Ruth Ansel* (Oyster Press, 2010), 21–22. AL phone interview with Ruth Ansel, August 23, 2003. Although Ansel dates Israel's dismissal to late 1962 and the cause to an argument over the January 1963 cover, the fact that the contentious cover was published suggests otherwise. Also, Walker Evans wrote to his wife, Isabelle, on February 23, 1963, with the "latest" news of Israel's dismissal; he had described previously, on February 1, 1963, a dinner he prepared for Israel and Arbus, when Evans was "trying to do business with" Israel, who was clearly still in possession of his job. Storey, *Walker's Way*, 182, 188.

298 *"I called to tell you"* DA to Walker Evans, n.d., Walker Evans Archive, reprinted in *Revelations*, 166.

 "My father told me" DA to Lisette Model, n.d. [postmarked April 22, 1963], Lisette Model Archive, reprinted in *Revelations*, 166.

 "spellbound" . . . *"resent that implication"* Studs Terkel.

 photographs of the body Contact Sheets 1848, 1862, 1868, 1870, 1876, 1877, 1881, Hulick Photo Roster. One of her photographs is reproduced in *Revelations*, 166.

 went to Gertrude *Fictive Life*, 166.

 illusion of wealth Studs Terkel.

299 *"Painting has filled"* David Nemerov Obituary, New York *World-Telegram*, clipping in Alisa Sparkia Moore Collection.

 "a stranger walks in" "The Desk Set," *Time*, November 24, 1958, 80.

 dubious facts . . . *"devastating technique"* Studs Terkel.

 "A Jewish couple dancing" The photograph, *A Jewish couple dancing, N.Y.C. 1963*, is reproduced in *Revelations*, 97. It appears on Contact Sheet 1822, Frame 4, Hulick Photo Roster.

300 *visited Amy at summer camp* AL interview with Roberta Miller, New York, NY, January 26, 2012.

 she took screen shots Contact Sheet 1211, Hulick Photo Roster.

 "separation was meaningful" AL interview with Zohra Lampert, New York, NY, July 20, 2011.

301 *refused to allow Allan* Ibid., June 12, 2015.

 announced that she was Ibid., September 22, 2011.

 periodic shelter AL interview with RS, Ventura, CA, March 1, 2011.

 "tired and a little delicate" DA to PH, n.d. [April 5, 1958], Pati Hill Collection.

302 *traditional masculine role* AL interview with Alisa Sparkia Moore, Ventura, CA, November 10, 2012.

Chapter 42: And Then You're a Nudist

303 *"How terrific!"* IFCP lecture; Westbeth class transcript, 40.

"walking into an hallucination" Diane Arbus, "Notes on the Nudist Camp," *Magazine Work,* 68.

Sunshine Park in early July *Revelations,* 167. Nudists first appear on Contact Sheet 1998. Many of the pictures of nudists that she printed and that were later exhibited come from this first visit, including *A husband and wife in the woods at a nudist camp, N.J. 1963* (the "Adam and Eve" couple) on Contact Sheet 2001; *A young waitress at a nudist camp, N.J. 1963,* on Contact Sheet 2003; *Husband and wife with shoes on in their cabin at a nudist camp, N.J. 1963* on Contact Sheet 2004; and *Retired man and his wife at home in a nudist camp one morning, N.J. 1963,* on Contact Sheet 2006. *Nudist man and his dog in trailer, N.J. 1963,* is on Contact Sheets 2021 and 2029 (with an alternate version on Contact Sheet 2029). Hulick Photo Roster.

thanks to Marvin Westbeth class transcript, 37.

avoided the spotlight IFCP lecture; "Notes on the Nudist Camp," 69.

called the director IFCP lecture.

"I hope you realize" Westbeth class transcript, 37. Arbus recounts the story with slight variations in "Notes on the Nudist Camp," 68.

304 *moral tone* Westbeth class transcript, 39–40. Although Arbus says this occurred at Sunny Rest, that camp was one she visited later, in the Poconos in Pennsylvania. In the lecture at the IFCP, she says that she photographed the young waitress (Lorna Jahrling) in the first camp she visited.

penalties reinforced Westbeth class transcript, 40.

she was nervous Ibid., 39.

"just takes a minute" Ibid., 37. She also told Alan Levy that she removed her clothing in the nudist camps. Levy, "Working with Diane Arbus," 81.

one thing she could be "The reasons I photograph freaks on the one hand and nudists on the other is that they're both apart from the norm, but I can't be a freak and I *can* be a nudist—there's the knowledge of the possibility of taking on a new role as a nudist, not just fantasizing," Arbus said in 1967. Ann Ray Martin.

305 *"really loathsome"* Westbeth class transcript, 39.

fallen cedar needles AL telephone interview with Lorna Jahrling Anton, August 7, 2012.

"pictures on the walls" "Notes on the Nudist Camp," 69.

"always jiggling" Westbeth class transcript, 41. She said that she hated volleyball especially because it was a sport in which, if you missed the ball, everyone noticed that you had let down the team.

"slip into something" IFCP lecture.

placed a towel AL phone interview with Lorna Jahrling Anton, August 7, 2012. In Lauren Collins, "Where Are They Now," *The New Yorker,* May 16, 2005, Anton said that she recalled Arbus wearing a tank top and shorts. But in this interview, she said that she remembered Arbus placing a towel on the stool, which she would not have done if clothed. Arbus talks about being naked and the towel custom in Westbeth class transcript, 37, 40.

waitress, Lorna Jahrling AL phone interview with Lorna Jahrling Anton, August 7, 2012; *A young waitress at a nudist camp, N.J. 1963,* reproduced in *Revelations,* 72.

306 *"one thing is missing"* Westbeth class transcript, 39.

pitched the nudist idea According to *Revelations,* 335 n. 181, Arbus photographed a nudist camp in Pennsylvania for *Esquire* in 1965, but there is no documentation of this extant in the magazine's files.

Hayes generously provided *Magazine Work,* 162–63.

backed out of a pledge Thomas Southall interview with Robert Benton, June 29, 1982.

didn't print them Of twenty-nine contact sheets, beginning with 1998 and continuing to 2033 (including three sheets of other events, mainly in nearby Atlantic City), most of the pictures are posed. Contact Sheets 2007 and 2009 include unposed pictures, with the volleyball game on Contact Sheet 2007, Hulick Photo Roster. Aside from the quality of the pictures, the difficulty of obtaining releases from all recognizable people in a group photograph generally discouraged such efforts by photographers in nudist camps. William E. Hartman, *Nudist Society: An Authoritative, Complete Study of Nudism in America* (New York: Crown Publishers, 1970), 48.

retired middle-aged couple *Retired man and his wife at home in a nudist camp one morning, N.J. 1963,* reproduced in *Revelations,* 253. Although one of the two portraits on the TV is hard to make out, Arbus in her caption for "A Box of Ten Photographs" wrote, "On the television set are framed photographs of each other." Catalog, Christie's, Sale 9298, October 5, 1999, Lot 301, Lot Notes.

307 *banality* Thomas Southall interview with Robert Benton, June 29, 1982.

nude pictorial ideal Kenneth Clark, *The Nude: A Study in Ideal Form* (New York: Pantheon, 1956) distinguishes between the naked and the nude, especially on pages 3–29.

overweight family *A family one evening in a nudist camp, Pa. 1965,* reproduced in *Revelations,* 295. Although the sex of the child is hard to determine, the release form indicates it is a girl. Curatorial Exhibition Files, Exh. #821. Museum of Modern Art Archives, New York.

a fête champêtre Clark, *The Nude,* 121–22, discusses the lineage from Giorgione's *"Concert champêtre"* to Manet's *"Le déjeuner sur l'herbe."*

at Pine Forest AL phone interview with Lorna Jahrling Anton, August 7, 2012.

308 *depicts a nude couple* *A husband and wife in the woods at a nudist camp, N.J. 1963,* reproduced in *Revelations,* 118–19.

owned a postcard *Revelations,* 151.

"way back in the Garden" "Notes on the Nudist Camp," published in *Magazine Work,* 69.

Chapter 43: It's Not Like You're Acting

309 *"Paul and the priest"* PH to Alain de la Falaise, October 1963, excerpted in Pati Hill journals, Pati Hill Collection.

Pati cunningly invited AL interviews with PH, Sens, France, January 20, 2011, and January 24, 2011. One of the photographs is in the Pati Hill Collection. Hill said that the story had been misunderstood by Violaine Binet, who recounts it in Binet, *Diane Arbus,* 93. Binet writes that Arbus wanted the girl in the picture, when the opposite was the case.

310 *one of two photographers* Thomas Southall interview with Sam Antupit, July 1, 1982.

atmosphere of nonconformity Burton R. Clark, *The Distinctive College: Antioch, Reed & Swarthmore* (Chicago: Aldine Publishing Co., 1970), 166.

310 *to Suzanne Victor* *Revelations*, 167–68.

311 *Mardi Gras, although the only picture* Ibid., 168. Arbus's photographs
 of Mardi Gras appear in Contacts Sheets 3268 to 3289, Hulick Photo
 Roster.
 astounding hairdo *Lady bartender at home with a souvenir dog, New Orleans,
 La. 1964,* reproduced in *Revelations*, 168.
 photographed Mrs. T. Charlton Henry *Mrs. T. Charlton Henry on a couch in
 her Chestnut Hill home, Philadelphia, Pa. 1965,* reproduced in *Revelations*,
 116.
 discovered Betty Blanc Glassbury In addition to information gleaned
 from the photograph, the description of the apartment relies on
 Pauline Peters, "Dr. Glassbury's Widow," *The Sunday Times Magazine*
 (London), January 7, 1968, 30(S)–31(S).

312 *perhaps in the same week* Arbus's photographs of David Nemerov dead
 in the hospital and in his coffin at the funeral appear on Contact Sheets
 1870, 1876, 1877 and 1881. Her pictures of Mrs. Glassbury are on
 Contact Sheets 1896, 1902, 1907 and 1909, Hulick Photo Roster.
 "terrifically moved" IFCP lecture.
 she wears a shiny *A widow in her bedroom, N.Y.C. 1963,* reproduced in
 Revelations, 44.
 earliest experiments Contact Sheet 86A, Hulick Photo Roster. At the
 same time, using her Nikon, she devoted a roll of film to shop displays
 of buttons, food, china, cutlery, dolls, hats, hair accessories, toys,
 cufflinks, lighters, hairbrushes, pots and pans, bras, cosmetics, meat
 and fruit. Contact Sheet 95, Hulick Photo Roster.
 atheist Madalyn Murray Bynum Shaw, "Nevertheless, God Probably Loves
 Mrs. Murray," *Esquire*, October 1964, 110–12, 168–71. The photograph is
 reproduced in *Magazine Work*, 55, along with an alternate version, 160.
 "We talked and talked" AL phone interview with Blaze Starr,
 February 2, 2015.

313 *strikes the same pose* Thomas B. Morgan, "Blaze Starr in Nighttown,"
 Esquire, July 1964, 59–62. The photographs were reproduced in
 Magazine Work, 46–47.
 " 'the Blaze Starr style' " Thomas Southall interview with Sam Antupit,
 July 1, 1982.
 less appealing subject "Lee Oswald's Letters to His Mother," *Esquire*,
 May 1964, 67–73, 75, 162. The photograph is reproduced in *Magazine
 Work,* 44.

314 *smug and self-satisfied* Westbeth class transcript, 30–31.
 "dumb girl business" . . . *"round and blank"* Ibid., 9.
 picture was unedifying Thomas B. Morgan, "The Long Happy Life
 of Bennett Cerf," *Esquire*, March 1964, 112–13, 115, 118, 150. The
 photograph is reproduced in *Magazine Work*, 160.
 "any public inference" . . . *"makes him tick"* Morgan, *Self-Creations*, 184,
 197.

315 *Robert Campin of Christ* *Christ in a Lobby, N.Y.C. 1964,* reproduced in
 Revelations, 169. The 35 mm picture appears on Contact Sheet 3412,
 Frames 1 to 6. The painting by Robert Campin, *Blessing Christ and
 Praying Virgin,* was completed circa 1424 and is in the collection of the
 Philadelphia Museum of Art.

Chapter 44: To Know People, Almost in a Biblical Sense

317 *moved from Astoria* Diane Arbus, "The Bishop's Charisma" in *Magazine
 Work,* 48.

317 *"a thousand cameras"* AL phone interview with Bunny Sellers,
 August 21, 2003.
 Arbus photographed the blissfully *Magazine Work,* 48–53.
318 *"feel that they were wonderful"* AL phone interview with Bunny Sellers,
 August 21, 2003.
 The previous summer, Joel Meyerowitz AL phone interview with Joel
 Meyerowitz, August 7, 2003. Photographs of the hotel golf course and
 swimming pool appear on Contact Sheet 2098, Hulick Photo Roster.
319 *"beautiful waif"* AL phone interview with Nicky Haslam, June 26, 2014.
320 *Arbus was breathless* AL phone interview with Robert Brown,
 August 13, 2003.
 West hated the pictures AL interview with AA, August 14, 2003.
 "Men are my kind" The unexpurgated text appears in Diane Arbus,
 "Mae West: Once Upon Our Time" in *Magazine Work,* 58–61. Abridged
 and edited, but with a third picture and an alternate version of West
 with the monkey, printed in color, it ran as Diane Arbus, "Mae West:
 Emotion in Motion," *Show,* January 1965, 42–45. Another color picture
 of West from the same session, in her bedroom but without the
 monkey, was published with Helen Lawrenson, "Mirror, Mirror, on the
 Ceiling: How'm I Doin'," *Esquire,* July 1967, 73.
 "never to have suffered" Arbus, "Mae West: Once Upon Our Time," 58.
321 *psychological collapse in 1961* Slivka, *Margaret Ponce Israel,* 14. According
 to Slivka, the nervous breakdown persisted until 1971.
 "You could babysit" AL phone interview with Patricia Patterson, June 6,
 2012.
 "not going to say anything" AL interview with Mary Frank, New York,
 NY, April 23, 2012.
322 *"guilt and sorrow"* Alexander Nemerov, *Silent Dialogues: Diane Arbus &
 Howard Nemerov* (San Francisco: Fraenkel Gallery, 2015), 32.
 extramarital affairs AL phone interview with Pamela Hadas, June 21, 2012.
 talked about on campus AL phone interview with Kathy Corley, June 14,
 2012.
 "We didn't know her" AL phone interview with Pamela Hadas, June 21,
 2012.
 "desire to be cared for" AL phone interview with Mary Frank,
 August 11, 2003.
 "Marvin was manipulating her" AL interview with Deborah Turbeville,
 New York, NY, November 17, 2011.
323 *"naughty thing to do"* IFCP lecture. This was not uncommon, until
 recently. Walker Evans said that when he took up photography, "I was
 a little shame-faced about it, because most photography had about it a
 ludicrous, almost comic side, I thought. A 'photographer' was a figure
 held in great disdain. Later I used that defiantly. But then, I suppose,
 I thought photographing was a minor thing to be doing." Leslie Katz,
 "Interview with Walker Evans," *Art in America* 59 (March–April 1971): 84.
 blind date Westbeth class transcript, 2.
 to take a picture Ibid., 2.
 sexual tryst Ann Ray Martin.
 "go where I've never been" Westbeth class transcript, 10.
 Moondog, a long-bearded Robert Scotto, *Moondog: The Viking of Sixth
 Avenue,* rev. ed. (Port Townsend, WA: Process Media, 2013), 19. Scotto's
 biography is the source of my information about Moondog and his
 habits, except for the color of the cape and the material of the spear,
 which are specified in William Borders, "Moondog Changes His

Costume, But Keeps His Iconoclastic Life," *New York Times,* May 15, 1965, 33.

324 *"Moondog's faith"* *Revelations,* 157.

knew Moondog well enough AL interview with Mary Frank, New York, NY, April 23, 2012.

accompany him home The photographs of Moondog sitting on the floor, next to his bed, appear on Contact Sheets 3331, taken with the Rolleiflex, and 3485A, in 35 mm. They are underexposed, with only highlights visible. Arbus photos of Moondog on the street are on Contact Sheets 3319, 3322 and 3325. Hulick also reports an earlier 35 mm roll of film, Contact Sheet 998, devoted to Moondog, taken at the end of 1960 or early in 1961, which was when Arbus was photographing such eccentrics as Uncle Sam. The only previous depictions of Moondog, this may well be a misidentification. Hulick Photo Roster.

cockroach-infested room Scotto, *Moondog,* 148–49.

"shocking, in the best sense" AL phone interview with John Szarkowski, August 6, 2003.

Chapter 45: An Element of Torture

325 *at least since 1962* *Three girls at a Puerto Rican festival, N.Y.C. 1962,* Fraenkel Gallery, San Francisco.

anger and hostility For example, reproduced in *Revelations, Three Puerto Rican women, N.Y.C. 1963,* 39, and *Puerto Rican woman with a beauty mark, N.Y.C. 1965,* 84.

"an aberration, a burden" DA to PC, n.d. [late March or early April, 1969].

Harold Hayes approved Harold Hayes to DA, August 9, 1965, Harold Hayes Papers.

326 *Sharon Goldberg* *Sharon Goldberg, N.Y.C. 1965,* along with the remark, *Revelations,* 175.

"very silvery ways" AL phone interview with Larry Fink, August 22, 2003.

"hard up for money" AL phone interview with Ruth Ansel, August 23, 2003.

"wanted to do debutantes" AL interview with Deborah Turbeville, New York, NY, November 17, 2011.

editors preferred "The Fashion Independent: The Young Heiresses," *Harper's Bazaar,* April 1964, 162–67.

327 *dragged on* Far from unprecedented, photographic portrait sessions that lasted for hours were standard for Sander and Nadar. Keller, "Conceptual and Stylistic Aspects," in *Sander: Citizens,* 27; Keller, "Sorting Out Nadar" in Maria Morris Hambourg et. al., *Nadar* (New York: Harry N. Abrams, 1995), 79.

"try to wear people down" AL interview with Deborah Turbeville, New York, NY, November 17, 2011.

"my idea" . . . "on our faces" AL interview with Robert Benton, New York, NY, January 24, 2012.

328 *"Sallie didn't know"* AL phone interview with Robert Benton, March 13, 2012.

married couples that Arbus "Fashion Independents: On Marriage," *Harper's Bazaar,* May 1965, 156–61.

"I refused to cooperate" Thomas Southall interview with Clay Felker, November 8, 1982.

greeted with greater cooperation AL interview with Jane Wilson and John Gruen, New York, NY, February 19, 2011.

330 *pale Courrèges pantsuit* AL interview with Frederick Eberstadt, New York, NY, February 1, 2011. Turbeville remembered an acid-green Rudi Gernreich dress, but the caption confirms Frederick's recollection.
 "looked like Morticia" AL interview with Deborah Turbeville, New York, NY, November 17, 2011.
 "deal of trouble" Frederick Eberstadt e-mail to AL, December 8, 2013.

331 *she didn't scruple* Thomas Southall interview with Harold Hayes, November 22, 1982.
 call Jayne Mansfield's AL phone interview with Mary-Louise Norton, December 3, 2011.
 perplexed but compliant AL interview with Deborah Turbeville, New York, NY, November 17, 2011.
 poignant picture of Mansfield Reproduced in *Magazine Work*, 66. The inspiration for Mansfield's makeup can be found in Raymond Strait, *Here They Are Jayne Mansfield* (New York: S.P.I. Books, 1992), 238.
 very gracious AL interview with Deborah Turbeville, New York, NY, November 17, 2011. The double portrait ran in *Harper's Bazaar*, September 1964, 187.

Chapter 46: People on Plinths

333 *"Are you Jewish?"* Marilyn J. Curry, "On Not Being Photographed by Diane Arbus," *New York Stories Magazine* (Spring 2005).
 LSD trips Carole Chomsker e-mail to Frish Brandt, January 29, 2004. Chomsker wrote that in the photograph *Young couple on a bench in Washington Square Park, N.Y.C. 1965* she and her soon-to-be husband were probably coming down from an LSD trip.
 observed the different cliques Westbeth class transcript, 26.

334 *"they've got rules"* IFCP lecture.
 girl from the Bronx Westbeth class transcript, 26.
 spring and summer of 1965 *Revelations*, 172.
 "very scary" Westbeth class transcript, 26.
 "There are times" AL interview with PH, Sens, France, January 22, 2011.

335 *"when I felt like it"* Ann Ray Martin.
 people felt like sculptures Westbeth class transcript, 26.
 "very, very keen" Ibid., 26. Reprinted in slightly edited form in *Revelations*, 172.
 fishnet bags AL phone interview with Michael Flanagan, August 25, 2003.
 "very high spirits" AL interview with Michael Flanagan, Lyme, CT, March 13, 2011.
 one lesbian couple *Two friends at home, N.Y.C. 1965* is reproduced in *Revelations*, 75, and the alternate version appears on page 176. *Two friends in the park, N.Y.C. 1965* is in the Fraenkel Gallery collection.
 "mysterious sort of body thing" IFCP lecture.

336 *pregnant wife, adorned* Curry, "On Not Being Photographed." *Young man and his pregnant wife in Washington Square Park, N.Y.C. 1965*, reproduced in *Revelations*, 79.
 characteristic of the portraits *Girl and boy, Washington Square Park, N.Y.C. 1965*, reproduced in *Revelations*, 45, is an excellent example. Another is *Young couple on a bench in Washington Square Park, N.Y.C. 1965*, reproduced in *Diane Arbus: An Aperture Monograph*, and in a small image in *Revelations*, 62. This gender disparity in her photographs of young couples persists, as can be seen in a Central Park picture taken in the

last year of her life, *A young man and his girlfriend with hot dogs in the park, N.Y.C. 1971,* reproduced in *Diane Arbus: An Aperture Monograph,* n.p.; and in a smaller image, in *Revelations,* 66–67.

336 *sultry star magnetism* *Girl with a cigar in Washington Square Park, N.Y.C. 1965,* reproduced in *Revelations,* 43.

 homosexual young men *A young Negro boy, Washington Square Park, N.Y.C. 1965,* reproduced in *Revelations,* 114; *Two young men on a bench, Washington Square Park, N.Y.C. 1965,* reproduced in *Revelations,* 172.

 edginess to the scene *Revelations,* 174.

 two or three images Keller in *Sander: Citizens,* "Conceptual and Stylistic Aspects," 27.

 shoot once and move on In a contact sheet of twelve exposures, each of Arbus's Washington Square Park subjects is different from the last. *Revelations,* 173.

Chapter 47: Teaching Younger People

339 *class on Tuesday afternoons* *Revelations,* 174.

340 *"have to teach"* DA to HN, n.d. [c. late fall 1965], Nemerov Papers.

 Flanagan had first met AL phone interview with Michael Flanagan, August 25, 2003.

 Michael nonetheless blurted AL interview with Michael Flanagan, Lyme, CT, March 13, 2011.

 referred all questions AL interview with Benedict Fernandez, Hoboken, NJ, June 29, 2012.

 "incredible stickler" AL phone interview with Michael Flanagan, August 25, 2003.

 "fabulous assignments" . . . *to munch* AL interview with Paulette Hunsicker Griefen, New York, NY, July 19, 2012.

341 *read them ghost stories* AL interview with Michael Flanagan, Lyme, CT, March 13, 2011. Arbus refers to this as well in DA to HN, n.d. [c. late fall 1965], Nemerov Papers.

 "my pride" AL phone interview with Patricia Patterson, June 6, 2012.

 "Which is the mother?" AL phone interview with May Eliot Paddock, March 20, 2011.

 "in a flash" DA to HN, n.d. [c. late fall 1965], Nemerov Papers.

342 *with Bruce Davidson* AL interview with Bruce Davidson, New York, NY, January 8, 2015. Except when otherwise stated, this interview is the source for the following account.

 "Arbus was a giant" AL phone interview with Bruce Davidson, August 20, 2003.

343 *Flanagan fantasized* AL phone interview with Michael Flanagan, August 25, 2003.

Chapter 48: This Is the Whole Secret

345 *Diane came up with the idea* *Revelations,* 178.

 Unlike Doon, Diane had seen Diane had seen Brown perform at the Apollo, in *Revelations,* 178. Doon wrote that she had seen him only on television. Doon Arbus, "James Brown Is Out of Sight," *New York* (New York *Herald Tribune*), March 20, 1966, 14.

 team pitched Thomas Southall interview with Clay Felker, November 8, 1982.

 two pictures The pictures of Brown in black tie and in a kimono appear, respectively, in Doon Arbus, "James Brown," 14, 15; and in *Revelations,* 178, 95. The frames are on Contact Sheets 4229 to 4338,

4240 to 4248 and 4256. The Brenda Frazier contact sheets are the next ones. Hulick Photo Roster.

345 *she ended her piece* Doon Arbus, "James Brown," 24.

346 *unusual phrase* Erving Goffman, *The Presentation of Self in Everyday Life* (Garden City, NY: Doubleday Anchor Books, 1959), 70.

"mixed feeling" IFCP lecture.

347 *"don't think you see"* AL phone interview with Paulette Hunsicker Griefen, July 24, 2012.

"Medical Science being" "Hubert's Obituary," *Magazine Work,* 81.

"I try not to" . . . *grandmother Rose* IFCP lecture.

cover of Life *Life,* November 14, 1938.

348 *at least thirty-one times* Gioia Diliberto, *Debutante: The Story of Brenda Frazier* (New York: Alfred A. Knopf, 1987), 233.

alcoholic beverage . . . *pills* Ibid., 235, 258.

household from her bed Ibid., 244.

smoking cigarettes . . . *friends* Bernard Weinraub, "The Girl of the Year, 1938," *Esquire,* July 1966, 74–75.

strained relationship . . . *forlorn* Brenda Frazier, "My Debut—A Horror," *Life,* December 6, 1963, 137.

on January 6, 1966 *Revelations,* 336 n. 240.

"she was underwater" . . . *not even an apple* AL phone interview with Bernard Weinraub, October 31, 2013.

Arbus's photograph The photograph appears in Weinraub, "Girl of the Year," 72–73, and is reproduced in *Revelations,* 261.

349 *"that picture totally erases"* AL phone interview with Bernard Weinraub, October 31, 2013.

"deceptively nice" AL phone interview with Byron Dobell, October 3, 2013.

unconscionably cruel Diliberto, *Debutante,* 259.

"really studied the person" Thomas Southall interview with Sam Antupit, July 1, 1982.

Chapter 49: Mysteries of Sex

351 *"wet and hairy"* Westbeth class transcript, 12.

"really beautiful" Ibid., 11, reprinted in *Revelations,* 336 n. 249.

envied Renee Anne Wilkes Tucker notes of interview with Marvin Israel, February 24, 1972.

swinging *to replace* Hartman, *Nudist Society,* 106. For more on the provincial, middle-class mindset of swingers, see David Allyn, *Make Love, Not War: The Sexual Revolution: An Unfettered History* (Boston: Little, Brown, 2000), 207–10.

352 *told Benton and Hayes* Thomas Southall interview with Harold Hayes, November 22, 1982.

group-sex parties or orgies Allyn, *Make Love, Not War,* 209–10.

irreverently catalogued "Petronius," *New York Unexpurgated* (New York: Matrix House, 1966).

pool party AL interview with Ti-Grace Atkinson, Cambridge, MA, May 20, 2013.

it would be droll AL interview with Estelle Parsons, New York, NY, February 12, 2015. This conversation occurred in spring 1967.

slept with any man AL interview with Frederick Eberstadt, New York, NY, February 1, 2011.

Greyhound rides AL phone interview with Gay Talese, September 13, 2011.

352 *masturbating patrons* AL phone interview with Buck Henry, June 25, 2015.

353 *sex photographs* *Couple under a paper lantern, N.Y.C. 1966,* reproduced in *Revelations,* 112. An even less convincing picture, *Couple in bed, N.Y.C. 1966,* is in *Revelations,* 62–63. Very few of the sex pictures Arbus took, which are listed in the Hulick Photo Roster, have been made public.

 "incredible romantic" Westbeth class transcript, 11.

 she was participating *Revelations,* 178.

 swingers are looking directly An example is the contact sheet reproduced in *Revelations,* 180.

 atlas of penises AL phone interview with Gay Talese, September 13, 2011.

 individuality of noses IFCP lecture.

 "Nothing is ever alike" Arbus, "Five Photographs," 64.

 sexual endowment of musclemen AL phone interview with Melvin Sokolsky, July 7, 2014.

354 *"a picture, a statue"* *Fictive Life,* 84–85.

 "kind of contagion" DA to HN, n.d. [c. November 1965], Nemerov Papers. Reprinted in *Revelations,* 176.

 "spectacular, shocking" *Fictive Life,* 80.

355 *self-created, cocaine-loving* AL phone interview with Monti Rock, April 20, 2014.

 Arbus squeezed Darlene de Sedle Vare e-mail to AL, May 5, 2014. Arbus can be seen (briefly) in the car, in the film *You're Nobody Till Somebody Loves You* by D.A. Pennebaker.

 Diane photographed Monti Contact Sheets 4541, 4542, 4545 to 4548, and 4552, Hulick Photo Roster.

 "fatal destiny" IFCP lecture.

 arranged for mid-May *Revelations,* 181.

356 *sex manual* The bookshelf is visible in a photograph in *Revelations,* 181.

 dyed her hair black DA to PC, n.d. [c. mid-October 1968].

 "incredibly rudimentary" IFCP lecture.

 picture that best captured "A young Brooklyn family going for a Sunday outing, N.Y.C. 1966," reproduced in *Revelations,* 8–9.

 "undeniably close" DA to PC, n.d. [c. mid-October 1968], reprinted in *Revelations,* 181.

 "Truth and Consequences" IFCP lecture.

Chapter 50: I Think We Should Tell You, We're Men

357 *second Guggenheim* *Revelations,* 177.

 much of the spring Ibid., 178.

 "not to be missed" Geri Trotta, "Not to Be Missed: The American Art Scene," *Harper's Bazaar,* July 1966, 80–85.

358 *"very meekly"* AL phone interview with Gideon Lewin, June 2, 2014.

 "never carried anything" Diana Hulick taped interview with Garry Winogrand, December 16, 1980, Hulick Photo Roster.

 "instinctive, nearly primitive" DA to the John Simon Guggenheim Memorial Foundation, December 10, 1968. Exhibited at the Winogrand retrospective at the Metropolitan Museum of Art, New York, 2014.

 hepatitis B Centers for Disease Control and Prevention, *Hepatitis B FAQs for the Public;* California Department of Public Health, *Acute Hepatitis B and C,* July 2013. Arbus's seemingly full recovery in about six weeks and the recurrence of the illness two years later strongly suggests it was Hepatitis B, and not A or C.

 orgies and other erotic Contact Sheet 4457, of a naked white woman

on the lap of a black man, with Arbus appearing naked in one frame, is reproduced in *Revelations*, 180. The sequencing in the Hulick Photo Roster suggests the pictures were taken at about the time of Easter Sunday, which in 1966 fell on April 10. According to *Revelations*, 178, Arbus around that time "photographs orgies in which she is a participant and some of her own individual sex partners posing naked in the aftermath."

359 **prophylactic injections** *Revelations*, 336 n. 254.

first installment Ibid., 181.

"The Fellowship enabled me" The application is in the archives of the John Simon Guggenheim Memorial Foundation, New York, and published in part in *Revelations*, 176.

Washington Square Park In spring 1966, for example, she photographed a man in Washington Square Park and also in his home, where he wore a bra and stockings. Contact Sheets 4410, 4432 to 4444, Hulick Photo Roster.

hair in curlers *A young man in curlers at home on West 20th Street, N.Y.C. 1966*, reproduced in *Revelations*, 46–47. In the note that she included in the 1971 Box of Ten Photographs and which also appeared in the catalogue to the Venice exhibition in 1972, Arbus said the young man was "dressing for an annual drag ball." *USA: XXXVI International Biennial Exhibition of Art/Venice*, June 11–October 1, 1972. See also *Seated man in bra and stocking, N.Y.C. 1967* in *Revelations*, 279.

Riding her bicycle IFCP lecture.

360 **Called Vicky** Although the name is spelled "Vickie" in *Revelations*, she signed her release for the photograph to be exhibited in the *New Documents* show ("but not in a magazine") as "Vicky Strasburg." Curatorial Exhibition Files, Exh. #821. Museum of Modern Art Archives, New York. Arbus said Vicky had named herself "after Lee Strasberg or Susan Strasberg or both of them." Westbeth class transcript, 44. Nevertheless, Vicky spelled it her own way.

aggressive ugliness . . . ladylike note IFCP lecture.

lobby evoked Hades Westbeth class transcript, 42.

only guests Anne Wilkes Tucker notes of interview with Marvin Israel, February 24, 1972.

photograph of Vicky *Transvestite at her birthday party, N.Y.C. 1969* is reproduced in *Diane Arbus: An Aperture Monograph*, n.p. Another photograph taken on the same occasion, *Transvestite and her birthday cake, N.Y.C. 1969*, appears in *Revelations*, 198. Speaking of Vicky, Arbus said, "She hustles, a lot of them do this, they wear a sanitary napkin and they permanently say they're women and they all say that they never, nobody's ever complained or asked for their money back." IFCP lecture.

361 **gender identity and sexual orientation** IFCP lecture.

gay men in sexual encounters Contact Sheet 4660, Hulick Photo Roster.

article on transsexuals Tom Buckley, "The Transsexual Operation," *Esquire*, April 1967, 111–15, 205–8. Arbus's photograph appears on page 112 and is reproduced in *Magazine Work*, 89.

"least threatening" Thomas Southall interview with Sam Antupit, July 1, 1982.

pioneering book Harry Benjamin, *The Transsexual Phenomenon* (New York: Julian Press, 1966). The description of Benjamin is in Buckley, "The Transsexual Operation," 113.

362 **just like Gertrude** IFCP lecture.

"people is the flaw" Westbeth class transcript, 4.

363 *shows Vicky as she was* *Transvestite on a couch, N.Y.C. 1966,* reproduced in *Revelations,* 250–51.
 candidate she could suggest DA to HN, n.d. [c. early 1967], Nemerov Papers.
 wallpaper mural *A lobby in a building, N.Y.C. 1966,* reproduced in *Revelations,* 78. It appears on Contact Sheet 4537, as does a photograph of a shirtless young man wearing lipstick. Hulick Photo Roster.

Chapter 51: Nancy and Pati in Middle Age

365 *star of malevolence* AL phone interview with Jeanne Christopherson, February 18, 2011; AL interview with Charles Atlas, New York, July 27, 2011.
 ended in a separation Judith Stein e-mail to AL, July 10, 2014.
 worked in its box office AL phone interview with Ralph M. Lee, February 25, 2011.

366 *put on rubber gloves* AL phone interview with Albert Poland, February 22, 2011.
 Nancy furnished it AL phone interview with Margaret Wright, September 30, 2011; *Nancy Bellamy's bedroom, N.Y.C. 1961,* reproduced in *The Plot Thickens,* Plate 10.
 favorite quotations AL interview with Charles Atlas, New York, July 27, 2011.
 reds and other dark colors AL phone interview with Jean Rigg, August 2, 2011.
 purple and morning-glory AL phone interview with Jeanne Christopherson, February 18, 2011.
 subtly modulated shifts AL phone interview with Ralph M. Lee, February 25, 2011.
 red or blue lightbulbs AL phone interview with Albert Poland, February 22, 2011.
 purple velvet curtains AL interview with Charles Atlas, New York, July 27, 2011.
 television room . . . container garden AL phone interview with Ralph M. Lee, February 25, 2011.
 Poets' Theater Details of the general history of the Judson Memorial Church and the Poets' Theater are drawn from Robert Joseph Cioffi, "Al Carmines and the Judson Poets' Theater Musicals" (Ph.D. diss., New York University, 1979), and Adrian Sayre Harris, "The Judson Poets' Theatre: 1960–1973" (Ph.D. diss., Florida State University School of Theatre, 1978). The correct spelling is "Poets' Theater."

367 *dreamed of Carmines* AL phone interview with Jean Rigg, August 2, 2011.
 plastic netting . . . safety pins Cioffi, "Al Carmines," 83.
 "wonderful ideas" AL phone interview with Lee Guilliatt, November 21, 2011.
 intricate backstory AL interview with Charles Atlas, New York, July 27, 2011.
 inspiration from the masques Cioffi, "Al Carmines," 86.
 standby books For Nancy's literary preferences, AL phone interview with Jeanne Christopherson, February 18, 2011. The record of Diane's library is found in Doon Arbus, *The Libraries.*

368 **Our Lady of the Flowers** Marvin Israel gave Arbus her copy of *Our Lady of the Flowers. Revelations,* 150.
 "She took credit" AL phone interview with Jean Rigg, August 2, 2011.

368 *"interested in so much"* AL phone interview with Margaret Wright, September 30, 2011.
suprisingly durable wig Ibid.
"totally eccentric and amazing" AL phone interview with Ralph M. Lee, February 25, 2011.
ideas in **Vogue** AL phone interview with Albert Poland, February 22, 2011.
despite being gay Ibid.

369 *she was schizophrenic* Ibid.
frequently brought her AL interview with Charles Atlas, New York, July 27, 2011.
last Carmines musical It was *Christmas Rappings,* which opened on December 14, 1969. Cioffi, "Al Carmines," 291.
"tough skin" AL phone interview with Ralph M. Lee, February 25, 2011.
estranged from her daughter AL phone interview with Wendy Clarke, August 7, 2013.
Pati detested Marvin AL interview with PH, Sens, France, February 2, 2014.

370 *published a novella* Pati Hill, *One Thing I Know* (Boston: Houghton Mifflin, 1962).
"absolutely to be lived" DA to PH, n.d. [c. 1961], Pati Hill Collection, published in *Revelations,* 165. The often-quoted Søren Kierkegaard remark, which is a condensation of a statement from his journals, is, "Life can only be understood backwards, but it must be lived forwards." *Kierkegaard's Journals and Notebooks* 2 (Princeton, NJ: Princeton University Press, 2008), 179. Interestingly for a photographer, Kierkegaard concluded that because time cannot be stopped, life can never be fully understood.
"You were right" PH to Alain de la Falaise, c. February 1968, excerpted in Pati Hill journals.
"dependent on me" PH e-mail to AL, June 15, 2011.

371 *"comeuppance of Dr. Heller"* AL interview with PH, Sens, France, January 22, 2011.
Diane visited and reminded Pati Hill journals. n.d. are the source of these recollections.
"brain in my head" AL interview with PH, Sens, France, January 22, 2011.

Chapter 52: Each with a Tiny Difference

373 *Christmas Day party in 1966* *Horizons* 1 (December 1972). (A publication of the Esso Research and Engineering Company.) Clipping in Museum of Modern Art Archives, New York.
met the Slota family Signed release from Mrs. J. Slota, February 7, 1967. Curatorial Exhibition Files, Exh. #821. Museum of Modern Art Archives, New York.
posed the sisters Contact Sheet 3378 is of twins and triplets and 3379 to 3381 are of the triplets at home, Hulick Photo Roster.
Dressed identically and primly *Triplets in their bedroom, N.J. 1963* is reproduced in *Revelations,* 84.
machine-made repetitions The contrast between the repetitive patterns in the setting and the slight differences among the triplets is discussed in Amy Goldin, "Diane Arbus: Playing with Conventions," *Art in America* 61 (March–April 1973): 74.
"They remind me" Ann Ray Martin.

374 *provide her with the lineups* IFCP lecture.

374 *"I don't like to arrange"* Ann Ray Martin.
 Covering competitions Westbeth class transcript, 15.
 two farm-girl sisters Farm girls, c. *1928* in *Sander: Citizens,* 19.
375 *two of the eight children* Horizons.
 baleful doppelgänger Identical twins, Roselle, N.J. *1967,* is reproduced
 in *Revelations,* 265. Despite the date, the picture was taken at
 Christmastime 1966. In the Hulick Photo Roster, the Roselle party for
 twins is the subject of Contact Sheets 4517–4519, 4521, 4522, 4525
 and 4539A. The last, identified as 4539 and published in *Revelations,*
 182, contains the image Arbus chose. Around this time, Arbus was
 photographing the New York lobby mural, which is dated 1966. The
 photograph of the Roselle twins was dated 1966 when it was first
 exhibited in the *New Documents* show of 1967 at the Museum of Modern
 Art. For unknown reasons, it was misdated in the 1972 Aperture
 monograph and thereafter.
 darker alter ego A "powerful consciousness of guilt which forces
 the hero no longer to accept the responsibility for certain actions
 of his ego, but to place it upon another ego, a double, who is either
 personified by the devil himself or is created by making a diabolical
 pact" was identified in an early psychoanalytic study. Otto Rank, *The
 Double: A Psychoanalytic Study* (Chapel Hill: University of North Carolina
 Press, 1971 [1914]), 76. The theme was later much explored in
 psychoanalytic thought, notably by Melanie Klein.
 "What's left after" The line is reprinted in *Revelations,* 264, juxtaposed
 with this photograph.
376 *"bobby pins" . . . "similar, but different"* IFCP lecture.
 "worst likeness" Horizons.
377 *"unhomelike"* Sigmund Freud, "The 'Uncanny,'" was published in
 1919 and translated into English by Alix Strachey. James Strachey ed.,
 The Standard Edition of the Complete Psychological Works of Sigmund Freud,
 vol. 17 (London: Hogarth Press, 1955), 217–52.
 "fantasy can be literal" Ann Ray Martin.
 "reality is reality" Westbeth class transcript, 23.

Chapter 53: Desperate to Be Famous

381 *without any curatorial attempt* Szarkowski makes the point explicitly in
 Mark Durden, "Eyes Wide Open: Interview with John Szarkowski," *Art
 in America* 94 (May 2006): 89.
 blocks to build a narrative Christopher Phillips, "The Judgment Seat
 of Photography," *October,* Autumn 1982, 27–63. For the significance
 of Szarkowski's approach and title in his first show, see page 53.
 The attitude is expressed more obliquely in a press release from the
 Museum of Modern Art, New York, March 28, 1963.
 "personal intentions of the photographer" John Szarkowski, *Mirrors and
 Windows: American Photography since 1960* (Boston: New York Graphic
 Society, 1978), 17.
 take his lead "I think I was quite clear in my mind when I came here
 that whatever a curator's responsibilities were, one was not to lead
 artists," Szarkowski said in an interview with Jerome Liebling. Quoted
 in Maren Stange, "Photography and the Institution: Szarkowski at the
 Modern," *Massachusetts Review* 19 (Winter 1978): 697.
 distinguished between the "realists" Szarkowski, *Mirrors and Windows,*
 18, 25.
382 *he brought attention* Sandra S. Phillips, "Szarkowski the Photographer"

in John Szarkowski, *Photographs* (New York: Bulfinch Press, 2005), 36, 135–36; press release, Museum of Modern Art, New York, January 25, 1966.

382 ***New Deal photographers*** Sharon Corwin, Jessica May and Terri Weissman, *American Modern: Documentary Photography by Abbott, Evans, and Bourke-White* (Berkeley: University of California Press, 2010), 6.

sought to understand it In his wall label introducing the show, Szarkowski wrote: "Their aim has been not to reform life but to know it, not to persuade but to understand." Press release, Museum of Modern Art, New York, February 28, 1967.

383 ***"absolutely the first breath"*** Typescript of Andy Grundberg interview with John Szarkowski, for Grundberg, "An Interview with John Szarkowski," *Afterimage* 12 (October 1984): 12–13, in John Szarkowski file, Museum of Modern Art Archives, New York.

"explore their own experience" AL phone interview with John Szarkowski, August 6, 2003.

Walker Evans and Robert Frank Evans said, "I *do* have a critical mind, and it creeps in, but I am not a social protest artist, although I have been taken as one very widely. If you photograph what's before your eyes and you're in an impoverished environment, you're not—and you shouldn't be, I think—trying to change the world or commenting on this and saying, 'Open up your heart, and bleed for these people. I would never dream of saying anything like that; it's too presumptuous and naïve to think you can change society by a photograph or anything else. . . . Anyway, I equate that with propaganda; I think that is a lower rank of purpose. I believe in staying out, the way Flaubert does in his writing." Lincoln Caplan, ed., "Walker Evans on Himself," *New Republic*, November 13, 1976, 25. Unlike Evans, Frank was not often categorized as a political partisan.

really novel Peter Galassi discusses Friedlander's affinities with Atget in Peter Galassi, *Friedlander* (New York: Museum of Modern Art, 2005), 53–54. He is considering Friedlander's work of the seventies, but the work of the sixties, particularly of reflective shop windows, also bears similarities to the earlier photographer. For Winogrand and Frank, see Tod Papageorge, *Core Curriculum* (New York: Aperture, 2011), 82. A decade after *New Documents,* Szarkowski wrote that Winogrand was "profoundly influenced by Frank." He identified Arbus's predecessors as Brassaï, Bill Brandt and Weegee. Szarkowski, *Mirrors and Windows,* 24.

"central photographer" Szarkowski, *Mirrors and Windows,* 23. See also Arthur Lubow, "The Spaces In Between," *Threepenny Review* 133 (Spring 2013): 21–22.

384 ***"ceremonial sensitivity"*** *Revelations,* 163–64, 179.

"I'm glad you are" DA to John Szarkowski, n.d. Department of Photography archives, Museum of Modern Art, New York.

duet with his wife Reproduced in *Revelations,* 183.

obtained seven Arbus submitted an "Artist Record" with a brief summary of her career and interests on October 5, 1964, at the time of the acquisition. The museum in 1964 purchased *Child, Night, Greenwich Street, N.Y.C. 1961, A husband and wife in the woods at a nudist camp, N.J. 1963, Child with a toy hand grenade in Central Park, N.Y.C. 1962, Widow in her bedroom, N.Y.C. 1962, Two female impersonators backstage, N.Y.C. 1961,* and *Retired man and his wife at home in a nudist camp one morning, N.J. 1963.* The seventh, *Miss Venice Beach, Venice, Calif. 1962,* has a 1962 acquisition number, probably because it was a gift from Arbus that

accompanied the purchase. Museum of Modern Art Archive, New York.

384 *"Diane was not at all eager"* Kelly Wise, "An Interview with John Szarkowski," *VIEWS: The Journal of Photography in New England* 3, no. 4 (1982): 13

385 *"thought that I'd wait"* . . . *"show at the Museum"* Ann Ray Martin. *wrote to Szarkowski* *Revelations,* 183.
only three were shot Checklist, *New Documents,* Museum of Modern Art Archives, New York.
she printed four Arbus credits Szarkowski with suggesting the larger size in the interview with Ann Ray Martin. The four are *A family one evening in a nudist camp, Pa. 1965, Puerto Rican woman with a beauty mark, N.Y.C. 1965, Identical twins, Roselle, N.J. 1967,* and *A young man in curlers at home on West 20th Street, N.Y.C. 1966,* as listed in the checklist for the traveling version of the show and visible in the installation photographs. Folder 821.4, Museum of Modern Art Archives, New York.
available for purchase Ann Ray Martin.

386 *"I want children"* . . . *handsome black waiter* AL interview with Pat Peterson, New York, NY, February 1, 2011. Arbus later also told her psychiatrist about going to bed with a black waiter in Jamaica. PB interview with Helen Boigon, August 13, 1981, Gotlieb Archive.
returned her crown AL interview with Pat Peterson, New York, NY, February 1, 2011.
guest list . . . "not greedy" Curatorial File 821, Museum of Modern Art Archives, New York.

387 *delighted when Howard* DA to HN, n.d. [c. February 1967]. Nemerov Archive.
formidable director *Revelations,* 183–84. "René d'Harnoncourt Dead at 67; Headed Museum of Modern Art," *New York Times,* August 14, 1968, 43.
About 250 people Curatorial Folder 821.5, Museum of Modern Art Archives, New York.

388 *helmet cut . . . makeup* *Revelations,* 185. Catalogue Note, Sotheby's, Lot 165, Photograph, October 7, 2015.
"Diane looks old" PH to Alain de la Falaise, spring [early March] 1967, excerpted in Pati Hill journals, Pati Hill Collection.
"appalling green dress" AL interview with Mary Frank, New York, NY, April 23, 2012.
radiant as a movie star . . . yellow roses *Revelations,* 185.
picture shows her watching See photo insert.
made up postcards *Revelations,* 183.
Even Elbert Lenrow DA to Elbert Lenrow, n.d. Nemerov Papers.
To Michael Smith AL phone interview with Michael Smith, July 14, 2014.
spying on spectators Ann Ray Martin; DA to Paul Salstrom, March 5, 1967, published in *Revelations,* 185.
"desperate to be famous" AL interview with Saul Leiter, New York, NY, December 16, 2011.
"desire for attention" AL interview with PH, Sens, France. December 18, 2011.

389 *"this sophisticated woman"* AL interview with Tod Papageorge, New Haven, CT, May 13, 2013.
Avedon was a master "Dick Avedon was the best self-PR schmoozer I've ever seen in my life," said photographer Melvin Sokolsky. AL phone interview with Melvin Sokolsky, July 7, 2014.

389 **Newsweek *devoted*** "Telling It As It Is," *Newsweek,* March 20, 1967, 110.
"*hard on the other*" David Vestal, *Infinity* 16 (April 1967): 16, 26.
"*urgent complicity*" Max Kozloff, "Photography," *The Nation,* May 1, 1967, 573.
Other critics reported Frank Gaynor, "Documentary Photos," March 5, 1967, unidentified newspaper; Martha Merrill, "Photography at the Modern," undated and unidentified paper. Museum of Modern Art Archives, New York.
Norman Mailer stated Norman Mailer to DA, May 24, 1967, typed copy, Harry Ransom Center, University of Texas at Austin.

390 ***shot of the Venice Beach*** Jacob Deschin, "People Seen As Curiosity," *New York Times,* March 5, 1967, Section 2, 21; *Miss Venice Beach, Venice, Calif. 1962,* is reproduced in *Revelations,* 58–59.
at the University of Wisconsin *Invitational Exhibition 10: American Photographers 10* (University of Wisconsin–Milwaukee, School of Fine Arts, March 2–26, 1965), n.p.
barely recognized AL interview with Deborah Turbeville, New York, NY, November 17, 2011.
similarly surprised to hear AL phone interview with Gideon Lewin, June 2, 2014.
more like a comma AL interview with Tod Papageorge, New Haven, CT, May 13, 2013.

391 ***admiring the glass-sided pool*** Her photographs are on Contact Sheets 4691 and 4695, Hulick Photo Roster.
Ansel and Feitler loved AL phone interview with Ruth Ansel, May 28, 2014.
loopy and ornate DA to MI, n.d. [mid-March 1967], Michael Flanagan Collection, reprinted in *Revelations,* 186. In this postcard, she also reports on seeing the lady wrestlers and the palazzo.
twenty-two-year-old Brooklyn-born AL phone interview with Stephen Salmieri, February 16, 2015.

392 ***"Diane had a show"*** Pati Hill journals, May 1967, Pati Hill Collection.

Chapter 54: Peace and Love

393 ***I've been jumpy*** DA to HN, n.d. [fall 1967], Howard Nemerov Papers, reprinted in *Revelations,* 188.
Bruce Davidson, who energetically For a longer discussion, see Arthur Lubow, "Documentary Art," *Threepenny Review* 138 (Summer 2014): 31.
exhibited forty-three of the East 100th Street Press release, Museum of Modern Art, New York, September 23, 1970.
were declining This is discussed in Szarkowski, *Mirrors and Windows,* 11–14.

394 ***any competent photographer*** Geoff Dyer, *The Ongoing Moment* (New York: Pantheon, 2005), 252. Dyer notes that this argument was made by Sontag, in *On Photography,* 133–35.
Arbus was the pivotal figure The change and Arbus's central role in it are discussed critically in Julia Scully and Andy Grundberg, "Currents: American Photography Today," *Modern Photography* 44 (February 1980): 94–99, 168–69, 175, and in Nicholas Lemann, "Whatever Happened to the Family of Man?" *Washington Monthly,* October 1984, 12–18.
look for people at the edges AL phone interview with Bob Adelman, March 17, 2014.

395 ***She accompanied Fernandez*** AL interview with Benedict Fernandez,
 Hoboken, NJ, June 29, 2012.
 she captured two specimens *Boy with a straw hat waiting to march in a
 pro-war parade, N.Y.C. 1967,* reproduced in *Revelations,* 87; *Patriotic young
 man with a flag, N.Y.C. 1967,* reproduced in *Revelations,* 38. They appear,
 respectively, on Contact Sheets 5027A and 5041, Hulick Photo Roster.
 The march took place on May 13, 1967.

396 ***shiny lipstick*** *Blonde girl with shiny lipstick, N.Y.C. 1968,* reproduced in
 Revelations, 77.
 silk turban IFCP lecture. *Woman with a veil on Fifth Avenue, N.Y.C. 1968,*
 reproduced in *Revelations,* 77. A kindred image is *Woman with pearl
 necklace and earrings, N.Y.C. 1967,* reproduced in *Revelations,* 185.
 round, bald *A very young baby, N.Y.C. 1968,* reproduced in *Revelations,*
 69. The photograph is misdated; it was taken in September 1967. The
 chosen frame appears on Contact Sheet 5231, Hulick Photo Roster. It
 was published, along with poems by Sandra Hochman, as "The New
 Life," *Harper's Bazaar,* February 1968, 160–61.
 "like Goldilocks's porridge" DA to Carlotta Marshall, n.d. [c. November
 1968], published in *Revelations,* 196.

397 ***She asked* Newsweek** Ann Ray Martin.
 consent not to change AL interview with PH, Sens, France, January 22,
 2011.
 She wrote to ask AL phone interview with Paul Salstrom, April 3,
 2012.
 Paul Salstrom, the leader . . . come visit Ibid.
 "very monkish young man" DA to PH, n.d. [postmarked August 1,
 1967], Pati Hill Collection.
 Newsweek *tracked her* AL phone interview with Paul Salstrom,
 August 7, 2003.

398 ***"These aren't freaks, Paul"*** Ibid., April 3, 2012. Supporting Salstrom's
 recollection, the Hulick Photo Roster lists no pictures of the San
 Francisco counterculture.
 led to many rivals Josh Sides, *Erotic City: Sexual Revolutions and the
 Making of Modern San Francisco* (New York: Oxford University Press,
 2009), 45–46, 50–51; Allyn, *Make Love, Not War,* 25–26.
 Yvonne gazes out in Arbus's photograph *Topless dancer in her dressing
 room, San Francisco, Cal. 1968,* reproduced in *Revelations,* 257. The
 photograph is misdated. Arbus's only trip to San Francisco was in
 July 1967. The photograph is Frame 10A, Contact Sheet 5113. Hulick
 Photo Roster. Although sometimes misidentified as Carol Doda, the
 performer is Yvonne D'Angers. A picture of her appears on the cover of
 Cabaret Queens Quarterly, Winter 1968. The book in the image is Giorgio
 De Santillana, ed., *Leonardo da Vinci,* first published in English in 1956
 by Reynal & Company.
 told Salstrom that she was ready Except where noted, the following
 account is based on AL phone interviews with Paul Salstrom, August 7,
 2003, and April 3, 2012.

399 ***disappointing sexual encounter*** PB interview with Paul Salstrom, July 1,
 1982, Gotlieb Archive.
 "I will not apologize" . . . she belonged DA to Paul Salstrom, July 28,
 1967, published in *Revelations,* 187.
 "nothing really delights me" . . . "irrational automobile" DA to PH, n.d.
 [postmarked August 1, 1967], Pati Hill Collection.
 purchased for $200 *Revelations,* 183.

399 *"I seem to have forgotten"* DA to PH, n.d. [postmarked August 1, 1967], Pati Hill Collection.

Chapter 55: An English Connection

401 *blend of sympathy and cruelty* AL phone interview with Michael Rand, July 10, 2015.

 "grit and glamour" Mark Edmonds, "Grit and Glamour in Full Colour," *Sunday Times* (London), February 5, 2012.

 "good on freaks and ugly people" Hunter Davies e-mail to AL, November 15, 2014.

402 *"all the pictures off my wall"* DA to Amy Arbus, n.d. [summer 1967], published in *Revelations,* 187.

 "your work and your laundry" AL interview with Doon Arbus, New York, NY, August 9, 2003.

 "counselors who read them" AL interview with AA, New York, NY, August 14, 2003.

 fretted anxiously AL phone interview with Carlotta Marshall, August 11, 2003.

 He spoke rapturously AL interview with PC, London, February 8, 2012. This interview is the source for the following account, except where noted. Much of this material (although not the orgy invitation) is also included in Peter Crookston, "Diane's All-Devouring Eye," *Sunday Telegraph* (London), October 5, 1997, 8.

 late October 1967 Arbus's appointment book has a first entry for Crookston on October 24, 1967, and then a second for the evening of November 5, which aligns with Crookston's recollection as the probable date of their dinner after his return from California, *Revelations,* 338 n. 312.

403 *"You looked at me"* DA to PC, n.d. [early June 1968].

 "it was the sixties" AL phone interview with PC, July 8, 2015.

 "terribly odd" DA to HN, n.d. [fall 1967], Nemerov Papers, reprinted in *Revelations,* 187.

 shot late that summer According to Arbus's appointment book, she took the photographs of Anderson Cooper on September 15 or 18, 1967, *Revelations,* 337 n. 304. The pictures are on Contact Sheets 5204 to 5208, 5214 to 5232, 5236, 5239, 5306, Hulick Photo Roster. The pictures of the Diaper Derby, Jason Solotaroff and Mel Lyman were processed at about the same time.

404 *took of Jason Solotaroff* AL interview with Jason Solotaroff, New York, NY, January 13, 2015, Contact Sheets 5155, 5158A, 5159, 5160, 5164A, 5166, 5168 to 5170, 5194, 5195, Hulick Photo Roster.

 "remorseless scrutiny" DA to PC, n.d. [late March or early April 1969].

 Parents hoping to win Pauline Peters, "How to Train a Derby Winner," *Sunday Times Magazine* (London), March 21, 1968, 44(S)–48(S).

 "rules of this game" . . . *"absolutely miserable"* IFCP lecture.

 photographed the juvenile *A child crying, N.J. 1967,* reproduced in *Revelations,* 281; *Loser at a Diaper Derby, N.J. 1967,* reproduced in *Revelations,* 117.

 knit-browed baby, teething *Mother holding her child, N.J. 1967,* reproduced in *Revelations,* 17.

 "little tiny bit" IFCP lecture.

 Crookston assigned a reporter Peters, "Dr. Glassbury's Widow"; Peters, "How to Train."

405 *$150 a page plus expenses* DA to PC, "Thursday eve." n.d. [c. June 1968].

"not so rich either" Ibid., n.d. [early June 1968].

prisoners on death row Ibid., July 4, [1968]. She also asked Lisette Model for help in pursuing this subject. Lopate, "Portrait of Lisette Model," 81.

"always struggling for money" AL phone interview with Ruth Ansel, August 23, 2003.

tended to assign her Thomas Southall interview with Sam Antupit, July 1, 1982.

"Being snotty" AL phone interview with Josephine Bradley Bush, June 26, 2014. The photographs appear on Contact Sheets 5332 to 5336, 5338 to 5343, Hulick Photo Roster. The print of the couple in Carl Schurz Park was shown to the author by Ms. Bush.

406 *turn around her life* DA to PC, November 30, [1967], reprinted in *Revelations*, 189.

never spoke of the trip Ibid., "December 12 or so," [1967], reprinted in *Revelations*, 189.

"Plans changed" Ibid., n.d. [December 19, 1967], mostly reprinted in *Revelations*, 189.

Chapter 56: The Heart of the Maelstrom

407 *Diane trudged off* *Revelations*, 189.

"dwelling places" . . . *"normal scroogeness"* DA to PC, "December 12 or so," [1967], reprinted in *Revelations*, 189.

"a fresh start" Ibid., n.d. [December 19, 1967].

two apartments *Revelations*, 189.

"pure housewife" DA to PC, n.d. [January 1968], reprinted in *Revelations*, 189.

408 *"old house fell apart"* Ibid., n.d. [late January 1968], reprinted in *Revelations*, 189.

plaster over chicken wire AL phone interview with Mary Louise Norton, December 3, 2011.

"dug into a wall" AL interview with PH, Sens, France, December 18, 2011.

dark and depressing AL interview with Saul Leiter, New York, NY, December 16, 2011.

"creating a stage set" Ibid., March 14, 2012.

"made my hair curl" Ibid., December 16, 2011.

"intricate human ballet" Jane Jacobs, *The Death and Life of Great American Cities* (New York: Alfred A. Knopf, 1961), 50–54. Jacobs describes the income mix in the West Village on page 38.

409 *"heart of the maelstrom"* DA to PC, May 18, 1968, reprinted in *Revelations*, 190.

accost the journalist John Gruen AL interview with John Gruen, New York, NY, February 19, 2011.

"amazingly flamboyant" DA to PC, May 18, 1968, reprinted in *Revelations*, 190.

being "strange to myself" Ibid., n.d. [January 1968], reprinted in *Revelations*, 189.

"some odd new thing" Ibid., n.d. [December 19, 1967], reprinted in *Revelations*, 189.

"see them more clearly" DA to Amy Arbus, n.d. [summer 1967], published in *Revelations*, 187.

409 *shedding her enthusiasm* Westbeth class transcript, 46.
410 *reeking of squalor* Bynum Shaw, "Let Us Now Praise Dr. Gatch," *Esquire,*
 June 1968, 108–11, 152, 154–56. Six photographs, including three not
 published in *Esquire,* are reproduced in *Magazine Work,* 100–105.
 "I never saw poverty" . . . *Jacob Riis* Studs Terkel.
411 *"decadent Andy Warhol figure"* Thomas Southall interview with Clay
 Felker, November 8, 1982.
 moved his headquarters Colacello, *Holy Terror,* 81; Victor Bockris,
 Warhol: The Biography (Cambridge, MA: Da Capo Press, 1997), 278–79.
 manufacture of hats Colacello, *Holy Terror,* 29.
 decorated by an amphetamine-fueled Andy Warhol and Pat Hackett,
 POPism: The Warhol '60s (New York: Harcourt Brace Jovanovich,
 1980), 64.
 a couple of the actors Malanga is in Contact Sheets 3491A, 3493A,
 3494, 3494D, Hulick Photo Roster. In the same period, Holzer was
 photographed both at home and at the Factory. AL interview with
 Jane Holzer, April 17, 2014. AL phone interview with Gerard Malanga,
 December 8, 2014.
412 *sleepy-eyed and sultry* *Young man on a sofa, N.Y.C. 1966,* is reproduced in
 Revelations, 73.
 Malanga was just waking up AL phone interview with Gerard Malanga,
 December 8, 2014.
413 *editors discussed what to do* Although Felker gave Southall an
 implausible account of making "a trial layout" that was then sent out
 hurriedly without his final approval, Glaser said, "I think Clay agreed
 to run those pictures, I know he did. With some trepidation." Thomas
 Southall interview with Clay Felker, November 8, 1982. AL interview
 with Milton Glaser, New York, NY, March 18, 2014.
414 *fourth issue* Barbara Goldsmith, "La Dolce Viva," *New York,* April 29,
 1968, 36–41.
 "They were so outraged" Thomas Southall interview with Clay Felker,
 November 8, 1982.
 "I think Clay after that" AL phone interview with George A. Hirsch,
 November 15, 2014.
 between the murders George A. Hirsch e-mail to AL, November 11, 2014.
415 *"harsh and humorless"* DA to PC, n.d. [early June 1968], reprinted
 in *Revelations,* 190, but misdated; it is extracted from the same letter
 elsewhere correctly dated as circa June 1968.
 "ranks up there with the worst" Viva Hoffmann e-mail to AL, April 13,
 2014.

Chapter 57: Fantasy Made Actual

417 *"chin was on the ground"* DA to PC, n.d. [early June 1968].
418 *"part of my snobbery"* Ibid., reprinted in *Revelations,* 192.
 "looks like a dentist" Ibid., reprinted in *Revelations,* 191.
 marriage lasted less *Revelations,* 338 n. 333; Gertrude Nemerov married
 Phillip Rosenberg on June 24, 1968; Alisa Sparkia Moore e-mail to AL,
 January 2, 2016.
 recognized a small-time grifter DA to PC, May 18, [1968]. The timing
 of the letter, and the fact that this cross-dresser "tells marvelous stories
 about the advantages of having a womans job as opposed to a mans,"
 make it almost certain that this is the same person Arbus described at
 length in her IFCP lecture.
 "female liberation sort of thing" IFCP lecture.

419 *a picture she titled* Reproduced in *Revelations*, 98.
 in the process of undressing The sequence is published in *Revelations*,
 194–95. The contact sheets that Arbus devoted to these photographs
 shortly antedate the Tarnopol pictures of mid-June 1968. To judge from
 the leafed-out trees, it was most likely late April or May. Contact Sheets
 5627 to 5645, Hulick Photo Roster.
420 *"purple passages"* DA to PC, n.d. [early June 1968].
 ardently and admiringly AL interview with PC, London, February 8, 2012.
 "there is a joke" DA to PC, n.d. [early June 1968]. The first part of the
 excerpt is published in *Revelations*, 344, where it is dated May 1968.
 It was written after May 18 and before June 16, most likely in June.
 As portions of the same letter are dated as circa June 1968 in three
 different excerpts in *Revelations*, 191, the discrepancy is evidently an
 oversight.

Chapter 58: A Family on Their Lawn in Westchester

421 *bought at Tape Measure* AL interview with June Kelly Tarnopol,
 Westport, CT, March 15, 2011. Except where noted, the following
 account is based on that interview, complemented by an interview with
 her son, Paul Tarnopol, on that day.
422 *"wanting to do families"* . . . *"any animal out"* DA to PC, n.d. [early June
 1968], reprinted in *Revelations*, 191.
 cartoonist Charles Addams Doon Arbus, *The Libraries*, n.p.; Charles
 Addams, *Dear Dead Days: A Family Album* (New York: G. P. Putnam's
 Sons, 1959).
423 *annual Reith Lecture* Edmund Leach, *A Runaway World?* (New York:
 Oxford University Press, 1968), 44.
 "stopped in a Bookstore" DA to PC, n.d. [early June 1968], reprinted
 in *Magazine Work*, 168, and in *Revelations*, 191. The phrase, "and
 miniskirted like a former show girl," which Arbus wrote in the margin
 of the letter, is not included in either publication.
 "all families are creepy" DA to PC, n.d. [early June 1968]. The first nine
 words are published in *Revelations*, 191.
424 *"It's a question"* Harold Pinter, *The Homecoming* (New York: Grove
 Press, 1965), 36.
 "none of us can ever" DA to PC, n.d. [early June 1968].
 "the most bedrock" Westbeth class transcript, 12.
 "As for the family again" DA to PC, n.d. [early June 1968].
 A couple of months elapsed Arbus called June Tarnopol on April 12 and
 visited on June 16. *Revelations*, 190 n. 331. This accords with Tarnopol's
 independent recollection that the bookstore meeting took place in late
 March or early April, and the photo shoot occurred in June.
425 *"a family that was like"* IFCP lecture.
 "the look of nowhere" DA to AE, June 13, [1951], Alexander Eliot
 Collection.
 "like a theatrical backdrop" Neil Selkirk, "In the Darkroom," in
 Revelations, 270.
426 *she could return in August* DA to PC, July 4 [1968].
 "it was the only good one" IFCP lecture.
 cold, distant separation AL interview with Pat Peterson, New York, NY,
 February 1, 2011.
 "nearly like Pinter" DA to PC, n.d. [September 1968], reprinted in
 Revelations, 195.
427 *"a photograph exists alone"* Westbeth class transcript, 24.

427 *"living its own independent"* Thomas, *Lisette Model,* 86. This is taken
 from Model's teaching notebooks.

Chapter 59: A Frightful Zombie

429 *collapse in exhaustion* DA to Carlotta Marshall, "August 4 or 5," [1968],
 published in *Revelations,* 192.
 "oddly out of sorts" . . . *"portentous to me"* DA to PC, July 4 [1968],
 reprinted in *Revelations,* 192.
 "shyster lawyer" . . . *keep resisting* DA to PH, n.d. [postmarked
 August 12, 1968], Pati Hill Collection.
 On July 18 *Revelations,* 192.
 air-conditioned private room DA to PH, n.d. [postmarked August 12,
 1968], Pati Hill Collection.
 In emergencies, Diane AL interview with PH, Sens, France, January 20,
 2011.
430 *decorated with rugs . . . kept a bottle* Storey, *Walker's Way,* 37, 42.
 Marvin had made love AL interview with PC, London, February 8,
 2012.
 "you couldn't liver" DA to Carlotta Marshall, "August 4 or 5," [1968],
 published in *Revelations,* 192.
 shivering with apprehension DA to PH, n.d. [postmarked August 12,
 1968], Pati Hill Collection.
 "total lack of imagination" Westbeth class transcript, 31.
 "melodramatic" . . . *"depressing me so"* DA to PH, n.d. [postmarked
 August 12, 1968], Pati Hill Collection.
431 *Vivactil* William Todd Schultz, *An Emergency in Slow Motion: The Inner
 Life of Diane Arbus* (New York: Bloomsbury, 2011), 174.
 "the oddest way" . . . *"how comical it is"* DA to PH, n.d. [postmarked
 August 12, 1968], Pati Hill Collection.
432 *"no longer a photographer"* DA to Carlotta Marshall, "August 4 or 5,"
 [1968], published in *Revelations,* 192.
 "I photograph, I can't even" IFCP lecture.
 contracted through group sex PB interview with Nancy Christopherson,
 May 2, 1982, Gotlieb Archive.
 gave her "the creeps" . . . *"eat like a cannibal"* DA to PH, n.d.
 [postmarked August 12, 1968], Pati Hill Collection.
433 *climbing a mountain* AL phone interview with May Eliot Paddock,
 March 20, 2011.
 strange "rage" DA to PC, n.d. [September 1968], reprinted in
 Revelations, 194.

Chapter 60: An Ideal Woman

435 *Robert urged Allan* AL interview with Robert Brown, Ojai, CA, March 2,
 2011.
436 *"confusingly and delightfully wed"* DA to PC, n.d. [early June 1968],
 reprinted in *Revelations,* 192.
 When Cooper Union asked *Revelations,* 194.
 "supporting my small self" DA to PC, n.d. [early June 1968], reprinted
 in *Revelations,* 192.
 "considerable insertions" . . . *"easily dwindle"* DA to HN, n.d.
 [c. November 10, 1968], Nemerov Papers, reprinted in *Revelations,* 194.
437 *colleagues regarded John Calley . . . charmer attractive* David Owen,
 "Return of the Mogul," *The New Yorker,* March 21, 1994, 68–86.
 "blow the whole thing" DA to PC, n.d. [c. mid-October 1968].

437 *excruciatingly artificial . . . would be "fun"* DA to Lisette Model, n.d.
 [postmarked October 21, 1968], Lisette Model Archive, National
 Gallery of Canada.
438 *sexual relationship with Calley* Sabrina Calley e-mail to AL, October 31,
 2013; AL phone interview with Buck Henry, June 25, 2015.
 her jutting teeth AL interview with RS, Ventura, CA, March 2, 2011.
 resembled Dracula AL interview with PH, Sens, France, January 22, 2011.
 "odd assortment of shapes" AL interview with Barbara Jakobson, New
 York, NY, April 10, 2015.
 braces for four months DA to Robert and Evelyn Meservey, n.d.
 [postmarked April 5, 1967], copy in Bosworth Collection, Gotlieb
 Archive.
 "dashing off everywhere" DA to HN, n.d. [c. November 10, 1968],
 Nemerov Papers, reprinted in *Revelations,* 195.
439 *fancy-dress party* "Kit Kat and Beaux Arts Costume Balls," *New York
 Times,* November 10, 1968, 104. The ball was held on November 15.
 The party dress was a choice of black tie or Mardi Gras costumes. Arbus
 wrote Crookston that she preferred to stay in New York that weekend
 "because there is a marvelous masquerade I wanted to photograph";
 DA to PC, November 8, [1968].
 beaded and bearded celebrants In 1967, she attended the Spring
 Mobilization to End the War in Vietnam on April 15 and the Human
 Be-In in June, both in Central Park. *Revelations,* 186. She seems not to
 have photographed there. However, she did take pictures (although
 apparently did not print the results) of hippies in the Sheep's Meadow
 of Central Park at Eastertime 1968. Contact Sheets 5582 and 5588,
 Hulick Photo Roster.
 Marilyn Neilson, who attended AL interview with Marilyn Neilson and
 Rulonna Neilson, New York, NY, October 19, 2014. Rulonna is Marilyn's
 daughter. Unless otherwise noted, Marilyn Neilson is the source for this
 account.
 male colleagues were conveying For examples of pictures that Winogrand
 took at parties at the Museum of Modern Art and the Metropolitan
 Museum in 1969, see Leo Rubinfien, ed., *Garry Winogrand* (New Haven:
 Yale University Press, 2013), Plates 262, 266 and 293. For Friedlander's
 pictures in his Gatherings series, from 1969 to 1971, see Galassi,
 Friedlander, Plates 219–230, and Galassi's discussion on page 43.
440 *the picture Arbus printed* Four people at a gallery opening, N.Y.C. 1968,
 reproduced in *Revelations,* 240–41. Marilyn Neilson identified the event
 as the Artists and Models Ball, not a gallery opening.
 Museum of Famous People The museum photographs are on Contact
 Sheets 6091 to 6094, 6099, 6100. The Artists and Models Ball pictures
 are probably on Contact Sheet 5975, but may be on a slightly earlier
 sheet. Hulick Photo Roster. Although the museum is not specified, the
 subject matter determines that it is the Museum of Famous People,
 which displayed dioramas of figures cast from a vinyl material known as
 plastisol. "History Lives in Museum," *Gazette* (Montreal), December 2,
 1967, 27. Allison Meier, "Lost Museums of New York," *Atlas Obscura,*
 November 24, 2014, atlasobscura.com.

Chapter 61: A Political Year

441 *judged her photographs "awful"* DA to Carlotta Marshall, October 10,
 1968, published in *Revelations,* 195 and 339 n. 356. In the letter, Arbus
 says she shot the photograph on October 2.

441 **almost as saccharine** Paul Engle, "On a Photograph of Mrs. Martin Luther King at the Funeral," *Harper's Bazaar,* December 1968, 106–7.
 "It is quite extraordinary" DA to HN, n.d. [c. November 10, 1968], Nemerov Papers, reprinted in *Revelations,* 339 n. 358.
 Mrs. King informed Diane DA to PC, n.d. [c. August 1969].

442 **visited him for Esquire** In a letter to Carlotta Marshall that fall, Arbus wrote, "I am supposed to do Agnew and McCarthy for Esquire." *Revelations,* 339 n. 357.
 "curious gesture" DA to HN, n.d. [c. November 10, 1968], Nemerov Papers, reprinted in *Revelations,* 195. In the original, "HowardNemerov" has no spacing.
 liked the results DA to PC, November 12, [1968].
 vague scheme Ibid., n.d. [c. late January 1968].
 sound like "sour grapes" Ibid., November 12, [1968], reprinted in *Revelations,* 339 n. 357.

443 **John Berendt, an editor . . . "depravity"** John Berendt e-mail to AL, April 25, 2013.

444 **"looks as innocent" . . . "wronged"** DA to PC, n.d. [mid-December 1968].
 "Diane liked the middle-class banality" John Berendt e-mail to AL, April 25, 2013.
 Arbus described . . . "under the bridge now" Diane Arbus, "Tokyo Rose Is Home," *Esquire,* May 1969, 168–69, reprinted in *Magazine Work,* 120–21.
 "very nicely" John Berendt e-mail to AL, April 25, 2013.
 brimming with ideas DA to PC, n.d. [late December 1968]. The photographs she took at the retirement home for old actors appear on Contact Sheets 6086 to 6090, 6095 to 6097, Hulick Photo Roster.

445 **knew someone who could help** DA to PC, n.d. [late December 1968].
 pay was generous: $5,000 *Revelations,* 203.
 stipulated that the credit AL interview with Pat Peterson, New York, NY, February 1, 2011.

Chapter 62: Flatland

447 **old tin letters** PB interview with Tina Fredericks, on October 23, [n.y.], Gotlieb Archive.
 Swedish waffle iron AL interview with Tina Fredericks, East Hampton, NY, March 23, 2011.
 metal puncher AL phone interview with Andrea Skinner, March 22, 2011.
 "It baffled me" PH e-mail to AL, June 14, 2011.

448 **"What the hell does Diane mean"** Bosworth, *Diane Arbus,* 140.
 Flatland is a fable Edwin A. Abbott, *The Annotated Flatland: A Romance of Many Dimensions* (New York, 2008), 54, 71, 100, 114–15, 127, and 193, in particular.

451 **"What's definitive is always calm"** Italo Svevo, *Zeno's Conscience* (New York: Everyman's Library, 2001), 97. Arbus recommended the book to Crookston in DA to PC, n.d. [c. early February 1969]. She had a copy of the 1948 edition of *The Confessions of Zeno* (its original title in English translation) in her possession. Doon Arbus, *The Libraries.*
 "One of the wonderful things" AL phone intervirw with John Szarkowski, August 6, 2003.

Chapter 63: Swinging London

453 **"This isnt exactly" . . . "lemme know"** DA to AA, n.d. [c. mid-June 1969], and DA to AA, n.d. [c. late June 1969], *Revelations,* 200.

453 *how to develop film* Selkirk, "In the Darkroom," in *Revelations,* 266, 269, 273.

454 *"arduous but good"* DA to AA, n.d. [c. mid-August 1969], *Revelations,* 203.
fundamentally fraternal Bosworth, *Diane Arbus,* 84.
Hillman assumed AL phone interview with David Hillman, December 17, 2014.
"I like to work for you" DA to PC, n.d. "Thursday eve." [c. June 1968].

455 *According to Eberhard, she suddenly* Schultz, *An Emergency,* 123–24.
"too verbal" . . . *rather not photograph* DA to PC, n.d. [c. mid-February 1969], partially reprinted in *Revelations,* 197.

456 *proposed two possibilities* DA to PC, n.d. [c. early February 1969].
Roy Hofheinz, a "terrible Texan" DA to PC, n.d. [April 2, 1969], reprinted in *Revelations,* 198.
posed him grinning Tex Maule, "The Greatest Showman on Earth, and He's the First to Admit It," *Sports Illustrated,* April 21, 1969, 36–37, 41, 44, 49.
New Jersey for Easter DA to PC, n.d. [c. March 20, 1969], reprinted in *Revelations,* 198.
"dirtiest secrets" DA to PC, n.d. [c. mid-February 1969], partially reprinted in *Revelations,* 198.
didn't know what she meant AL interview with PC, London, February 8, 2012.
secretaries performed stripteases DA to PC, n.d. [April 2, 1969].
"As soon as she started working" AL interview with PC, London, February 8, 2012.
wide-eyed, vacuous Lulu Helen Lawrenson, " 'Lulu's Career Is Important,' " *Nova,* January 1970, 30–33.

457 *Valentino look-alike contests* *Valentino look-alike at an audition, N.Y.C. 1963,* reproduced in *Revelations,* 232–33.
winnow a short list AL phone interview with Margaret Pringle, April 10, 2012.
Arbus's inspired notion AL phone interview with David Hillman, December 17, 2014.
it resembled the sort Pauline Peters and Margaret Pringle, "People Who Think They Look Like Other People," *Nova,* October 1969, 66–71. The portrait of the Queen wannabe and an outtake of a Winston Churchill impersonator appear in *Magazine Work,* 130–31, and *Revelations,* 198. The statement in *Revelations* that the Churchill picture appeared in *Nova* is mistaken. Maxine Kravitz, a friend of Marvin Israel's, tinted the photograph. DA to PC, n.d. [July 11, 1969]. See also *Revelations,* 198.
coatings of Jordan almonds AL phone interview with Maxine Kravitz, January 13, 2015.
Arbus sympathetically propped up AL phone interview with Margaret Pringle, April 10, 2012.
"Oh, you are like Elizabeth Taylor" Peters and Pringle, "People Who Think," 70.

458 *"really sweet kids"* . . . *bright oranges and greens* AL phone interview with Peter Martin, April 16, 2012.
"cakes with cream oozing" AL interview with PC, London, February 8, 2012.
Dressed in her customary black jacket AL phone interview with Peter Martin, April 16, 2012, is the source for this account, as well as Peter Martin, "Get to Know Your Local Rocker," *Nova,* September 1969, 60–65.

459 *"donquixoteness"* DA to PC, n.d. [c. May 1969].

459 *"family album"* . . . *resembled snapshots* DA to PC, n.d. [c. May 1969],
 reprinted in *Revelations*, 198.
 "more than any published thing" Ibid., n.d. [c. late September or
 October 1969], reprinted in *Revelations*, 198.
 not received any payments Ibid., n.d. [c. late September or October 1969].
 "difficult to find subjects" AL phone interview with Michael Rand,
 July 10, 2015.
460 *with the writer Francis Wyndham* James Fox e-mail to AL, July 12, 2015.
 Fox questioned Wyndham on the author's behalf.
 a village near East Grinstead . . . *valediction* AL phone interview with
 May Eliot Paddock, March 20, 2011; AL phone interview with AE,
 March 22, 2010.
 pay a call on Pati . . . *serious illness* Pati Hill, "Fear of Not Dying,"
 unpublished manuscript; AL interviews with PH, Sens, France,
 January 20 and 23, 2011.
461 *a trendy leather shop* AL interview with PC, London, February 8,
 2012.
 surprised to receive in the mail AL phone interview with Margaret
 Pringle, April 10, 2012.

Chapter 64: Asylum

465 *"turning to Rolleis and Portriga"* DA to AA, n.d. [c. mid-June 1969],
 published in *Revelations*, 201.
 at nudist colonies Westbeth class transcript, 37.
 carnival sideshows . . . *strobe-lit close-ups* Ibid., 46.
466 *met in September 1959* AL phone interview with Carlotta Marshall,
 August 8, 2003.
 quickly Adrian felt AL interview with Adrian Condon Allen, New York.
 August 12, 2003.
 Robert Condon . . . *Millicent Fenwick* AL phone interview with Carlotta
 Marshall, August 11, 2003.
 setting determined the tone The portrait of a young woman holding a
 handkerchief is *Untitled (12) 1970–71*, reproduced in *Revelations*, 282.
 Five children in a common room, N.J. 1969, *Revelations*, 292–93. The other
 referenced photographs are in *Untitled*, unpaginated. Although the
 Untitled series are all dated 1970–71, Arbus began taking them in 1969.
 Revelations, 203.
467 *Established in 1888* AL phone interview with Whelma Irby, July 16,
 2012. Irby worked at the Vineland Developmental Center for about fifty
 years, beginning in 1961. Chris Mondics, "N.J. Developmental Centers
 Brace for Huge Change," Philly.com, May 21, 2013.
 a portrait she took in 1968 *Jorge Luis Borges in Central Park, N.Y.C. 1969*,
 reproduced in *Revelations*, 283; and, with a second photograph of
 Borges with his wife, in *Magazine Work*, 118–19. The photographs were
 first published (with preference in size and placement given to the
 less interesting one with his wife) in "Editor's Guest Book" and "Three
 Poems," *Harper's Bazaar*, March 1969, 155, 238–39.
 the "ultimate photograph" IFCP lecture.
 "exhausted by the trip" DA to PC, n.d. [late April 1969].
 "all my tears" DA to PC, n.d. [postcard, late April 1969].
468 *"totally ashen"* . . . *unable to communicate* DA to PC, n.d. [late April
 1969], partially reprinted in *Revelations*, 202.
 new darkroom . . . *specifications* *Revelations*, 198.
 Diane traveled to Florida Ibid., 199.

469 *"It was romantic"* AL interview with Duane Michals, New York, NY, May 1, 2015.

week she spent DA to PC, n.d. [c. May 1969]. She was there from May 25 to June 1.

Arbus also shot *Revelations*, 199. The photographs were published in "SSA Program Circular, Public Information No. 235, Section 39-01. December 1, 1970," provided courtesy of Duane Michals. The photograph of Ratoucheff and his friend Al Krauze is reproduced in *Revelations*, 199.

"wondrously dense" Philip Norman e-mail to AL, September 5, 2012.

"a fine artist" . . . *her opinion* Philip Norman, " 'But Ladies, I Am 76 Years Old,' " *The Sunday Times Magazine* (London), October 19, 1969, 26(S)–29(S).

470 *$400 fee* The amount is noted in a letter from DA to AA, n.d. [June 6, 1969], published in *Revelations*, 199.

small exhibition of his work A small one-man show of Uelsmann's work ran at the Museum of Modern Art from February 15 to April 16, 1967. Press release, Museum of Modern Art, New York, February 15, 1967.

"go to the airport" AL phone interview with Jerry Uelsmann, April 10, 2013.

short skirt . . . wax museums AL phone interview with Douglas Prince, April 9, 2013.

471 *potbellied naked man* *Nudist man and his dog in a trailer, N.J. 1963,* Fraenkel Gallery. This photograph has been exhibited but not published.

"is that in focus?" AL phone interview with Jerry Uelsmann, April 10, 2013.

"lousy" . . . *"fraudulent"* DA to AA, n.d. [c. June 6, 1969], published in *Revelations*, 199.

best part of the Gainesville AL phone interview with Marilyn Schlott, April 13, 2013, is the source for the following paragraphs, except where specified.

Social Security submission Contact Sheet 6453, Hulick Photo Roster. The photograph of Minnie Austin and Jesse Lee Woodcock, Gainesville, FL, appears in "SSA Program Circular, Public Information No. 235, Section 39-01. December 1, 1970," courtesy of Duane Michals.

Chapter 65: Art and Money

473 *from Jean-Claude Lemagny* Jean-Claude Lemagny to DA, May 31, 1969; DA to Jean-Claude Lemagny, June 30, 1969. The correspondence between Lemagny and Arbus is housed in the Bibliothèque nationale de France in Paris and was reprinted in a limited-edition publication that accompanied the Arbus exhibition at the Jeu de Paume in Paris in 2012. Courtesy of Fraenkel Gallery, San Francisco.

474 *Julien Levy, a young* Ingrid Schaffner and Lisa Jacobs, eds., *Julien Levy: Portrait of an Art Gallery* (Cambridge, MA: MIT Press, 1998), 30–35, 80–93, 128; Julien Levy, *Memoir of an Art Gallery* (New York: G. P. Putnam's Sons, 1977), 11, 47, 59, 68, 94–96.

In 1954, Helen Gee Helen Gee, *Limelight* (Albuquerque: University of New Mexico Press, 1997); Helen Gee, *Photography of the Fifties: An American Perspective* (Tucson: Center for Creative Photography, University of Arizona, 1980), 15–16.

consignment six Arbus photographs Lee Witkin/Witkin Gallery Inc., AG

62:28/18. Center for Creative Photography, University of Arizona. The six photographs that Witkin took on October 24, 1969, are *Russian midget friends in a living room on 100th Street, N.Y.C. 1963* (incorrectly dated in the invoice as "1962," it was taken in the summer 1963 and appears on Contact Sheet 2042, Hulick Photo Roster), *Xmas tree in a living room, Levittown, L.I. 1963* (correctly dated "1962" in the invoice), *A young Brooklyn family going for a Sunday outing, N.Y.C. 1966, Identical twins, Roselle, N.J. 1967* (correctly dated as "1966"), *Patriotic young man with a flag, N.Y.C. 1967,* and *A family on their lawn one Sunday in Westchester, N.Y. 1968.*

474 *he took courage* AL phone interview with Bevan Davies, February 12, 2015.

complained to Allan DA to AA, n.d. [c. mid-June 1969], published in *Revelations,* 200.

Witkin expressed . . . She hung back Bosworth, *Diane Arbus,* 273.

475 *"being broke is no disgrace"* DA to AA, n.d. [c. late June 1969], published in *Revelations,* 200.

acquired five prints *Revelations,* 200.

for the cut-rate sum Jean-Claude Lemagny to DA, July 27, 1969; DA to Jean-Claude Lemagny, October 4, 1969; Jean-Claude Lemagny to DA, October 14, 1969; DA to Jean-Claude Lemagny, October 25, [1969].

Irving Blum had approached *Revelations,* 200, cites a letter from DA to AA, n.d. [c. mid-August 1969], reporting that Blum approached Arbus for twenty prints on behalf of a local collector who wanted to donate them to the Pasadena Art Museum. Years later, Blum believed that the collector was probably Edwin Janss Jr. AL phone interview with Irving Blum, April 29, 2013.

"I'll pray the Good Lord" Jean-Claude Lemagny to DA, October 28, 1969.

desperately needed check DA to Jean-Claude Lemagny, March 13, 1970. In that letter, Arbus complains that the payment has still not come. In an undated exchange of letters, evidently within the next two weeks, she writes back that the money has arrived.

an offer from Blum *Revelations,* 200, cites a letter from DA to AA, n.d. [c. mid-August 1969], which is the sole source for Blum offering a show and Arbus declining. For more general information about the policies of the Irving Blum Gallery, AL phone interview with Irving Blum, April 29, 2013. Also, the oral history interview with Irving Blum, May 31–June 23, 1977, conducted by Paul Cummings, in the Archives of American Art, Smithsonian Institution, Washington, D.C.

476 *"literally been somewhat ashamed"* Studs Terkel.

Friedan hated it . . . into "freaks" AL interview with Ti-Grace Atkinson, Cambridge, MA, May 20, 2013.

"plucked out the essence" Ti-Grace Atkinson e-mail to AL, October 7, 2012.

477 *"super-special spectacular"* Ibid., October 8, 2012.

destroyed most of the negatives *Revelations,* 201.

"shaky and going around" DA to PC, n.d. [July 11, 1969].

When Irma arrived AL phone interview with Irma Kurtz, October 3, 2012.

"I hang by a thread" DA to PC, n.d. [July 11, 1969].

to photograph Jacqueline Susann Sara Davidson, "Jacqueline Susann: The Writing Machine," *Harper's Magazine,* October 1969, 65–71. The photograph is reproduced in *Magazine Work,* 132–33, and *Revelations,* 200.

478 *he was embarrassed* Bosworth, *Diane Arbus,* 282.

478 *the kind of people who would wear* IFCP lecture.
 "middleaged super fag Joan Crawford fan" DA to AA, n.d. [c. early June
 1969], *Revelations,* 199. The photograph is reproduced in *Revelations,*
 201, and in *Magazine Work,* 138–39, where it is much larger.
 "a certain intransigence" DA letter to May Eliot, n.d. [c. mid-May 1969],
 published in *Revelations,* 198.
 story on two baton-twirling DA to PC, n.d. [c. early February 1969].
 by Terry Southern Terry Southern, "Twirling at Ole Miss," *Esquire,*
 February 1963, 100–105, 121.
 supremely useless art DA to PC, n.d. [c. early February 1969].
479 *"raising butterflies, or training"* Arbus's remarks on baton twirling are
 excerpted from her 1969 Notebook in *Revelations,* 201–2.
 three days in Syracuse *Revelations,* 201, Contact Sheets 6681 to 6699,
 6702, Hulick Photo Roster.

Chapter 66: Fantastic and Real

481 *If the leader commanded . . . "First Somersault"* DA to Amy Arbus, n.d.
 [c. early August 1969], *Revelations,* 340 n. 420, and reproduced on page
 205. Also, DA's notes from July 1969 in her 1969 Notebook, reproduced
 on page 204.
 Arbus conveys in a picture *Untitled (6) 1970–71,* reproduced in
 Revelations, 115.
482 *"idiots, imbeciles and morons"* DA to PC, n.d. [late December 1968].
 "strangest combination" DA to Amy Arbus, n.d. [c. early August 1969],
 published in *Revelations,* 202, and reproduced, 205.
 "often too narrow" Ann Ray Martin.
483 *people in a ballroom* They are reproduced, respectively, on pages 97
 and 40 in *Revelations.*
 slow down the shutter . . . she had done before DA to AA, n.d. [c. mid-
 August 1969], published in *Revelations,* 203.
484 *prints with a black border* Selkirk, "In the Darkroom," in *Revelations,*
 270–71.
 "black edge is what defines" AL phone interview with Peter Bunnell,
 August 22, 2003. See also Allan Arbus's statement that Diane preferred
 not to mask the defect of the enlarger, in Binet, *Diane Arbus,* 252.
 a new technique Selkirk, "In the Darkroom," in *Revelations,* 271, 273.
 "tender" DA to AA, November 28, 1969, *Revelations,* 203.
 exulted over the photographs DA to AA, November 28, 1969,
 Revelations, 203. Good examples of the soft lighting and slight blurring
 in the Halloween pictures (displaying a similarity to an aquatint) can
 be seen in *Untitled (4) 1970–71,* which is reproduced in *Revelations,*
 277, and in *Untitled (3) 1970–71,* of a woman costumed as a ghost,
 Untitled (27) 1970–71, of a masked woman in a long coat, with many
 blurred figures on the field behind her; *Untitled (31) 1970–71,* of two
 women, one in a clown suit and the other in a coat over pajamas;
 and *Untitled (26) 1970–71,* of a woman in a scarecrow costume.
 Contact Sheet 6746, which dates from Halloween 1969, on which
 these four images appear, is published in *Revelations,* 65. All of these,
 as well as other examples, are reproduced far better in *Untitled,*
 which is not paginated. Interestingly, the large blemish on the sky
 of the negatives of *Untitled (26) 1970–71,* and *Untitled (31) 1970–71,*
 apparent on the contact sheet and probably resulting from dust on
 the lens, was eliminated from the posthumous prints in *Untitled.* This
 is not in accordance with Arbus's customary practice. Also note that,

notwithstanding the titles of these Vineland pictures, they were taken in 1969. See the caption in *Revelations*, 203.

485 ***Bruegel's depiction of the blind*** The comparison between Arbus's *Untitled (7) 1970–71*, and Bruegel's *The Blind Leading the Blind* (or *The Parable of the Blind*), is made in Nemerov, *Silent Dialogues*, 16. He also, less convincingly, relates it to the painter's *Mad Meg*.
"pocketbooks seem to keep" From her 1969 Notebook, *Revelations*, 204.
Winogrand's book Garry Winogrand, *The Animals* (New York: Museum of Modern Art, 1969).
Friedlander self-published Lee Friedlander, *Self Portrait* (New City, NY: Haywire Press, 1970).

486 ***photographs of Bob Dylan*** Daniel Kramer, *Bob Dylan* (Secaucus, NJ: Castle Books, 1967).
Diane sent him a postcard AL interview with Daniel Kramer, New York, NY, August 1, 2012.
When Robert Delpire AL phone interview with Sarah Moon, June 9, 2015. Also see *Magazine Work*, 171, where Southall's source was Marvin Israel. See also John Pultz, "Searching for Diane Arbus's 'Family Album' in Her *Box of Ten Photographs*, Monograph, and *Esquire* Work" in Anthony W. Lee and John Pultz, *Diane Arbus: Family Albums* (New Haven, CT: Yale University Press, 2003), 2.
"ought to be able" DA to AA, November 28, 1969, published in *Revelations*, 203.
"I think the subject" Westbeth class transcript, 34.
Doon and Amy lauded them DA to AA, November 28, 1969, *Revelations*, 203.

487 ***Mary Frank was "stunned"*** AL interview with Mary Frank, New York, NY, April 23, 2012.
Pat Peterson found AL interview with Pat Peterson, New York, NY, February 1, 2011.
Pati Hill loved them PH e-mail to AL, May 14, 2011.
May Eliot, for instance AL phone interview with May Eliot Paddock, March 20, 2011.
Diane told Ti-Grace AL interview with Ti-Grace Atkinson, Cambridge, MA, May 20, 2013.
Lisette Model remarked AL interview with Eva Rubinstein, New York, NY, November 19, 2013.
an affectionate little hand AL interview with Nancy Grossman, Brooklyn, NY, August 1, 2013.

Chapter 67: A Dowsing Rod for Anguish

489 ***She called Pat Peterson*** DA to AA, n.d. [c. mid-November 1969], *Revelations*, 203 and 340–41 n. 426.
convinced Clay Felker DA to AA, November 28, 1969, *Revelations*, 203.
multiplicity of white-bearded Alan Levy, " 'This Ho-Ho-Ho Business,' " *Saturday Evening Post*, December 12, 1964, 20–21. Two different photographs from the same assignment were published in *Magazine Work*, 46–47. On that trip, Arbus also produced *Lady in a rooming house parlor, Albion, N.Y. 1963*, which is published in *Revelations*, 106. The photographs are misdated, and were taken in the summer 1964, following Arbus's trip to Los Angeles. The Santa pictures are on Contact Sheets 3630, 3632A, 3633A, 3635A, 3636A, 3638, 3640A, 3641A, 3643A, 3645A, 3647A, 3648A, 3649, 3652, 3653, 3654, 3656, 3658 to 3663. The lady in the rooming house is on Contact Sheet 3638. The later photographs for *New York* appear on Contact Sheets 6761 to 6766. Hulick Photo Roster.

489 *Diane wryly commented* DA to AA, November 28, 1969, published in
 Revelations, 341 n. 430.

490 *from that list, Gay Matthaei* AL phone interview with Josephine Bradley
 Bush, June 26, 2014; AL phone interview with Marcella Matthaei,
 July 23, 2014.
 the Matthaeis outdid the Nemerovs The following is based on AL
 phone interview with Marcella Matthaei, July 23, 2014, and AL phone
 interview with Konrad Matthaei, July 30, 2104. The photographs and
 the circumstances that surrounded Arbus's visit to the Matthaeis are
 discussed (with some variances from my account) in Lee and Pultz,
 Diane Arbus: Family Albums. Also, Anthony W. Lee e-mail to AL, March 5,
 1970. Marcella Matthaei kindly shared all the contact sheets, including
 those that were suppressed from publication in the *Diane Arbus: Family
 Albums* catalogue.

491 *delicate pre-Raphaelite beauty* DA to Doon Arbus, August 5, 1960,
 Revelations, 170. Diane compares her beauty to the "paintings of a
 certain art nouveauish period I can't remember the name of."
 a perfectly turned out Woman on a park bench on a sunny day, N.Y.C.
 1969, reproduced in *Diane Arbus: An Aperture Monograph*, n.p., and
 Revelations, 64.
 "I had never seen this woman" AL interview with Adrian Condon Allen,
 New York, August 12, 2003.

492 *Marvin, overwhelmed* PB interview with Helen Boigon, New York, NY,
 August 13, 1981, Gotlieb Archive.
 "motivation and the whole notion" DA to MI, March 24, 1960, published
 in *Revelations*, 341 n. 447.
 frightened by her brilliance AL phone interview with Patricia Patterson,
 June 6, 2012.
 turned to David Shainberg AL interview with Lawrence Shainberg, New
 York, NY, May 2, 2012; see also *Revelations*, 207, 340 n. 404 and 341
 n. 445.
 rejected or adjusted some of Freud's Bernard J. Paris, *Karen Horney:
 A Psychoanalyst's Search for Self-Understanding* (New Haven, CT: Yale
 University Press, 1994), 66–75; Susan Quinn, *A Mind of Her Own: The
 Life of Karen Horney* (New York: Summit Books, 1987), 221–25.

493 *observed a compulsive and indiscriminate* Paris, *Karen Horney*, 105–11.
 her personal history Ibid., 5, 16–17, 41, 45, 47, 57–59, 140, 142–43, 172.
 showy jewelry, iridescent PB interview with Helen Boigon, New York,
 NY, September 26, 1981, Gotlieb Archive.
 feet elevated . . . stroking Boigon's knee Schultz, *An Emergency*, 153, 157.

494 *lack "any comprehension"* PB interviews with Helen Boigon, New York,
 NY, August 13 and September 26, 1981, Gotlieb Archive. According to
 Schultz, Boigon was less direct when he interviewed her. She said that
 Diane "described her brother as one of her more intriguing sexual
 playmates" with a "suggestion" that their sexual relationship continued
 past childhood, but "there was no elaboration and Boigon never
 pushed it." Schultz, *An Emergency*, 162.
 Arbus gave her a print PB interview with Helen Boigon, New York, NY,
 April 2, 1982, Gotlieb Archive; Schultz, *An Emergency*, 152.
 enjoyed hearing about other patients' reactions DA to AA, January 16,
 1970, published in *Revelations*, 208.
 alluding to the duality PB interview with Helen Boigon, New York, NY,
 April 2, 1982, Gotlieb Archive.

495 *Childbirth and menstruation* Ibid., August 13, 1981, Gotlieb Archive.

495 *"Why do brilliant people"* AL interview with Deborah Turbeville, New York, NY, November 17, 2011.
whether she was benefiting DA to AA, n.d. [c. September 1969], published in *Revelations*, 207.
"not half as much fun" IFCP lecture.

496 *"sad a lot"* AL phone interview with Andrea Skinner, March 22, 2011.
mannish little boys Boy above a crowd, N.Y.C. 1956, reproduced in *Revelations*, 284, is a good example.
"I love that boy"... composing postcards and letters AL interview with Pat Peterson, New York, NY, February 1, 2011.
"I really don't like" DA to MI, n.d. [c. early January 1970], published in *Revelations*, 206.

Chapter 68: Wild Dynamics

497 *in mid-October* *Revelations*, 341 n. 427.
"a very lively person" AL phone interview with John Szarkowski, August 6, 2003.
portray subjects that recur John Szarkowski, ed., *From the Picture Press* (New York: Museum of Modern Art, 1973), 4.

498 *"get the actual killing"* Weegee, *Naked City*, 78.
"newsworthy is not photographable" John Szarkowski to Inez Garson, January 19, 1970, MoMA Exhs. Series Folder 1022.12, Museum of Modern Art exhibition files.
tentatively titled John Szarkowski to Floyd Barger, August 11, 1970, MoMA Exhs. Series Folder 1022.12, Museum of Modern Art exhibition files.
"person of acute intelligence"... manageable show John Szarkowski to Inez Garson, January 19, 1970. MoMA Exhs. Series Folder 1022.12, Museum of Modern Art exhibition files.
preferred photo research DA to AA, November 28, 1969, published in *Revelations*, 341 n. 428.
accept the job DA to John Szarkowski, November 6, [1969], MoMA Exhs. Series Folder 1022.12, Museum of Modern Art exhibition files, reprinted in *Revelations*, 203.

499 *museum obtained a grant* Mrs. Frank Y. Larkin to Walter Bareiss, February 27, 1970, and Walter Bareiss to Mrs. Frank Y. Larkin, March 4, 1970, MoMA Exhs. Series Folder 1022.12, Museum of Modern Art exhibition files. The grant was issued by the Edward John Noble Foundation, named for Mrs. Larkin's father.
four segments over eight months John Szarkowski to Inez Garson, January 19, 1970, MoMA Exhs. Series Folder 1022.12, Museum of Modern Art exhibition files.
two days a week DA to PC, n.d. [June 28, 1970].
228 photographs into eight categories The checklist of photographs in the exhibition is in MoMA Exhs. Series Folder 1022.12, Museum of Modern Art exhibition files. A partial selection, subdivided with the same categories, was included in the catalogue, Szarkowski, *From the Picture Press*.
in 1962, riding around DA to PH, n.d. [postmarked October 1, 1962], Pati Hill Collection.
supermarket robbery Westbeth class transcript, 15.
rituals and competitions Szarkowski, *From the Picture Press*, 36–37.

500 *woman lathered up* DA to PC, n.d. [June 28, 1970], reprinted in *Revelations*, 341 n. 455.

500 *requisition by Arbus for twenty-eight* An invoice from Underwood &
 Underwood News Photos was sent to John Szarkowski on August 18,
 1971, for photographs that had been ordered by Arbus. MoMA Exhs.
 Series Folder 1022.12, Museum of Modern Art exhibition files.
 created a taxonomy Westbeth class transcript, 14.
 one critic perceptively Margery Mann, "West: A Picture a Day . . ."
 Camera 35 (May 1975): 22; see also A. D. Coleman, "Recognition for the
 News Photo," *New York Times*, February 11, 1973, Section 2, 31.
501 *prim Midwestern psychologist* Judith Keller, ed., *In Focus: Weegee* (Los
 Angeles: J. Paul Getty Museum, 2005), 93.
 "cultivated" and "sterling" DA to AA and Mariclare Costello, n.d.
 [c. late October 1970], published in *Revelations*, 212.
 born Usher Fellig Miles Barth, *Weegee's World* (Boston: Bulfinch Press,
 1997), 15–17. Barth is the main source for my biographical facts on
 Weegee.
 "People pushing, shoving" DA to AA and Mariclare Costello, n.d. [c. late
 October 1970], published in *Revelations*, 212.
 strobe attachment, starkly According to Szarkowski, the photographer
 using a flash typically positioned himself twelve feet from his subject.
 Szarkowski, *From the Picture Press*, 6. Weegee is said to have focused at ten
 feet. Keller, *In Focus: Weegee*, 114.
 "looking through a keyhole" AL phone interview with John Szarkowski,
 August 6, 2003.
 "flash is something that she learned" AL phone interview with John
 Szarkowski, August 6, 2003.
502 *"he was SO good"* DA to AA and Mariclare Costello, n.d. [c. late
 October 1970], published in *Revelations*, 212.
 Thanksgiving Day balloon *Macy's Santa, November 21, 1940*, reproduced
 in Barth, *Weegee's World*, 166.
 dwarf Jimmy Armstrong *Jimmy Armstrong, c. 1943*, reproduced in Barth,
 Weegee's World, 233.
 rabidly anti-Japanese *Down with the Japs the Rats, October 18, 1942*,
 reproduced in Barth, *Weegee's World*, 180.
 movie theatre audiences . . . Washington Square Park Keller, *In Focus:
 Weegee*, 78–79, 80–81, 129.
 "wild dynamics" DA to AA and Mariclare Costello, n.d. [c. late October
 1970], published in *Revelations*, 212.
 also admired his pictures Thomas, *Lisette Model*, 83, 99.
 she owned both Doon Arbus, *The Libraries*.
503 *"debutante balls to hatchet murders"* Florence Meetze, "How 'Pop' Photo
 Crashes an Opening," *Popular Photography* 1 (December 1937): 37,
 quoted in Anthony W. Lee and Richard Meyer, *Weegee and "Naked City"*
 (Berkeley: University of California Press, 2008), 34.
 about to die . . . "so goddamn still" IFCP lecture. The photograph of the
 Warsaw ghetto Jews can be seen in the photograph of her collage wall
 published in *Revelations*, 12–13
 "photos of exploded stomachs" AL phone interview with Ruth Ansel,
 August 23, 2003.

Chapter 69: An Urban Palace

505 *"a palace you got"* DA to John Szarkowski, n.d. [c. late January 1970],
 Revelations, 207. Although it is said in an endnote to be found at the
 Museum of Modern Art, it could not be located, either in the archives
 or in the files of the Department of Photography.

505 *on January 22, 1970* *Revelations,* 207.
 fortress that once housed The description of the founding of Westbeth
 is based on interviews conducted for the Greenwich Village Society for
 Historic Preservation, by Jeanne Houck, with Joan Davidson on
 March 13, 2007; Peter Cott, March 19, 2007; Dixon Bain, April 27,
 2007; and Richard Meier, November 8, 2007; and also on Gabrielle Selz,
 Unstill Life (New York: Norton, 2014), 170–206.

506 ***Arbus was understandably grateful*** Szarkowski's role is misunderstood
 in *Revelations,* 207, to have consisted of providing her with the future
 stipend, which "helped make her new home a reality." Arbus did not
 receive her first check until five months after moving into Westbeth.
 "Best place I ever had" DA to PC, n.d. [late January 1970], reprinted in
 Revelations, 206.
 coveted duplex The apartment description is drawn from DA to AA,
 January 16, 1970, published in *Revelations,* 208; and on the author's visit
 to the apartment on June 12, 2014.

507 ***black nylon sheets*** Pati Hill, "Fear of Not Dying," unpublished
 manuscript.
 gather leftover pieces *Revelations,* 218. The description of how Arbus
 obtained the scraps comes from AL interview with the current tenant of
 the apartment, who requested anonymity.
 Saul Leiter found AL interview with Saul Leiter, New York, NY,
 December 16, 2011.
 needed a portrait . . . "The screen was a biography" AL interview with
 Saul Leiter, New York, NY, March 14, 2012.

508 ***whimsical items*** DA to PC, n.d. [late January 1970], reprinted in
 Revelations, 206.
 "spiking her tea" . . . fondled Andrea's leg AL interview with Lawrence
 Shainberg, New York, NY, May 2, 2012.

509 ***composed the successful proposal*** Model's grant proposal was called
 "Glamour: The Image of Our Image," and reads in part: "We are
 glamored daily. . . . It is both artificial and profound. It is our most
 precious export. . . . You cannot have beauty, success and happiness
 without it. Its origins are sacred and no one is immune. Marilyn
 Monroe died of it. A Christmas tree in our landscape shines with it.
 Costumes and decoration, fun and games, crime and theater, politics
 and religion follow where it leads. I want to follow this Pied Piper too:
 to photograph America's self-portrait a million times projected and
 reflected, to make the image of our image." Thomas, *Lisette Model,*
 142–43.
 "It was an amazing thing" AL phone interview with Mary Frank,
 August 11, 2003; see also *Revelations,* 341 n. 438.

Chapter 70: A Modern-Day Ingres

511 ***"softly sexy"*** Martha Weinman Lear, "The Second Feminist Wave," *New
 York Times Magazine,* March 10, 1968, 51.
 media-oriented self-promoter Maren Lockwood Carden, *The New Feminist
 Movement* (New York: Russell Sage Foundation, 1974), 90.
 "I'll only do it" Except where noted, the following account is based on
 AL interview with Ti-Grace Atkinson, Cambridge, MA, May 20, 2013.

516 ***Atkinson in front of a microphone*** Helen Dudar, "Women's Lib: The War
 on Sexism," *Newsweek,* March 25, 1970, 72.
 deplored the media . . . Atkinson quit Judith Hole and Ellen Levine,
 Rebirth of Feminism (New York: Quadrangle Books, 1971), 147.

Chapter 71: The Mexican Dwarf and the Jewish Giant

517 *Mexican dwarf, no later than 1957* The earliest photographs of Morales in Arbus's archive appear on Contact Sheets 111 and 113, and date from April or May 1957. She may have photographed him earlier at the circus, before she started numbering her contact sheets. The earliest pictures of Carmel are on Contact Sheet 848, taken in 1960, probably in early April.

"the dwarf I quite adore" DA to PH, n.d. [May 1957], Pati Hill Collection. It is possible that she had photographed Morales in previous years, before she began numbering her contact sheets, because, to judge from this letter, she already knew him.

clowning there were banal Contact Sheet 846, Hulick Photo Roster, reproduced in *Revelations,* 152.

on March 24, 1970 *Mexican dwarf in his hotel room, N.Y.C. 1970,* reproduced in *Diane Arbus: An Aperture Monograph,* n.p., and *Revelations,* 66. Although Arbus judged this to be one of her finest photographs, as evidenced by its inclusion in the boxed portfolio, it is reproduced inadequately in *Revelations* at playing-card size.

518 *he stands naked* Contact Sheets 6893A and 6893B, Hulick Photo Roster.

potbellied nudist *Nudist man and his dog in trailer, N.J. 1963,* on Contact Sheet 2021, Hulick Photo Roster.

"A seduction scene . . . the beginning" IFCP lecture. Arbus had been photographing her casual sex partners at least since 1966. *Revelations,* 170.

519 *Jewish Giant, too, reported* AL phone interview with Michael Flanagan, August 25, 2003; AL interview with Michael Flanagan, Lyme, CT, March 13, 2011.

A Jewish giant at home Reproduced in *Revelations,* 300–301.

ethnic or national identification Bogdan, *Freak Show,* 205–8.

"metaphorical family" DA to PC, n.d. [c. May 1968.]

"point of dying" . . . his plight Westbeth class transcript, 35–37.

520 *"very touching boy"* MoMA Exhs. Series Folder 821.8, Museum of Modern Art exhibition files.

"Fee fi fo fum" AL phone interview with Richard Del Bourgo, June 22, 2011.

"before my operation" Ibid.; Richard Del Bourgo e-mail to AL, April 4, 2015.

"eight foot nine" . . . "like a mountain range" Westbeth class transcript, 36.

told Gay Talese Talese, *Serendipiter's,* 73.

521 *basketball scholarships* Richard Lamparski, *Free Time,* television broadcast, January 1972.

truth was sadder The information on the Carmel family is based on a radio documentary *The Jewish Giant,* made for Sound Portraits Productions by Eddie's cousin, Jenny Carchman. It premiered on *All Things Considered* on National Public Radio, on October 6, 1999. A transcript is available at http://soundportraits.org/on-air/the_jewish _giant/transcript.php. Additional details come from AL phone interview with Jenny Carchman, March 30, 2014.

"curly-headed baby" Westbeth class transcript, 37.

strapping and handsome Two photographs are published in *Revelations,* 153. Although one photograph is identified as being taken at Hubert's, the location was probably backstage at the circus. There is no evidence that Eddie ever worked at Hubert's. The other photograph is in the

same living room that Arbus revisited ten years later. Another portrait of a younger and healthier Eddie at this time was taken by Marvin Lichtner and published in Talese, *Serendipiter's,* 74.

521 *photograph him on April* Her appointment book indicates that she took the photograph on April 10, 1970, reproduced in *Revelations,* 341 n. 449.

"Marvelous," she exulted DA to PC, n.d. [June 28, 1970], reprinted in *Revelations,* 209.

photograph portrays the family dynamic *A Jewish giant at home with his parents in the Bronx, N.Y. 1970, Revelations,* 300–301.

522 *"really can't endure"* . . . *"sneaking admiration"* Westbeth class transcript, 36–37.

"vignetting" A too-small lens hood may be responsible for the dark corners of the image. Arbus's positioning of the condenser on her enlarger in a raised position and shielding it with a black paper sleeve, because of a scratched lens, and her setting of the enlarger lens near the maximum aperture, may have added to the illumination fall-off. Hulick, "Diane Arbus's Expressive Methods," 109.

523 *"Why did it have"* Carchman, *The Jewish Giant,* as recalled by Eddie's aunt, Carchman's grandmother.

six months before "Eddie Carmel, 500-Pound Giant at Ringling Circus, Dies at 36," *New York Times,* July 31, 1972, 30. His height and genealogy are both exaggerated in his obituary.

grimaced for a moment and then said Lamparski, *Free Time.*

made her giggle Some of this material was previously published in Arthur Lubow, "The Woman and the Giant (No Fable)," *New York Times,* April 13, 2014, AR24.

Chapter 72: Almost Like Ice

527 *Israel in the fall* DA to AA, November 28, 1969, published in *Revelations,* 203.

clear receptacle could double At least some of the boxes had two holes drilled in the back, for a string or wire. AL phone interview with Jeffrey Fraenkel, April 22, 2015.

manufactured by Robert Kulicke AL phone interview with Peter Bunnell, March 27, 2013.

Kulicke's firm was retained AL phone interviews with Gideon Lewin, June 2, 2014, and April 18, 2015.

In March 1970 *Revelations,* 341 n. 448.

Bunnell spent two days AL phone interview with Peter Bunnell, March 27, 2013.

528 *using a blotter roll* DA to AA and Mariclare Costello, n.d. [c. June 1970], published in *Revelations,* 208.

"almost like ice" Philip Gefter, "In Portraits by Others, a Look that Caught Avedon's Eye," *New York Times,* August 27, 2006, AR7; see also *Revelations,* 214.

"No, no, you can't" AL phone interviews with Gideon Lewin, June 2, 2014, and April 18, 2015.

"in financial straits" DA to PC, n.d. [June 28, 1970], reprinted in *Revelations,* 210.

two ideas that he accepted Ibid.

increased her rate Ibid.

instead of the $250 Harold Hayes to DA, August 9, 1965, Harold Hayes Papers.

528 **paid her $371** Ibid., October 5, 1970.
529 **indignities it chronicled** Gina Berriault, "The Last of Life," *Esquire,* May
 1971, 118–19, 28–30.
 On May 22 *Revelations,* 341 n. 449. The photographs appear on
 Contact Sheets 6915, 6916, 6947 and 6972, Hulick Photo Roster.
 photographed Yetta Granat *The King and Queen of a Senior Citizens'
 Dance, N.Y.C. 1970,* reproduced in *Revelations,* 247. An alternate version
 appears in *Magazine Work,* 147, alongside the opening magazine spread,
 which is republished on page 146.
 "heartbreaking" AL interview with AA, New York, NY, August 14, 2003.
 Against the inclinations AL phone interview with Paul Corlett,
 February 8, 2015; AL phone interview with Gideon Lewin, June 2, 2014.
 "We extended tremendous" Jodie Ahern, "ArtsTalk: Behind the Scenes at
 the Institute," *Arts* (Minneapolis Institute of Arts) 25 (April 2002): 19.
 They insisted on it Christian Peterson interview with Ted Hartwell,
 May 18, 1993, Diane Arbus Artist File, Minneapolis Institute of the Arts;
 AL phone interviews with Dare Hartwell, May 7, 2015, and David Ryan,
 May 8, 2015. Ryan served as exhibition coordinator.
530 **including Gene Thornton** Gene Thornton, "Wicked Fun, but What Are
 They Really Like?" *New York Times,* July 26, 1970, 74.
 they changed their minds AL phone interview with Paul Corlett, February 8,
 2015; AL phone interview with Gideon Lewin, January 5, 2016.
 in the sixth and final Thornton, "Wicked Fun"; AL phone interview
 with Paul Corlett, February 8, 2015.
 Doon had started working *Revelations,* 208; Doon Arbus and Richard
 Avedon, *The Sixties* (New York: Random House, 1999).
 "more open" AL phone interview with Peter Waldman, May 20, 2015.
 Margie attended the openings AL interview with Nancy Grossman,
 Brooklyn, NY, August 1, 2013.
 three days before *Revelations,* 208.
531 **the huge prints** DA to AA and Mariclare Costello, n.d. [c. early July
 1970], published in *Revelations,* 210.
 "funny and splendid" DA to Amy Arbus, n.d. [c. early July 1970],
 published in *Revelations,* 210.
 opening-night invitations AL phone interview with Tom Arndt, April 30,
 2015; Dare Hartwell e-mail to AL, June 17, 2015.
 Avedon stick masks AL phone interview with Paul Corlett, February 8,
 2015; AL phone interview with Gideon Lewin, June 2, 2014.
 jumped fully dressed DA to Amy Arbus, n.d. [c. early July 1970],
 published in *Revelations,* 210.
 "a benediction" Ibid., August 11, 1970, *Revelations,* 211.
 "sort of lousy" DA to Amy Arbus, August 11, 1970, published in
 Revelations, 211.
 "terrible funk" DA to Carlotta Marshall, n.d. [c. November 1970],
 published in *Revelations,* 212.
 Shainberg later speculated AL interview with Lawrence Shainberg, New
 York, NY, May 2, 2012.
532 **nine years before** *The man who swallows razor blades, Hagerstown, Md.
 1961,* reproduced in *Revelations,* 234. Frames from the earlier trip
 appear on Contact Sheets 1098 to 1106, Hulick Photo Roster.
 pictures of the burlesque dancers They appear on Contact Sheets 6973 to
 6978, Hulick Photo Roster.
 circus fat man *Fat man at a carnival, Md. 1970,* Metropolitan Museum
 of Art, New York.

532 ***hermaphrodite in her trailer*** *Hermaphrodite and a dog in a carnival trailer, Md.*
 1970, reproduced in *Diane Arbus: The Aperture Monograph,* n.p.
 man, bare-chested *Tattooed man at a carnival, Md. 1970,* reproduced
 in *Revelations,* 231. The image appears on Contact Sheet 6921, Hulick
 Photo Roster.

533 ***Carlin Jeffrey, who painted*** AL phone interview with Robert Rosinek,
 April 9, 2014. The photograph was published in a catalogue for
 Christie's, Sale1713, Lot 319, Photographs, New York, October 17–18,
 2006. It appears on Contact Sheet 6878, Hulick Photo Roster.
 dominatrix with a naked middle-aged *Dominatrix with a kneeling client,*
 N.Y.C. 1970, reproduced in *Revelations,* 66. The photographs of
 the dominatrix and client appear on Contact Sheets 6907 to 6914.
 Dominatrix embracing her client, N.Y.C. 1970, is reproduced in *Revelations,*
 108.
 Sandra Reed was an albino The source for the following account is AL
 phone interview with Sandra Reed, August 6, 2003.

534 ***In an embroidered*** *Albino sword swallower at a carnival, Md. 1970,*
 reproduced in *Revelations,* 304–5. It is on Contact Sheet 6918, Hulick
 Photo Roster.
 considered including in the portfolio *Revelations,* 211.

Chapter 73: Storms

535 ***Marc Hessel was waiting*** Except where noted, the account in this
 chapter is based on AL phone interview with Marc Hessel, May 27,
 2013, and AL phone interview with Henry Wessel, May 22, 2013.

538 ***professional picture she selected*** *The Recital* is reproduced in *Silver Lining:*
 Photographs by Anne Noggle (Albuquerque: University of New Mexico
 Press, 1983), 11. Noggle's admiration for Arbus is discussed in *Silver*
 Lining by Janice Zita Grover, "Anne Noggle's Saga of the Fallen Flesh,"
 11–12, 26–27.

539 ***had his champions*** AL phone interviews with Peter Bunnell, April 29,
 2015, and May 10, 2015.
 convention of the Little People Les Krims e-mail to AL, April 24, 2015.
 formal request . . . falsely stereotyped AL phone interview with Nancy
 Grossman, May 14, 2013.

Chapter 74: It's All Chemical

541 ***She knew John Gerbino*** AL phone interview with John Gerbino, July 24,
 2015; see also Catalog, Phillips de Pury and Company, Live Auction,
 October 19, 2006, Description, Lot 183.
 "a nightmare" DA to AA, n.d. [c. early October 1970], published in
 Revelations, 341 n. 471. The photographs appeared in "Conversation:
 Ida Lewis and Rev. Albert B. Cleage, Jr.," *Essence,* December 1970,
 22–27. The one of the pastor, but not the the one of the shrine, is
 reproduced in *Magazine Work,* 140–41.

542 ***to extract the $1,000*** DA to AA, February 2, 1971, *Revelations,* 216 and
 342 n. 504.
 a check, which she tore up DA to AA, n.d. [c. June 1969], *Revelations,* 200.
 to use as needed DA to AA and Mariclare Costello, n.d. [c. December
 1970], *Revelations,* 340 n. 405.
 fortified them emotionally *Revelations,* 200.
 management grumbled AL phone interview with David Hillman,
 December 17, 2014. David Gibbs, ed., *Nova 1965–1975* (London:
 Pavillion Books, 1993), 79.

542 *didn't recognize "the cheery pensioners"* Ann Leslie, *Killing My Own Snakes* (London: Pan Books, 2009), 323.

543 *people in Arbus's photographs* Ann Leslie, "The Affluent Ghetto," *The Sunday Times Magazine* (London), January 3, 1971, 8(S)–15(S). The six pictures are published in *Magazine Work*, 142–45, with one substitution—a young couple on a chaise longue instead of the bikini-clad woman alone.

 "they might all be pleased" DA to PC, n.d. [late January or early February 1971].

 adapting her personal attitudes Westbeth class transcript, 2–3.

 she is not responding Sara Davidson, "The Happy, Happy, Happy Nelsons," *Esquire*, June 1971, 97–101, 157–68. The pictures are reproduced in *Magazine Work*, 148–49, with a photograph of Ozzie and Harriet on their bed substituted for one of them standing holding hands outdoors.

 "oddly enough the finality" DA to Carlotta Marshall, n.d. [c. November 1970], published in *Revelations*, 212.

544 *"the father looking" . . . "all chemical"* AL interview with AA, New York, NY, August 14, 2003.

 no resolution in sight DA to AA, n.d. [c. mid-September 1970], published in *Revelations*, 211.

 "Your generosity to me" Ibid., n.d. [c. early October 1970], published in *Revelations*, 211.

Chapter 75: Old Photographs, New Camera

545 *Avedon bought . . . different bonus photograph* *Revelations*, 220.

 start peddling DA to AA, n.d. [c. early October 1970], published in *Revelations*, 212; DA to AA and Mariclare Costello, n.d. [c. mid-December 1970], published in *Revelations*, 214.

 Ted Hartwell tried AL phone interview with Tom Arndt, April 30, 2015; Christian Peterson interview with Ted Hartwell, May 18, 1993, Diane Arbus Artist File, Minneapolis Institute of the Arts.

 "Dracula has been at him" DA to AA and Mariclare Costello, n.d. [c. late April 1971], published in *Revelations*, 218.

546 *Feitler's colleague Ruth Ansel* AL phone interview with Ruth Ansel, August 23, 2003.

 the actress Estelle Parsons AL interview with Estelle Parsons, New York, NY, February 12, 2015.

 Paul told Pati he hated Pati Hill, "Fear of Not Dying," unpublished manuscript.

 phoned Barbara Jakobson AL interview with Barbara Jakobson, New York, NY, April 10, 2015.

 disposed of one to Jasper Johns AL phone interview with Irving Blum, April 29, 2013.

 Arbus at the time reported DA to AA, n.d. [c. mid-May 1971], published in *Revelations*, 220.

 Johns remembered buying it Jasper Johns e-mail to AL, May 5, 2015.

 delivered each box personally *Revelations*, 220. This was confirmed by Jasper Johns e-mail to AL, May 5, 2015.

 purchased by the Fogg Art Museum Davis Pratt to DA, December 10, [1970]; Davis Pratt to Doon Arbus, Ianuary 5, 1972; Doon Arbus to Davis Pratt, January 7, 1972, Invoice, March 22, 1972; Diane Arbus Artist File, Harvard Art Museums. The purchase price was $1,000.

 scripts on a sheet of vellum Reproduced in *Revelations*, 222, and discussed on page 208.

547 **"in wrapping paper"** AL interview with PH, Sens, France, December 18, 2011.

contrasts through dodging and burning Neil Selkirk, the only person authorized to print Arbus photographs for sale or exhibition after her death, wrote that she never dodged or burned. Selkirk, "In the Darkroom," in *Revelations*, 275. But Allan Arbus demurred. "On rare occasions she dodged and burned," he said. "I know Neil Selirk wrote otherwise. When I spoke with him, he was very surprised, because he felt she never did it. It was not a great amount. Occasionally, something would need to be held back or burned in." AL interview with AA, New York, NY, August 14, 2003.

considered for the box *Revelations*, 208.

Arbus warned him AL interview with William Burback, New York, NY, May 5, 2014.

inscribe on the back Diana Emery Hulick, "Diane Arbus's Expressive Methods," *History of Photography* 19 (Summer 1995): 109. Israel told Hulick in June 1981 that the Arches paper for the title page and the vellum paper for the interleafs were materials he used in his studio.

contemplated but eliminated She wrote a caption for that photograph on the vellum sheet. *Revelations*, 222.

548 **untrue the moment she said it** Westbeth class transcript, 28.

described it, a camera discovered in Wonderland DA to PC, n.d. [late January or early February 1971], reprinted in *Revelations*, 215.

"large-scale film in a camera" AL phone interview with Paul Corlett, February 8, 2015.

"marvelous shape" . . . **"more things happening"** DA to AA and Mariclare Costello, December 6, 1970, published in *Revelations*, 213.

549 **I didnt think it counted"** DA to PC, n.d. [c. early February 1969].

she had seen Cartier-Bresson do AL interview with Michael Flanagan, Lyme, CT, March 13, 2011.

"sick of strobe" DA to AA, n.d. [c. early November 1970], published in *Revelations*, 212.

Bill Brandt and Brassaï Westbeth class transcript, 16–18.

"greater degree of reality" DA to AA and Mariclare Costello, December 6, 1970, published in *Revelations*, 213.

Chapter 76: Blood

551 **Israel had been able to dedicate** Harrison, *Marvin Israel*, 11.

paintings he produced in 1969 and 1970 Marvin Israel's paintings were seen in a storage facility, courtesy of Shelley Dowell.

552 **"sinister quiet"** Hilton Kramer, *New York Times*, October 17, 1970, 25.

"devastating loneliness" John Gruen, "Ecco, Deco!" *New York*, November 2, 1970, 63.

dollhouse furniture at B. Shackman AL phone interview with Susan Doukas, June 4, 2013.

For one diorama Marvin Israel's dioramas were seen in a storage facility, courtesy of Shelley Dowell. The one with the man in a pig mask was seen in photoreproduction.

a particularly macabre diorama AL phone interviews with Nancy Grossman, October 9, 2012, and February 25, 2013.

553 **Through Israel, they met** . . . **"the more validating"** AL interview with Nancy Grossman, Brooklyn, NY, August 1, 2013.

third at Cordier & Ekstrom His first show at Cordier & Ekstrom ran from March 1 to 26, 1966.

553 *"I never realized"* AL interview with Nancy Grossman, Brooklyn, NY, August 1, 2013.

554 *"Marvin thinks he's really"* AL interview with Michael Flanagan, Lyme, CT, March 13, 2011.

 "From my outside" . . . *"to be in"* AL interview with AA, New York, NY, August 14, 2003.

 the club Max's Kansas City The description of Max's Kansas City is based on Yvonne Sewall-Ruskin, *High on Rebellion: Inside the Underground at Max's Kansas City* (New York: Thunder's Mouth Press, 1998). See also Steven Kasher, ed., *Max's Kansas City: Art Glamour Rock and Roll* (New York: Abrams Image, 2010).

 trying to schedule AL phone interviews with Lawrence Shainberg, August 3, 2003, and February 24, 2011.

555 *"considerate, not a snob"* AL phone interview with Susan Doukas, June 4, 2013.

 Abigail Rosen, the bouncer AL phone interview with Abigail Rosen McGrath, April 13, 2014.

 "didn't want any endearments" AL interview with Lawrence Shainberg, New York, NY, May 2, 2012.

 "Hollywood type" Bosworth, *Diane Arbus,* 278. She made the remark to Studs Terkel.

 the "Englishman" (Crookston) AL phone interview with Allan Porter, May 9, 2013.

 startled and upset AL phone interview with Maxine Kravitz, January 13, 2015; AL phone interview with John Lotte, January 28, 2015.

 "so vulnerable sometimes" AL phone interview with Nancy Grossman, November 29, 2011.

556 *"God, here I am"* AL interview with Tod Papageorge, New Haven, CT, May 13, 2013.

 "be horrified" . . . *"make it public"* AL phone interview with Nancy Grossman, May 14, 2013.

Chapter 77: Aging

557 *"hated losing her looks"* AL interview with PH, Sens, France, January 21, 2011.

 "dropped into another world" AL interview with PH, Sens, France, January 22, 2011.

 "like Granny, so haggard" AL interview with Nancy Grossman, Brooklyn, NY, August 1, 2013.

 resembled Isak Dinesen AL interview with PH, Sens, France, January 21, 2011.

 Pierrot in clown makeup AL phone interview with Bruce Davidson, August 20, 2003.

 started using pancake powder AL phone interview with Robert Brown, August 13, 2003.

 "a bit theatrical" AL phone interview with Mary Frank, August 23, 2003.

558 *"whether it was Diane or Doon"* AL phone interview with Ruth Ansel, August 23, 2003.

 "often mistake . . . didn't want to know" AL phone interview with Mary Frank, August 23, 2003.

 Fredericks responded with dismay AL phone interview with Tina Fredericks, August 20, 2003.

 "putting herself in danger" AL phone interview with Nancy Grossman, July 16, 2012.

558 *taboos existed to be broken* Georges Bataille, in a book Arbus owned, referred to "the taboos bearing on incest and menstruation that are at the bottom of all our behavior patterns." If that is true, Arbus violated both. Bataille also wrote that "only the violation of a taboo can open the way" to the sacred. Georges Bataille, *Erotism: Death & Sensuality* (San Francisco: City Lights, 1986), 84, 121. Arbus owned the earlier English-language edition, which was titled *Death and Sensuality: A Study of Eroticism and the Taboo,* published in 1962. Doon Arbus, *Diane Arbus: The Libraries.*

 "gave me the impression" AL phone interview with Mary Frank, August 11, 2003.

559 *"She talked about it"* AL interview with Saul Leiter, New York, NY, March 14, 2012.

 felt she was distraught Ibid., December 16, 2011.

 "terribly admire Avedon's work" Ann Ray Martin.

 "in adoration of Dick" AL interview with Deborah Turbeville, New York, NY, November 17, 2011.

 greatest living photographer Christian Peterson interview with Ted Hartwell, May 18, 1993, Diane Arbus Artist File, Minneapolis Institute of Arts.

 "bad dream" DA to PC, n.d. [c. March 20, 1969], reprinted in *Revelations,* 197–98.

 "have a contempt" AL interview with Ti-Grace Atkinson, Cambridge, MA, May 20, 2013.

560 *confidence in her older daughter* PB interview with Helen Boigon, New York, NY, September 26, 1981, Gotlieb Archive. Boigon also told William Todd Schultz that Arbus up until the end directed most of her anger at Marvin. She rarely talked about Allan, Doon, Amy or Howard. Schultz, *An Emergency,* 150, 190.

 "Doon was the person" PB interview with Helen Boigon, New York, NY, April 2, 1982, Gotlieb Archive.

Chapter 78: Song and Dance

561 *children's fashion supplement* AL interview with Pat Peterson, New York, NY, February 1, 2011; DA to AA and Mariclare Costello, n.d. [c. mid-December, 1970], published in *Revelations,* 214.

 grant from the Ingram Merrill Foundation *Revelations,* 218.

562 *"It occurred to us both"* AL phone interview with Alvin Eisenman, July 8, 2011.

 taught the previous spring AL interview with Alvin Eisenman, Bethany, CT, November 15, 2011.

 posted flyers . . . "that mysterious thing" DA to AA and Mariclare Costello, January 11, 1971, published in *Revelations,* 214.

563 *twenty-eight at one count* DA to PC, n.d. [c. late January or early February 1971].

 "People would crowd around" AL interview with Eva Rubinstein, New York, NY, November 19, 2013.

 "I all but sing and dance" DA to AA and Mariclare Costello, n.d. [c. late January 1971], published in *Revelations,* 215.

 "Your work is fake" AL interview with Deborah Turbeville, New York, NY, November 17, 2011.

 "in awe" of her AL phone interview with Norman Bringsjord, May 9, 2013.

564 *"going on in your head"* AL phone interview with Paul Corlett, February 8, 2015.

564 *"I was mostly interested"* AL phone interview with Anne Wilkes Tucker, February 10, 2015.

 talked like Dorothy Parker AL phone interview with Barbara Kruger, November 7, 2012.

 male-female pairs AL phone interview with Norman Bringsjord, May 9, 2013.

 After blinking a few times AL interview with Eva Rubinstein, New York, NY, November 19, 2013.

 "a little bit cold" and "harsh" Westbeth class transcript, 3.

 "very hard to submit" . . . see their portraits IFCP lecture.

565 *ten sessions, ending* *Revelations,* 214.

 Turbeville sent Arbus AL interview with Deborah Turbeville, New York, NY, November 17, 2011.

Chapter 79: "Love"

567 *for $500, the concept of "love"* DA to AA and Mariclare Costello, n.d. [c. late January 1971], published in *Revelations,* 215.

 "understanding with misunderstanding" *The Art of Photography,* 110.

 "if they're performing" Westbeth class transcript, 45.

 bridal fashion . . . gay couple *The Art of Photography,* 110; see *Blind couple in their bedroom, Queens, N.Y. 1971,* reproduced in *Revelations,* 280.

 identical male twins Westbeth class transcript, 35.

568 *"incredible heart-stopping"* DA to PC, n.d. [c. late January or early February 1971], reprinted in *Revelations,* 215, and in Peter Crookston, "Extraordinary photographer Diane Arbus," *Guardian,* October 1, 2005.

 "pale white" . . . "totally knockout" Westbeth class transcript, 20–21. She described this man to Crookston in DA to PC, n.d. [c. early February, 1971], reprinted in part in *Revelations,* 215.

 stump-tailed macaque monkey DA to PC, n.d. [c. late January or early February 1971]. Arbus identified the variety of monkey in the caption she added to the eleventh photo in the portfolio purchased by Bea Feitler, which is now in the collection of the Smithsonian American Art Museum, Washington, D.C. John Jacob e-mail to AL, July 28, 2015.

 infant Doon resembled DA to PH, n.d. [1945], Estate of Diane Arbus, *Revelations,* 131. After Diane's death, Pati gave this letter to Doon. It is the one letter she received from Diane that is not in the Pati Hill Collection.

 with the monkey in two rooms Contact Sheets 7139, 7147, 7150 to 7167, 7171, Hulick Photo Roster.

569 *"terrible dodo"* Westbeth class trasncript, 16.

 Kodak Instamatic aesthetic *Woman with her baby monkey, N.J. 1971,* reproduced in *Revelations,* 217.

 placed the flash attachment close *The Art of Photography,* 110.

 Madonna and child Bosworth, *Diane Arbus,* 306.

 photographs that Bea Feitler *Revelations,* 220.

 show in Hannover . . . intervene angrily Ibid., 217–19. The portrait of Weigel is reproduced on page 218, and in *Magazine Work,* 110.

570 *Upon their return . . . "function of prophecy"* *Revelations,* 219.

 Ted Hartwell urged DA to Ted Hartwell, n.d. [May 1971]; Christian Peterson interview with Ted Hartwell, May 18, 1993, Diane Arbus Artist File, Minneapolis Institute of Arts.

 Fogg Art Museum Davis Pratt to DA, December 10, 1970; DA to Davis Pratt, February 4, 1971; DA to Davis Pratt, n.d. [received February 22, 1971], Diane Arbus Artist File, Harvard Art Museums.

570 *meeting with Philip Leider* Catalogue Note, Sotheby's, Photographs, October 16, 2004, Lot 186.

571 *he did take six* Arbus, "Five Photographs," 64.

 she "sweated" and Doon helped DA to AA, n.d. [c. mid-May 1971], published in *Rvelations*, 219.

 poetic and gnomic Arbus, "Five Photographs," 64.

572 *banana in his ear* When she first heard this joke, in fall 1960, Arbus told Israel that it expressed "the real secret" of the eccentrics she was photographing. DA to MI, n.d. [c. early November 1960], published in *Revelations*, 343 n. 522. She included the joke, in a slightly different telling, in Arbus, "The Full Circle," *Infinity*, 9.

 treasure a motto 1940 Autobiography.

 free advertisement *Artforum* 9 (June 1971): 9; DA to Ted Hartwell, n.d. [May 1971], Diane Arbus Artist File, Minneapolis Institute of Arts.

 in the Best Bets column "Best Bets," *New York*, May 31, 1971, 45.

Chapter 80: A Woman Passing

573 *elegant, middle-aged woman* *A woman passing, N.Y.C. 1971*, reproduced in *Revelations*, 351.

 not so different *Woman in a floppy hat, N.Y.C. 1971*, reproduced in *Revelations*, 67; *Woman with white gloves, N.Y.C. 1963*, reproduced in *Revelations*, 59.

574 *"it will change things"* DA to PC, n.d. [c. late January or early February 1971], reprinted in *Revelations*, 215.

 traditional subjects *Young man in a trench coat, N.Y.C. 1971*, and *Blonde girl with a hot dog in the park, N.Y.C. 1971*, reproduced in *Revelations*, 221. The trench-coated man bears a family resemblance to *Young man in a baggy suit, N.Y.C. 1961*, *Revelations*, 56. Using the Mamiya, Arbus that year shot the closely related photograph, *A young man and his girlfriend, N.Y.C. 1971*, *Revelations*, 66–67. The picture of the young couple evokes the Washington Square Park portraits.

 she visited blind couples DA to PC, n.d. [c, late January or early February 1971].

 people sleeping in the same bed AL phone interview with Richard Lamparski, May 1, 2014.

 Elgin cinema in Chelsea *An empty movie theater, N.Y.C 1971*, in *Revelations*, 215. Contact Sheets 7127 and 7143, Hulick Photo Roster.

575 *no gratification from photography* AL phone interview with Nancy Grossman, March 13, 2012.

 brain was deteriorating AL phone interview with Peter Bunnell, March 27, 2013.

 "gave her nothing back" PB interview with Helen Boigon, August 13, 1981, Gotlieb Archive.

 "in so much pain" AL phone interview with Bunny Sellers, August 21, 2003.

 deeply distressed AL phone interview with Sonia Gechtoff, October 15, 2012.

 "in and out of the conversation" AL phone interview with Athos Zacharias, New York, NY, June 13, 2014.

 "Yes, if I get paid" AL interview with David Gillison, New York, NY, July 10, 2014.

576 *freelancer's rollercoaster* DA to AA, n.d. [c. mid-May 1971], published in *Revelations*, 221.

576 *"a terrible new magazine"* Ibid.; also, AL phone interview with John Gerbino, July 27, 2015.

 Barbara Hackman Franklin Lester A. Barrer and Myra E. Barrer, "Barbara Hackman Franklin, President Nixon's New Woman," *New Woman,* October 1971, 36–38, 106, 108. The photograph is on pages 36–37.

 Paul Lepercq Eleanor Prescott, "Paul Lepercq, New Woman's New Man," *New Woman,* November 1971, 72–73, 96. The photograph is on page 73.

 animated conversation while simultaneously AL interview with Ti-Grace Atkinson, Cambridge, MA, May 20, 2013.

577 *Calling on Greer at the Chelsea* Germaine Greer, "Wrestling with Diane Arbus," *Guardian,* October 7, 2005. In a slightly different recollection, Greer recounted a similar session, but told Patricia Bosworth that Arbus did talk during the shoot, asking "all sorts of personal questions." Bosworth, *Diane Arbus,* 314.

 "fun and is terrific looking" DA to AA, n.d. [c. mid-May 1971], published in *Revelations,* 220. The story never ran. A photograph from the session was reproduced as *Feminist in her hotel room, N.Y.C. 1971, Revelations,* 302.

 "bold lusty funny" DA postcard to John Gerbino, n.d. [c. mid-May 1971], John Gerbino Collection.

 she recoiled AL phone interview with John Gerbino, July 27, 2015.

 "a lousy page" DA to AA, n.d. [c. mid-May 1971], published in *Revelations,* 220.

 portraits of world leaders Ibid., n.d. [c. February 1971], *Revelations,* 217.

 "ex-champions" DA to PC, n.d. [c. late spring 1971].

 "heavyweights" DA to AA, n.d. [c. mid-May 1971], published in *Revelations,* 221.

 a framed print *Revelations,* 219.

 chose it for the banner AL phone interview with Erica Magnus, May 3, 2015.

578 *memorializing the nuptials* DA to PC, n.d. [c. mid-June 1971], reprinted in *Revelations,* 221, 223, is the source for this account of the Nixon wedding.

579 *whereabouts of the negatives* *Revelations,* 343 n. 534.

 told Estelle Parsons AL interview with Estelle Parsons, New York, NY, February 12, 2015.

 a low moment AL interview with Ti-Grace Atkinson, Cambridge, MA, May 20, 2013.

Chapter 81: You Can't Come In

581 *Allan Porter, the editor* AL phone interview with Allan Porter, May 9, 2013. Some of this information (although not the story about Doon) is included in Allan Porter, "A Visit with Diane Arbus—On a Hot Summer Day in New York, One Month Before Her Death," available on Porter's website at artmedia.ch/porter.

 the book edition August Sander, *Menschen Ohne Maske* (Frankfurt and Lucerne: Verlag C. J. Bucher, 1971).

582 *photograph that Robert Frank* The date and locale of Frank's photograph is uncertain. Although the *Exile on Main St.* art director, John Van Hamersfeld, has identified it as *Tattoo Parlor, Eighth Avenue, New York City, 1951,* the venue is unlikely and the date is impossible. Arbus's picture on the wall was taken in the late fifties. Since many of the portraits are of Hubert's performers, this was almost certainly where

Frank took the photograph. Sotheby's, Catalogue, Photographs, New York, April 13, 2010, Lot 163.

582 ***Witkin Gallery photography show*** The David Vestal show at the Witkin Gallery, the opening of which Porter attended, ran from June 9 to July 2, 1971. Lee Witkin/Witkin Gallery Inc., AG 62:61/19; AG 62:36/4; AG 62:61/17, Center for Creative Photography, University of Arizona. ***On June 20*** *Revelations*, 343 n. 537.

583 ***her standard assignments*** AL phone interview with Bill Dane, May 29, 2013. Dane is the source for the account of Arbus's week at Hampshire College, unless otherwise stated.
 visit from Amy *Revelations*, 223.
 a "euphemism" DA to AA, n.d. [c. early November 1970], published in *Revelations*, 211.
 "I fall apart" Ibid., August 29, 1970, *Revelations*, 211.

584 ***Diane photographed her daughter*** Contact Sheets 7258 to 7272, 7287, Hulick Photo Roster. She visited from May 5 to 7. *Revelations*, 219.
 "She sounds happier" DA to Carlotta Marshall, n.d. [c. November 1970], published in *Revelations*, 212.
 decamped to Woolman Hill Ralph Gardner, " 'Nobody Else Sees the Way I Do,' " *Wall Street Journal* online, March 26, 2013.
 Doon came in a car AL phone interview with Bill Dane, May 29, 2013.
 didn't take many photographs From mid-May until late July, Arbus took uncharacteristically few photographs in New York—primarily at Coney Island, the circus and the Puerto Rican Day parade—that were not on assignment. Hulick Photo Roster.
 Marvin's studio and sit AL interview with Lawrence Shainberg, New York, NY, May 2, 2012.
 paint canvases Marvin Israel's paintings from 1971 were seen in a storage facility, courtesy of Shelley Dowell.

Chapter 82: Loose Ends

585 ***Diane was obviously distraught*** The following account is based on AL interview with Nancy Grossman, Brooklyn, NY, August 1, 2013.

586 ***"How does it work?"*** AL phone interview with Nancy Grossman, April 2, 2013.
 daily high averaging . . . to 96 WeatherSpark website https:// weatherspark.com/history/31081/1971/New-York-United-States.
 "Diane couldn't bear" AL phone interview with Nancy Grossman, November 29, 2011.
 "that summer was worse" Levy, "Remembering Deeyann."
 traveled to Grand Rapids DA to PC, n.d. [c. late spring 1971], Contact Sheets 7358 to 7378, Hulick Photo Roster. Crookston thinks he never received these photographs. AL phone interview with PC, July 8, 2015.
 actor Cliff Gorman Contact Sheets 7379 to 7390, Hulick Photo Roster.
 Puerto Rican Day parade Contact Sheets 7399 to 7402, Hulick Photo Roster; "19 Police Injured at Parade Here," *New York Times,* June 14, 1971, 1, 41.
 picnic hosted on July 10 *Revelations*, 224; Contact Sheets 7391 to 7398, 7403, 7457 to 7459, Hulick Photo Roster.

587 ***Gorman in a cardinal's costume*** *Cliff Gorman in "Lenny," N.Y.C. 1971*, J. Paul Getty Museum. The print was made for *Vogue*. Paul Martineau e-mail to AL, February 8, 2016.
 particular letter that Pati Pati Hill, "Polar Bear World bis," unpublished manuscript.

587 *"Of course!" Tina said* AL phone interview with Tina Fredericks, August 20, 2003.
 "I didn't recognize" AL phone interview with Devon Fredericks, April 4, 2011. Contact sheets were viewed by the author, courtesy of Tina Fredericks.

588 *"you are really something"* DA to Tina Fredericks, n.d. [postmarked July 16, 1971], Tina Fredericks Collection.
 Lotte had never considered AL phone interview with John Lotte, January 28, 2015.
 "in bloom and strong" McQuaid/Tait interview, Episode Six.
 she told Peter Bunnell AL phone interview with Peter Bunnell, March 27, 2013.
 vigilance was unnecessary AL phone interview with Michael Putnam, August 10, 2003.
 "that was my mistake" McQuaid/Tait interview, Episode Six.

Chapter 83: Like Hamlet and Medea

589 *"afraid of dying"* PH e-mail to AL, November 25, 2011; Pati Hill, "Fear of Not Dying," unpublished manuscript.
 called "Deathbed" AL phone interview with Tom Duncan, October 15, 2012. The Westbeth suicides are discussed in Selz, *Unstill Life,* 190–93.
 "didn't want to live here" AL interview with David Gillison, New York, NY, July 10, 2014.

590 **before Marshall sailed back** *Revelations,* 224.
 concerned that Amy AL phone interview with Carlotta Marshall, August 11, 2003.
 "maybe hypothetical" Ibid., August 8, 2003.
 hid the print Nemerov, *Silent Dialogues,* 9; AL phone interview with Pamela Hadas, June 21, 2012.
 essay comparing Wordsworth Nemerov, *Silent Dialogues,* 84–86. Alexander Nemerov doesn't mention that Howard wrote that Wordsworth, unlike Blake, avoided discussing evil or sex; and that, the psychoanalyst Ella Freeman Sharpe, in Howard's paraphrasing, proclaimed that "good is whatever has nothing to do with sex, and evil is whatever has anything to do with sex." Howard Nemerov, "Two Ways of the Imagination: Blake & Wordsworth" (1967), reprinted in Howard Nemerov, *New and Selected Essays* (Carbondale and Edwardsville: Southern Illinois University Press, 1985), 147–48. This adds a suggestive gloss to Arbus's saying to Lisette Model that what she wanted to photograph was "evil."

591 *"Howard Nemerov's sister"* AL phone interview with Kathy Corley, June 14, 2012. Nemerov told this to Corley in connection with a documentary film she produced about him.
 went to bed together PB interview with Helen Boigon, August 13, 1981, Gotlieb Archive.
 intestinal surgery AL interview with Nancy Grossman, Brooklyn, NY, August 1, 2013; AL phone interview with Maxine Kravitz, January 13, 2015.
 "Who cooks?" . . . *"make it any softer"* AL phone interview with Andra Samelson, February 25, 2011.

592 **she was angry** PB interview with Helen Boigon, August 13, 1981, Gotlieb Archive.
 mainly, she was agitated PB interview with Helen Boigon, April 2, 1982, Gotlieb Archive.

592 *"have a drink"* AL phone interview with Lee Guilliatt, November 21, 2011.
Last Supper . . . *never recovered* *Revelations,* 225; AL phone interview with Elisabeth Sussman, August 25, 2003.
hexagram that was interpreted AL interview with PH, Sens, France, January 21, 2011; Pati Hill, "Fear of Not Dying," unpublished manuscript. Hill said she heard this from Doon Arbus.
slashed across her The autopsy report is published in *Revelations,* 225. The unaltered bathroom was seen by the author on June 12, 2014.
the phrase evokes The first discussion of the possible meaning of the "Last Supper" note appears in Arthur Lubow, "Arbus Reconsidered," *New York Times Magazine,* September 14, 2003, 114.

Chapter 84: Runes

595 *unable to reach her* *Revelations,* 225.
picked up the receiver, laughing AL phone interview with Lawrence Shainberg, February 24, 2011.
"difficult to comprehend" AL phone interview with Peter Waldman, May 20, 2015.
"I'm going in there" AL phone interview with Lawrence Shainberg, August 23, 2011.

596 *Thalia Selz, too agitated* AL phone interview with Sonia Gechtoff, October 15, 2012. There is a slightly variant account by Thalia's daughter in Selz, *Unstill Life,* 201.
"a lot of sadness" AL phone interview with Athos Zacharias, June 13, 2014.
an artist of Arbus's stature Selz, *Unstill Life,* 204.
"what hope did we have?" AL phone interview with Joel Meyerowitz, August 7, 2003.
Allan was in Santa Fe *Revelations,* 224.
Howard, ashen AL phone interview with David Nemerov, March 18, 2011.
Joan had known him for five years AL phone interview with Joan Elkin, June 20, 2012.

597 *not even with his closest friends* AL phone interview with Naomi Lebowitz, June 20, 2012.
"stinking drunk" AL phone interview with Joan Elkin, June 20, 2012.
drunk when he telephoned AL interview with Alisa Sparkia Moore, Ventura CA, November 10, 2012.
"It didn't surprise me" AL interview with RS, Ventura CA, March 3, 2011.
called Gertrude, crying PB interview with Gertrude Nemerov, June–July 1979, Gotlieb Archive; Bosworth, *Diane Arbus,* 37.
stayed overnight in the Shainberg home AL phone interview with Andra Samelson, February 25, 2011.
"terrible thing for Amy" AL interview with AA, New York, NY, August 14, 2003.
"a sorry occasion" Howard Nemerov, "Diane Arbus Eulogy," Nemerov Papers.

598 *"I hate intelligence"* *Fictive Life,* 92.
"Runes" "Runes" appears in *Collected Poems,* 211–18.
"fascinated with these confessions" AL interview with AA, New York, NY, August 14, 2003.
"I would give anything" AL interview with Frederick Eberstadt, New York, NY, February 1, 2011.

599 *"the sky was knowledgeable"* AL interview with Lucas Samaras, New York, NY, April 7, 2015.

In a sonnet First published in *Poetry* magazine in July 1972, it is reprinted in *Collected Poems*, 431.

"All that he was interested in" AL phone interview with Pamela Hadas, June 21, 2012.

she reminded him AL phone interview with Judith Ortiz Cofer, August 30, 2012.

"I am enraged" MI to HN, n.d. [postmarked August 2, 1971], Nemerov Papers.

600 *reading Louis L'Amour* AL interview with Lawrence Shainberg, New York, NY, May 2, 2012.

turned away Michael Flanagan AL phone interview with Michael Flanagan, August 25, 2003.

self-imposed blackness AL interview with Lawrence Shainberg, New York, NY, May 2, 2012.

guilty about Arbus's death AL phone interview with Maxine Kravitz, January 13, 2015.

what he had done was wrong AL interview with Saul Leiter, New York, NY, March 14, 2012.

"could never refuse a dare" AL phone interview with Lawrence Shainberg, August 25, 2003.

"he forgave himself" AL phone interview with Michael Flanagan, August 25, 2003.

601 *desertion infuriated Andra* AL phone interview with Andra Samelson, February 25, 2011.

"wring Marvin's neck" AL interview with Nancy Grossman, Brooklyn, NY, August 1, 2013.

Mary Frank was staying AL phone interview with Mary Frank, August 23, 2003.

"he behaved very badly" AL phone interview with Tina Fredericks, August 20, 2003.

"absolutely enraged" AL interview with PH, Sens, France, January 21, 2011.

"it's all right" Pati Hill, "Fear of Not Dying," unpublished manuscript.

"my mother was so sick" AL phone interview with May Eliot Paddock, March 20, 2011.

Robert Brown received AL interview with Robert Brown, Ojai, CA, March 2, 2011.

602 *Marvin had murdered Diane* AL phone interview with Jeanne Christopherson, February 11, 2011.

"absolutely shattered" AL phone interview with AE, January 5, 2015.

"Why are you crying" Lopate, *Portrait*, 82–83.

a greeting card arrived Lisette Model Archive, Correspondence with Students, Diane Arbus, Box 2, File 3. Lisette Model Archive, Library and Archives, National Gallery of Canada, Ottawa. Model told Peter Bunnell that Israel challenged the authenticity of the card and she had a graphologist corroborate it. AL phone interview with Peter Bunnell, March 27, 2013.

Chapter 85: Things That Nobody Would See

603 *"nothing in the art world"* AL phone interview with Anne Wilkes Tucker, February 10, 2015.

603 ***"The irony is"*** AL interview with Ti-Grace Atkinson, Cambridge, MA,
 May 20, 2013.
 closed the door AL phone interview with Anne Wilkes Tucker,
 February 10, 2015.
604 ***Money was scarce*** AL phone interview with Peter Bunnell, June 3, 2015.
 Szarkowski felt he had to produce The following account is based on AL
 phone interview with John Szarkowski, August 6, 2003.
 socialized and traveled AL phone interview with May Eliot Paddock,
 March 20, 2011. PH e-mails to AL, March 12 and 26, 2011. AL phone
 interview with Michael Flanagan, August 25, 2003.
 lunch with Michael Hoffman Szarkowski's recollection is corroborated
 by Michael E. Hoffman to Shirley C. Burden, September 11, 1972.
 Aperture Foundation Archives. In his letter to Burden, who is the
 unnamed friend in the text, Hoffman states that the initial discussions
 occurred in July. Hoffman also discussed the forthcoming publication
 and his changed opinion of Arbus's work in Hoffman to Paul Strand,
 August 21, 1972. Aperture Foundation Archives.
605 ***112 prints*** Although the press release for the exhibition states that there are
 125 prints, the checklist numbers 112. Department of Public Information
 Records, II.B.1012, Museum of Modern Art Archives, New York.
606 ***Hopps's overtures ranked high*** PB phone interview with Helen Boigon,
 November 4, 1982, Gotlieb Archive.
 Hopps gave Arbus only part USA: XXXVI International Biennial Exhibition
 of Art/Venice, June 11–October 1, 1972; Grace Glueck, "U.S. Photos and
 Movies for Biennale," New York Times, April 20, 1972, 51.
 "most audacious thing" Hilton Kramer, "Venice Biennale Is Optimistic
 in Spirit," New York Times, June 12, 1972, 45.
607 ***eagerly anticipated the wider range*** Hilton Kramer, "Arbus Photos, at
 Venice, Show Power," New York Times, June 17, 1972, 25.
 most popular photography exhibition The evidence is anecdotal, as the
 Museum of Modern Art did not keep attendance figures for exhibitions
 prior to 1980. Margaret Doyle e-mail to AL, October 23, 2015. At the
 time, the show was reported to have set a new attendance record of
 250,000 visitors. "Arbus Photography on Exhibition," St. Petersburg
 (Florida) Evening Independent, March 21, 1975, 10-B. Although there
 are no hard numbers to substantiate it, no MoMA photography show
 since The Family of Man has drawn comparable public attention, and
 the perception is widespread and most likely correct. See, for instance,
 Judith Thurman, who credits the 1972 Arbus show with "setting an
 attendance record for a solo photography exhibition," in Thurman,
 "Exposure Time," The New Yorker, October 13, 2003, 104.
 "on our hands for years" AL phone interview with John Szarkowski,
 August 6, 2003. Szarkowski recalled ordering five thousand of the
 special paperback edition for the Museum of Modern Art, New York,
 NY. His memory is corroborated by Aperture Invoice 27812 to Carl
 Moran, Museum of Modern Art, New York, NY, November 22, 1872;
 and Purchase Order, J. McElhinney, Purchasing Manager, Museum of
 Modern Art, New York, NY, to Michael Hoffman, November 30, 1972,
 Aperture Foundation, Millerton, NY.
 supplemented the first Michael E. Hoffman to Stan Aberle,
 September 29, 1972, Aperture Foundation Archive, Millerton, NY.
 "twenty times in hardcover and twenty-two times" Sarah Dansberger
 e-mail to Sarah McNear, October 22, 2015, courtesy of the Aperture
 Foundation.

607 *half a million* "Neil Selkirk Talks to Elizabeth Avedon," *L'Oeil de la Photographie,* March 18, 2015. Aperture could not supply a more precise figure.
 "tone in the exhibition . . . not just a mistake" AL phone interview with John Szarkowski, August 6, 2003.
 "knowledge of moral frailty" Szarkowski, *Mirrors and Windows,* 13.
 middle-aged man saluting *Man at a parade on Fifth Avenue, N.Y.C. 1969,* reproduced in *Revelations,* 303. It was taken at the Veterans Day parade and appears on Contact Sheet 6758, Hulick Photo Roster. In *Mirrors and Windows,* in addition to the cover it is reproduced on page 113.
 "completely relaxed acceptance" Hilton Kramer, "125 Photos by Arbus on Display," *New York Times,* November 8, 1972, 52.

608 *praised her "humor"* A. D. Coleman, "Diane Arbus: Her Portraits Are Self-Portraits," *New York Times,* November 5, 1972, Section 2, 33.
 "was not a voyeur" Peter C. Bunnell, "Diane Arbus," *Print Collector's Newsletter* 3 (January–February 1973): 129.
 "sympathy at the end" Robert Hughes, "To Hades with Lens," *Time,* November 13, 1972, 83.
 "process is sort of cruel" IFCP lecture.
 Sontag inflicted the heaviest Sontag, *On Photography,* 25–48. An almost identical version of this piece was published originally as "Freak Show" in *The New York Review of Books,* November 15, 1973.
 Israel marked his copy Courtesy of Lee Marks, who purchased some books, including Sontag's *On Photography,* from Israel's library, following his death in 1984.
 "Diane was absolutely delighted" Sheila Nevins interview with Marvin Israel, WRVR Radio, November 27, 1972. Transcript.

609 *"This woman, she knows everything"* AL interview with Eva Rubinstein, New York, NY, November 19, 2013.
 too personally expressive Citing Sontag in her essay, one critic writes disparagingly that Arbus uses the camera to produce "subjective responses that override differences in individual personalities and circumstances and transform all of her subjects into reflections of her own personal trauma." Shelley Rice, "Essential Differences: A Comparison of the Portraits of Lisette Model and Diane Arbus," *Artforum* 18 (May 1980): 70.
 deflecting the social goals Nicholas Lemann, "Whatever Happened to the Family of Man? Diane Arbus and the Death of Documentary Photography," *Washington Monthly,* October 1984, 12–18. Arbus is also credited, although less negatively and more knowledgeably, with an oversize influence on the direction of documentary photography in Julia Scully and Andy Grundberg, "Currents: American Photography Today," *Modern Photography* 44 (February 1980): 94–99, 168–70.
 distance traveled between Lewis Hine's Although he doesn't make this explicit comparison, this is very much Allan Sekula's argument, more nuanced than Sontag's, in "Dismantling Modernism, Reinventing Documentary (Notes on the Politics of Representation)," *Massachusetts Review* 19 (Winter 1978): 865. In another essay, Sekula does cite Hine's *Madonna:* Allan Sekula, "On the Invention of Photographic Meaning," *Artforum* 13 (January 1975), 44.
 threatened vindictive vandalism AL phone interview with John Szarkowski, August 6, 2003.

610 *at the behest of lawyers* A note on the removal of the two photographs

appears in "Revised Checklist, Diane Arbus, 11/7/72–1/21/73," Exhibition File, Museum of Modern Art Archives. Regarding *Two girls in identical raincoats, Central Park, N.Y.C,* there is this typed remark: "Two girls and their lawyers requested removal of this picture—both from exhibition and book (by 12.8.72 3,000 copies of book sold); in reprint of book this picture will not be included."

610 *"Naturally, I like"* Johnson, *The Pictures Are a Necessity,* 178.
611 *"After Diane became famous"* AL phone interview with John Szarkowski, August 6, 2003.
612 *"some slight corner"* Studs Terkel.

PERMISSIONS

Excerpts from *The Collected Poems of Howard Nemerov,* from *Journal of the Fictive Life,* and from unpublished letters by Howard and Peggy Nemerov are used by permission of Alexander Nemerov.

Excerpts from Patricia Bosworth's *Diane Arbus: A Biography* and from interview notes in the Patricia Bosworth Collection at the Howarrd Gotlieb Archival Research Center of Boston University are used by permission of Patricia Bosworth and the Gotlieb Center.

Excerpts from the Diane Arbus lecture on March 26, 1970, at the International Fund for Creative Photography are courtesy of Benedict Fernandez.

Excerpts from Phillip Lopate's unpublished manuscript "Portrait of Lisette Model" are used by permission of Phillip Lopate.

An unpublished letter by Marvin Israel is used by permission of Lawrence Israel and the Estate of Marvin Israel.

Excerpts from Studs Terkel's interview with Diane Arbus are used by permission of the Chicago History Museum.

Excerpts from Thomas Southall's taped interviews are used by permission of Thomas Southall.

Excerpts from unpublished manuscripts by Pati Hill are used by permission of the Estate of Pati Hill.

Excerpts from unpublished manuscripts by Alexander Eliot are used by permission of the Estate of Alexander Eliot.

Excerpts from the journals of Roy Sparkia courtesy of Alisa Sparkia Moore.

An excerpt from a letter by Norman Mailer to Diane Arbus on May 24, 1967 (copyright ©1967, 2015), is courtesy of the Norman Mailer Papers at the Harry Ransom Center and used by permission of the Wylie Agency LLC.

INDEX